I would like to thank
everyone who visited
these beautiful gardens.

CHIHULY
GARDEN INSTALLATIONS

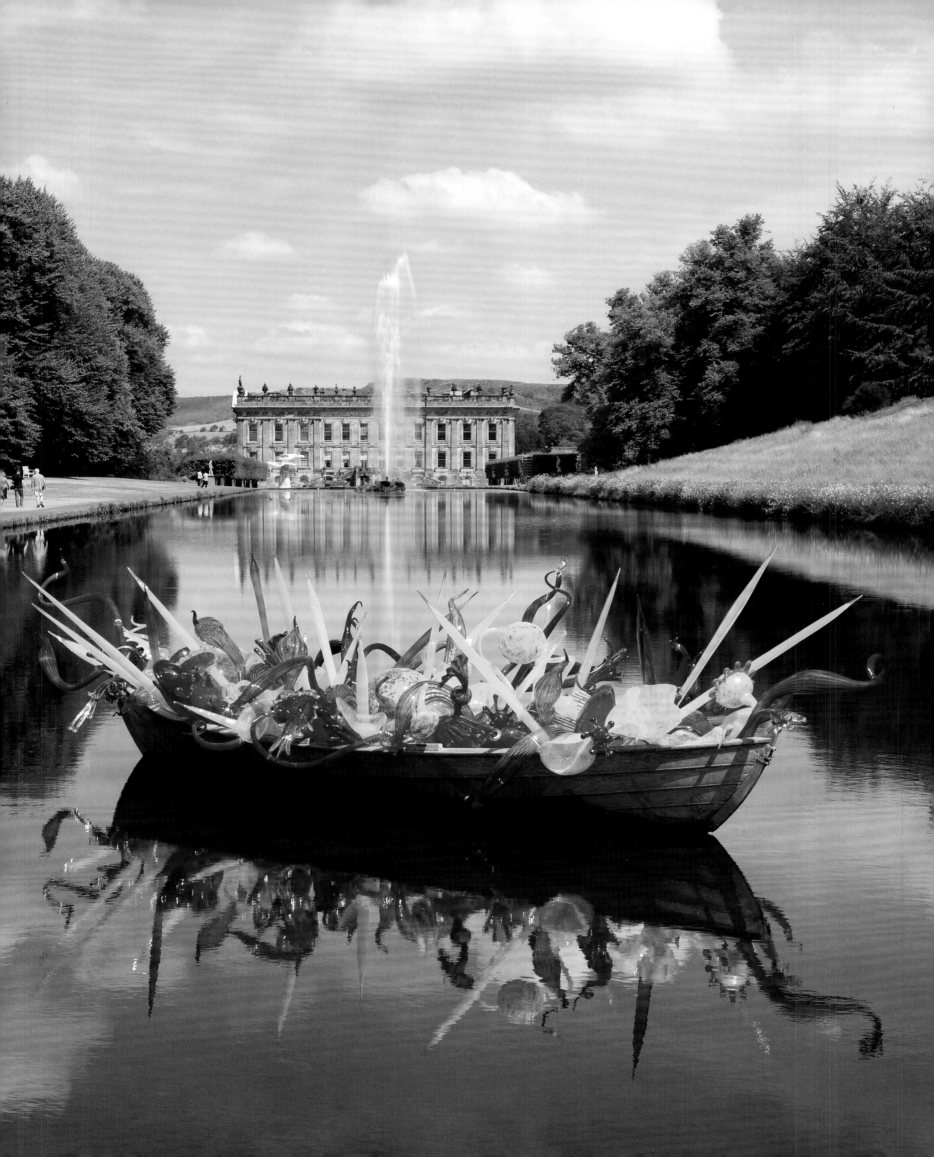

CHIHULY
GARDEN INSTALLATIONS

Foreword by Mark McDonnell
Essays by David Ebony and Tim Richardson

THE **ART OF BOOKS** SINCE 1949

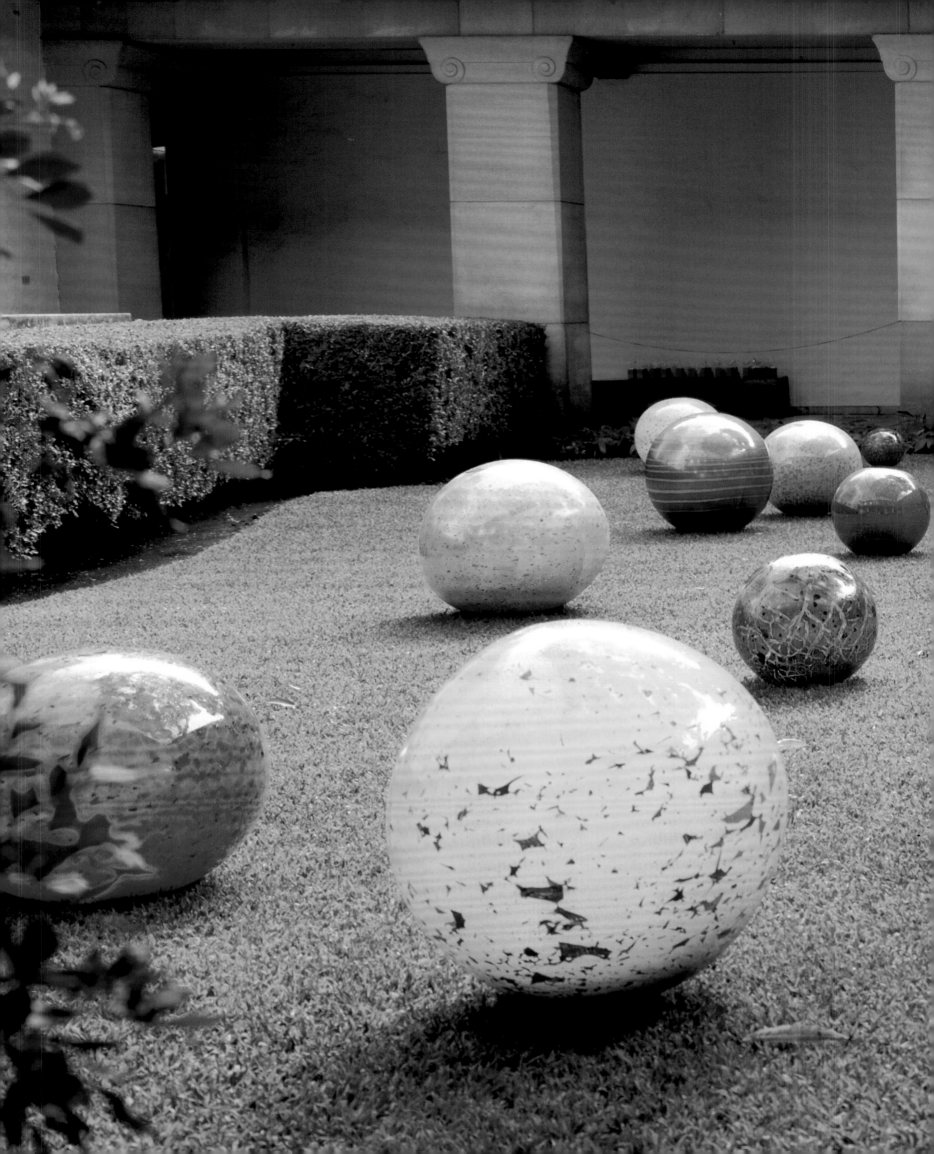

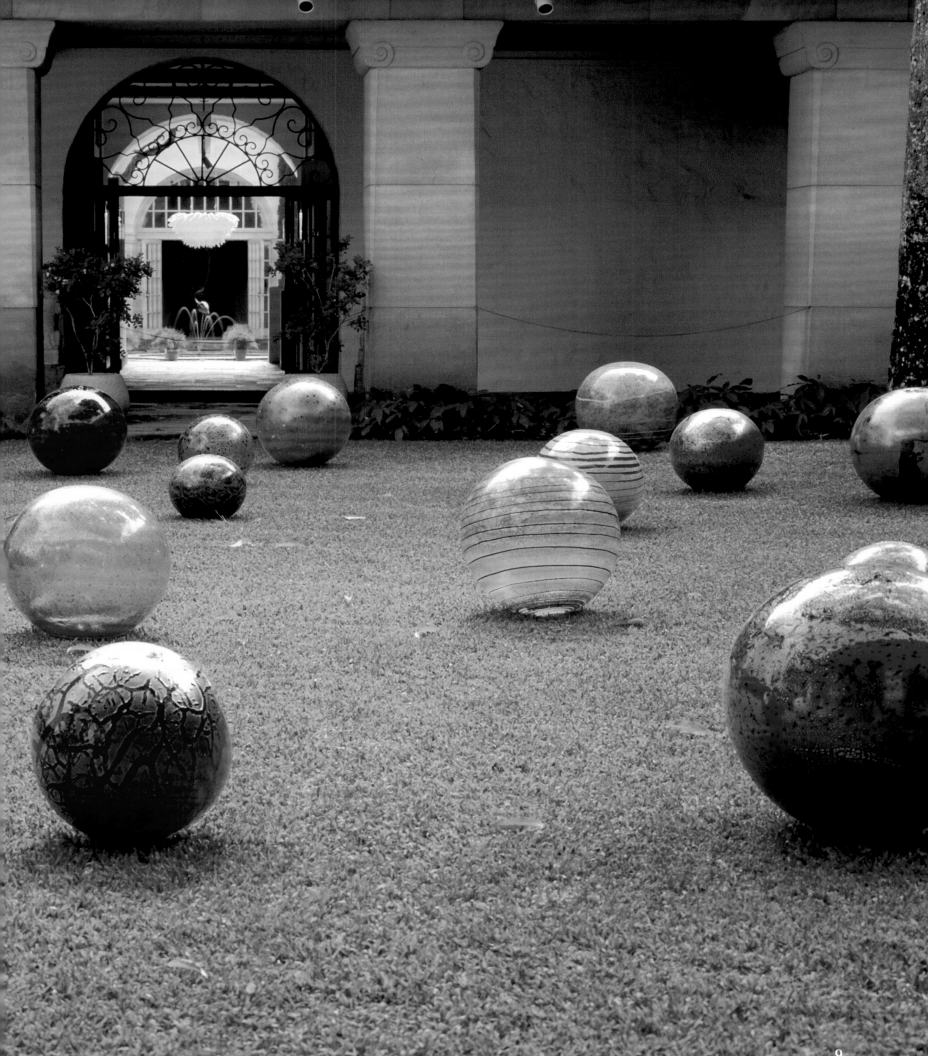

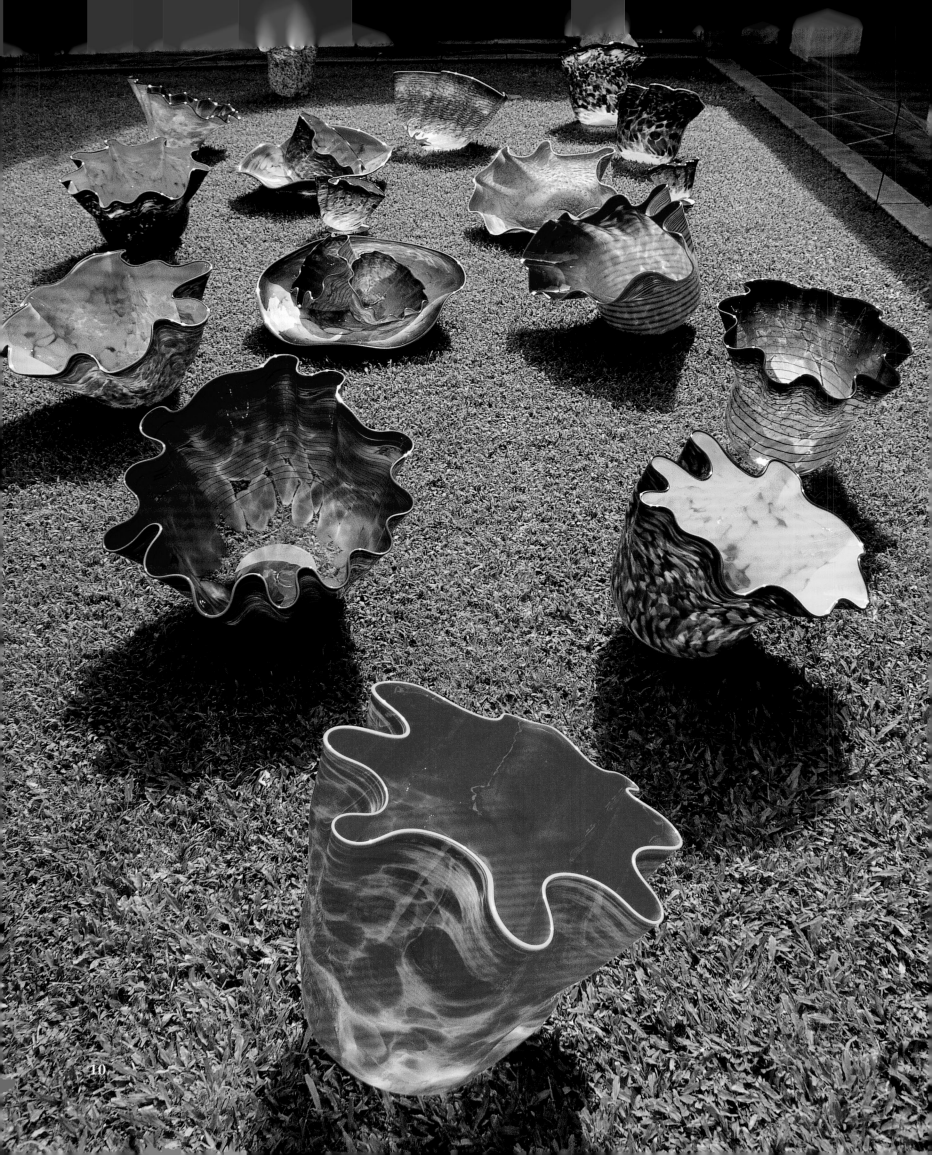

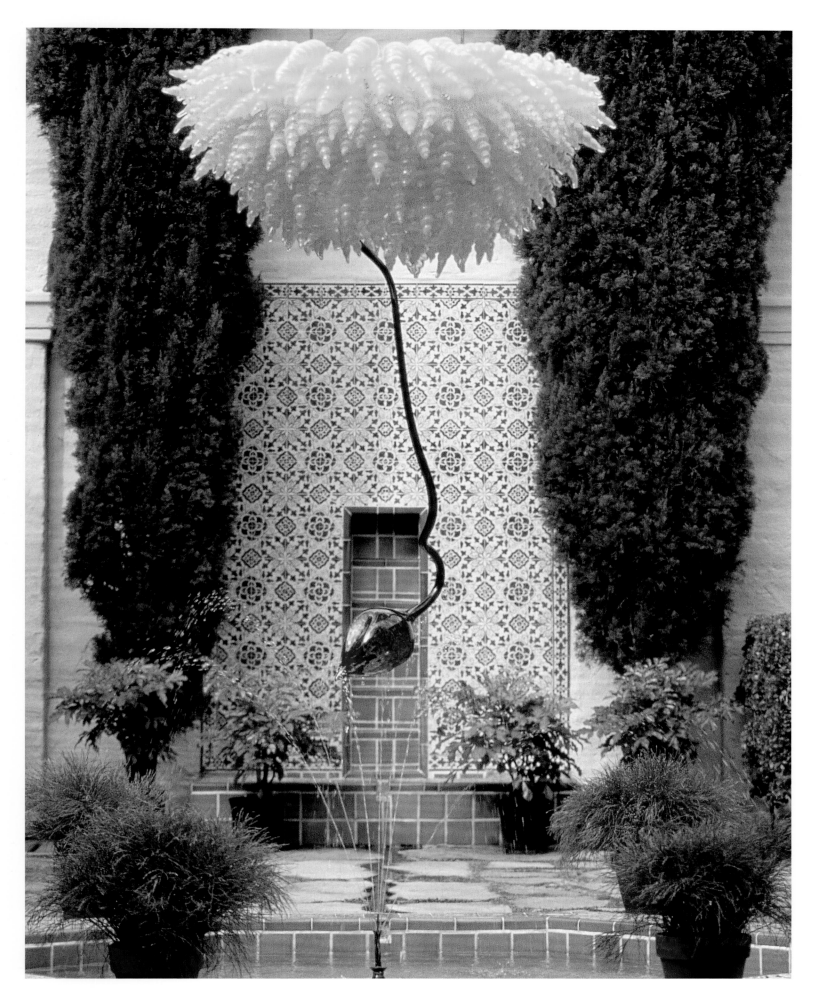

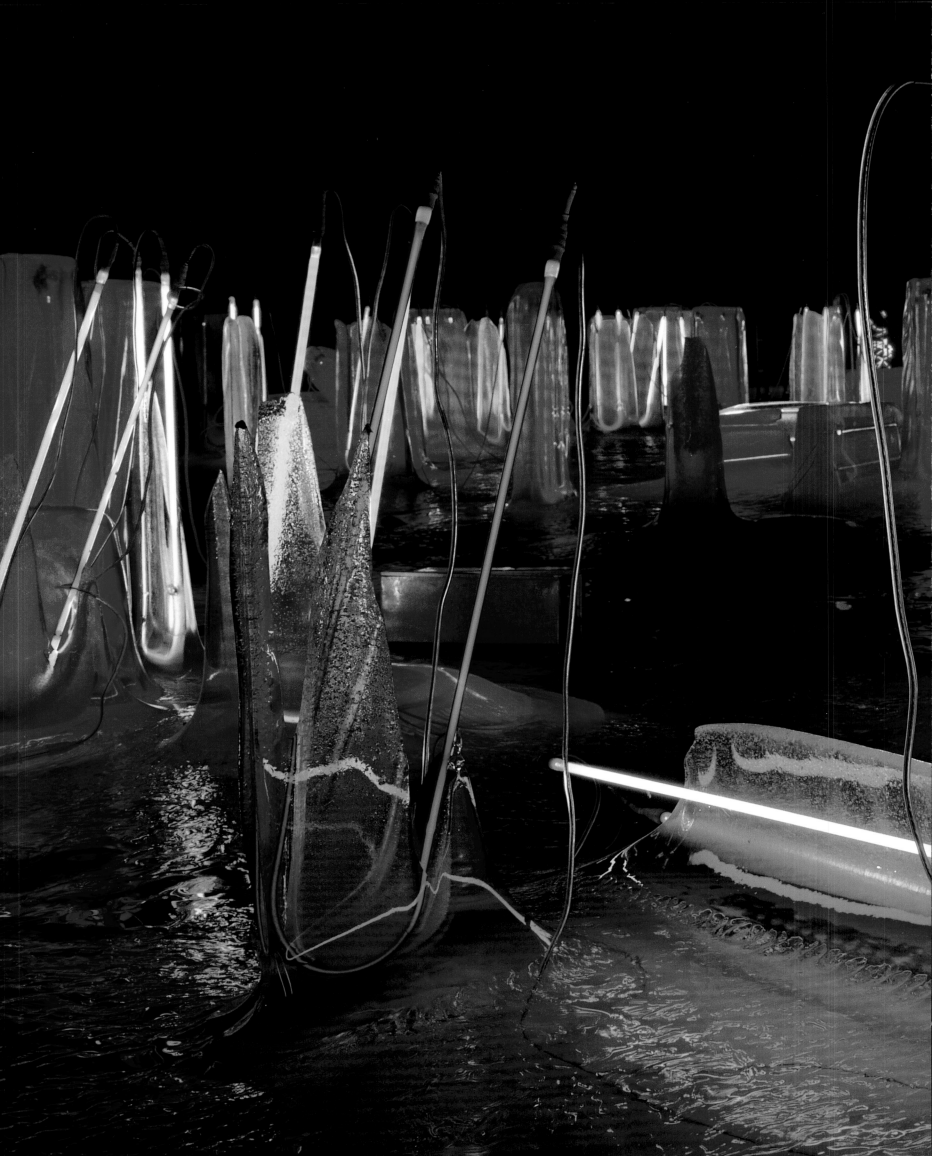

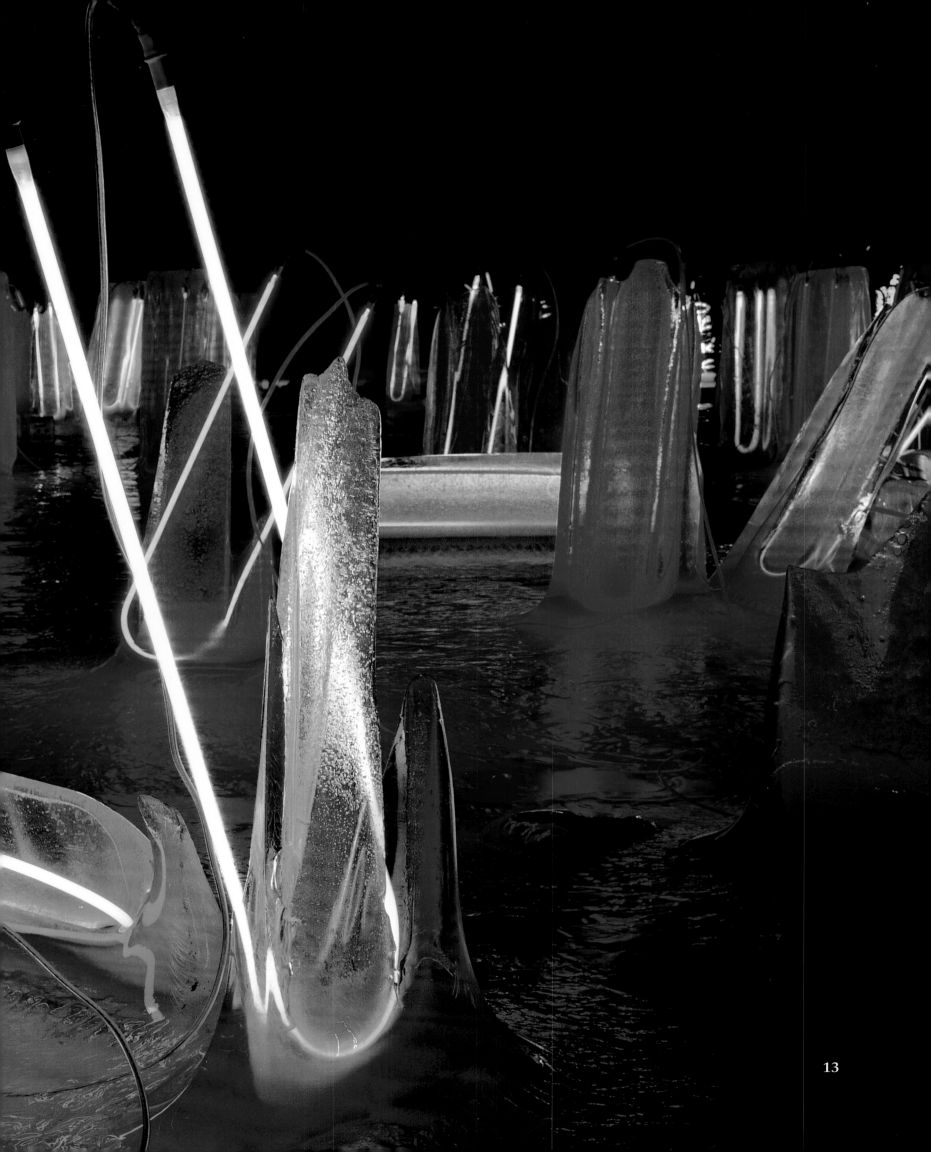

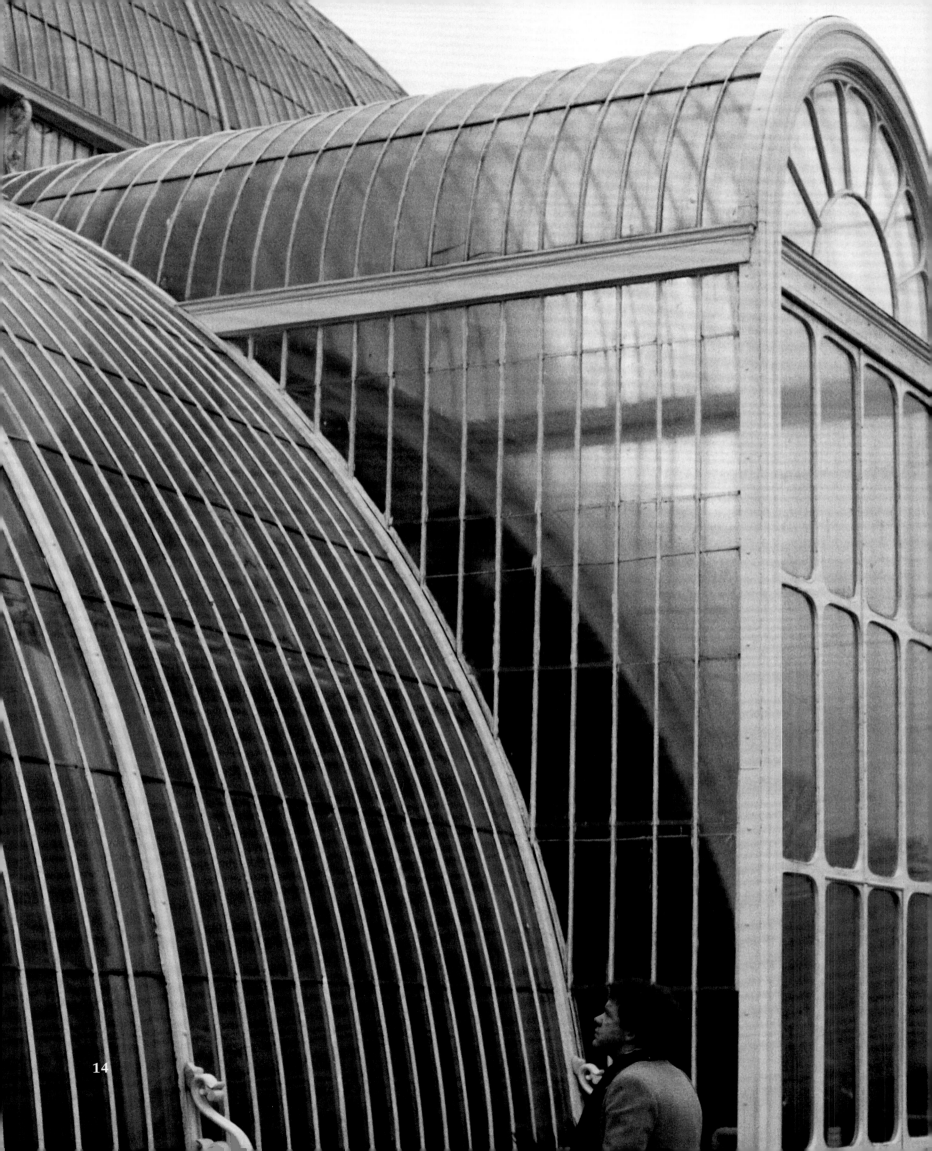

14

CONTENTS

FOREWORD

Toward a New Language of Forms

Much has been written about Dale Chihuly as a child of the Pacific Northwest. Throughout his childhood, Chihuly was touched by nature. He grew up in a middle-class neighborhood in Tacoma, Washington, in a house distinguished by his mother's garden, which featured a lawn surrounded by azaleas and rhododendrons. He has fond memories of family outings to the beach, searching for beach glass and glass fishing floats that had blown across the Pacific. Late in the afternoon, he and his mother, Viola, would often dash up the hill behind their house in time to catch the sunset. On special holidays, the family would visit the Seymour Conservatory in Wright Park to see seasonal flower shows. Still, Chihuly's interest in working in nature doesn't come solely from a deep-seated appreciation of the natural world. Other seemingly unrelated interests and discoveries over the course of his career helped set the artist on a path toward working in the grand world of conservatories and gardens.

Chihuly received a master's degree from the Rhode Island School of Design in 1968—a transformative period in the art world when everything was being questioned and challenged. Minimalism was de rigueur, but performance art, happenings, conceptual art, land art, and earthworks had also emerged as viable art movements. Many renegade artists opposed the commodification of art. They rejected the idea that museums and galleries were the only places to display and experience art. Artists were working in nature with materials often found on-site, and at times photographs were the only documentation of their work. The notion of impermanence in art, and the role of photography in documentation, resonated deeply with Chihuly.

Page 387

Pages 376–77

17

While in England in 1976, Chihuly was in a devastating automobile accident, which cost him the sight in his left eye. Remarkably, he turned his loss of depth perception into a positive. Chihuly, a very skilled glassblower, began questioning why glass objects needed to be symmetrical as they had been for the past 2,000 years, since their invention. Glassmakers often have to push, if not actually force, molten glass to make it symmetrical. Instead, using centrifugal force and the heat of the furnace, Chihuly began making forms that deliberately allowed glass to spin off-center. He invented a mode of working with the molten material that let it find its final shape in its own organic way. This approach to glassblowing places very difficult demands on glassblowers, obliging them to take their craft right to the edge, where success and failure are mere seconds apart. But Chihuly is not at all concerned with losing a piece if it creates an opportunity for something new to happen.

Starting in 1977, Chihuly spent the next fifteen years single-mindedly developing about a dozen new series, such as *Baskets*, *Seaforms*, *Macchia*, and *Persians*, that apply his asymmetrical mode of glassblowing. Many artists would have made an entire career out of just one of these vessel-based series. In Chihuly's case, the result has been some of the most beautiful glass objects ever made.

In 1992, a major exhibition at the Seattle Art Museum allowed Chihuly to reconsider his environmental installations from the early 1970s, which he had stopped making some twenty years earlier while focusing on the vessel-based series. An important development in that exhibition was the inclusion of his first *Chandelier*. The term "chandelier" is somewhat of a misnomer, since Chihuly's sculpture was not internally lit. It was a sculpture composed of hundreds of yellow glass elements attached to an armature hung from the ceiling much like a traditional chandelier, but at eye level. Chihuly was taken with the potential of this idea.

Pages 8–9

Page 10

That same year, Chihuly had an exhibition at the Honolulu Academy of Arts in Hawaii, for which he created some new environmental installations. Chihuly massed *Niijima Floats* on one courtyard lawn and *Macchia* on another. This was the first time he took work from his vessel-based series and made outdoor installations. Chihuly also re-created an ice-and-neon installation based on his 1971 *20,000 Pounds of Ice and Neon*, but in a more linear configuration. In addition, he installed his second *Chandelier*, a variant of the first yellow one, this time with a blue, pod-like stem.

Page 11

Chihuly's interest in temporary, site-specific installations continued the following year with *100,000 Pounds of Ice and Neon*, a massive work placed on an ice-skating rink in the Tacoma Dome and open to the public for three days. Ice shaped like blocks and balls, with neon tubes frozen inside, were configured at one end of the rink and left to melt; at the other end was an installation of neon that Chihuly called *Tumbleweeds*.

Pages 12–13

Chihuly was now fully committed to pursuing opportunities to create installations. To this day, he actively continues the exploration of vessel-based forms that he started in the mid-1970s. Meanwhile, Chihuly began developing a new body of work—indeed, a new language of forms—to be used in large-scale installations.

Chihuly Over Venice

In 1995, Chihuly embarked on the first of three career-defining epic projects, *Chihuly Over Venice*, which came to life in multiple venues on two continents. Chihuly explored the glass-

making cultures of Finland, Ireland, Mexico, and Italy, and the project culminated in the installation of fourteen enormous *Chandeliers*, made in these countries and mixed with glass from Chihuly's own studio, over and near the canals of Venice. Imagine someone from outside the guarded world of Venetian glassmakers creating this big event and thereby publicly redefining the chandelier, a commodity the Venetians have been mass-producing for centuries on the island of Murano. This was a bold move on his part—especially considering that up to this point, his *Chandeliers* had not met with any critical success.

Chihuly Over Venice began at the glass factory in the picturesque village of Nuutajärvi, Finland, north of Helsinki, a factory that had been established in 1793. It was able to make exciting colors; perhaps even more important, it had a long oven with a conveyor belt, which allowed Chihuly to execute handblown glass objects of unprecedented size. He worked in the facility for ten days in mid-June 1995, making a suite of *Chandeliers* as well as other forms for future works. Although the factory was fully staffed, Chihuly deployed his own team of forty people from the United States: glassblowers, installers, a registrar, a photographer, and two film crews, all coordinated by project manager Leslie Jackson.

While the first *Chandelier* was being hung in the factory, Chihuly's team built small glass installations in the village. As more and more glass was produced, the excitement grew. The summer solstice, together with increased interest in new possibilities, created a wave of energy that pushed the artist in new directions. While looking for sites, he discovered a new footbridge across the Nuutajoki. Chihuly conceived the idea of using the river as a location for temporary environmental installations.

Partially for fun and partially as a photo op, Chihuly threw some of the new glass forms Pages 24, 25, 26–27 off the footbridge and watched them float downstream while rowboats chased them. Seeing the boats return with the glass piled high, stacked like treasure, gave Chihuly further ideas. Thinking about his upcoming Venice exhibition, he installed a *Chandelier* under the town bridge. Once Page 31 this was done and photographed, the *Chandelier* was dismantled and tossed into the water. While floating downstream, it was collected and hung from a tree in a new configuration. This process continued for the rest of the week with the creation of more new glass *Chandeliers*, Pages 29, 30 boat installations, and small installations along the banks of the river. Back in the factory, fueled by loud rock and roll, glassblowers worked as fast as they could, trying to keep up with a rapid flow of new ideas.

Later in the year, Chihuly took his team to the Waterford Crystal chandelier factory in Waterford, Ireland—a factory renowned for its optically pure lead crystal and arguably the best glass cutters in the world. Chihuly focused on making *Chandeliers* for the Venice exhibition, even as new opportunities arose for other installations. On the grounds of Lismore Castle, owned by the 12th Duke of Devonshire and located overlooking the Blackwater River, Chihuly installed works in both the Upper Garden and the Lower Garden. He placed a particularly in- Pages 32, 33 teresting piece in the Vinery, a small glass conservatory for growing grapes that was designed by the renowned architect Sir Joseph Paxton, best known for London's Crystal Palace in 1851.

Chihuly had long been interested in the great nineteenth-century glass palaces, once he discovered they were clad entirely in sheets of handblown glass. He has made a point of seeking out these buildings during his travels around Europe and North America. He is particularly keen on the work of Lord & Burnham, which designed and built many of the greatest conservatories in the United States: the New York Botanical Garden, the Bronx; Phipps Conservatory in

Pittsburgh; the United States Botanic Garden, Washington, D.C.; and the Conservatory of Flowers in Golden Gate Park, San Francisco.

Pages 34, 35

In Dublin in 1995, Chihuly constructed his first exhibition inside a major conservatory—the Curvilinear Range at the National Botanic Gardens, Glasnevin, designed by Richard Turner. Together with Decimus Burton, Turner also designed the famous Palm House at the Royal Botanic Gardens, Kew, which Chihuly has described as his favorite conservatory. Glasnevin's filigree architectural jewel had just undergone a complete restoration, bringing it back to the pristine condition of opening day in 1848. With this installation, Chihuly realized the full potential for exhibiting work in an all-glass building.

The following year, Chihuly and his team traveled to Monterrey, Mexico, to work at the enormous industrial facility, Vitrocrisa. There he made *Chandeliers* and glass for future installations in bold new colors. In addition, he experimented with having glass forms silvered in their interior. Pleased with the dramatic results, Chihuly has continued incorporating silvered glass, to great effect, in subsequent installations. While in Mexico, he also constructed works in and around the factory as well as in the desert beside the foothills of the Sierra Madre.

Pages 36, 37

Chihuly Over Venice took place during the first two weeks of September 1996. A mind-boggling logistical operation was devised to move the glass and installation crews in a flotilla of various-sized boats that were needed to navigate Venice's waterways. The authorities never issued any permits, but work proceeded and all fourteen *Chandeliers* were installed as planned. It was a huge success, with an overwhelmingly positive response to the installations. *Chihuly Over Venice* was ultimately the artist's gift to a city that had shared some of its glass secrets with him when he was a young man.

Pages 38–43

A Sense of Place

Energized by the success in Venice, Chihuly moved ahead with a relentless exhibition schedule. Turned upside down, *Chandeliers* became *Towers*, their colors evolving from monochromatic to polychromatic. Other new works employed reflective gold leaf applied to the surface of glass. Chihuly also worked with optic molds to manipulate and increase the refraction of light through his glass.

Over the next five years, Chihuly executed numerous projects around the world, including an exhibition at LongHouse Reserve in East Hampton, New York, and a commission at Sleeping Lady resort in Leavenworth, Washington.

Pages 46, 47
Pages 44, 45

In 1997, he and his team blew glass and created installations both on the island of Niijima, off the coast of Japan, and at a glass factory in Vianne, France. He had an exhibition at the Ukai Museum in Hakone, Japan, and placed an informal installation in front of the Portland Japanese Garden, in Oregon.

Pages 48, 52–53
Pages 50–51
Page 49

Three years later, Chihuly participated in the *Contemporary American Sculpture* exhibition in Monte Carlo, Monaco, and created installations in Napa Valley, California, and at various sites in Australia, including the wonderful Palm House at Adelaide Botanic Garden.

Pages 60, 61

In 2001, Chihuly had a major exhibition at the prestigious Victoria and Albert Museum in London. At the entrance to the museum, under the main rotunda, he installed what may be his most sublime *Chandelier*, as well as the largest he had ever executed. It has undoubtedly been seen by more people than any other work by Chihuly in a cultural institution. Along with the

exhibition in the museum's Medieval Treasury, he also placed various outdoor installations in what was then called the Pirelli Garden.

Pages 62, 63

The success of Chihuly's installations, whether temporary or permanent, depends in great part on the tremendous care he takes to ensure that they are well conceived and sited. Generally, his installations are initially mocked up full scale in the studio. This is done with the assistance of a large team of project managers, architects, engineers, fabricators, lighting designers, installers, packers, and shippers. Such initial preparation plays a vital role in the success of an exhibition.

In the Light of Jerusalem

During this energetic period of exhibitions and installations, Chihuly embarked upon his second epic project, at the Tower of David Museum of the History of Jerusalem in Israel. Next to the Jaffa Gate in the Old City, the museum is housed in a monumental 700-year-old restored stone citadel originally built more than 2,000 years ago. Partially a ruin and partially reconstructed, the fortress is a daunting multilevel site with many vantage points from which to visualize the artwork. Chihuly visited Jerusalem five times in 1999 before deciding exactly how to approach the project. Initially, he conceived of three glass *Towers*, each one representing one of the monotheistic religions laying claim to the Holy Land. By the time the exhibition opened, however, his concept had grown into sixteen site-specific works. Installing the work required a team of forty people from the artist's studio, along with a local one of a hundred Arabs and Jews, working together for a month.

Pages 54–57

In this exhibition, Chihuly mixed large installations with smaller, more subtle works in and around the Citadel. The glass was made in the United States, France, Finland, Japan, and the Czech Republic. Chihuly also created an installation with glass made in nearby Hebron, at a small Palestinian-owned factory that had been in continuous use for 500 years. The furnaces, tools, and techniques that the glass workers used were unchanged from those employed when the factory was first founded. Chihuly decided to make the installation an homage to the birthplace of the art of glassblowing.

The extreme brightness of Jerusalem light, and the way it intensifies when reflected off the Citadel's stone walls, obliged Chihuly to take great care in selecting his colors. For the large installations, he chose white, pink, blue, and silver. Red and yellow were employed in the *Spears* and black in the *Saguaros*.

Two of the Jerusalem installations were particularly ambitious. The fifty-foot-high *Crystal Mountain* took more than six weeks to erect. Its 2,000 large pink crystals, made of a polymer that Chihuly calls Polyvitro, were particularly stunning both at sunrise and at sunset. This installation was a nod to Bruno Taut and the Crystal Chain, a little-known and short-lived German Expressionist architectural movement in 1920 that believed society could be changed if everyone lived in all-glass buildings. Chihuly returned later that year to install the *Jerusalem Wall of Ice*. For this piece, he used sixty-four tons of ice that had been shipped halfway around the world from Fairbanks, Alaska. The ice was cut and stacked like the huge blocks of stone in the Citadel walls. The installation was twelve feet high and forty feet long. Its fast-melting ice was backlit by forty stage lights with a number of different-colored gels. The work lasted only three days, due to an intense heat wave.

Pages 58–59

One of the many aspects of this project that resonated deeply with the artist was that it took place where glass was first created, almost 5,000 years ago. It is also thought to be where glassblowing began, 2,000 years ago. At the time, Chihuly considered this his most rewarding project ever.

The Garden Cycle

The Garden Cycle, the third and most ambitious of Chihuly's epic projects, builds on the strongest aspects of the first two. It consists of a group of exhibitions at a number of different sites: the extraordinary Royal Botanic Gardens, Kew, in England, and ten of the greatest gardens in the United States. When he began in 2001, Chihuly focused on working within glass conservatories. Then he moved on to botanic gardens with conservatories and finally to venues chosen by garden type: a tropical garden, a desert garden, a sculpture garden, and estate gardens. The cycle format was a brilliant way to go about reworking the original set of ideas that Chihuly established in the first exhibition, inside Garfield Park Conservatory in Chicago. Subsequent exhibitions expanded on that central theme and included new works developed for each garden, resulting in a different experience each time. It is important to note that these glass forms were not directly based on examples found in nature; they came more from the natural process of glassblowing that Chihuly and his team have explored and perfected in the hotshop.

It is not easy to work in a dialogue with nature. Plants grow, bloom, and otherwise follow their natural cycles over the course of an exhibition. Garden exhibitions can look like an afterthought when not successfully integrated with the plants. Planning these installations required lengthy discussions about plantings and their colors. For some venues, Chihuly's studio installed lighting for very popular night viewings. His glass installations were so responsive to light and the surroundings that many visitors felt as if no two visits to an exhibition produced the same experience.

Nature and natural processes do not progress in an idealized manner. In gardens and conservatories, plants are pruned, shaped, and espaliered into submission in much the same way that molten glass has been made to assume symmetrical shapes. Chihuly may have intuitively understood this when he made his own break with history and encouraged glass to drift off-center. There would almost seem to be a synergy in the way that Chihuly's forms evolve and how nature grows when left to its own devices. I suspect this helps to explain why his installations integrate seamlessly with their natural surroundings.

Mark McDonnell
Former Chairman of the Glass Department,
California College of the Arts

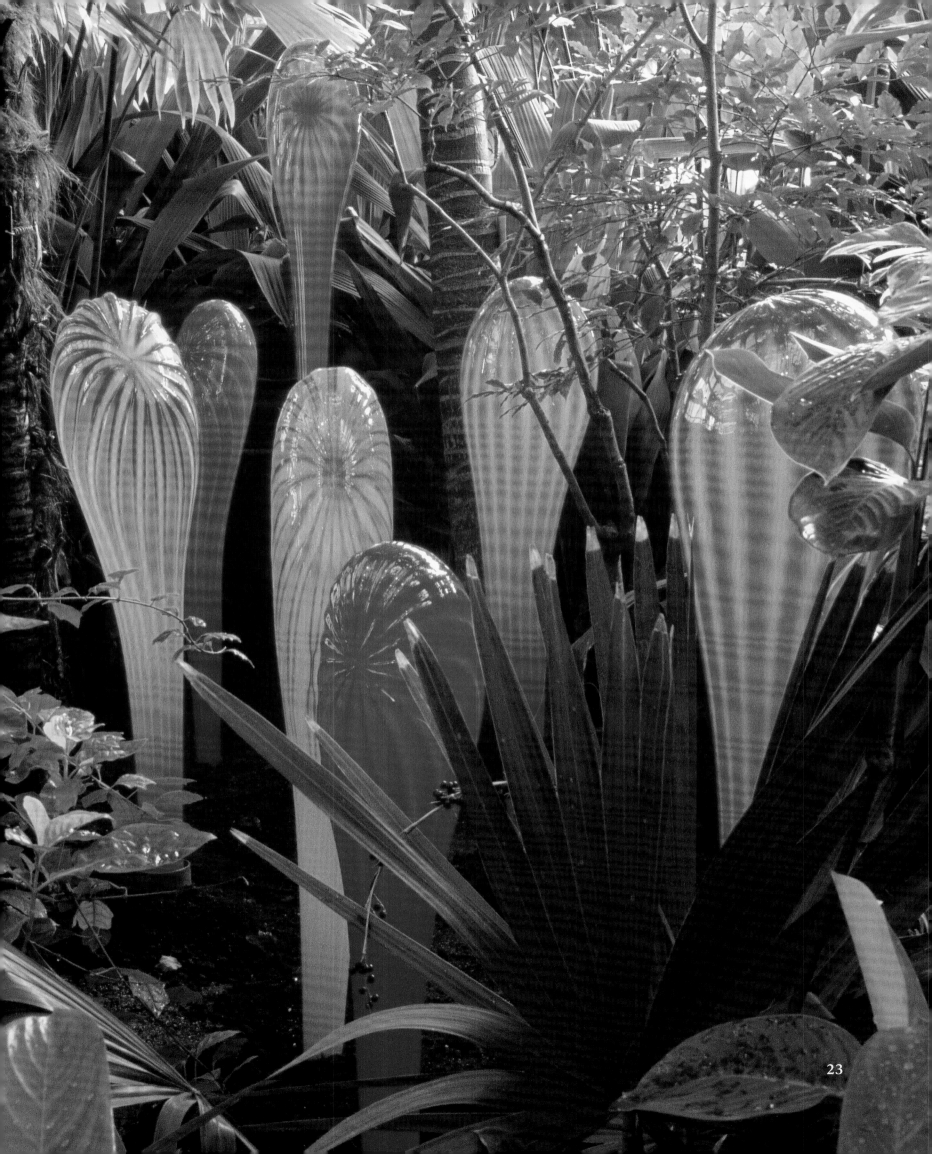

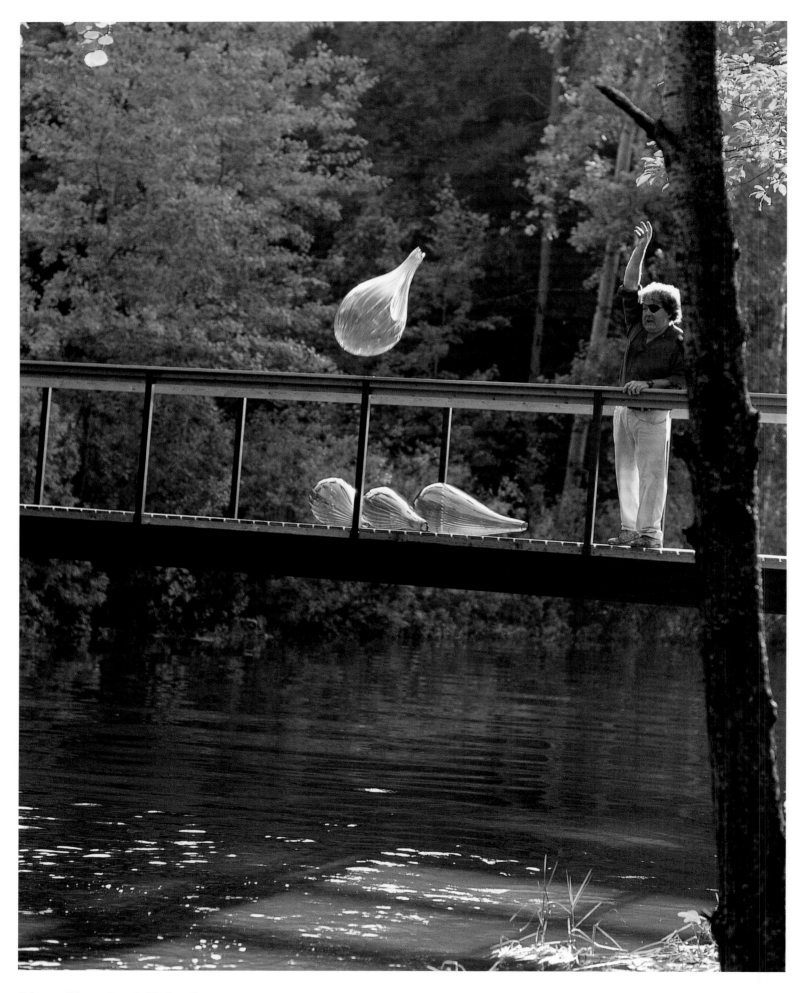

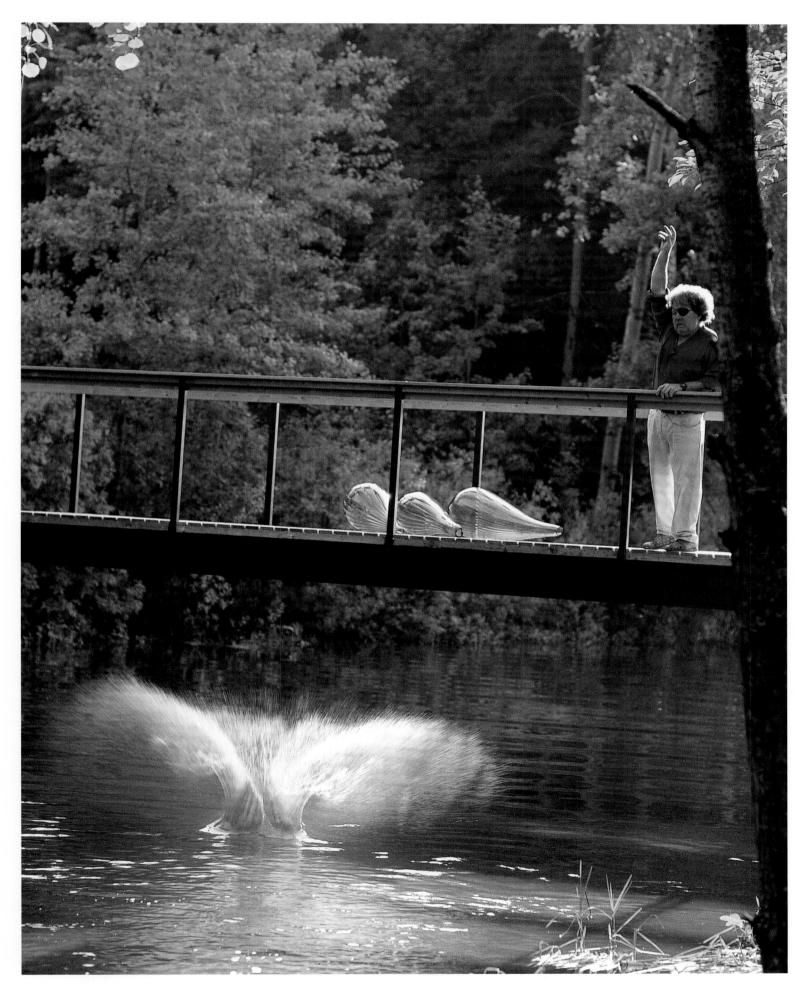

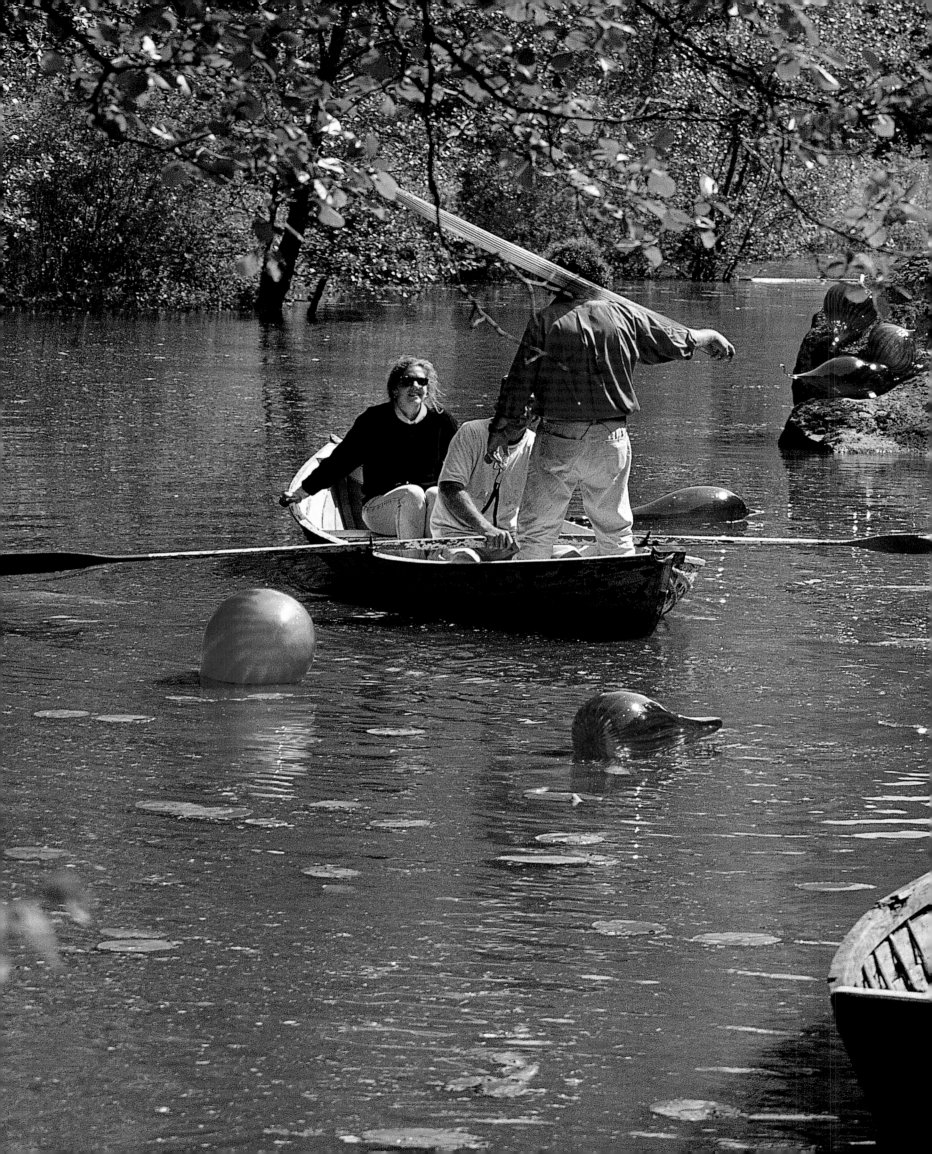

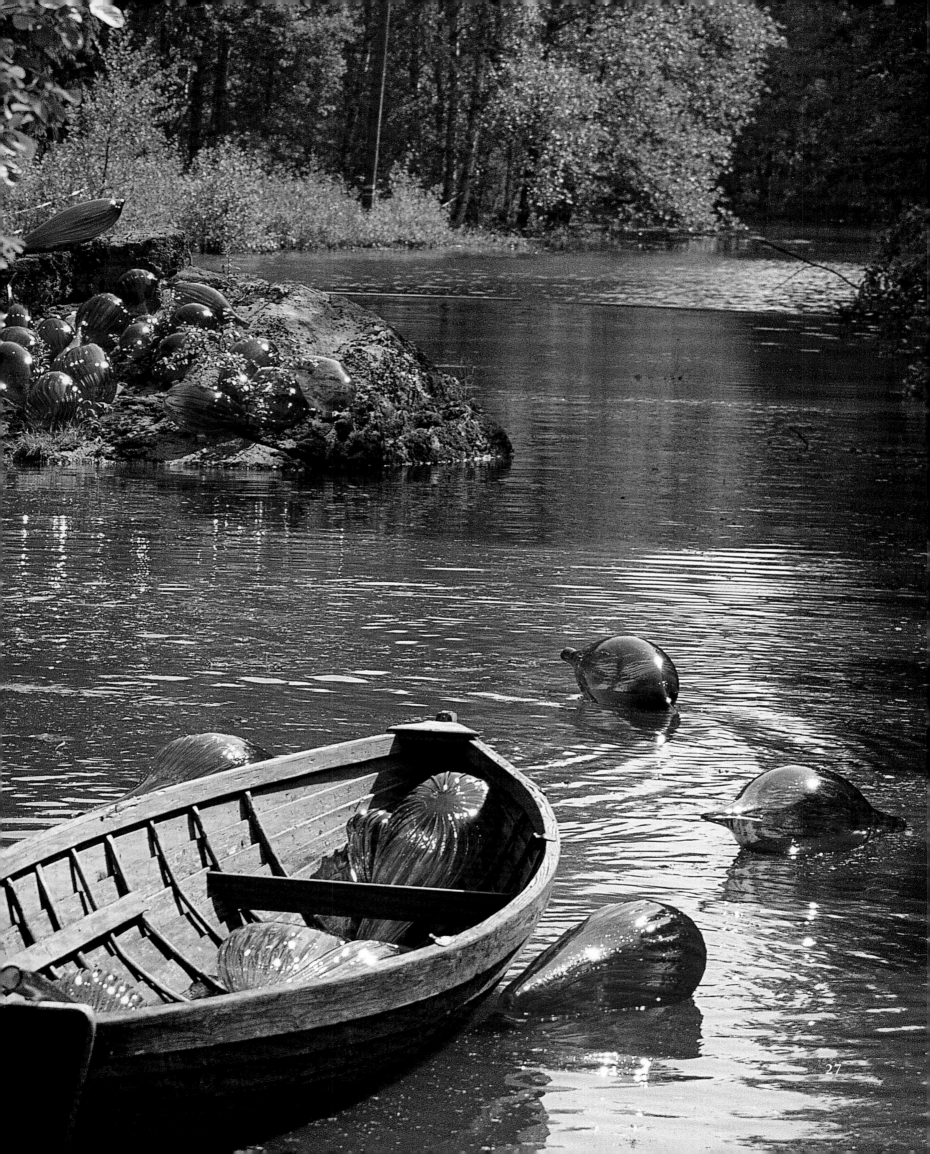

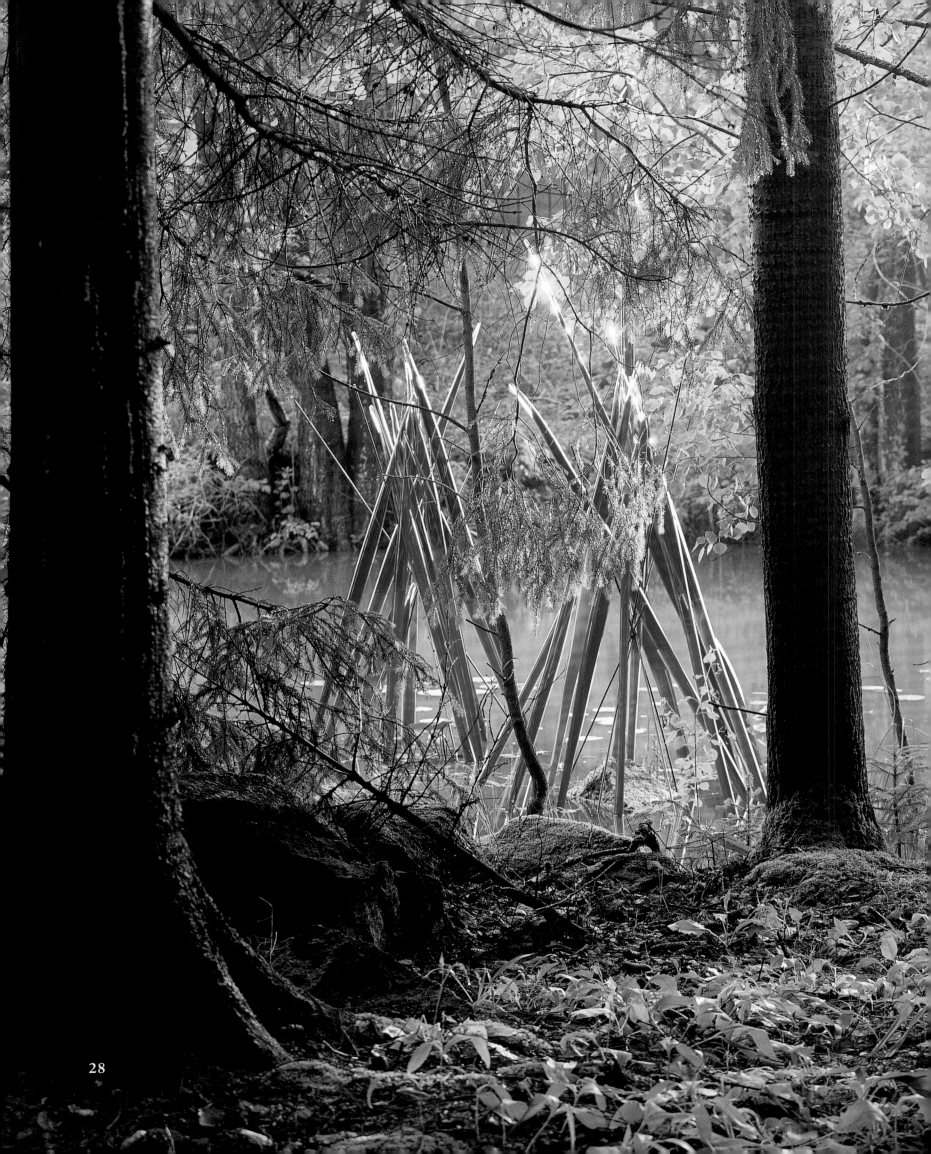

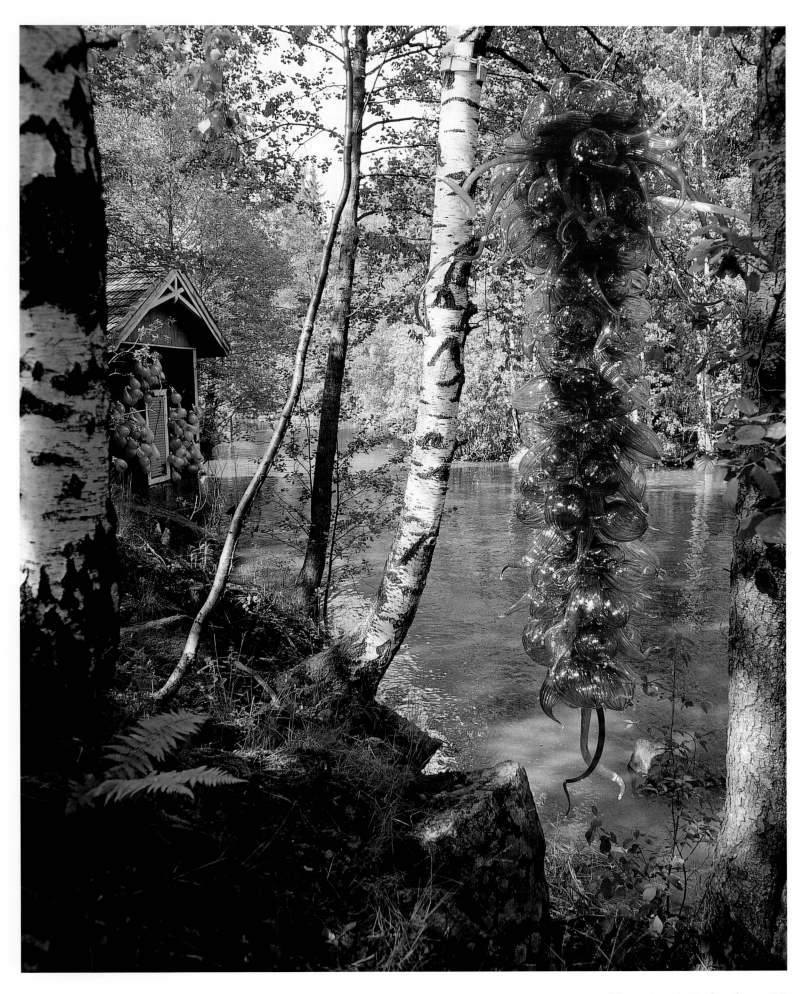

Nuutajärvi, Finland 29

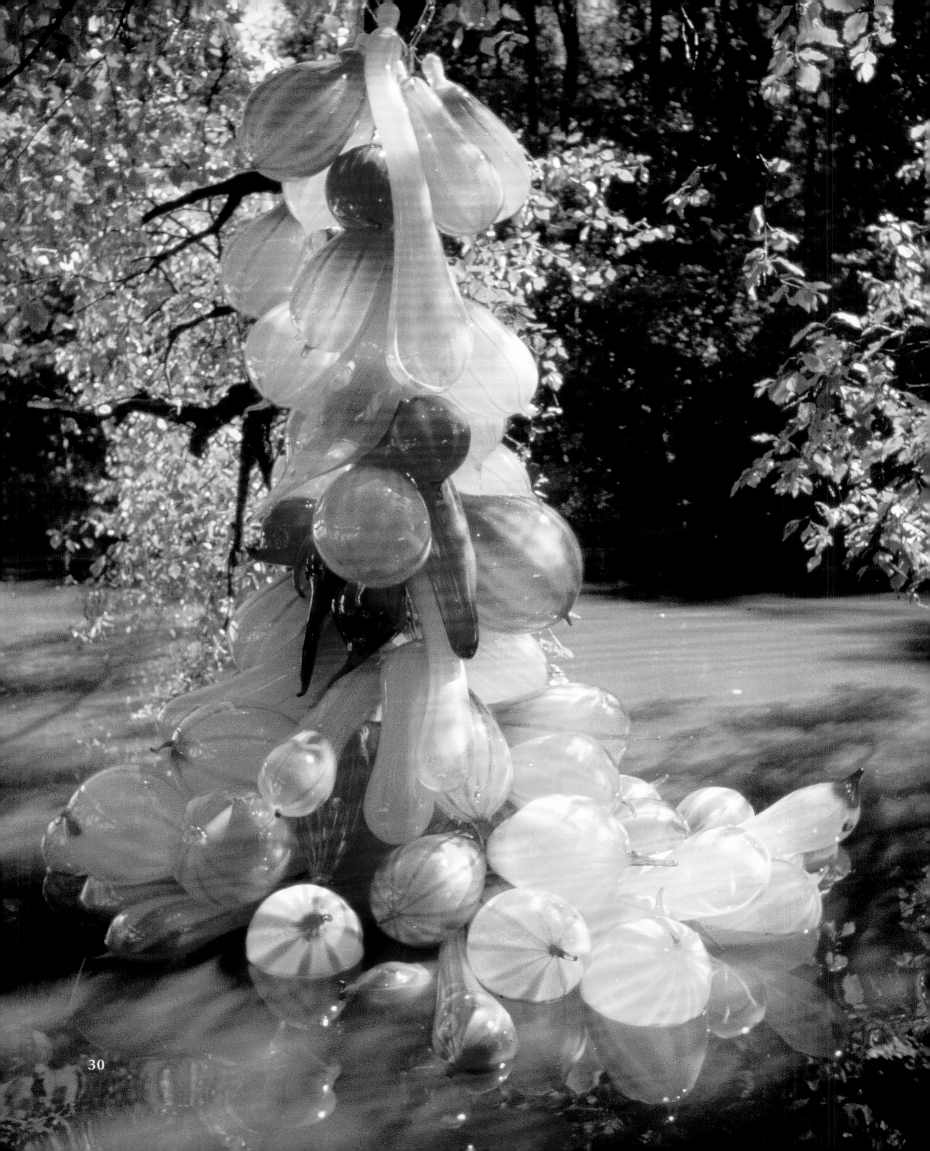

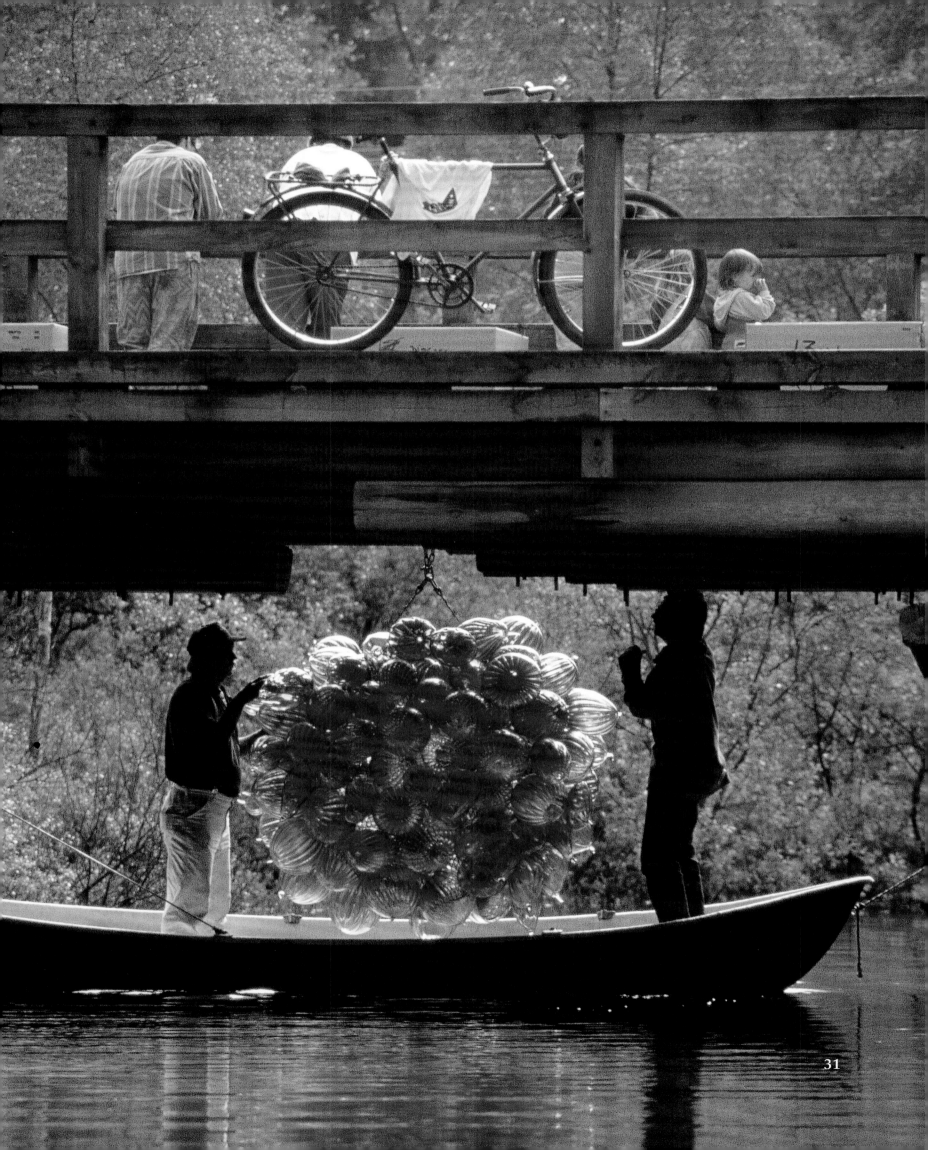

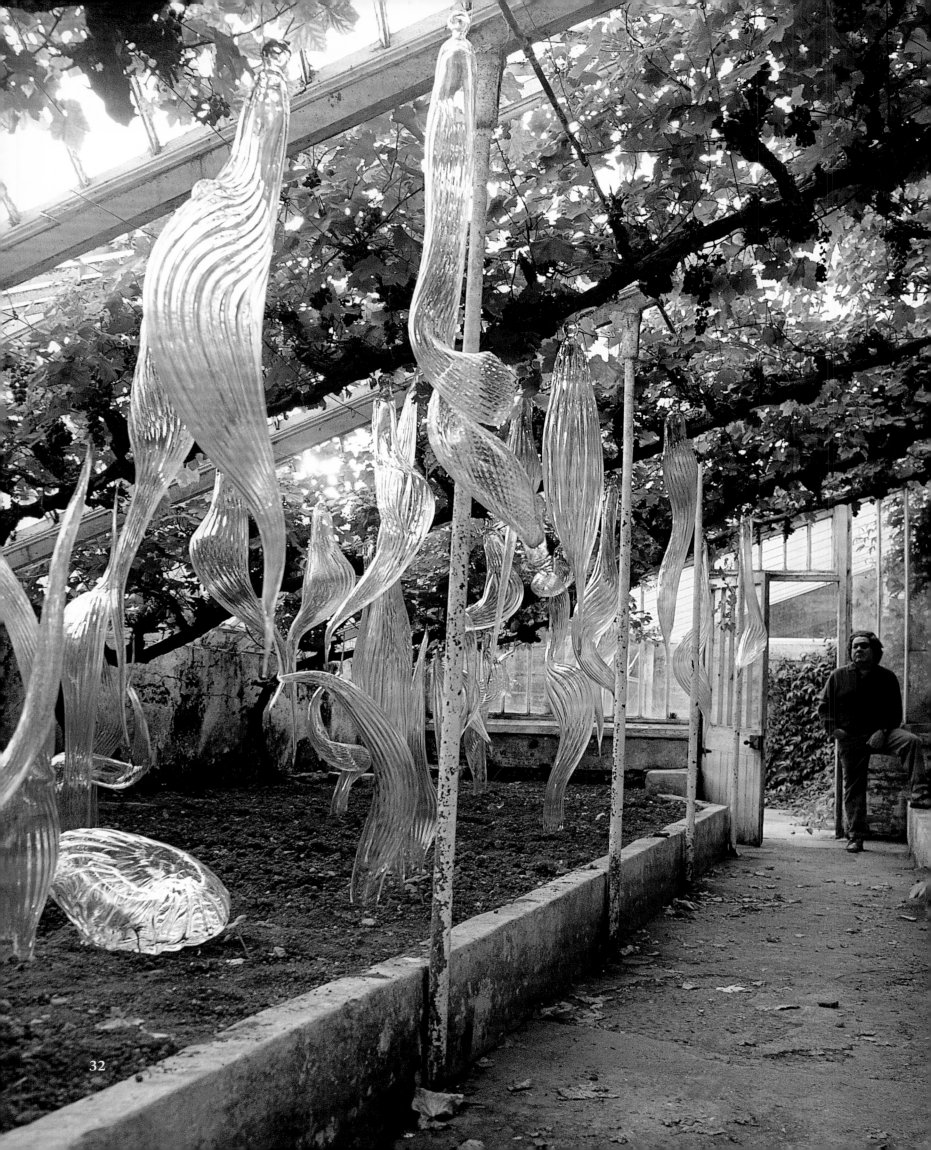

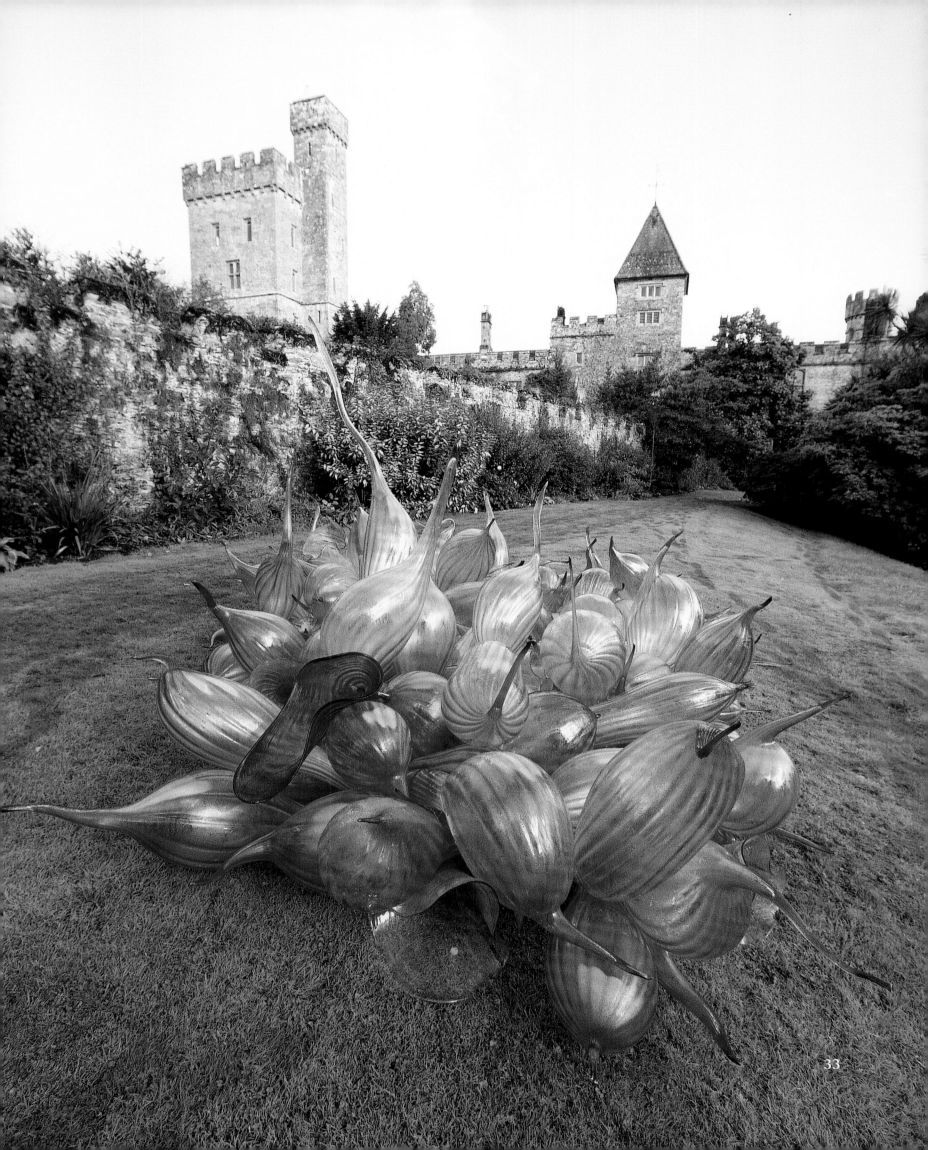

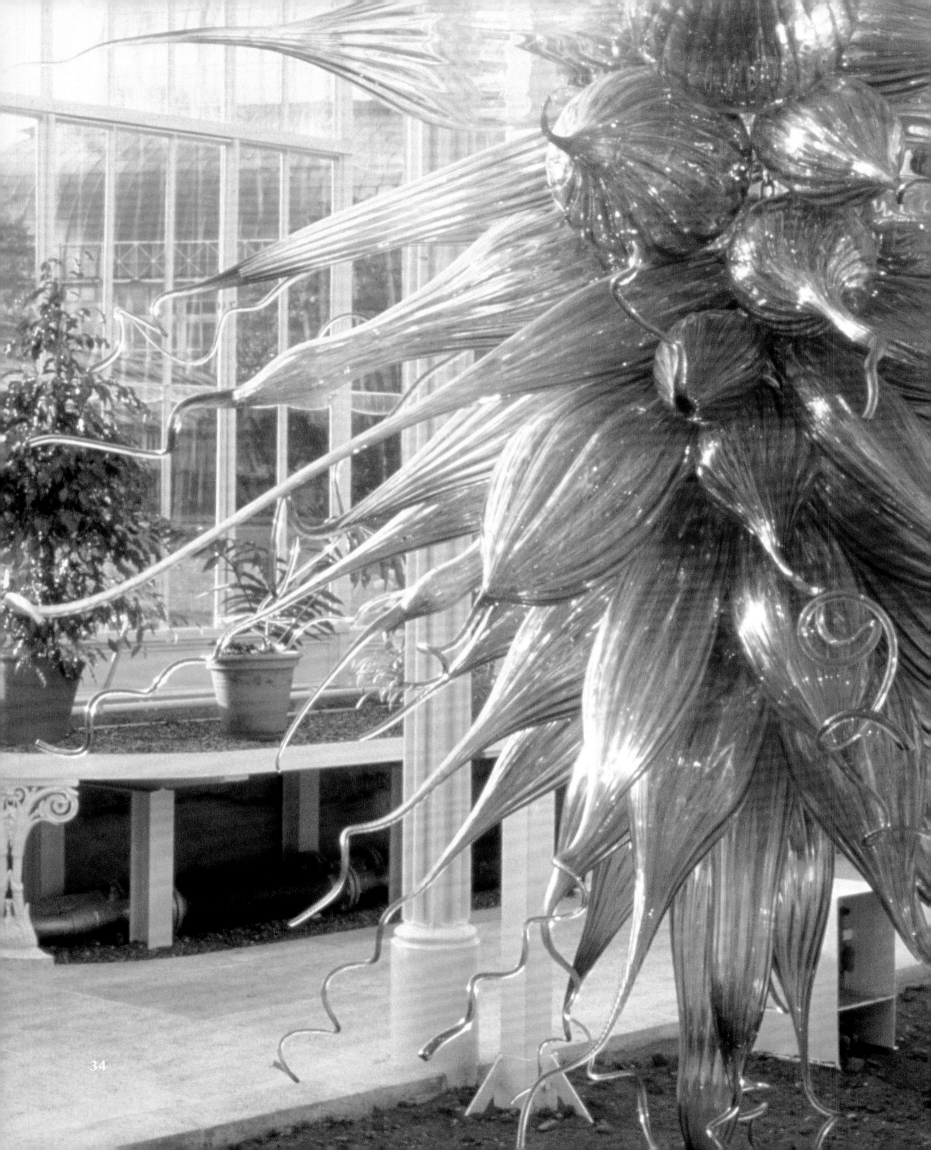

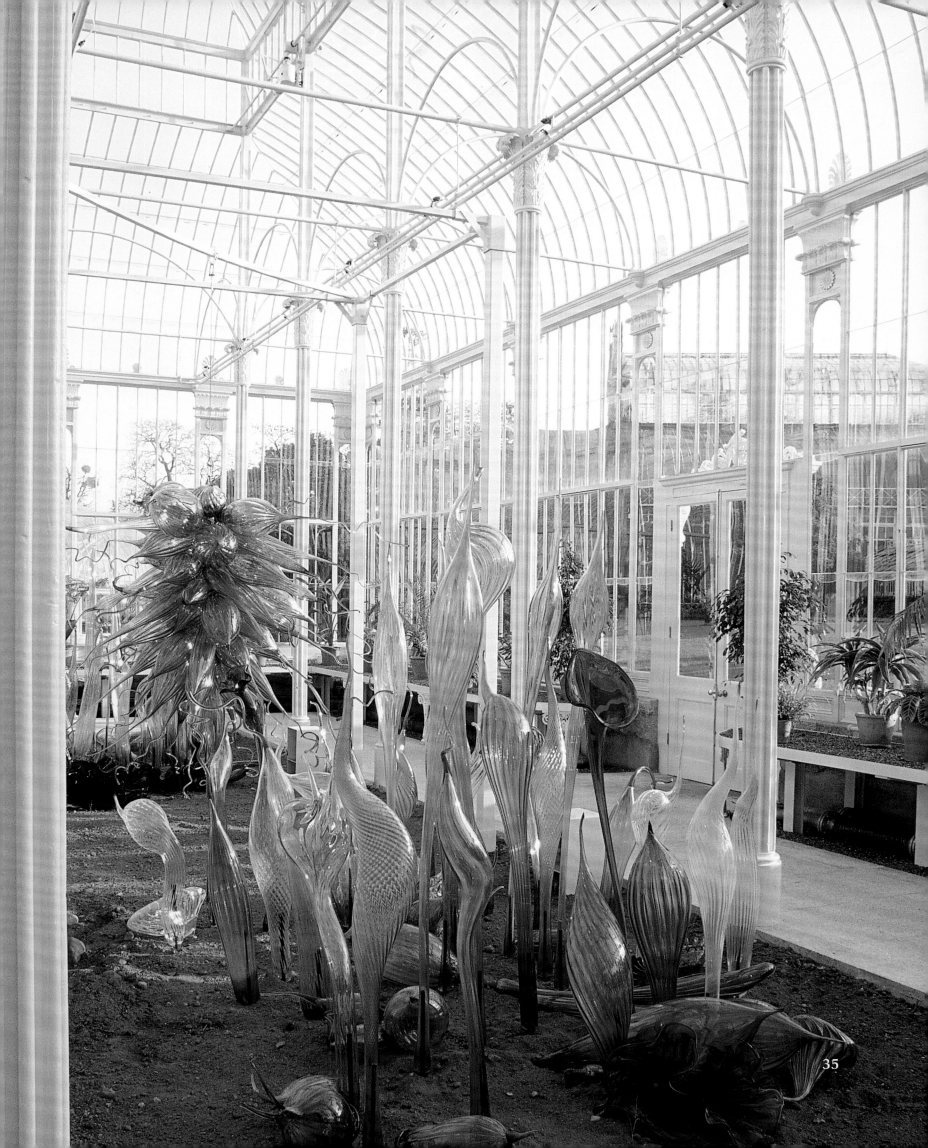

35

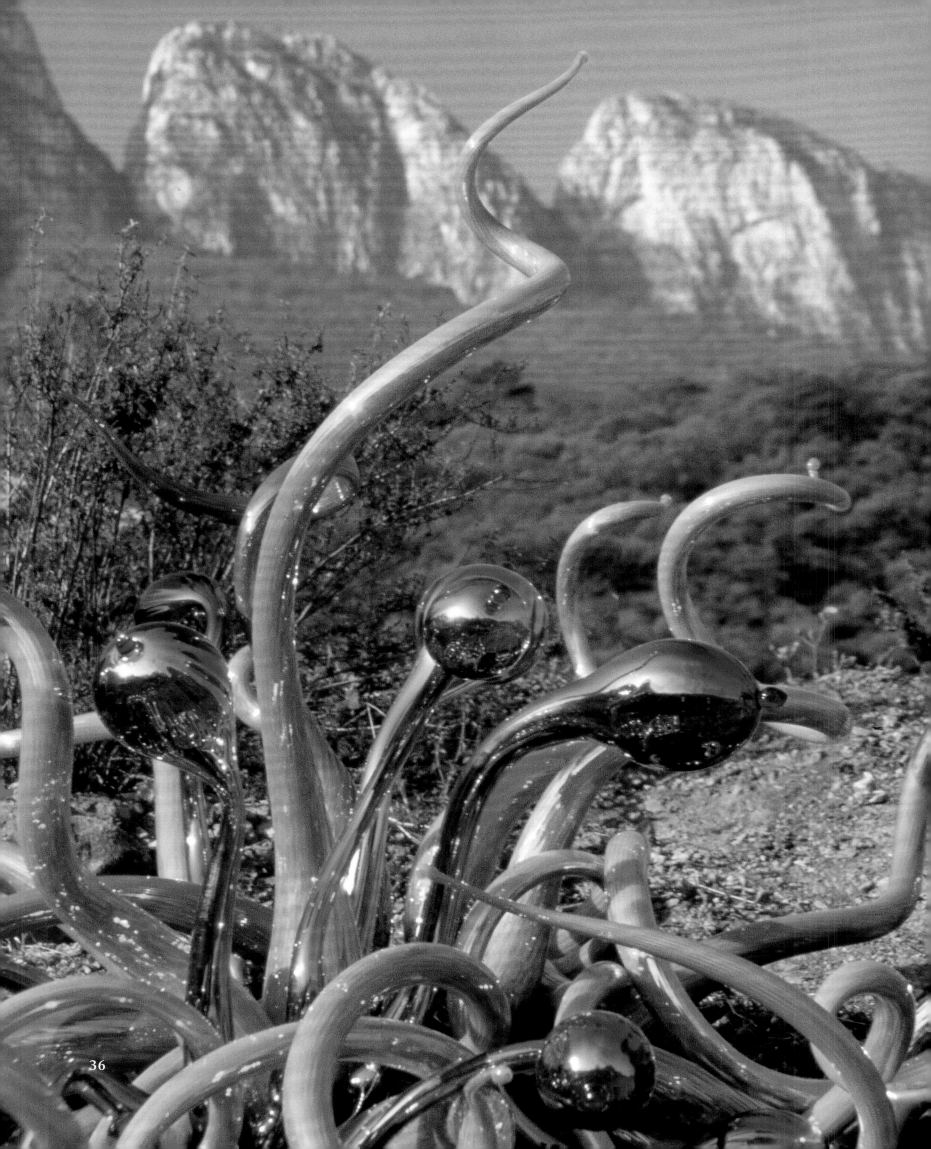

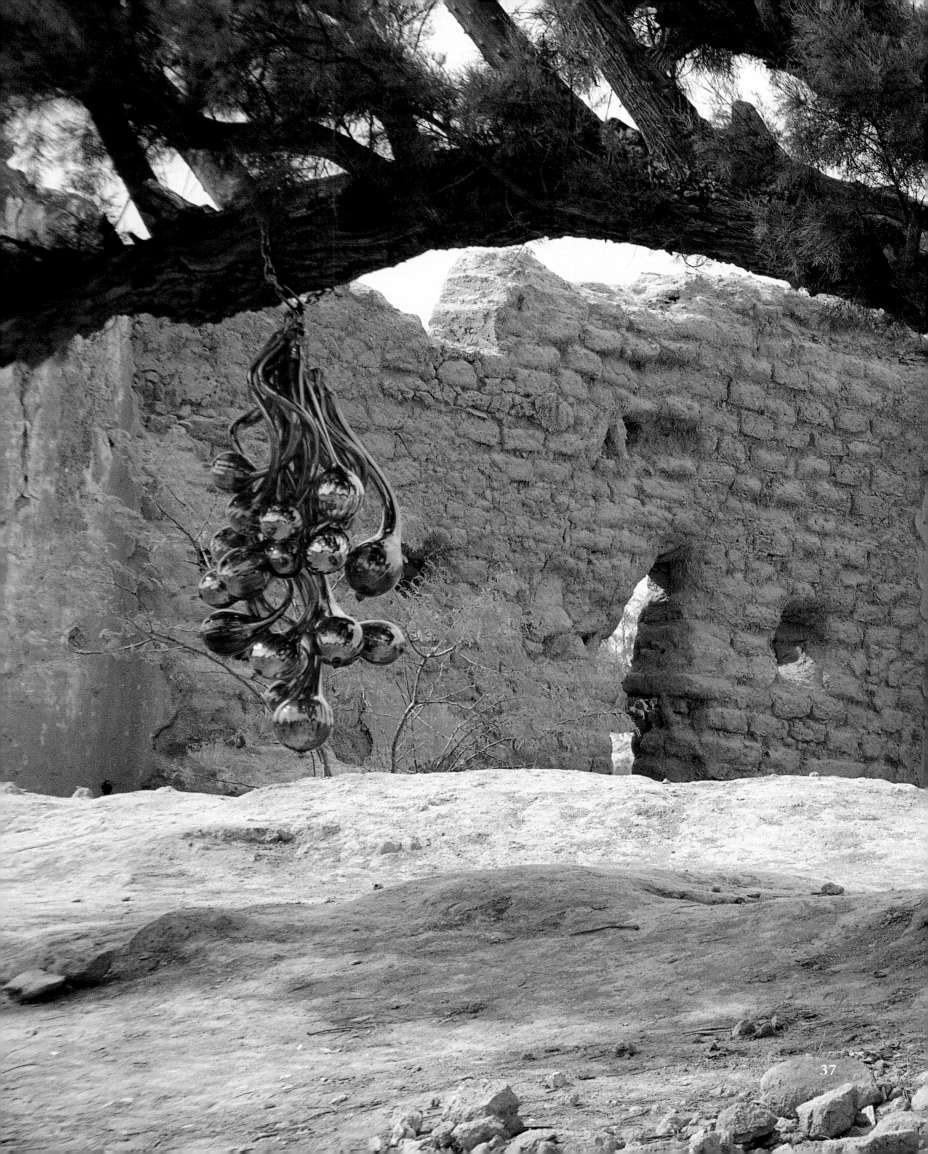

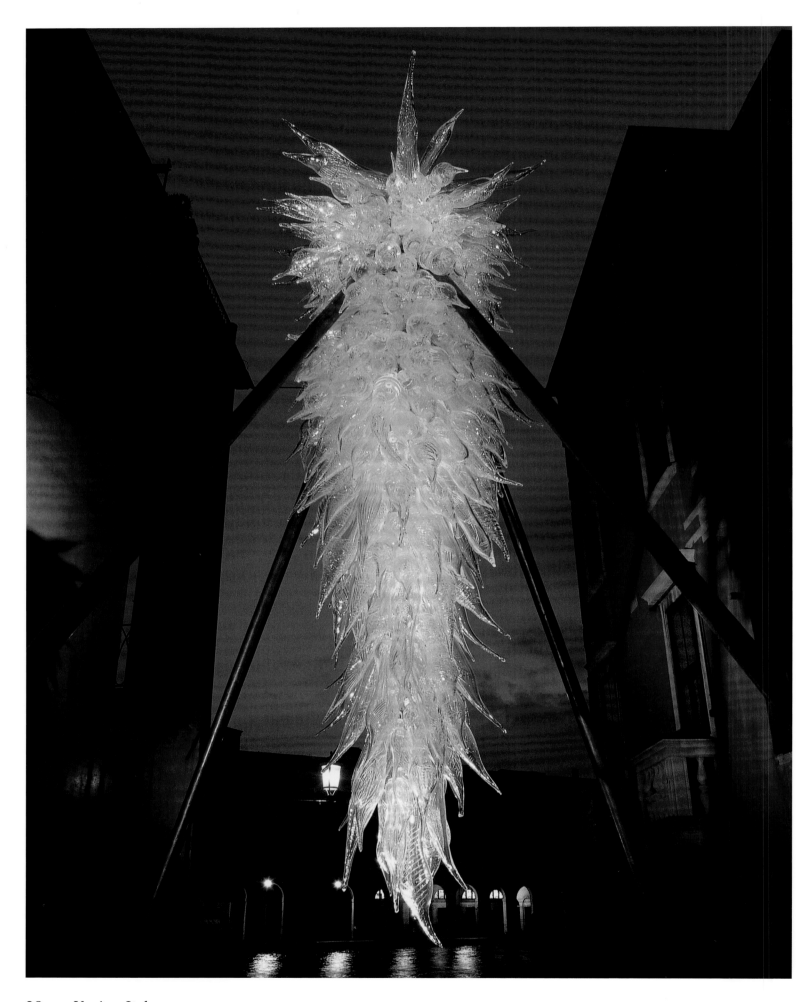

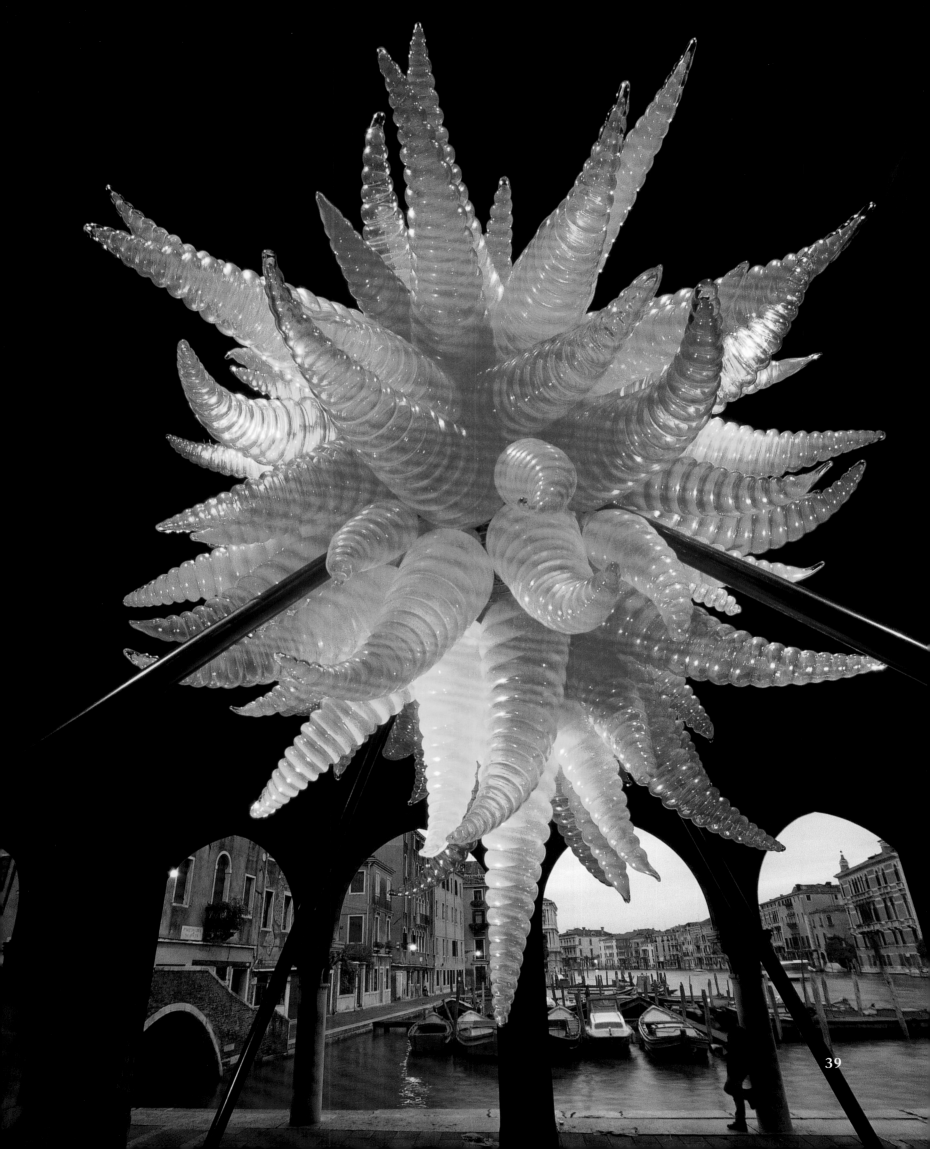

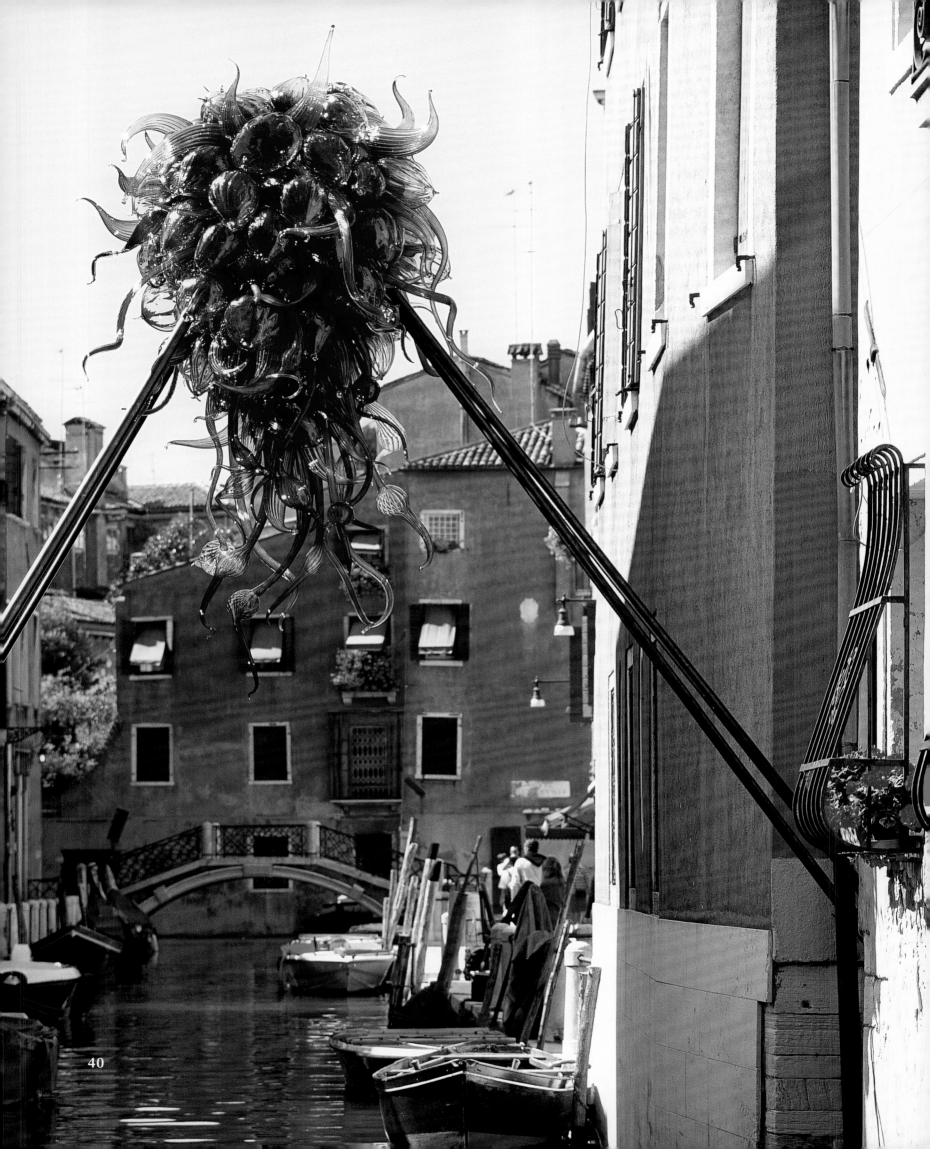

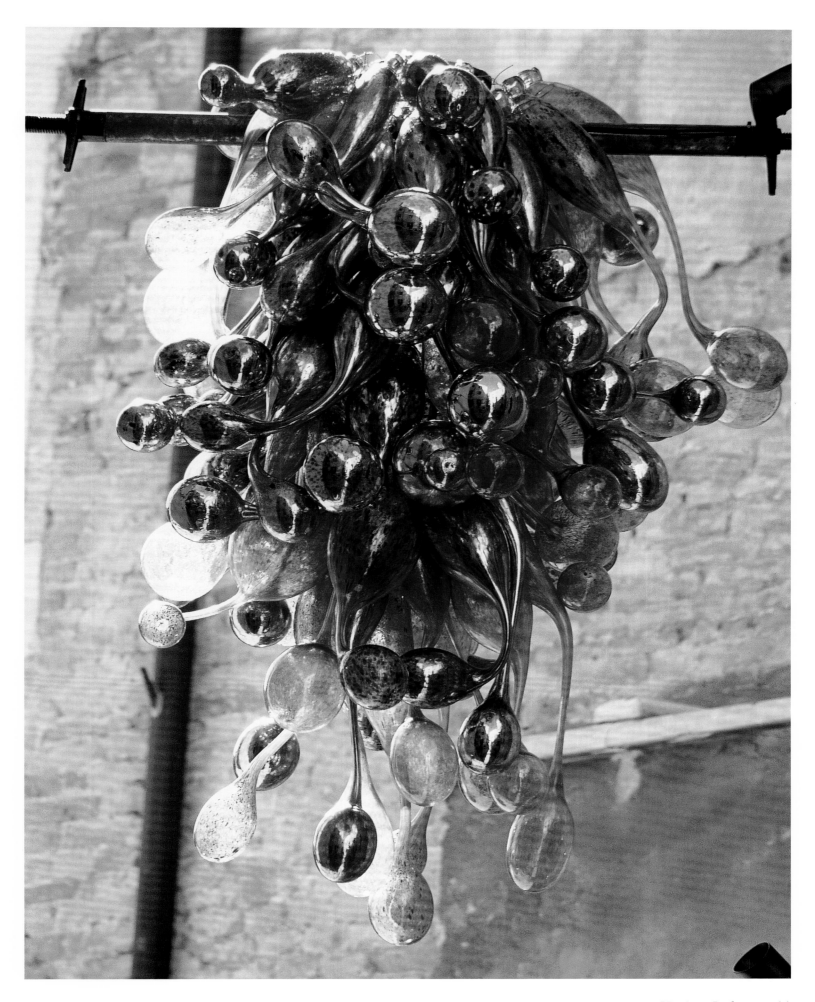

Venice, Italy **41**

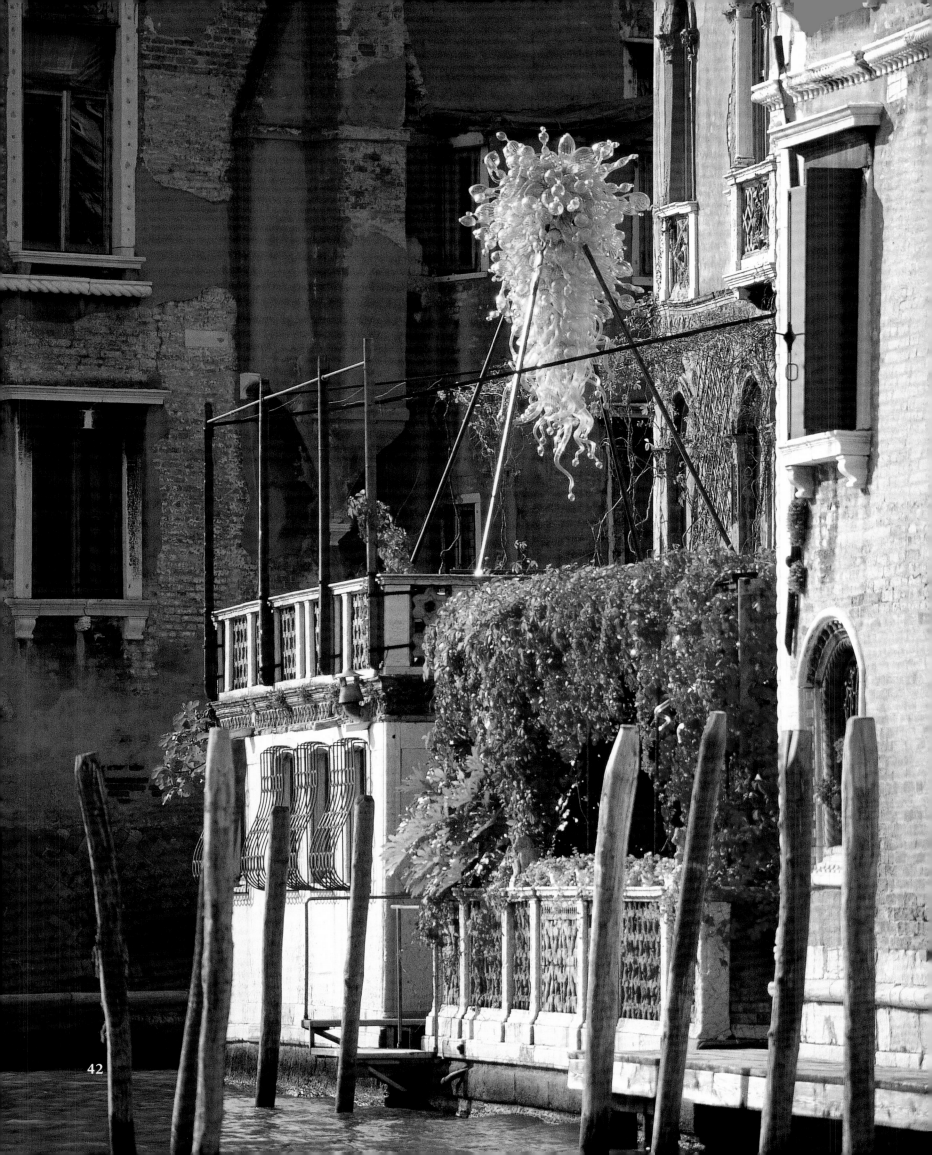

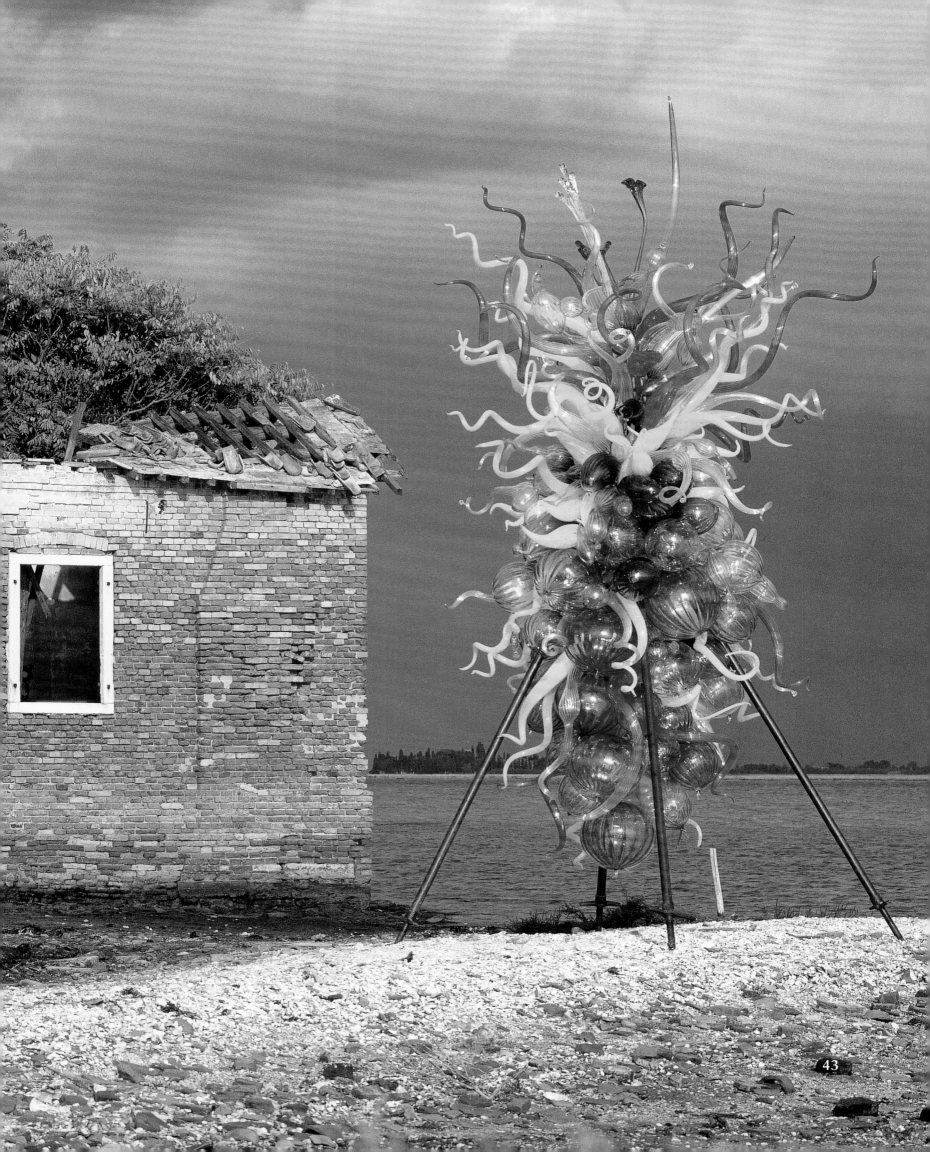

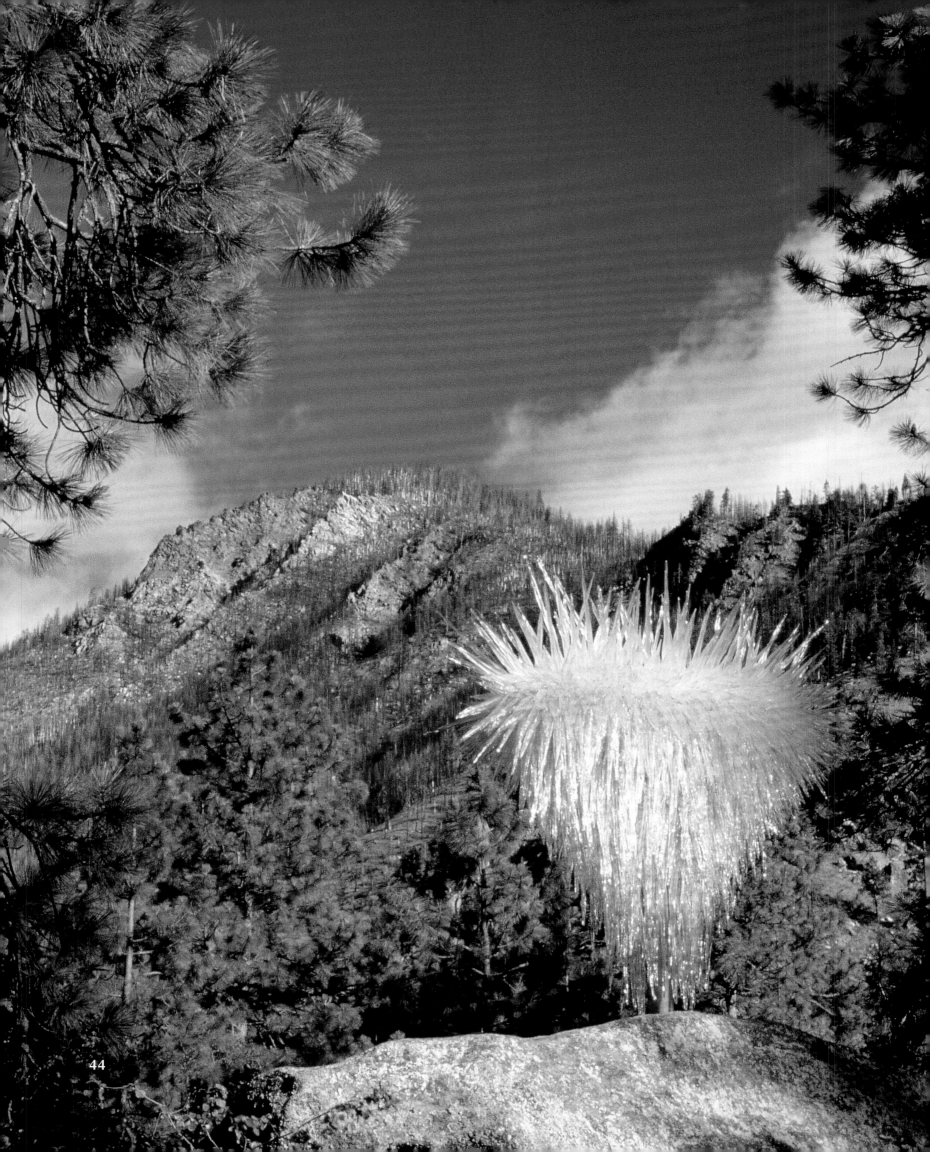

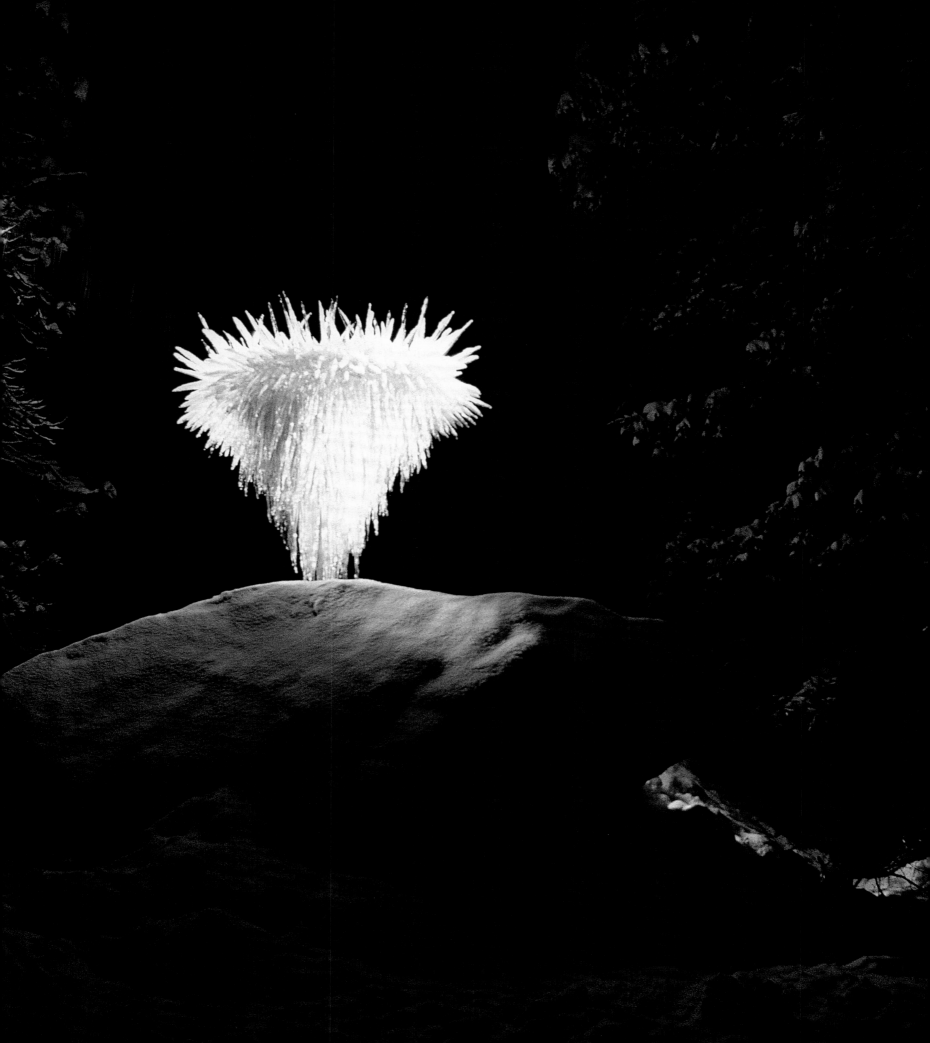

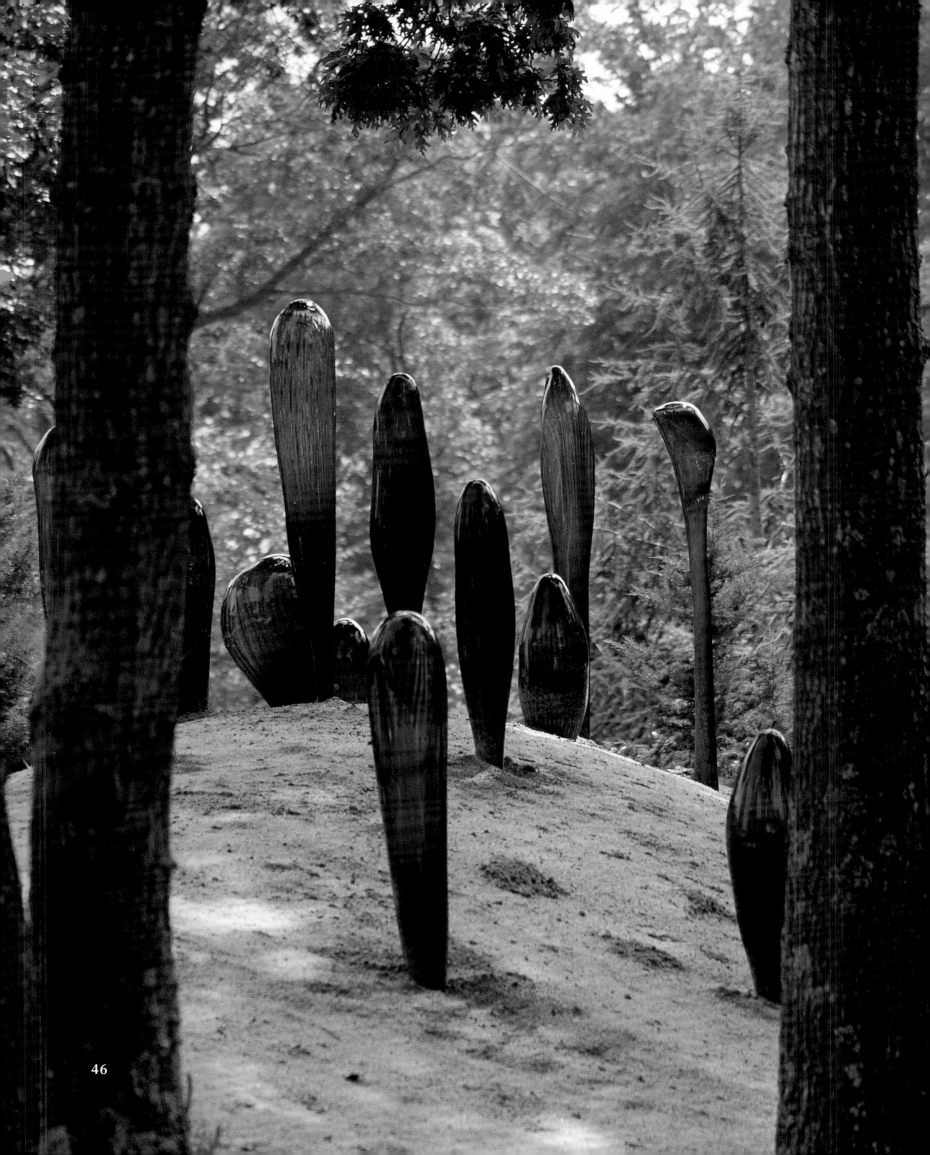

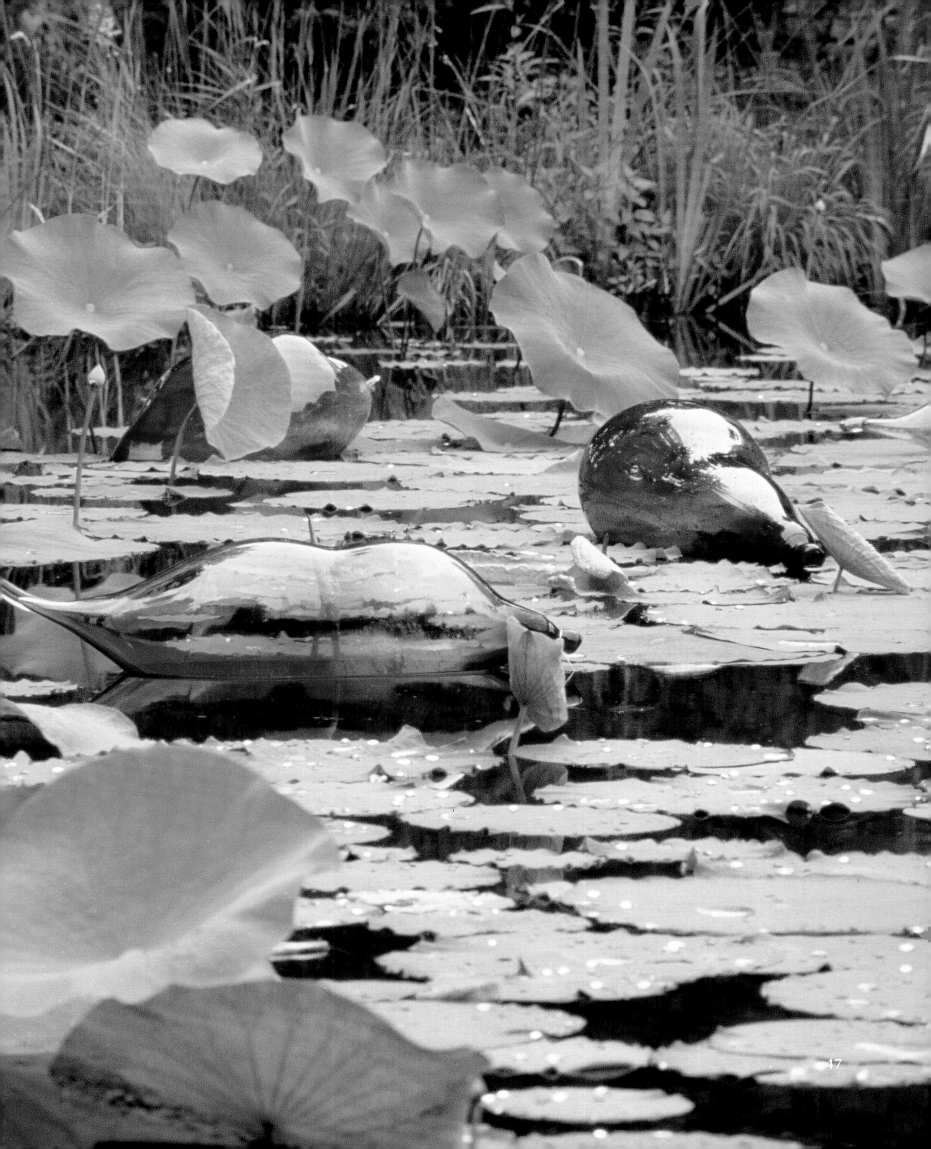

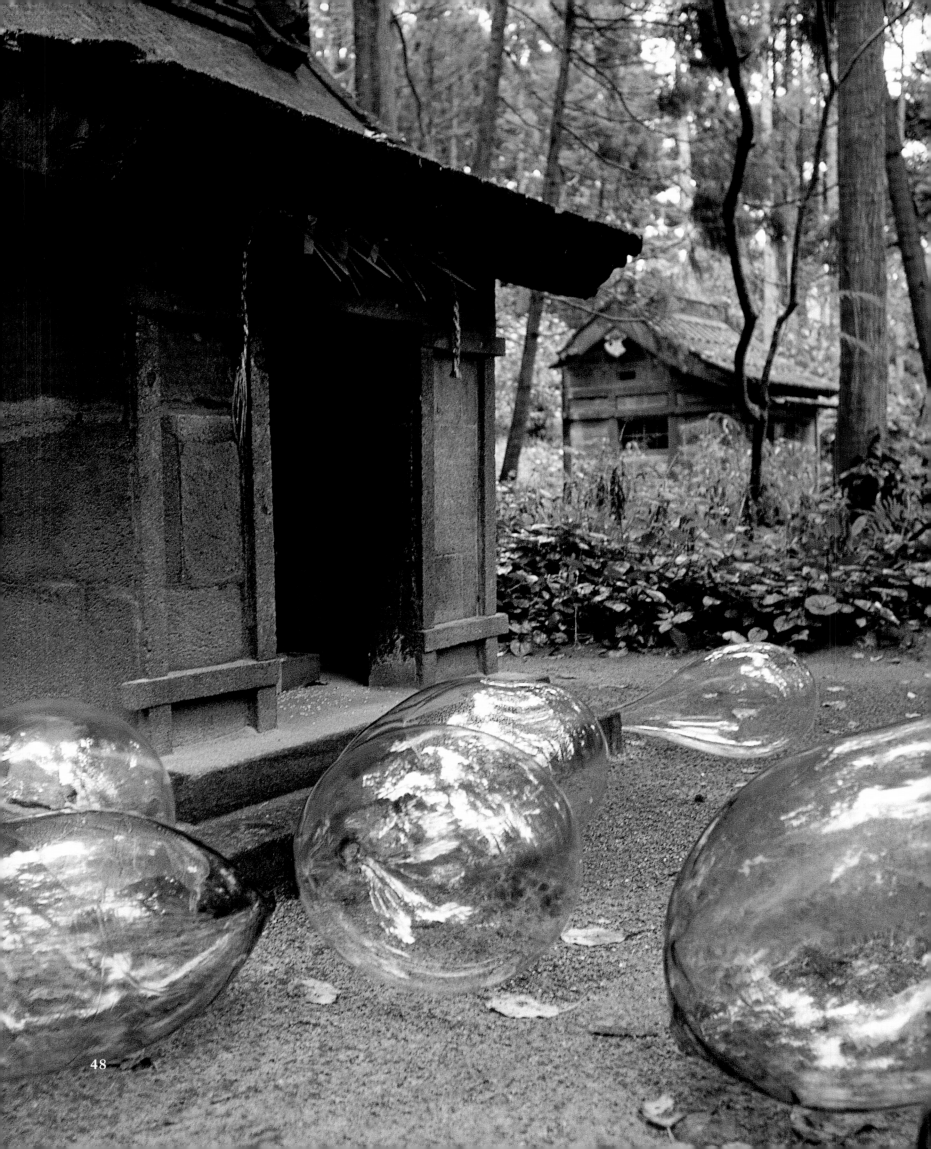

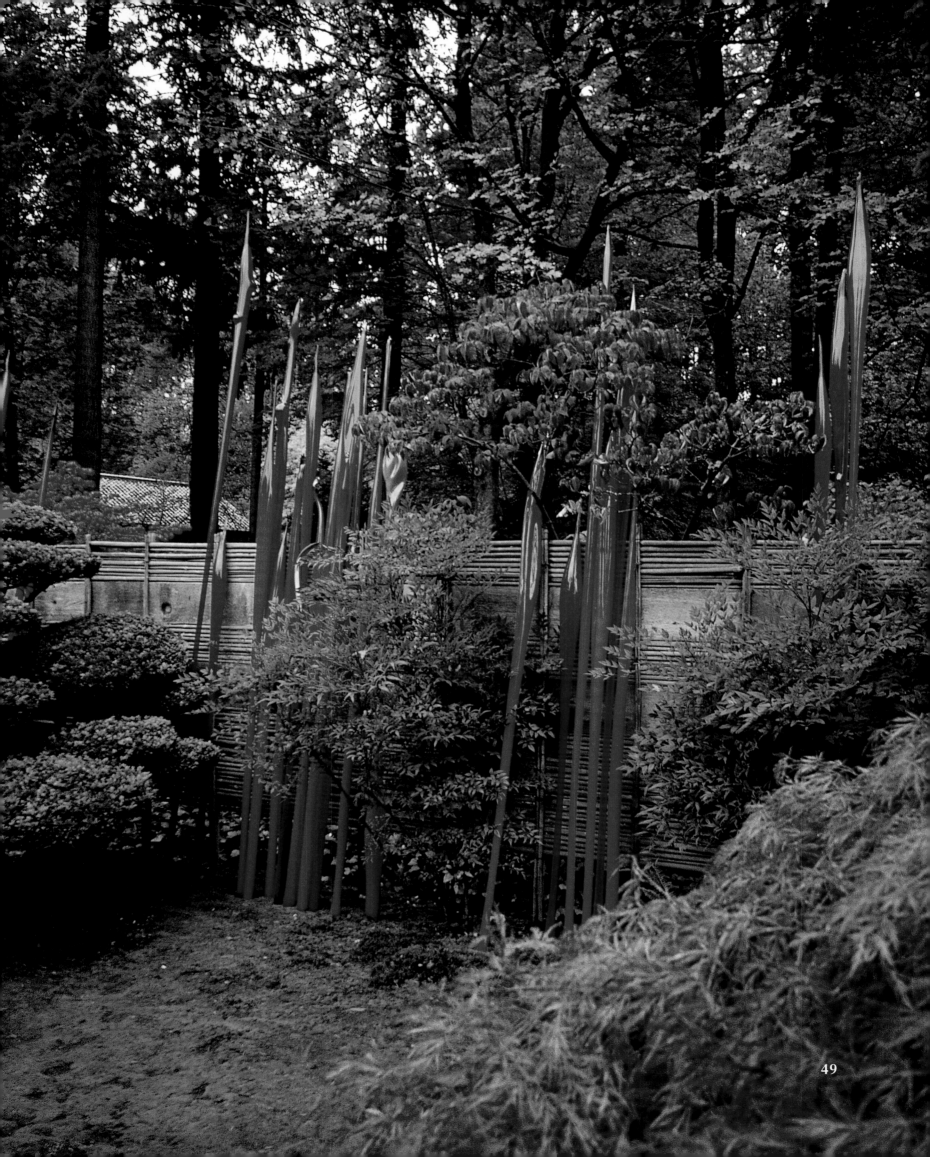

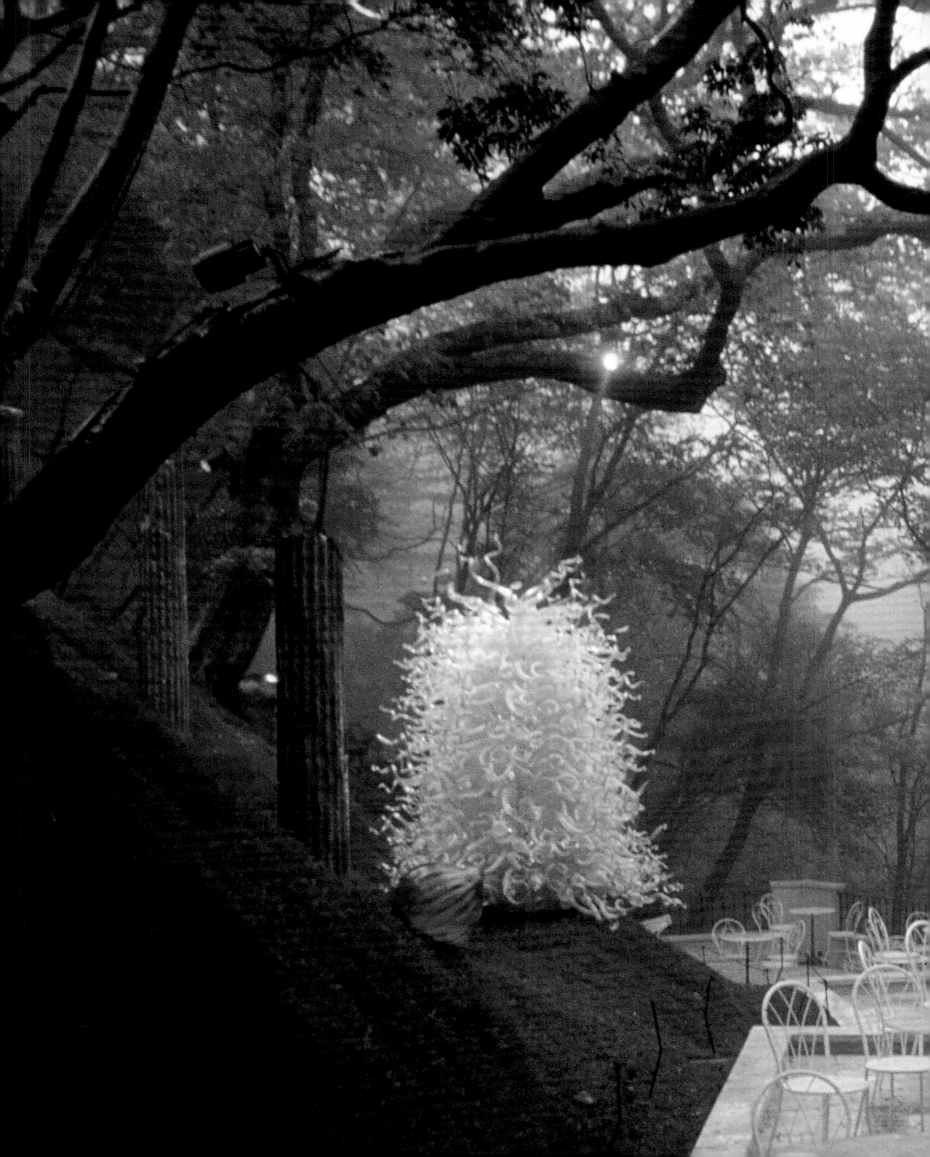

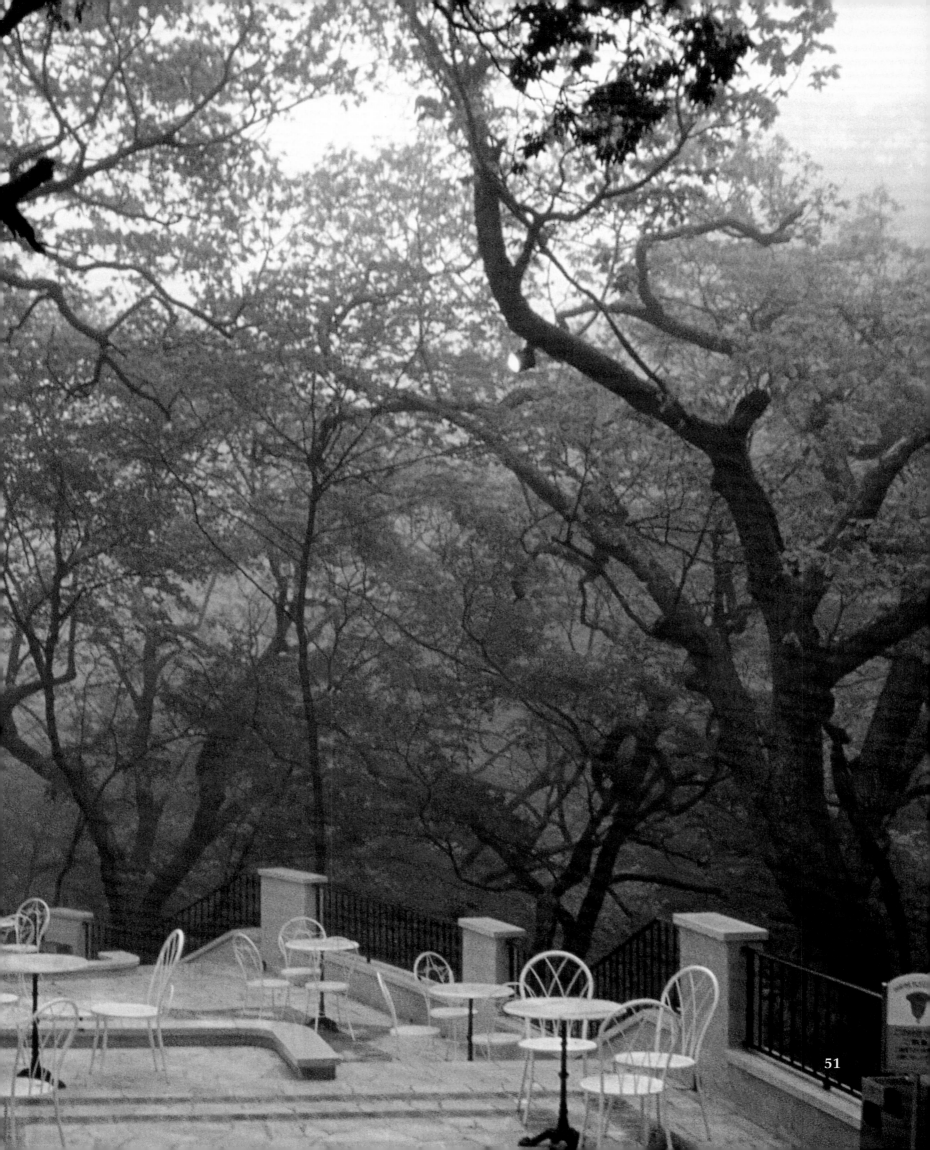

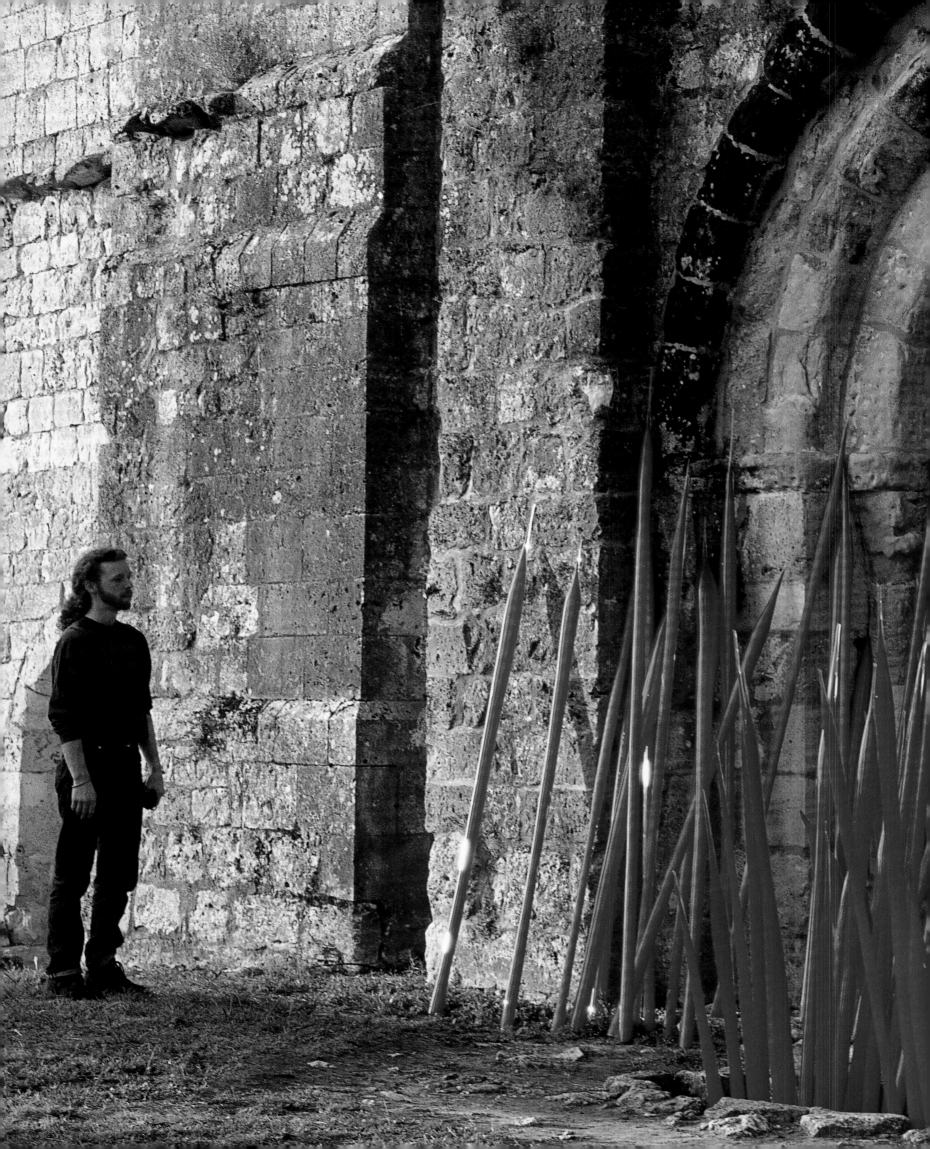

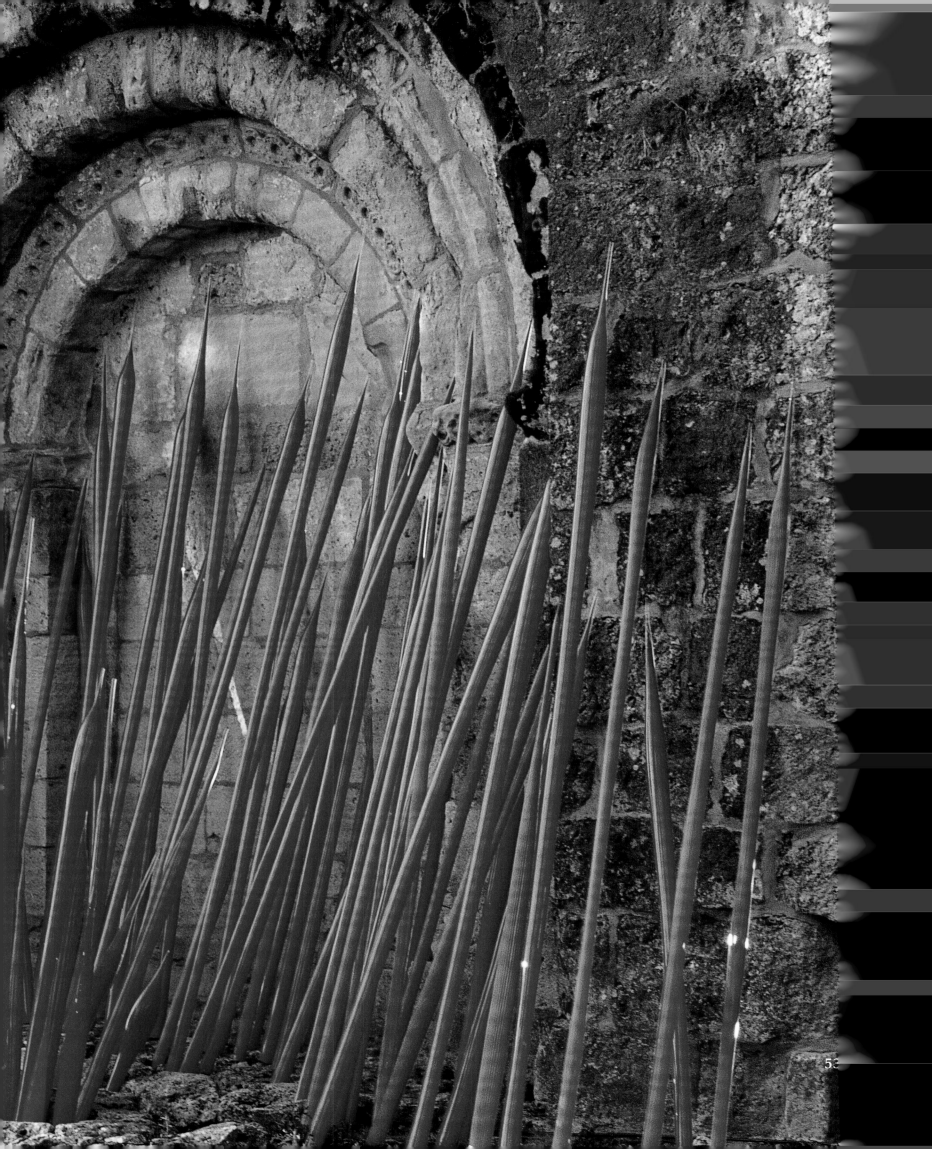

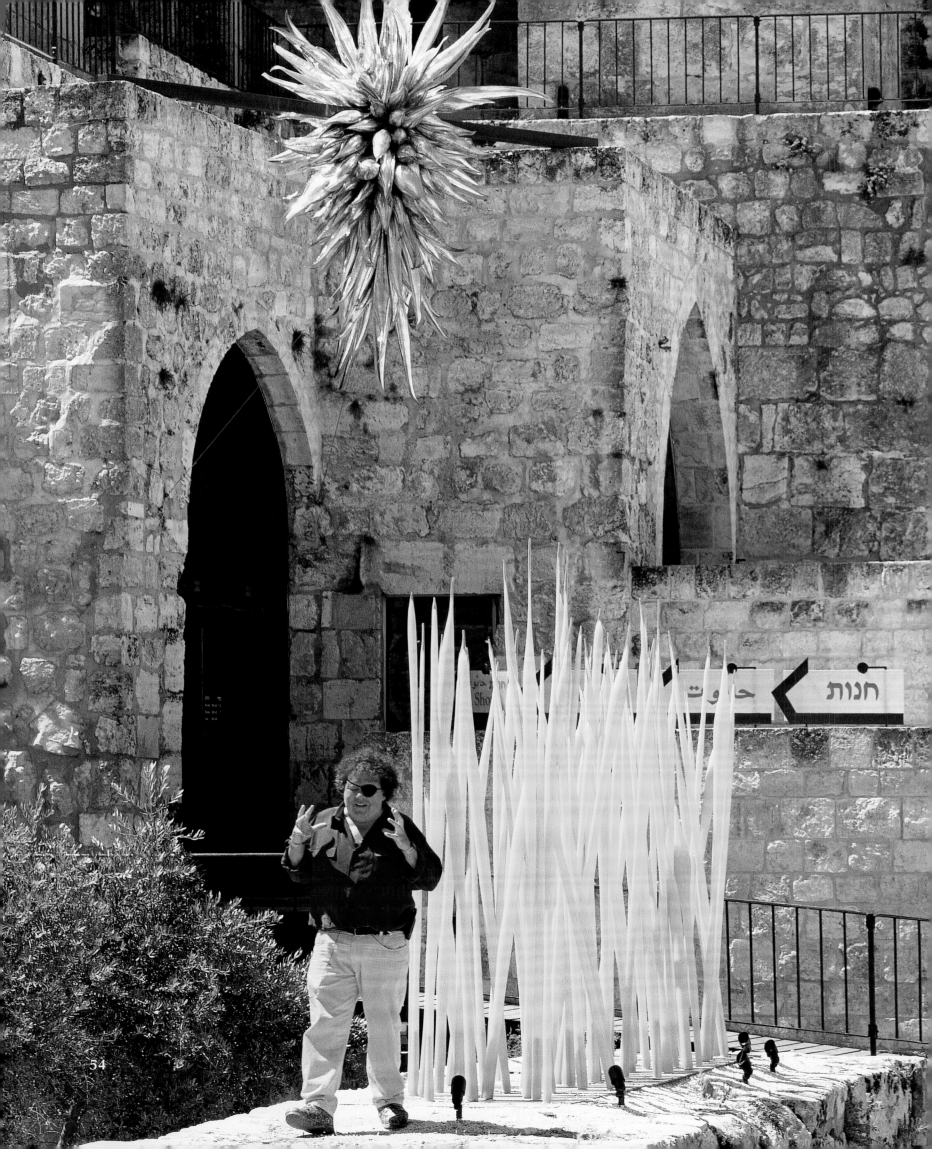

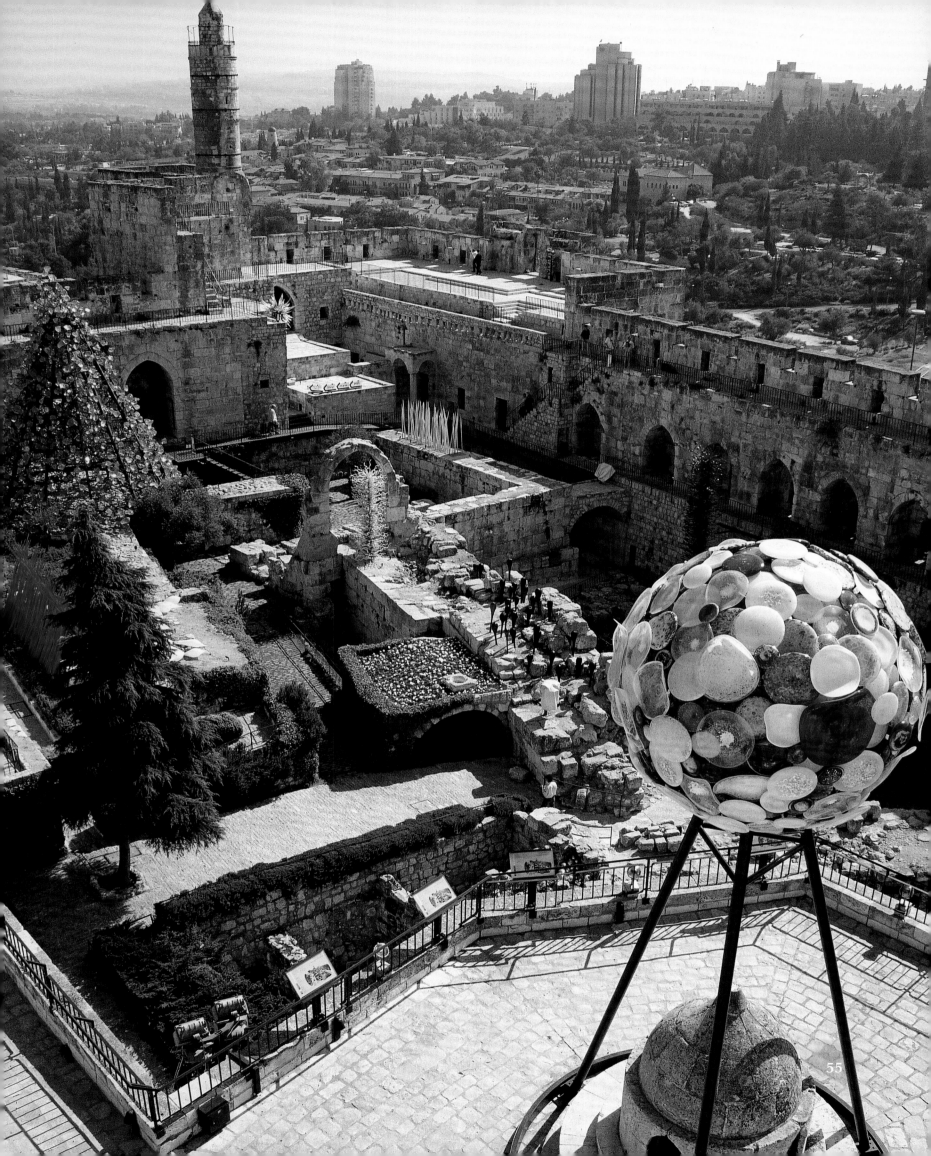

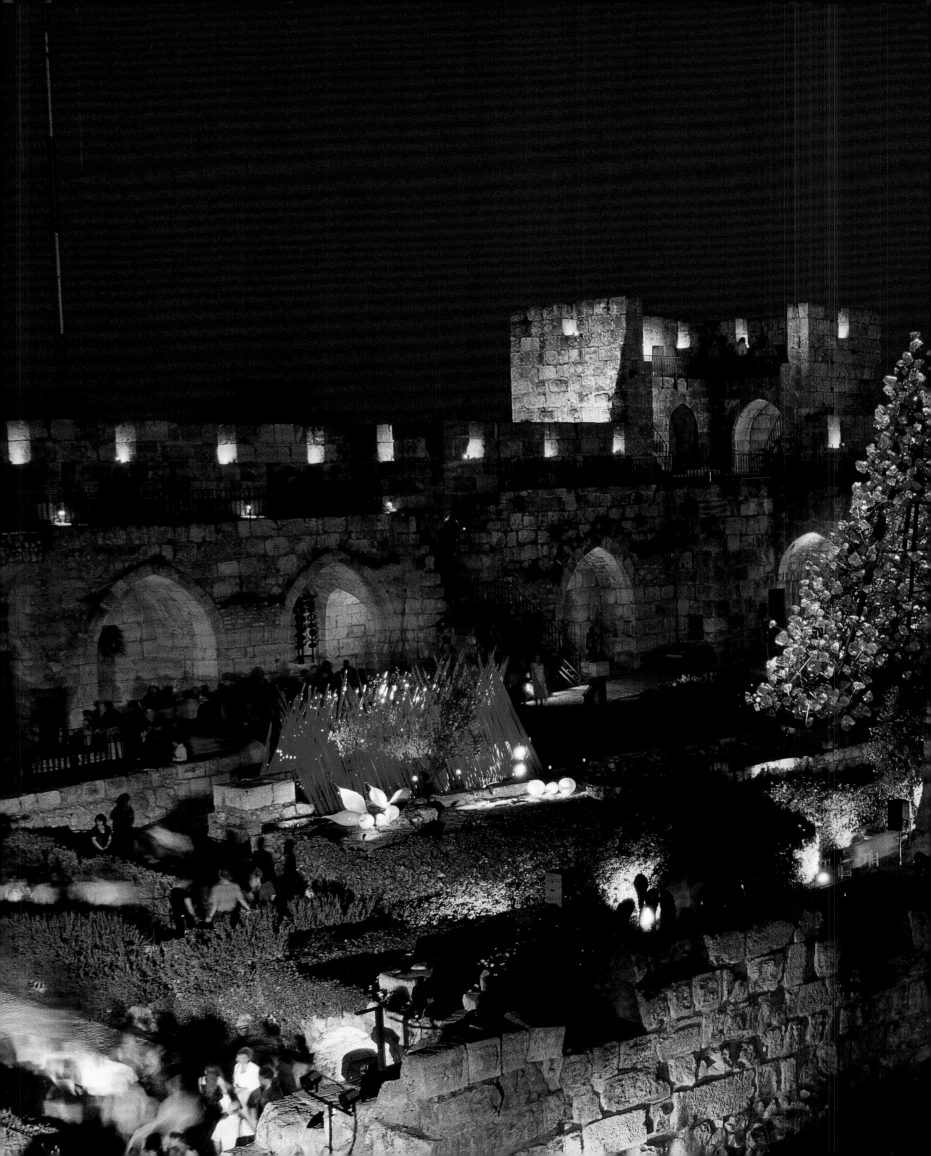

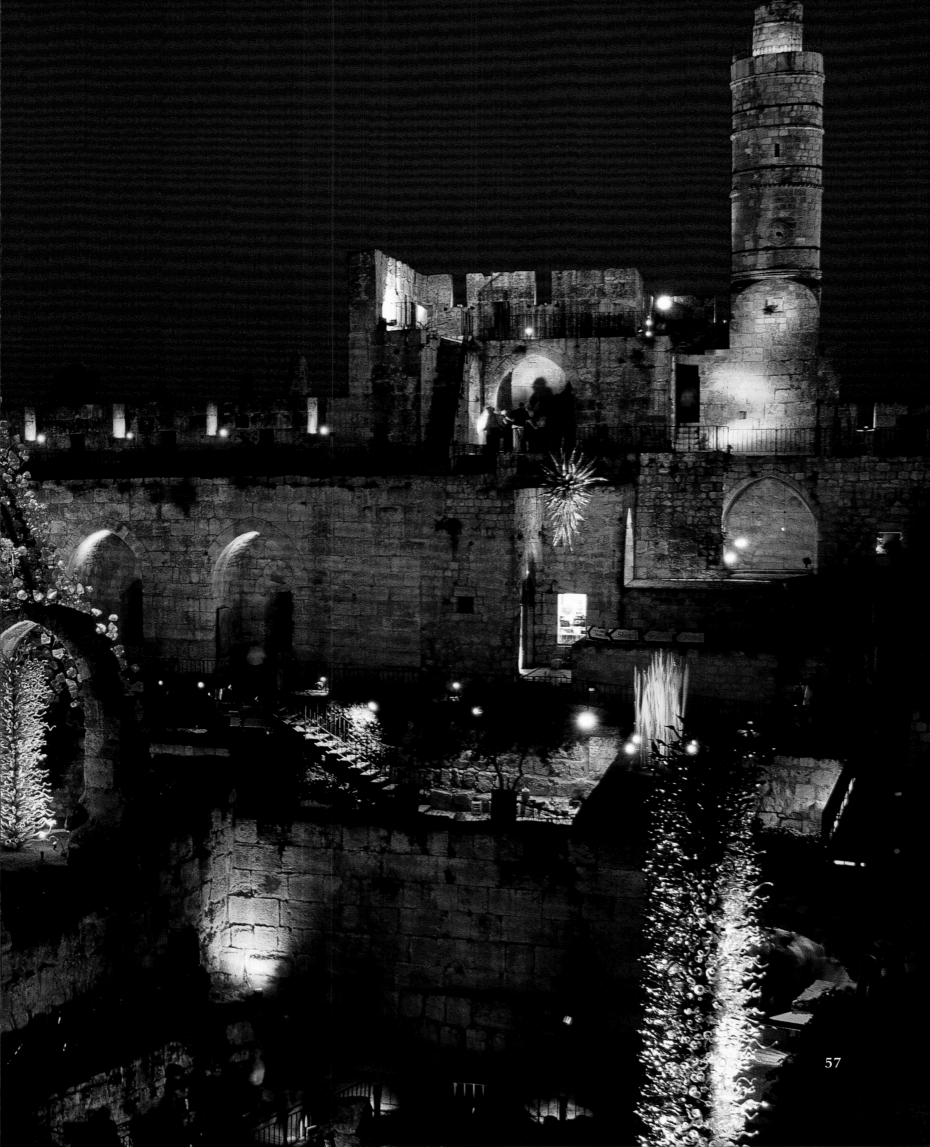

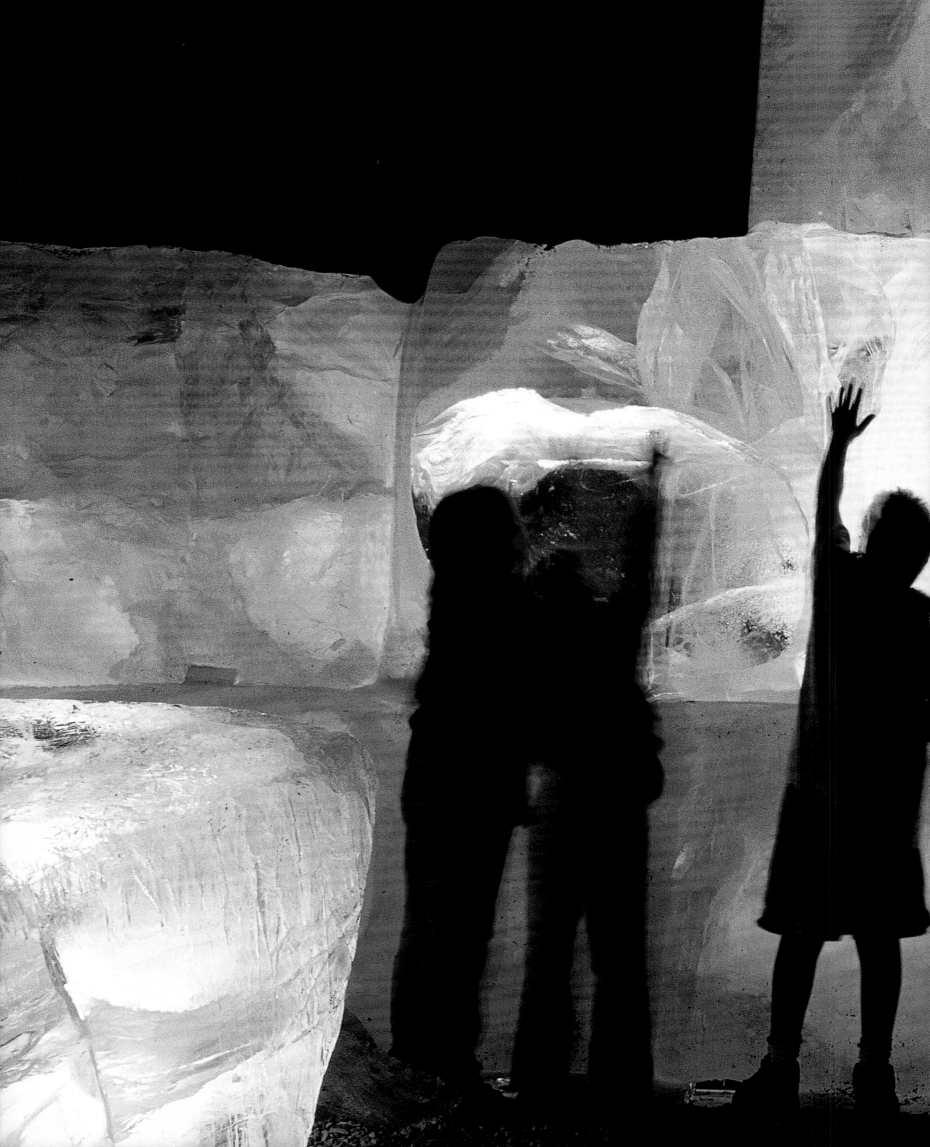

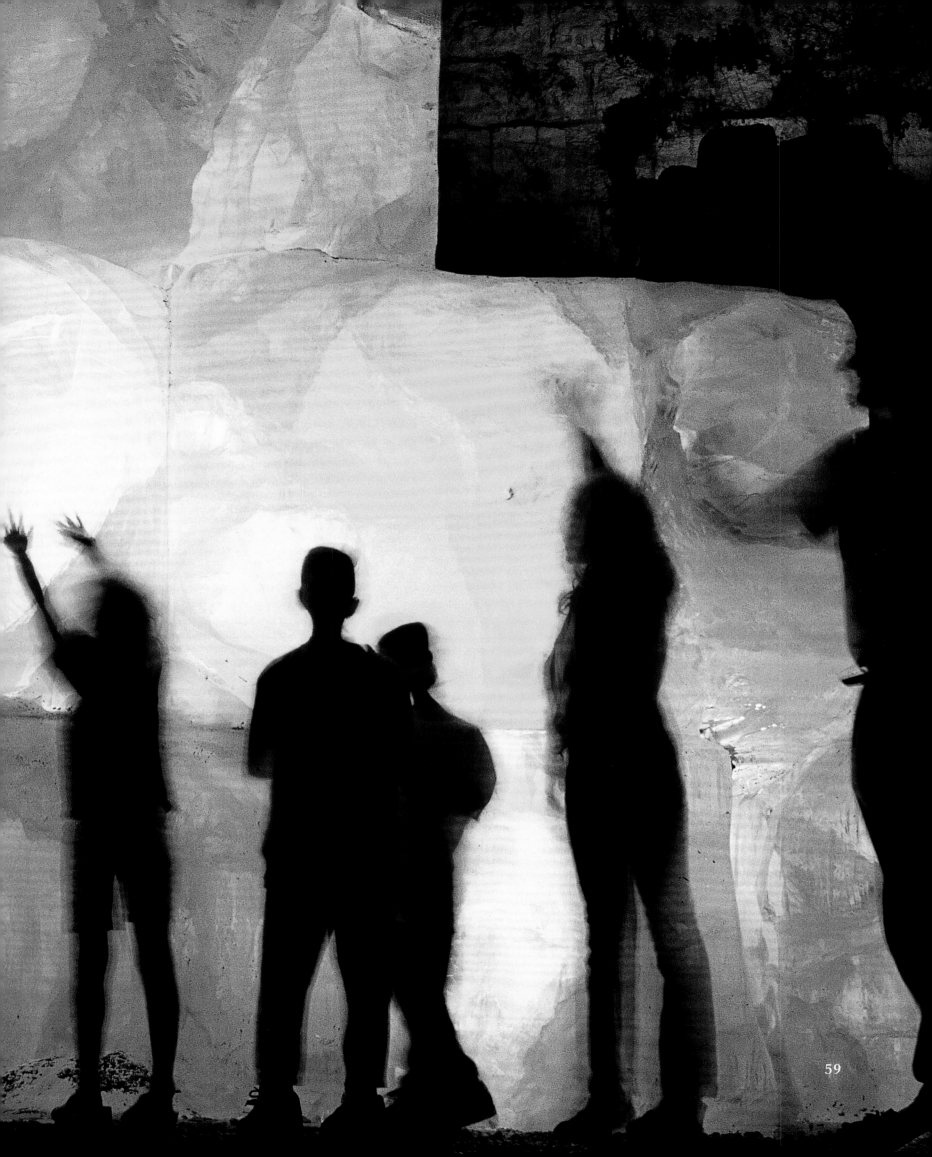

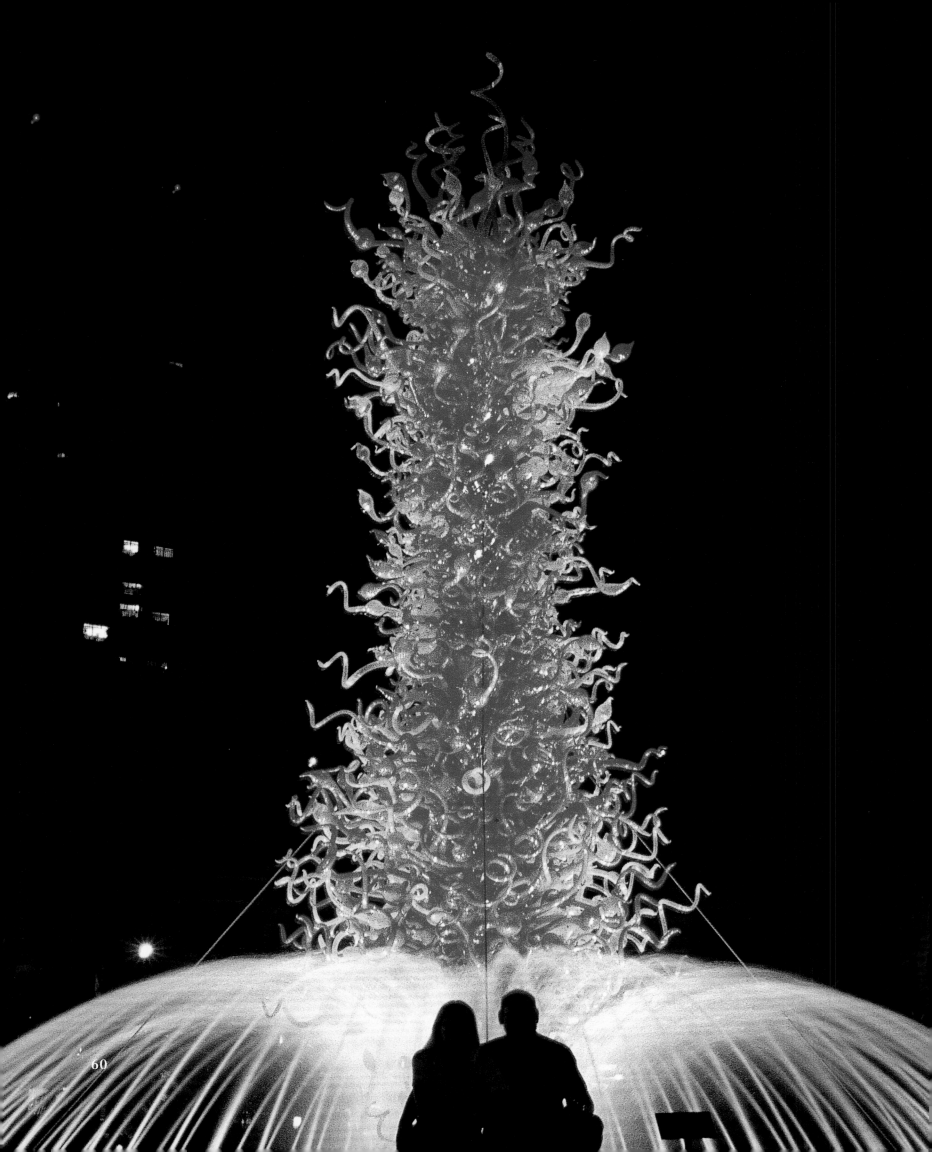

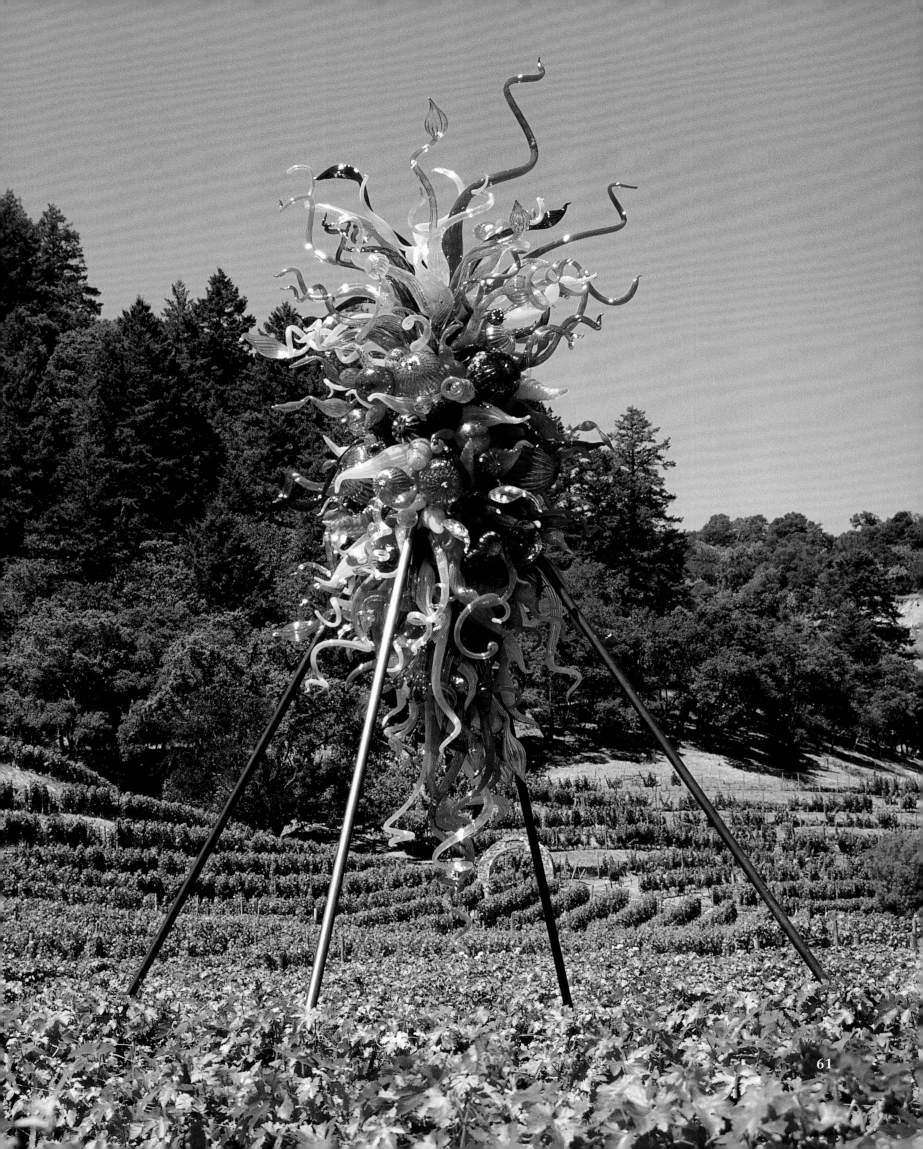

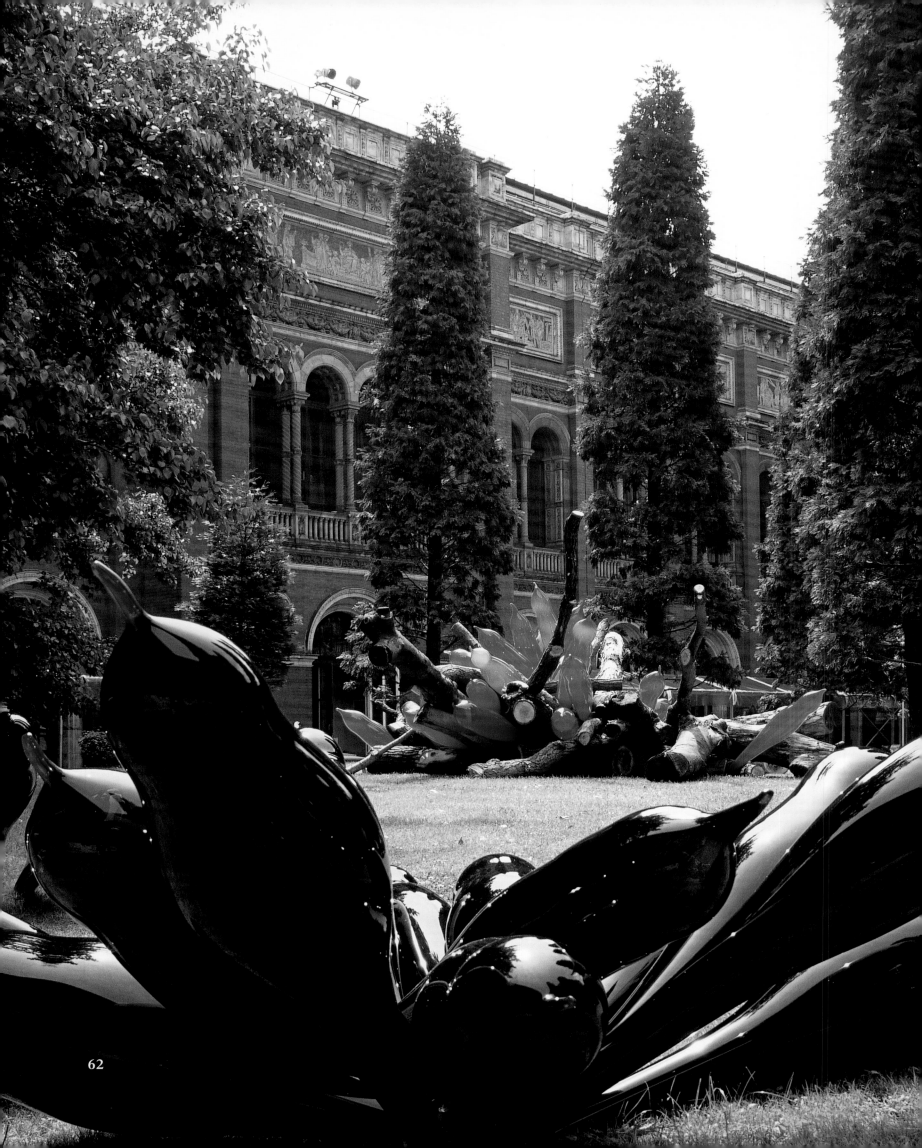

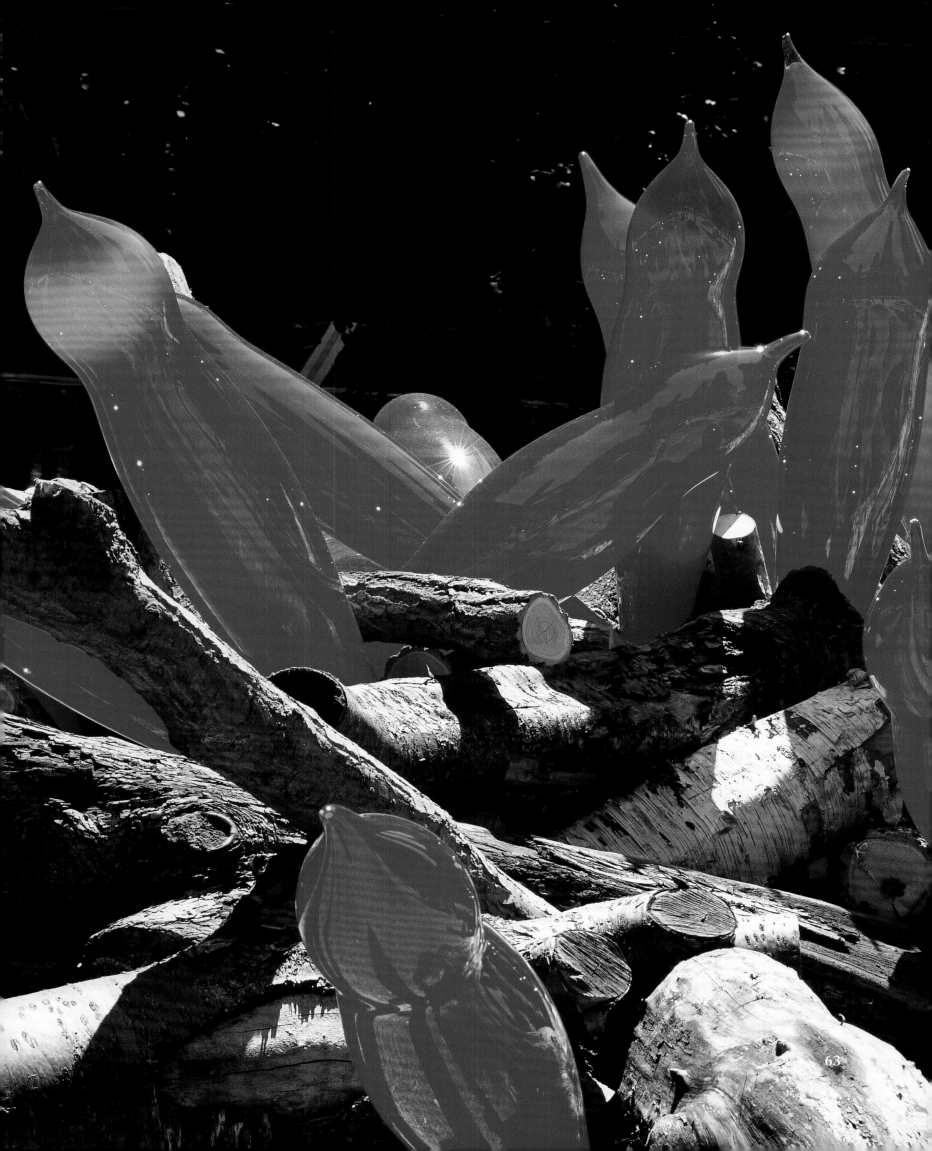

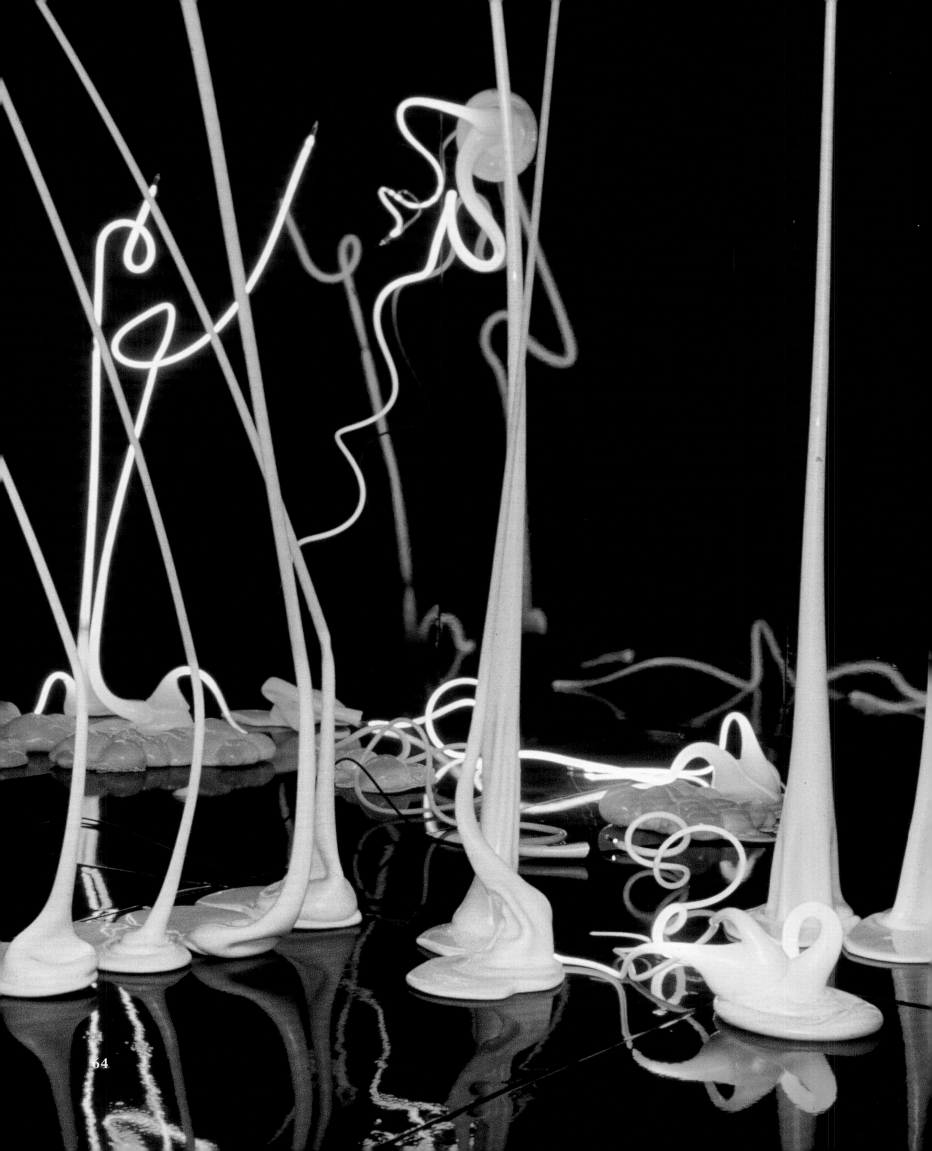

DALE CHIHULY: *THE GARDEN CYCLE*

David Ebony

The rich dark green of the tulip trees and the oaks, the gray of the swamp willows, the dull hues of the sycamores and black walnuts, the emerald of the cedars (after rain), and the light yellow of the beeches.

—Walt Whitman, *Specimen Days*

Introduction

Dale Chihuly's ambitious endeavor to create a unique environmental art, using mostly glass, is fully realized in the sprawling greenhouse and outdoor installations he presents around the world. An unprecedented synthesis of nature and art, *The Garden Cycle* can inspire in each viewer a personal and poetic reverie of color, shape, texture, and feeling in the great outdoors

that would not be unfamiliar to Walt Whitman. It is as if Chihuly, having borrowed his remarkable plant/animal hybrid sculptural forms from nature, now affords them a return visit home.

Glass sculptures are not often displayed outdoors. Aside from its fragility, the material's cold, hard surface reflectivity and translucent color could appear incongruous in a landscape setting, clashing with nature's softer, more porous surfaces and subtle palette. Chihuly's landscape installations, however, are convincing primarily because of the imaginative shapes he uses that he abstracts from many varieties of flora and fauna. The color relationships—often exaggerated versions of those already found in nature—add to the work's credibility.

There's a rightness about the approach as well as the effect. In the natural environment, among living vegetation, his multifarious glass objects flourish. They appear to breathe and thrive, nourished by the sun, water, fresh air, and the earth's bountiful resources. By comparison, as spectacular as his individual creations may be in a gallery setting, the works are nevertheless confined there, by necessity restrained. A rarefied venue such as an art gallery or a museum space inevitably presents the pieces as quiet, well-behaved art-world captives, no matter how outlandish they may appear to be. But in a lush landscape setting, or in a climate-controlled conservatory, surrounded by nature, their colors beckon, sensuality is enhanced, and a considerable amount of energy is unleashed.

Origins and Evolution

The Garden Cycle made its debut in 2001 at Chicago's Garfield Park Conservatory, which was attended by an astounding 600,000 people over the next twelve months. To date, the exhibition has appeared, with various site-specific alterations and additions, in ten other venues in the United States and Britain, among them the New York Botanical Garden in the Bronx and the Royal Botanic Gardens, Kew, England. Chihuly's spectacular show at the Missouri Botanical Garden in St. Louis, in 2006–7, drew more than 900,000 visitors, an astonishing attendance figure for an exhibition of any kind in any institution. In many ways, *The Garden Cycle*'s extraordinary success may be seen as both a tribute to Chihuly the artist and a celebration of his exceptional career. As his culminating achievement up to now, *The Garden Cycle* in many respects constitutes a Chihuly retrospective: it offers a broad range of objects and installations incorporating examples of many of the various types of works for which he is internationally renowned.

To grasp the full significance of *The Garden Cycle*, including how important the displays outdoors and in conservatory settings are for Chihuly, it would be helpful to briefly reexamine the evolution of his career. Since nearly the beginning, installation art has been one of Chihuly's primary concerns. In 1969, a year after studying the techniques of the Murano glass masters in Venice, he taught at the Rhode Island School of Design and established the college's glass department. There, he soon embarked on a series of large-scale installations using glass and neon. Working with James Carpenter, then one of Chihuly's most gifted undergraduate students, he created complex environmental pieces such as *Glass Forest* (1971–72), now in the collection of the Museum Bellerive in Zurich, Switzerland.

With these endeavors, Chihuly addressed the most avant-garde concerns of the day. Against the backdrop of the civil upheavals of the late 1960s and early 1970s, pioneering sculptors such as Robert Smithson, Walter de Maria, Richard Long, Christo and Jeanne-Claude, Dennis

Page 64

Oppenheim, Michael Heizer, Nancy Holt, and Robert Morris, among others, took art outside the conventional gallery or museum setting.[1] These artists were engaged with enormous works—typically made of earth, stone, wood, and found industrial materials—in vast outdoor installations. Austere and monumental, the pieces were constructed and assembled rather than sculpted. In the creation of the work, the hand of the artist was secondary to the overall intellectual and conceptual design. Like his contemporaries, Chihuly was less concerned at the time with producing individual, autonomous art objects intended for the gallery or home, but rather with spatial relationships and human interaction with an environment beyond sculpture's traditional domain.

Glass Forest—a version of which Chihuly recently created for his 2008 exhibition at the de Young Museum in San Francisco—consists of a darkened room filled with dozens of tall, thin, white blown-glass tubing nearly nine feet tall, some filled with neon. Softly enveloping the room with an ethereal light, the glowing tubes, sensuously curving here and there, are thin at the top and bulbous at the bottom. Ribbon-like coils of glass tubing meander on the floor like sprawling vines. The conglomeration of elements appears fluid, organic, and alive, reminiscent of giant coral or rudimentary plant or animal forms. The early 1970s work portends what would later evolve into Chihuly's sumptuous garden installations. The shapes in *Glass Forest* prefigure the extravagant elements of his so-called *Mille Fiori* (from the Italian for "one thousand flowers") series featured in *The Garden Cycle*.

In 1971, Chihuly cofounded the Pilchuck Glass School on the site of a tree farm near Seattle.[2] He invited many of the most advanced sculptors working in glass to teach there. Among them, the Italian-born American sculptor and painter Italo Scanga (1932–2001) made a lasting impact, not only on the students' work but on Chihuly's as well. "I didn't learn from Italo by watching him make art," Chihuly has said, "I learned by watching him live."[3] A charismatic figure whose work is inexplicably under-known to today's art audiences, Scanga was and still is highly regarded by both the craft- and fine-art cognoscenti. His idiosyncratic and enthusiastic approach and attitude had a strong influence on me as an art critic and writer after I had the good fortune to attend one of his sculpture seminars as an undergraduate. Though focused on technical innovation, Scanga experimented with new ways to incorporate glass into the broader conceptual foundation of his art, which frequently broached mythological and religious themes. In so doing, he managed to overturn many ideological distinctions between fine art and craft. It was left to Chihuly to further dismantle those critical barriers in the years ahead.

Page 75

An important opportunity arose for Chihuly in 1975, when he was invited to participate in Artpark, a program of environmental art. Each summer from 1974 to 1984, Artpark invited artists to create temporary outdoor installations on a 172-acre site near Lewiston, in western New York, near Niagara Falls. Working in collaboration with Seaver Leslie, Chihuly produced a series of large, rectangular, multicolored blown-glass plates that were partially submerged in a pond. Exploring the translucency of the glass, and its relationship to the reflectivity of the water, Chihuly created a panorama of shimmering, geometric forms. Although it employed a spare, Minimalist visual vocabulary, this striking work nevertheless prefigured the installations in ponds and streams that are among the highlights of *The Garden Cycle*.

By the mid-1970s, Chihuly was already widely regarded as a master craftsman in the field of glass. Also adept at the most avant-garde sculptural idioms of the day, which emphasized conceptual acumen over technical skill, he nevertheless unselfconsciously flaunted his unique

technical prowess in everything he did. Without seeking to provoke, Chihuly, more than any other contemporary artist, ignited with his audacious experiments the fierce art-world battle over the boundaries of "fine art" and "craft" that continues to this day. Likewise, he is often the focal point in the critical debate over the place of spectacle in art. This has become an increasingly controversial issue in recent years, since installation art is now a preeminent means of expression for a new generation of artists.[4] The central question here surrounds the "festivalization" of art: should art—or *can* art—be entertaining as well as thought-provoking?

Through it all, Chihuly has shrewdly chosen to ignore the fray and to follow his own destiny. Master of the hotshop, he refined his glassblowing skills in a momentous return to object making in the mid-1970s. A remarkable series of glass *Cylinders* emerged from the studio during that period. Inspired by Navajo blankets, the works feature irregular patterns of embedded glass threads. The pieces, produced in collaboration with Kate Elliott, then later Flora C. Mace and Joey Kirkpatrick, evoke Navajo textile design without sacrificing the fluid and translucent properties of the material. Exhibitions of these pieces in 1976 garnered considerable attention, and the Metropolitan Museum of Art in New York acquired three of them.

That same year, Chihuly lost the sight of one eye as a result of a car accident in England. This, combined with a shoulder injury three years later, forced him to radically change his working method. Although physically impaired, he never lost sight of his artistic goals. He turned to the team-effort studio system of the Venetian glass masters as a model for reconfiguring his hotshop. There was also the example of Andy Warhol and his "Factory," with which Chihuly was quite familiar at the time.[5] Rather than being sidelined in the studio, Chihuly organized the most competent of his assistants into a precisely coordinated team, in which he positioned himself at the center of activity. Acting as master designer and director, he produced drawings and paintings in a rapid-fire, almost Abstract Expressionist technique, to be used as guidelines by the blowers and gaffers. Early on, eschewing the tradition-bound symmetry of the Murano masters who taught him, Chihuly favored eccentric and flamboyant compositions.

He delivers verbal instructions to the team throughout the creative process to bring the results close to what he has visualized. But a key element in his success has to do with his ability to embrace a great deal of chance in his work. In each session, he goes with the flow, not only in terms of the forces of nature—centrifugal force and gravity, for instance—but also with respect to the unique talents of each member of his team. For Chihuly, speed is optimal. He encourages the team to work quickly, not to spend too much time laboring over each piece, and to focus on the process rather than over-anticipate the results. His conviction is that form inevitably follows action. Working in this way—as he continues to do today—Chihuly has produced a staggering number of pieces in a breathtaking array of styles and innovative techniques. By the early 1980s, he had already succeeded in revolutionizing the medium.

Soon after Chihuly's forced change in working method, the *Cylinders* were followed in 1977 by the *Baskets*, inspired by Native American basketry. Vessels in muted shades of brown and tan, with collapsed or irregularly crinkled walls, the *Baskets* are thoroughly American in feel. They appear casual and offhanded in design, distinct from the refined compositions and rigid symmetry of the Murano masters. Then, in 1980, the *Seaforms* began appearing. Like undulating jellyfish or exotic underwater plants, these luminous pieces, typically with thin, ribbed, and striped crenellated walls, frequently feature multiple components. Small bowl-like pieces nest inside larger ones in increasingly complex arrangements. They often recall some of the

more elaborate glass objects that Louis Comfort Tiffany created in the early years of the twentieth century, as well as the eccentric ceramic works of the same period by George E. Ohr, the so-called Mad Potter of Biloxi. Claiming only a distant kinship with the long tradition of glass vessels, Chihuly's objects at this point forgo all attributes of utilitarian purpose; they reside firmly in a sculptural realm.

Next came the giant *Macchia* (meaning "spotted" in Italian), dubbed by Italo Scanga in 1981. These vessels, shaped like enormous conch shells, feature wild, mostly opaque colors and an unprecedentedly large scale, sometimes several feet wide. In the series, Chihuly aimed for a mosaic-like appearance, using unusual combinations of the more than 300 pigment rods for glass that he keeps in his studio. Because of the almost infinite variety of color combinations that the process offers, it is a series Chihuly has returned to on occasion throughout the years, producing works in ever larger sizes and outlandish color combinations. The speckled exteriors of the objects often contrast with monochrome interiors. In sunlight or when spotlighted, the walls of the enormous vessels appear to glow and to evoke the effect of stained-glass windows. Henry Geldzahler, the late curator of the Metropolitan Museum of Art who was an eloquent champion of Chihuly's work, wrote of the series, "You walk into a gallery of twenty *Macchia* up on white columns and you see color as you've never seen it before, as if color itself were floating in the air. It is an elevating experience. It makes you walk a bit lighter for the rest of the day."[6]

Chihuly introduced the *Persians* in 1986. These flamboyant, rather saucer-like rondel forms sometimes resemble flowers. With brilliant colors, interlacing patterns of bands, and scalloped edges with a lip wrap of contrasting color, they are well suited for use as elements in architectural projects. Chihuly arranged dozens of multicolored *Persians* on complex steel armatures mounted on walls and ceilings in a wide range of public and private commissions. One of the most famous examples, the lobby ceiling of the Bellagio Resort in Las Vegas, was enthusiastically received by the public and critics alike when it was unveiled in 1998.

Chihuly's glass sculptures and installations, like those in *The Garden Cycle*, often correspond to works by other modern and contemporary artists. Perhaps more surprisingly, they also spark associations with well-known artists and paintings throughout art history. For example, a major inspiration throughout Chihuly's career, the light and prismatic color in Vincent van Gogh's paintings, may be observed in the *Macchia* and a number of other series. The shapes of the *Persians* were inspired by details in Venetian Renaissance paintings that Chihuly saw, especially those by Vittore Carpaccio, such as *Saint George Slaying the Dragon* (1502–7) in the Scuola di San Giorgio degli Schiavoni in Venice. Here, particularly in details of the fantastic dragon's immense, unfurled wings, one can see the genesis of the *Persians'* glass forms.

In a subsequent series, *Venetians*, begun in 1988, Chihuly collaborated with Murano glass master Lino Tagliapietra to produce some of the most outrageous—and courageous—works ever produced in the medium. Inspired by Venetian Art Deco, Chihuly provided the design impetus with his exuberant paintings on paper, but he allowed his collaborator free rein to contribute his own aesthetic vision to the work. Later, Chihuly worked in a similar way with master glass sculptor Pino Signoretto on a series of *Putti* and with Tagliapietra, and occasionally with American Dante Marioni, on a series of *Piccolo Venetians*. The results of these collaborations are over-the-top, wildly colored, hyperactive objects. Some are covered with jarring excrescences of sinuous vines and flowers, as well as, in the case of the *Putti*, animals and figures. Somehow, in

each work, a cohesive whole arises from the cacophony of multifarious parts and diverse aesthetic contributions. It is important to note the reciprocal inspiration that has resulted from these collaborations. The experience of working with Team Chihuly transformed the rarefied and relatively conservative approach of the Murano masters to tap the limitless sculptural possibilities of the medium. Tagliapietra's 1998 *Flying Boats* installation, with dozens of colorful, gracefully elongated glass shapes suspended from the ceiling, is a good example of Chihuly's influence on these artists.[7]

Another Chihuly series from this period, the *Ikebana*, was inspired by the ancient tradition of Japanese flower arranging. These pieces are highly stylized vessels from which emerge one or more extravagant organic shapes, like extraterrestrial flowers. Perhaps more literal than other Chihuly inventions, the *Ikebana*, like the *Persians*, allude to painting, specifically Van Gogh's *Sunflower* series. The *Ikebana* were followed in the 1990s by other Chihuly series, including the *Niijima Floats*, *Chandeliers*, and *Towers*.

One of the most recent series, the *Mille Fiori*, a diverse array of tall vegetal and floral shapes, as well as totem-like abstractions of animals, first appeared in 2003 and is the most adaptable to outdoor installations. In the *Fiori* category are such recent shapes as *Green Grass*, *Seal Pups*, *Pods*, *Blue Marlins*, *Tiger Lilies*, *Herons*, *Eelgrass*, *Fiddleheads*, *Reeds*, and *Trumpet Flowers*, among others. While many of these seem to reference real flowers and plants, especially exotic, tropical ones, Chihuly emphasizes their abstract qualities. He has never claimed to be a horticulturalist, a connoisseur of plants, or a landscape expert. A deep appreciation of plants and flowers, however, took hold early in his youth, with the elaborate flower gardens his mother carefully tended surrounding their modest home in Tacoma, Washington.

Page 387

The Garden Cycle

Chihuly has presented his glass pieces and installations outdoors around the world since 1992. At first, he showed only *Niijima Floats* and *Macchia* in outdoor settings, sometimes accompanied by a *Chandelier* or *Tower*. Gradually, the exhibitions grew more elaborate, until he arrived at the rambling environmental installations of *The Garden Cycle*. These shows require audience participation in terms of demanding some effort to seek out the works of art temporarily occupying, and sometimes hidden within, the natural environment. Unlike displays in a conventional gallery or museum setting, these exhibitions encompass to a certain degree a physical experience as well as a visual, intellectual, and emotional one. Exploring the terrain, and making discoveries of the created wonders as well as the natural ones, delivers unexpected thrills for visitors used to more staid art experiences. Audiences thereby inevitably connect with the works in an intimate way and, in a sense, become part of them. This helps explain *The Garden Cycle*'s wild popularity and the record-breaking attendance figures.

Wandering through one of the gardens or parks that have hosted Chihuly's sprawling outdoor exhibitions is, indeed, unforgettable. Visitors encounter the artworks with a great sense of surprise and wonder, even a bit of shock in some instances, not unlike that of seeing for the first time an exceptional Surrealist painting such as Salvador Dalí's *Persistence of Memory*, with its haunting landscape of melted watches. The effect can be similarly unnerving. Chihuly's installations dramatically transform the landscape, but they are far more subtle interventions than most of the works of his colleagues creating earth art in the 1960s and 1970s, whose tool

of choice was sometimes a bulldozer. Working with the curators and horticulturalists in charge of the parks, gardens, and conservatories that host these exhibitions, Chihuly's team ensures that *The Garden Cycle* is ecologically sound and the works make only a minimal impact on each site.

Chihuly's glass objects gracefully mesh with the surroundings, although they do retain a considerable degree of their inherent strangeness. For a moment upon approach, one has the exhilarating sensation of discovering, as if by accident, a hitherto unknown or unrecorded plant or animal species that has suddenly revealed itself. Then, glistening beneath the midday sun or glowing in muted twilight, the fantastical things seem animated, self-absorbed, and wholly undisturbed by the unexpected human presence.

I examined this phenomenon firsthand at the Frederik Meijer Gardens & Sculpture Park in Grand Rapids, Michigan, in the early fall of 2010. With its brilliant installations in a gorgeous setting, the show was in many ways characteristic of other exhibitions on *The Garden Cycle* tour. The scale of the exhibition was slightly smaller than most of the other venues, but it was exceptional because the place afforded an opportunity to compare and contrast Chihuly's endeavor with examples of sculptures by some of his most important contemporaries. Under the guidance of the chief curator, Joseph Becherer, the Meijer has assembled a world-class permanent collection of contemporary outdoor sculptures, all of which are carefully and exquisitely sited in the park. To help mark Meijer Gardens's fifteenth anniversary, Chihuly installed fifteen temporary, site-specific installations interspersed throughout the park's 132 acres, among the eighty top-notch modern and contemporary outdoor works by Henry Moore, Alexander Calder, Louise Nevelson, Tony Smith, Mark di Suvero, Richard Hunt, Claes Oldenburg and Coosje van Bruggen, Magdalena Abakanowicz, Arnaldo Pomodoro, Antony Gormley, and Juan Muñoz, to name just a few. Some Chihuly works commingled with the more than 500 tropical plant species inside the Meijer's cavernous conservatory. All his installations corresponded in eloquent and unexpected ways with both the natural beauty of the vegetation and the art-historical significance of the park's permanent sculptures.

In one area of the park was Chihuly's radiant and ravishing *Summer Sun*, a tree-like construction about fourteen feet high with a centralized cluster of flaming red, orange, and yellow glass branches—or, rather, resembling tentacles—that dramatically curled outward and upward. Like tongues of flame from the surface of the sun itself, the elements appeared to glow, bathing the surroundings in a warm and invigorating light. In a clearing just beyond *Summer Sun*, Mark di Suvero's imposing abstract sculpture *Scarlatti* (2000), made of thick Corten steel beams, stood in cold, dark contrast. As an indestructible monument to the once-invincible Industrial Age, this work, in many ways, could not be more different from Chihuly's crystalline paean to the sun. Yet both artists' roots lie in the feverish milieu of experimentation with form and spatial relationships that were attributes of avant-garde art of the 1960s and early 1970s. Chihuly's and di Suvero's works each convey a sense of contained power and energy, and seen together in this manifestation of *The Garden Cycle*, they conspired in an almost emotional way to deliver a kind of yin-yang sense of divergence, harmony, and balance.

Page 325

Similarly, Chihuly's glowing yellow neon *Saffron Tower*, situated near a pond, played a striking counterpoint to Claes Oldenburg and Coosje van Bruggen's *Plantoir* (2001), placed on a slight incline just behind it. More than twenty feet tall, Chihuly's Minimalist structure, encased with tightly clustered neon tubing, suggested infinite verticality; it appeared as a rather casual

Page 347

and playful homage to Constantin Brancusi's *Endless Column* (1938), one of the key works in all of twentieth-century art. Employing a humorous Pop Art sensibility, the Oldenburg and van Bruggen work showed an outsize garden spade, some twenty-five feet tall, stuck in the ground on a slight incline just behind Chihuly's *Tower*. There was an almost giddy sense of visual delight in the pairing of these two unlikely totems.

Pages 348–51

A group of Chihuly's smaller neon pieces, *Tumbleweeds*, featured shining clusters of thin, bright monochrome neon tubing, about eight feet in diameter. Indoors, dangling above the cacti and other desert plants of Meijer Gardens's Arid Garden, the scraggly orbs illuminated the space in brilliant tones of orange, red, green, and blue, evoking the searing heat of the desert sun.

Chihuly transformed the Tropical Conservatory into a revelatory place, full of unexpected colors and shapes. Large, majestic *Macchia*, installed low to the ground along a pathway, emerged from the greenery like exotic flowers in full bloom. Surrounded by palms and other

Page 342

tropical vegetation, large, irregularly shaped blue *Baskets*, set on tall metal stands, seemed from a distance to be attached to the plants as if they were overgrown tropical fruit. Equally at home here were several outlandish *Ikebana*. Glistening just above the surface of a pond in the center of the space, clusters of *Persians* in various sizes and shades of yellow appeared as vibrant specimens of a previously unknown variety of water lily—and attracted the giant koi flashing in the water below.

Suspended from the Tropical Conservatory's ceiling, high above the palms and exotic vegetation, Chihuly's enormous *Polyvitro Chandelier* commanded the space with a dense conglomeration of shiny orbs in various sizes and riotous colors. This fantastic invention is made of a hollow plastic, a material that Chihuly uses in a several guises. While some purists may question his unorthodox diversion from glass, he uses this synthetic material for its formal properties that are akin to glass. Its light weight is also a factor, as it enables the artist to create ever more imposing monumental sculptures. But it is the translucency of the plastic that is its primary appeal. Chihuly includes plastic in the same category as glass, ice, and water. As he explains,

> And so when you're working with transparent materials, when you're looking at glass, plastic, ice, or water, you're looking at light itself. The light is coming through, and you see that cobalt blue, that ruby red, whatever the color might be—you're looking at the light and the color mix together. Something magical and mystical, something we don't understand, nor should we care to understand. Sort of like trying to understand the moon. Water has magical powers, and glass has magical powers. So does plastic, and so does ice.[8]

Page 339

Chihuly also uses Polyvitro in outdoor installations. Tall metal armatures support large, rough-hewn chunks of the material in sculptures such as *Lime Crystal Tower* and *Rose Crystal Tower*, which were also on view at Meijer Gardens. Glowing in the sunlight, these tall columns appeared to be covered with enormous uncut gemstones. The most evocative Polyvitro instal-

Page 333

lation at Meijer Gardens, *Blue Polyvitro Crystals*, jutted out from the water along the shore of a large marshy lake bordering the park. A rather incongruous sight, the elements looked like irregular blocks of ice floating in the lake—remnants, perhaps, of a disintegrating glacier.

Water is a key component in *The Garden Cycle*. Just as plants need to be close to water sources to thrive, many of the glass installations are situated along ponds, streams, and waterfalls. As water multiplies the translucent reflectivity of the glass, it heightens the poetic

effect of each work and the indelible impact it has on the viewer. As the theorist Gaston Bachelard noted, "Water, by means of its reflections, doubles the world, doubles things. It also doubles the dreamer, not simply as a vain dreamer, but through his involvement with a new oneiric experience."[9]

Chihuly's work has always revolved around the limitless metaphorical possibilities of glass. He shares with his many admirers a fascination with the mythological status of the material in terms of its alchemical transformation—by means of fire and air—from a liquid state to a solid. There are several documentary films of Chihuly at work on *The Garden Cycle* installations sited near streams, lakes, or rivers. A number of these films contain scenes in which the artist gleefully tosses *Belugas*, *Seal Pups*, and *Walla Wallas* into the lakes and streams. With each mighty splash, Pages 24, 25 he exudes a palpable sense of satisfaction as the glass sculptures hit the water. Apparently oblivious of the camera and crew, Chihuly seems engaged in his own private reverie, or personalized ritual. Symbolically, at least, he returns the glass to its original liquid state.

Scattered among the cascades of a multileveled terraced waterfall at the Meijer, large, round *Niijima Floats*, like giant, multicolored bowling balls or beach balls, punctuated the scene. Pages 336–37 Altering the course of the water's path, they also transformed the mood. The waterfall's once hushed and melancholy tone was now unabashedly playful, offering visitors young and old a place of giddy enchantment. Approaching a nearby pond elsewhere in the park, visitors came upon a lush, glittering water festival that seemed well under way; it called to mind a garden party scene from a Rococo painting by Antoine Watteau or Jean-Honoré Fragonard. Hovering over the pond and reflected in it, an imposing *Blue Moon*, made of long spikes of blue and clear Pages 326–29 glass emanating from a central core, was fixed to a tall metal pole planted along the shore. In the middle of the pond, large, bulbous glass *Walla Wallas* bobbed in the water like the heads of some fanciful aquatic creatures. Visible on the opposite shore, a small *Yellow Boat* hugged the Pages 330–31 shoreline, crowded with what appeared to be revelers in colorful regalia—some holding long green spears or lances. On closer inspection, the boat's wildly gesticulating occupants turned out to be dozens of *Fiori*, tightly packed into a rowboat. Upward-spiraling yellow *Eelgrass*, tall, spiky green *Reeds*, and fat, elongated maroon *Belugas* suggested the bodies and limbs of the spirited and gesticulating characters in colorful costumes that had been observed from the opposite shore.

More sobering, but no less fantastical, were a dozen or more large *White Belugas* clustered Pages 340–41 along the banks of a marshy forest pond. Like the eggs or larvae of some long-extinct Jurassic creature, cozy in their muddy nests, the ominous pods conjured all sorts of science-fiction imagery and intrigue. The uncanny installation evoked paintings by Surrealist masters such as Max Ernst and Yves Tanguy. Chihuly's most haunting installations, such as a field of tall, violet *Reeds* and purple- and magenta-striped *Herons* surrounded by gently swaying swamp grass, recalled for me paintings of the 1940s and 1950s by the English artist Graham Sutherland. Like Chihuly, Sutherland produced a series of images of hybrids, ambiguous life forms that are at once animal and vegetable. Defiantly thrusting upward toward the sun, Chihuly's dynamic forms echo those in Sutherland's works, which center on the endless struggle of organic forms to defy the passage of time and survive the onslaught of natural forces. Sutherland's statements about his work closely correspond to the intellectual and emotional tenor of *The Garden Cycle*. "It is not a question so much of a 'tree like a figure' or a 'root like a figure,'" he has stated, "it is a question of bringing out the anonymous personality of things; at the same time they must bear the mould

of their ancestry. There is a duality; they can be themselves and something else at the same time. They are formal metaphors."[10]

Throughout *The Garden Cycle*, the *Reeds* present a particularly potent source of metaphor. Deceptively simple, almost Minimalist inventions, the *Reeds* are often rather casually displayed in groups of a dozen or more, sticking straight up from the ground seven to ten feet high, or nonchalantly leaning against a wall or one another. In one installation, for instance, a batch of tall *Reeds* jutted skyward from a log rotting on the forest floor: an aggressive new species of fungus, perhaps, standing triumphant, having gradually felled the tree. An especially evocative grouping of cobalt blue *Reeds* soaring from an incline near the edge of the park sparked a whole new set of allusions, this time to Baroque painting. One thinks particularly of Diego Velázquez's iconic image of a battlefield truce, *The Surrender of Breda (Las Lanzas)* of 1634–35, in which a crowd of dozens of victorious soldiers on the right bear upward-thrusting lances that majestically fill the space. One of the most effective installations of all was a grass-covered verdant hillside pierced with hundreds of tall, upright *Red Reeds*. The remnants of an intergalactic battle, perhaps, or a field of blazing lightning rods, this stunning work challenged the viewer with a bountiful resource of endless speculation. Are these strange objects made by humans, or are they a product of nature? Chihuly intentionally confounds the answer.

Pages 344–45

Herein lies the key to Chihuly's great accomplishment in *The Garden Cycle*. In exciting and unexpected ways, he elicits a deep emotional and intellectual response to art. At the same time, his work insists upon a new approach to nature, one that leads to a renewed respect for, and a further understanding of, an increasingly endangered planet. *The Garden Cycle* stimulates the imagination of all who enter, while appearing at first to offer nothing more—and nothing less—than infinite visual delights.

1 For a comprehensive survey of key earthworks of the period, see Gilles A. Tiberghien, *Land Art* (Princeton, N.J.: Princeton Architectural Press, 1995).

2 Tina Oldknow, *Pilchuck: A Glass School* (Seattle: Pilchuck Glass School / University of Washington Press, 1996), is a definitive study of the founding and development of the school.

3 Dale Chihuly, quoted in "The Passion of Italo," *Glass*, no. 105 (Winter 2006–7): p. 48.

4 See Janet Koplos and Bruce Metcalf, *Makers: A History of American Studio Craft* (Chapel Hill: University of North Carolina Press, 2010), p. 411.

5 For a discussion of Chihuly's acquaintance and interaction with Andy Warhol, see Timothy Anglin Burgard, *The Art of Dale Chihuly* (San Francisco: Fine Arts Museums of San Francisco / Chronicle Books, 2008), pp. 44–45.

6 Henry Geldzahler, *Making It New: Essays, Interviews, and Talks* (New York: Turtle Point Press, 1994), p. 317.

7 Susanne K. Frantz, *Lino Tagliapietra in Retrospect: A Modern Renaissance in Italian Glass* (Seattle: University of Washington Press, 2008), pp. 98–99.

8 Dale Chihuly, quoted in *Chihuly Gardens & Glass* (Seattle: Portland Press, 2002), pp. 154–56.

9 Gaston Bachelard, *Water and Dreams: An Essay on the Imagination of Matter* (Dallas: Dallas Institute of Humanities and Culture, 1994), p. 48.

10 Graham Sutherland, quoted in Francesco Arcangeli, *Sutherland* (New York: Harry N. Abrams, 1975), p. 11.

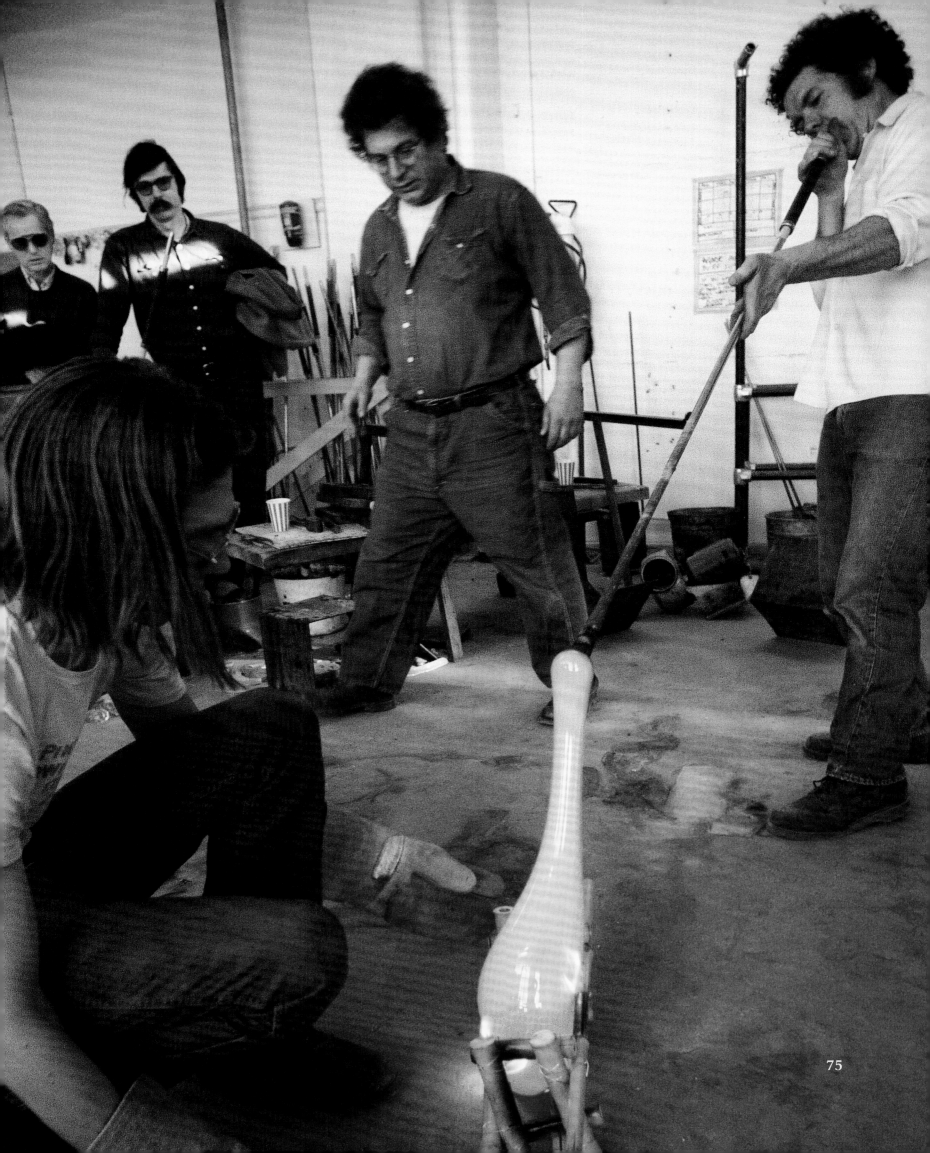

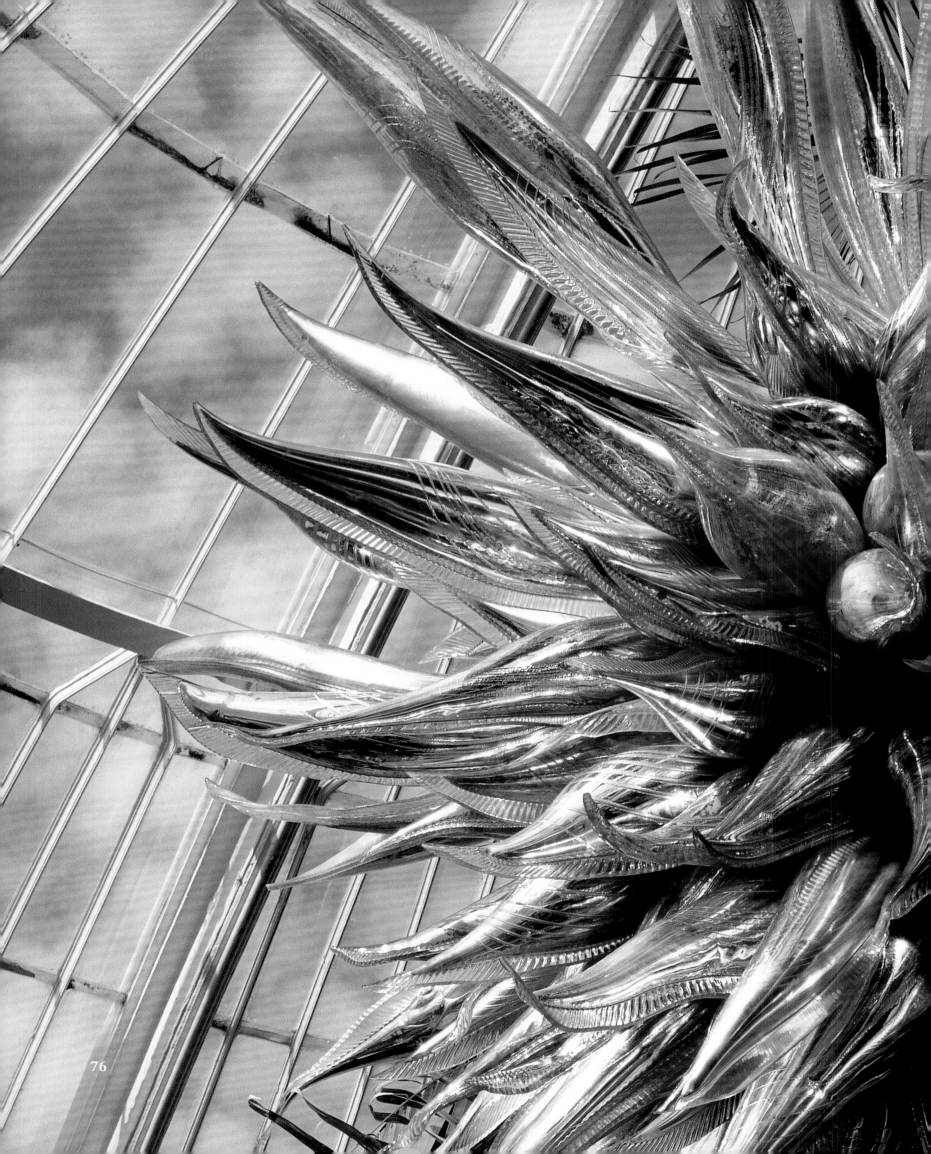

GLASS IN THE LANDSCAPE: THE INFINITE AFFINITIES OF FORM

Tim Richardson

The genesis of Dale Chihuly's ongoing *Garden Cycle* (2001 to date) lies in the artist's interest in and appreciation of historical glasshouses. On one level, it was simply the thrill of exhibiting "glass inside glass" that first drew him to formal botanic-garden environments. But that interest soon developed into something much deeper and more enduring: a series of exhibitions set in a range of different garden environments, each of which takes the form of episodic installations of glass sculpture, all of which are distinctive and unique to a specific place.

The obvious affinities between Chihuly's glass works and the manifold natural forms of plant life remain perhaps the most striking feature of the series as a whole. But in addressing these exhibitions on the scale of landscape—which is how they came to be conceived—it becomes clear that Chihuly and his team expend just as much time, care, and thought on the rhythm of the experience, on the atmospheric or tonal particularities of each setting within the whole landscape, as they do on the smaller-scale juxtaposition of art objects and plants.

For these exhibitions to be successful, visitors ought to be able to leave with a strong and satisfying sense that they have been immersed in a variety of glass/garden episodes that have somehow coalesced into an overall picture. The success of this is most dependent not on detail but on the manner in which the glass installations or episodes are set within the garden. *The Garden Cycle* has been successful partly because Chihuly responds to the individual particularities of each place and sites his own works in sympathy with it, so that they complement the landscape and collaborate with it, rather than simply utilizing it as a backdrop (which has been the general tradition of siting sculpture in gardens since the early twentieth century).

While each exhibition in *The Garden Cycle* thus far has contained works specially fabricated in response to the site, the works on view in these exhibitions cannot in general be described as "site-specific," in that they include pieces from the same sets or series, either repeated or presented as variations on themes. On the other hand, some of the power of *The Garden Cycle* as a whole derives from the idea that a new artistic taxonomy—in this case, an artistic classification based on Chihuly's various glass series—has been imposed on the scientific taxonomy of the natural world that is historically associated with botanic gardens. So while site-specific is certainly the contemporary fashion when it comes to commissioning works for landscape settings, in the case of Chihuly's work there is no obvious advantage in its being conceived in this way. His work in glass complements the surrounding plant life, but not by means of "blending in" with it. In that sense, it has been quite appropriate to develop a range of different series of glass forms for use in disparate situations—just as plants crop up in different environments in the wild.

Equally, Chihuly's art is possessed of such material consistency and elemental power that it can stand up to a landscape setting in its own right, existing genuinely in balance with it. (The same can be said of the work of Henry Moore, for example, a major retrospective of which formed the theme of the next big sculpture exhibition at the Royal Botanic Gardens, Kew, after Chihuly's, which was just as successful.) The sense of the autonomy of Chihuly's works is exaggerated by the bold notion of spreading them all the way across the botanic gardens involved in *The Garden Cycle*—which was quite a leap of faith for many of the institutions, because it meant decisively altering the character of the garden for a number of months. An awareness of the temporary nature of the exhibitions was an important aspect of their transformative—and arguably transcendent—power, since each provides those familiar with that garden with a once-in-a-lifetime experience. All the curators of the scientific institutions involved thus far should be congratulated for their role in fostering such an ambitious crossover experiment.

Indoor art exhibitions have long been regarded as appropriate distractions in botanic gardens, generally taking the form of works on paper—most often, botanical illustrations. At Kew, for example, there are two permanent displays of botanical art: the nineteenth-century Marianne North Gallery and the Shirley Sherwood Gallery of Botanical Art, which opened in 2008. Outdoor art exhibitions and permanent installations are a more recent phenomenon in botanic gardens, a reflection of the growing popularity of dedicated sculpture gardens in the later twentieth century. The Royal Botanic Garden Edinburgh, for example, frequently holds art and sculpture exhibitions in a purpose-built gallery and in the garden itself, as do the new National Botanic Garden of Wales, in Llanarthne, and the National Botanic Gardens at Glasnevin in Dublin, Ireland. One of the gardens involved in *The Garden Cycle*, the Frederik Meijer Gardens & Sculpture Park in Grand Rapids, Michigan, was conceived from the beginning (1995) as a hy-

brid between sculpture garden and botanical institution. Sculpture plays a permanent role at Singapore Botanic Gardens and also at the exuberant and whimsical Ventnor Botanic Garden, on the Isle of Wight off the southern coast of England. Some botanic gardens (such as that in Birmingham, England) even host their own short sculpture courses..

The exhibitions in Chihuly's *Garden Cycle*, however, stand apart from all these ventures in that they represent an artistic marriage between the work of a single artist and the entire fabric of a single garden. Chihuly's works are not simply scattered about; they are enmeshed and interwoven with the place itself—with the topography, the buildings, the ponds, the roads and pathways, and of course the plants. As a result, the artworks not only respond to their settings but are palpably enriched by them. Emplaced as episodes within the wider landscape, they can play a role, too, within vistas, acting as new and exciting punctuation marks in the rhythm of the garden, while also colonizing perhaps unlikely features such as lakes, rockeries, and formal Japanese gardens. It is this comprehensive, immersive quality that sets *The Garden Cycle* apart from a "regular" sculpture-in-the-garden event.

The exhibitions in *The Garden Cycle* also enact a performative role, reinstating a tradition of wonderment in garden design that is evocative of the fêtes champêtres of Louis XIV's Versailles, where sculptural, automotive, musical, or light shows dazzled and impressed visitors in the wooded bosquets on either side of the Grand Canal. As with Chihuly's garden exhibitions, there were set routes to follow around the gardens at Versailles. The nocturnal openings that are a feature of most of Chihuly's *Garden Cycle* exhibitions enhance this sense of drama and occasion, as regular visitors are enchanted to find a familiar and much-loved garden transformed by glowing artworks in colored glass. Seeing the glass lit at night is a completely different experience from that of seeing it by day. In the festive atmosphere of night, it is as if the gardens are there to be admired in their party dress, like a debutante who at long last has the chance to go to the ball.

At Kew in 2005–6, the focus of the exhibition was the celebrated Temperate House, designed by Decimus Burton in 1859 and an icon of glasshouse design worldwide. But that was just the beginning—there were also works that floated on the lakes or were placed at the ends of vistas and in various other glasshouses and buildings. There was, in fact, Chihuly glass sculpture everywhere. If there were any concerns that regular visitors might regard this "invasion" as some kind of desecration of the botanic garden—the repository, after all, of the botanical riches of the British Empire throughout the nineteenth century, and still the most important botanical institution in the world—these were soon dispelled by an overwhelmingly positive response from those who came.

The Temperate House, home to tender woody plants arranged geographically, contained a wide range of Chihuly's works, either placed right in among the plants or presented more formally, on black metal platforms. Among Chihuly's most recognizable forms are the spear-like *Reeds*, colorful globular *Niijima Floats*, *Chandeliers* of entwined tentacles, *Towers* (which are upside-down *Chandeliers*), and *Ikebana* displays. In the Temperate House, *Macchia* (shaped like clamshells) were formally arranged in tiers among pots of brugmansia, rather like an eighteenth-century "auricula theater"—that is, tiered shelving on a painted black background, ideal for showing off the intricacies of these primulas' petals. There were also globular, speckled *Floats*; *Baskets* based on Native American craftworks; and *Reeds*, which erupted from the dark earth in apparently organic groups, the bright lavenders, reds, blues, and oranges

Pages 164, 165

Pages 170, 171

of the glass catching the light as it dappled through a filigree of ferns and fronds. *Ikebana* pieces—twin stems thrusting forth from "vases" below—appeared on black platforms amid the plants, while hovering above these were some of Chihuly's most celebrated works: *Chandeliers* of glassy tentacles that look like extraterrestrial octopi or exploding suns. They could also be compared with Baroque gilded decoration or the seething, encrusted complexities of sixteenth-century late Gothic Manueline architecture, as seen at the Mosteiro dos Jerónimos at Belém in Lisbon, Portugal.

Page 168

One of the most beguiling moments in the Kew show was a cluster of slender, vertical lavender *Reeds* set in the shade of giant tree ferns—there was the contrast of texture between the shaggy stems of the ferns and the perfectly smooth glass, of course, but it was the gorgeously unusual color combination of lavender in dusky green light that was most affecting. Elsewhere in the Temperate House, the surface of a pond was adorned with orange-yellow disks or platters that looked like thin, translucent slices of fruit, some turned up at the edges, a scene prefaced by a magnificent group of pure white arum lilies.

Another wonderful moment was the discovery of a set of red-orange *Reeds* amid the massive red-brown stems of the *Musa basjoo* species of banana, shaded by its vast, graceful leaves. Nearby was a cluster of clear glass tendrils thrusting above the delicate white star flowers of *Arthropodium cirratum*, while another section of the Temperate House was graced with a vivid

Pages 173, 174–75

red *Chandelier* that appeared to be exploding overhead. Elsewhere, glass forms that were a mass of yellow tentacles and green, silvery, and blue bulbs clasped and encrusted the four vertical ironwork columns. The hothouse plants (in that case, the purple trumpet-flowered climber *Calystegia affinis*) were already beginning to entwine the glass pieces.

Outside, the most dramatic intervention consisted of several score multicolored, onion-like

Pages 154–55

floats (which Chihuly calls *Walla Wallas*), scattered on the lake in front of the Palm House. The incongruity was amusing enough, but the vista from the far side of the lake made this piece into something of a folly itself, somehow in keeping with the various temples (and surviving pagoda) that Sir William Chambers added to Kew in the mid-eighteenth century. A giant tree

Page 153

(*Taxodium distichum*) framed a view that took in a boat in the foreground, crammed with colored gourds and grasping tentacles (an echo of naumachia—mock battleships of Renaissance gardens), then the floating *Walla Wallas*, and finally the tall scarlet and orange *Towers* that flanked the entrance to the Palm House, each made of 355 separate pieces of glass attached in sequence to an armature. The phantasmagoria continued inside the glasshouse, where the *Palm*

Pages 76, 157

House Star, a silvery Polyvitro piece that resembled a cluster of young bananas, was suspended over a huge specimen of the ferny *Encephalartos altensteinii*.

The success of the Kew exhibition (which was extended due to public demand, like a number of others in *The Garden Cycle*), and the evident affinity of his work with plants, led Chihuly to drop everything else and embark on a concerted and still-continuing program of botanic-garden exhibitions, most of them in the United States. Chihuly deliberately sought out different kinds of gardens in various climate zones, to add variety and richness to the series. Working out of his warehouse-sized studios in Seattle, Chihuly and his glassblowing team have further developed a vocabulary of glass forms that can be deployed to good effect in garden settings: tall *Towers*, elegantly stooping *Herons*, thin *Reeds*, clamshell-like *Macchia*, glittering *Chandeliers*, bulbs and boats floating on lakes, and climactic *Suns*—gorgon-like balls of yellow and orange. Chihuly's glass is certainly not for the color-phobic, which is perhaps why the work has

been so warmly received by the garden audience—gardeners being, by and large, chromatic hedonists and unreformed sensualists.

These colored, squirming, and writhing concoctions seem to reflect the fecundity and variety of plants in the wild, both in the violence of their coloring and in the unpredictability of their forms. It means that Chihuly's work—though clearly man-made—sits well alongside the expected delights of the tropical or temperate house. "I love to juxtapose the man-made and the natural to make people wonder and ask, 'Are they man-made or did they come from nature?'" he explains. There is something about the endless variation and mutation in Chihuly's work that gives it a tangible affinity with natural selection, particularly the plant world.

Chihuly's series of shapes have all been developed obsessively over decades, and multicolored "mistakes" or mutations are displayed alongside more perfect examples, just as in nature. "I think a lot of it comes from the fact that we don't like to use a lot of tools," Chihuly says, "but natural elements to make the glass—fire, gravity, centrifugal force. As a result, it begins to look like it was made by nature." Few of the pieces are based on specific botanical forms, but there is no shortage of bulbous gourds, curly tendrils, and arching stalks.

It might seem surprising that the violence of the coloring and the disturbing level of mutation in these works make them seem more natural rather than less. At Kew, the groupings of pieces appeared to surge and recede rhythmically in imitation of the vagaries of nature, an impression enhanced by the way the hothouse plants began, almost immediately, to grow through and around the sculptures. The moist, dripping, mulch-like atmosphere of the greenhouse also works well with the palpable fluidity of the glass pieces, since the visitor knows that each is a moment frozen in time, a snapshot of an organic development controlled but not wholly created by the artist-glassblower. An awareness of the changefulness of materials and the limits of human control also unites the glassblower and the gardener. These are clearly man-made interventions, but the way they have been created—not as stand-alone pieces but in serial form as part of a continuous process of experimentation and variation—does seem to reflect the brutal integrity of nature in the raw.

Despite their obvious artificiality, the glass pieces seem to complement the plants extremely well. Chihuly has been developing—or evolving—these series since the 1970s, continually varying them and experimenting, and seeing them in a botanical setting does bring to mind the habits of plants in the wild: grouped in clusters or spread as if self-seeded, with small mutations and differences in size and shape. There are other similarities: glass objects, like flowers, are usually much tougher than they look; Chihuly's many studio failures "die" just like plants in the wild; and different types of light can transform them. The frozen liquidity of glass as a material also seems appropriate in the moist, throbbing, fecund setting of the hothouse.

The work, in fact, emerges as analogous to that produced by the self-sustaining regimes of nature. The idea of "evolution" in an artist's practice is an overused analogy, but it is perhaps pertinent here because variation, repetition, death (in the sense of material failure), and selection are constant themes in Chihuly's work. The idea of a series being perfected or finished is anathema to him. As he has stated of his *Macchia* series, "Like much of my work, the series inspired itself."

One or two British art critics have described Chihuly's work as "vulgar"—though for the most part approvingly. His works are not just colorful, they glow with color, which can seem a little bit much to some gallerygoers. Garden visitors, however, actively crave intense color, so

Chihuly's work is perfect for this environment. Nature tends to extremes, after all. And is there not perhaps the slightest frisson of danger bound up with Chihuly's creations? Coming across them, alone, in a botanic-garden setting, one can feel ever so slightly vulnerable when faced with their physicality, virility, and explosive aura. Shouldn't these things be behind bars? Perhaps that is overstating the case, but there is certainly something thrilling yet almost disturbing about some of these objects, deployed as they are in a setting—a botanic garden—that one reasonably expects to be polite, ordered, rational, and probably gentrified. The subversion of prevailing atmosphere is one of the ideas at play in *The Garden Cycle*.

The most recent installment in *The Garden Cycle* to date was the exhibition at Cheekwood Botanical Garden in Nashville, Tennessee, in 2010. Although Cheekwood describes itself as a botanical garden, it is also an interesting and attractive example of an American country house and garden designed in the "English" style. Completed in 1932, it was commissioned by members of the Cheek dynasty, the local family that developed the Maxwell House coffee blend.

As *The Garden Cycle* has progressed, more and more emphasis has been placed on the siting of the glass in the landscape, and the Cheekwood exhibition was in this regard perhaps the most sophisticated experiment. The work was spread through the garden's spaces, including a series of three descending pools looked down on from the house on its hill, as well as the formal terraces that rise up to the central drawing room and its balcony-arbor. Lower down in the garden, there were some inspired glass/plant combinations, such as the purple-leaved plant *Setcreasea pallida* (purple queen) in the arbor leading to a particularly explosive purple and green glass piece entitled *Green Grass and Optic Reeds*. The *Setcreasea* was also used to good effect as a kind of launchpad for a group of writhing orange-red *Cattails* near the entrance to the garden. Another highlight was the formal Japanese garden, both the mysterious path that prefaces it (vivid red *Reeds* among the bamboo stems) and the "Zen" gravel garden itself, which was strewn with large, multicolored glass spheres (*Niijima Floats*), like a giant's game of marbles.

Up at the house, however, Chihuly's skill at siting episodic installations in glass was deployed to even more powerful effect. The lowest of the formal terraces was almost filled by a rectangular pool bookended by statues of Thalia and Urania. Into this, Chihuly placed a floating piece, an astonishing and explosive concoction in greens, silvers, and gold, backed by stands of purple and blue *Reeds*. On the top terrace, meanwhile, a collection of deep blue *Marlins* was the perfect complement to a pool of water lilies and other aquatic plants. These considered interventions coalesced as episodes to create an experience that was less an "exhibition" but could, in fact, be read as a single, unified work of art in its own right. Another staging post has been reached in Dale Chihuly's *Garden Cycle*, and it will be intriguing to see how the series develops further, as the variety of garden settings used as venues grows ever wider.

Page 356

Pages 366–67

Pages 370, 371
Pages 362–63

Pages 83, 353

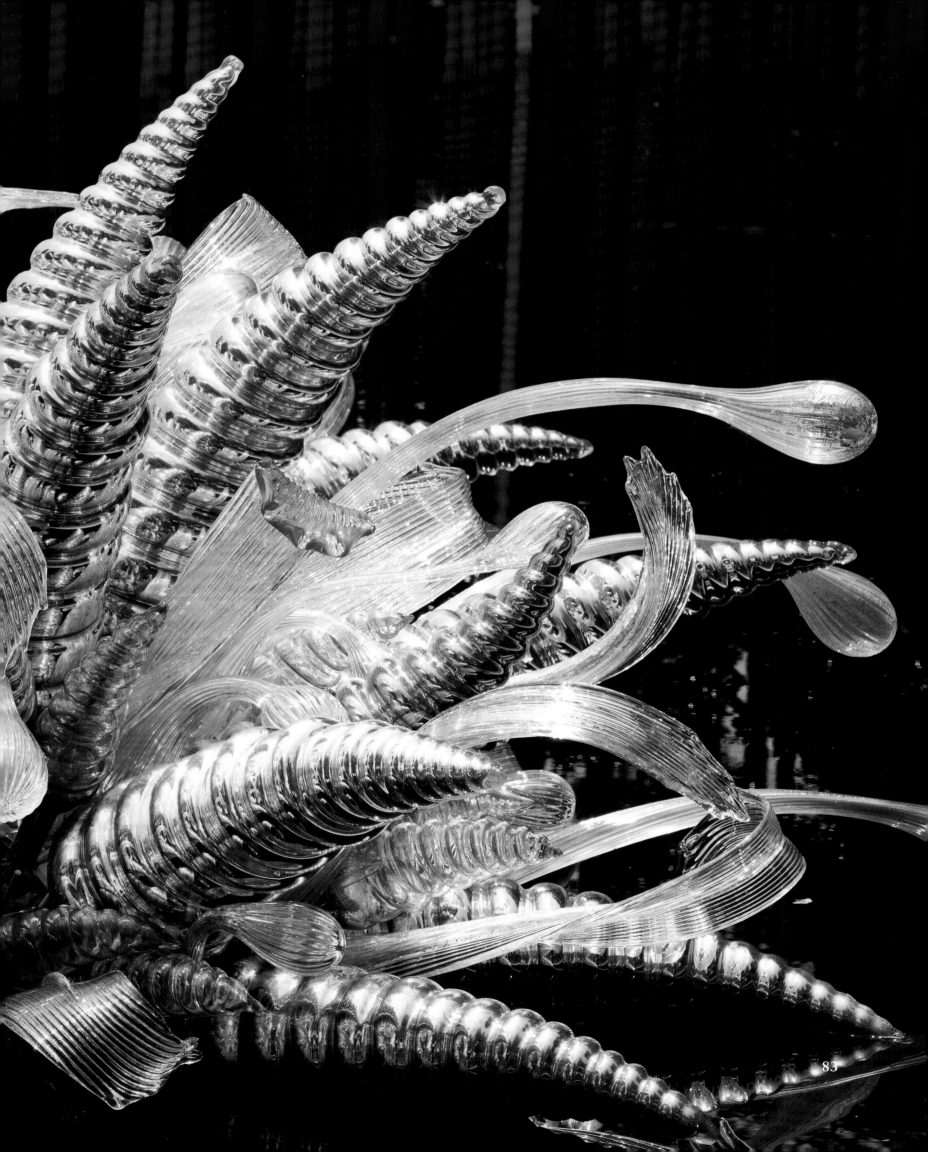

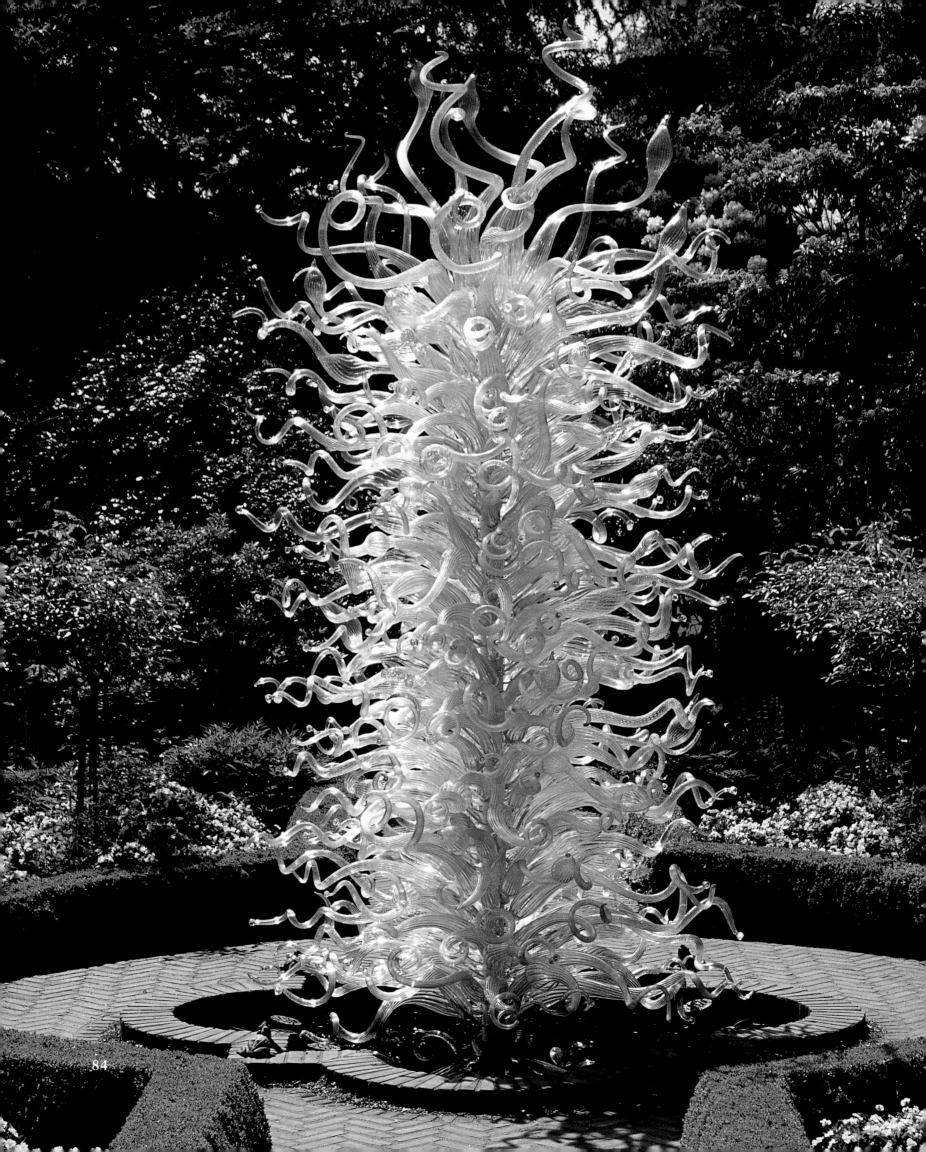

Garfield Park Conservatory
Chicago, Illinois
November 23, 2001–November 4, 2002

Franklin Park Conservatory
Columbus, Ohio
October 11, 2003–July 4, 2004
September 25, 2009–March 29, 2010

Atlanta Botanical Garden
Atlanta, Georgia
May 1–December 31, 2004

Royal Botanic Gardens, Kew
Richmond, Surrey, England
May 28, 2005–January 15, 2006

Fairchild Tropical Botanic Garden
Coral Gables, Florida
December 3, 2005–May 30, 2006
December 9, 2006–May 31, 2007

Missouri Botanical Garden
St. Louis, Missouri
April 30, 2006–January 7, 2007

New York Botanical Garden
The Bronx, New York
June 25–October 29, 2006

Phipps Conservatory and Botanical Gardens
Pittsburgh, Pennsylvania
May 12, 2007–February 24, 2008

Desert Botanical Garden
Phoenix, Arizona
November 22, 2008–May 31, 2009

Frederik Meijer Gardens & Sculpture Park
Grand Rapids, Michigan
April 30–October 31, 2010

Cheekwood Botanical Garden and Museum of Art
Nashville, Tennessee
May 25–November 7, 2010

Garfield Park Conservatory
Chicago, Illinois

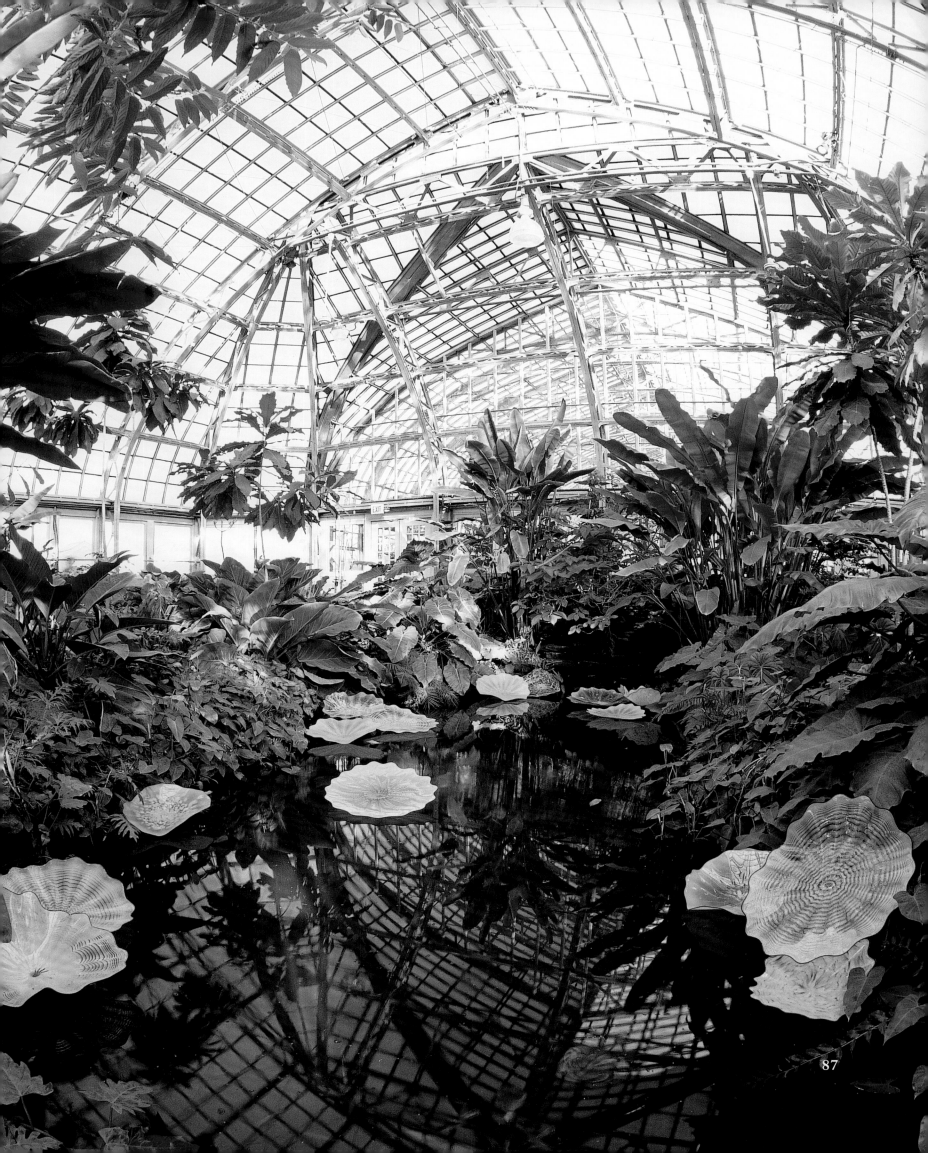

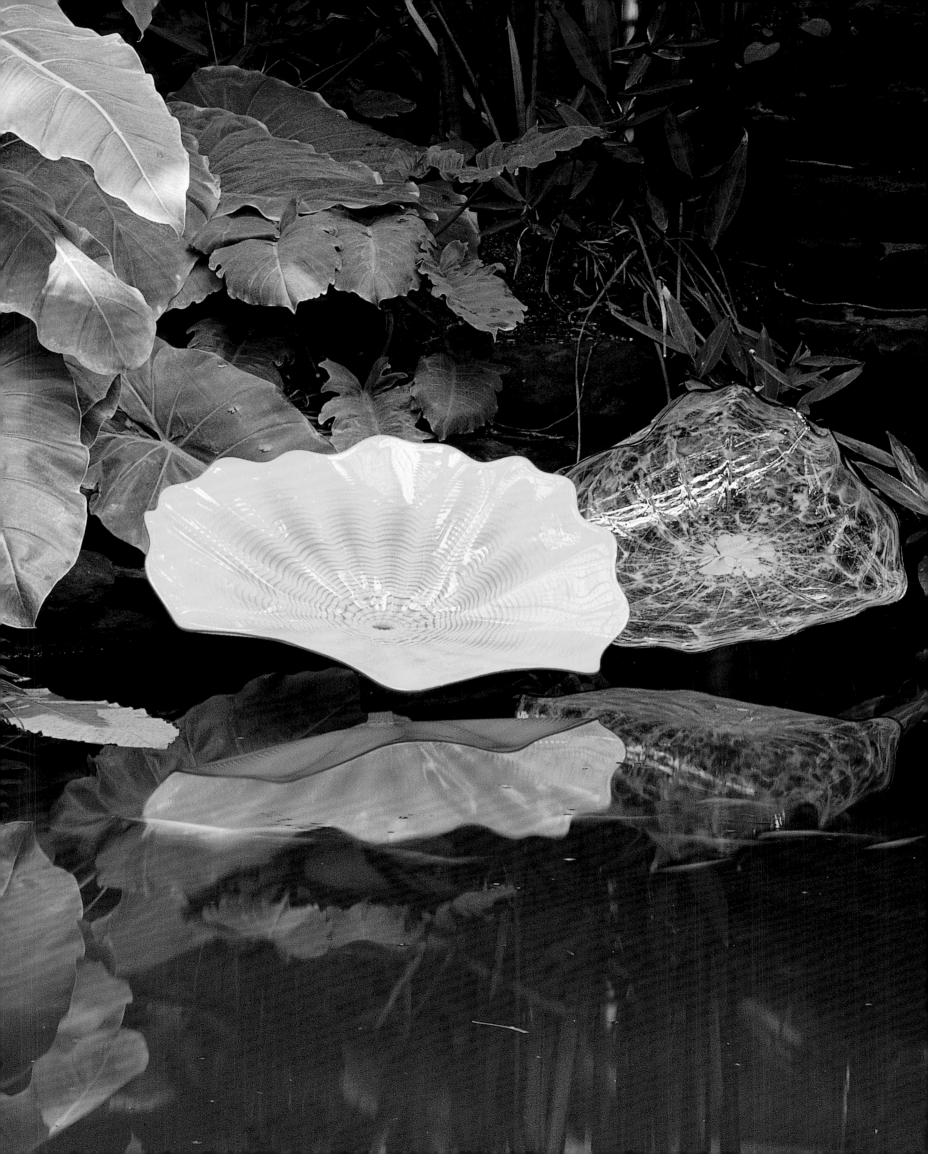

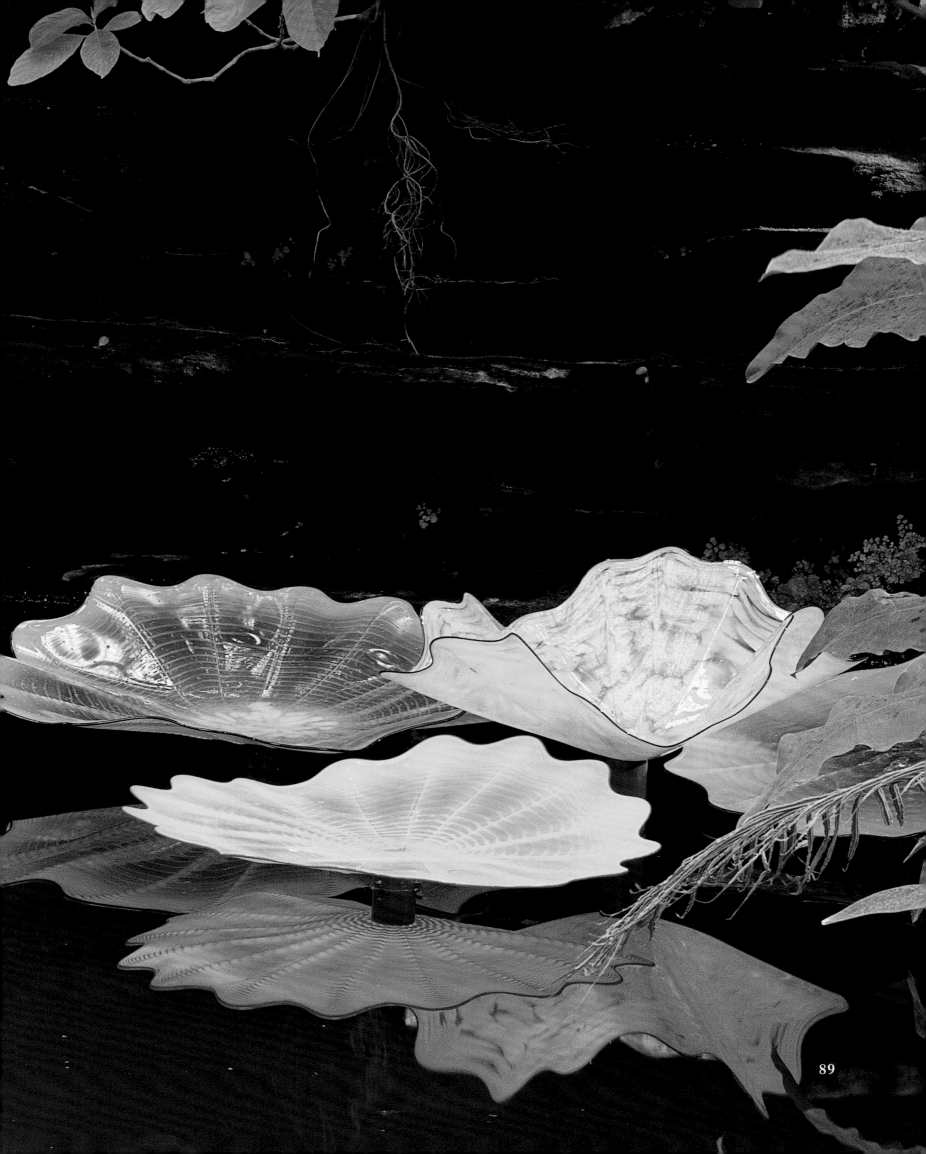

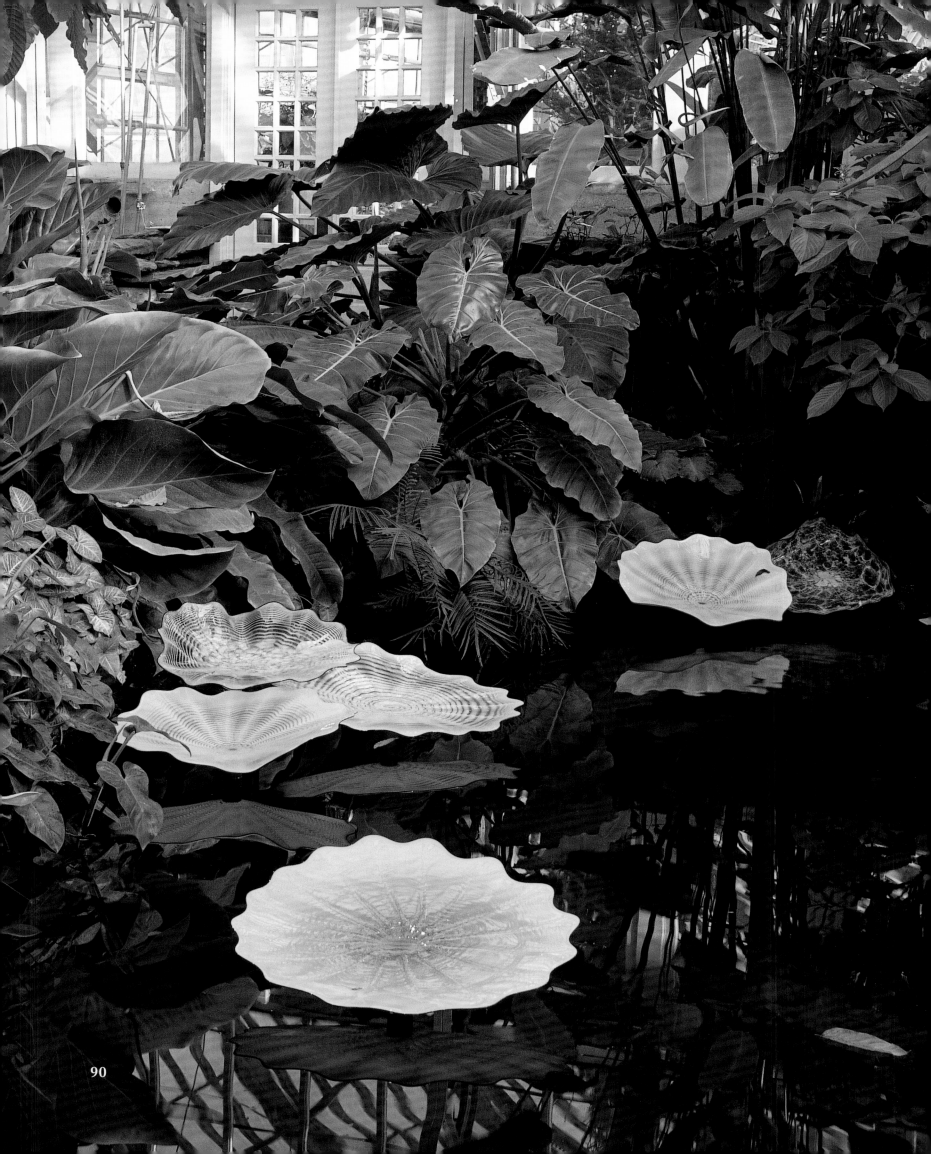

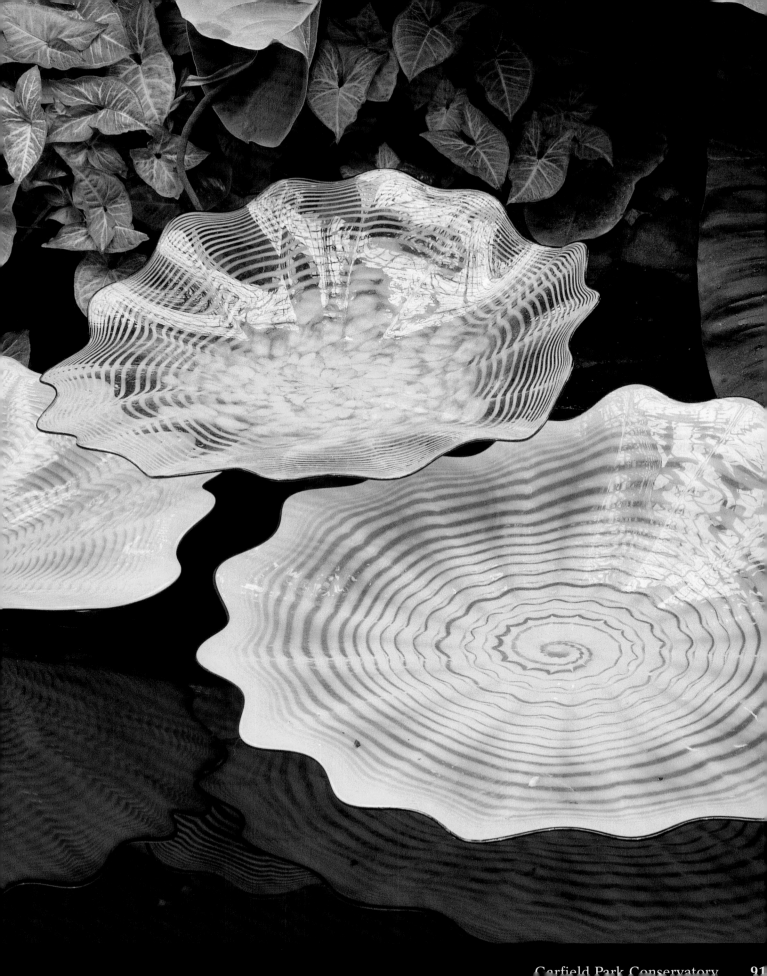

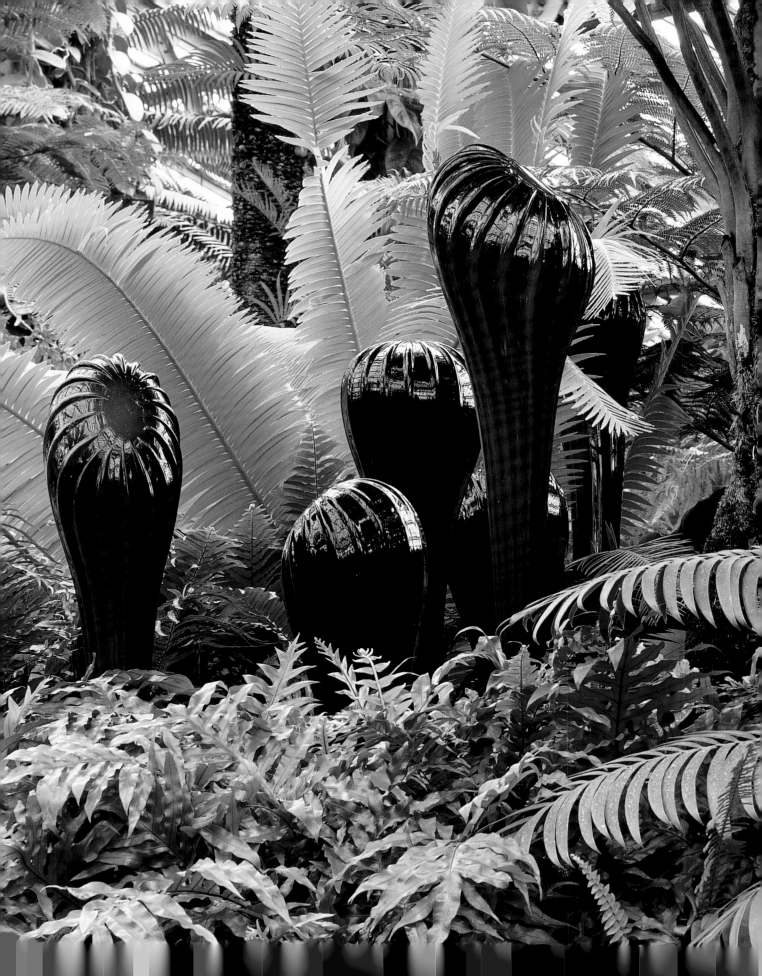

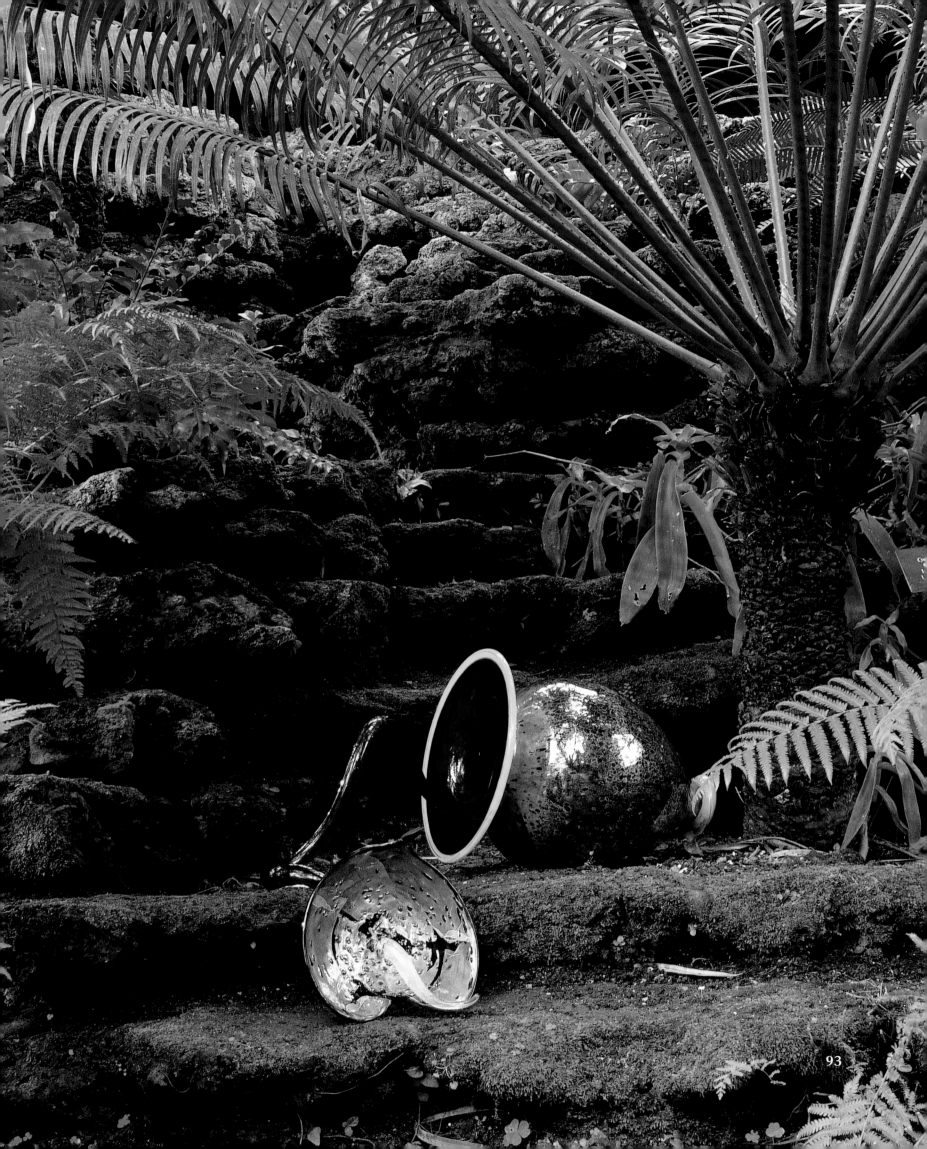

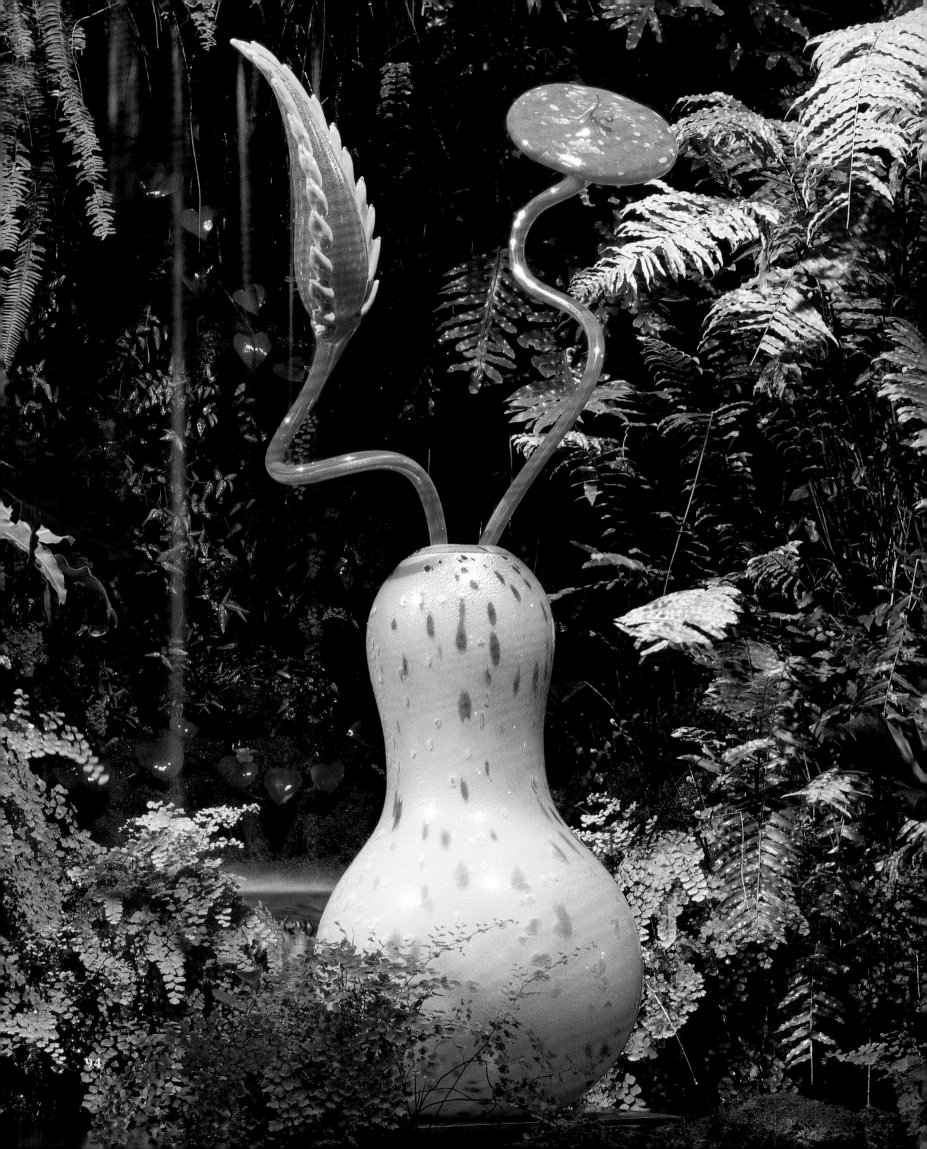

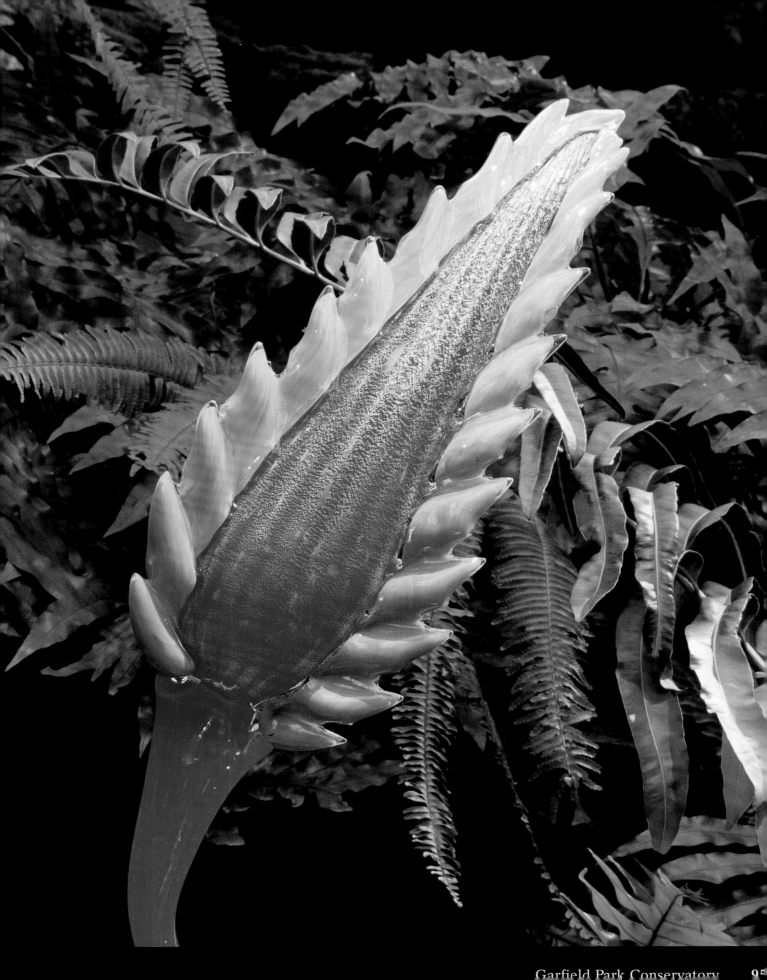

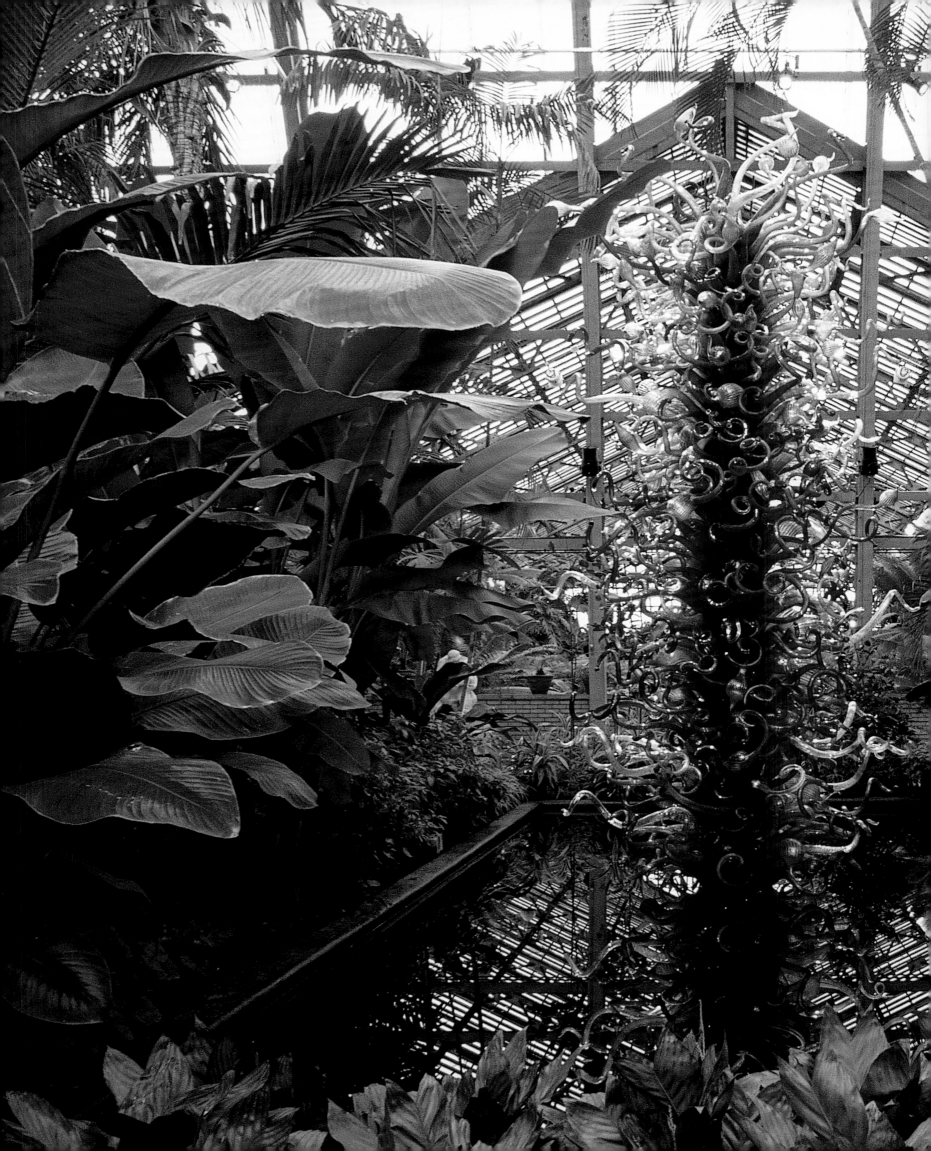

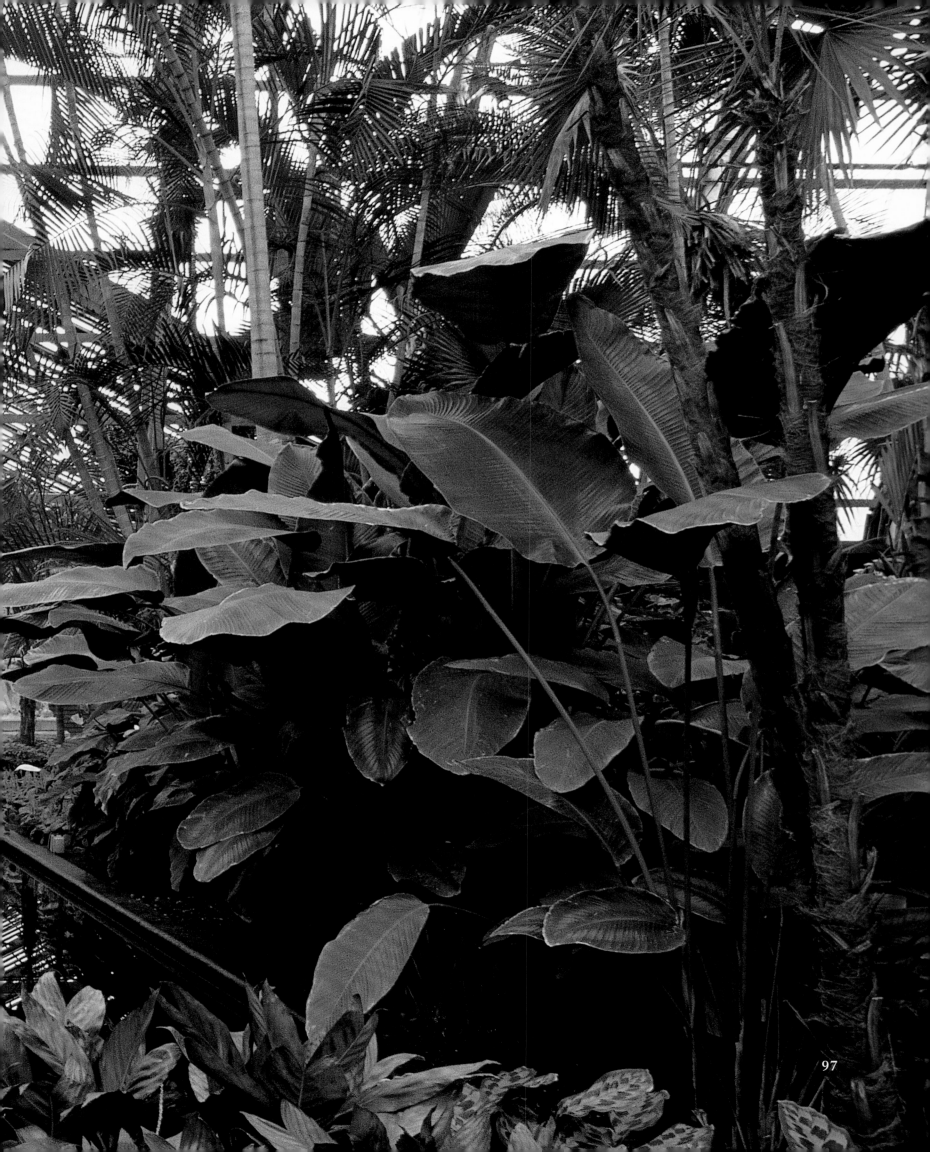

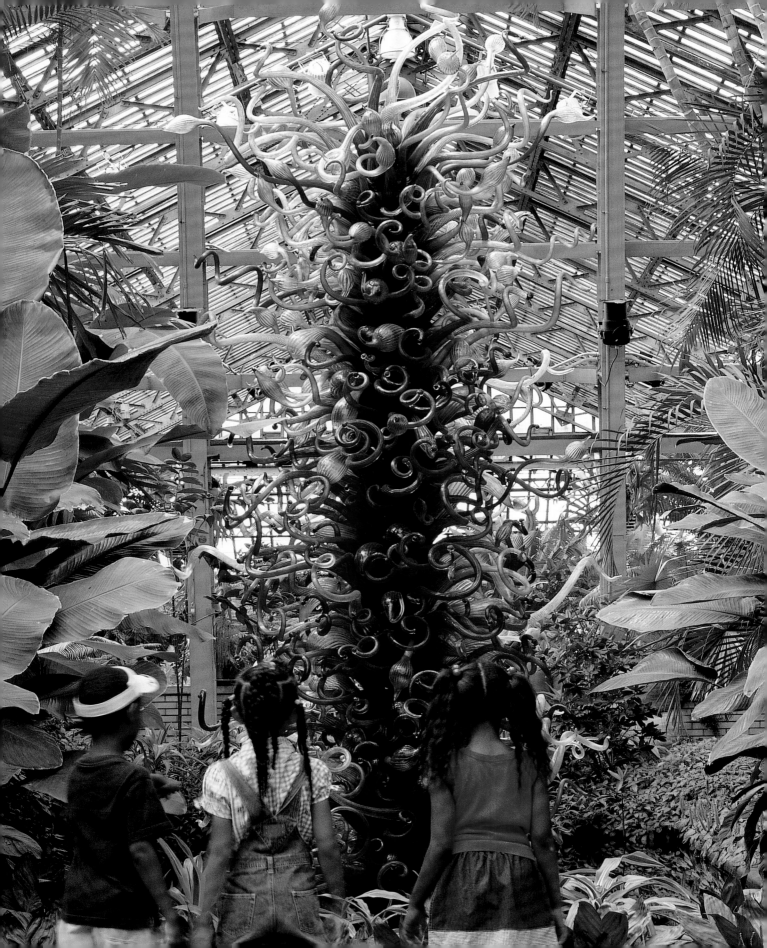

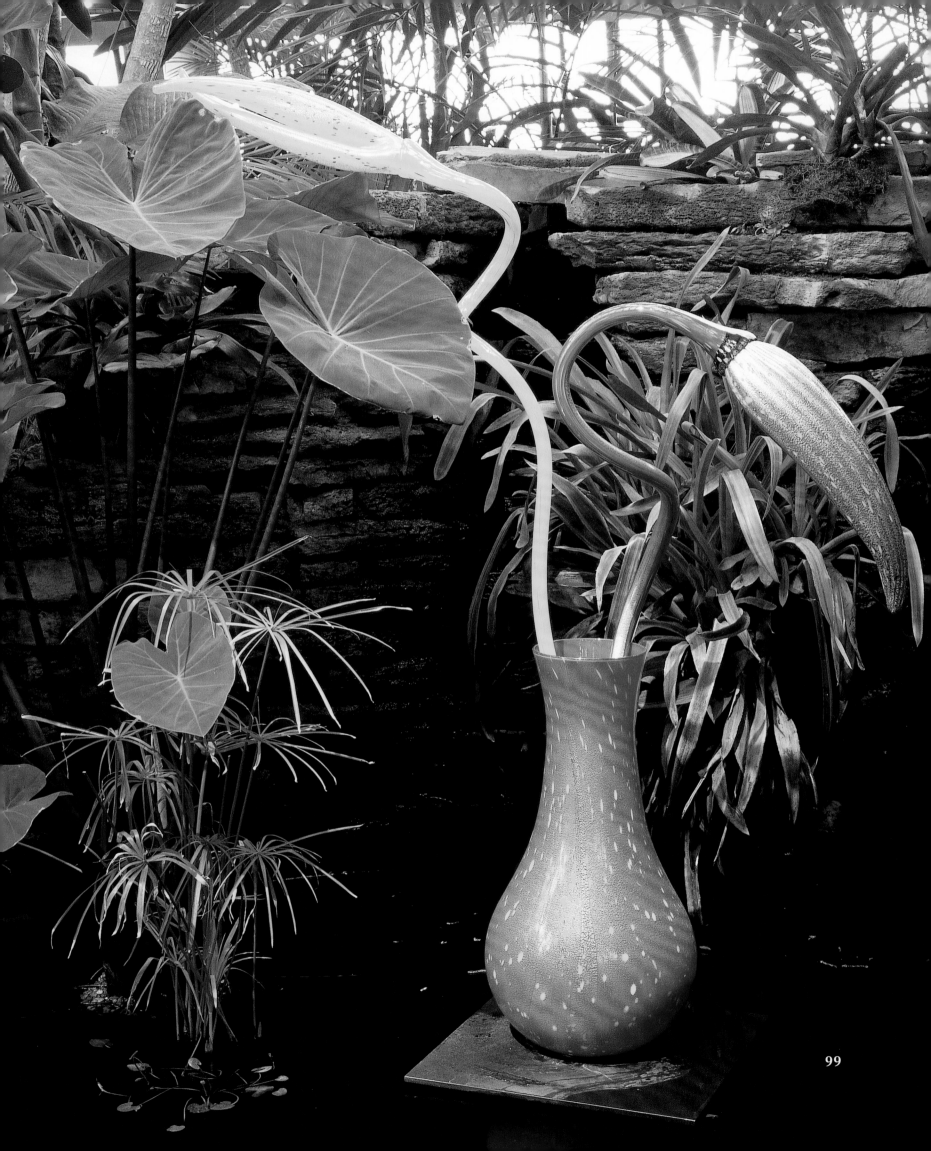

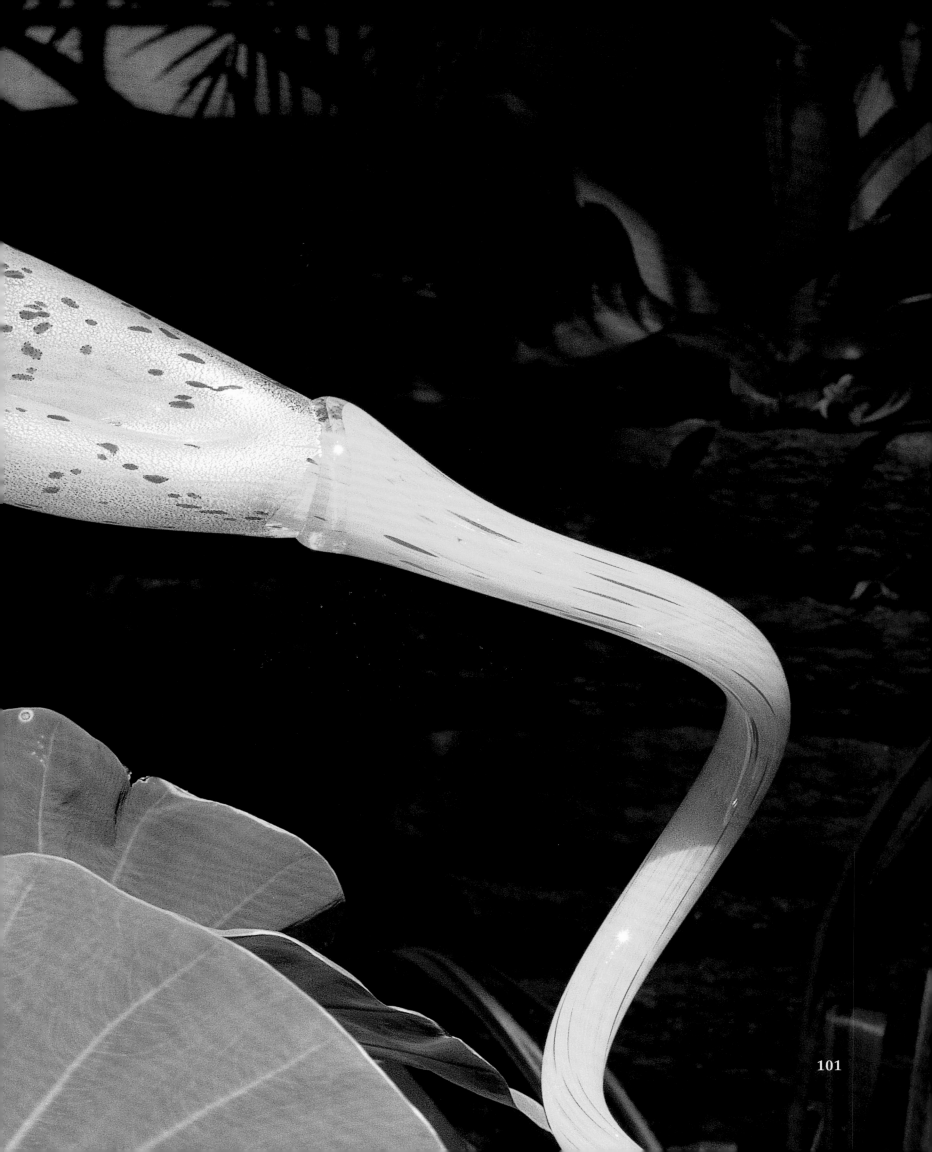

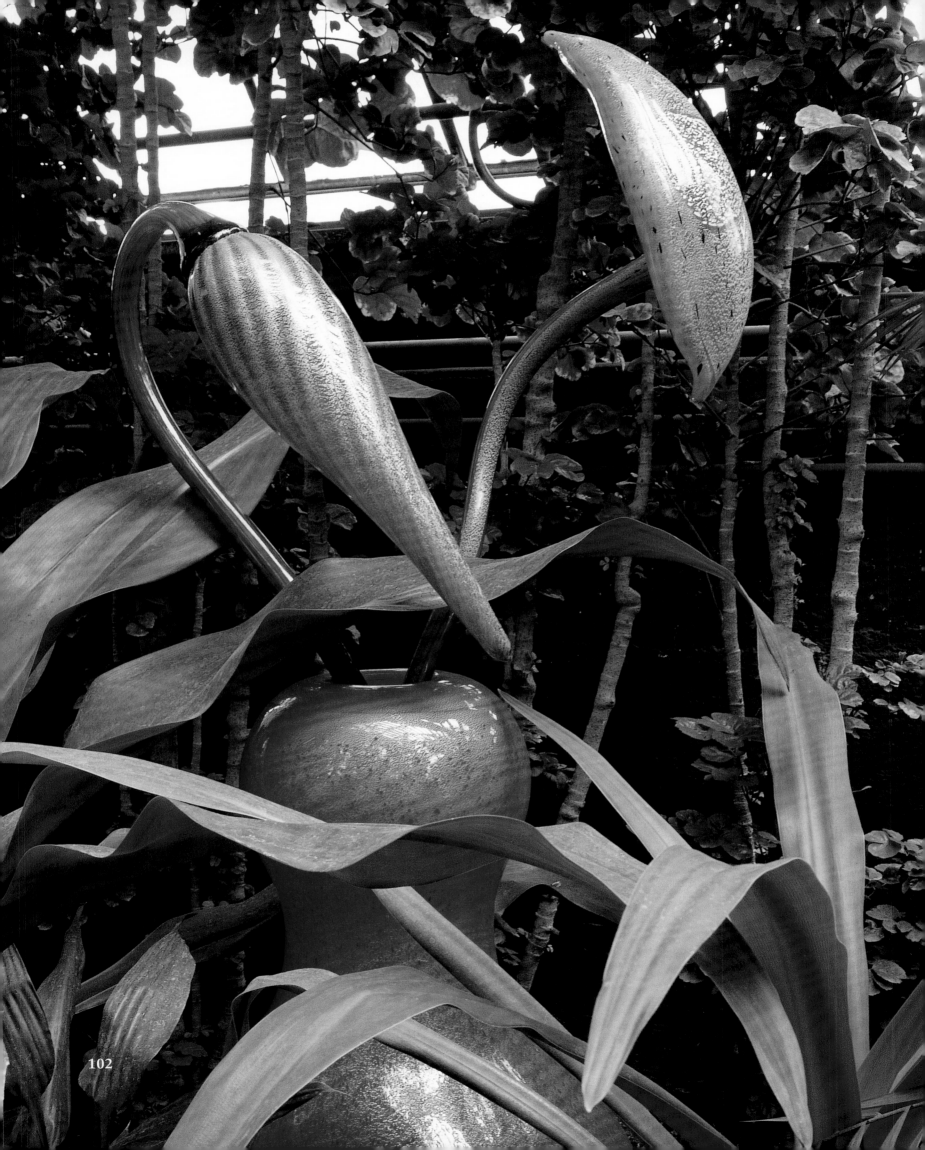

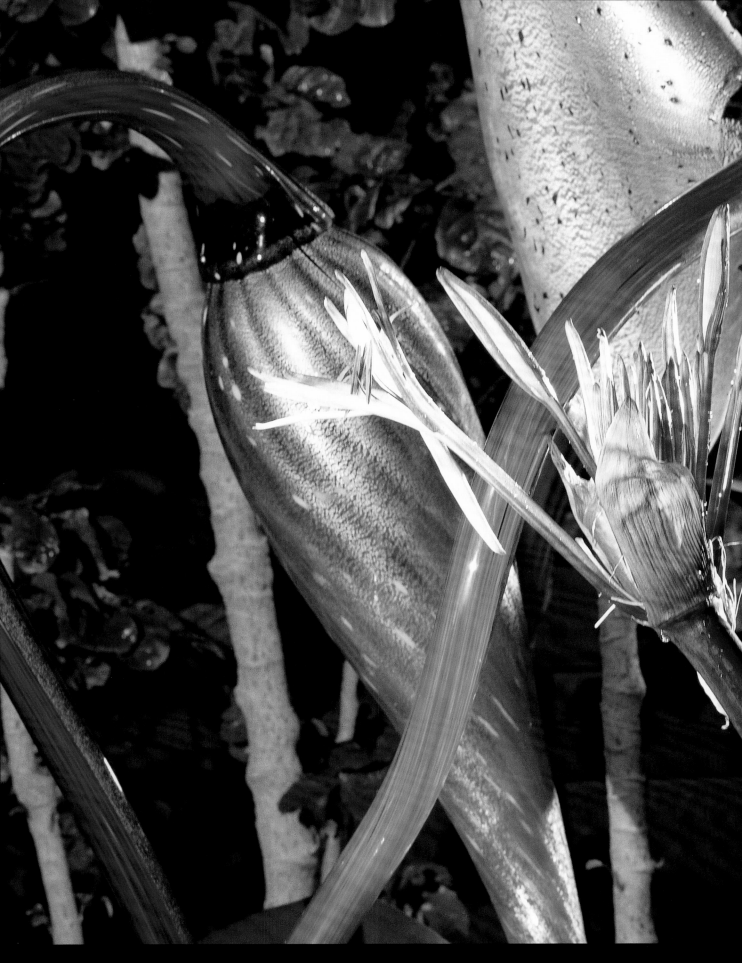

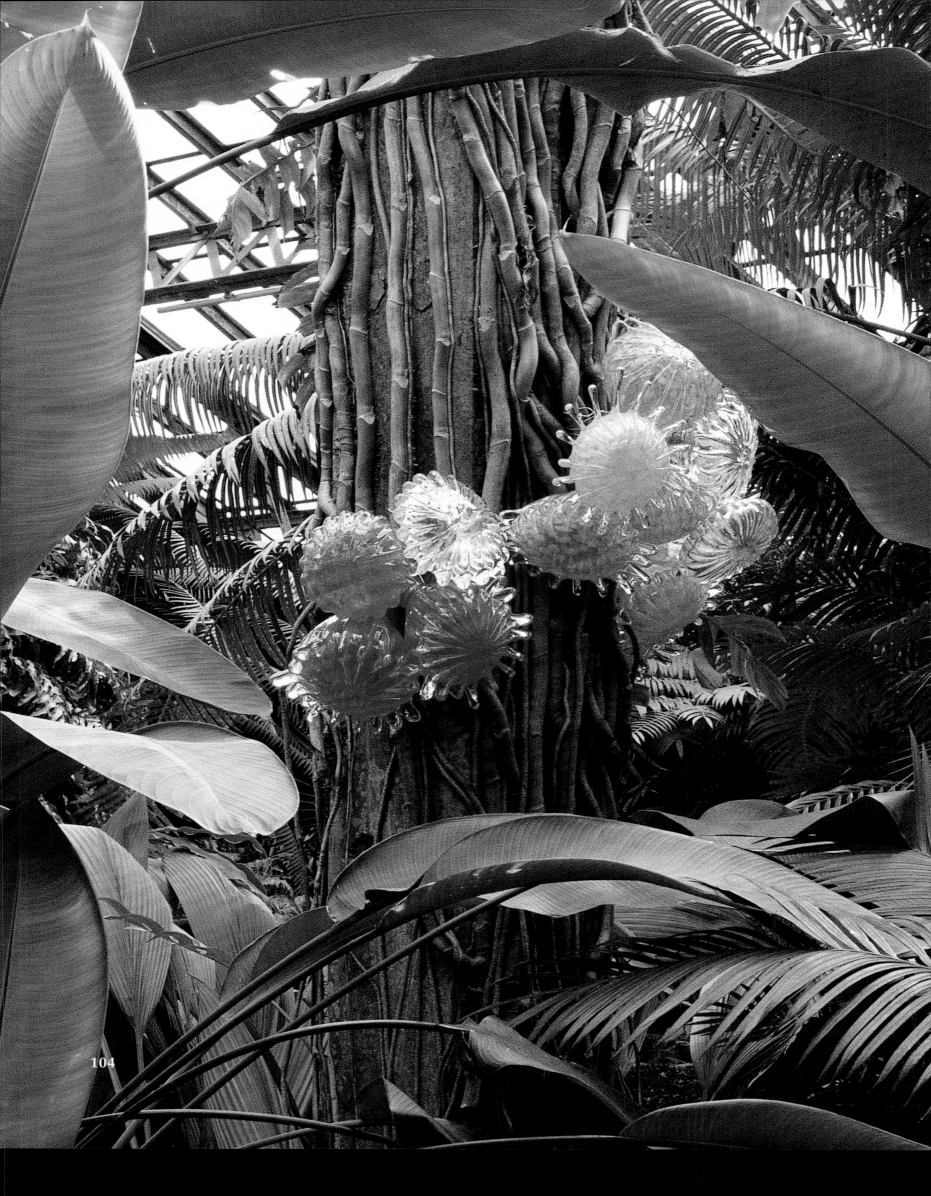

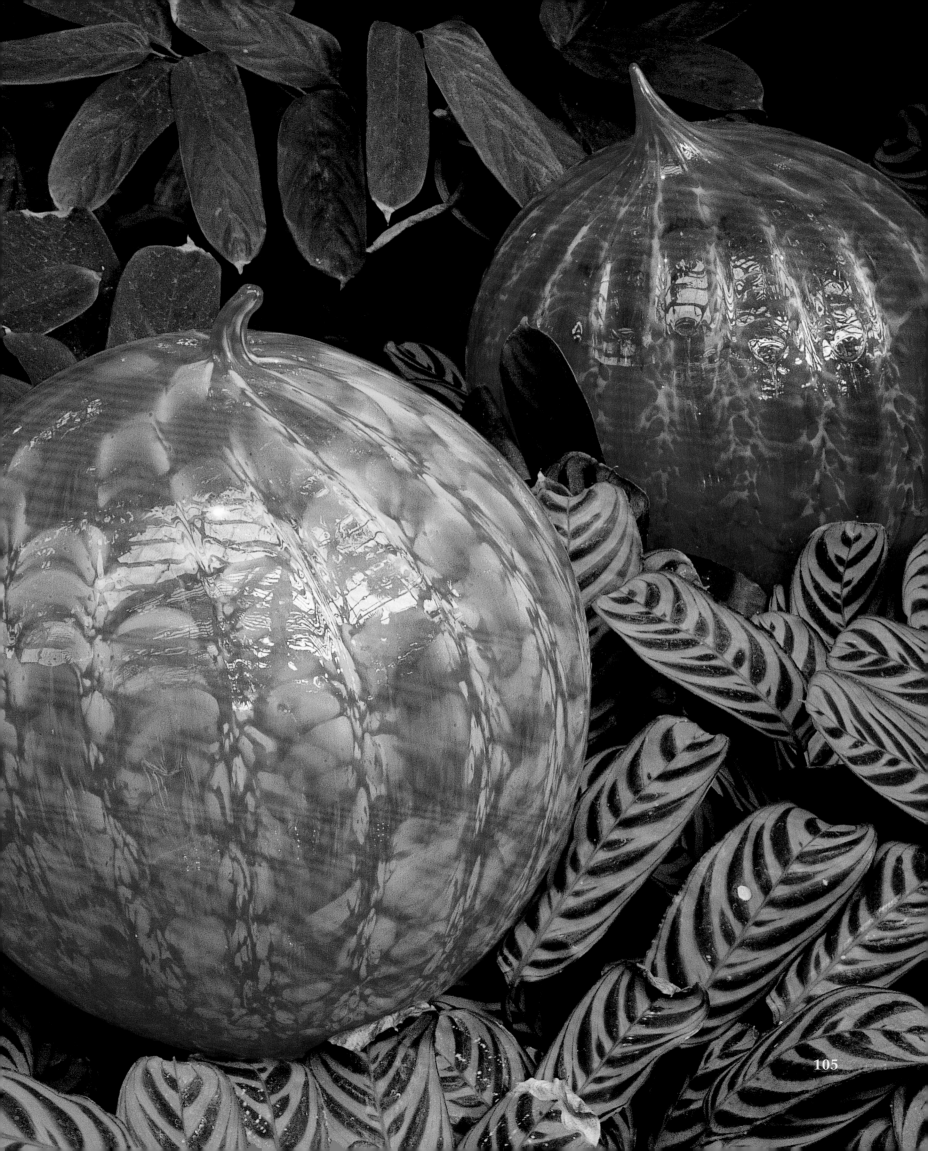

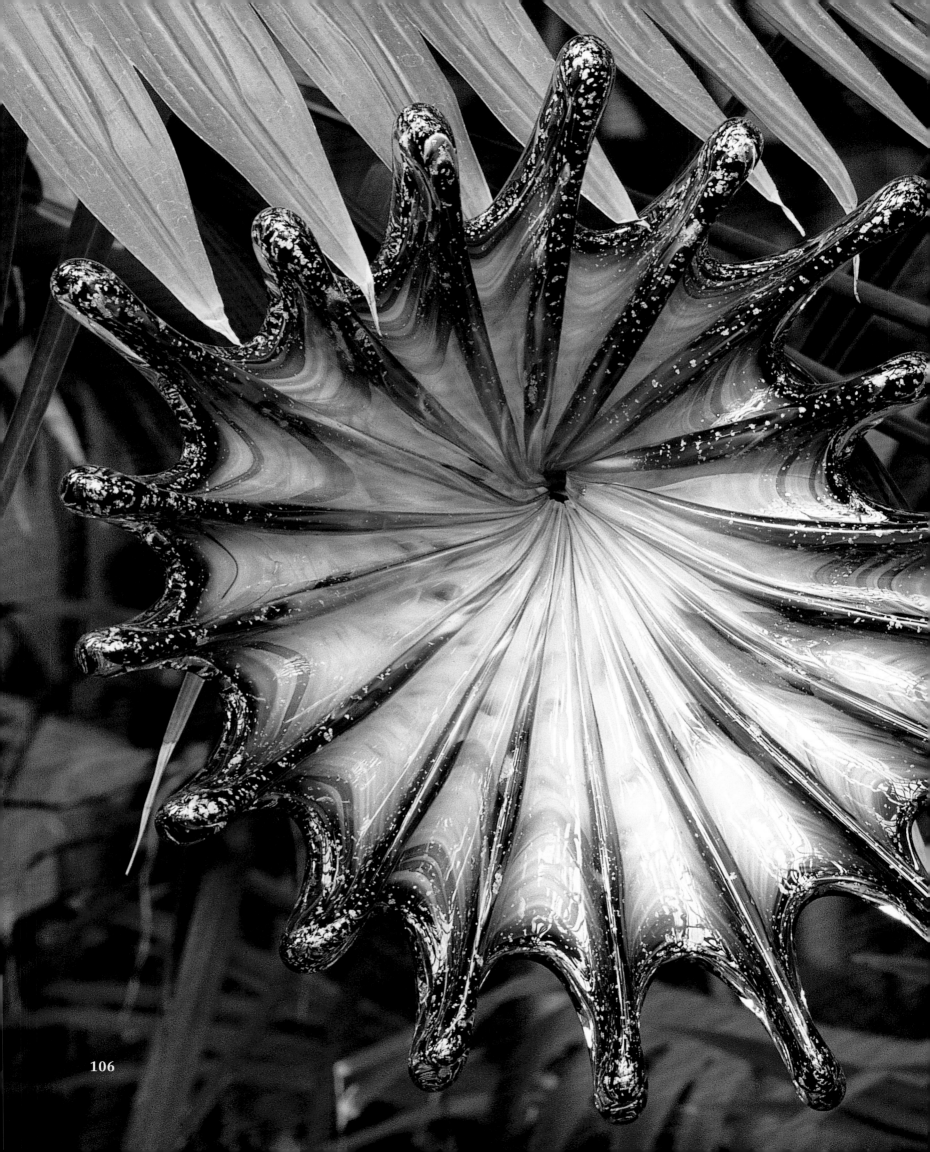

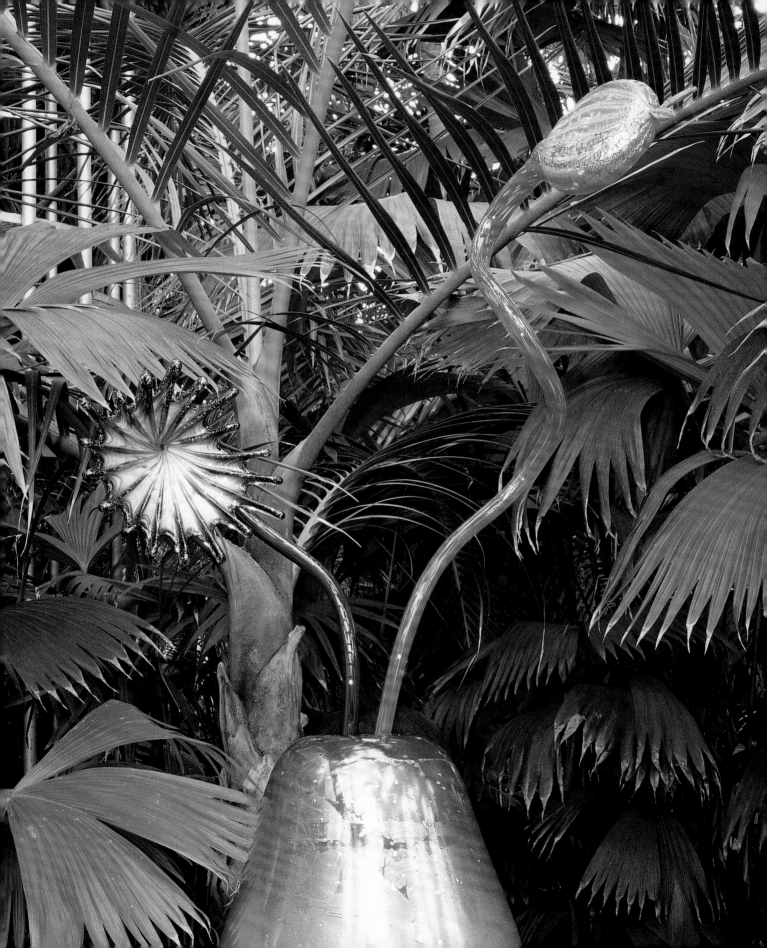

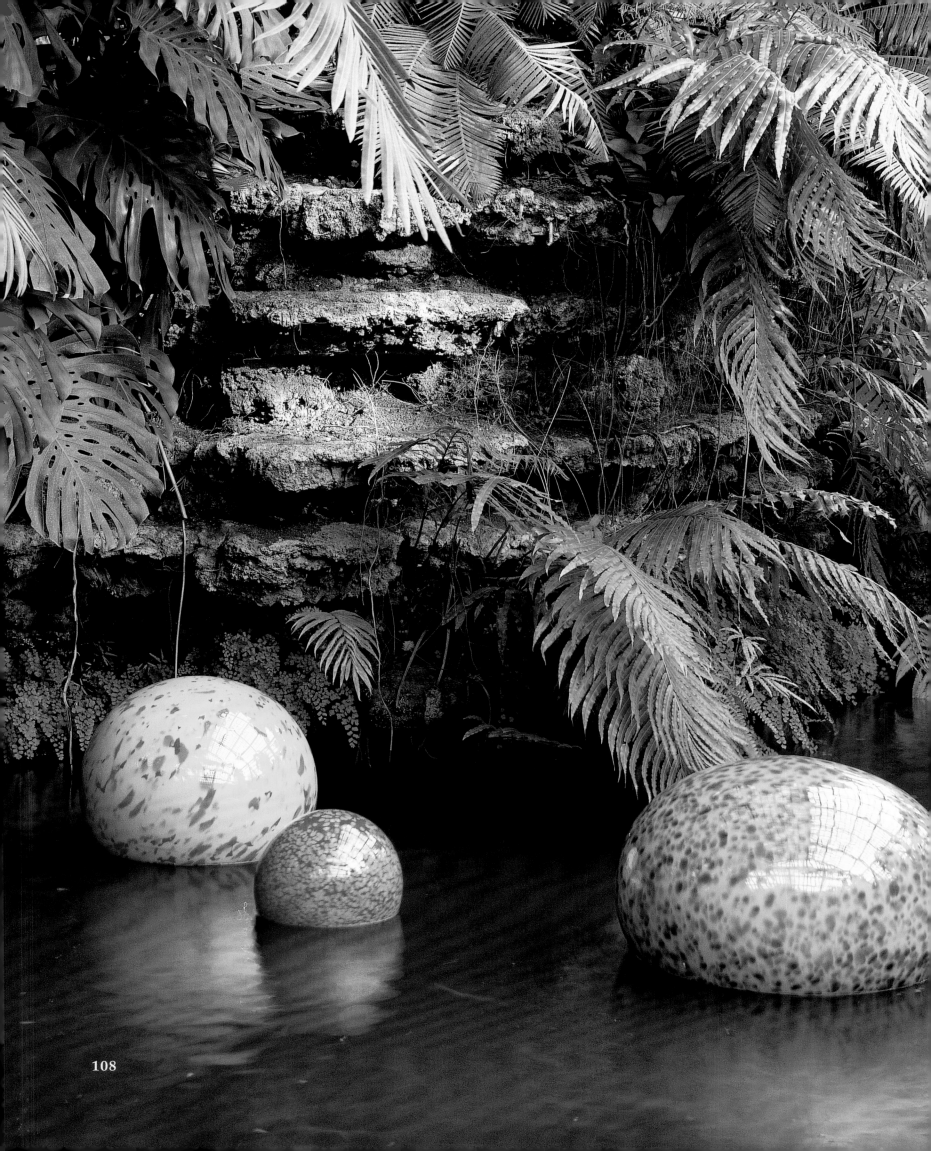

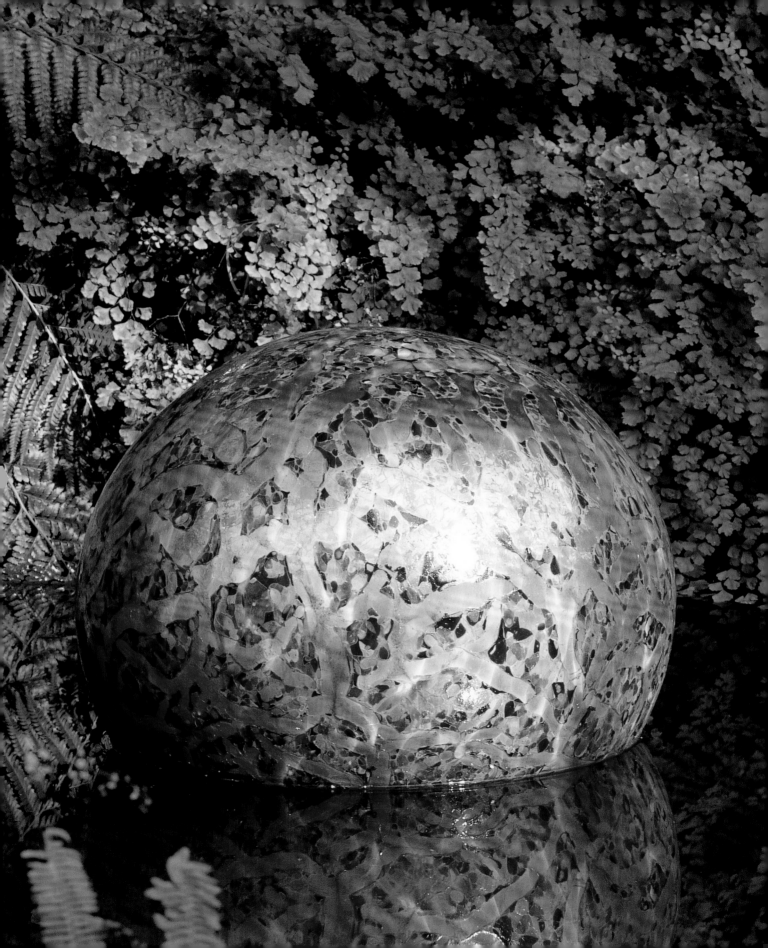

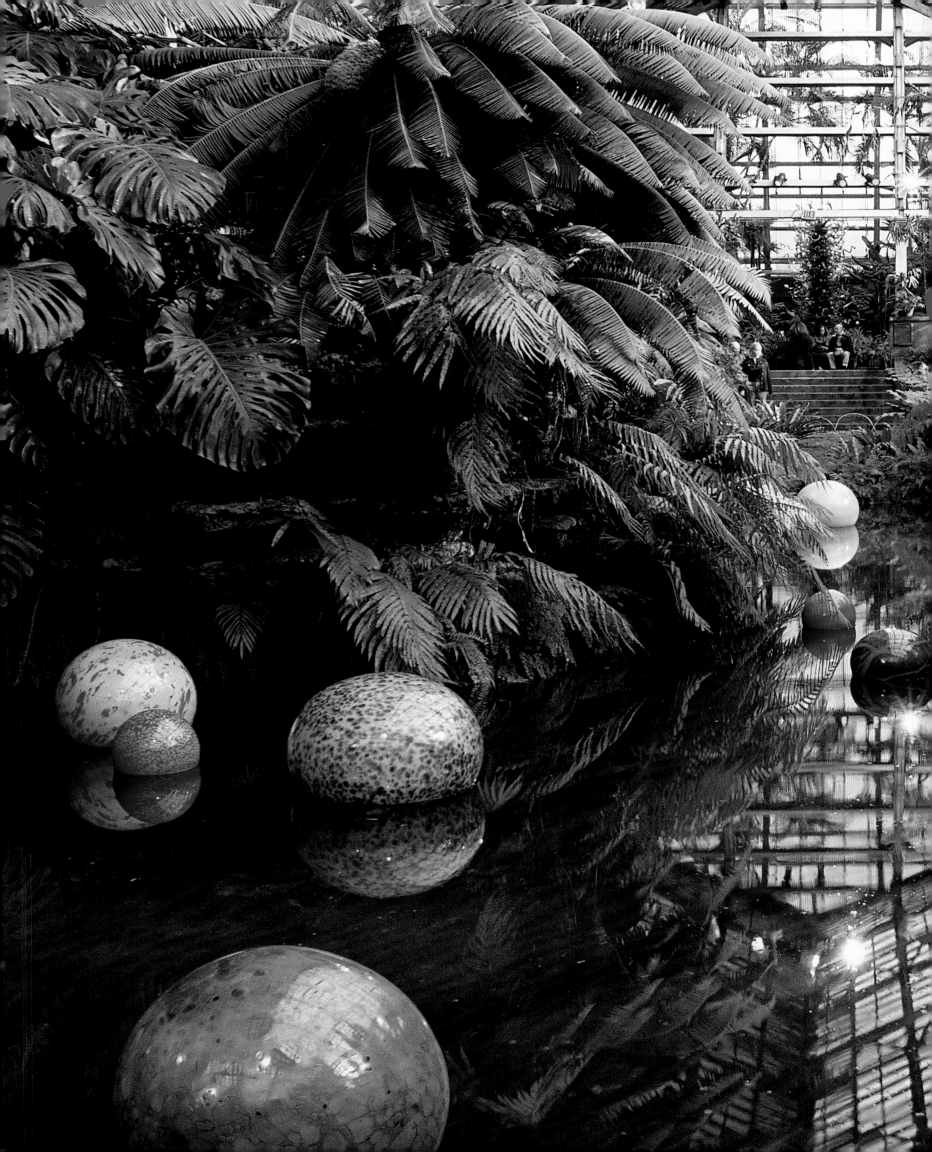

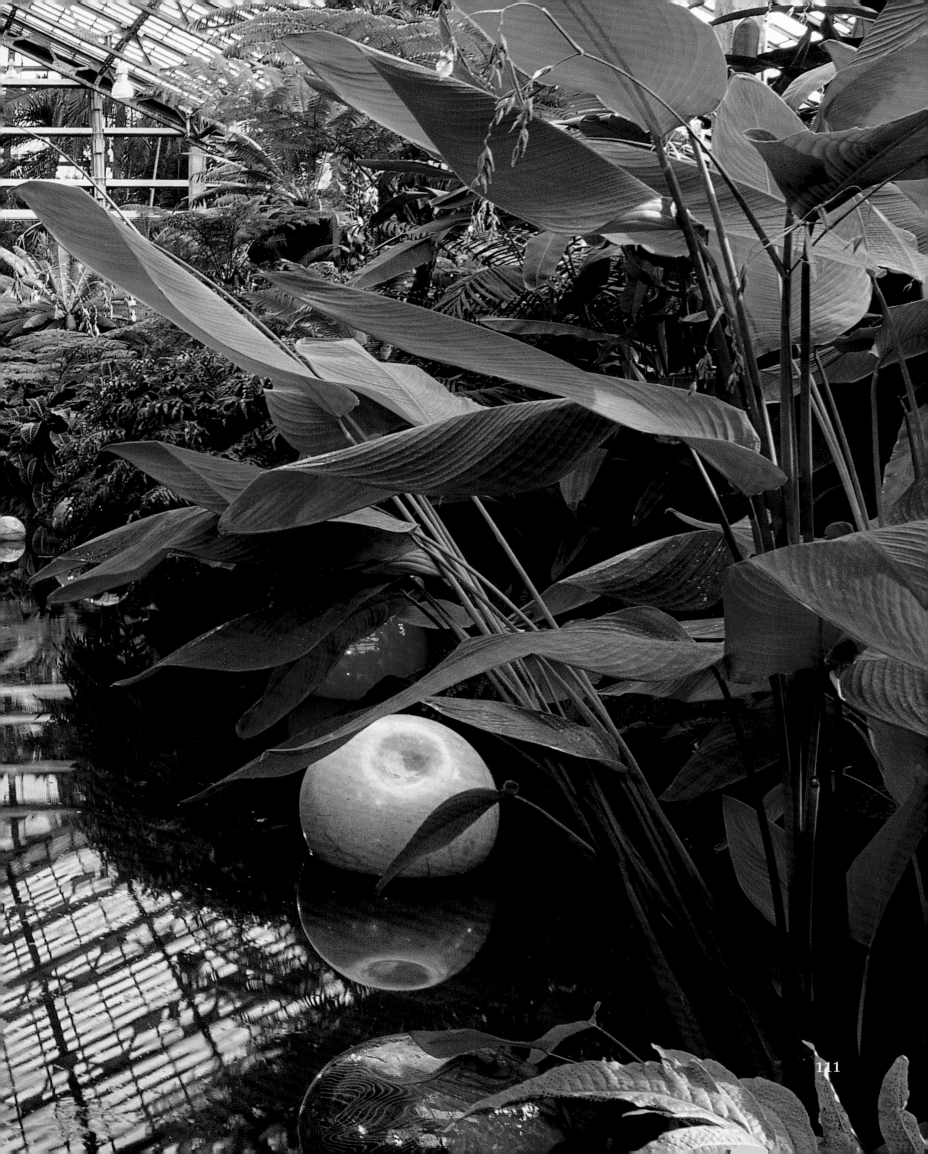

Franklin Park Conservatory
Columbus, Ohio

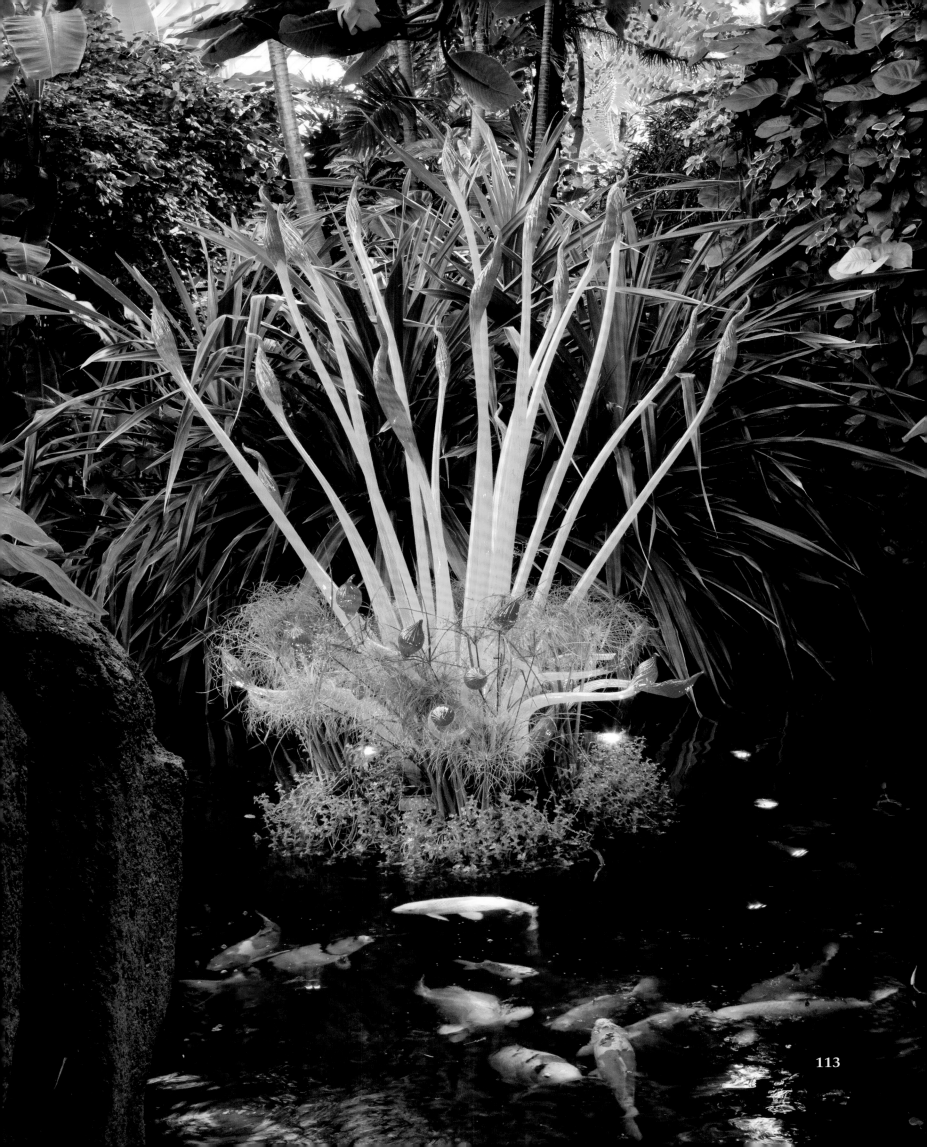

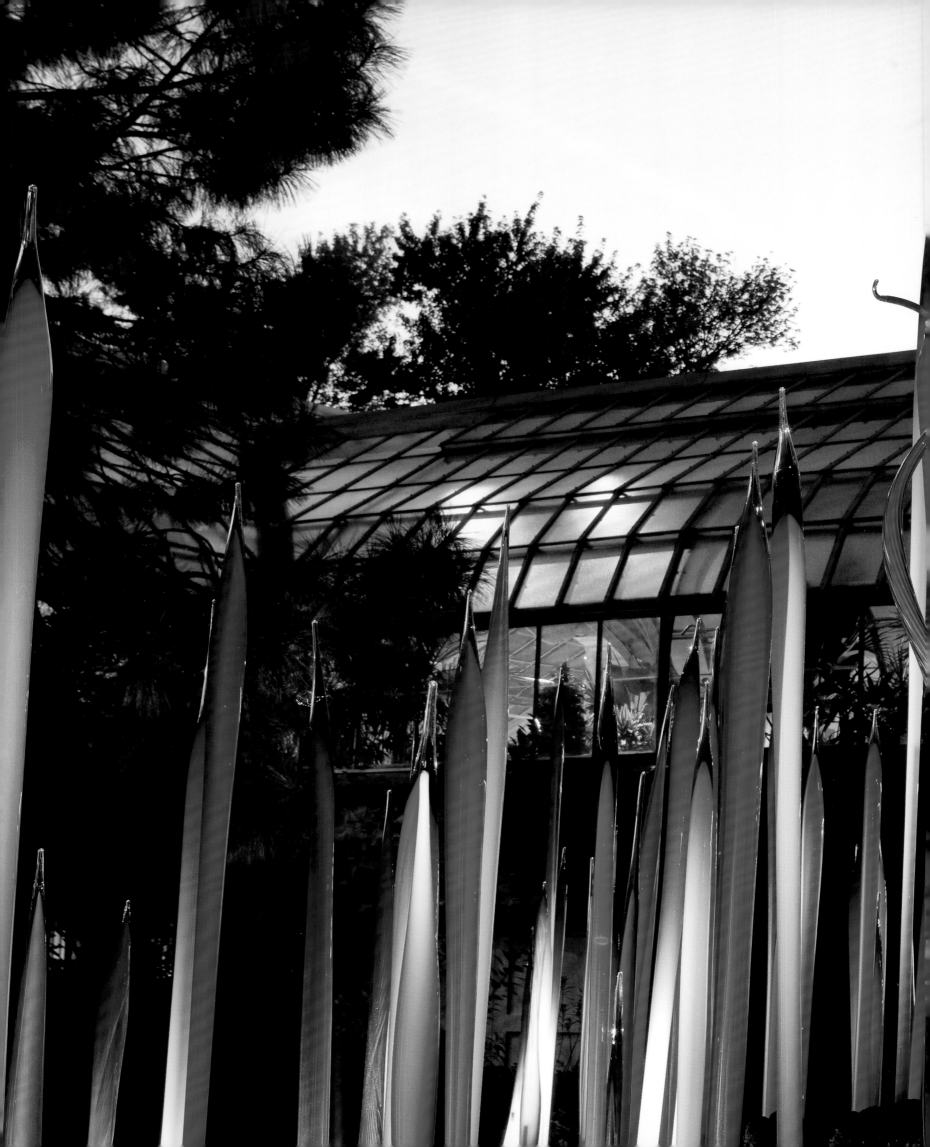

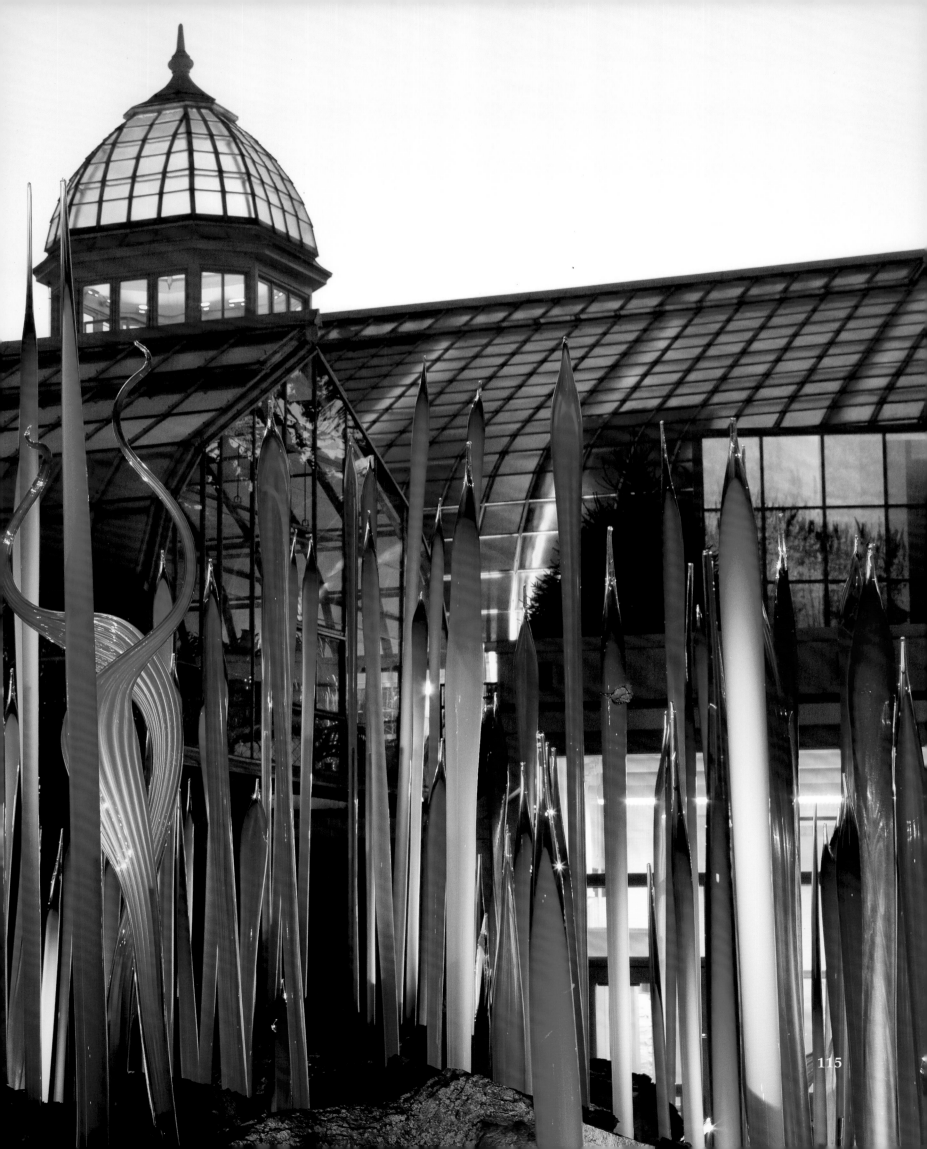

115

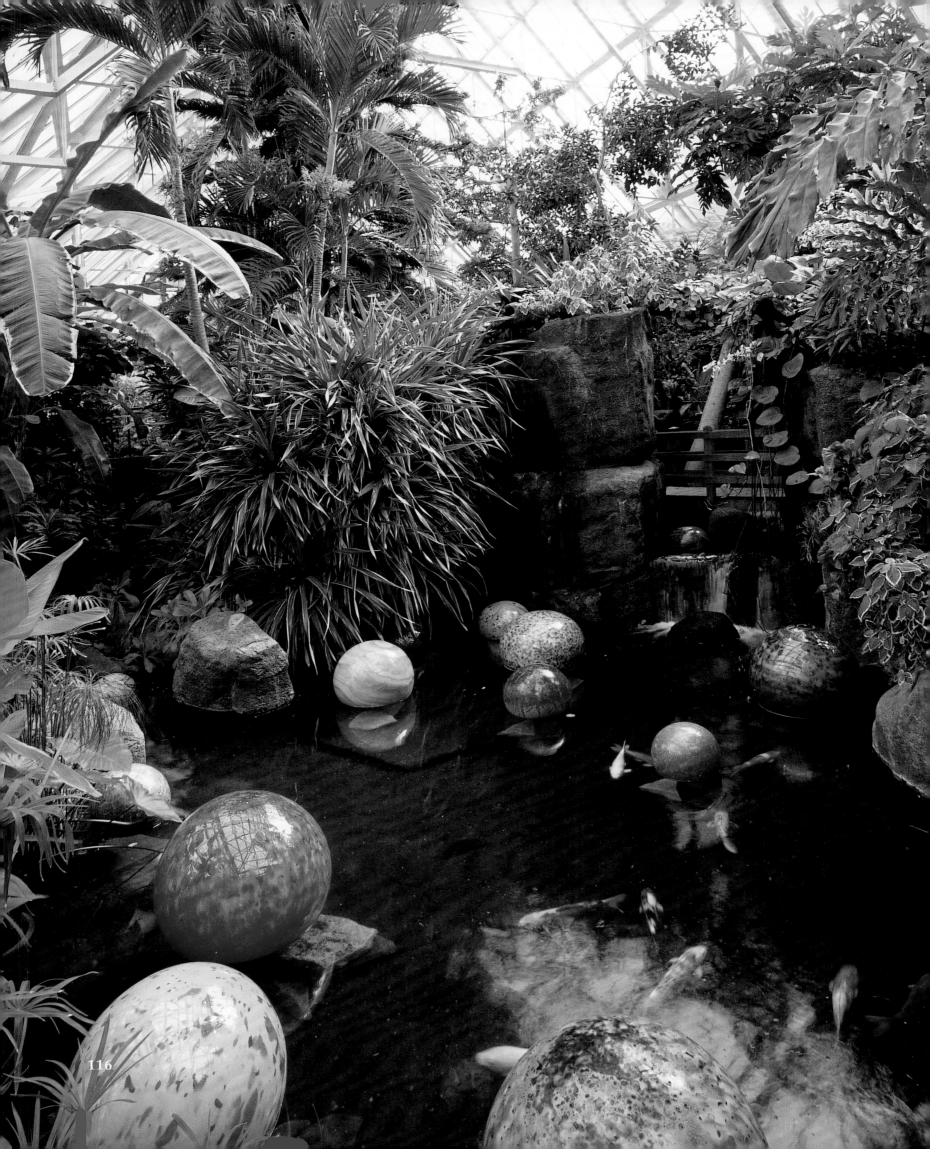

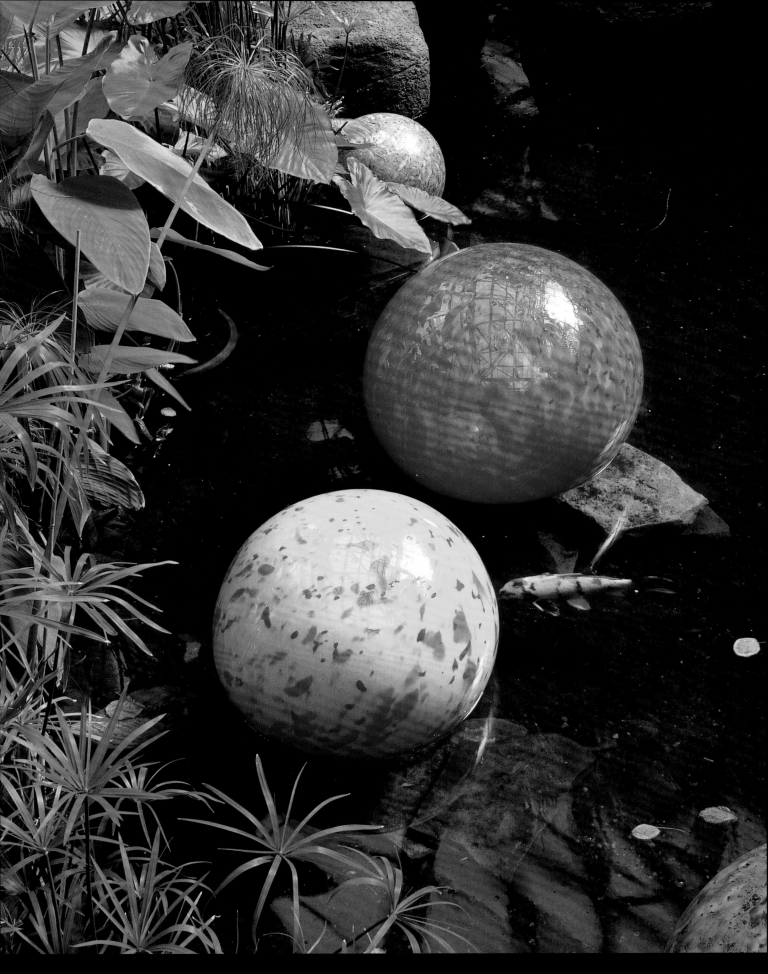

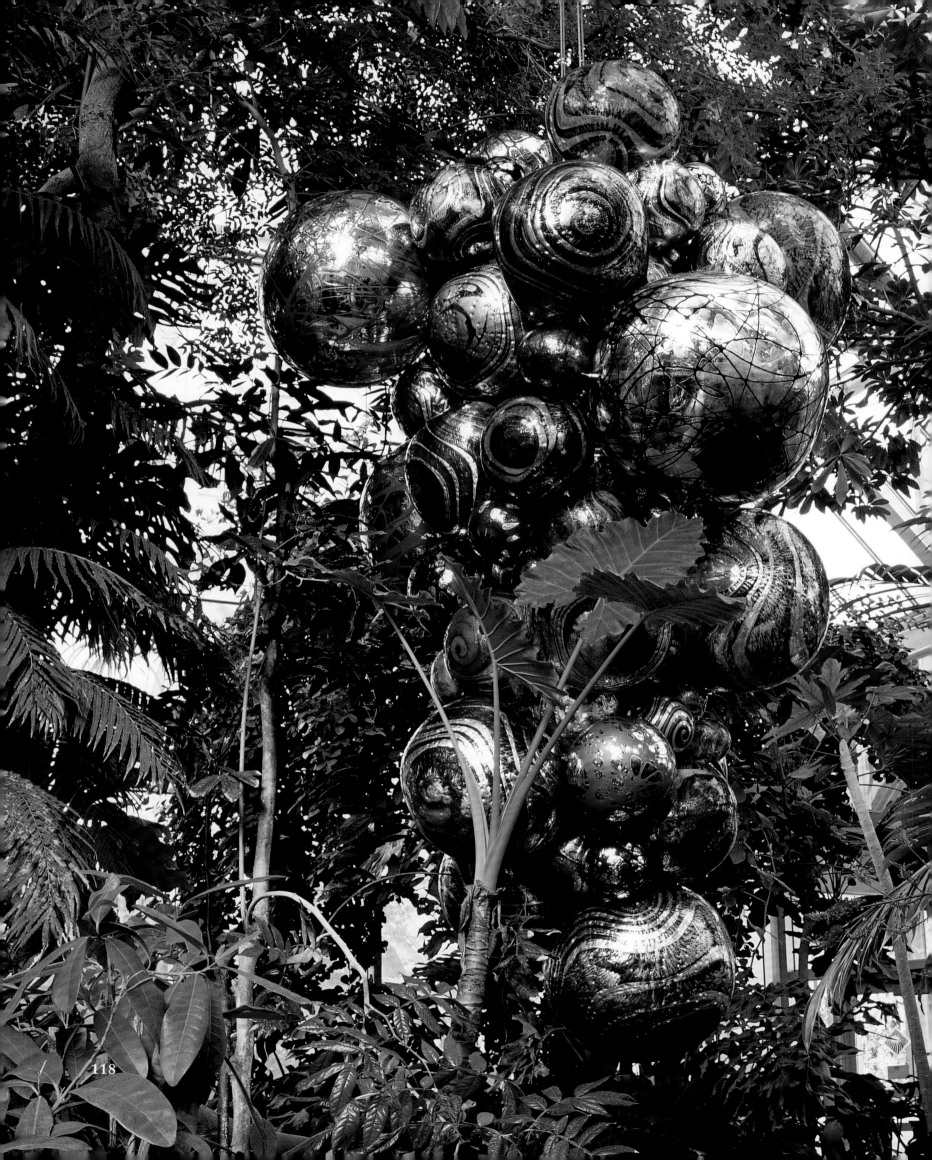

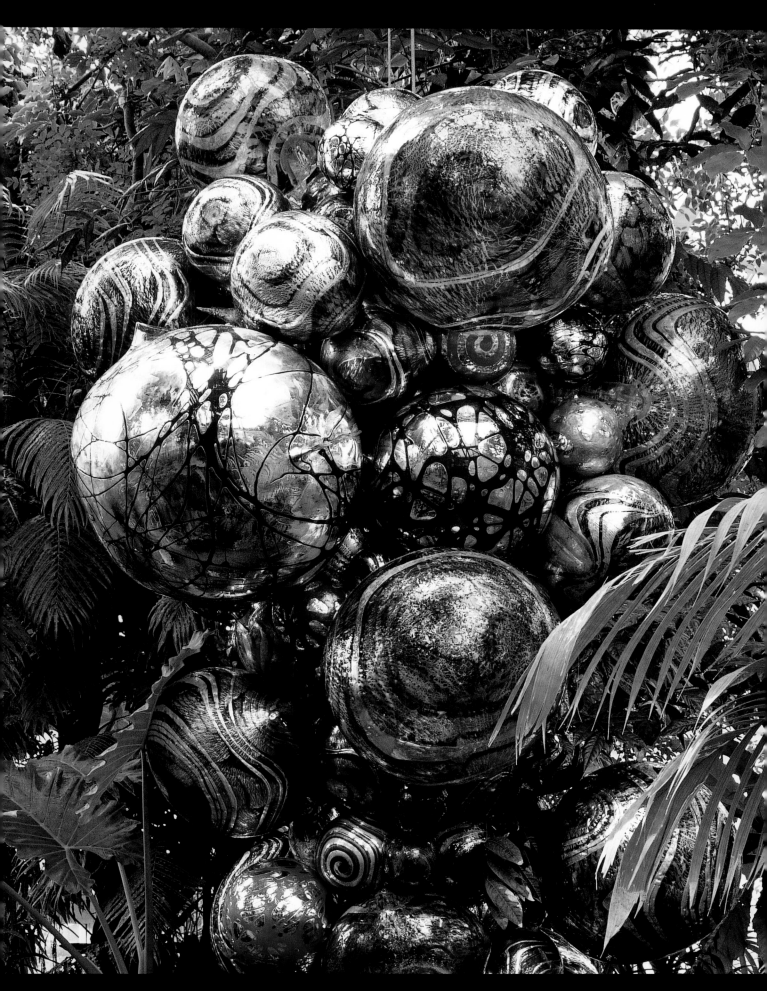

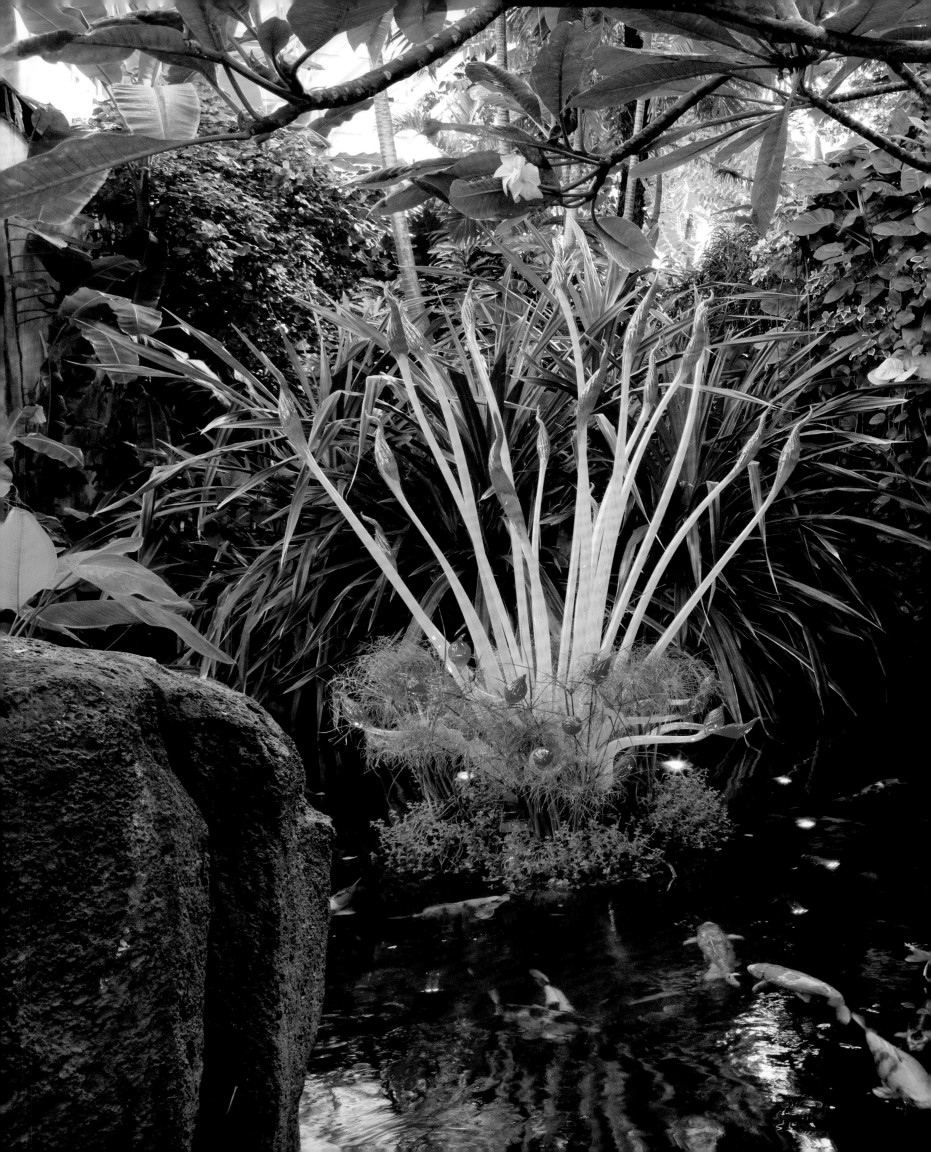

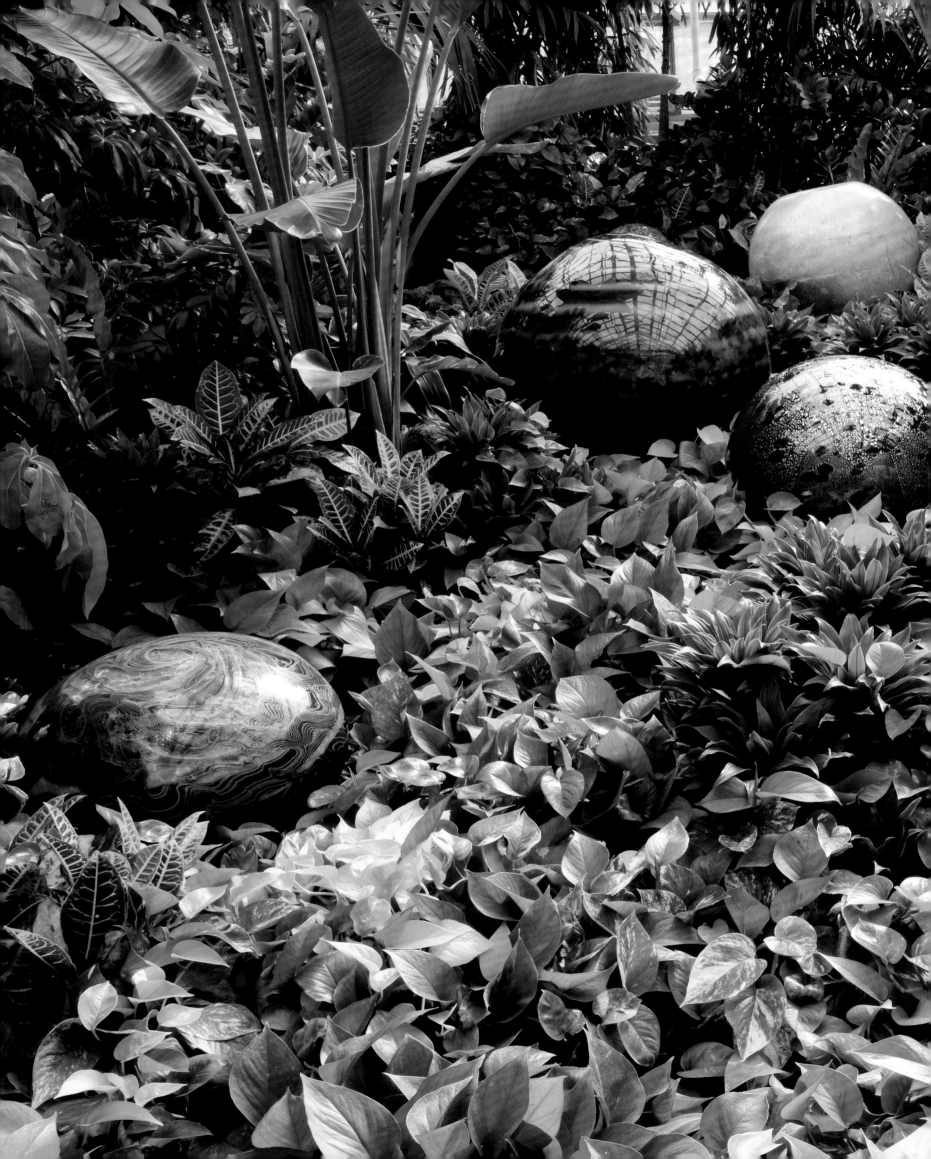

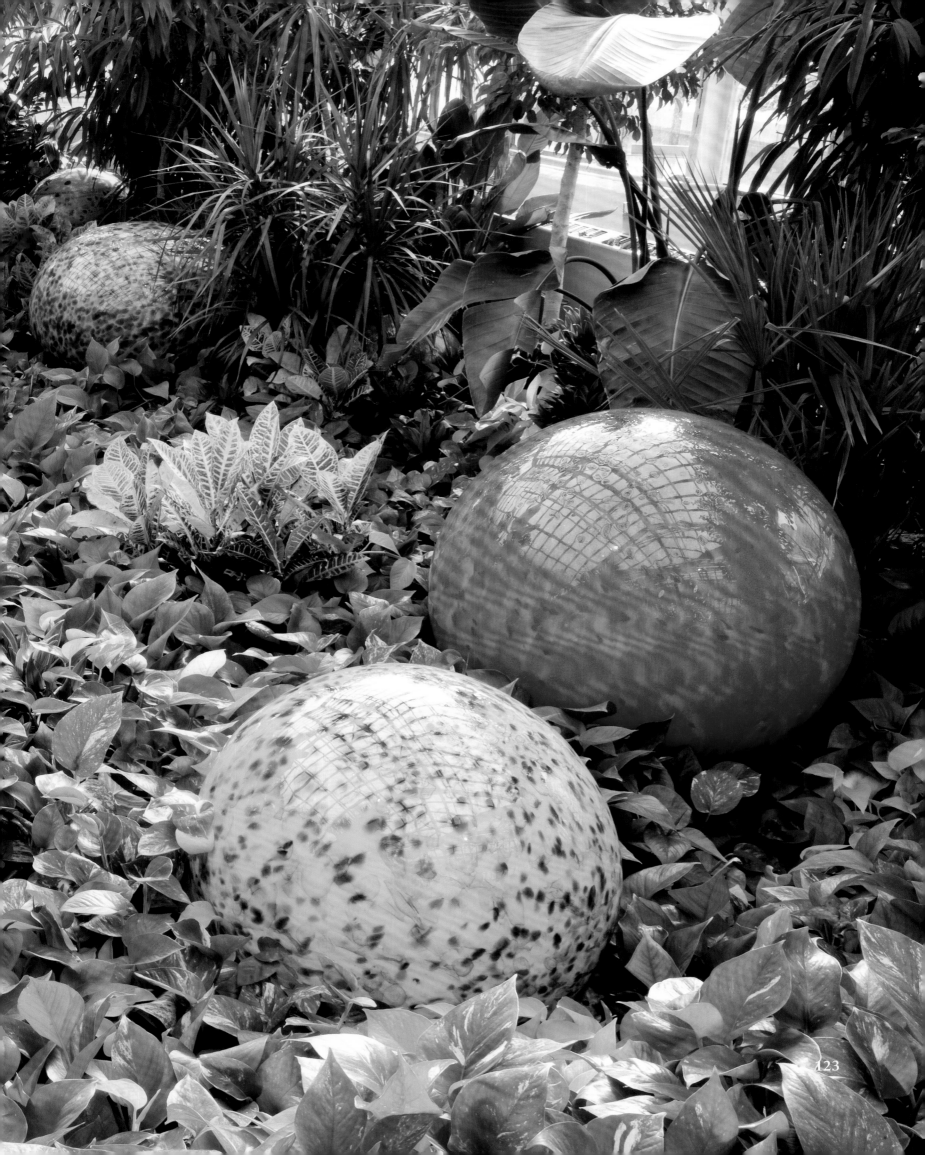

123

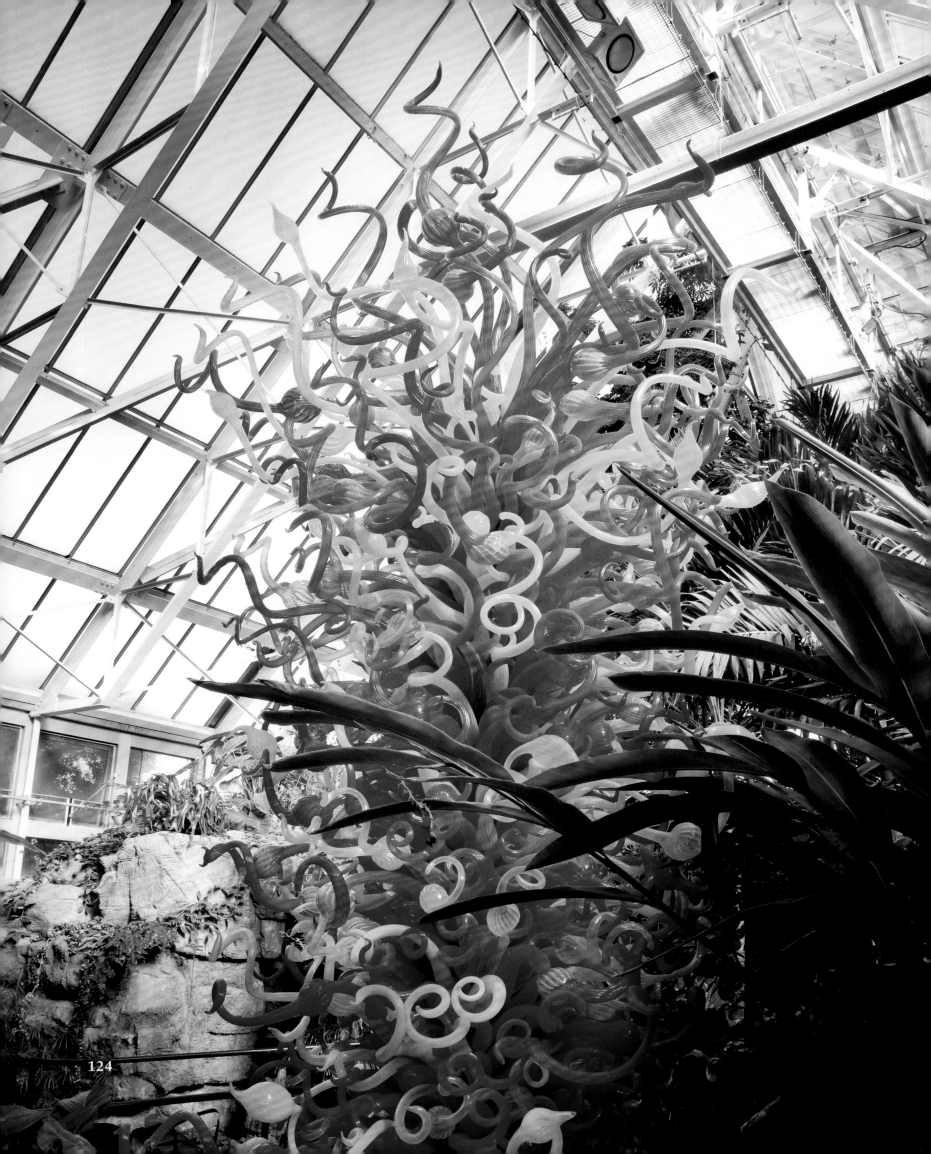

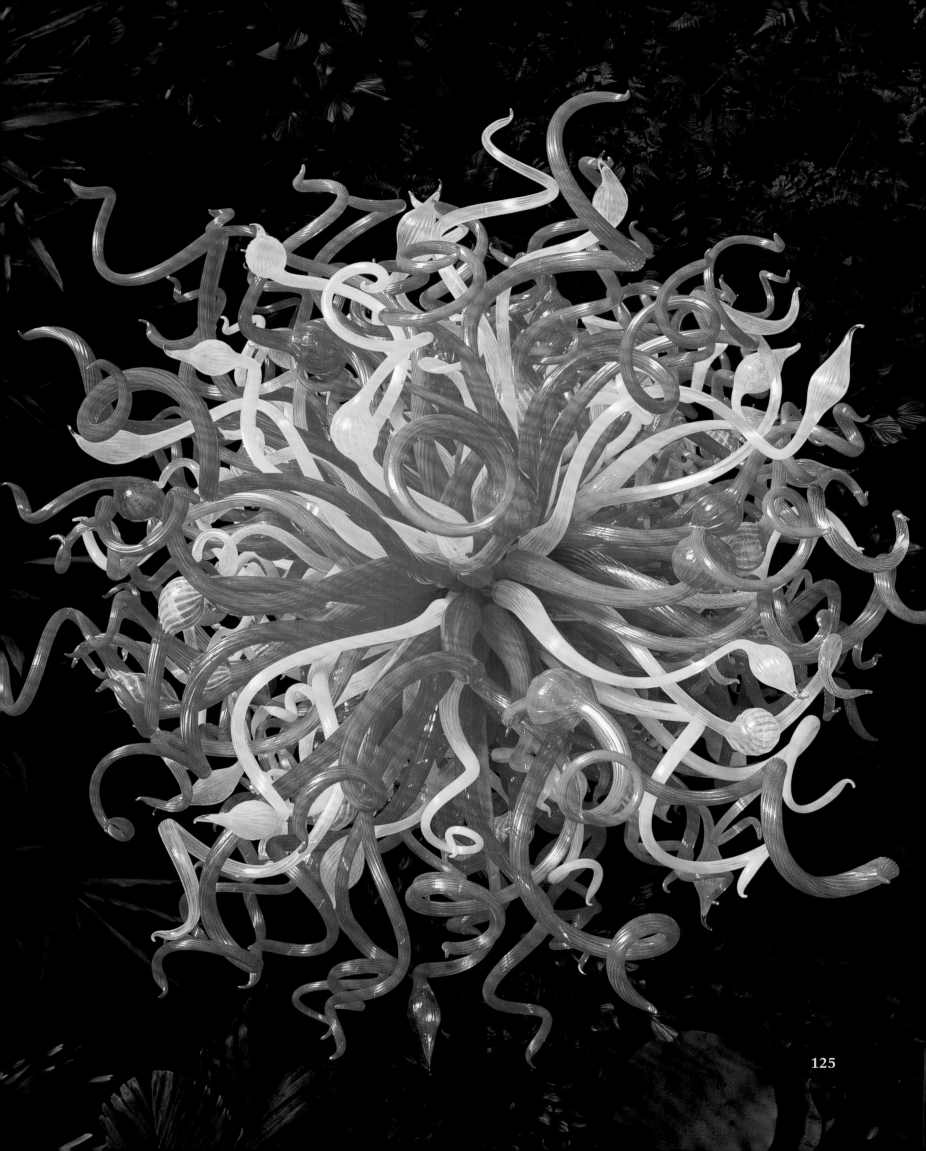

125

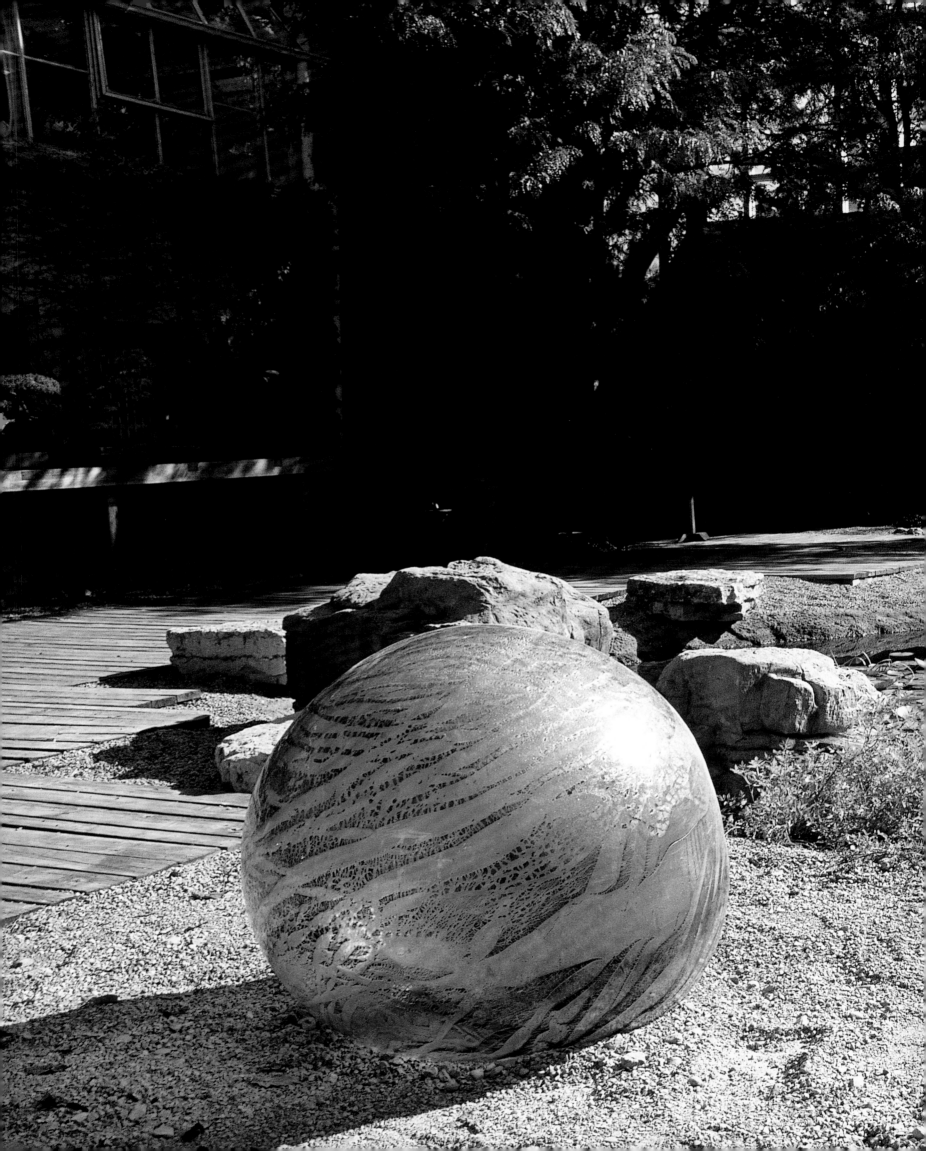

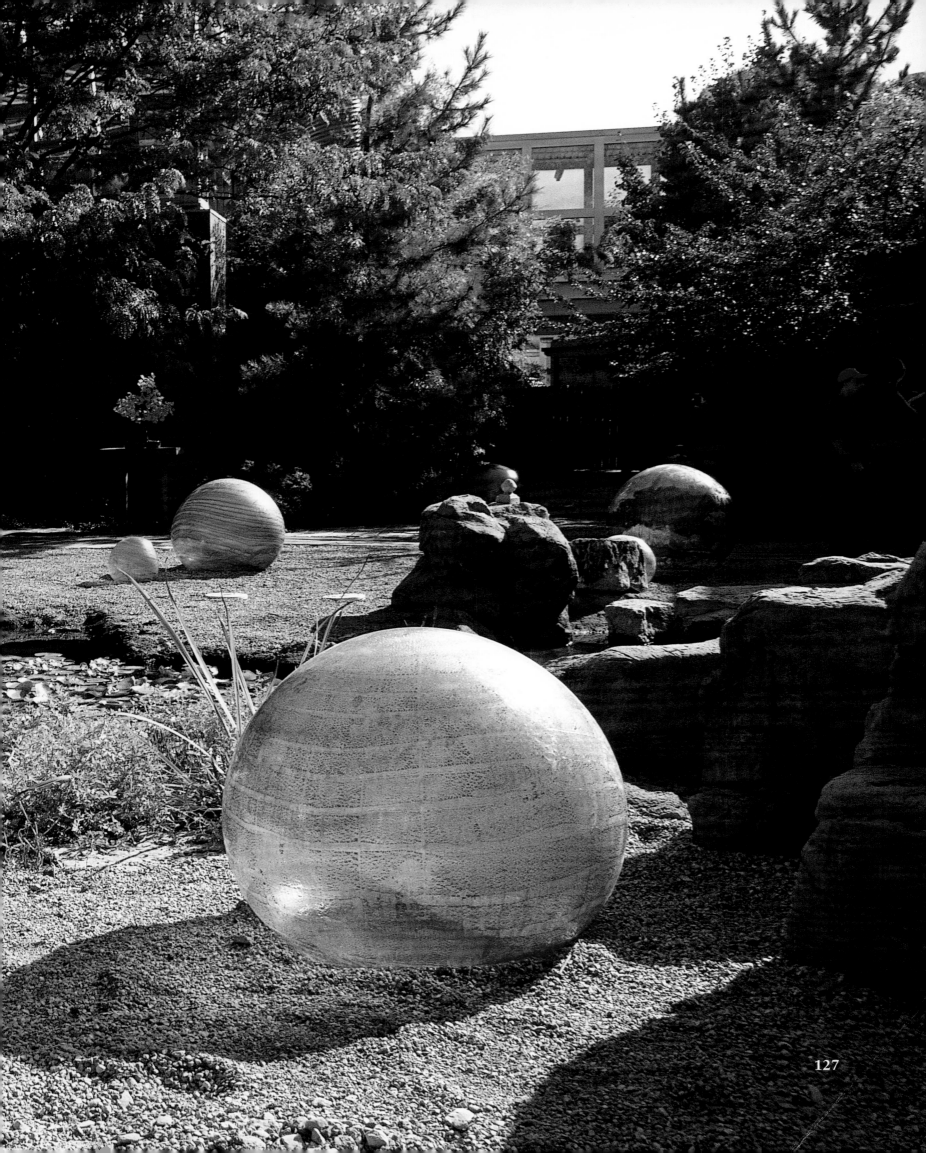

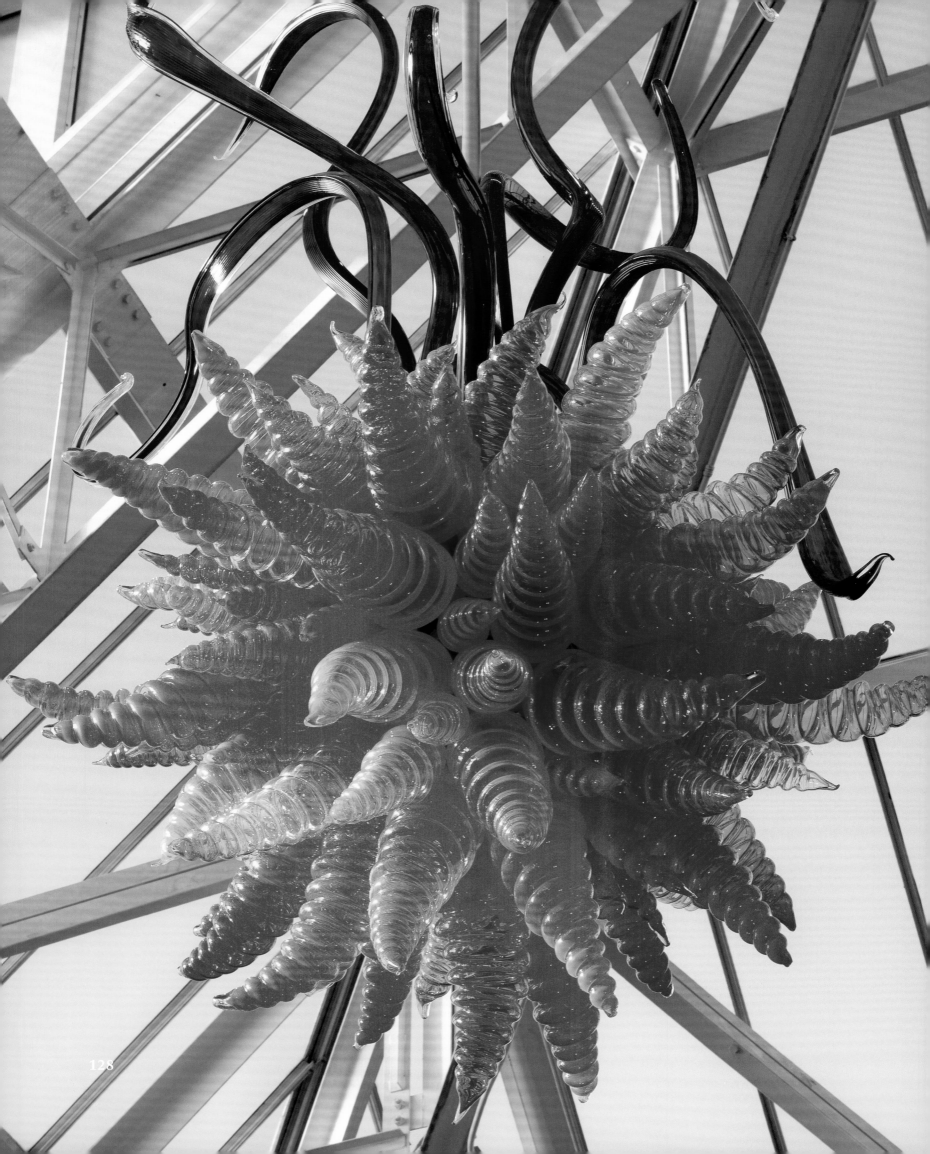

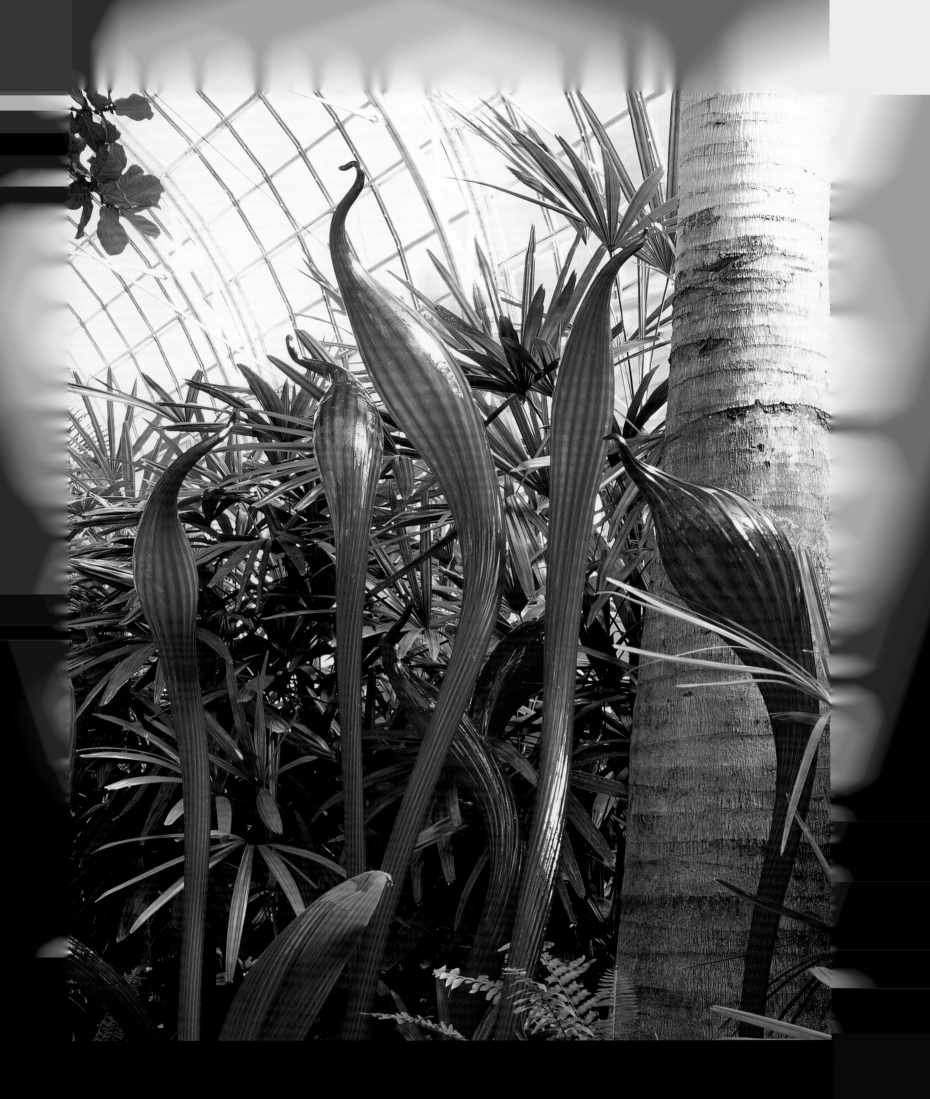

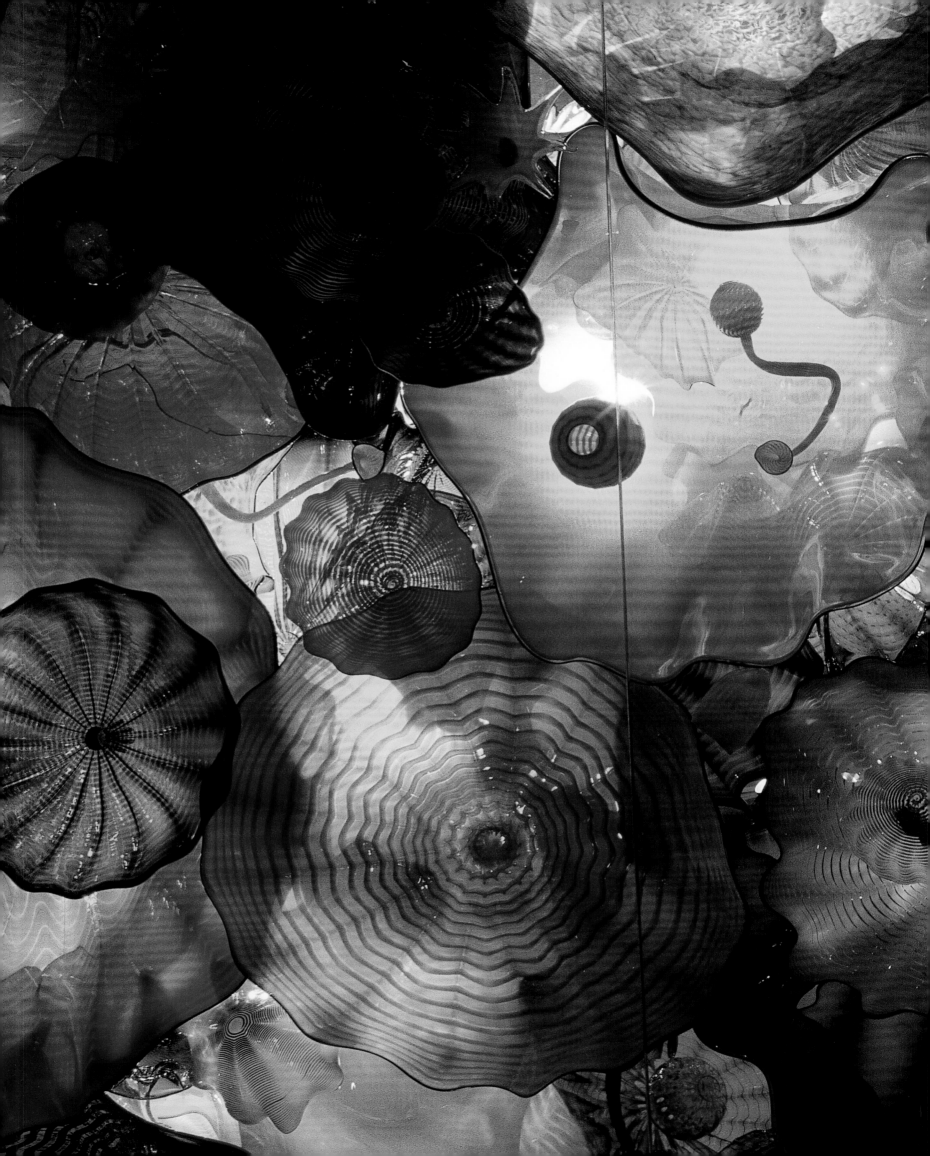

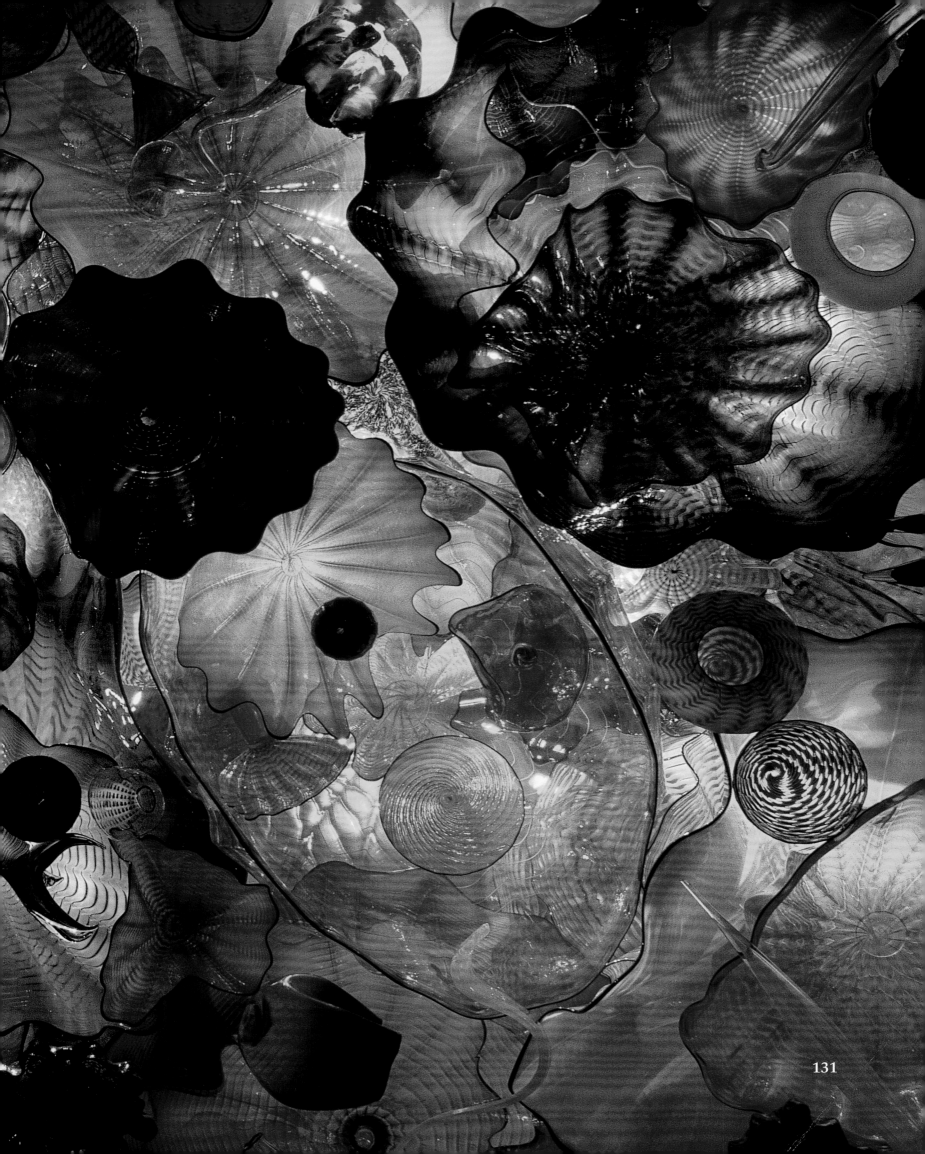

Atlanta Botanical Garden
Atlanta, Georgia

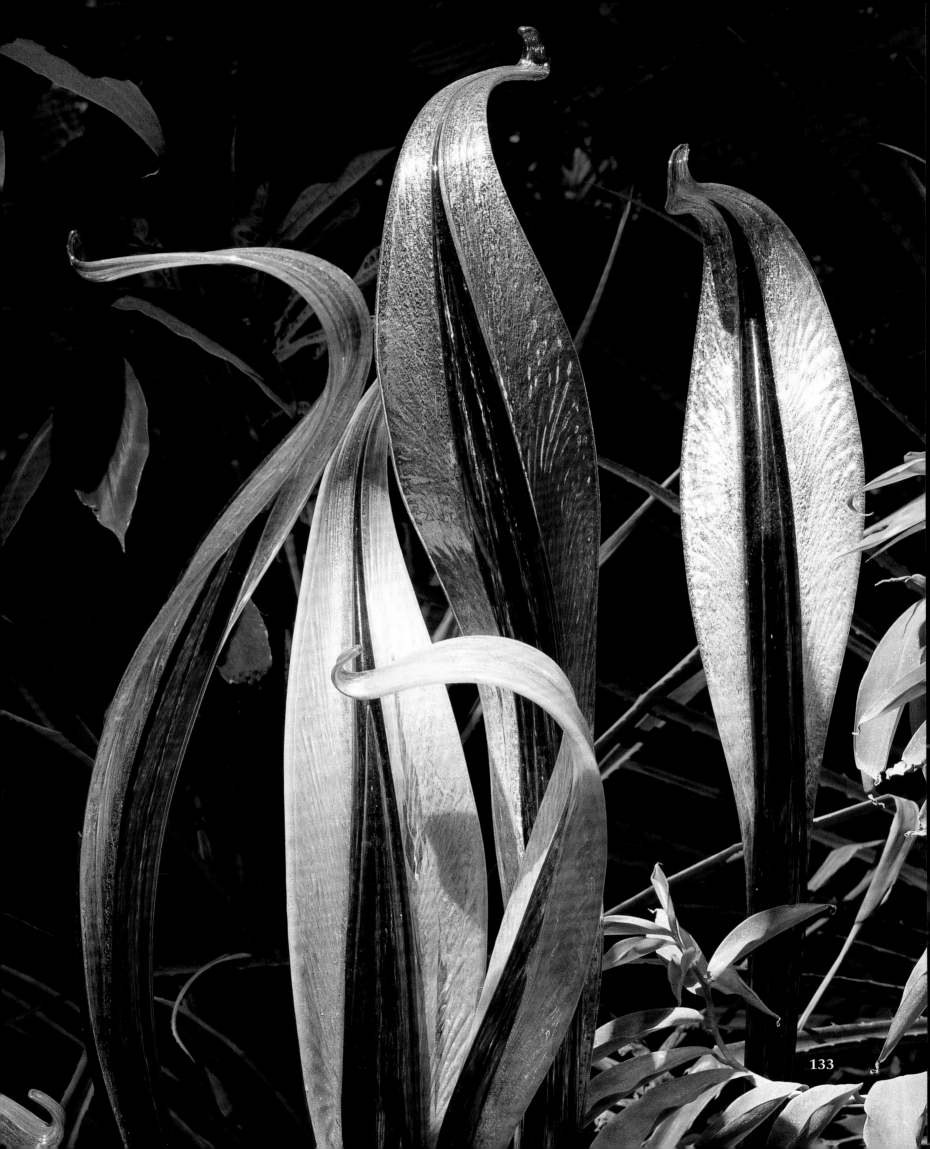

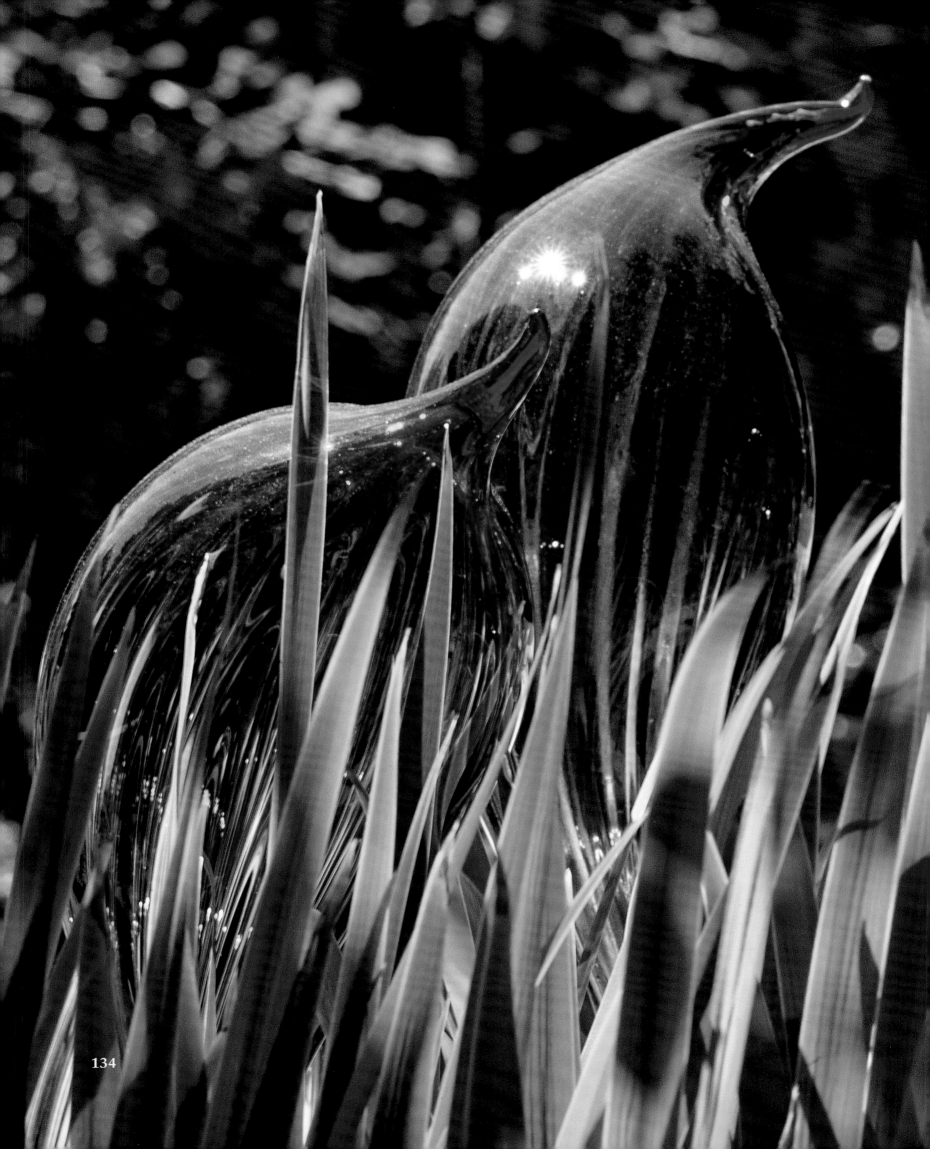

134

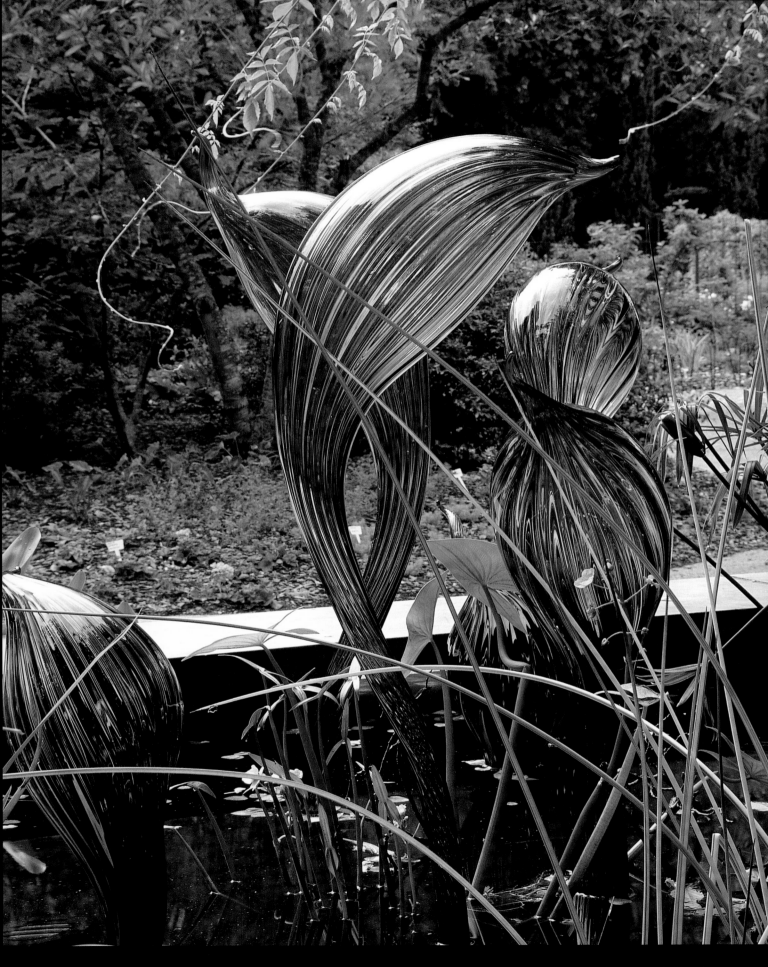

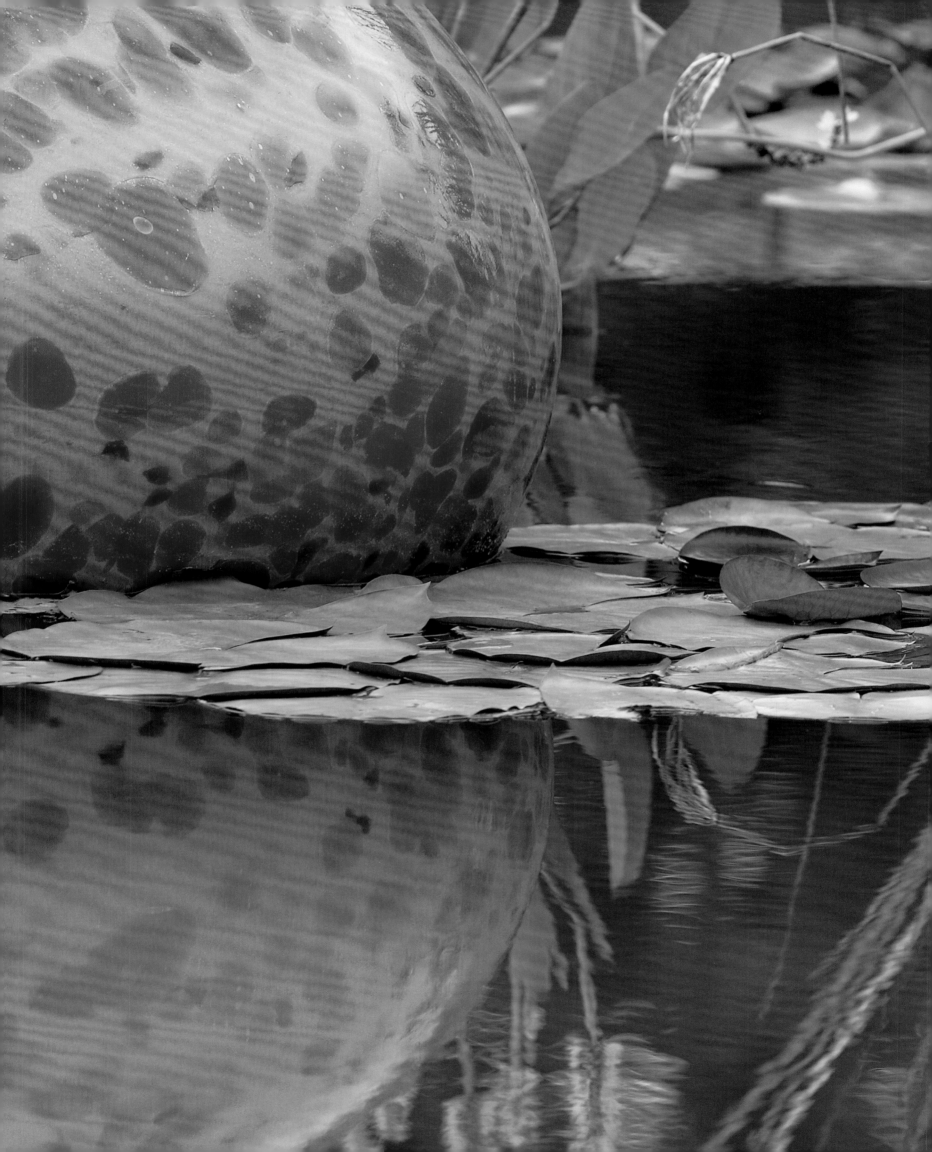

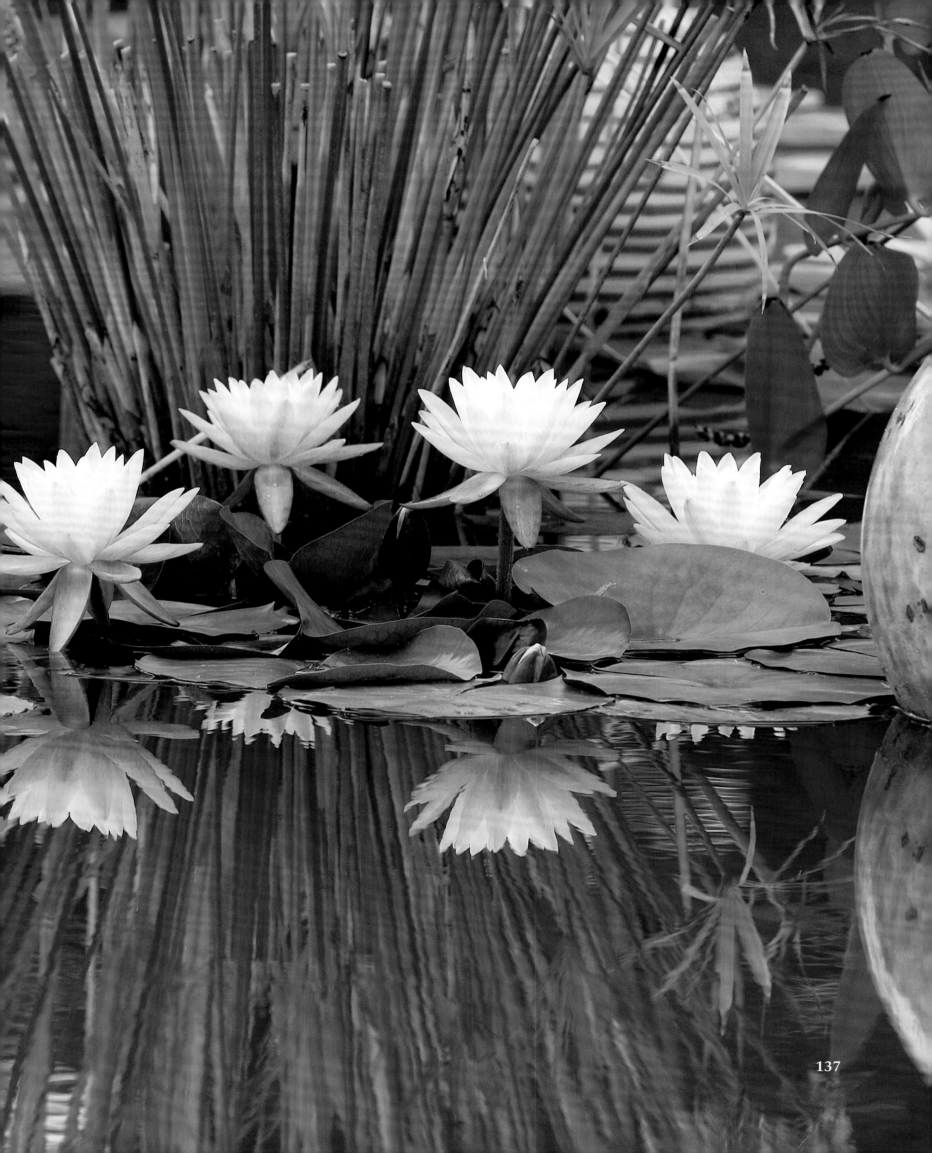

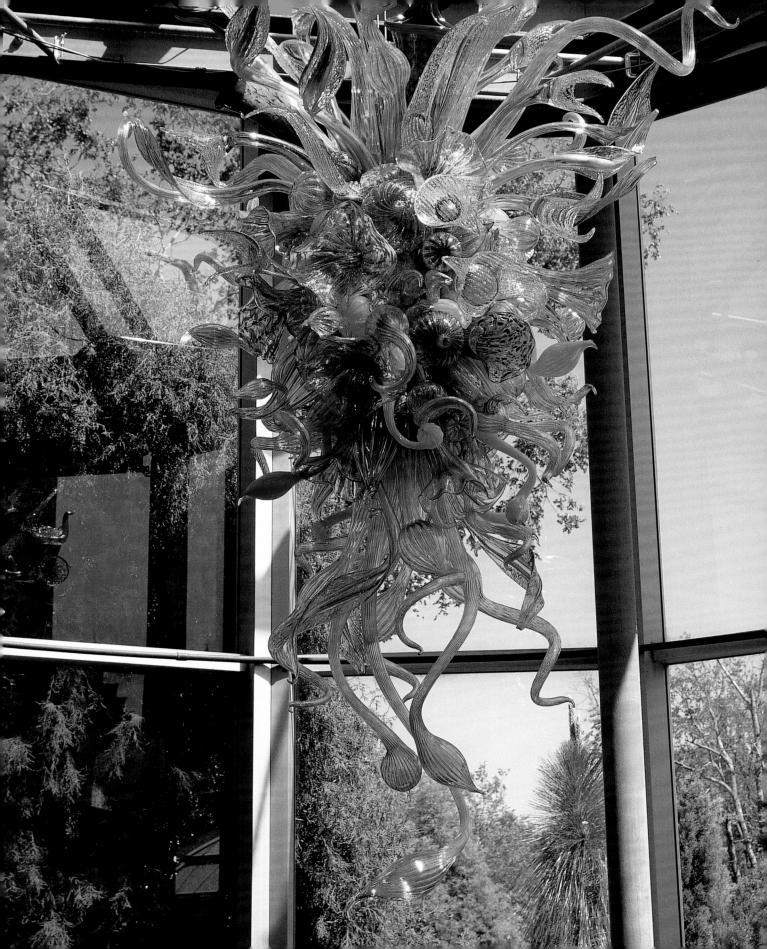

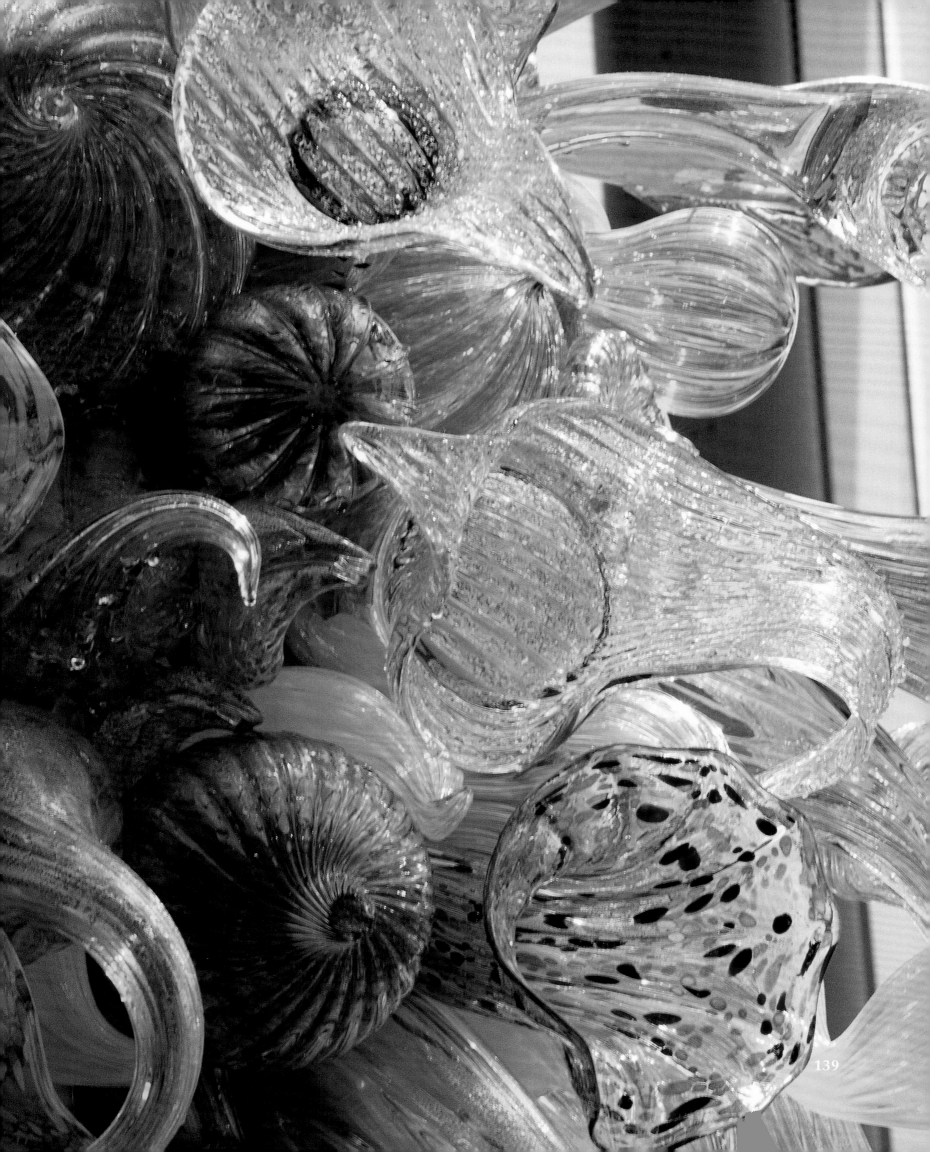

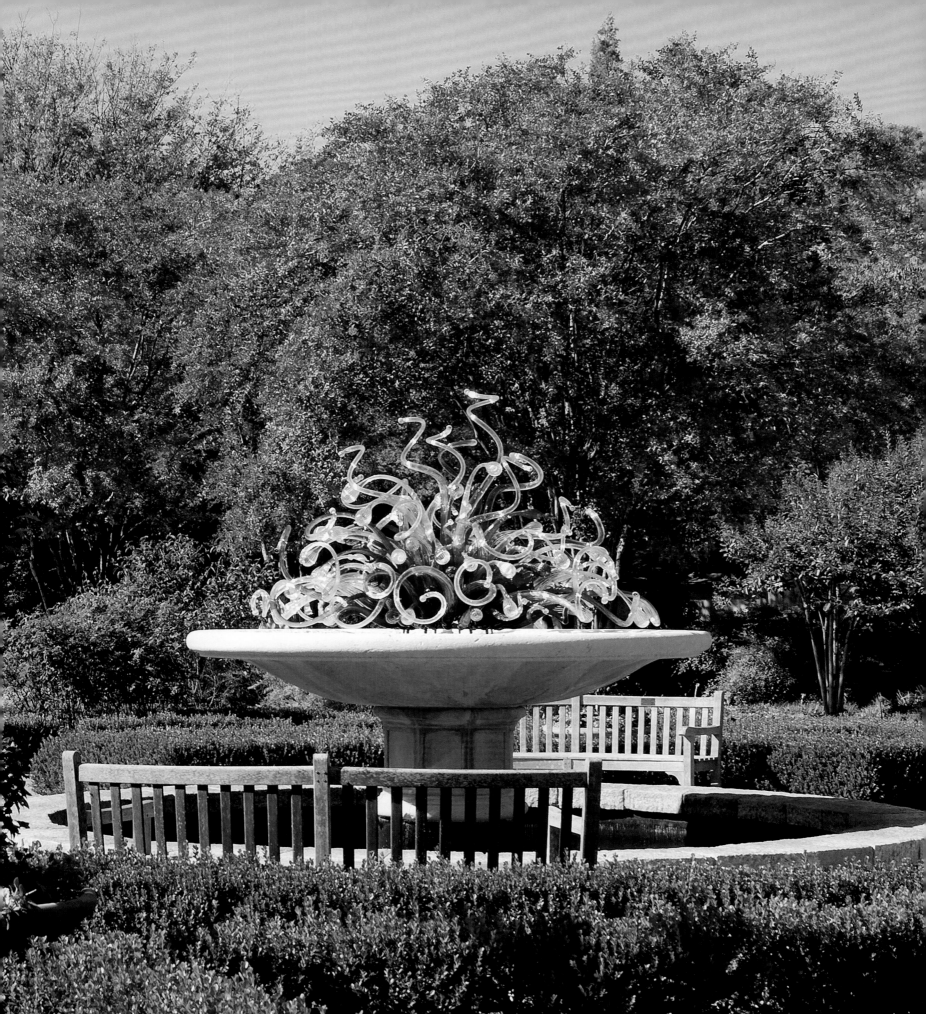

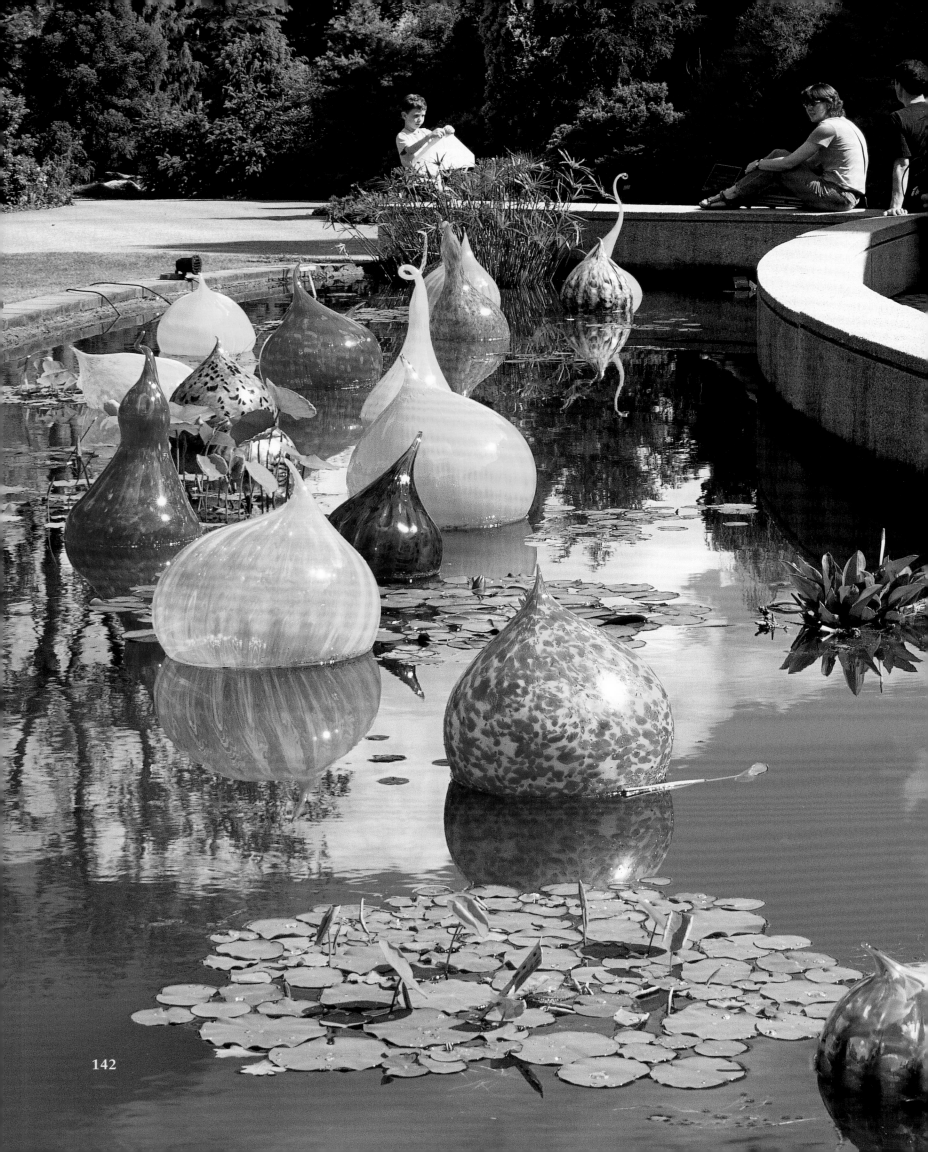

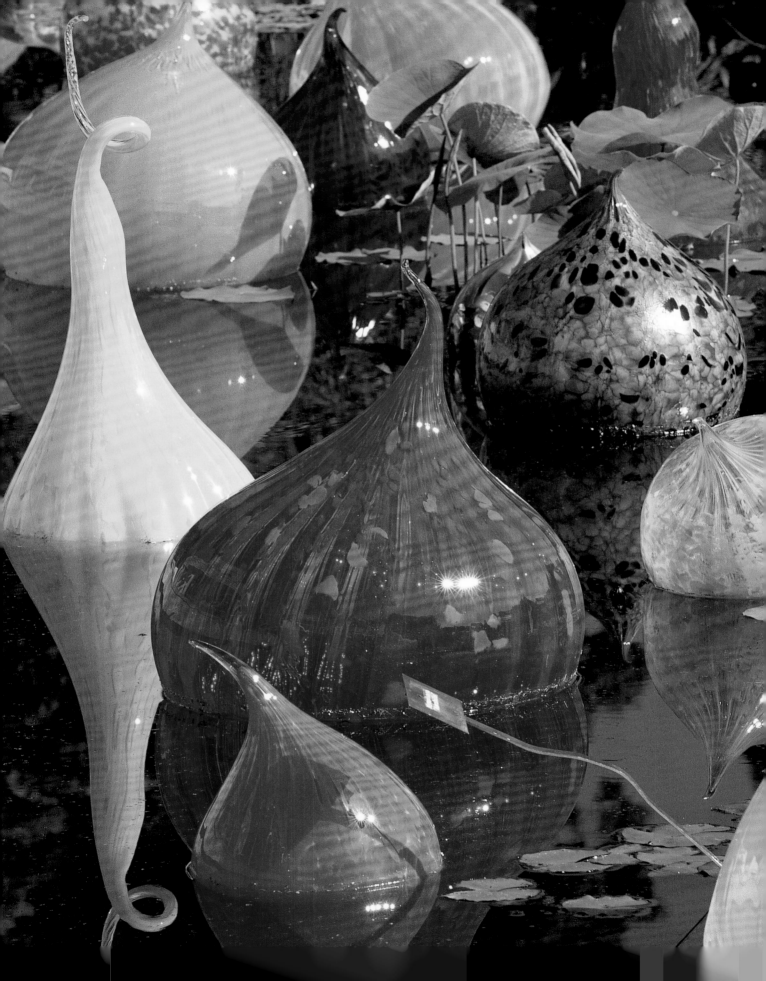

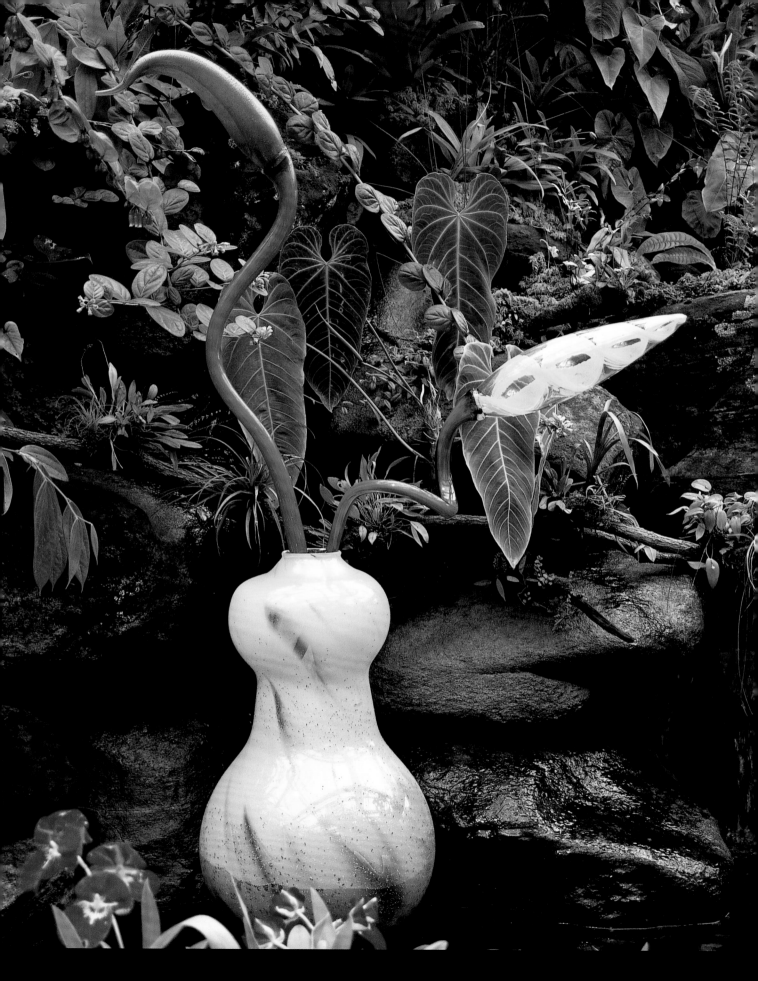

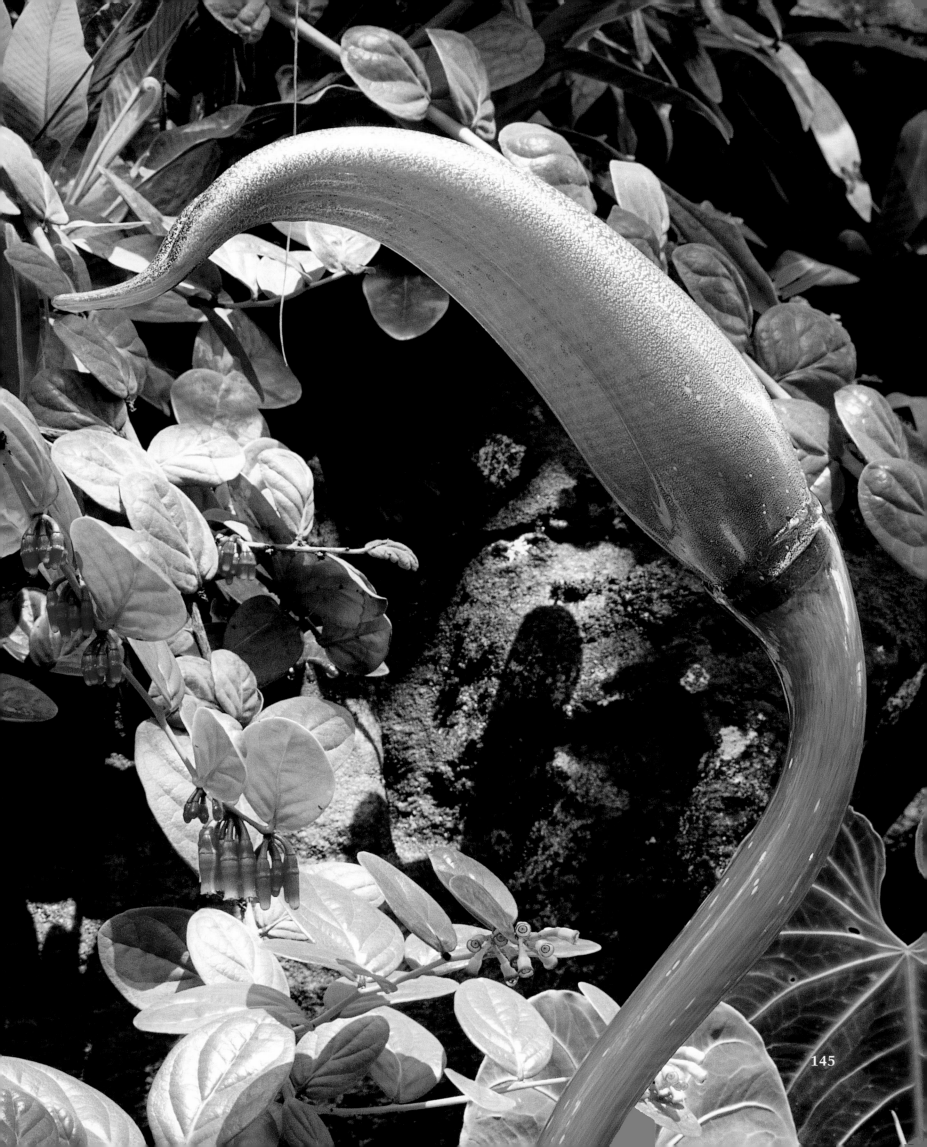

145

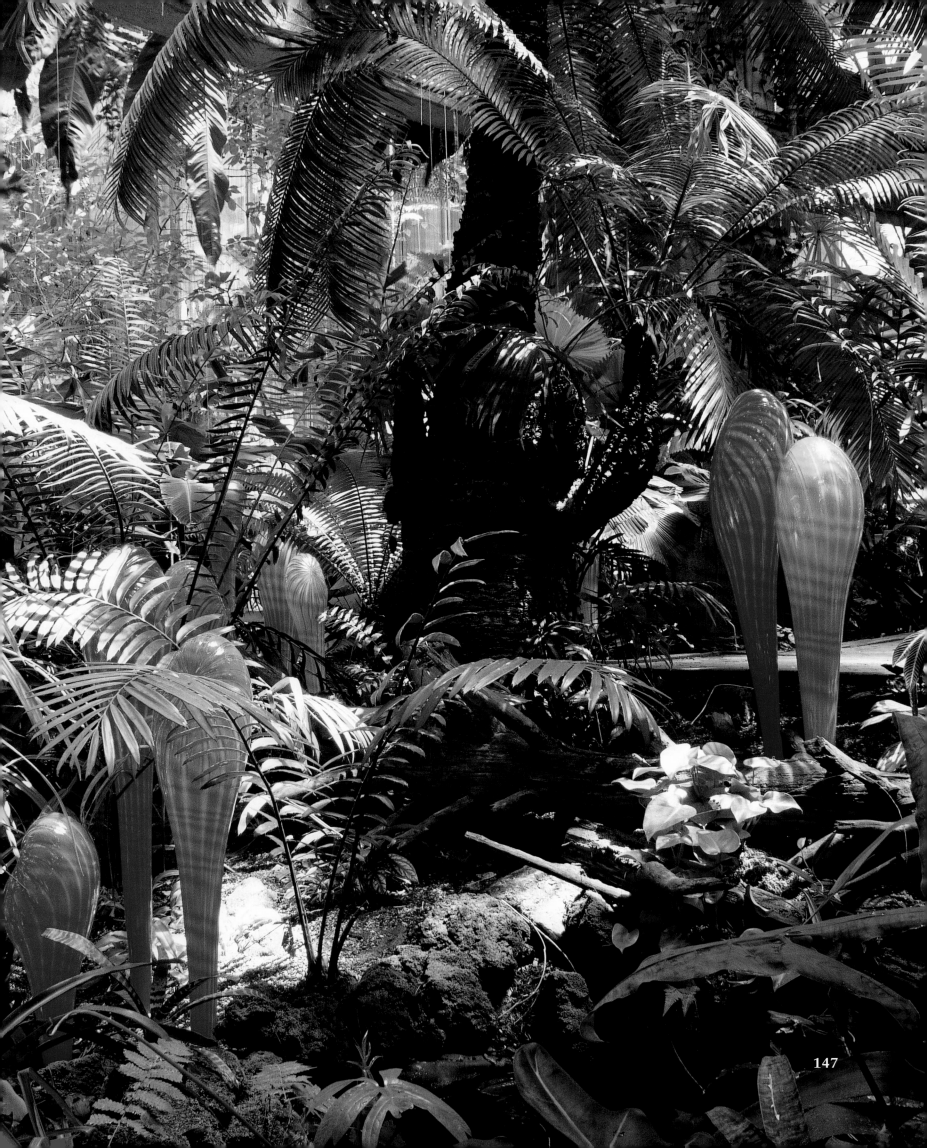

147

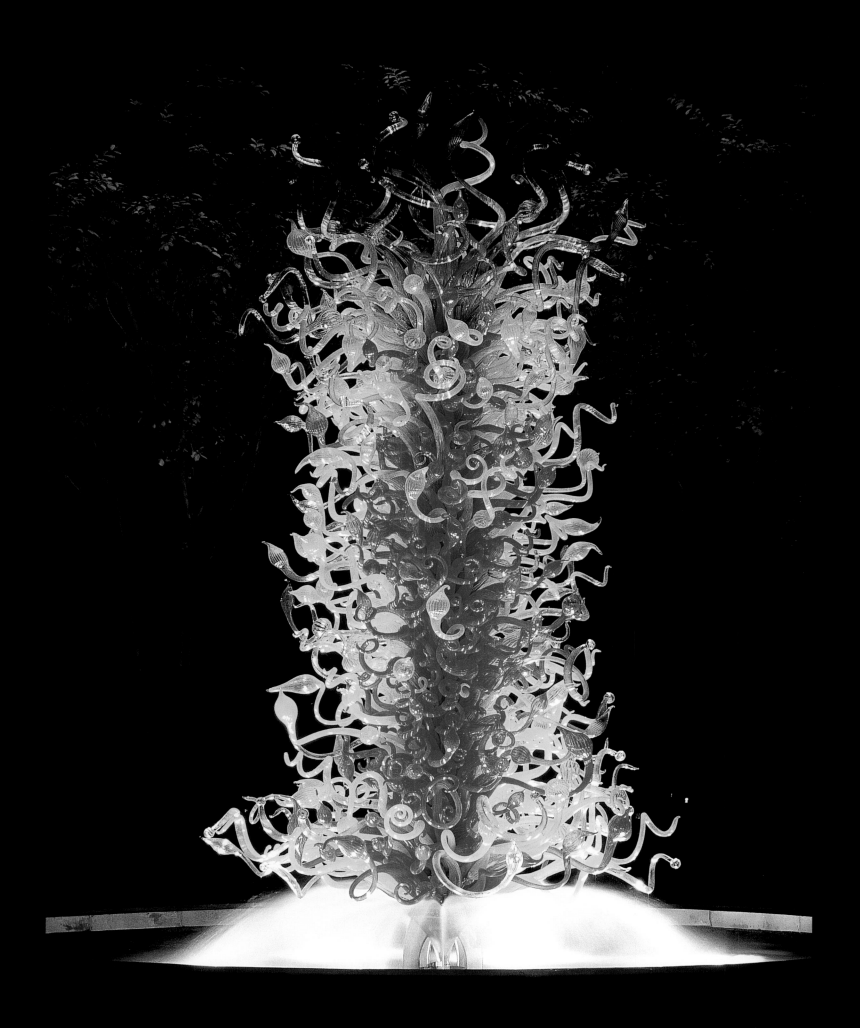

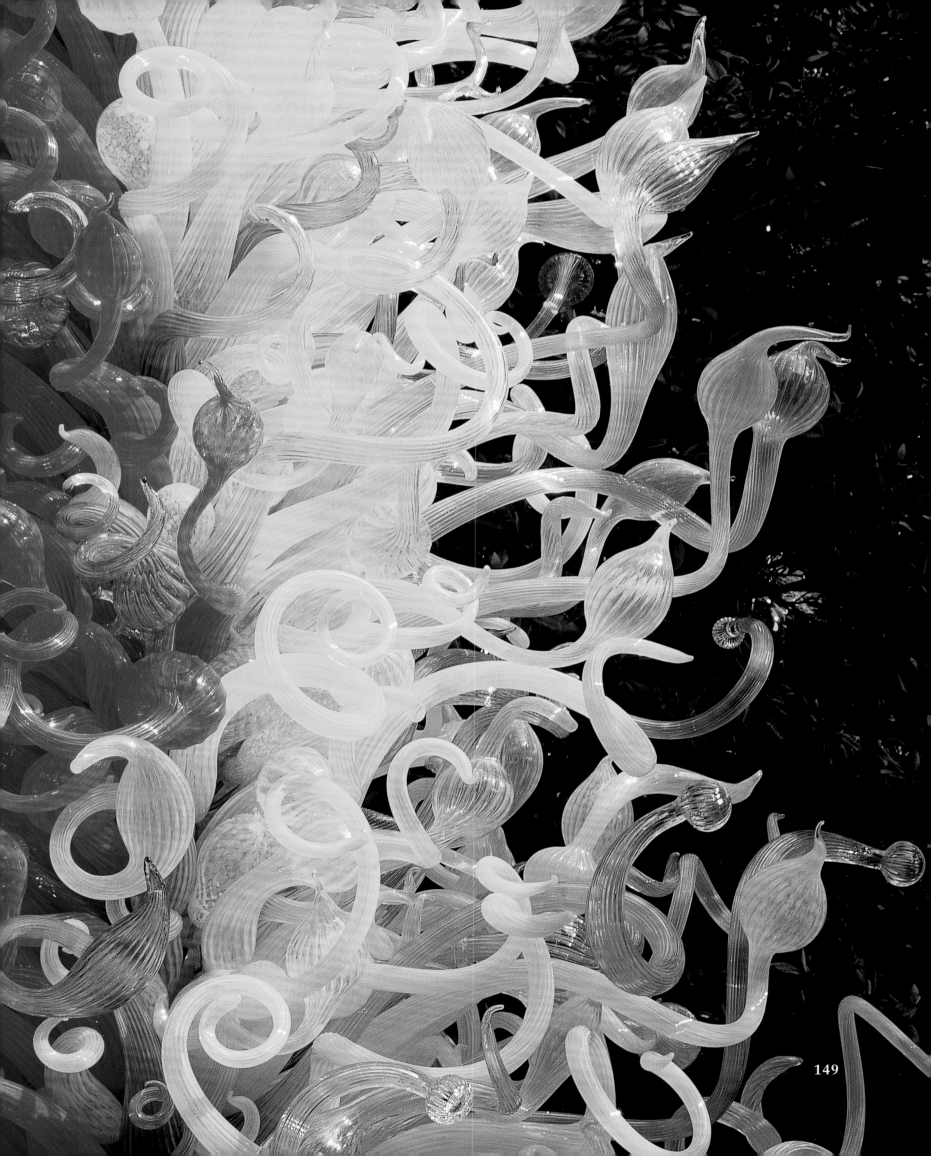

149

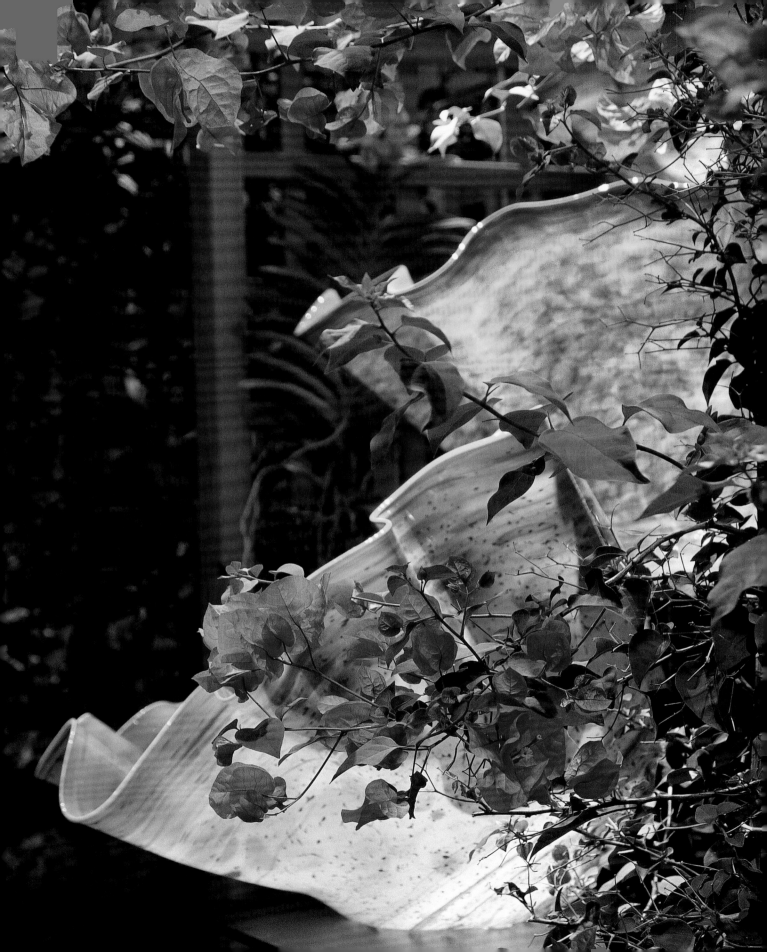

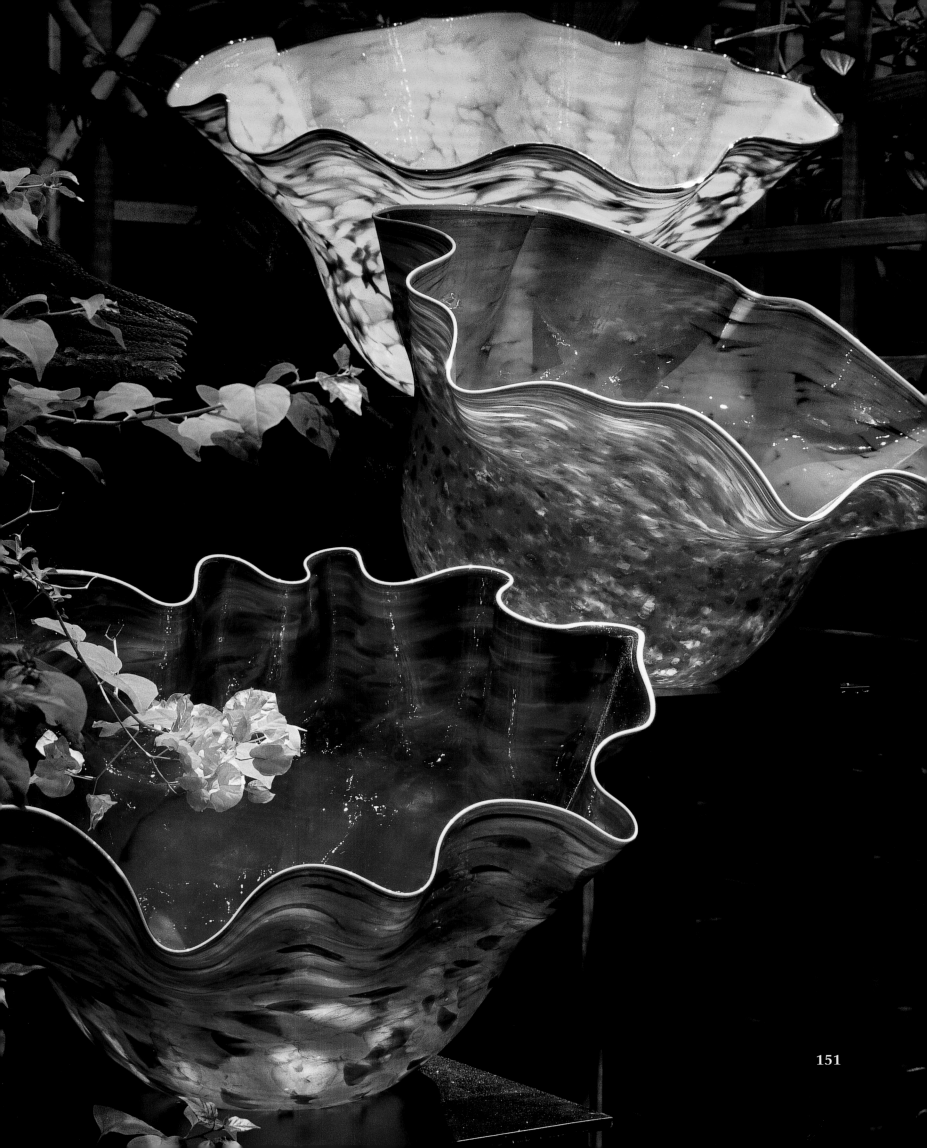

Royal Botanic Gardens, Kew
Richmond, Surrey, England

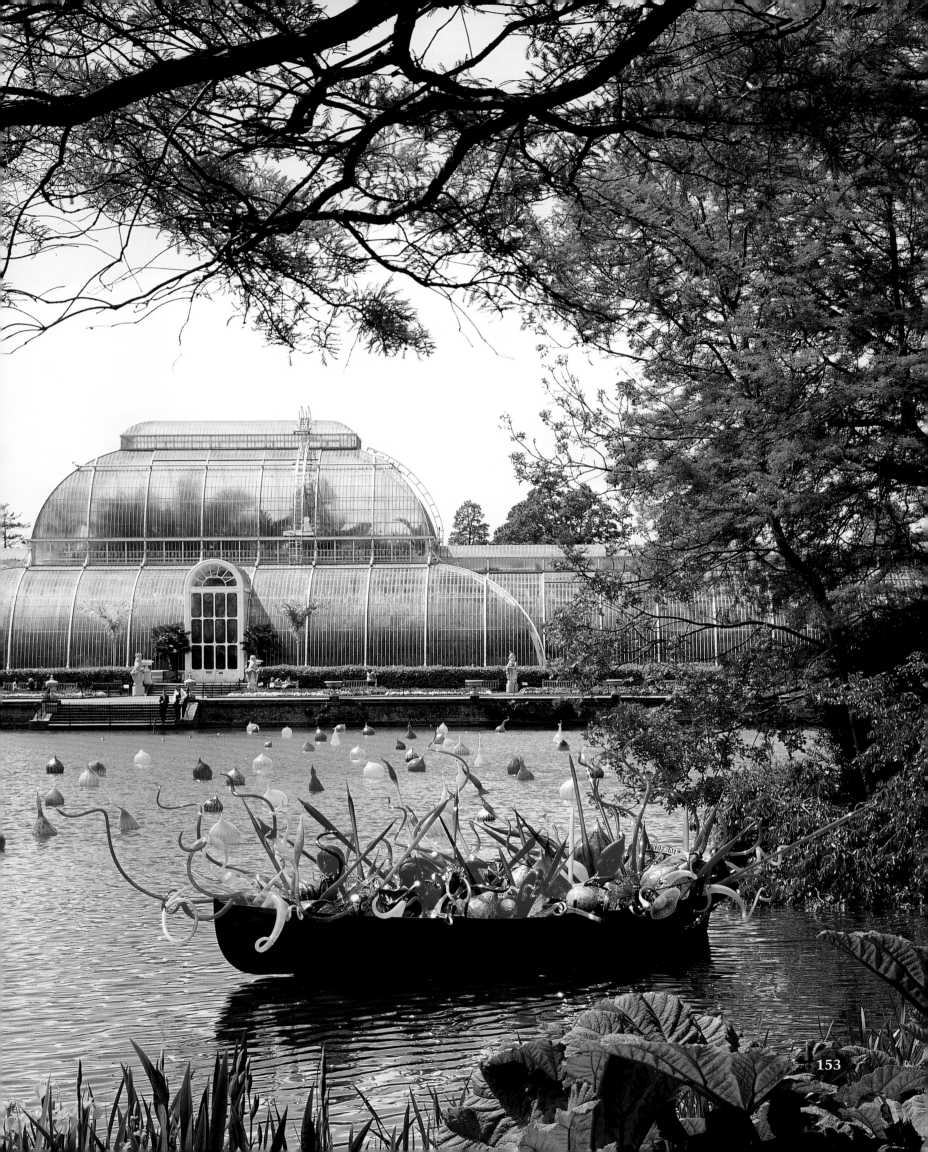

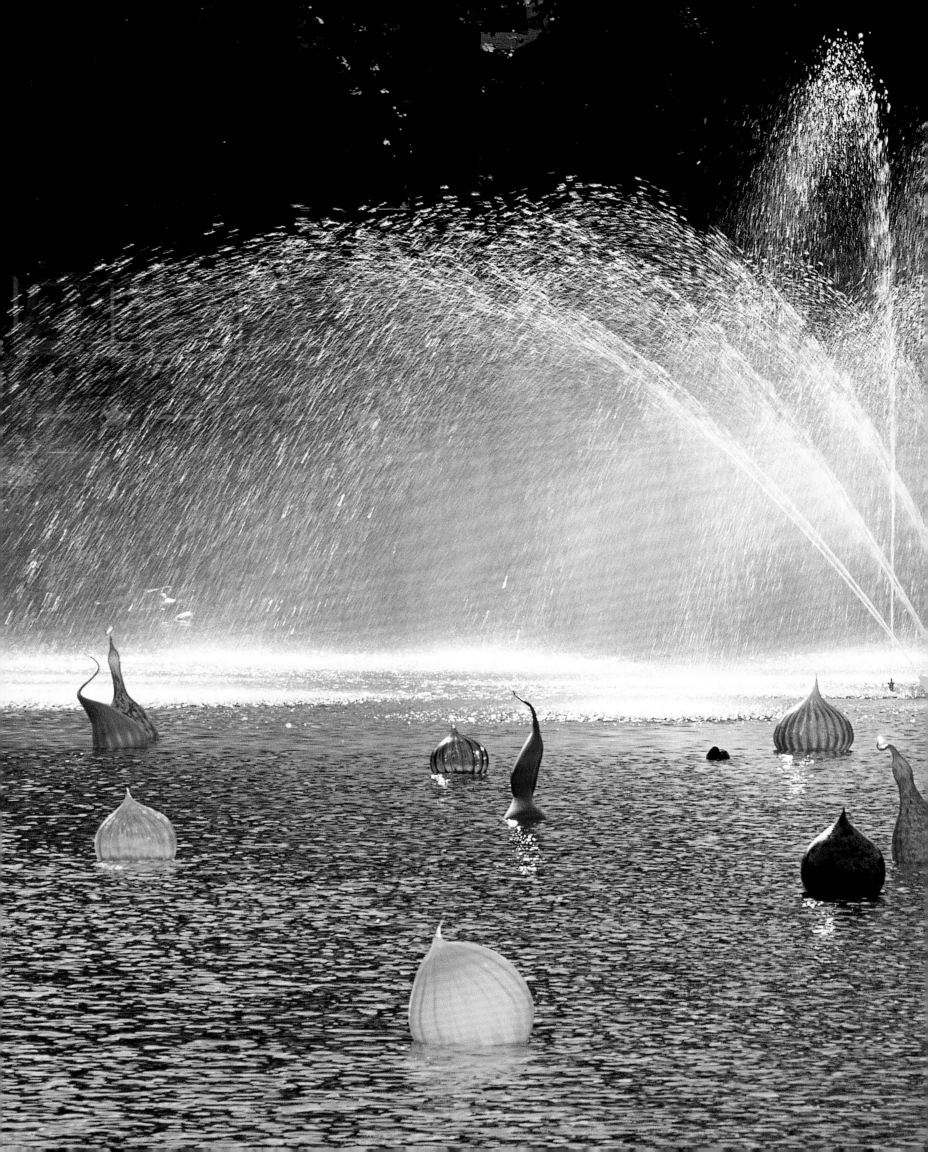

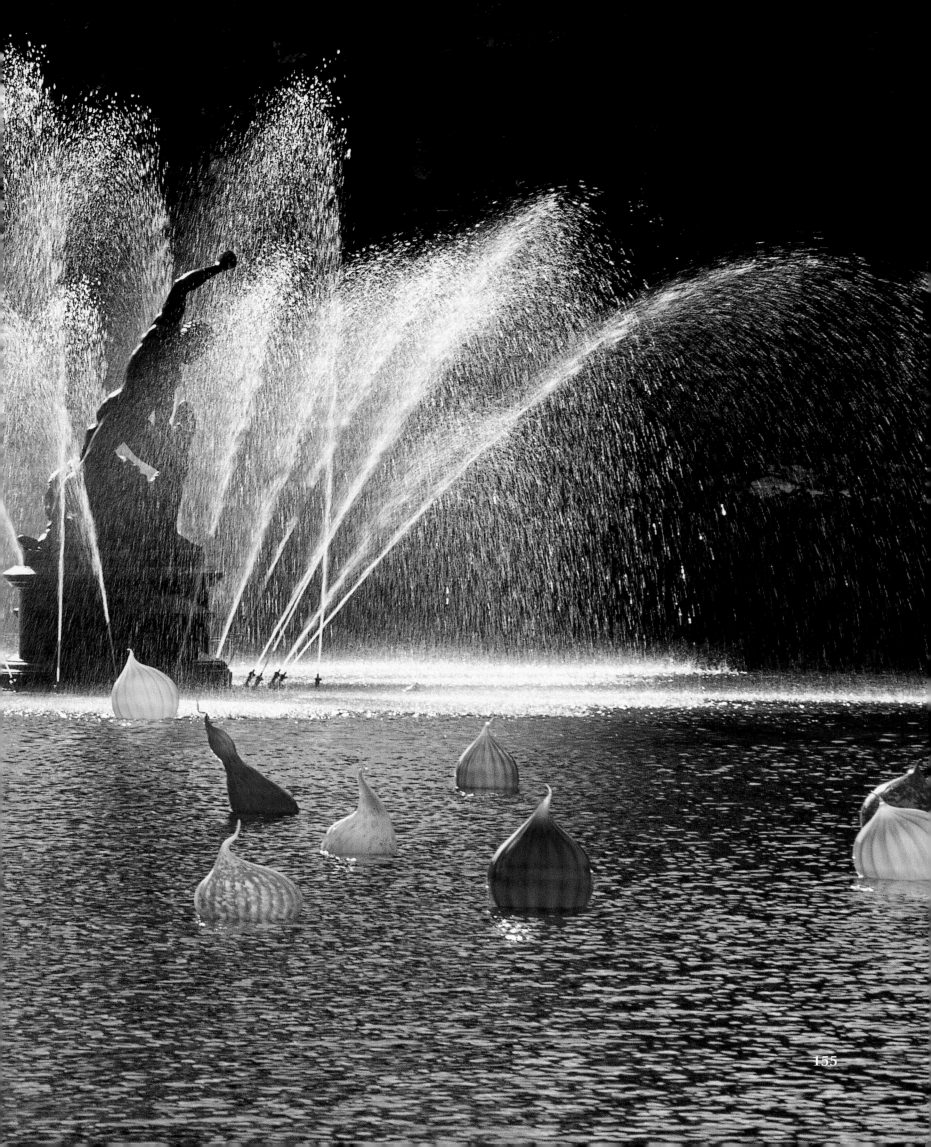

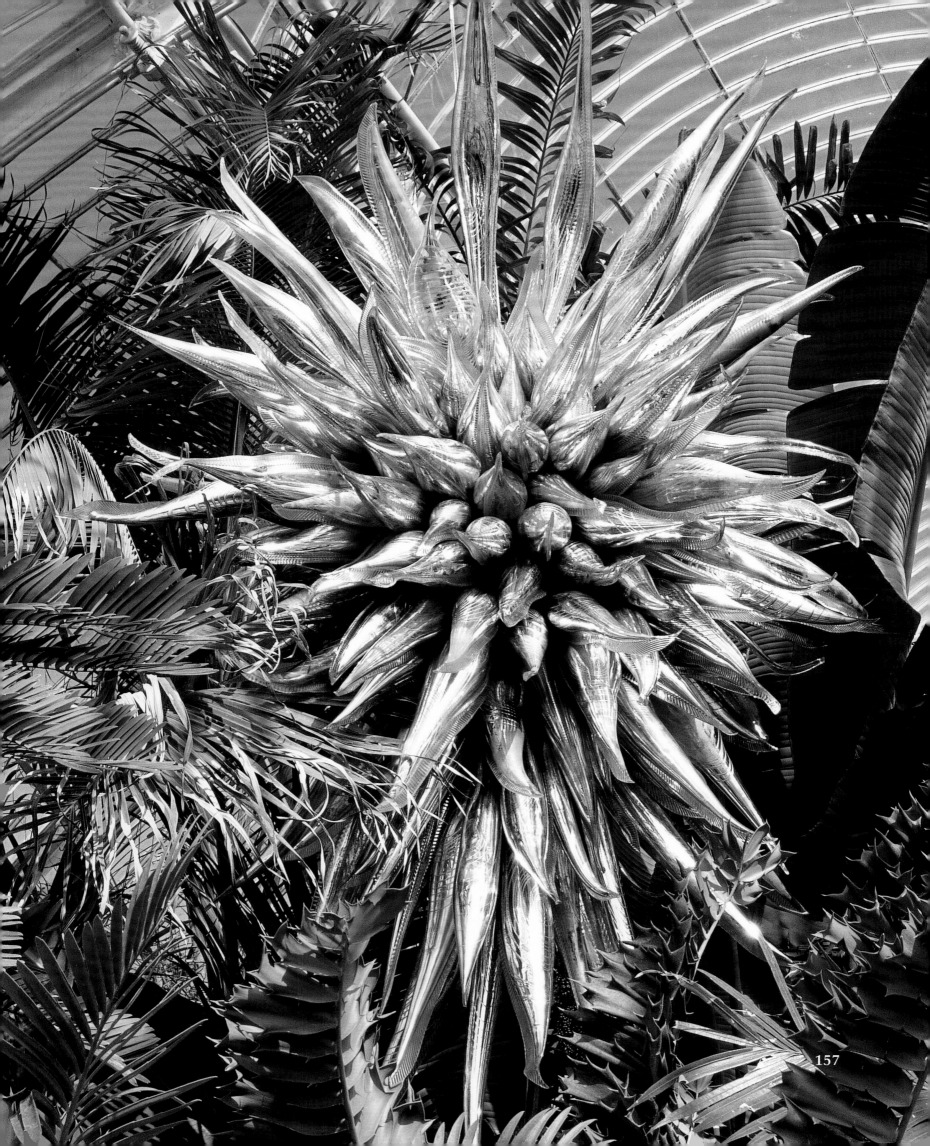

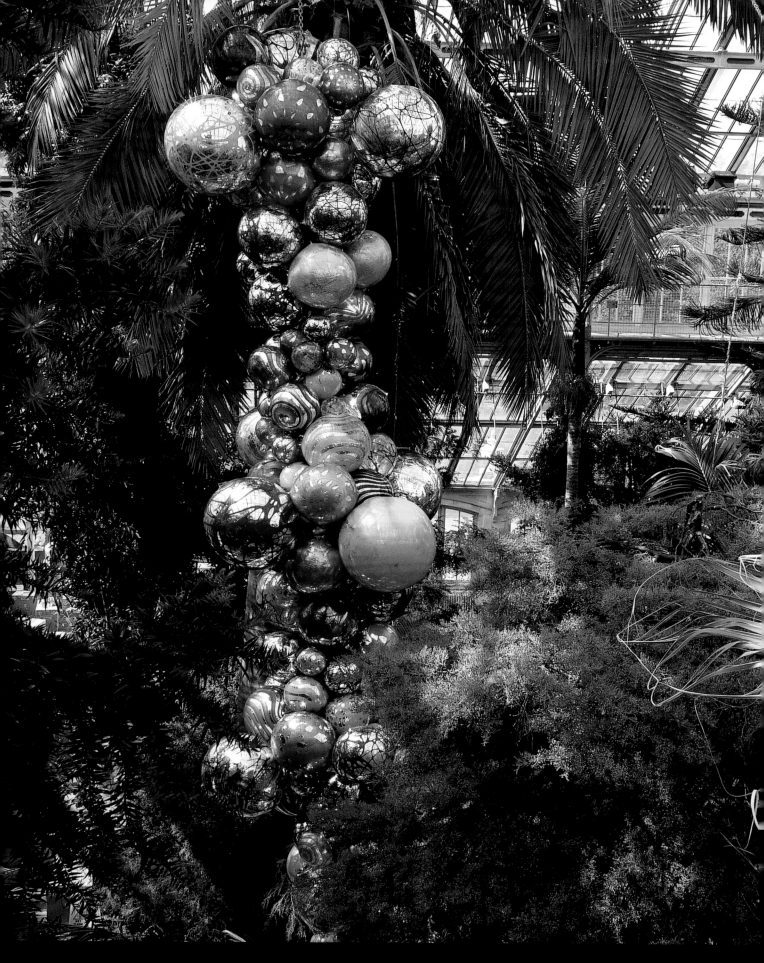

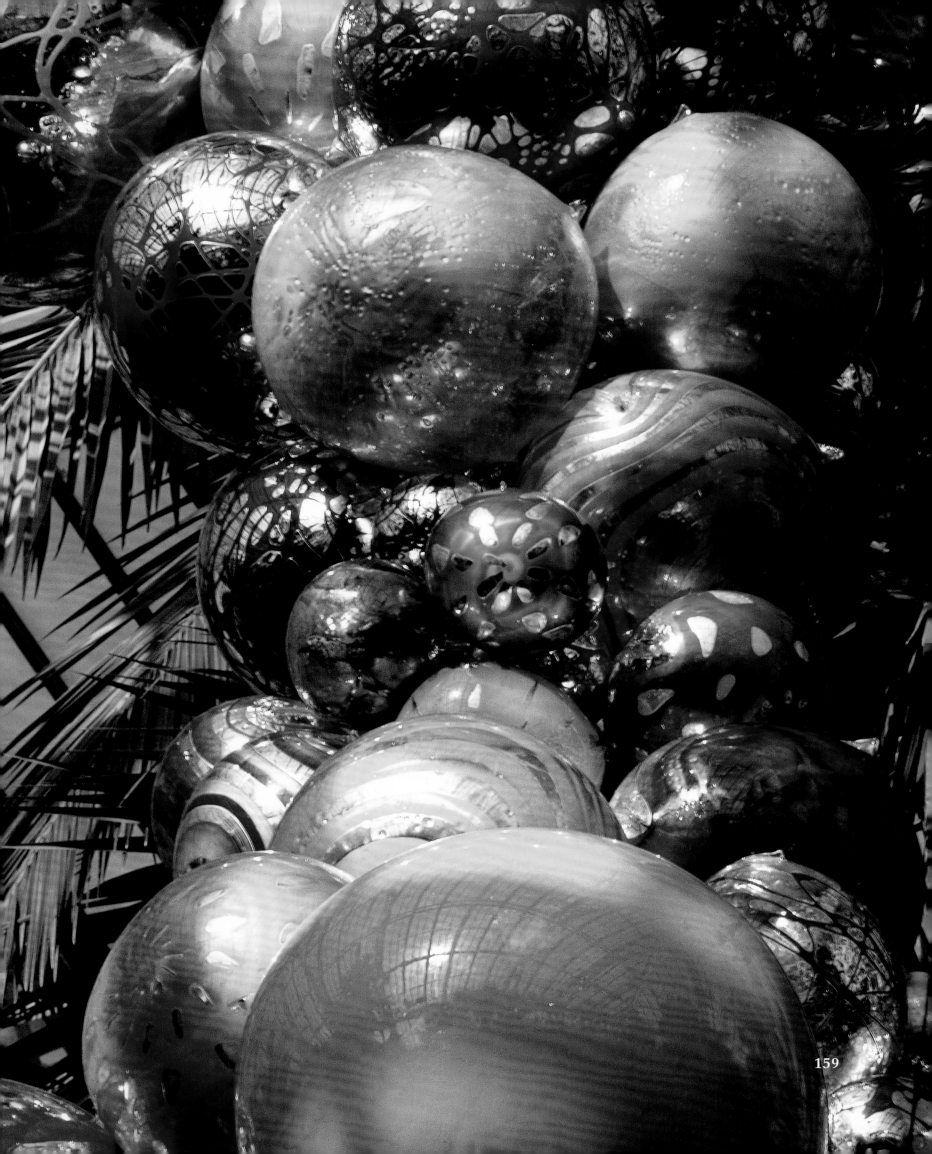

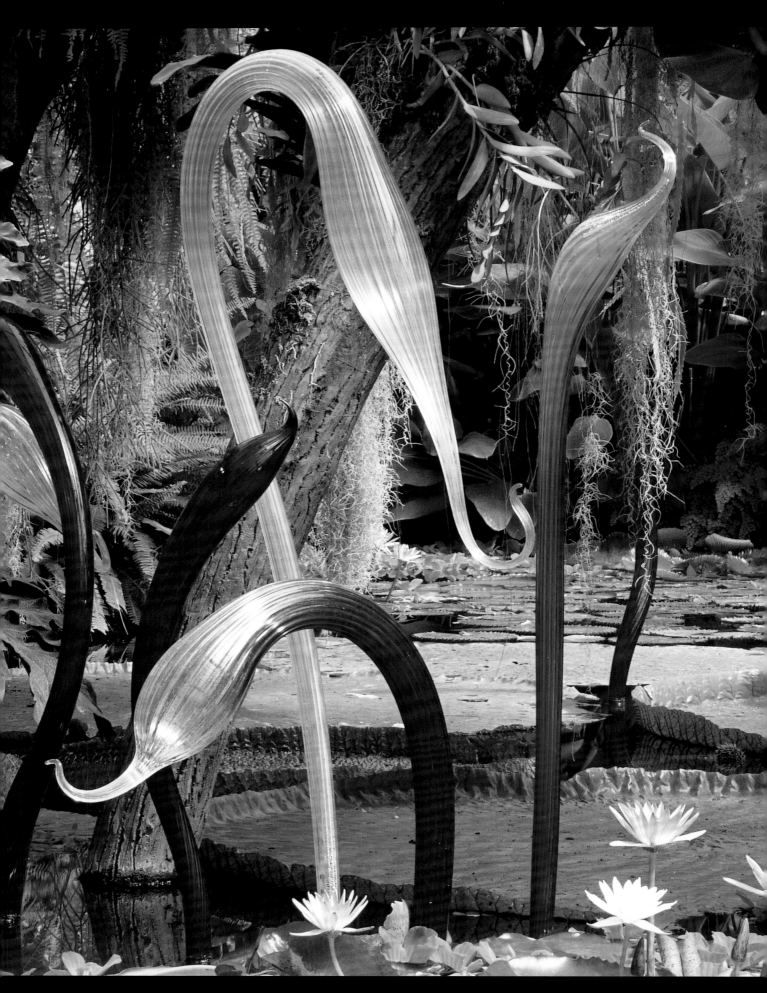

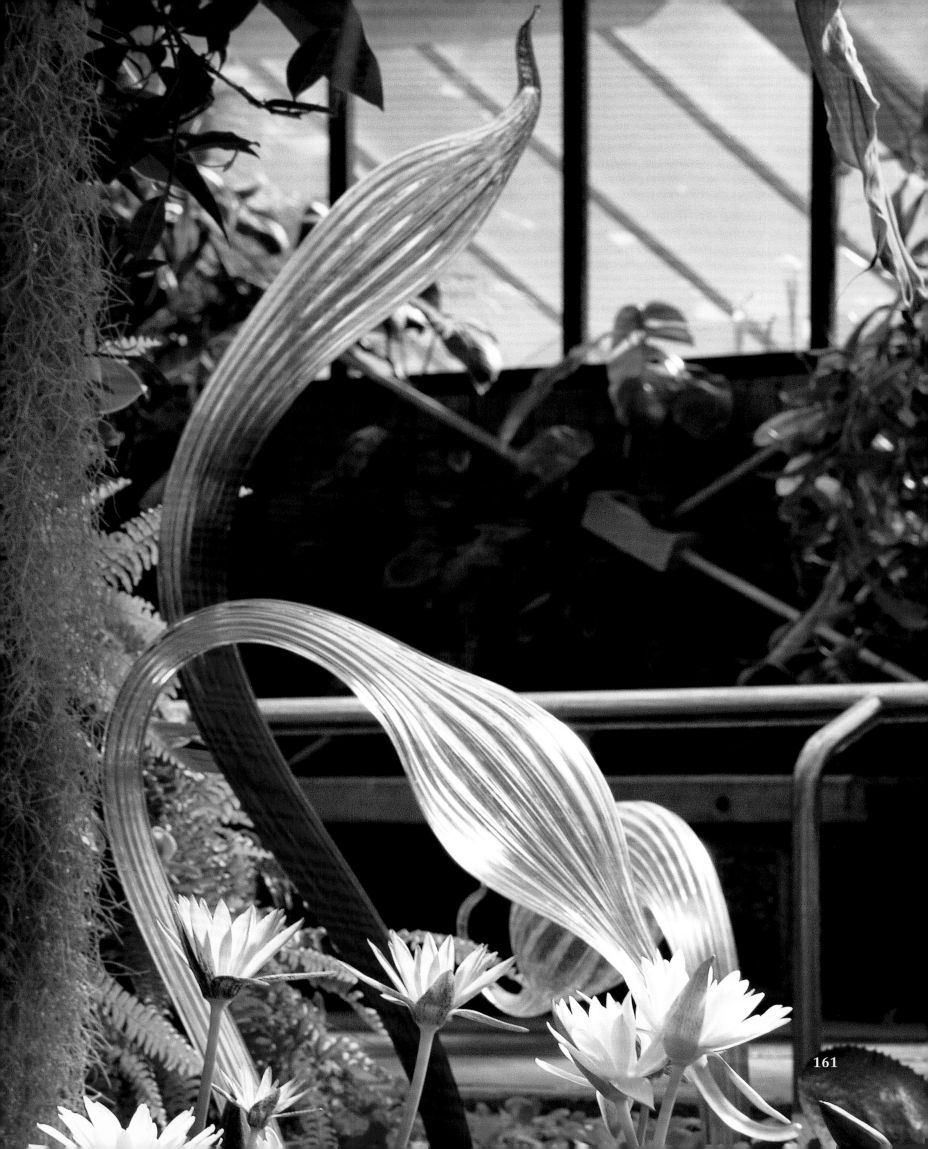

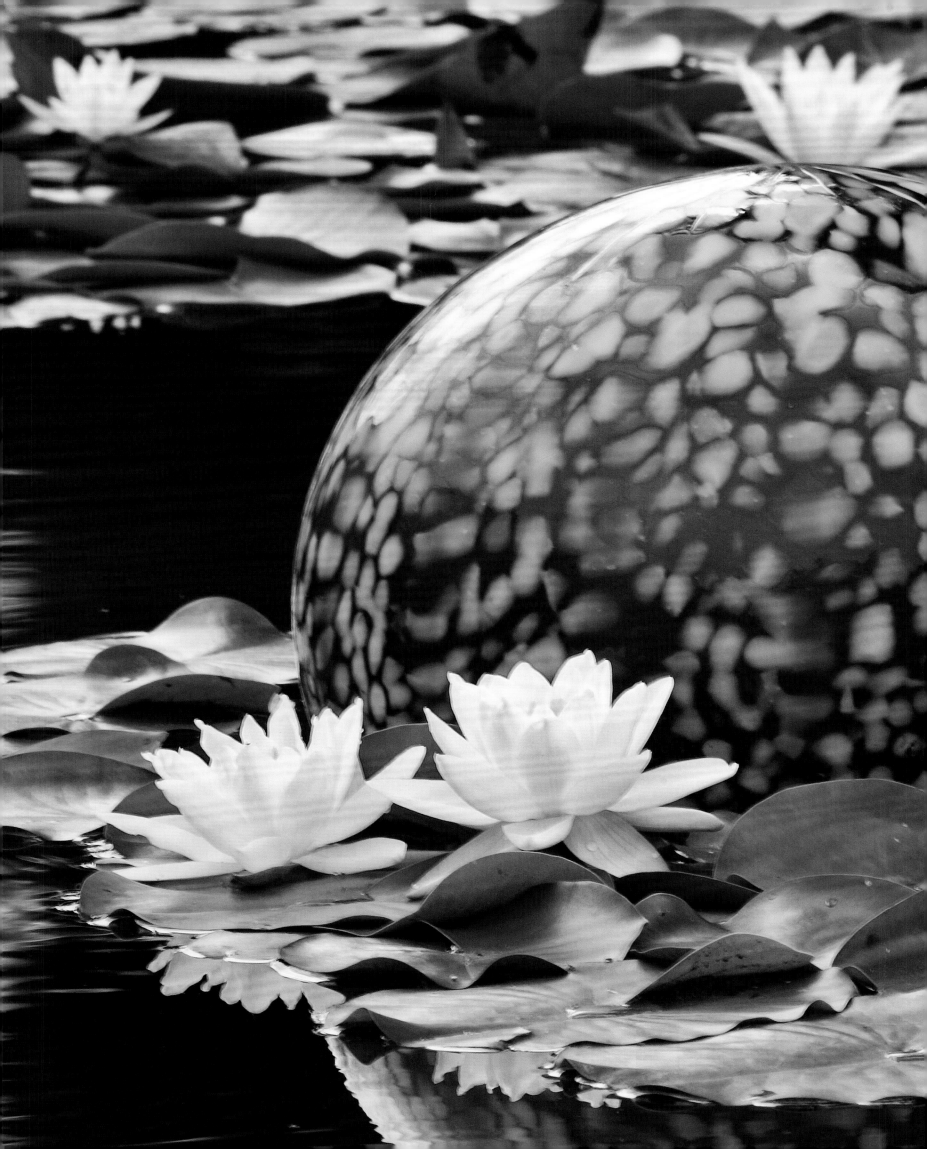

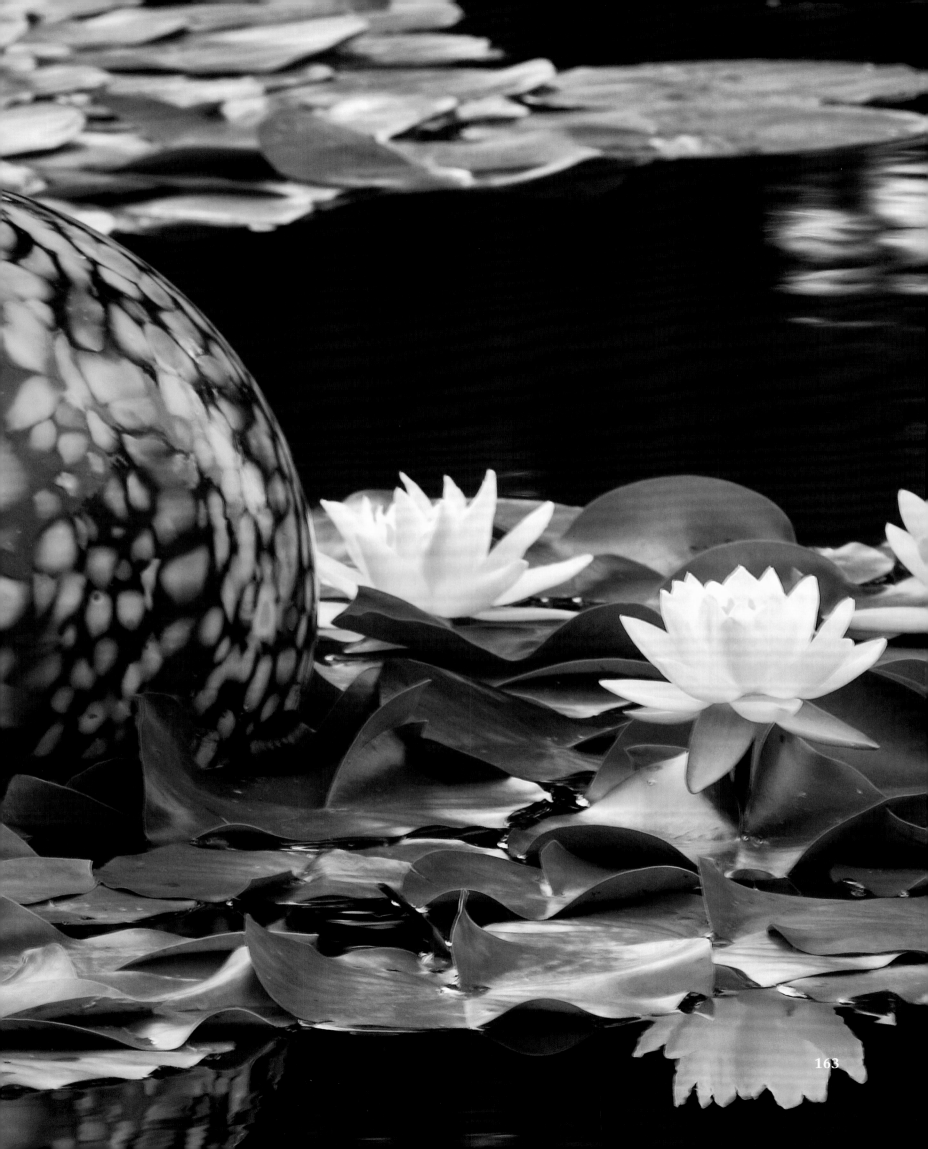

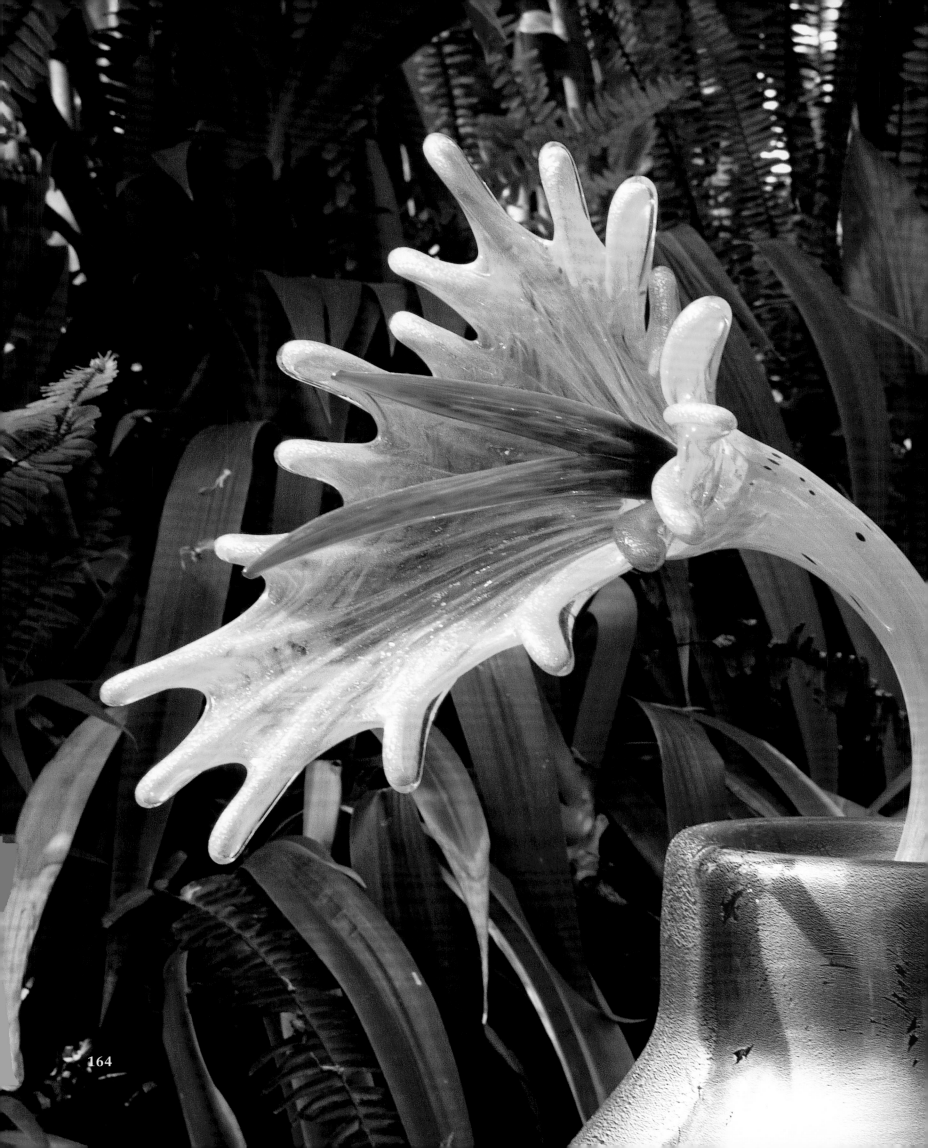

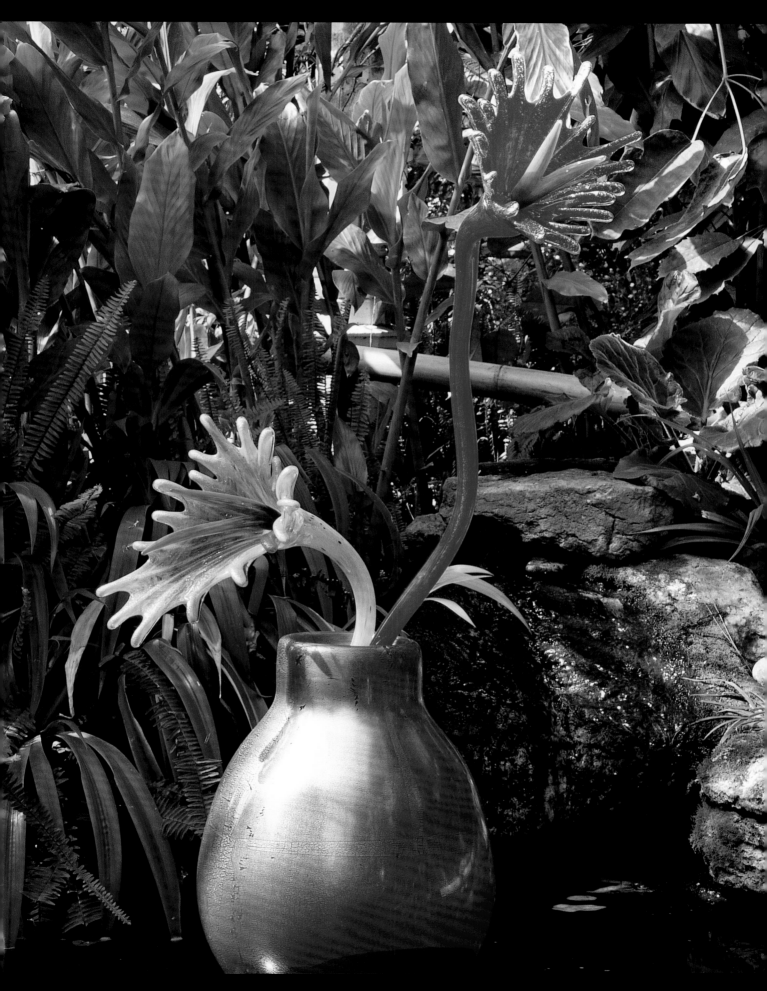

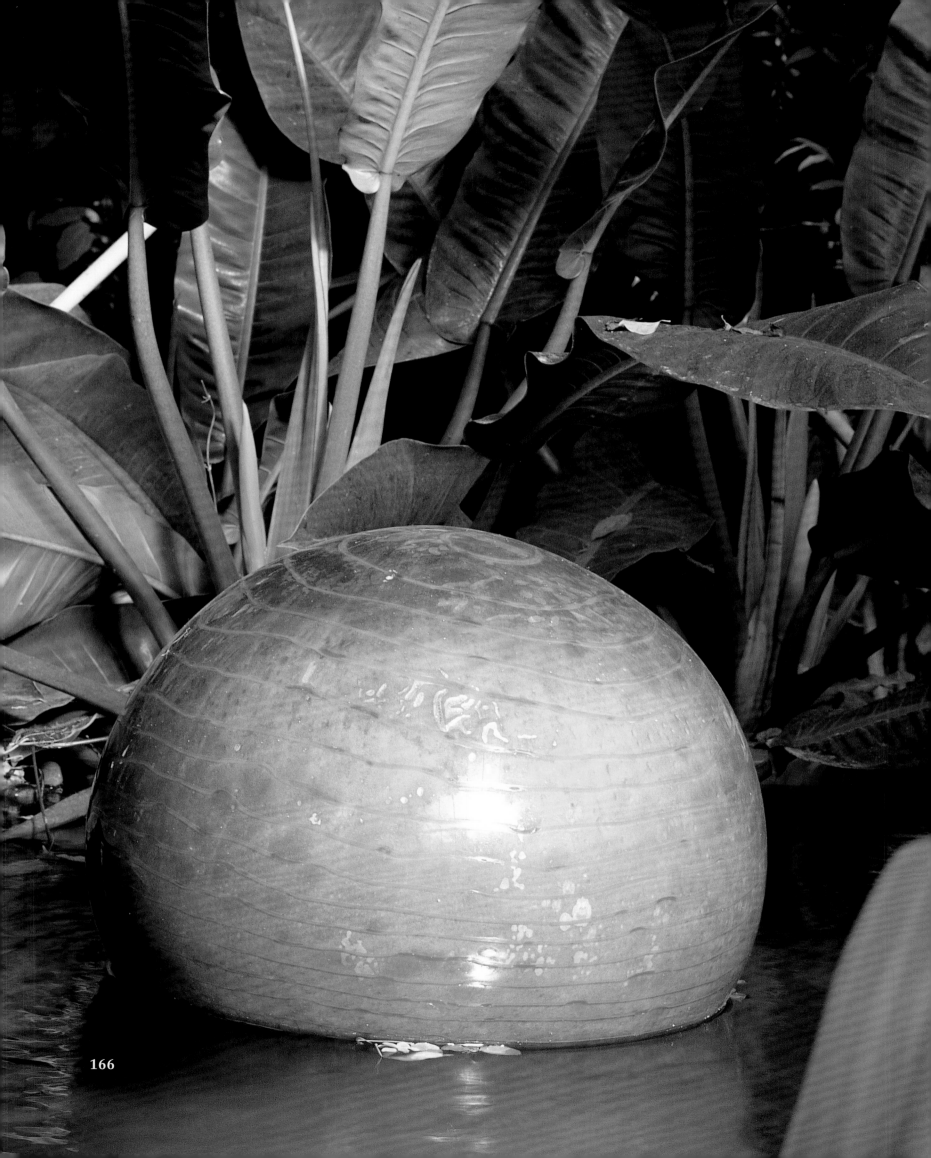

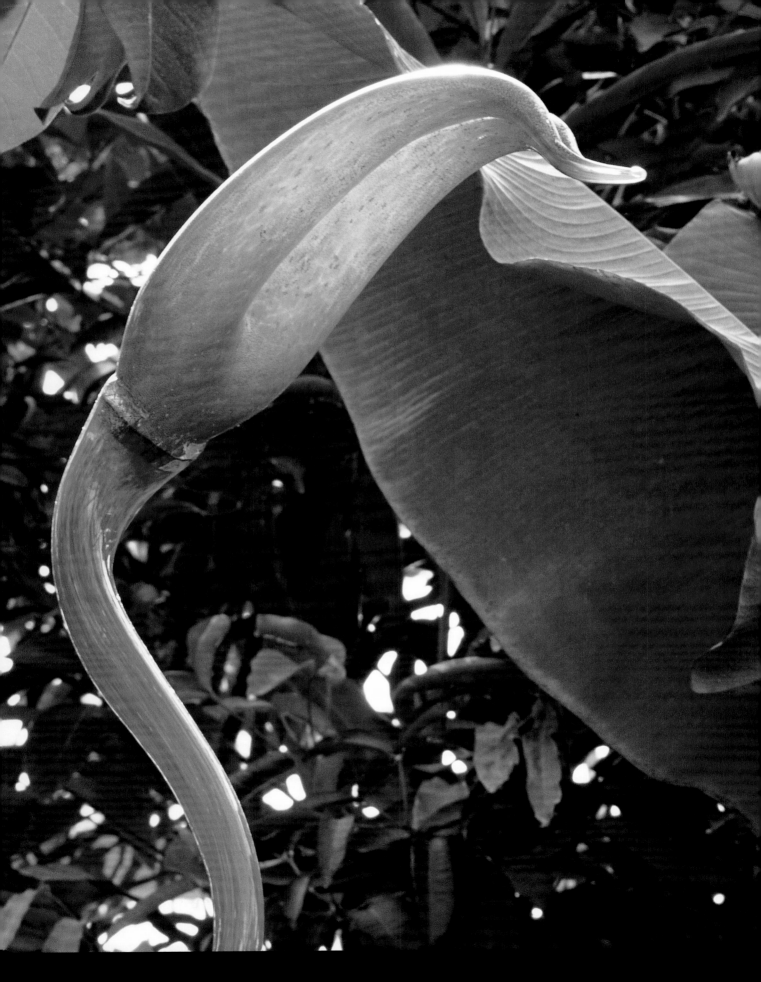

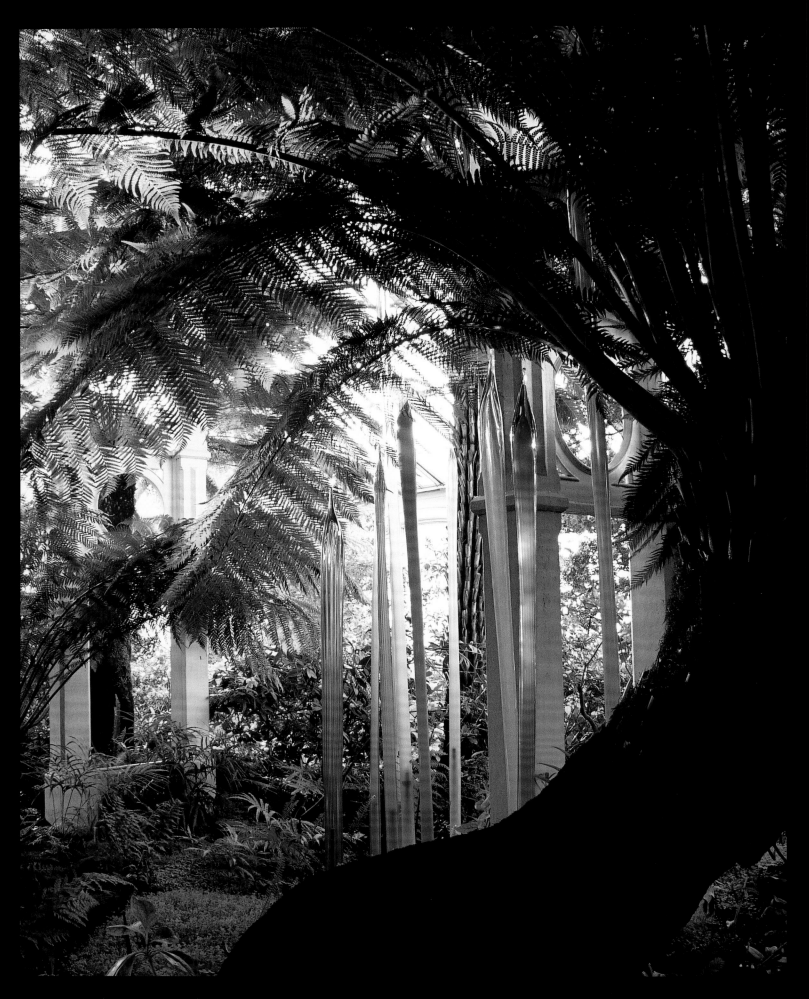

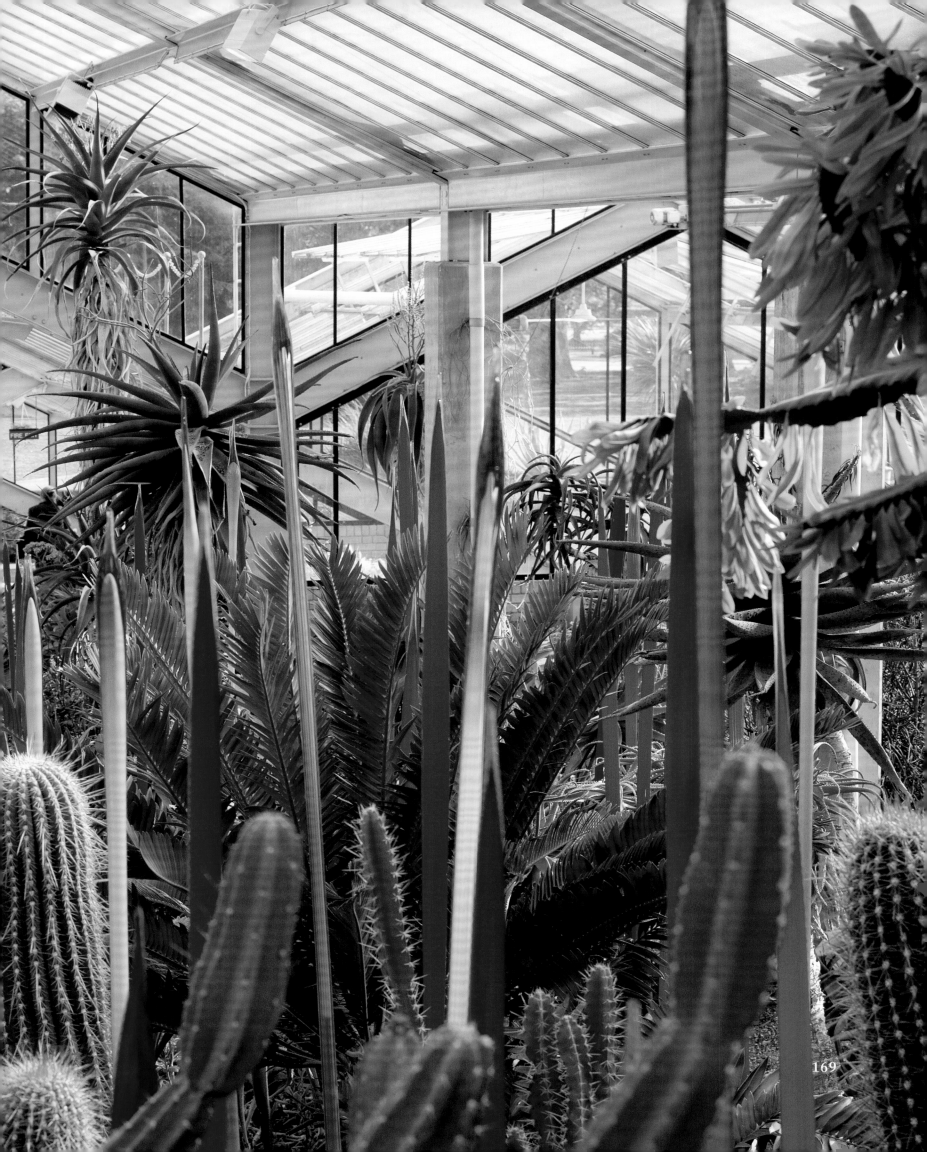

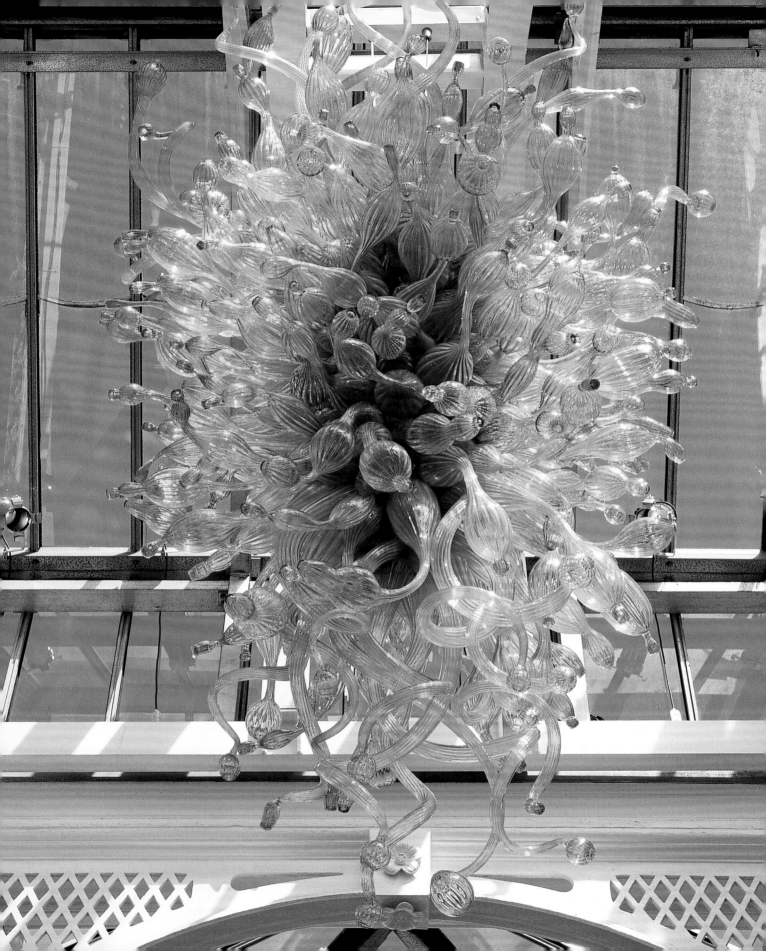

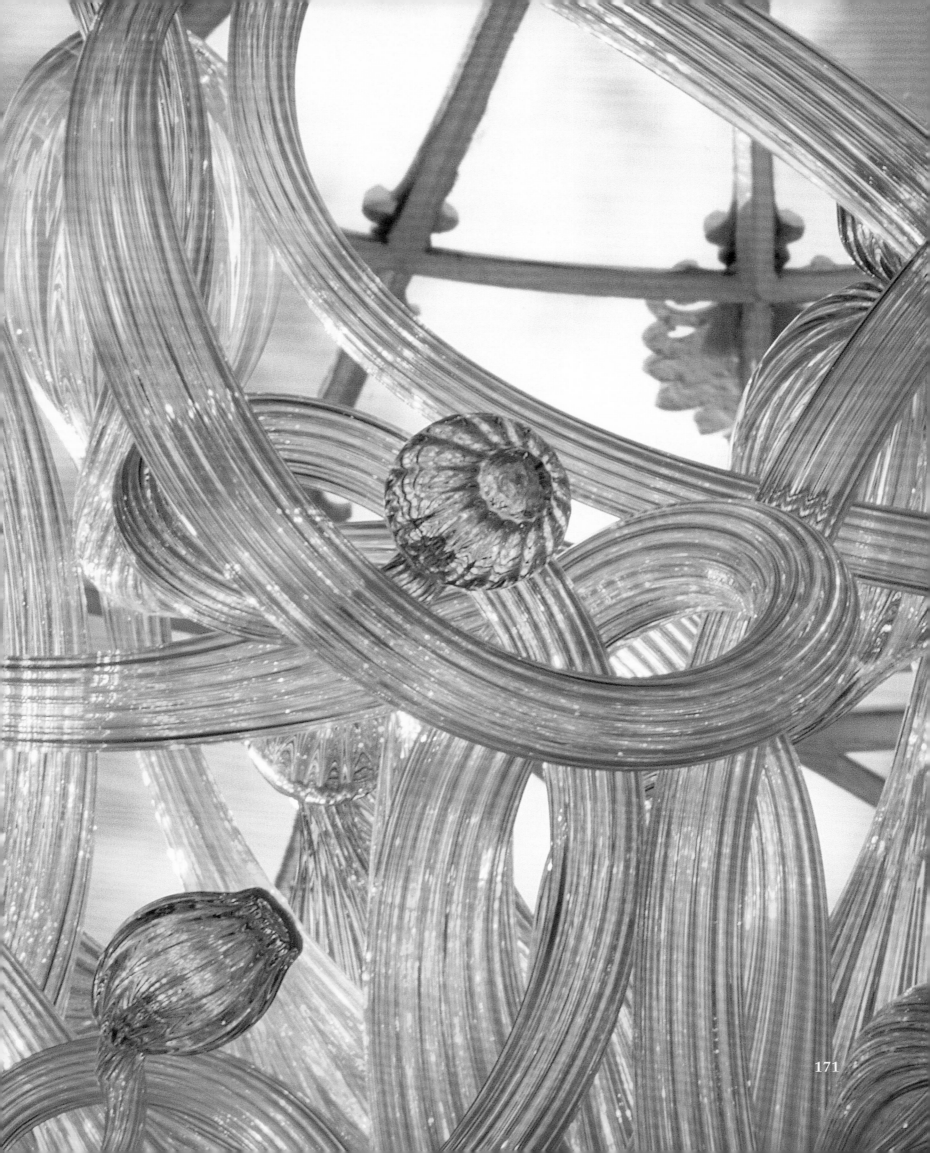

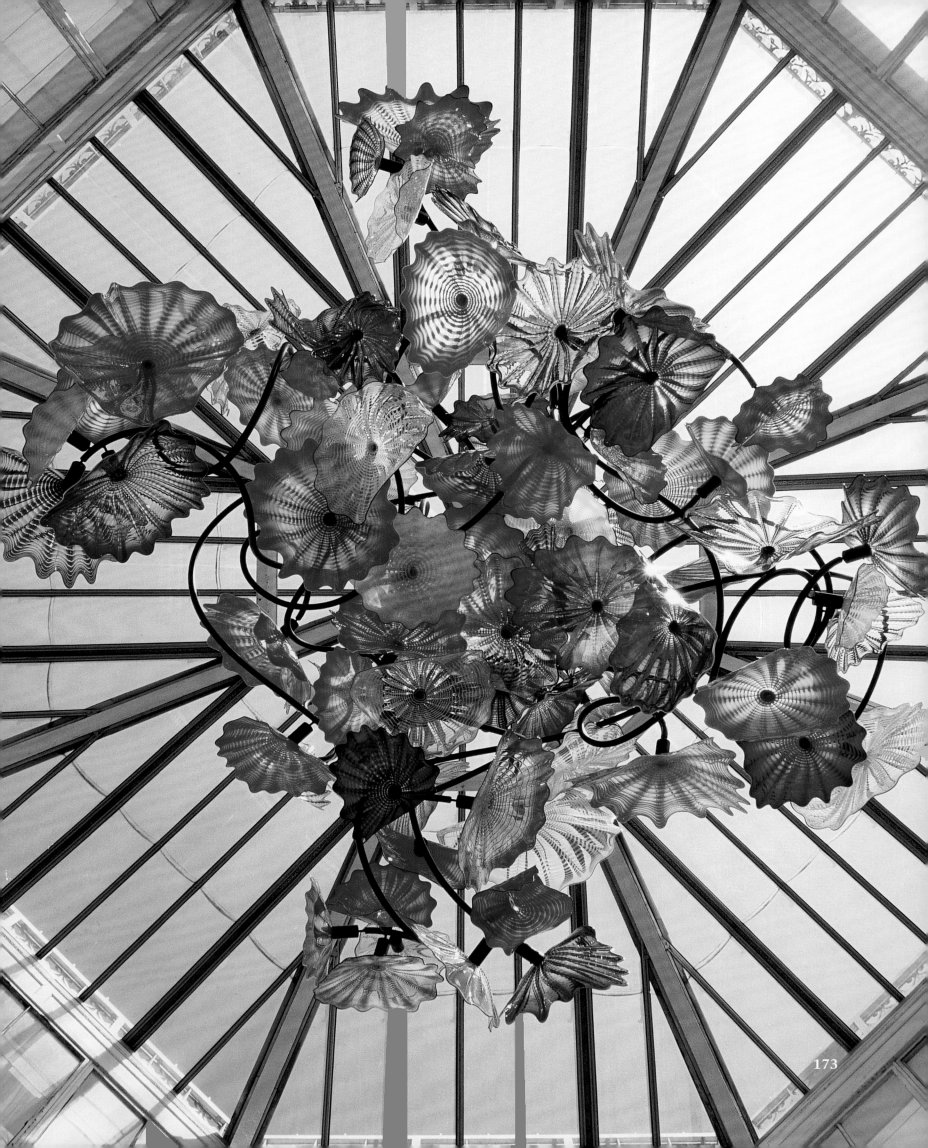

173

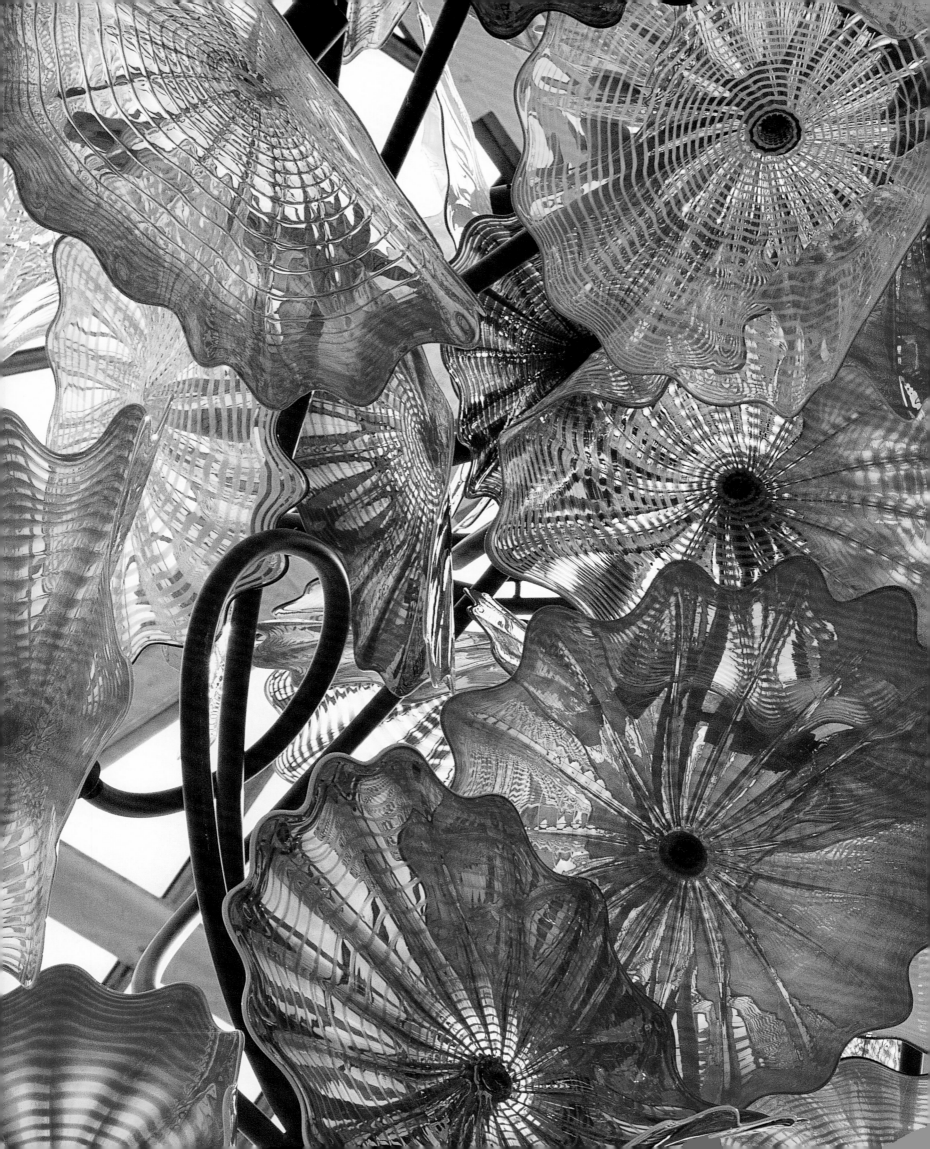

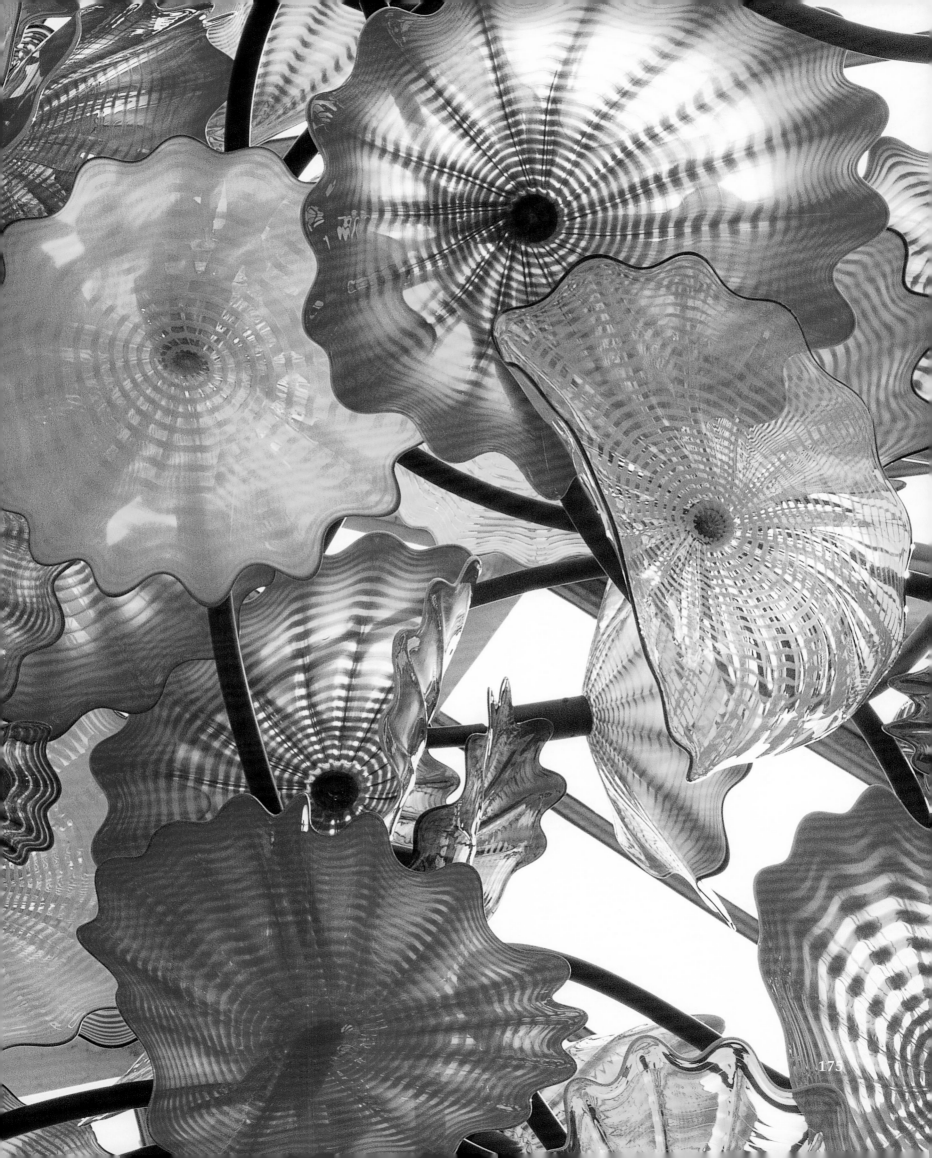

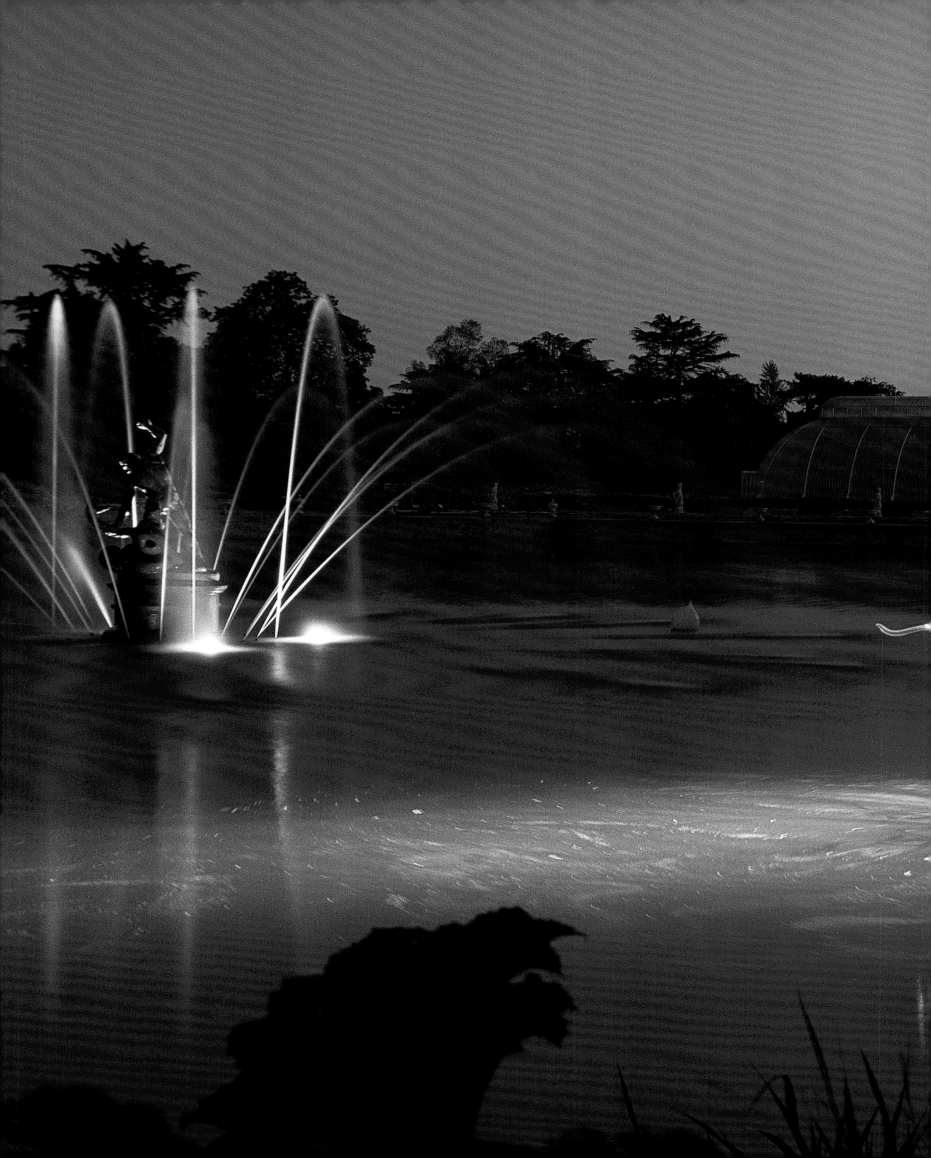

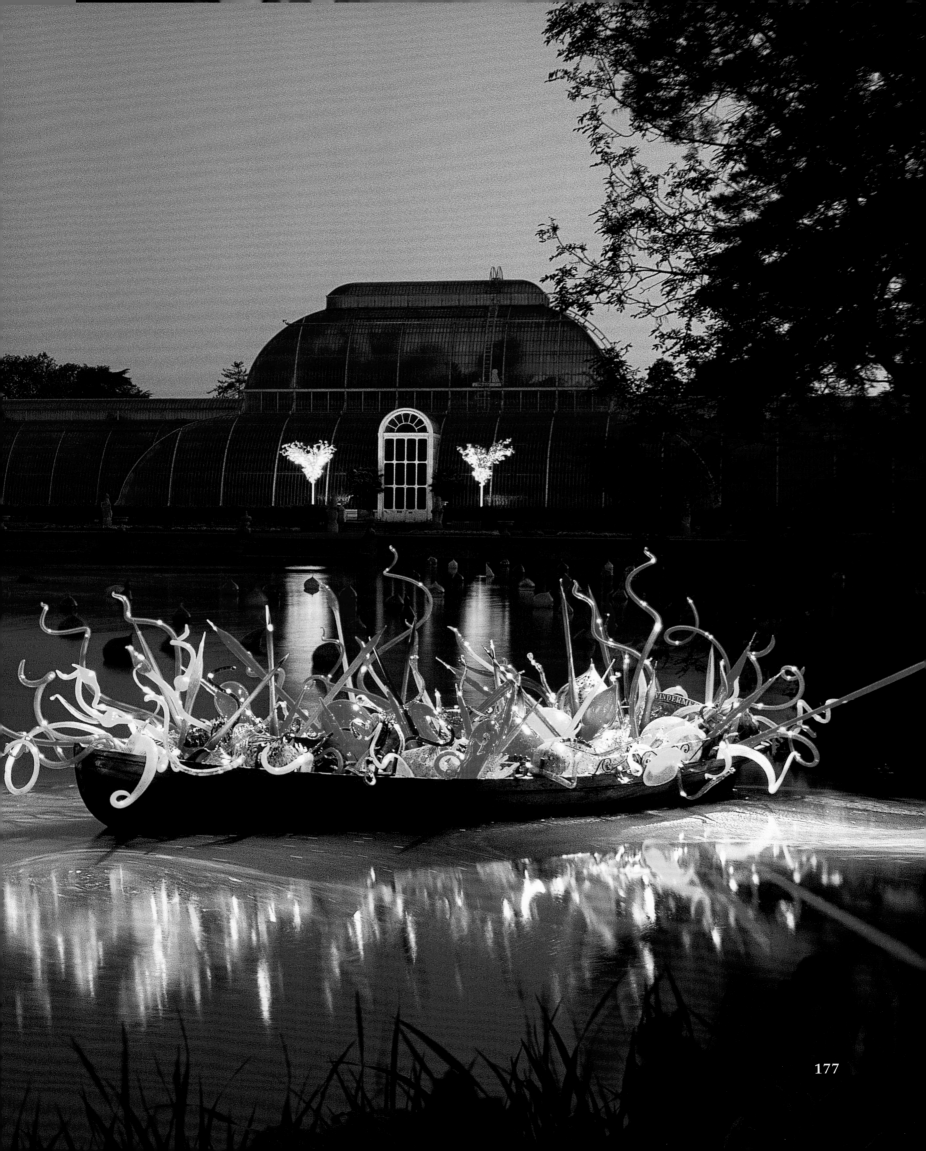

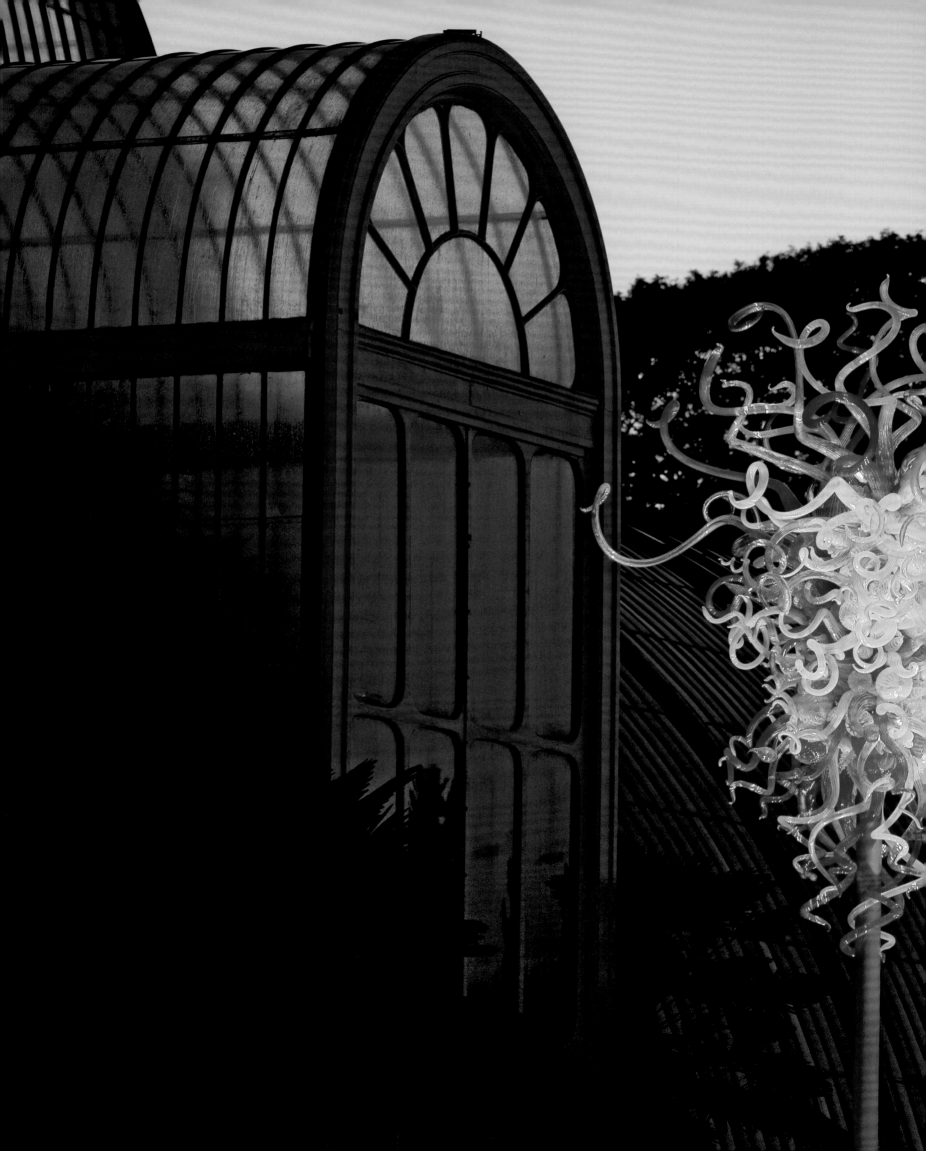

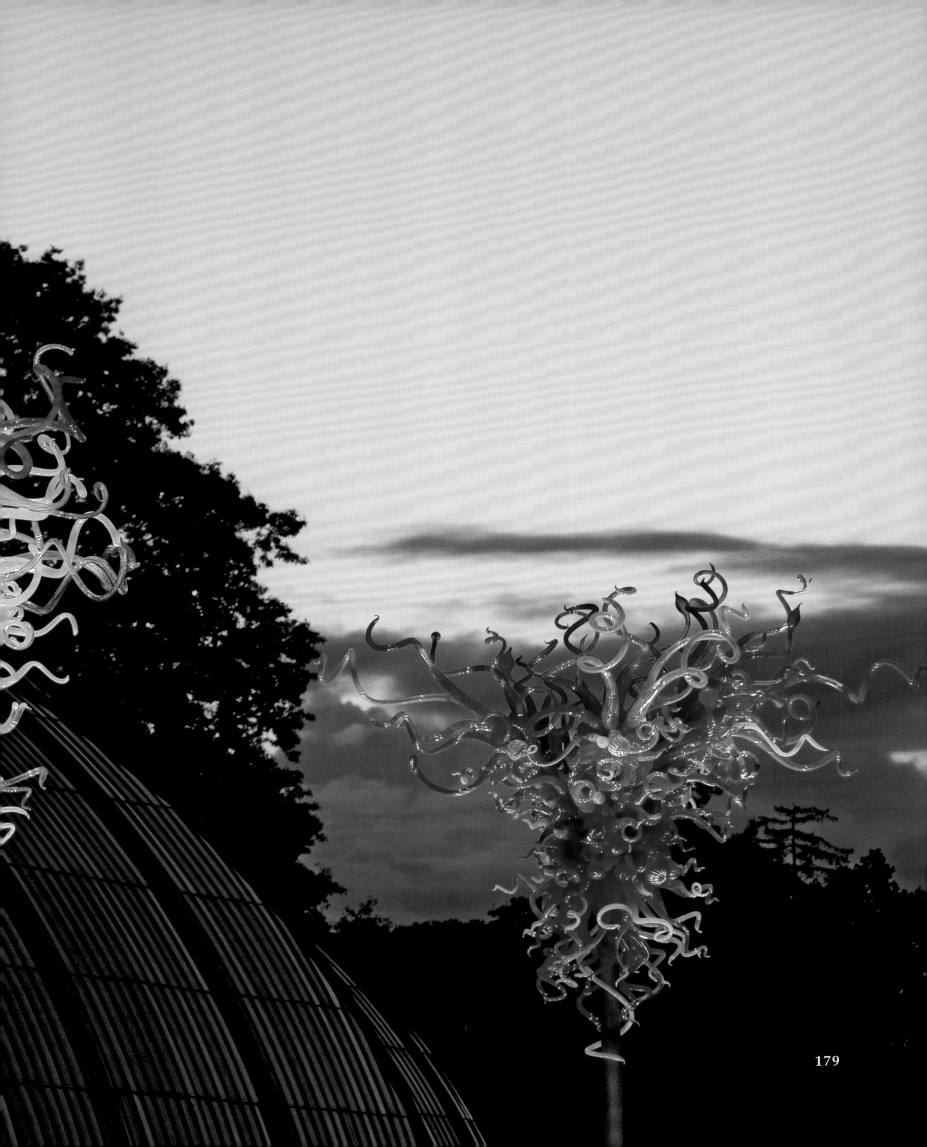

179

Fairchild Tropical Botanic Garden
Coral Gables, Florida

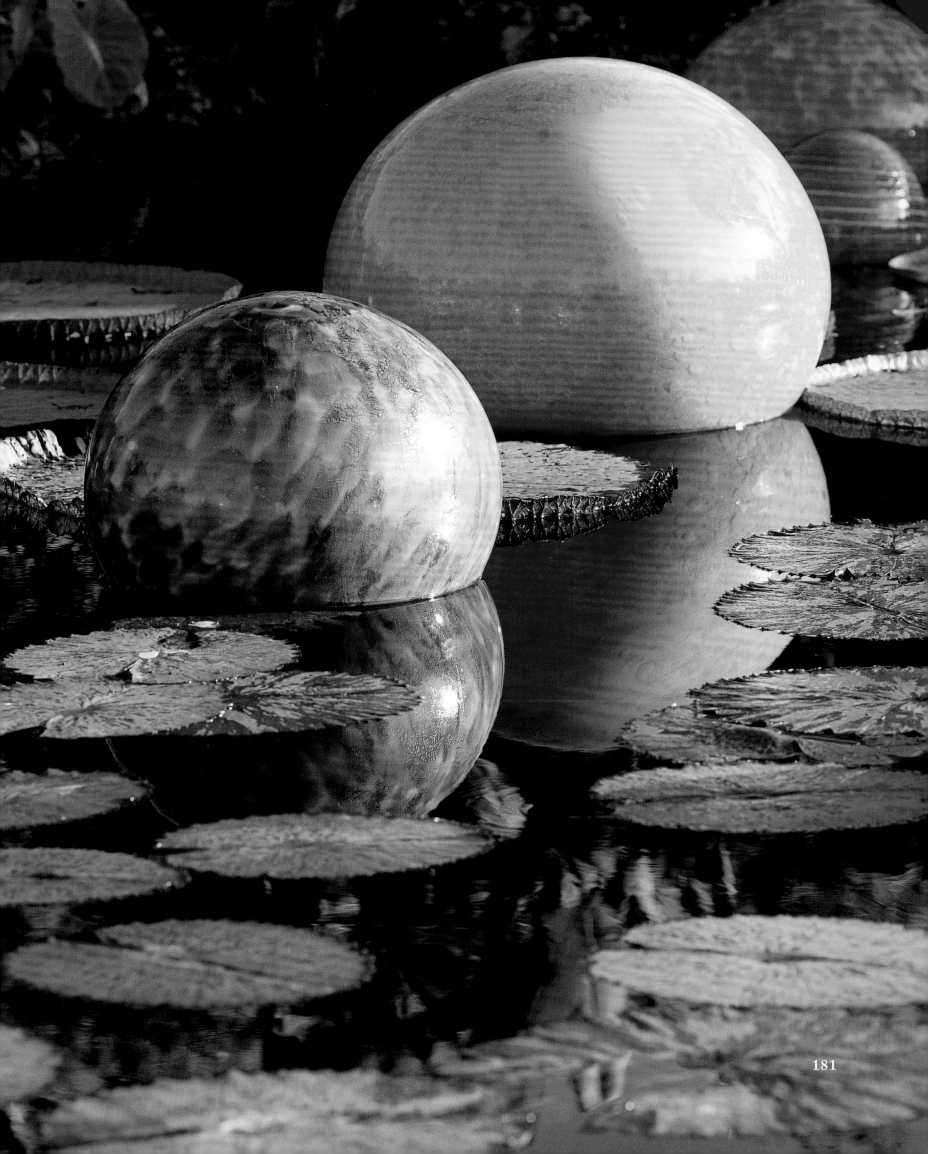

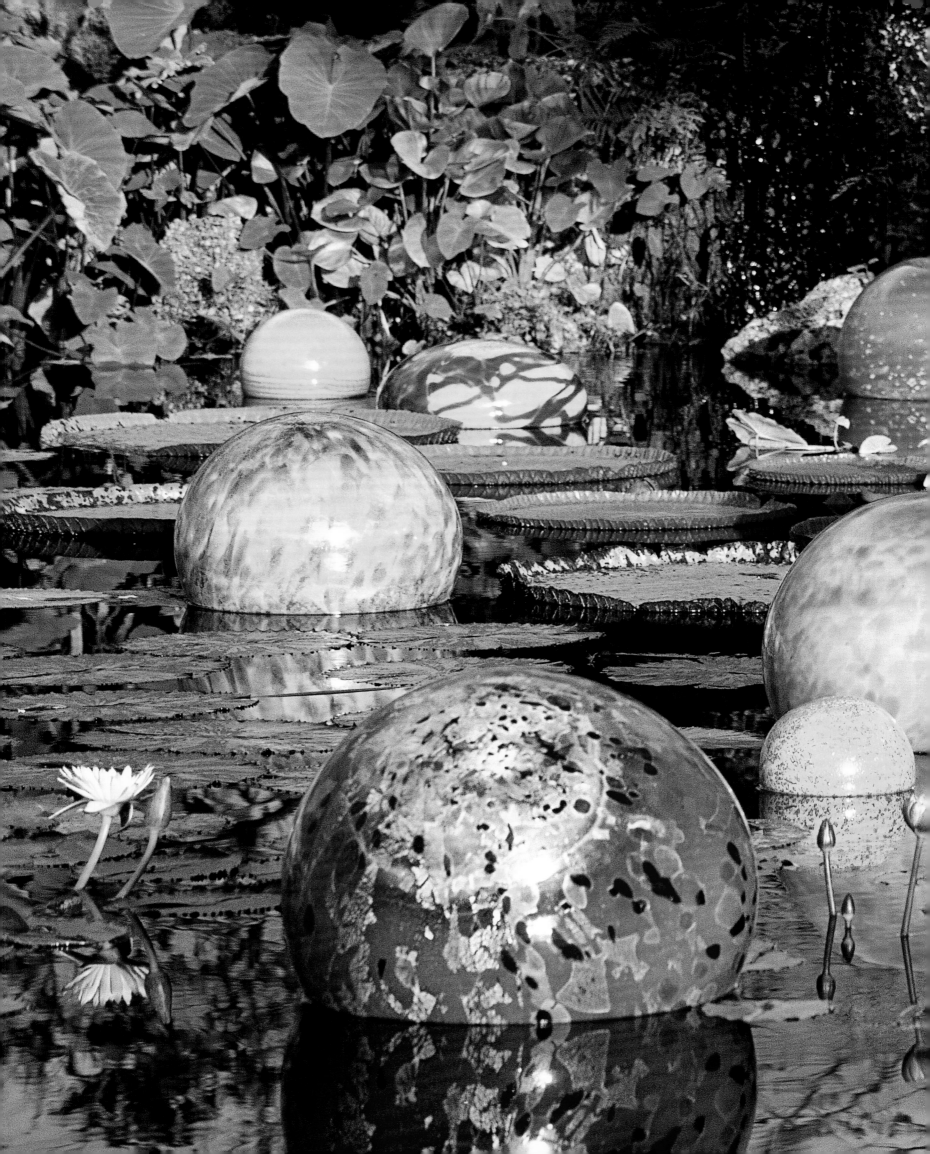

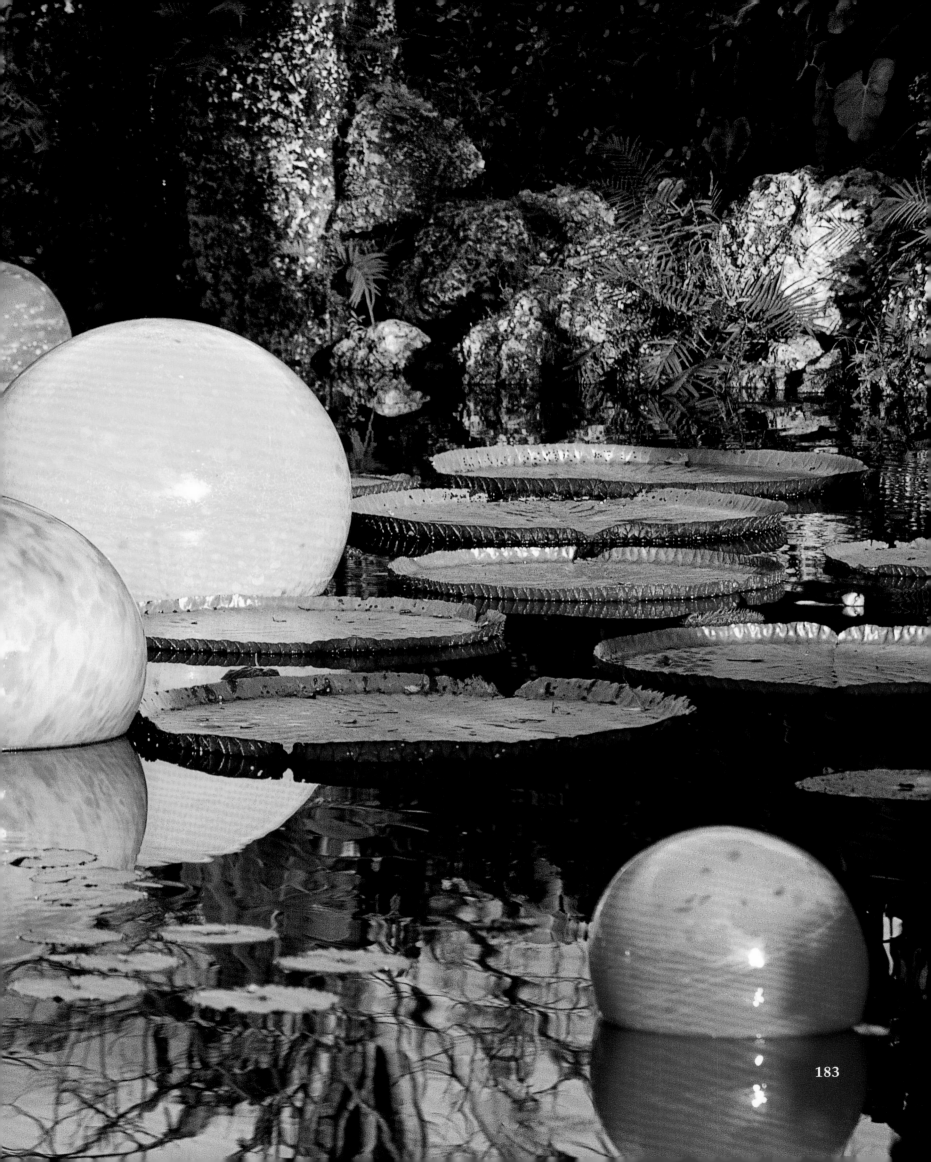

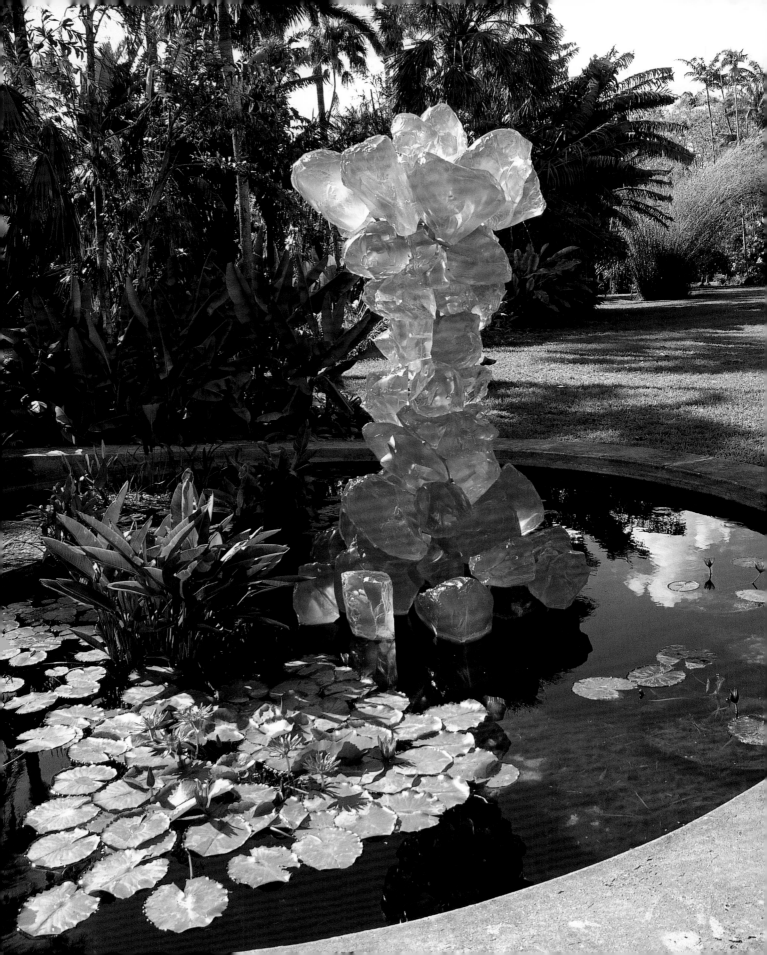

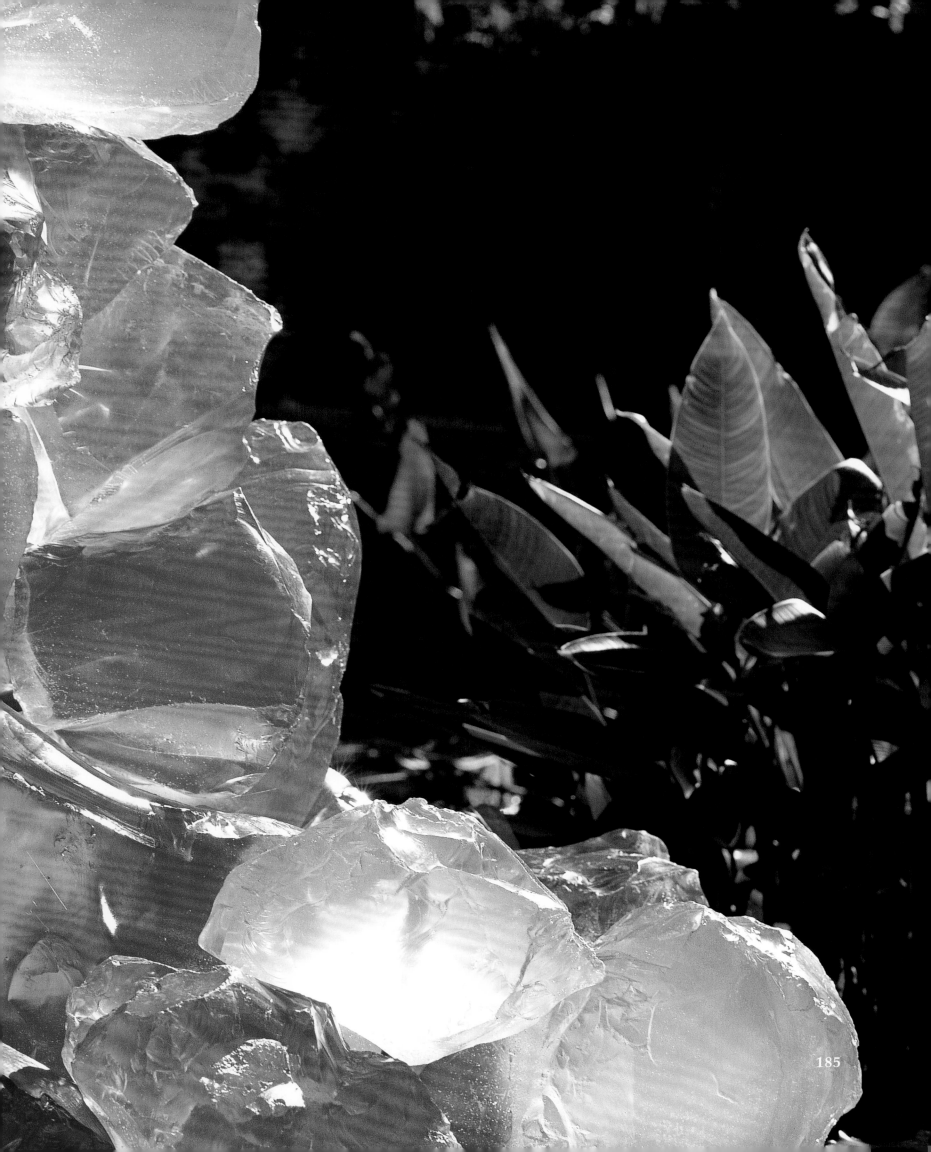

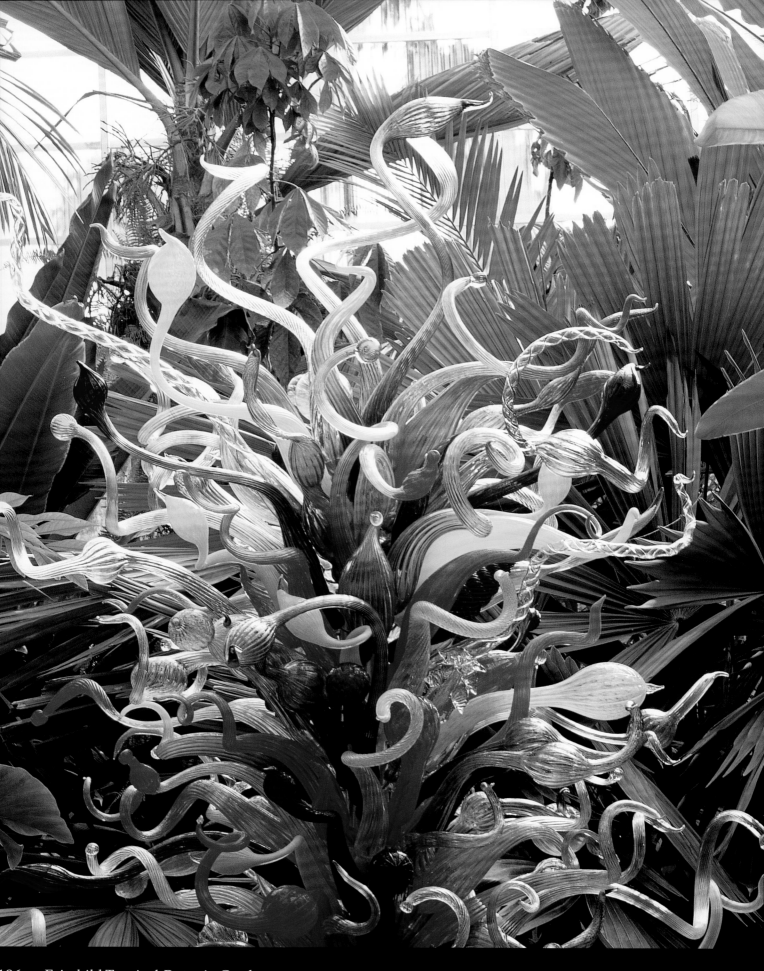

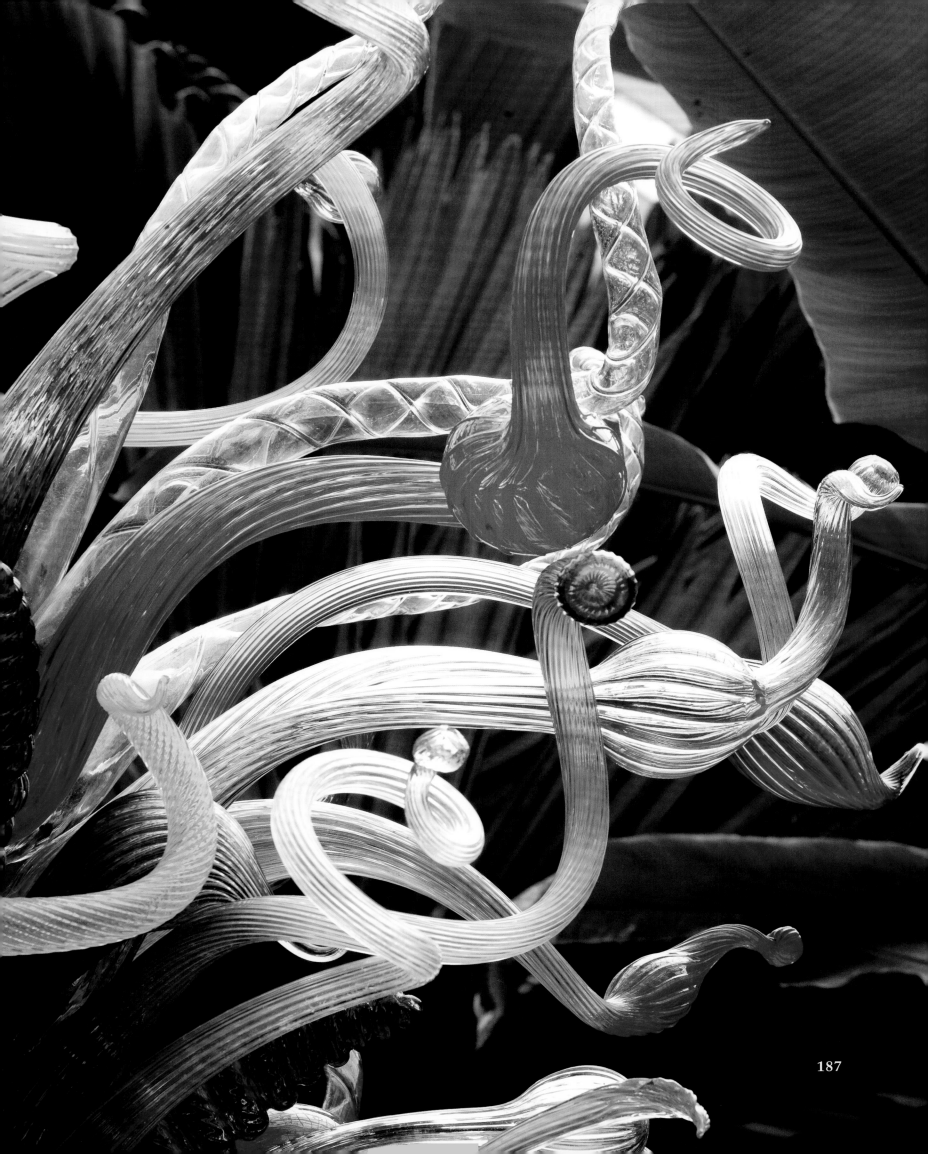

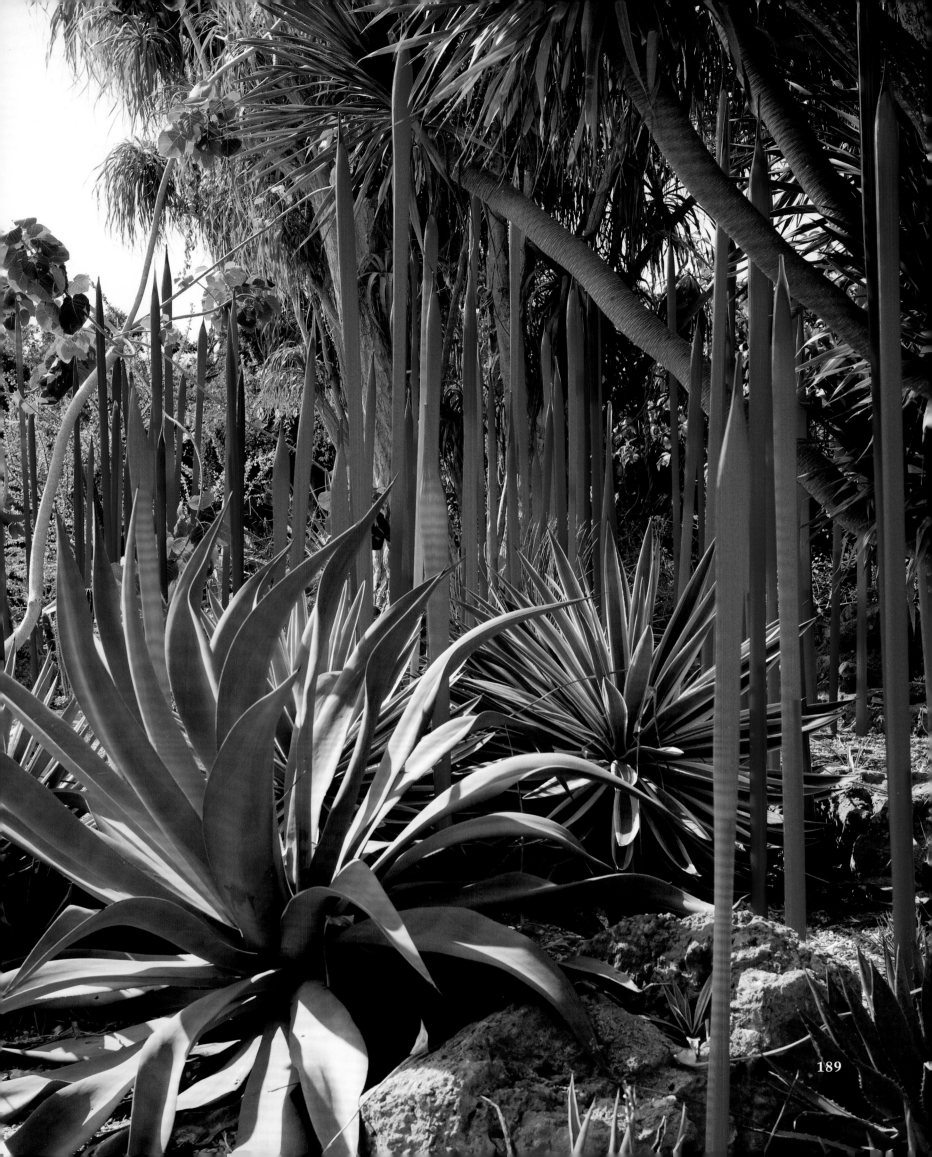

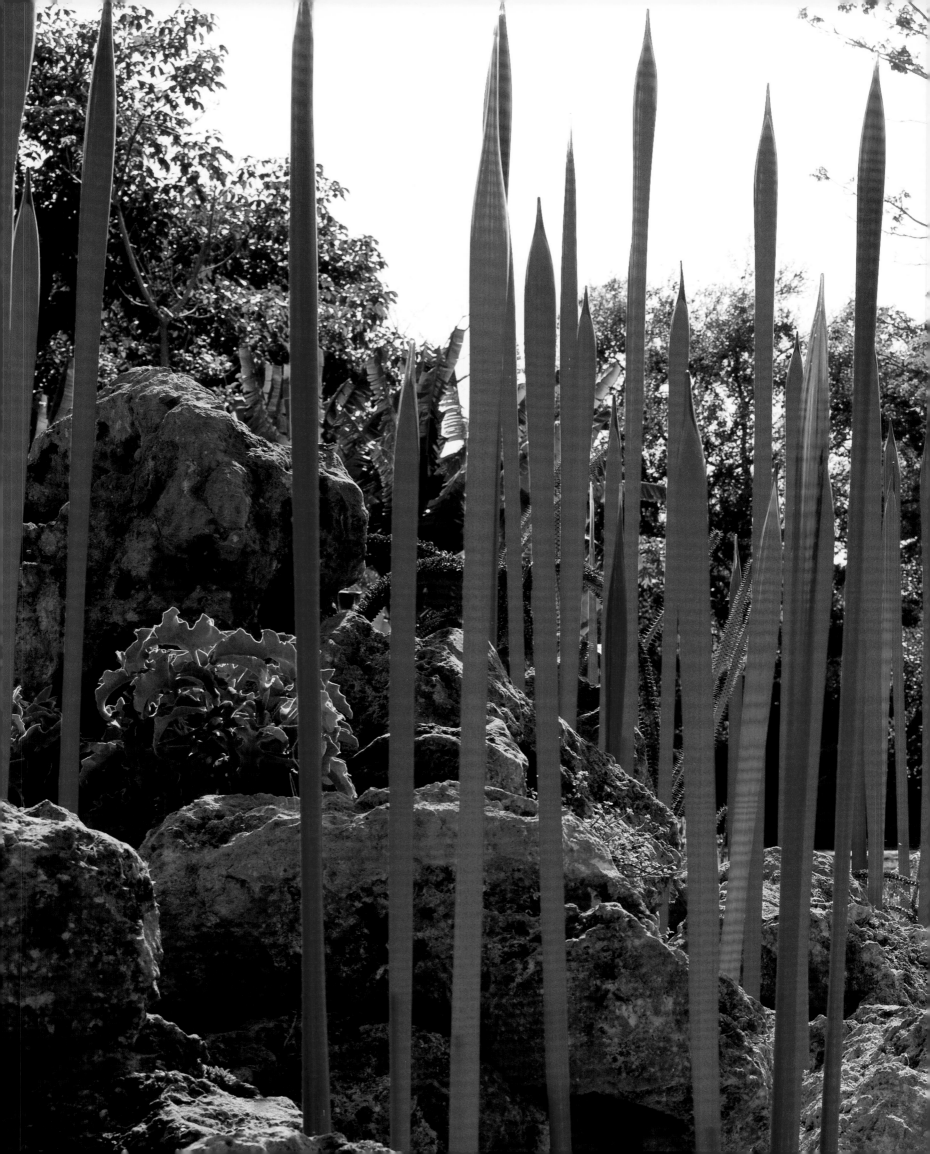

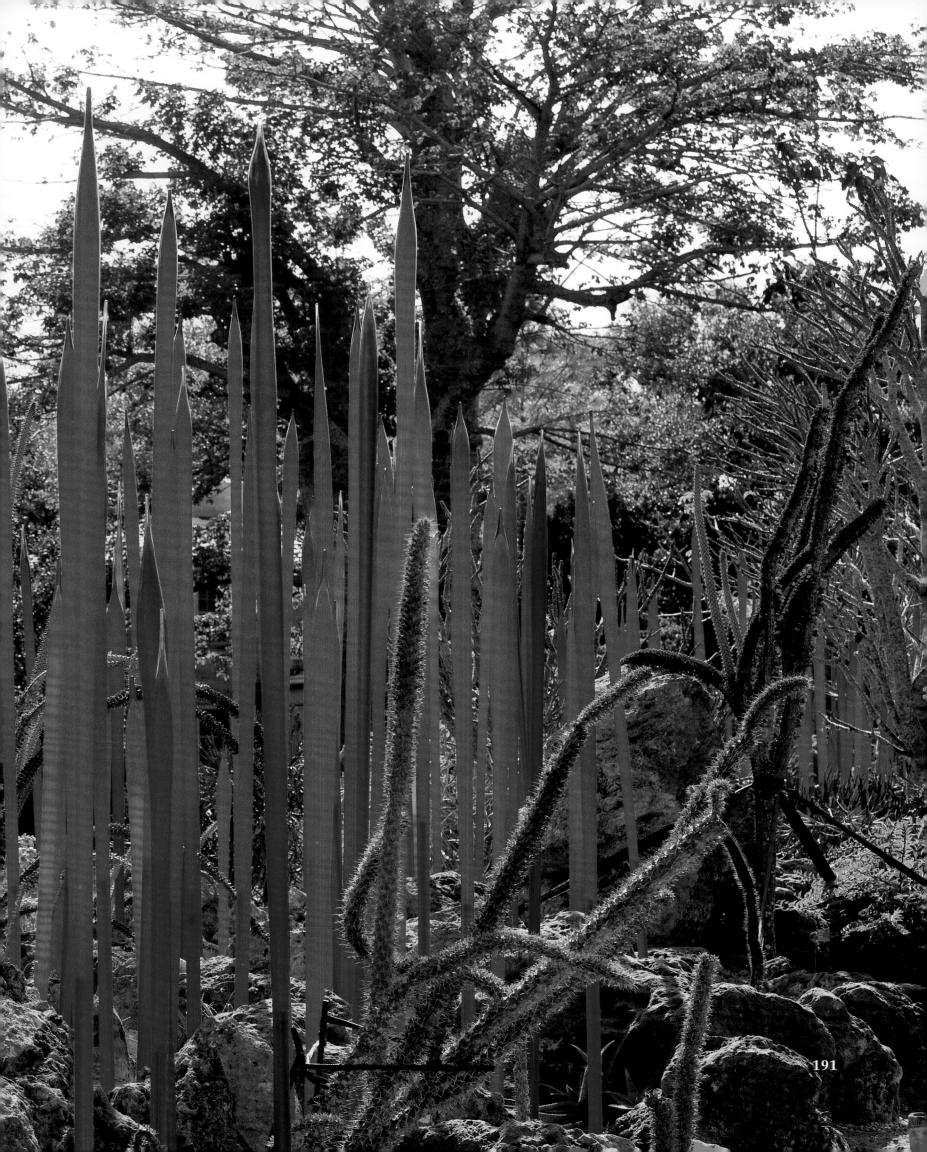

191

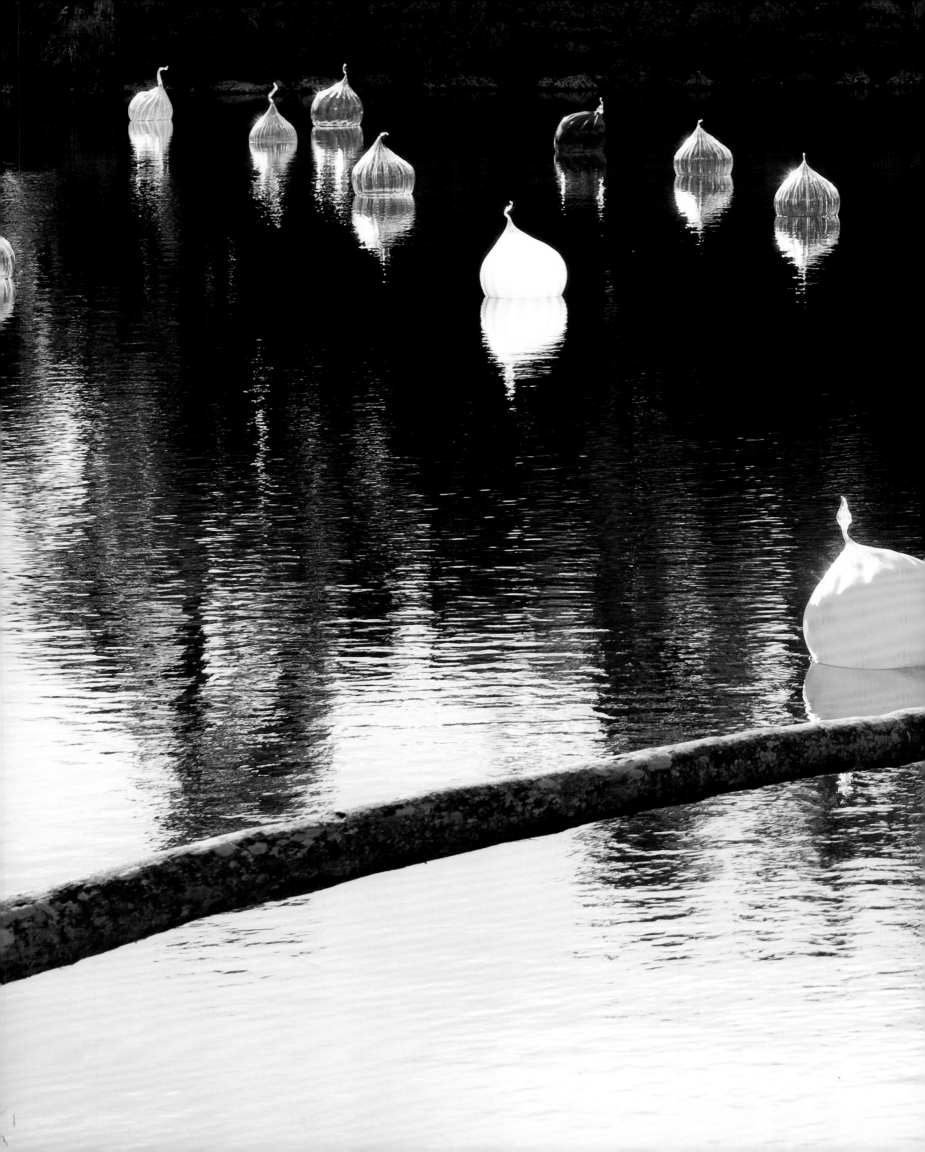

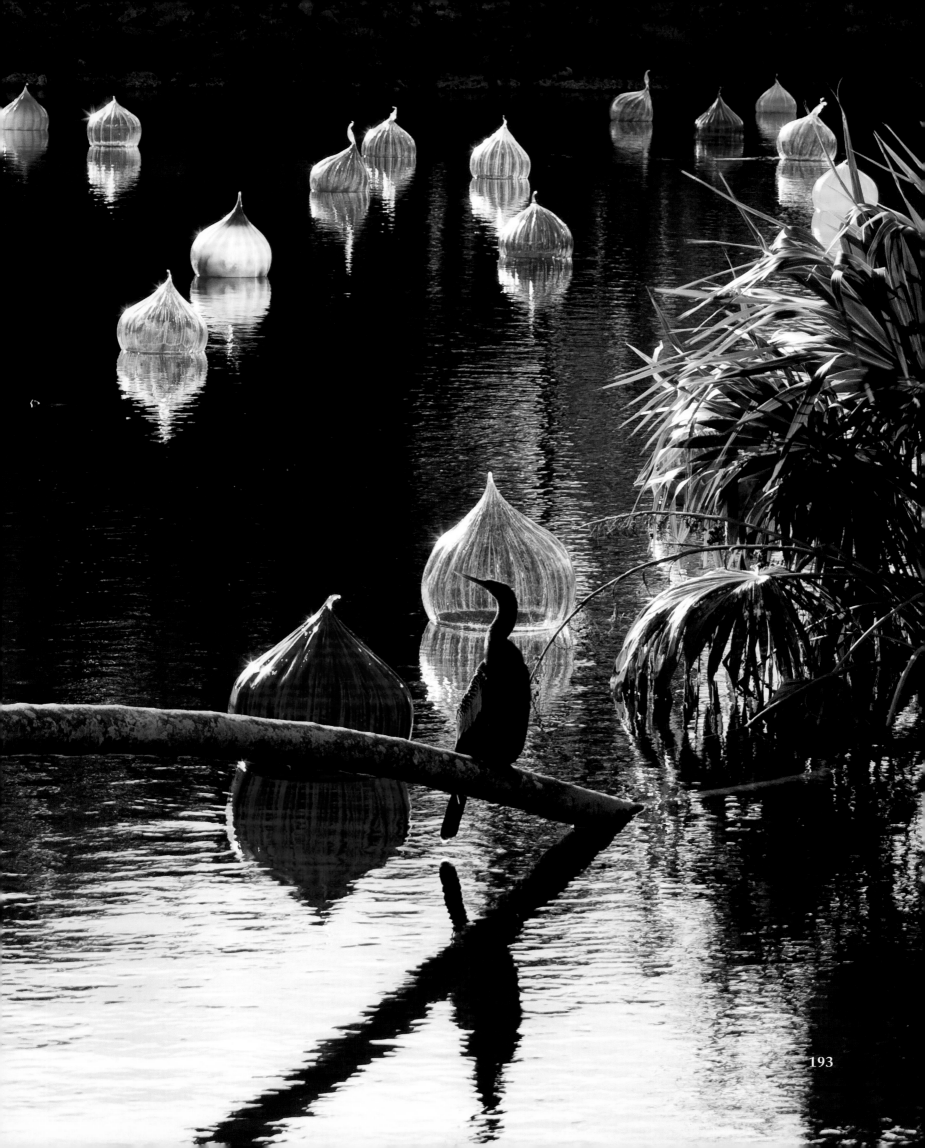

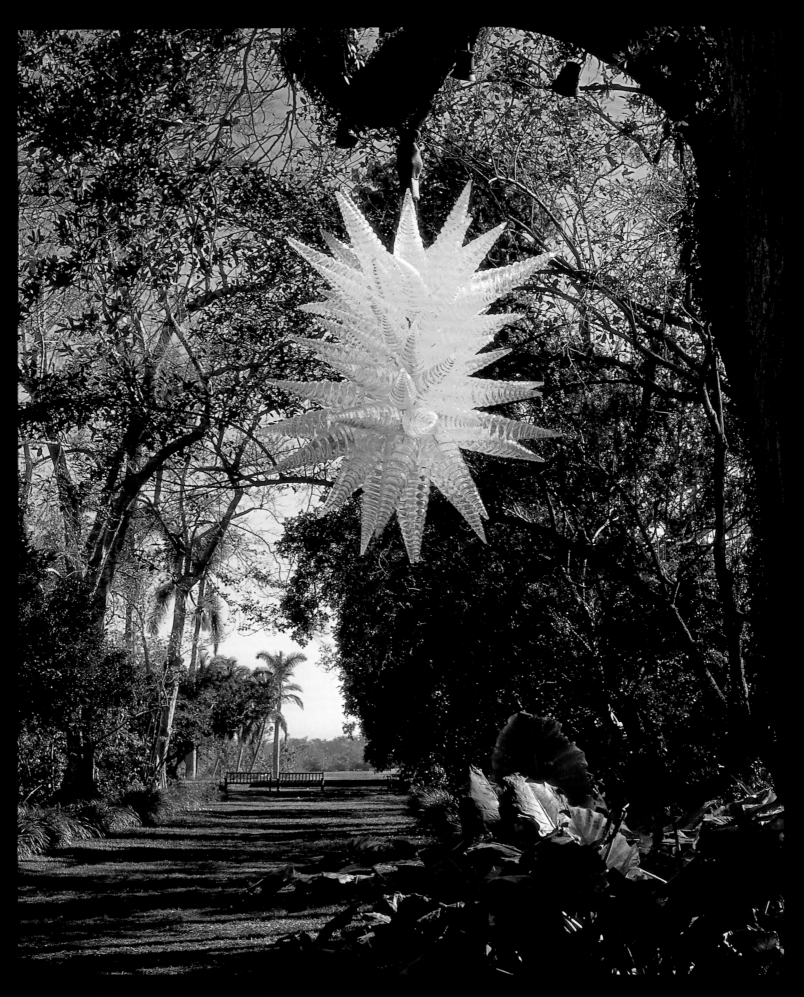

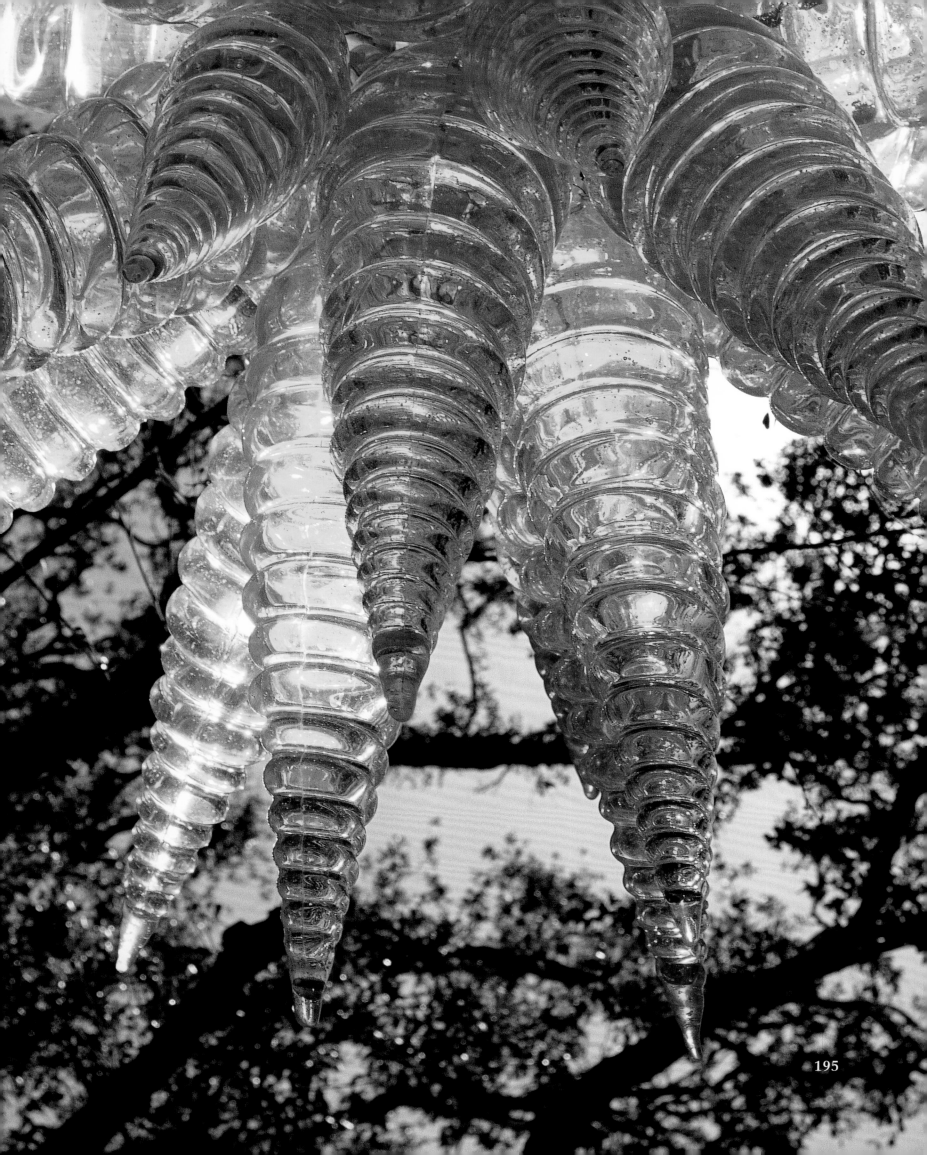

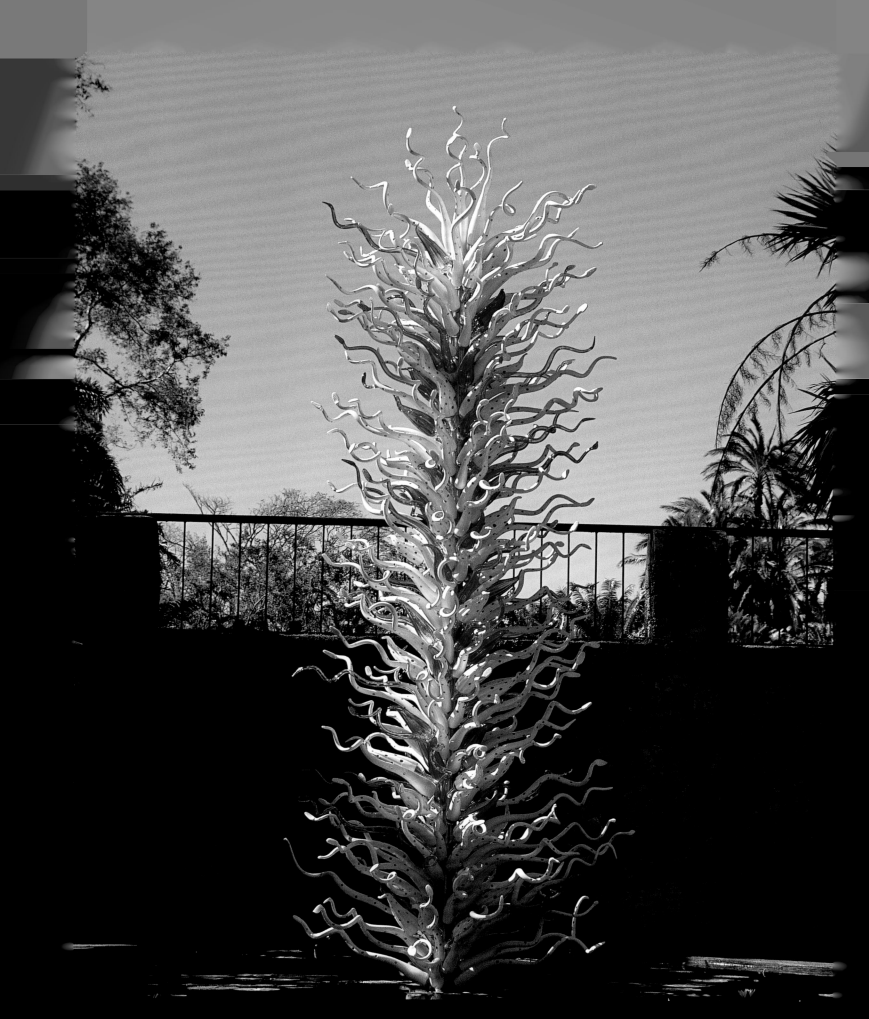

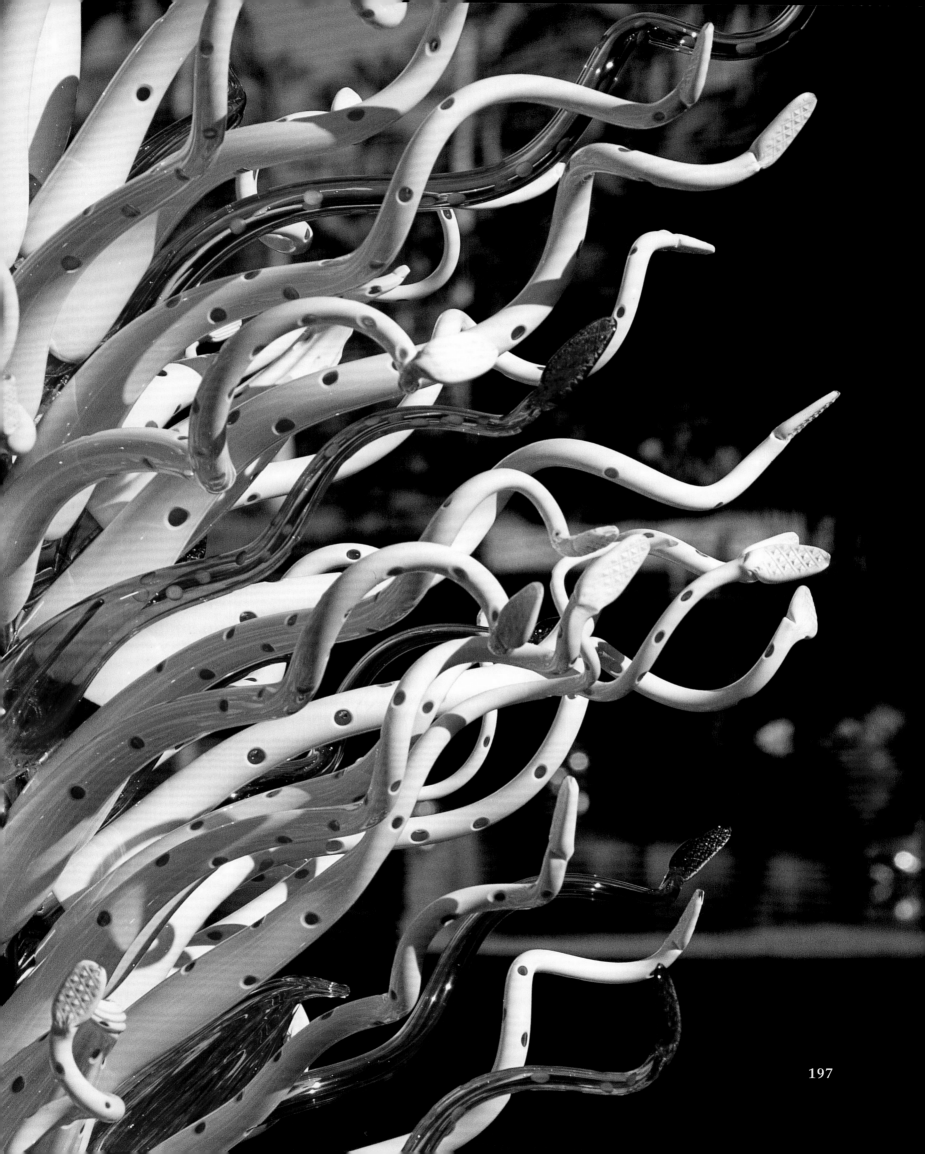

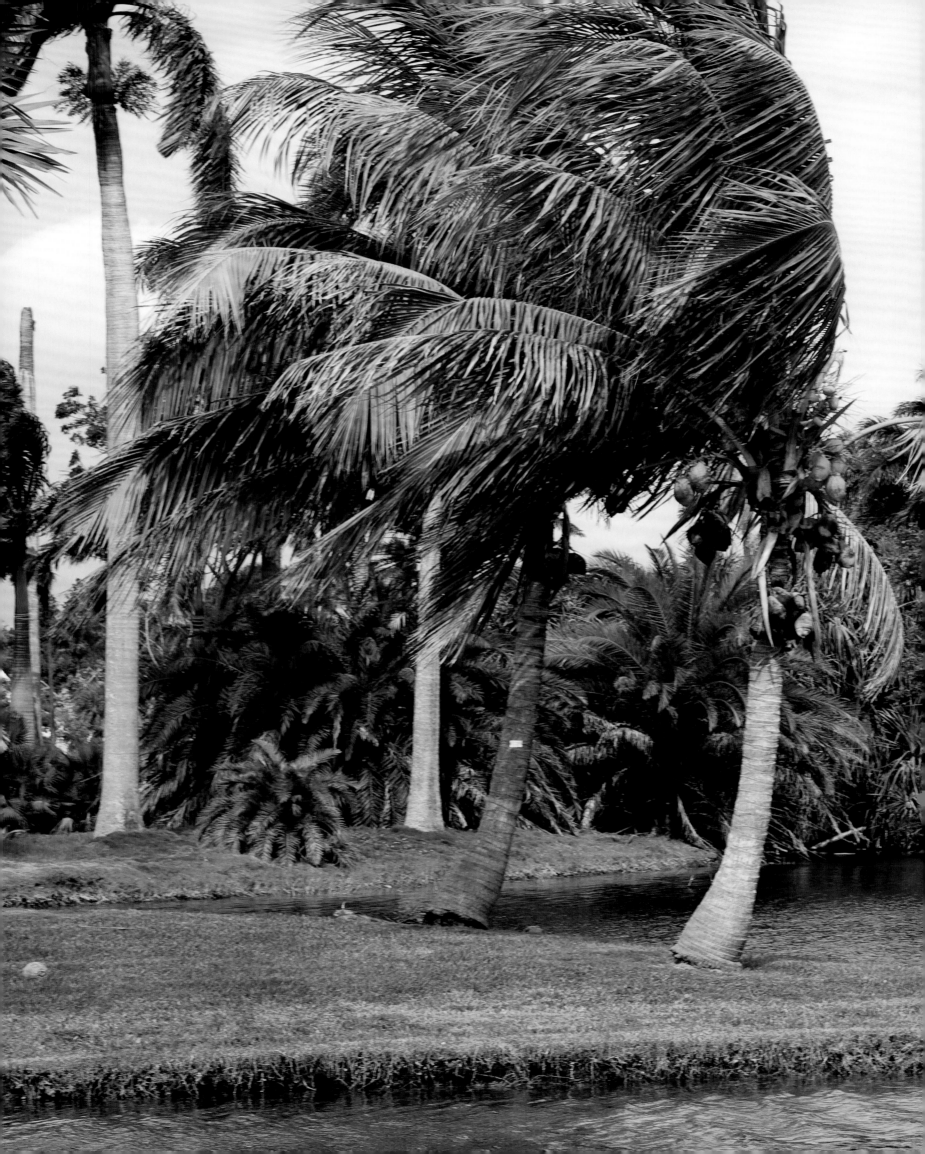

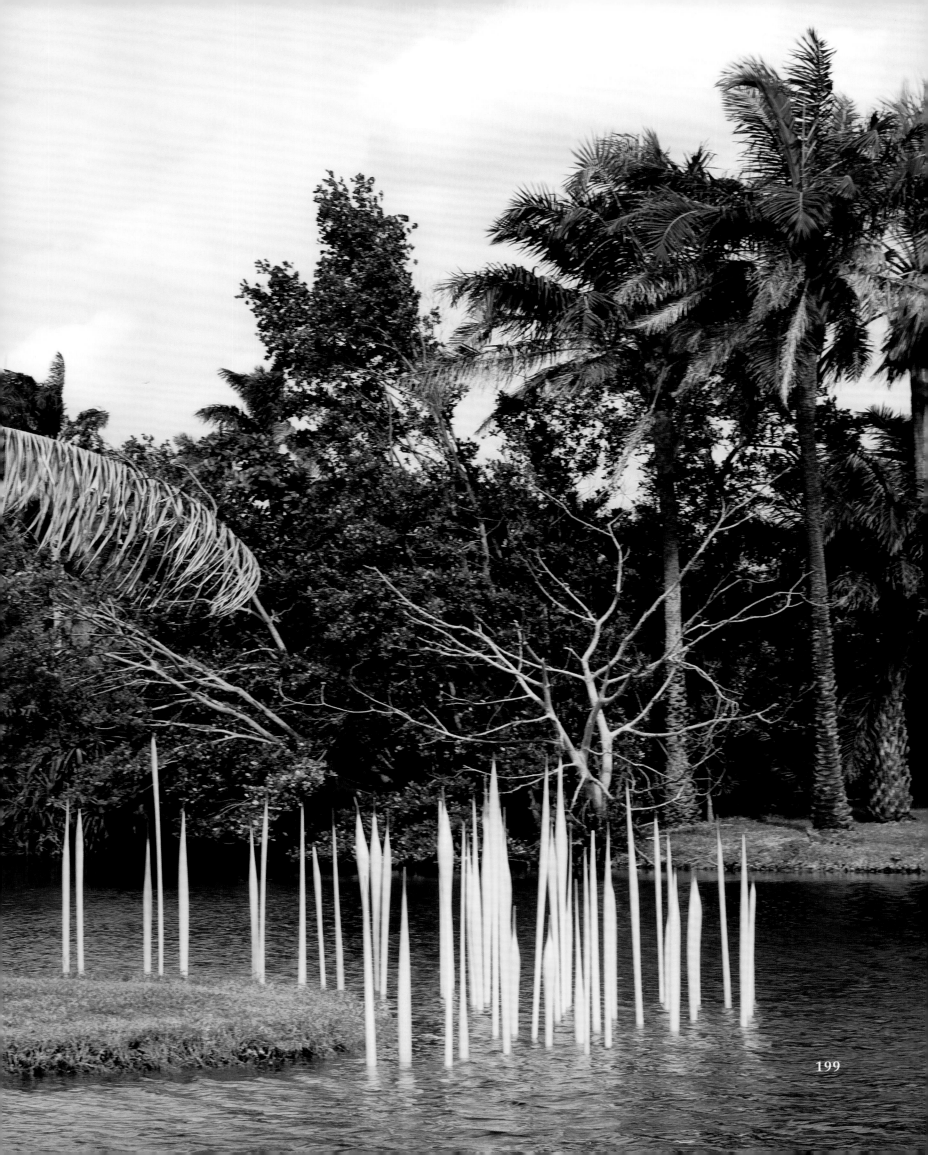

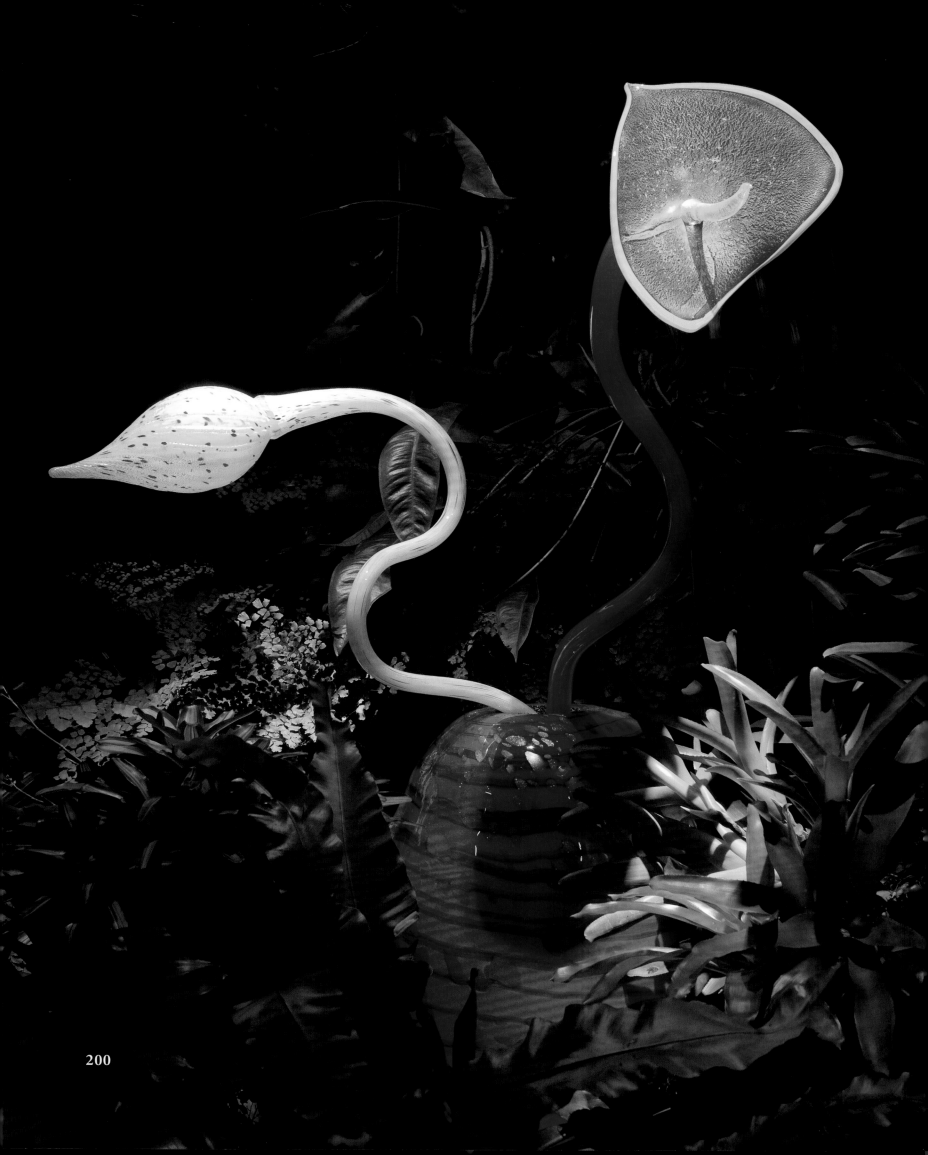

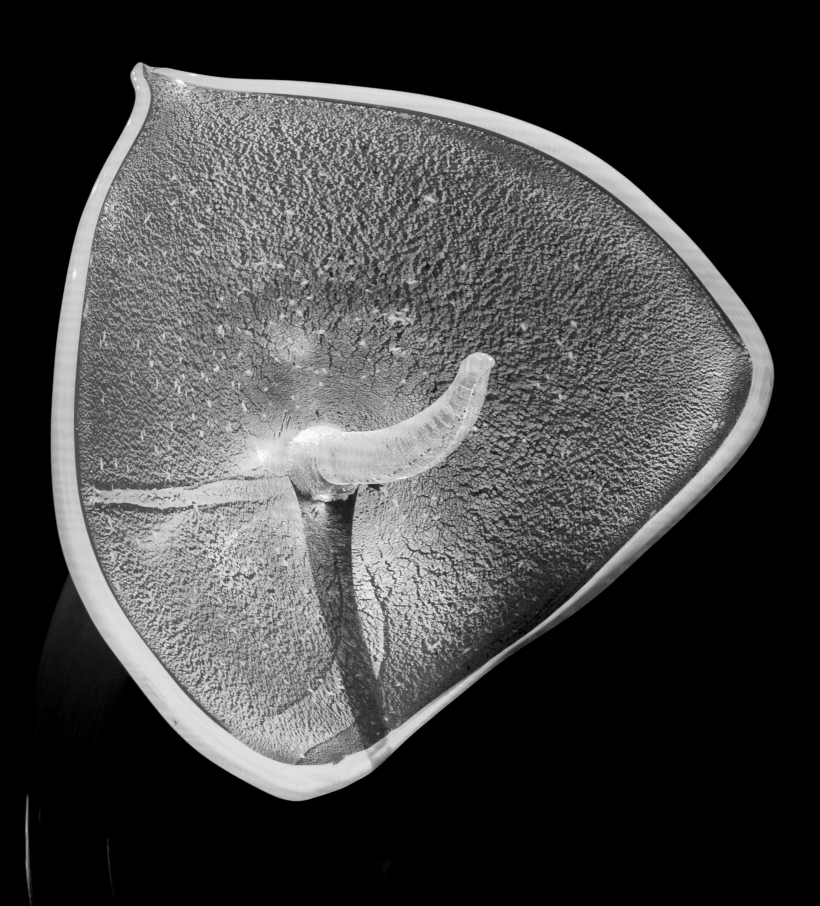

201

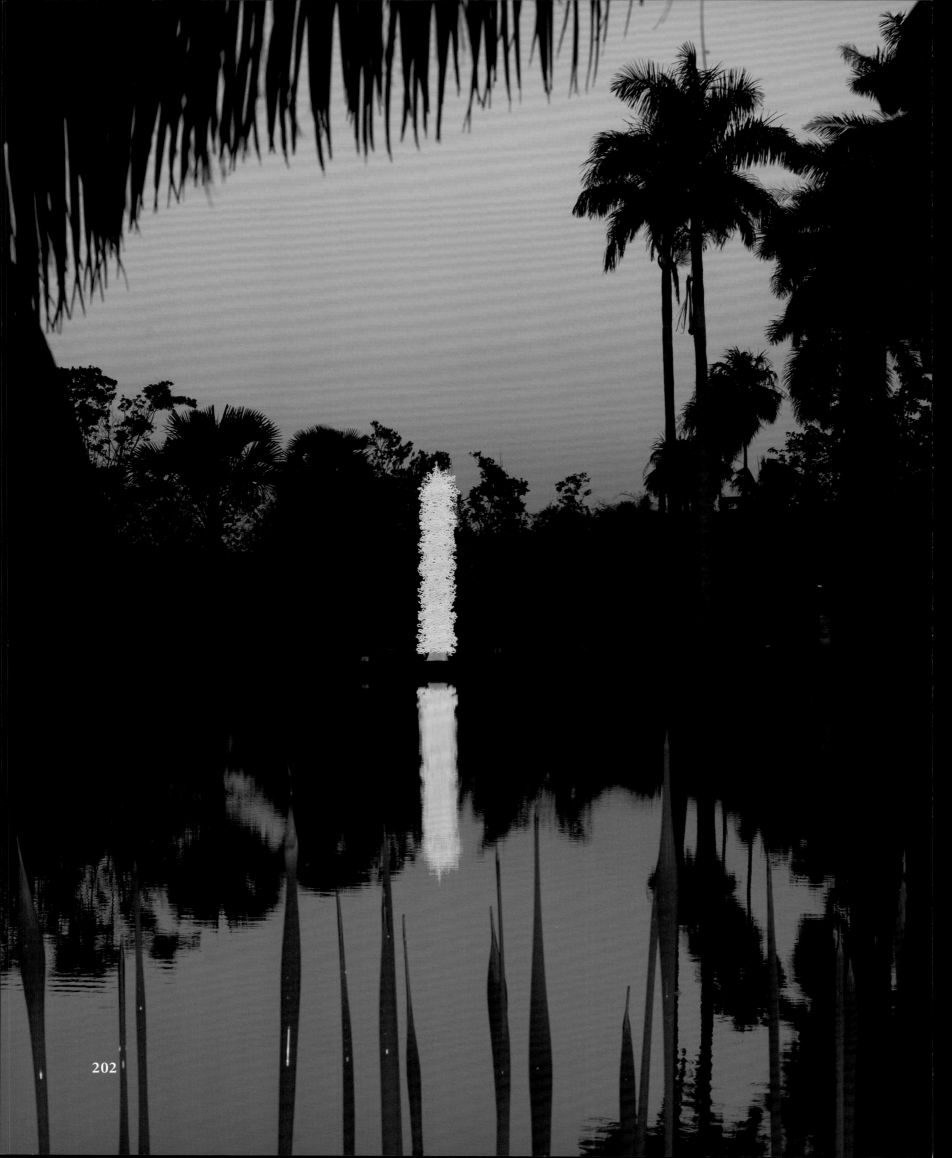

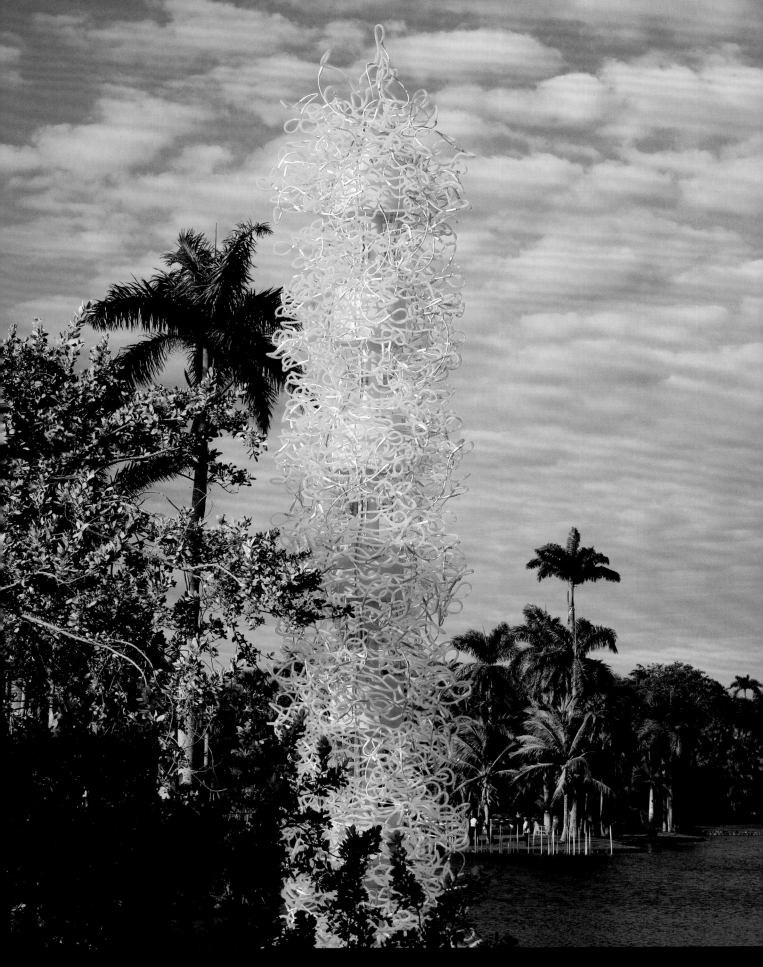

Missouri Botanical Garden
St. Louis, Missouri

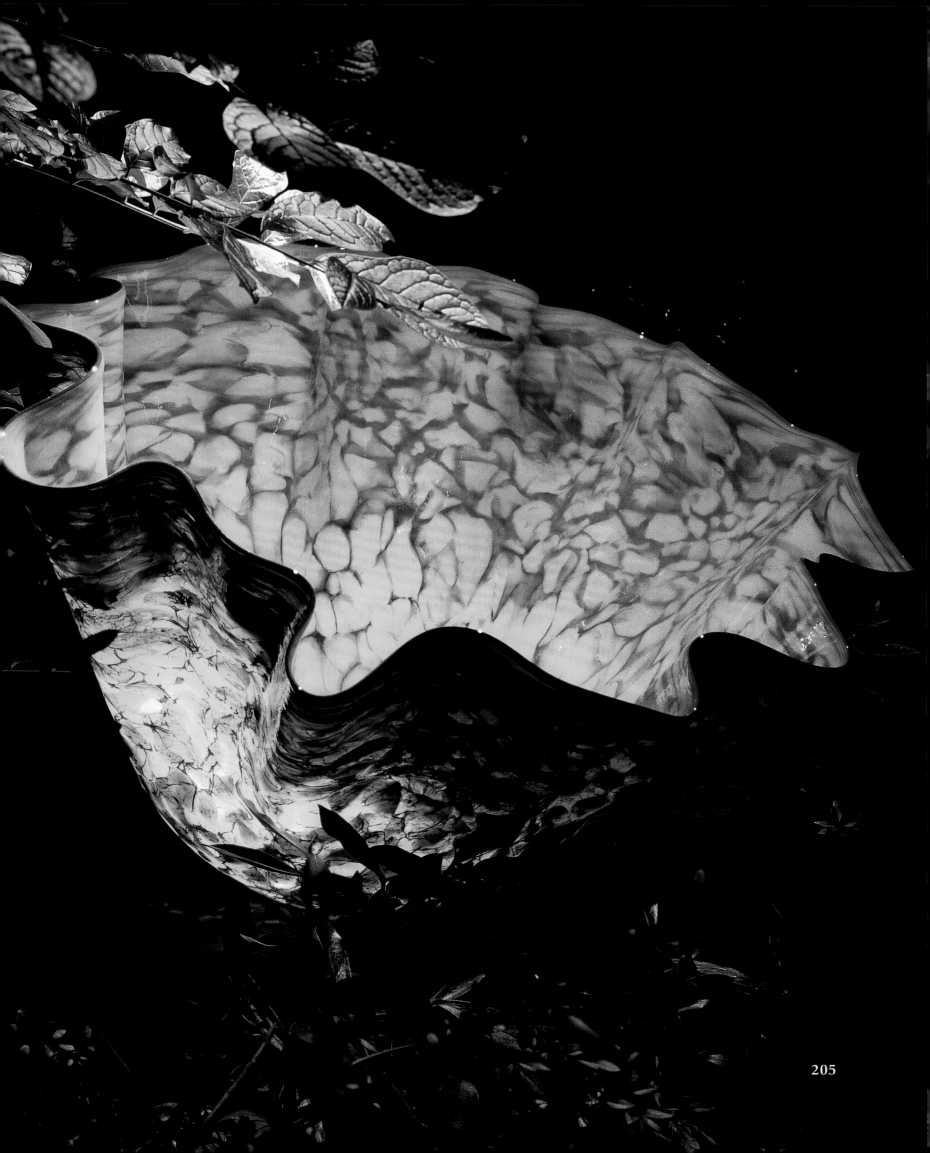

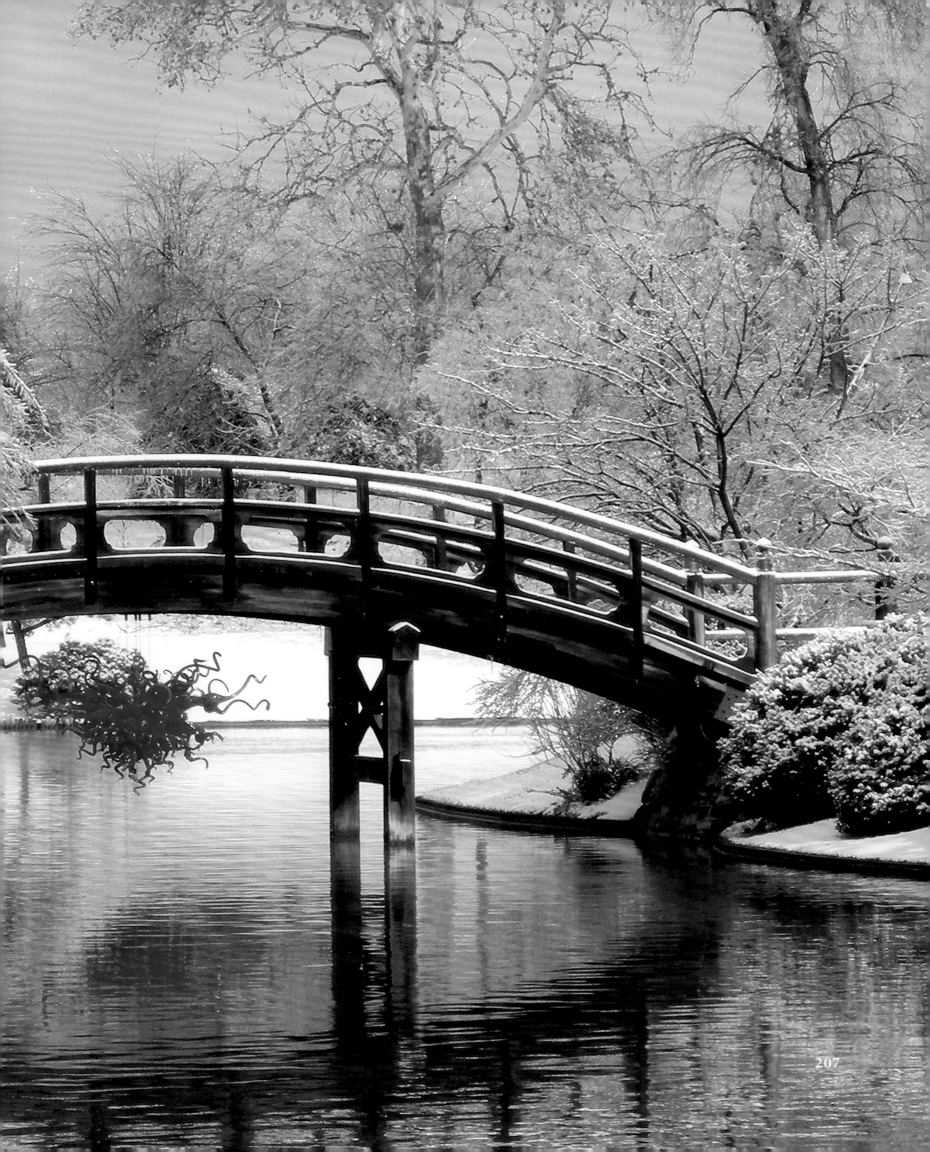

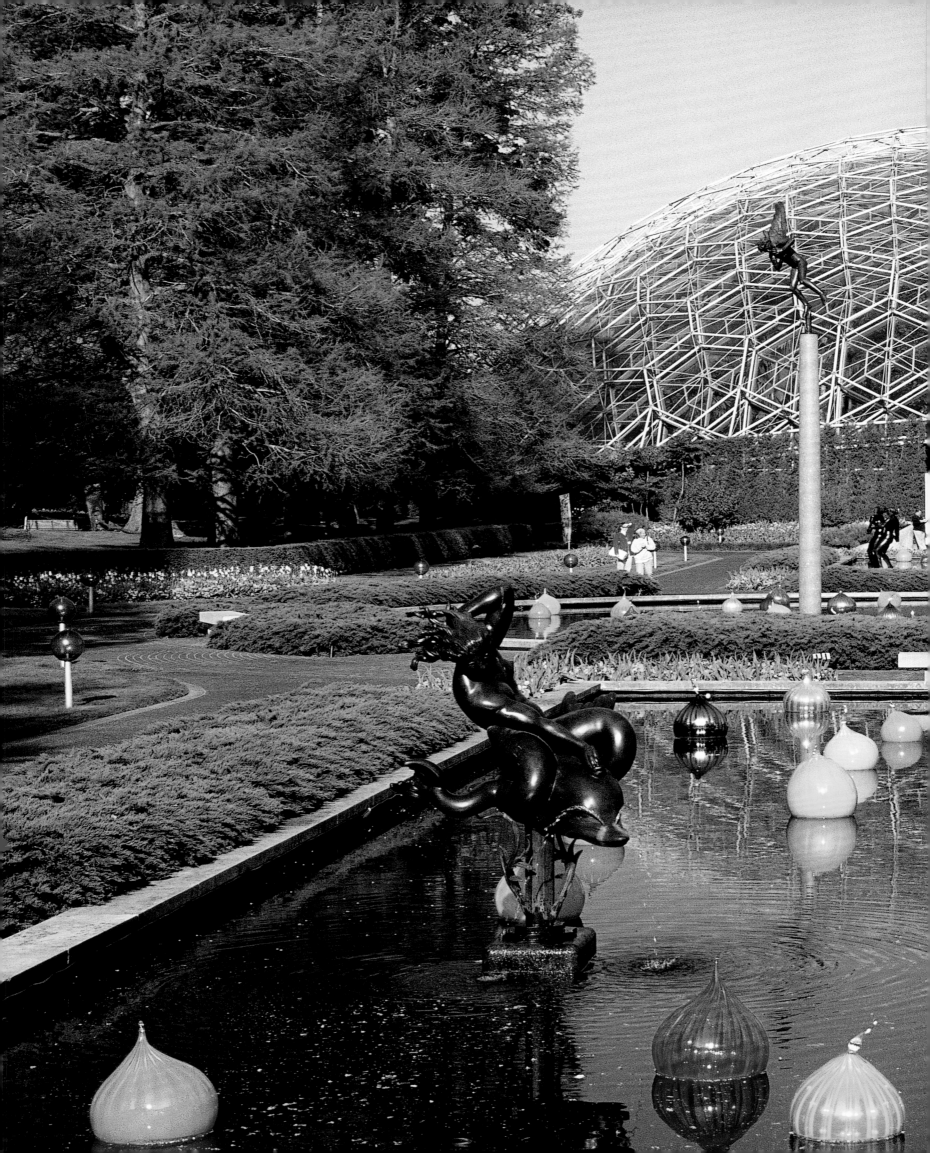

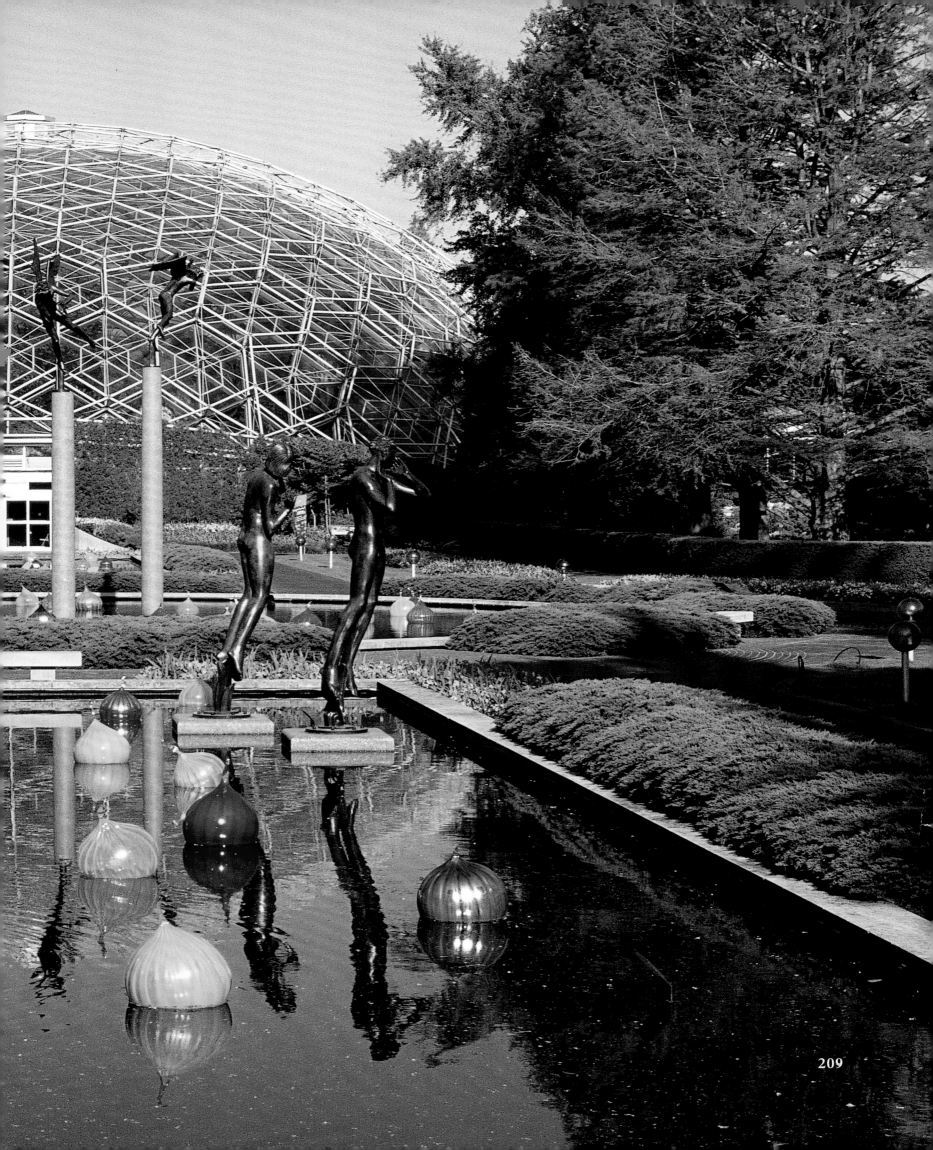

209

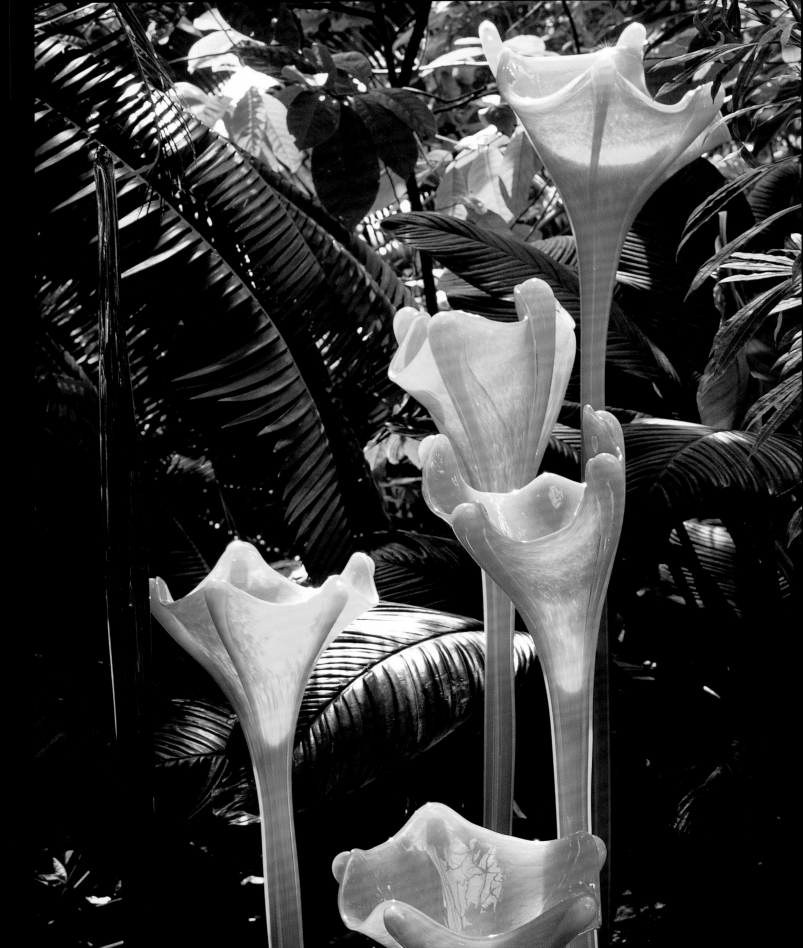

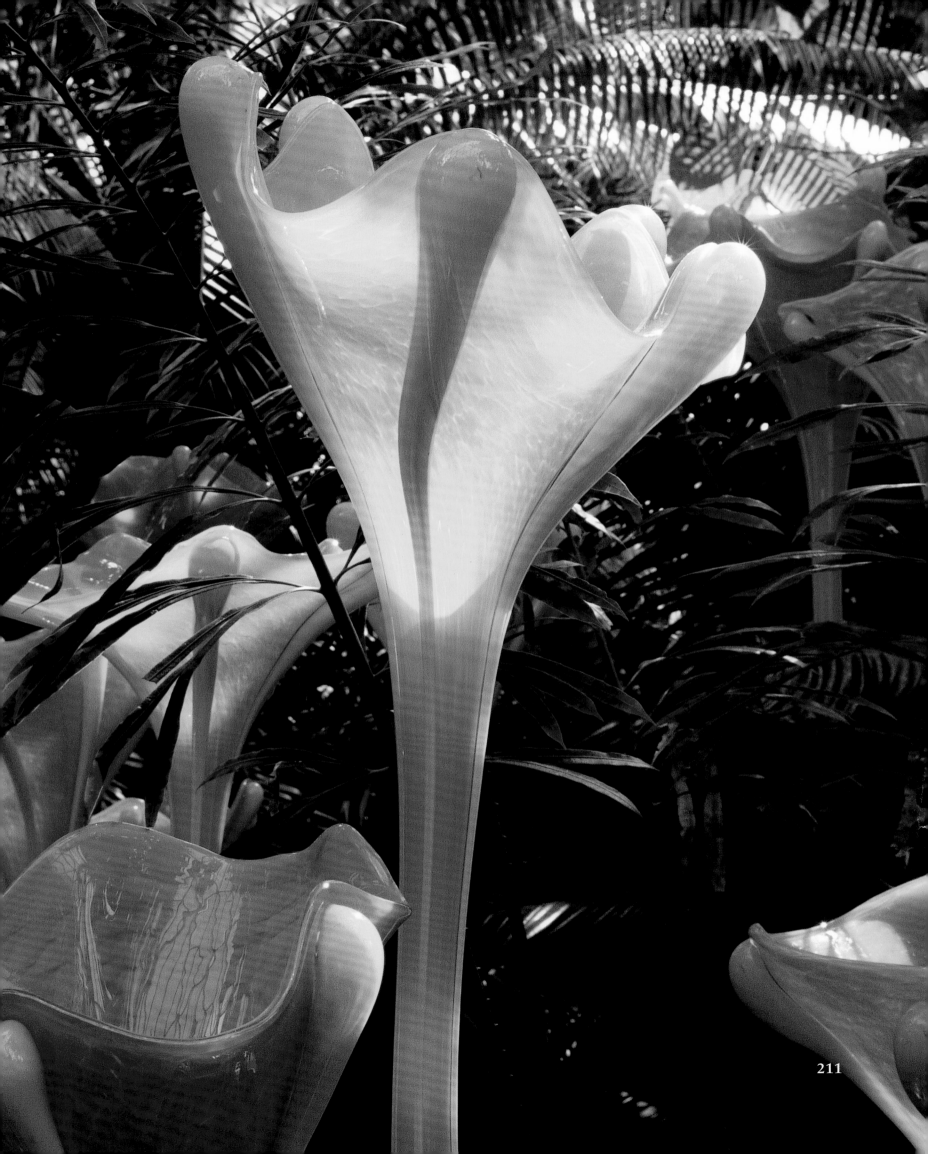

211

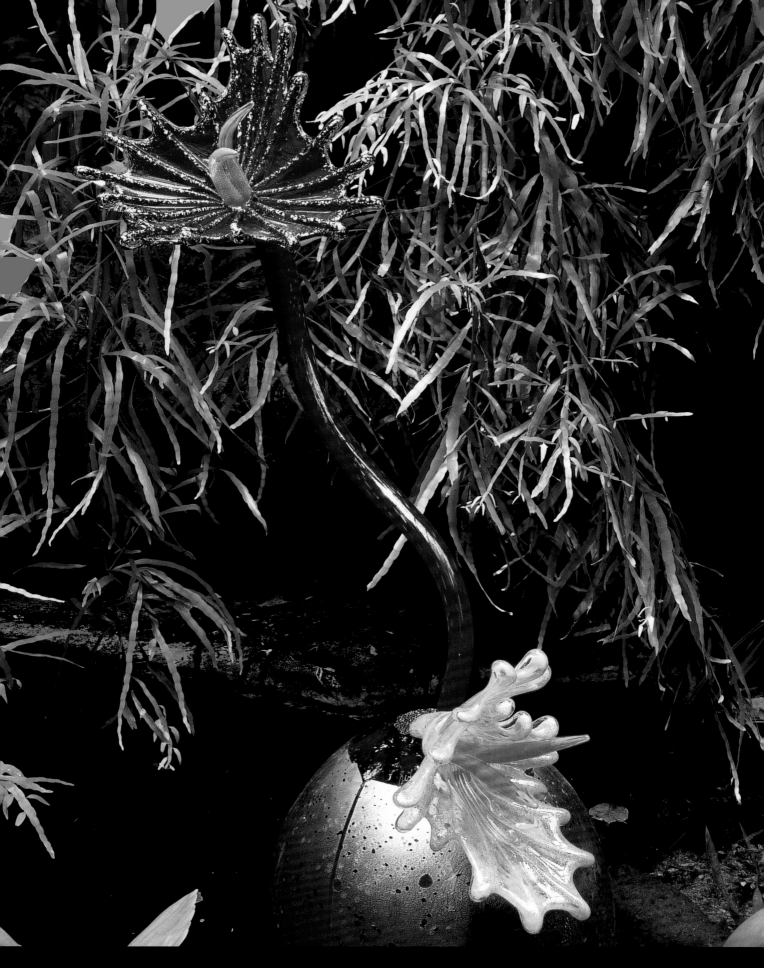

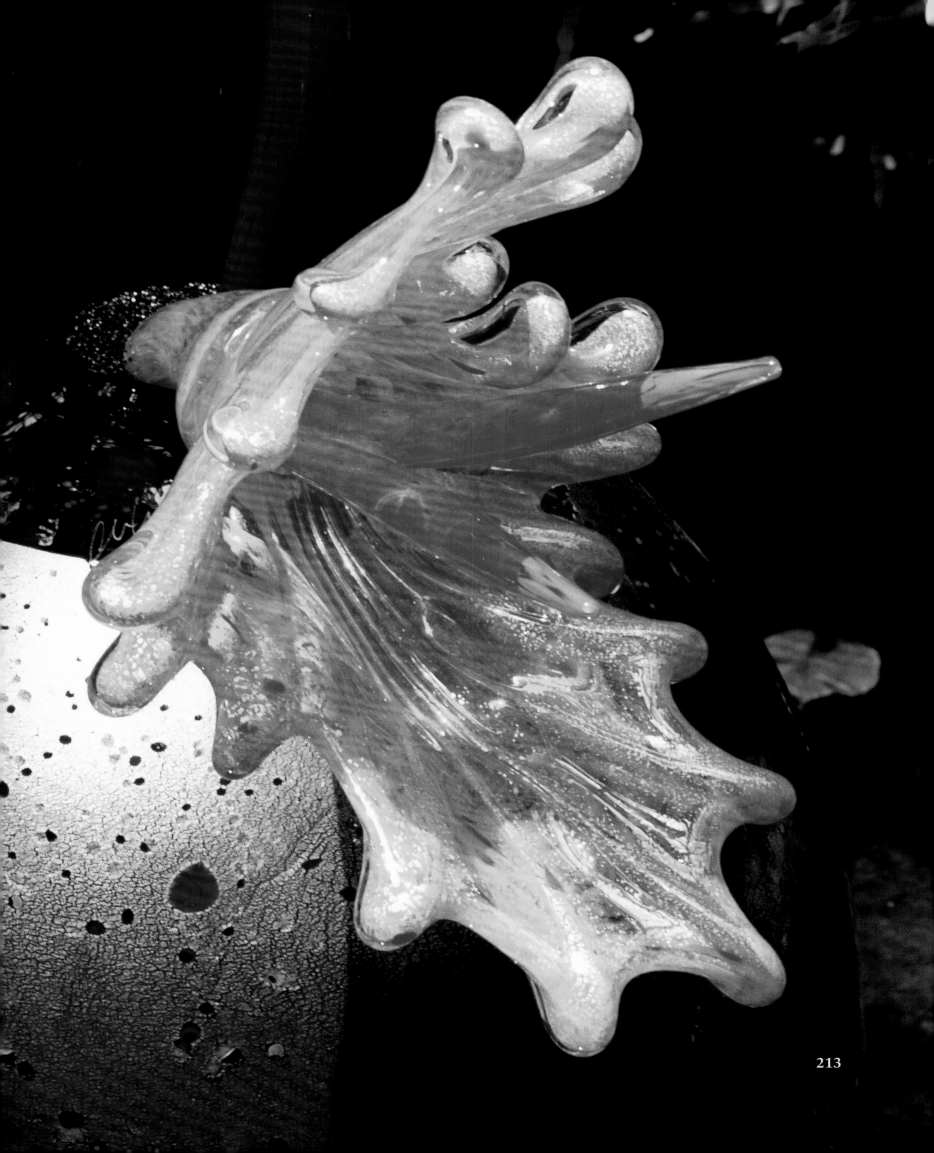

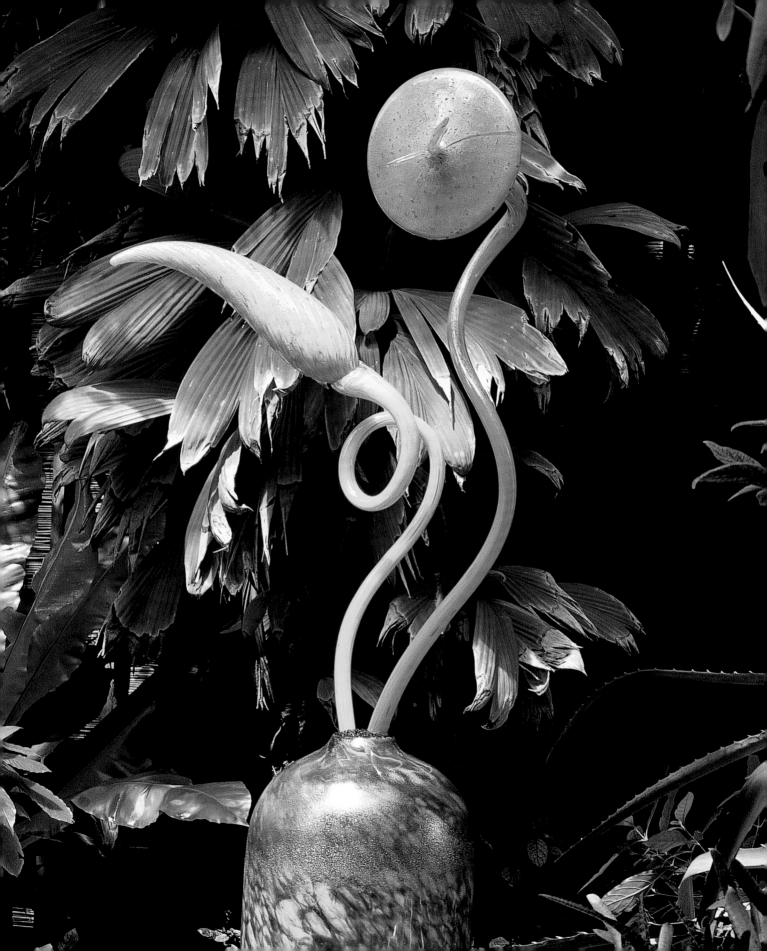

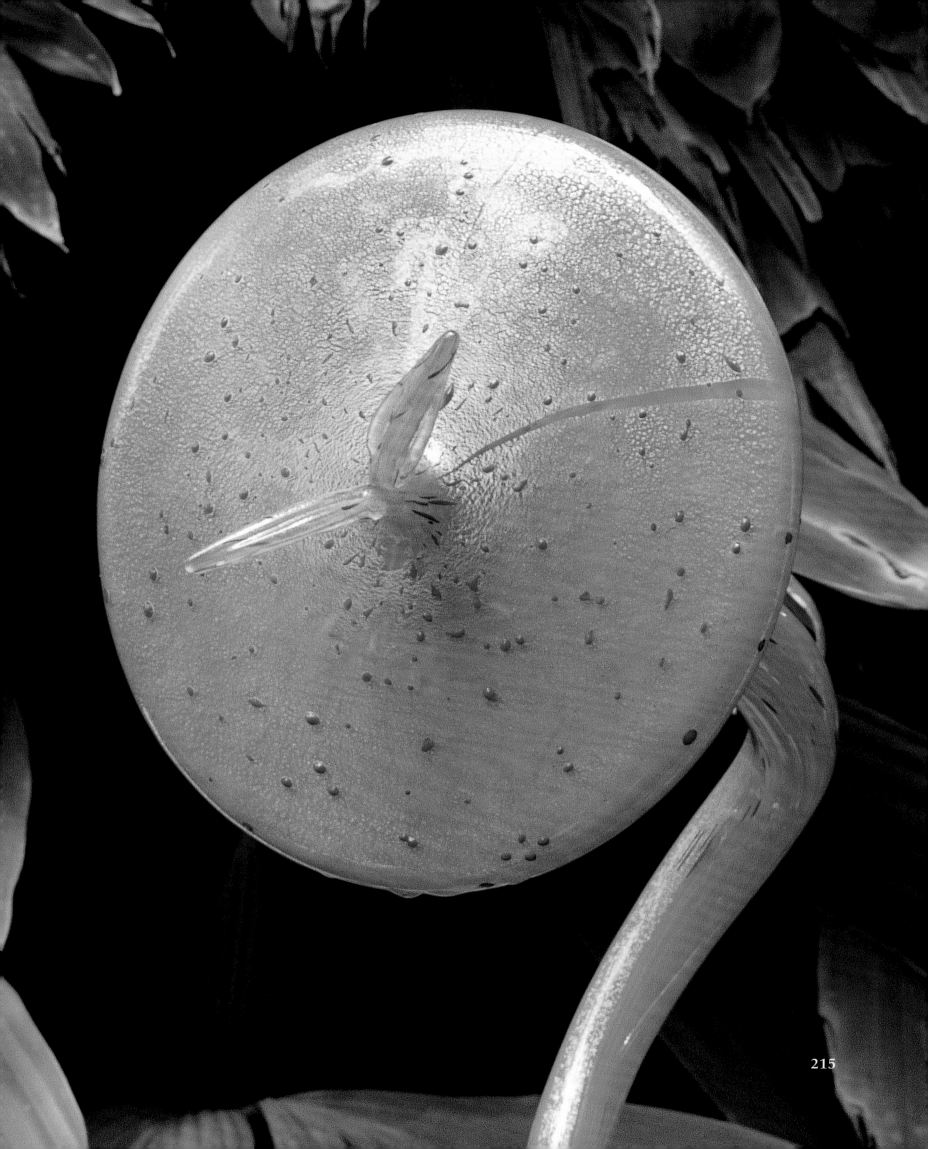

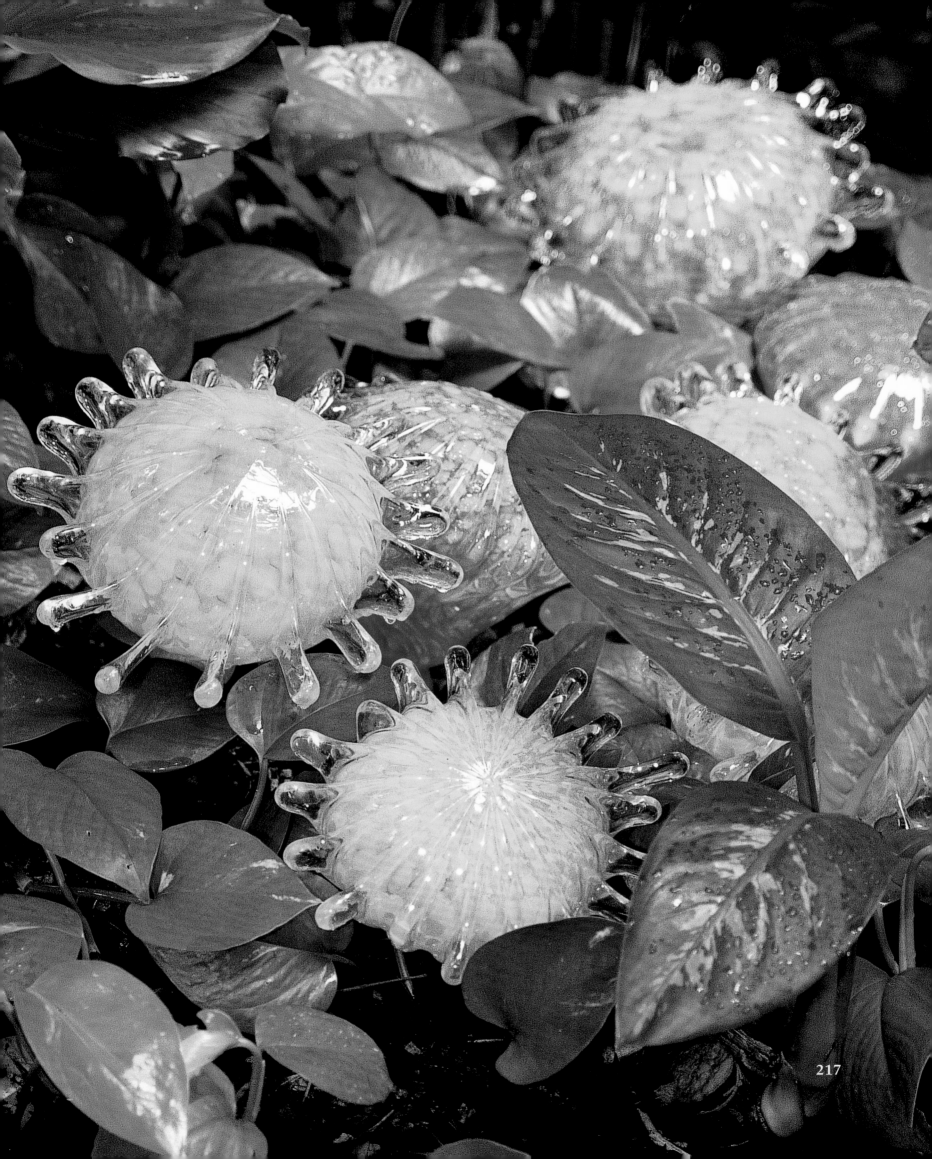

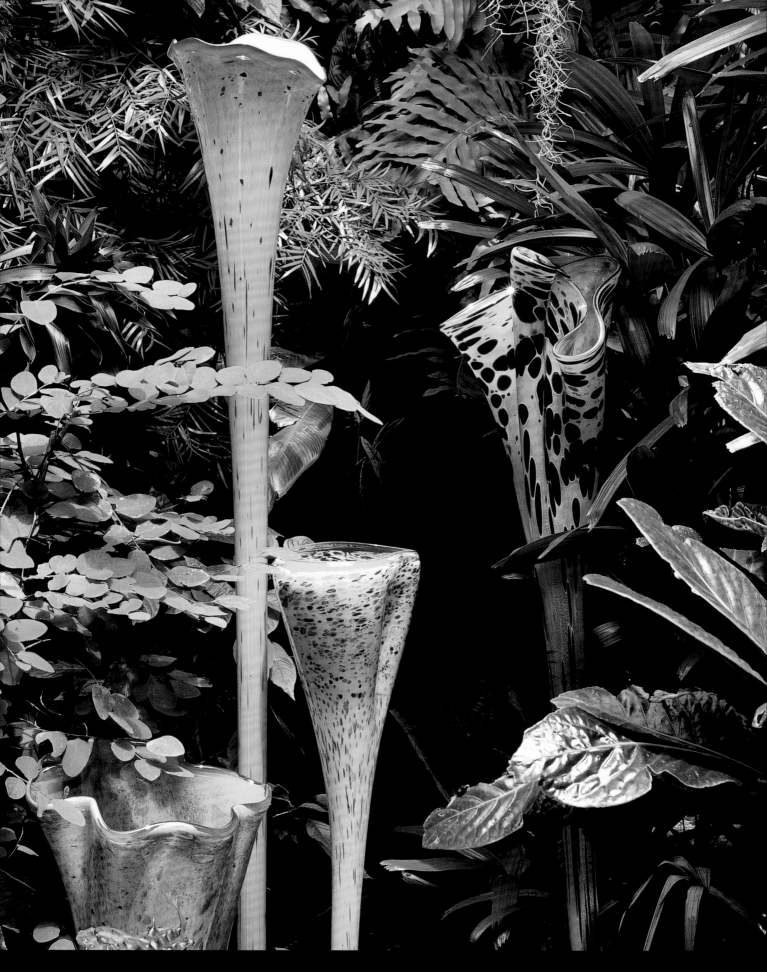

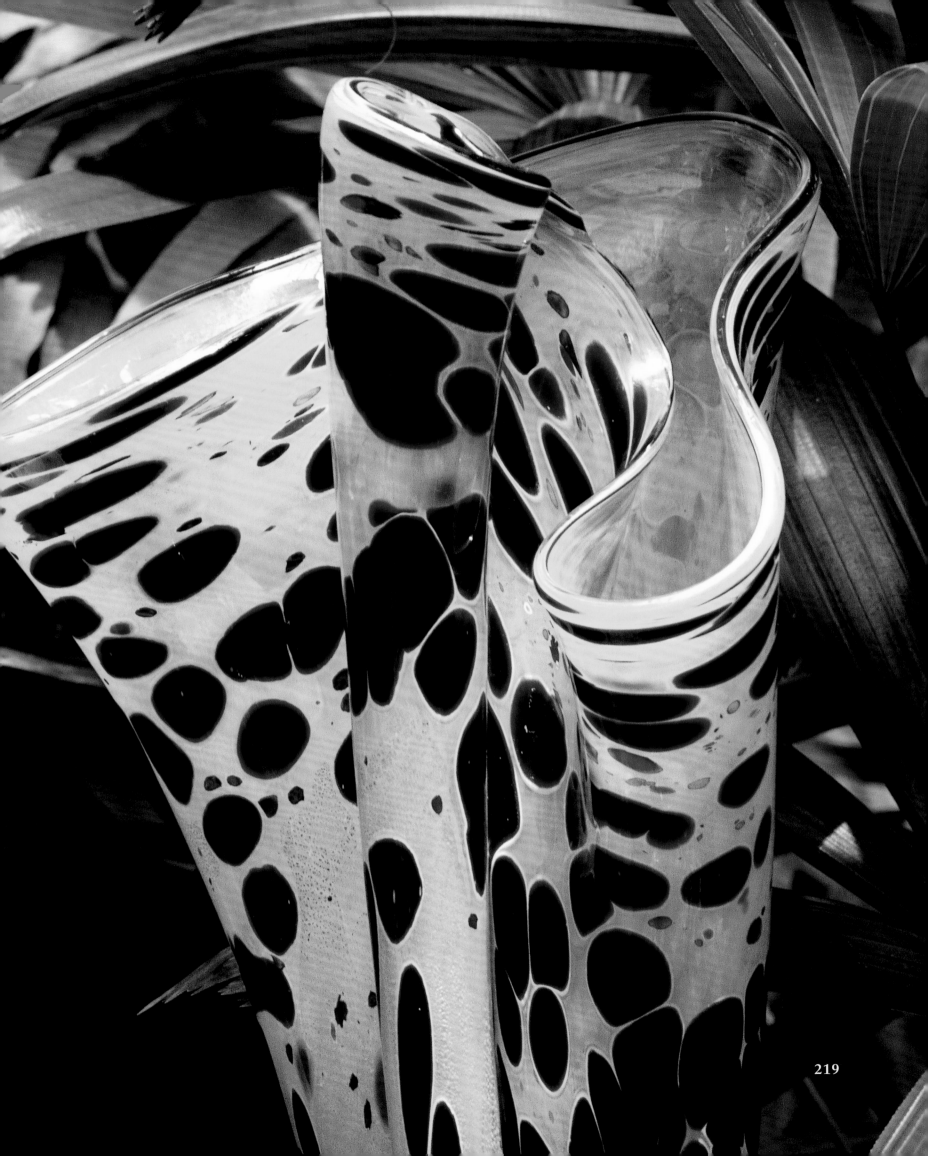

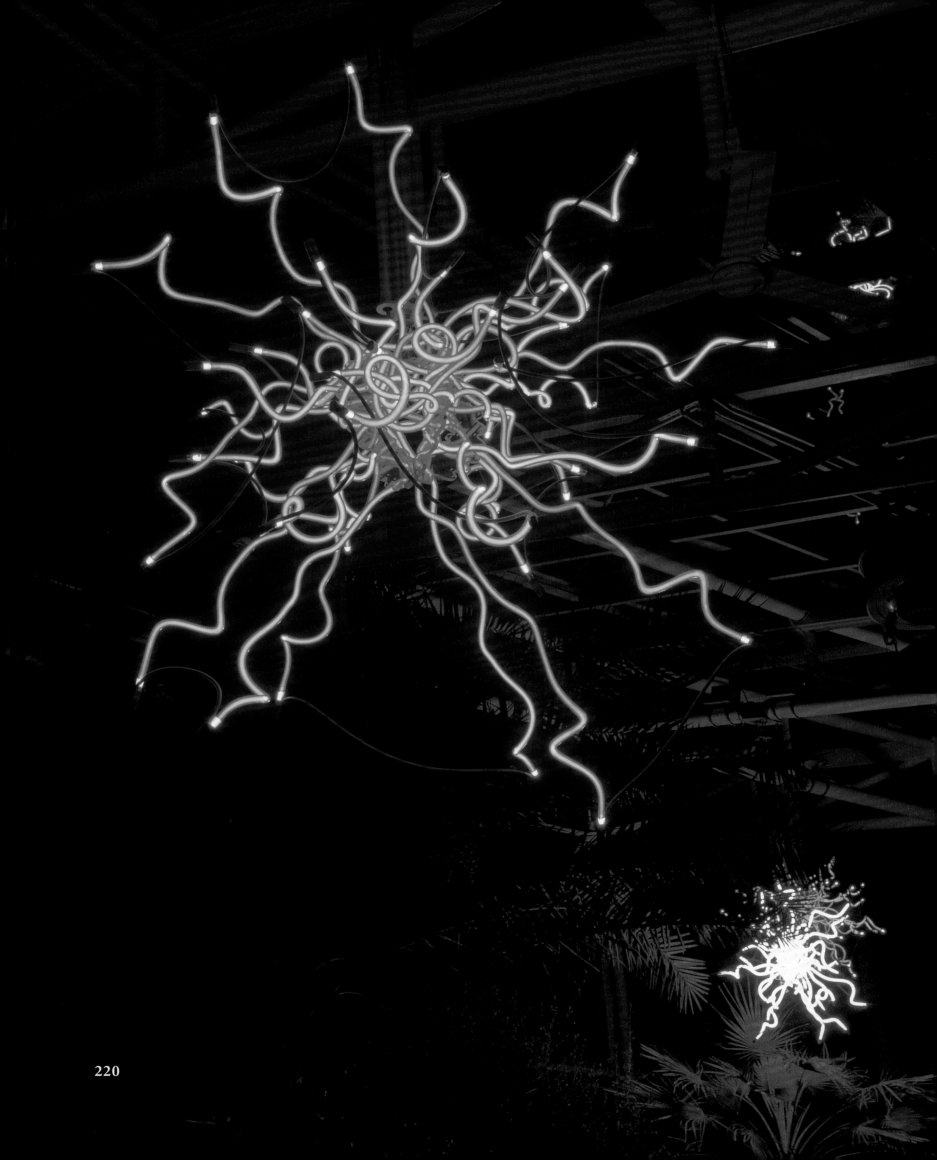

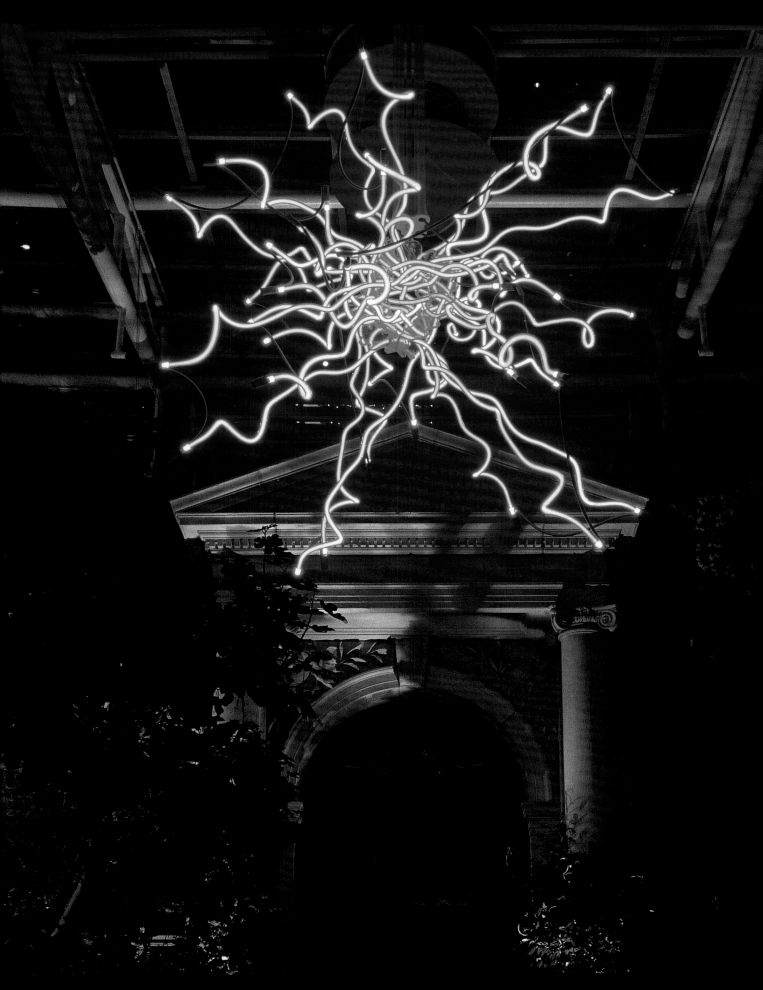

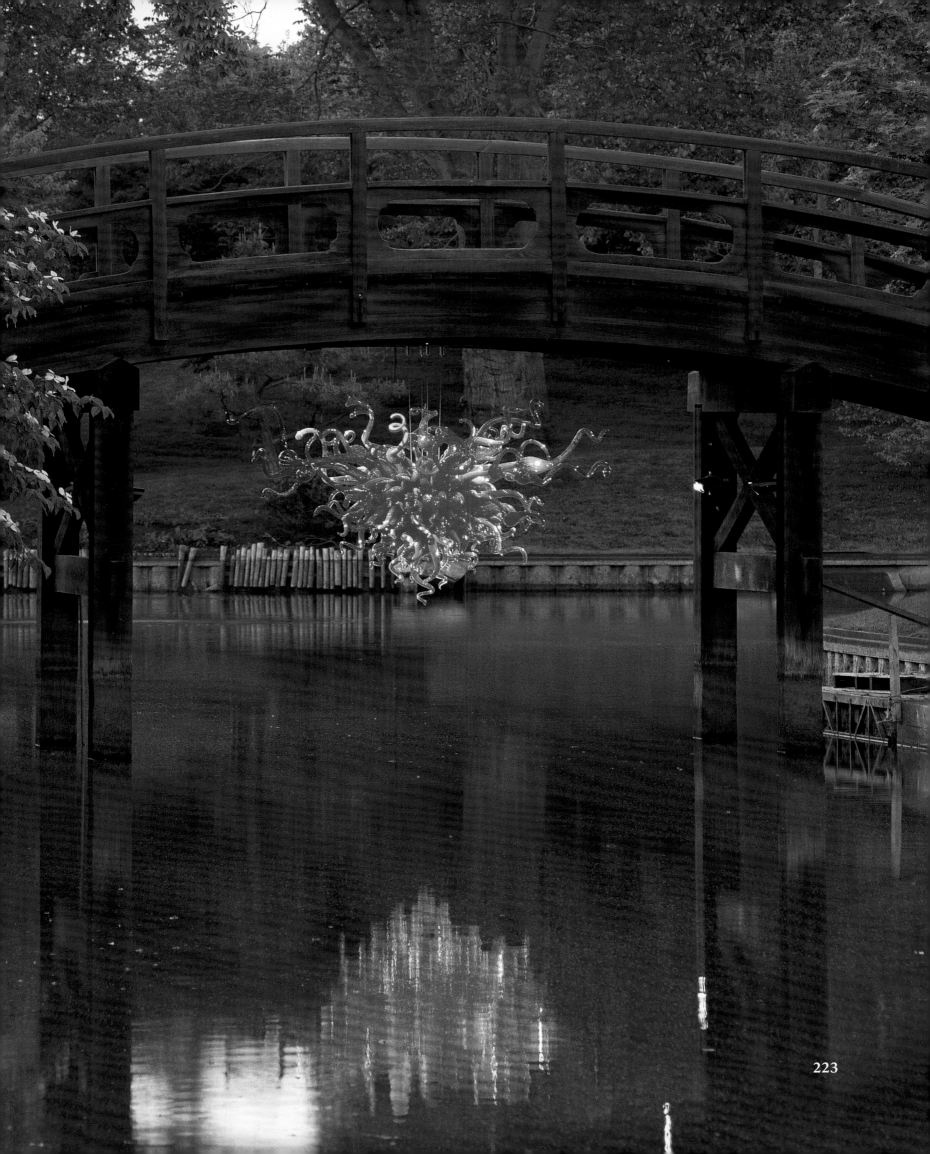

New York Botanical Garden
The Bronx, New York

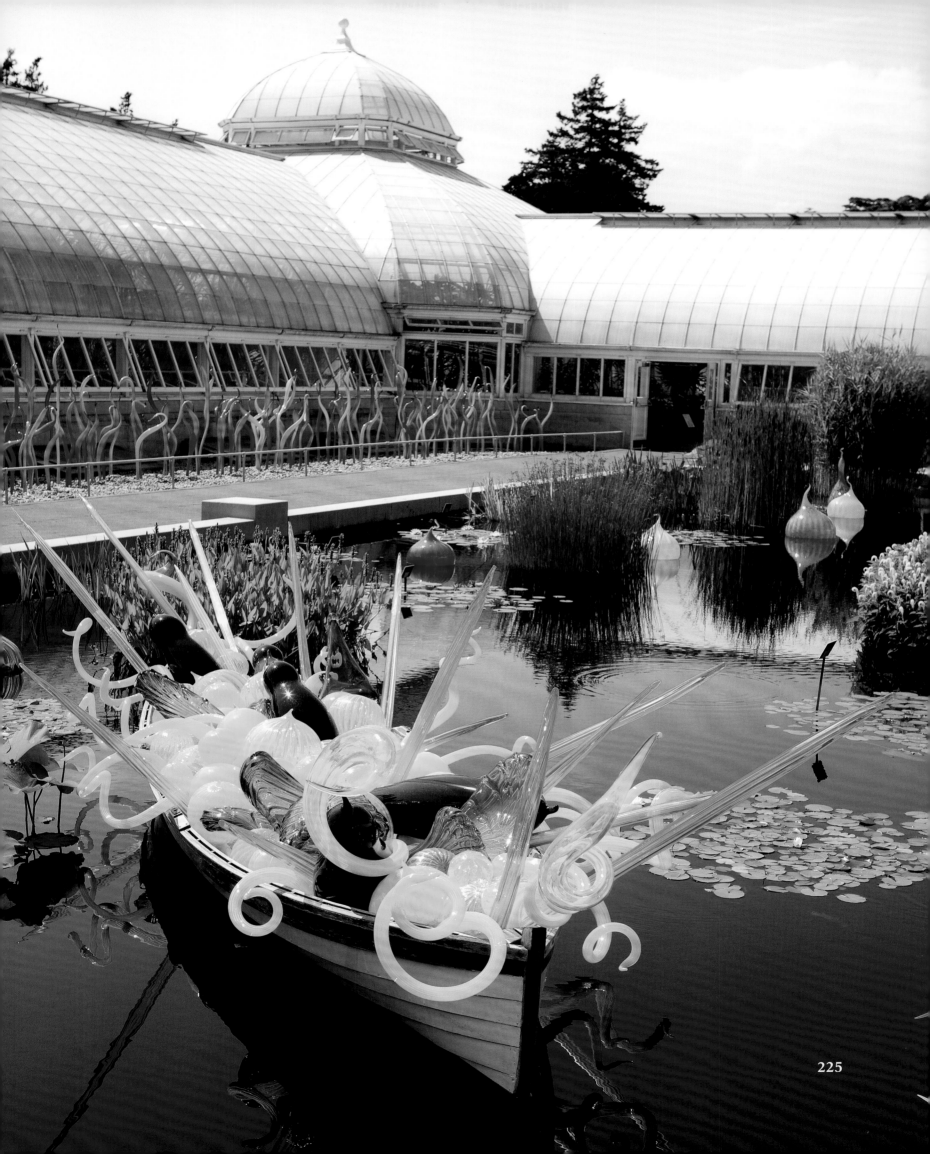

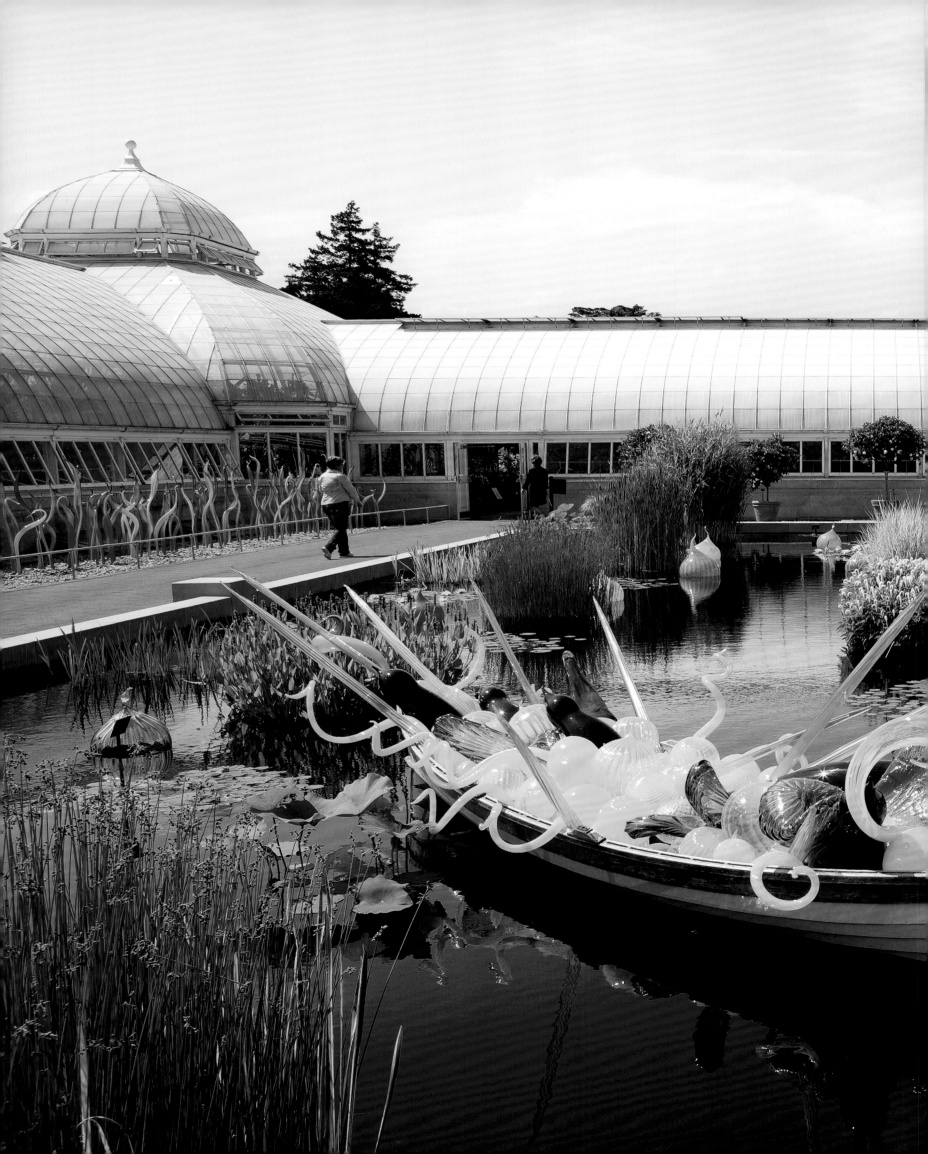

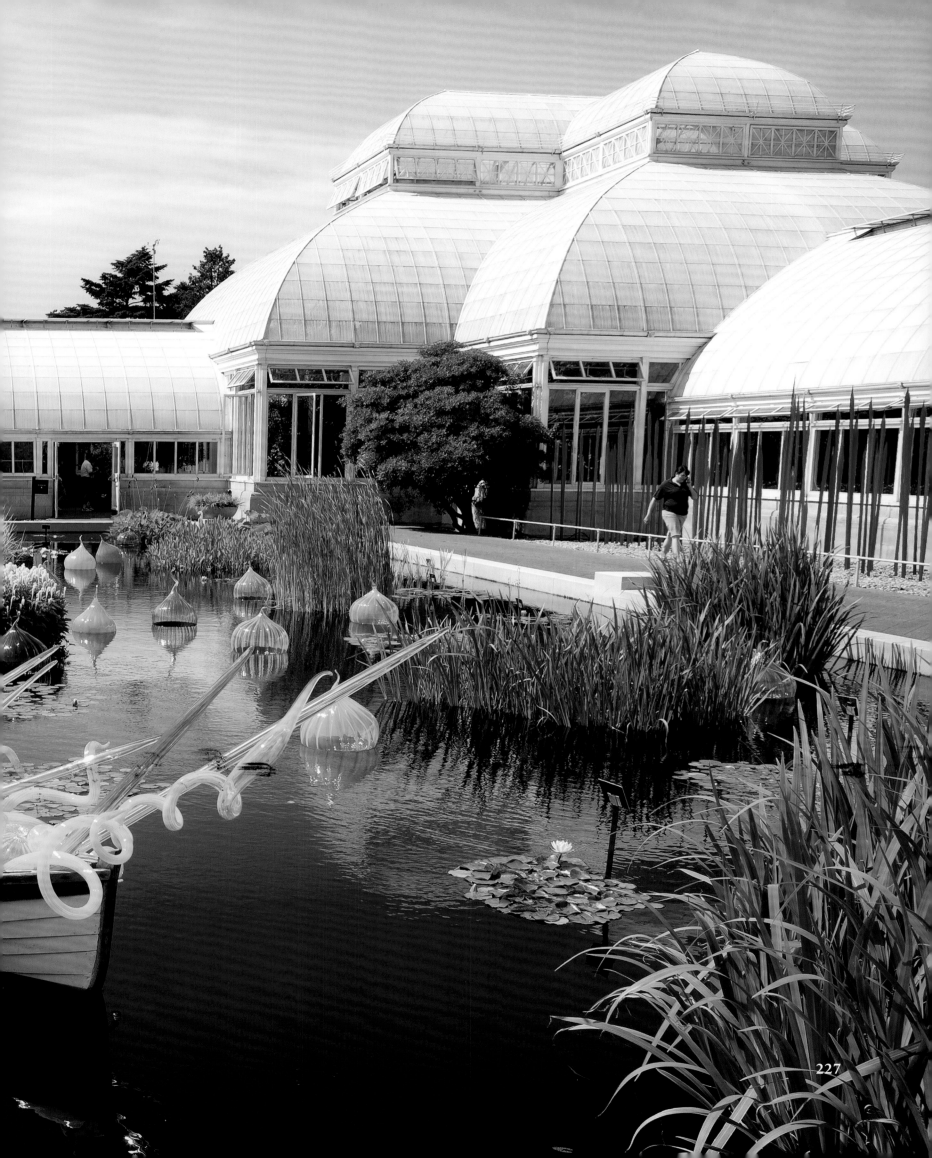

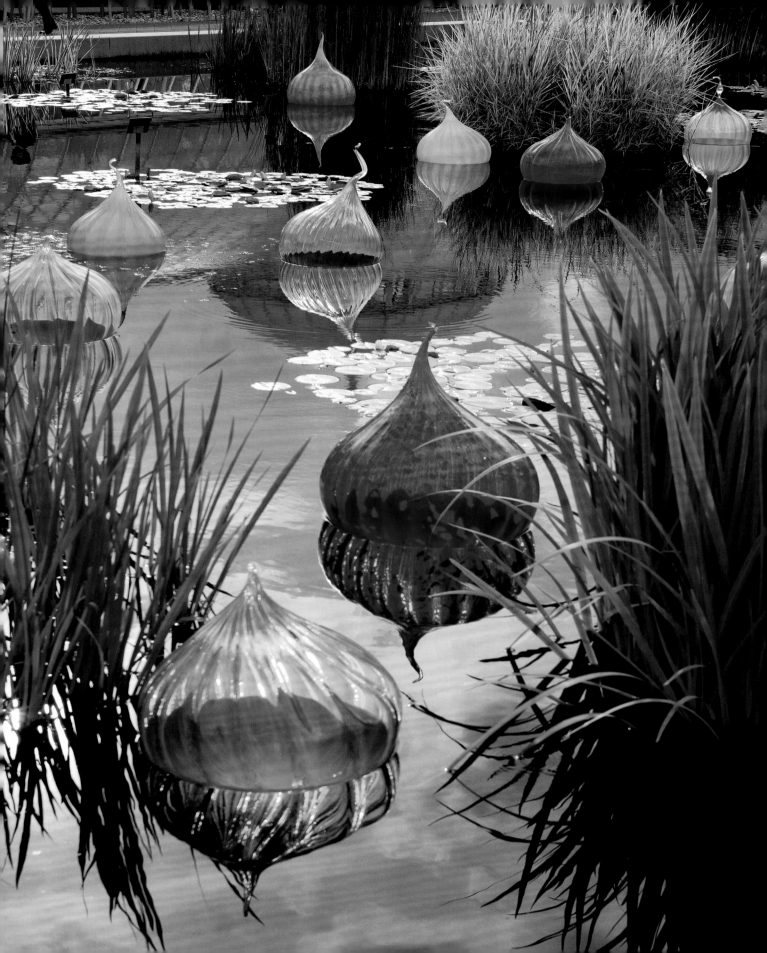

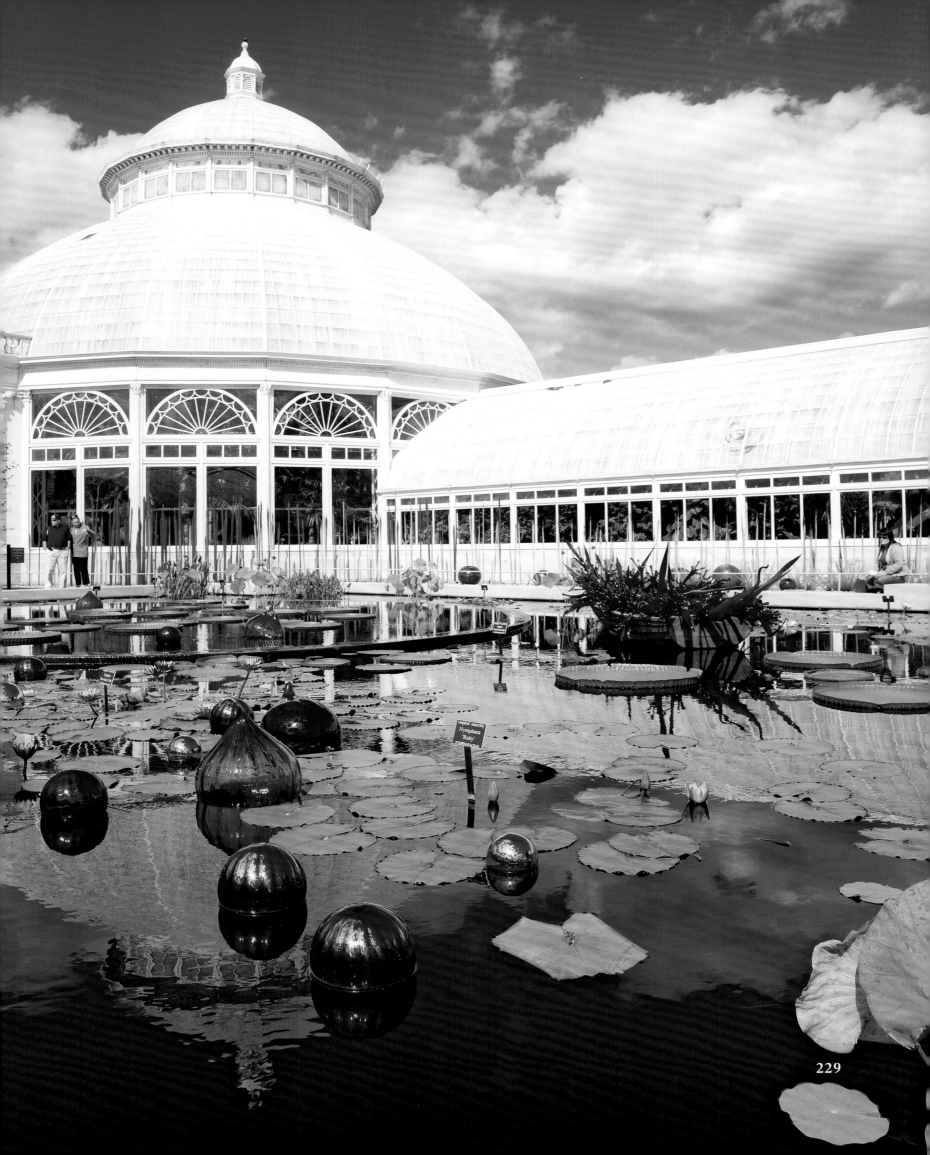

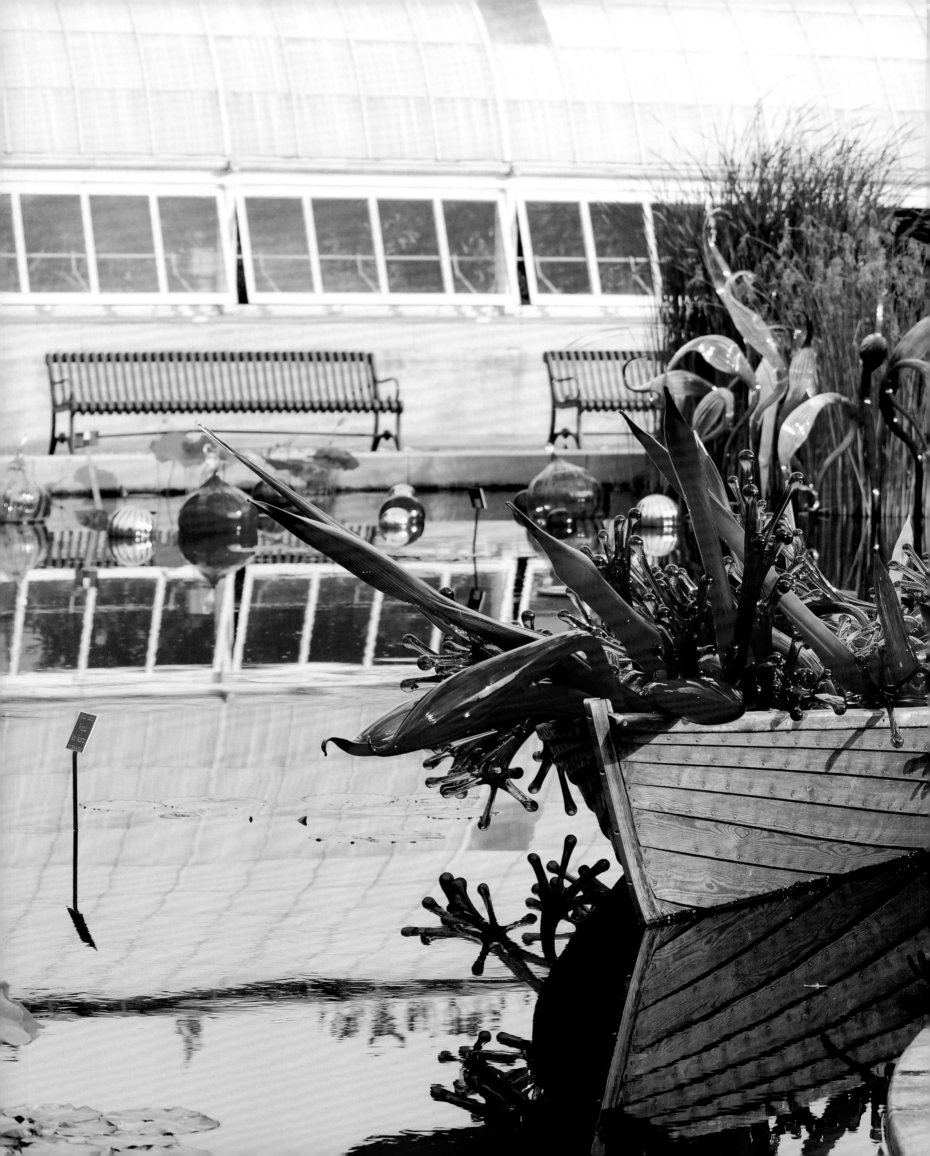

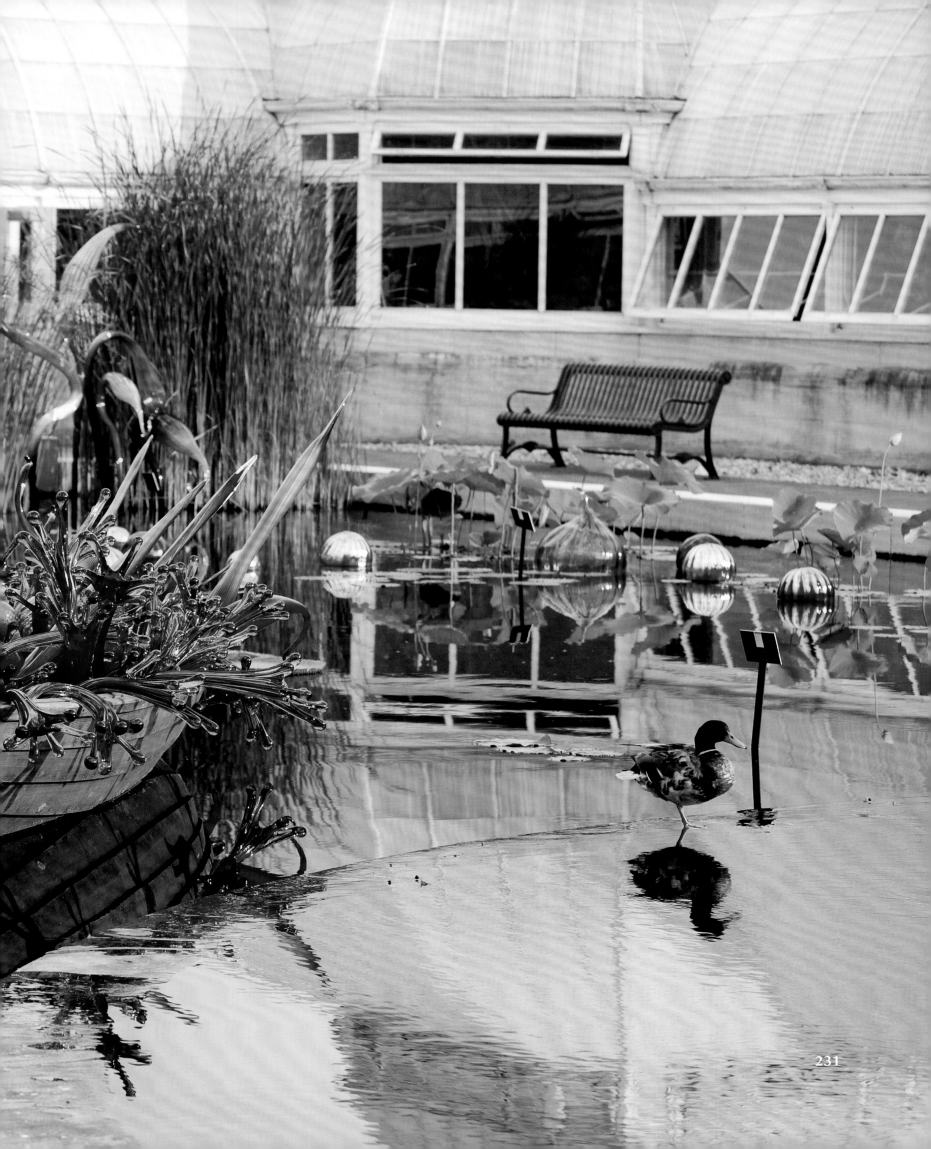

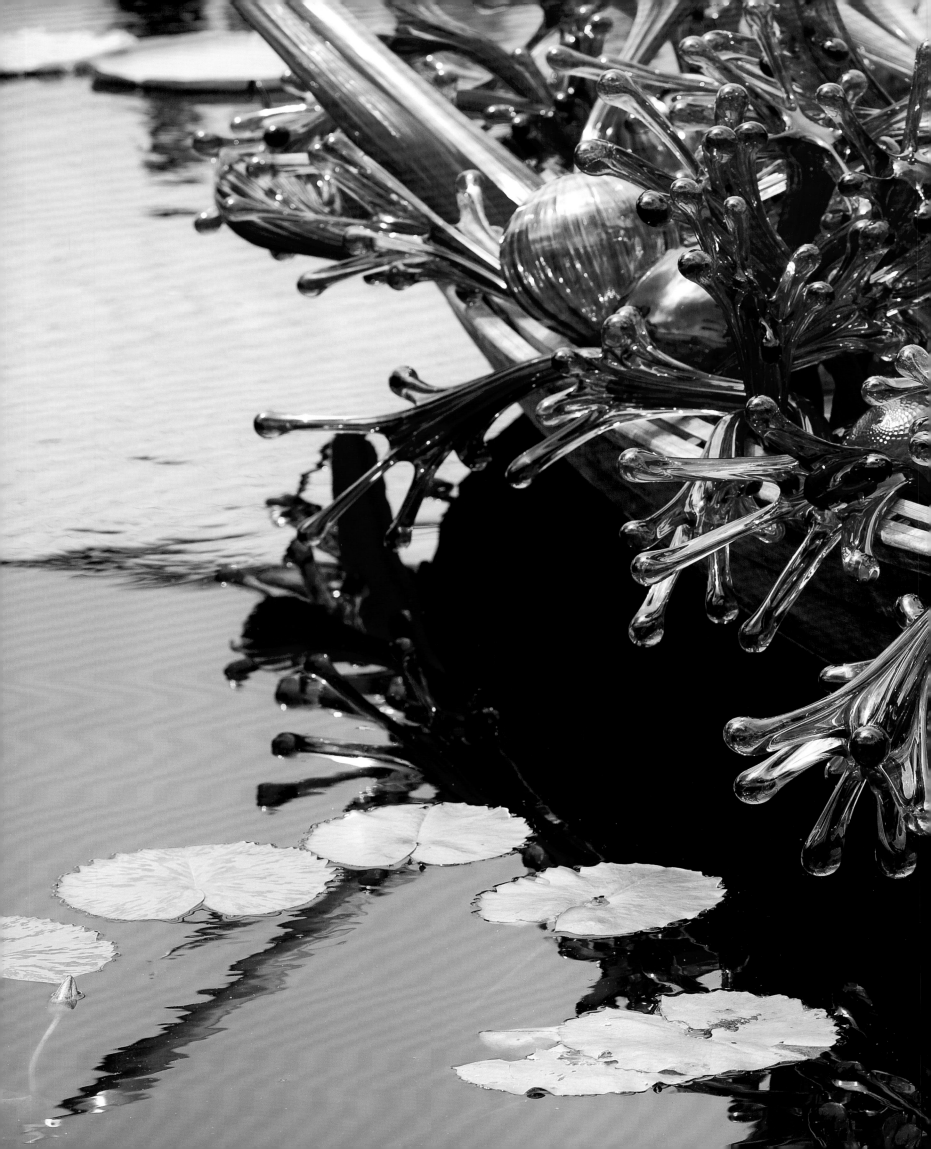

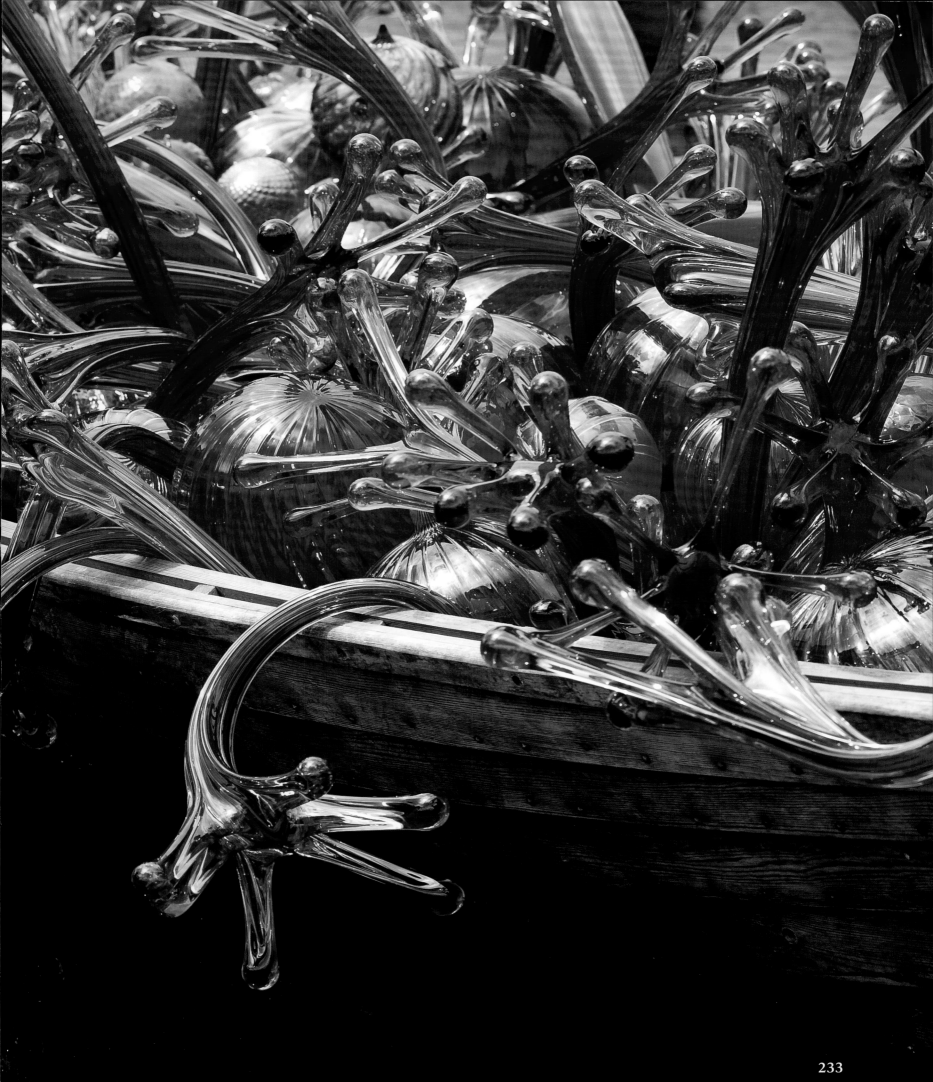

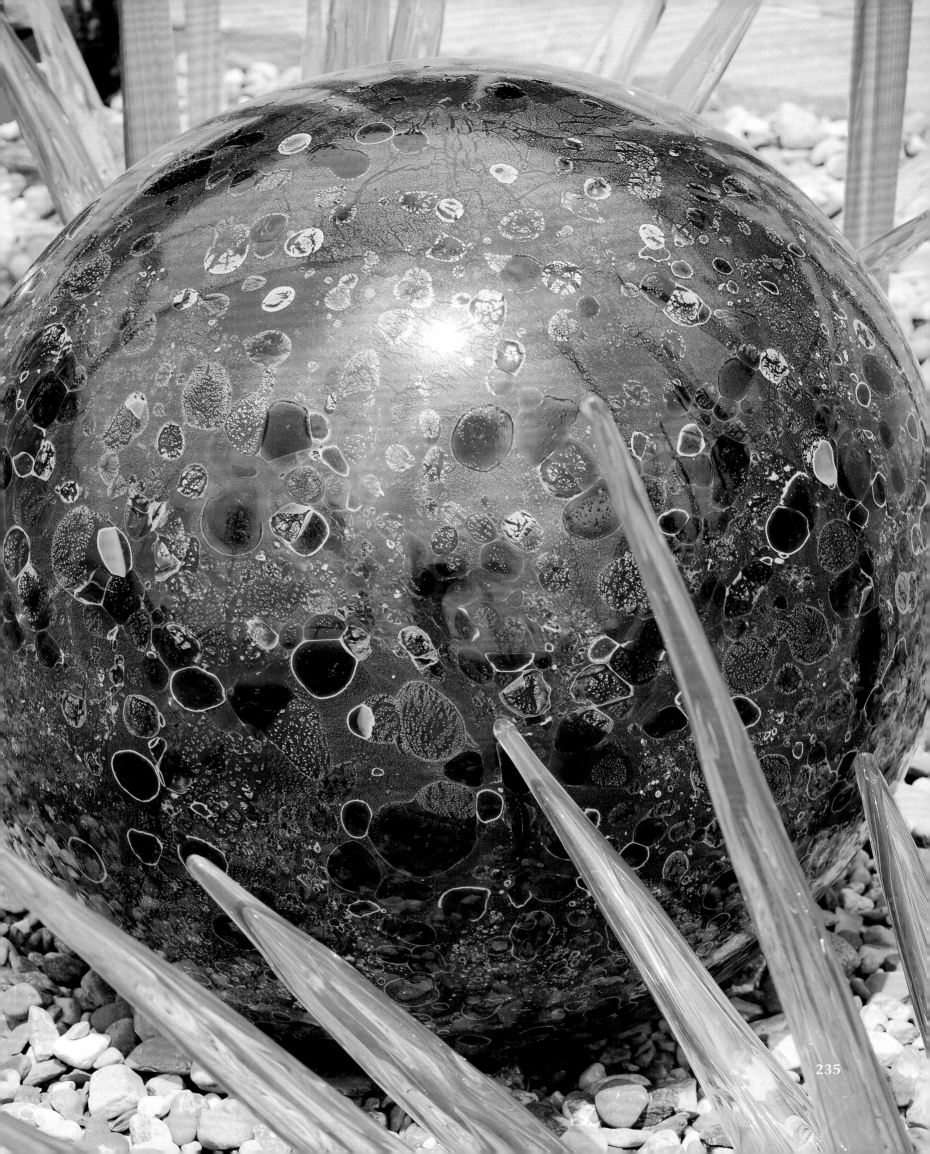

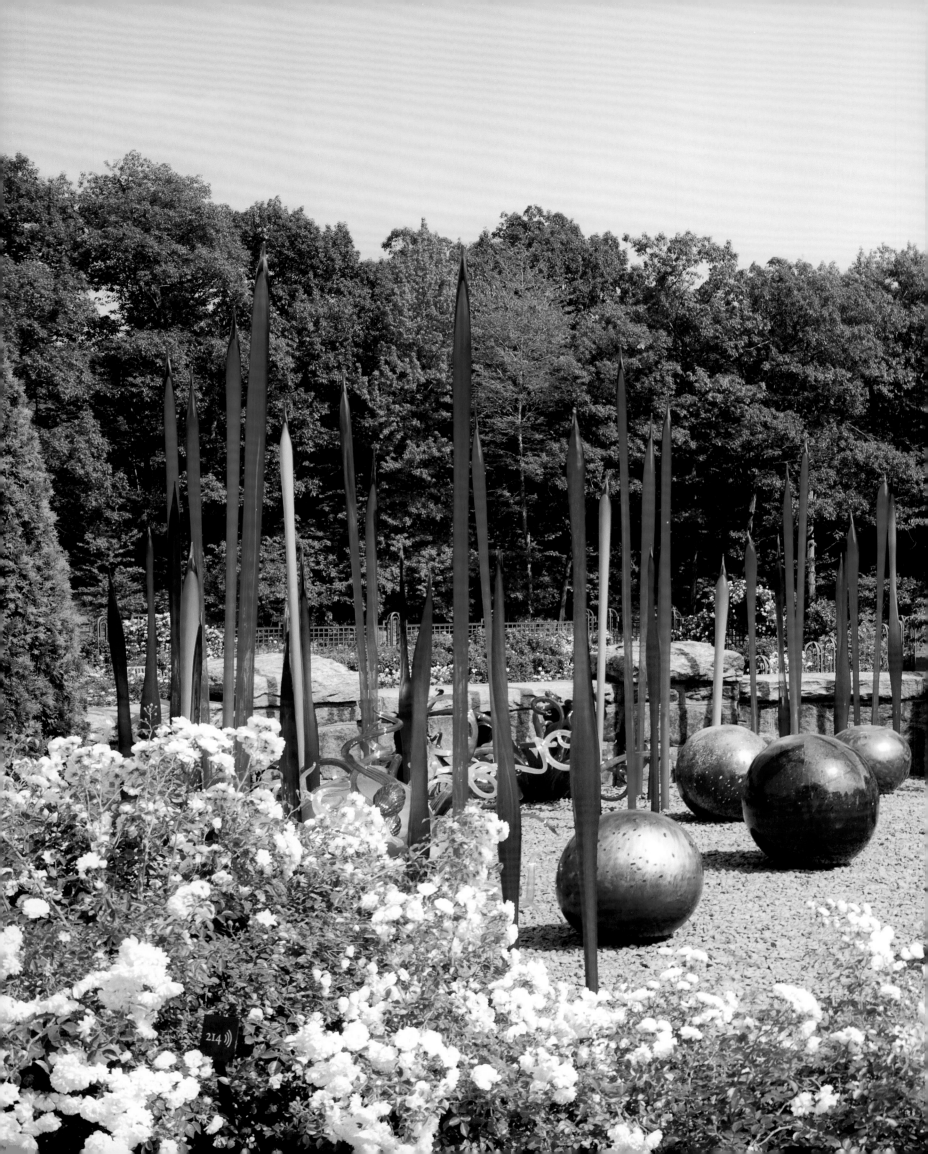

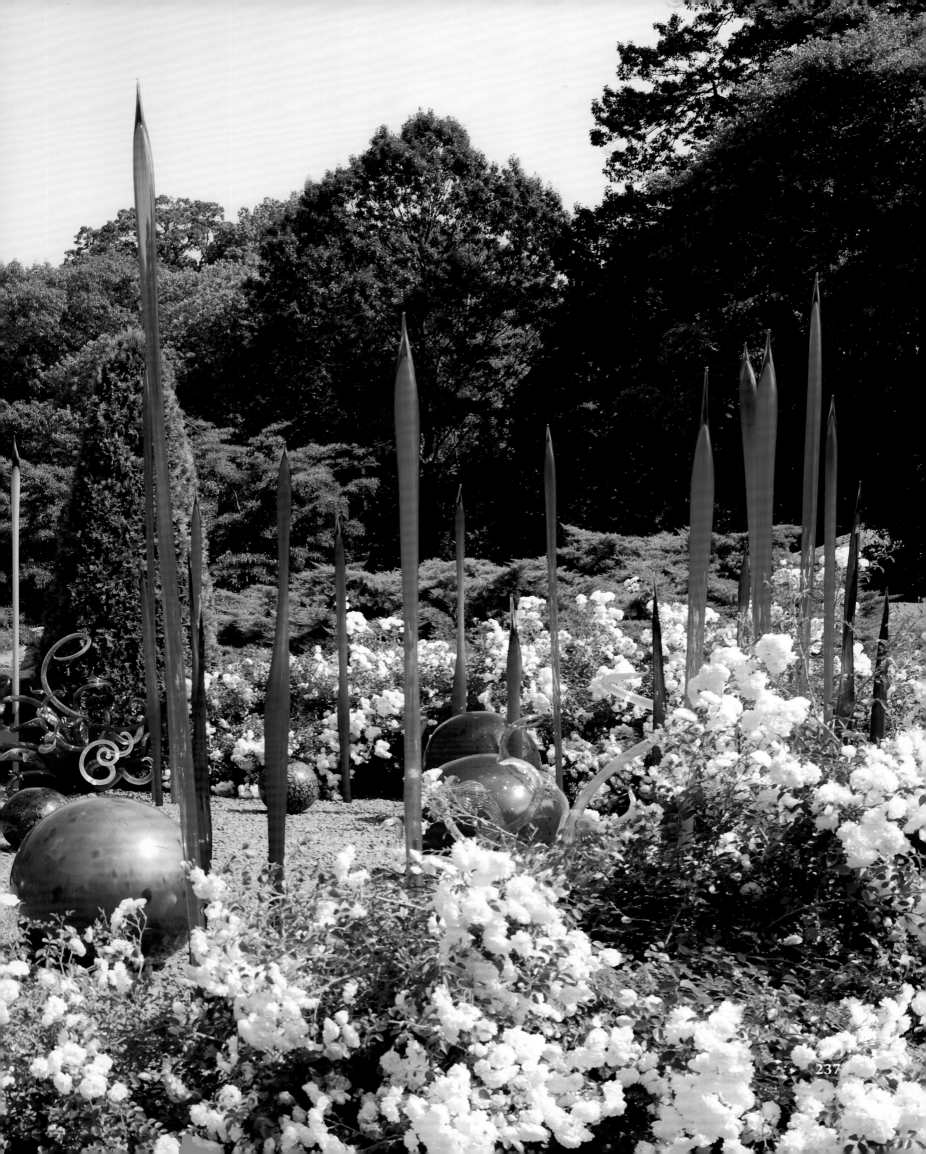

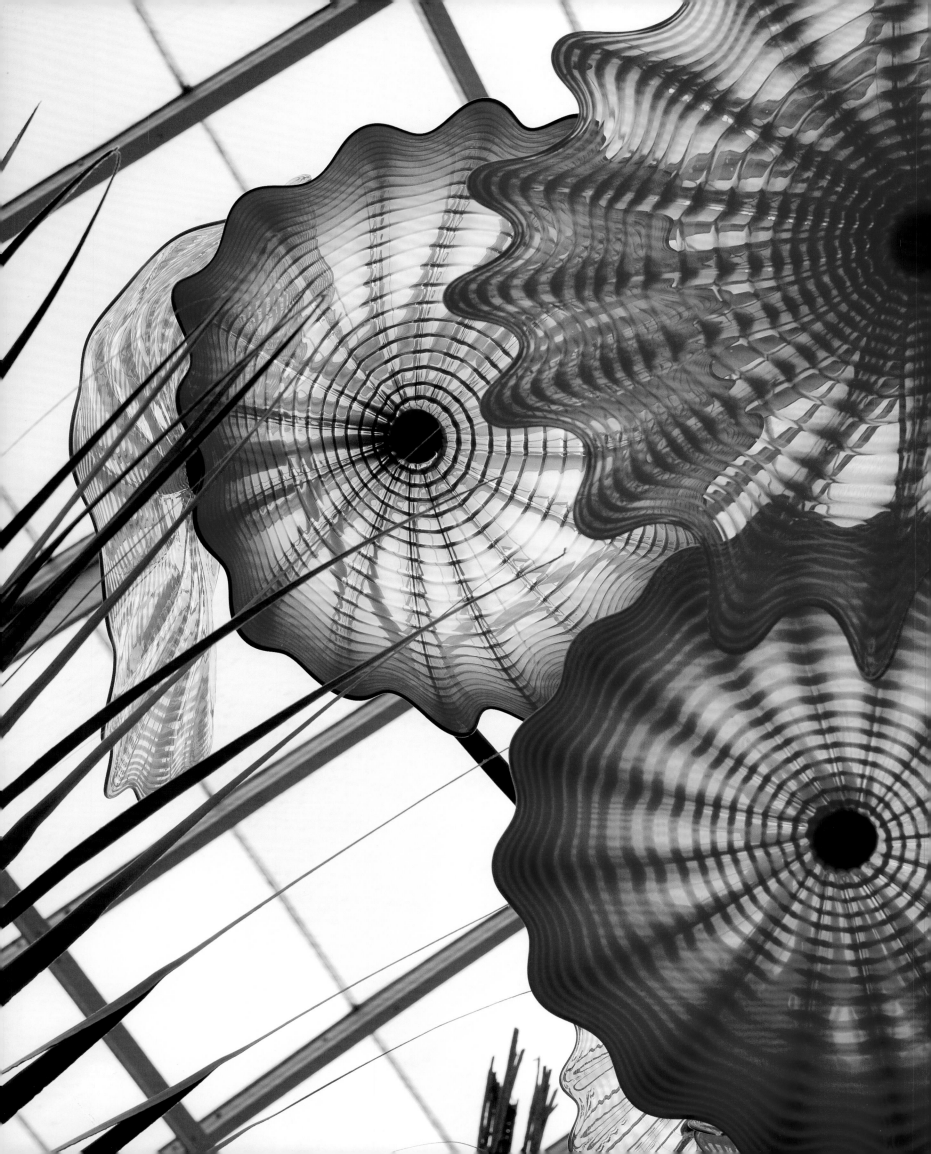

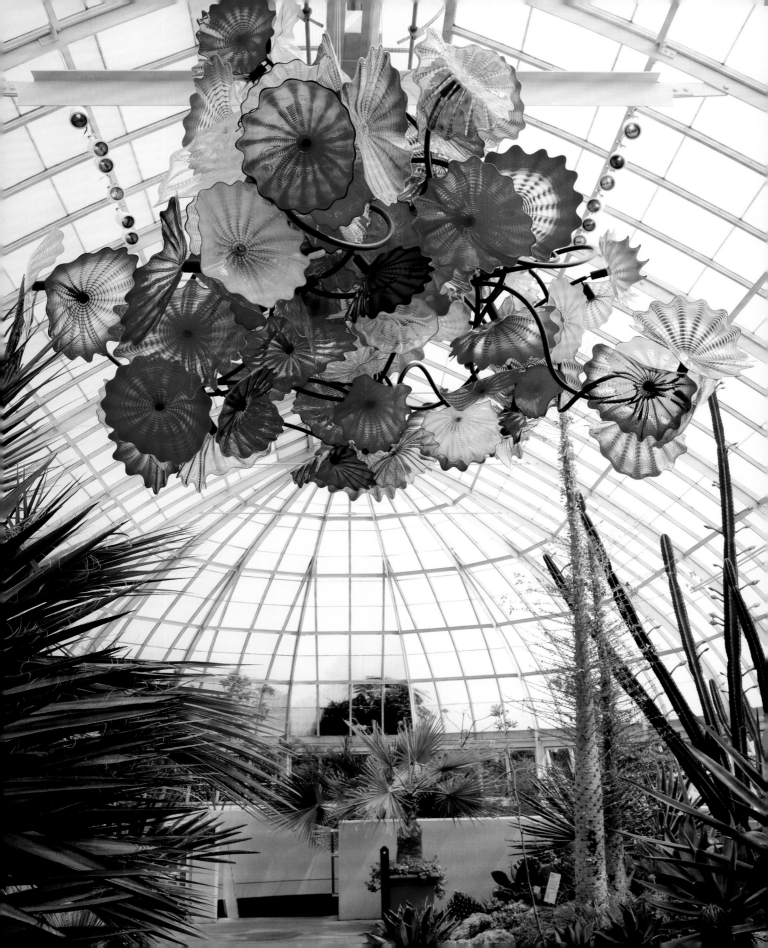

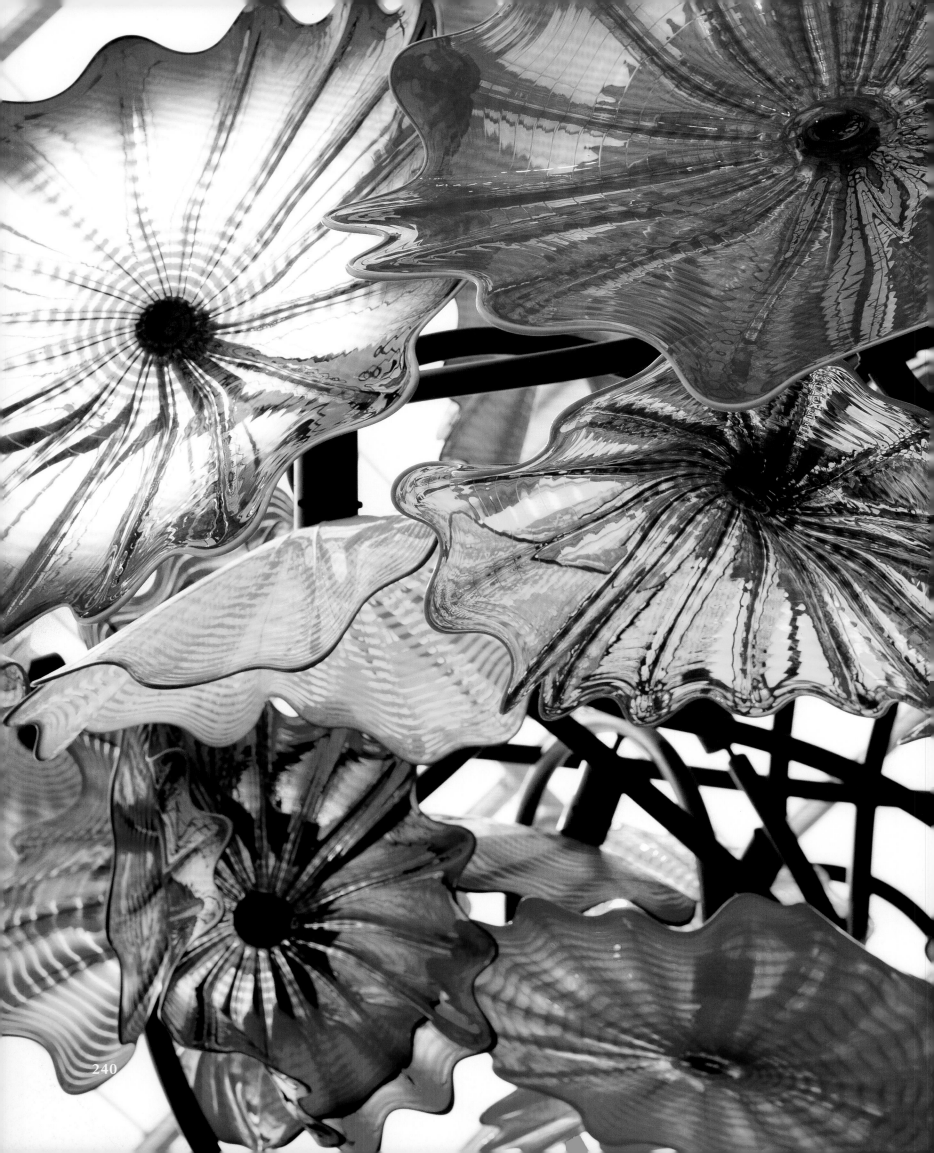

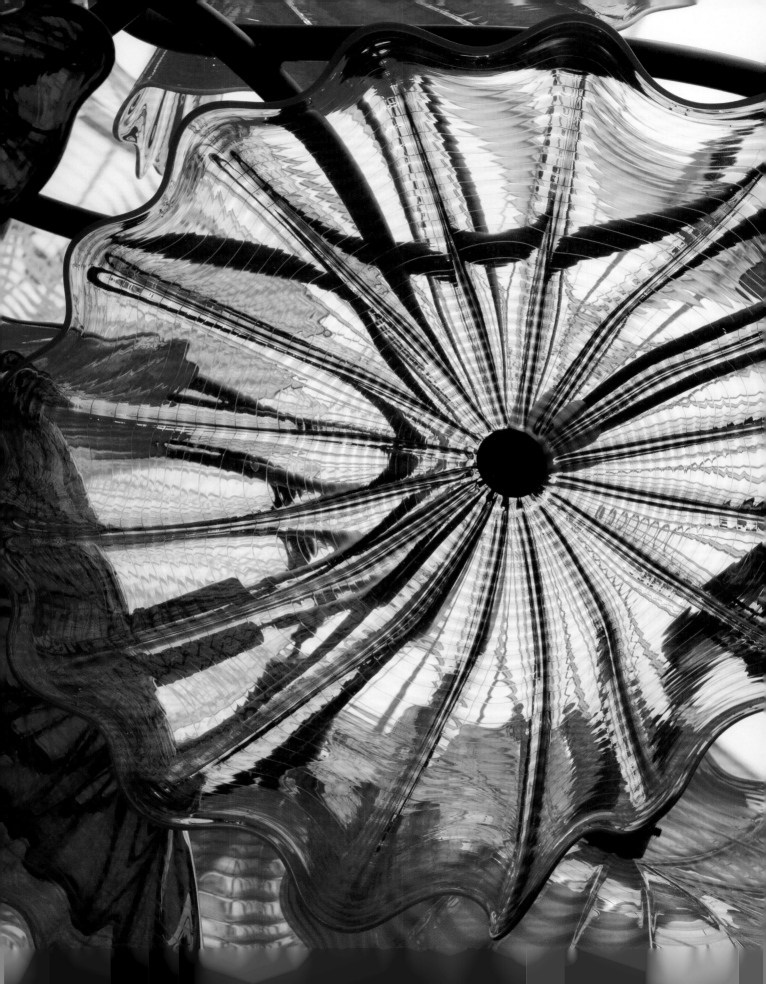

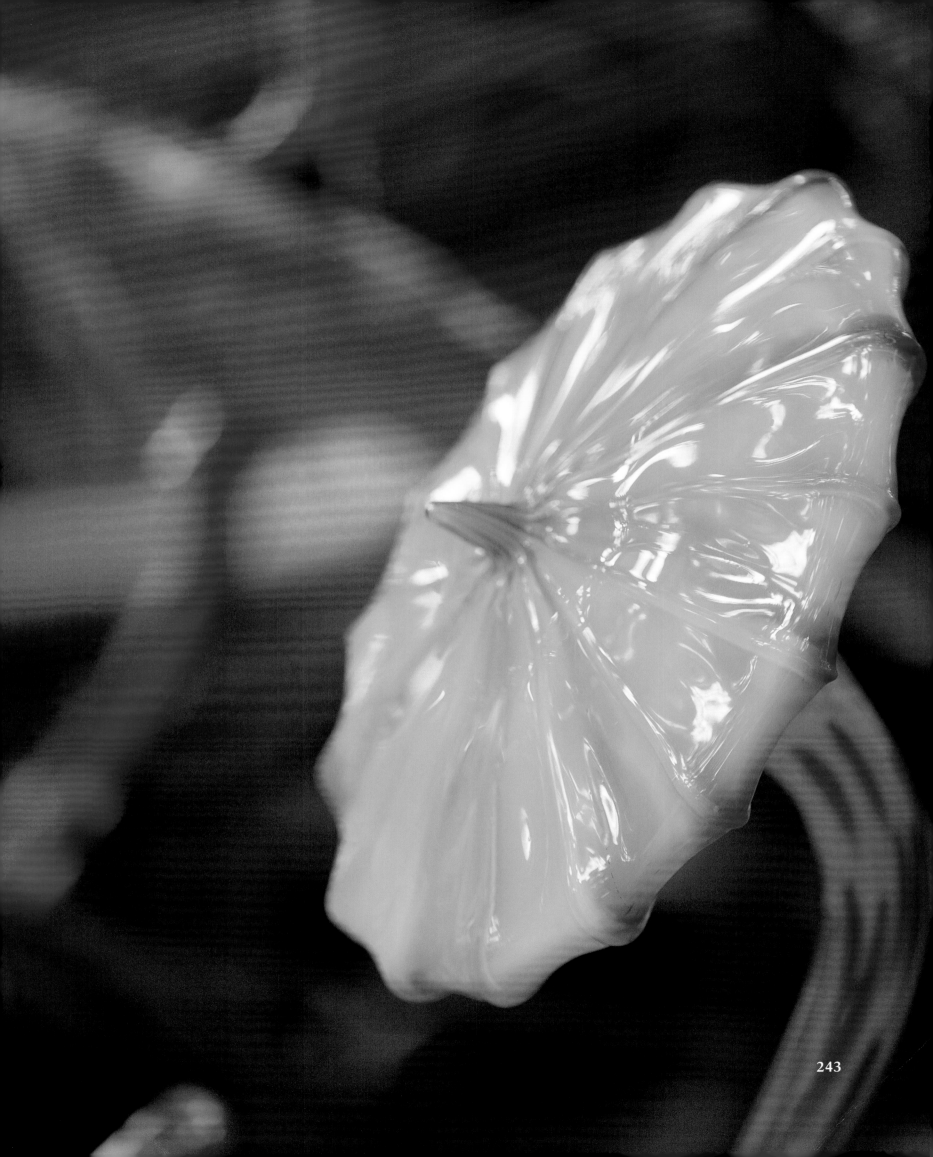

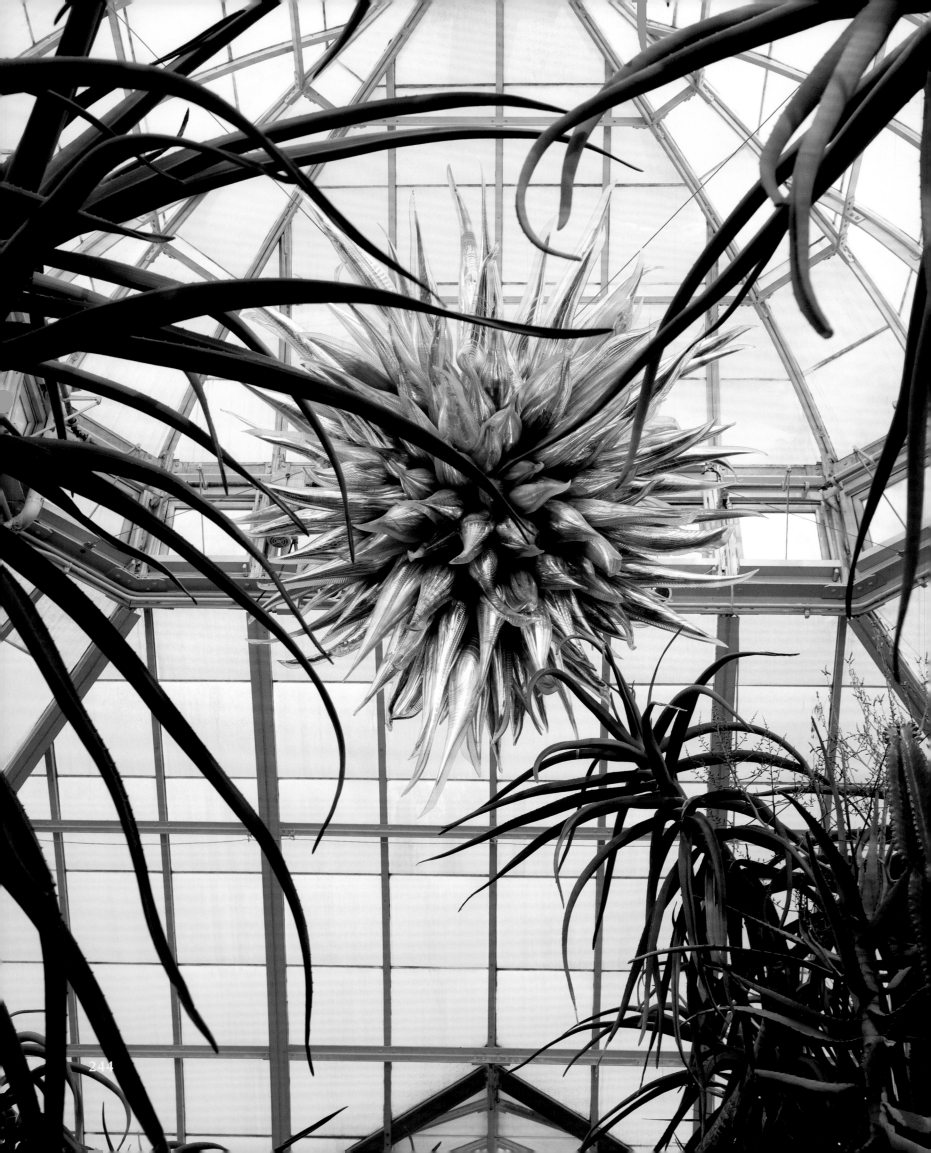

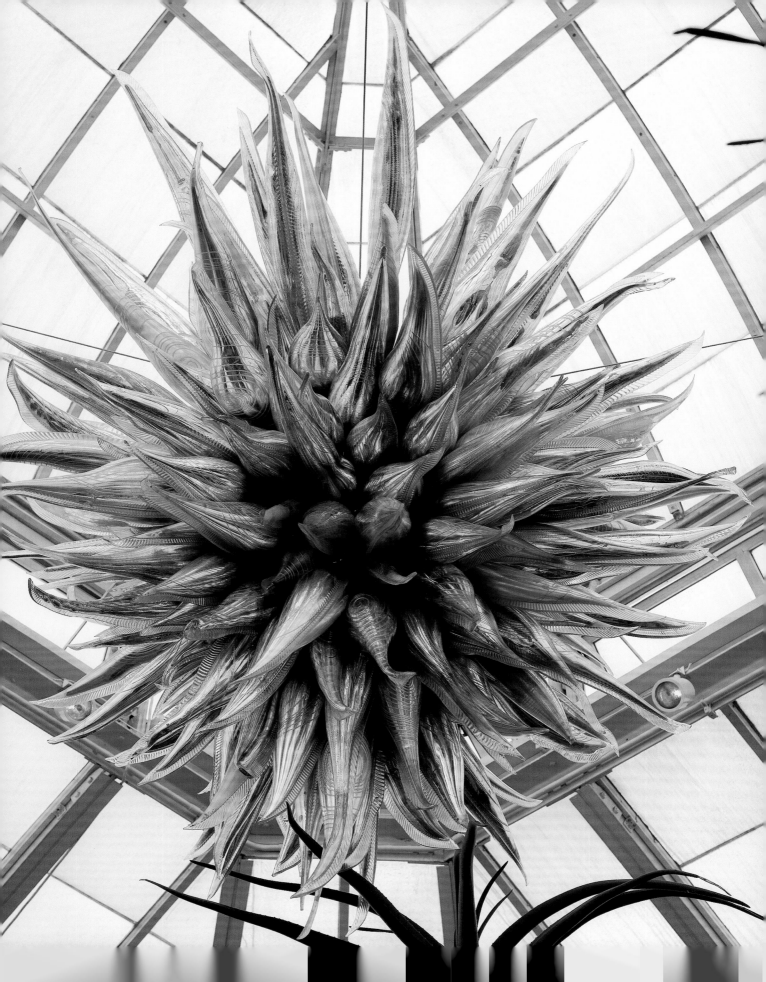

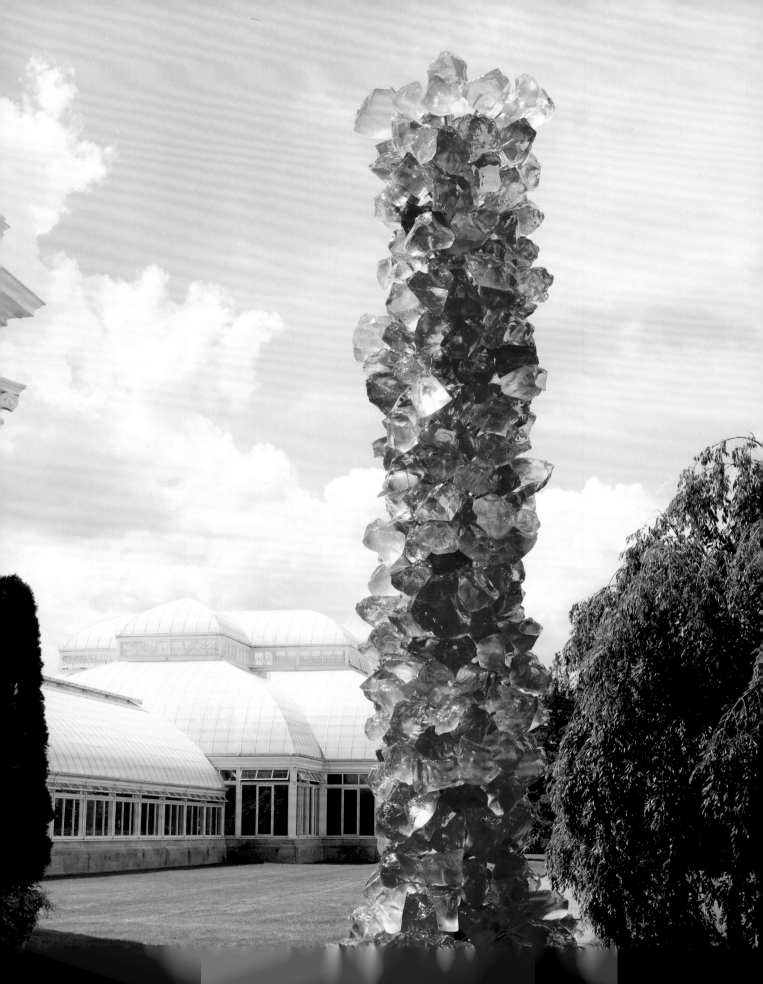

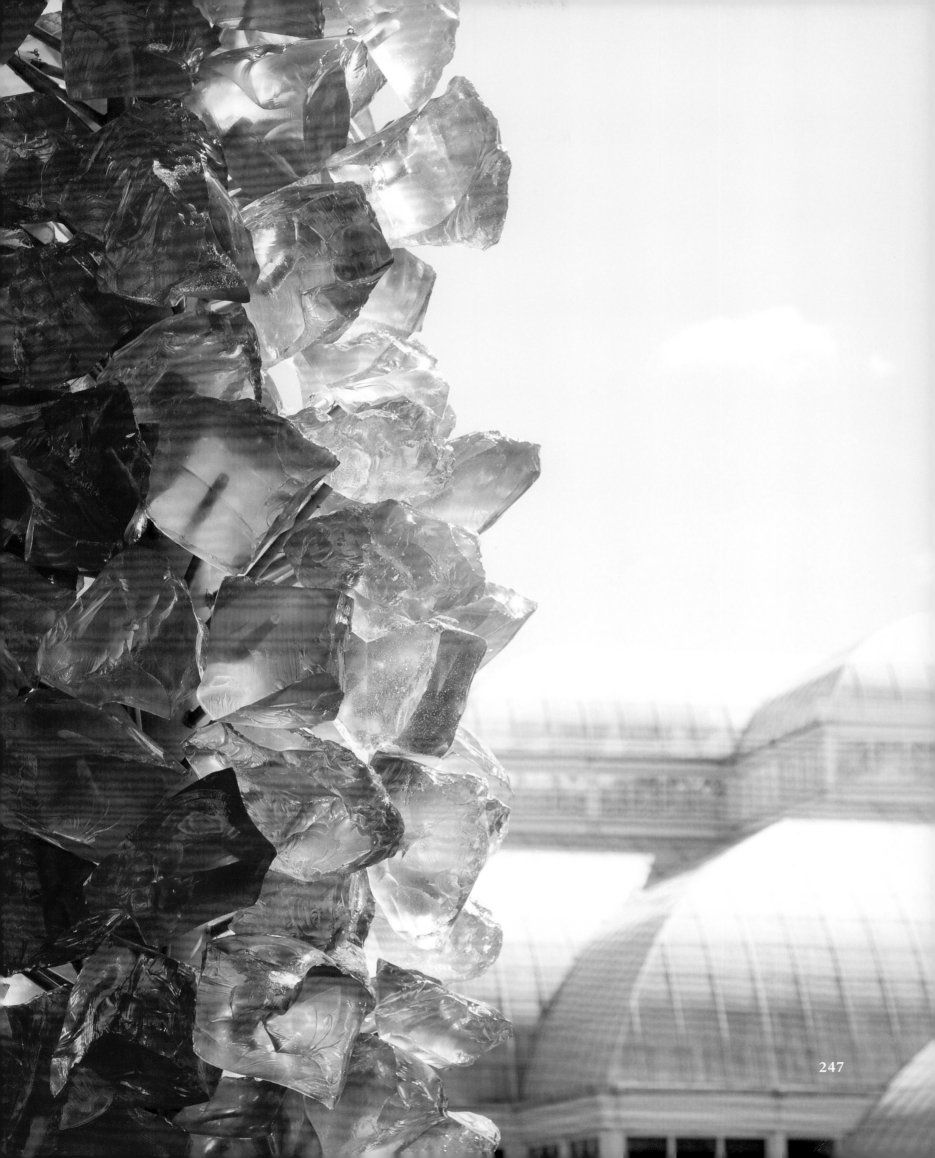

247

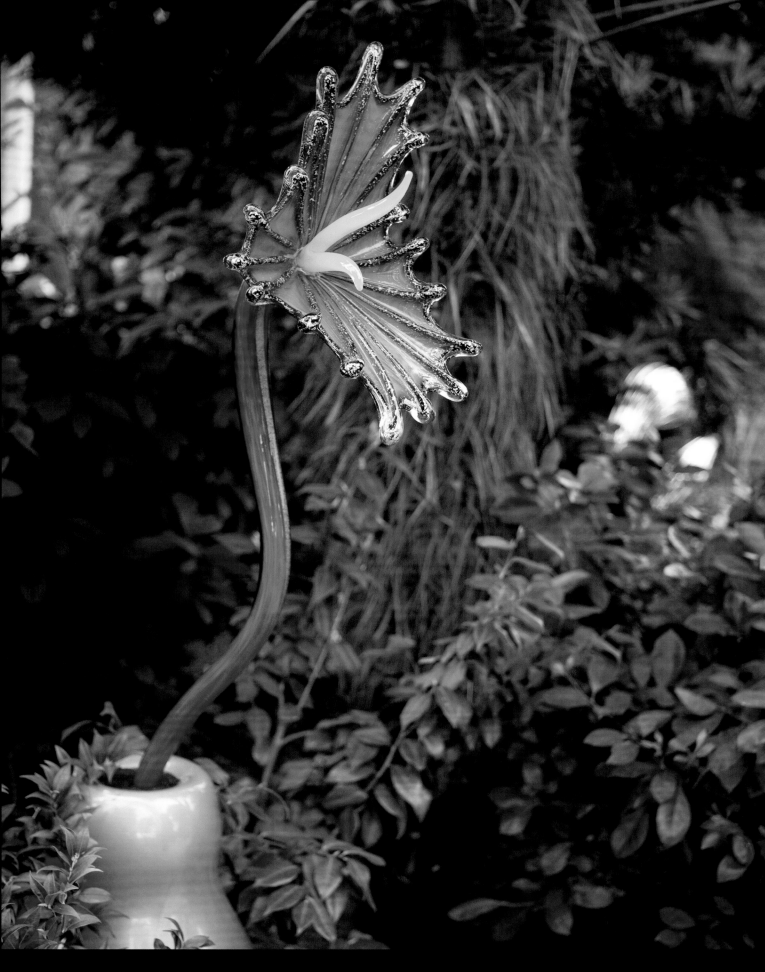

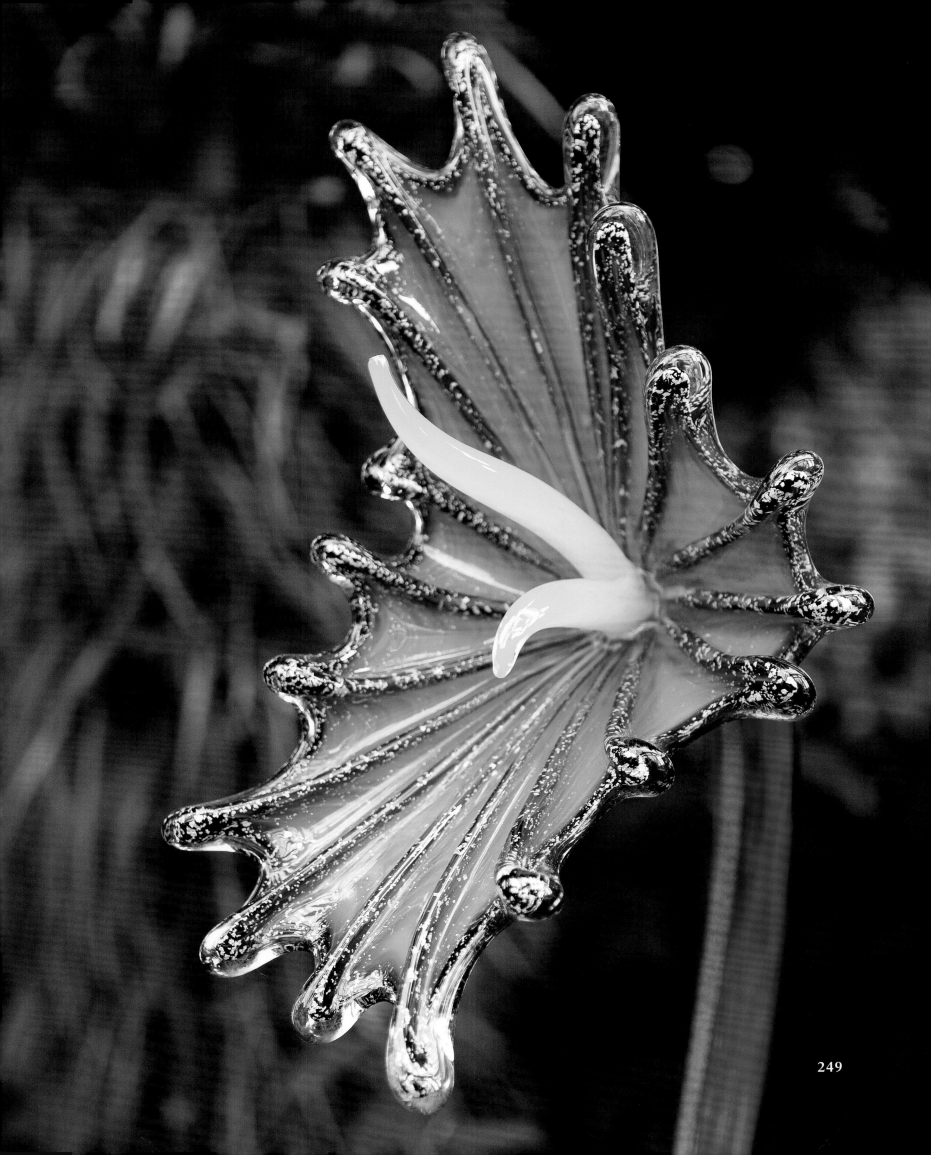

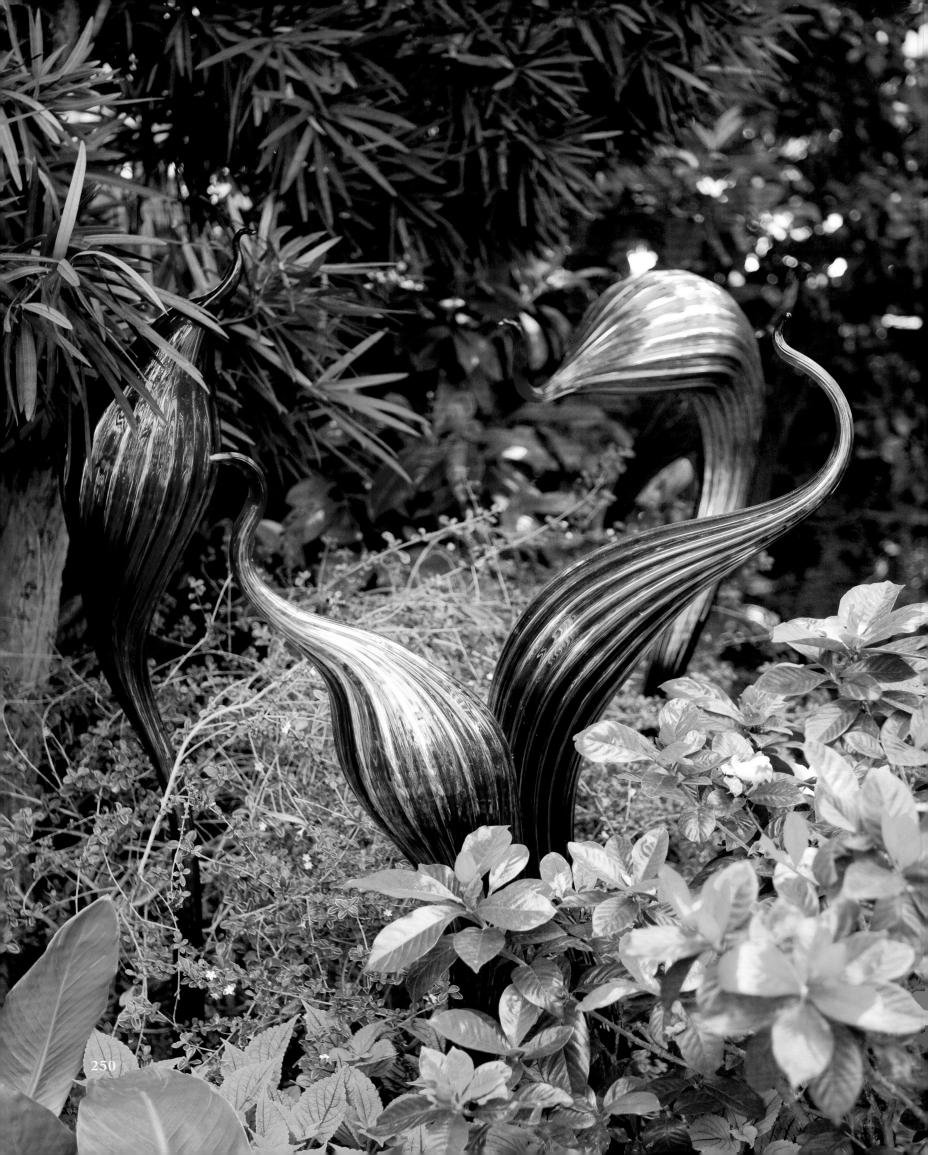

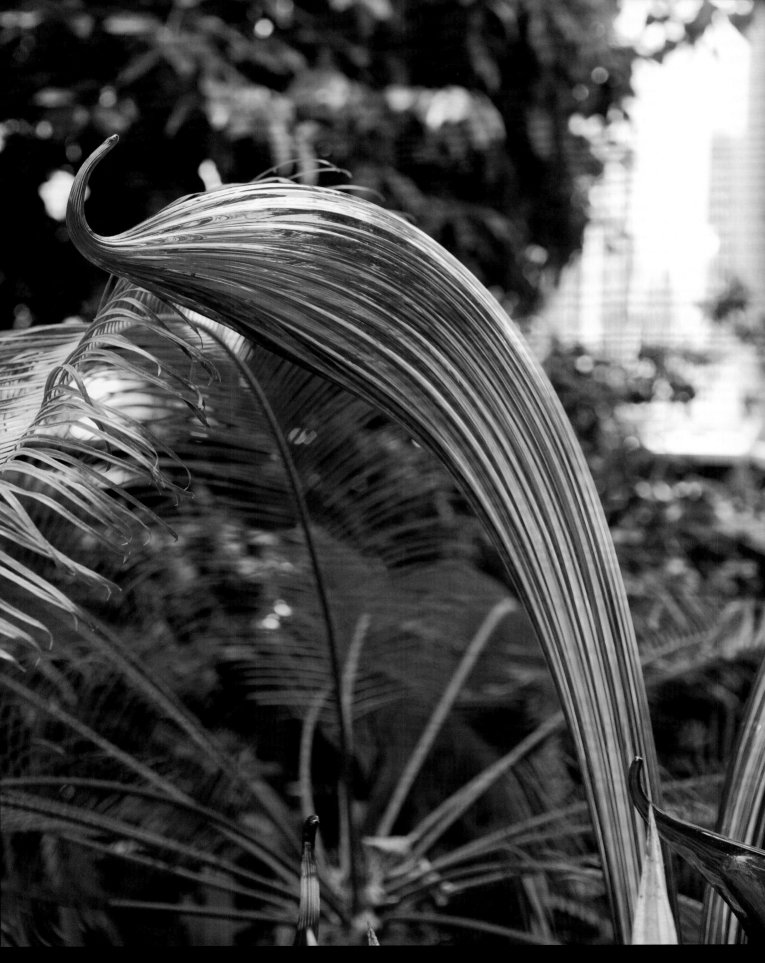

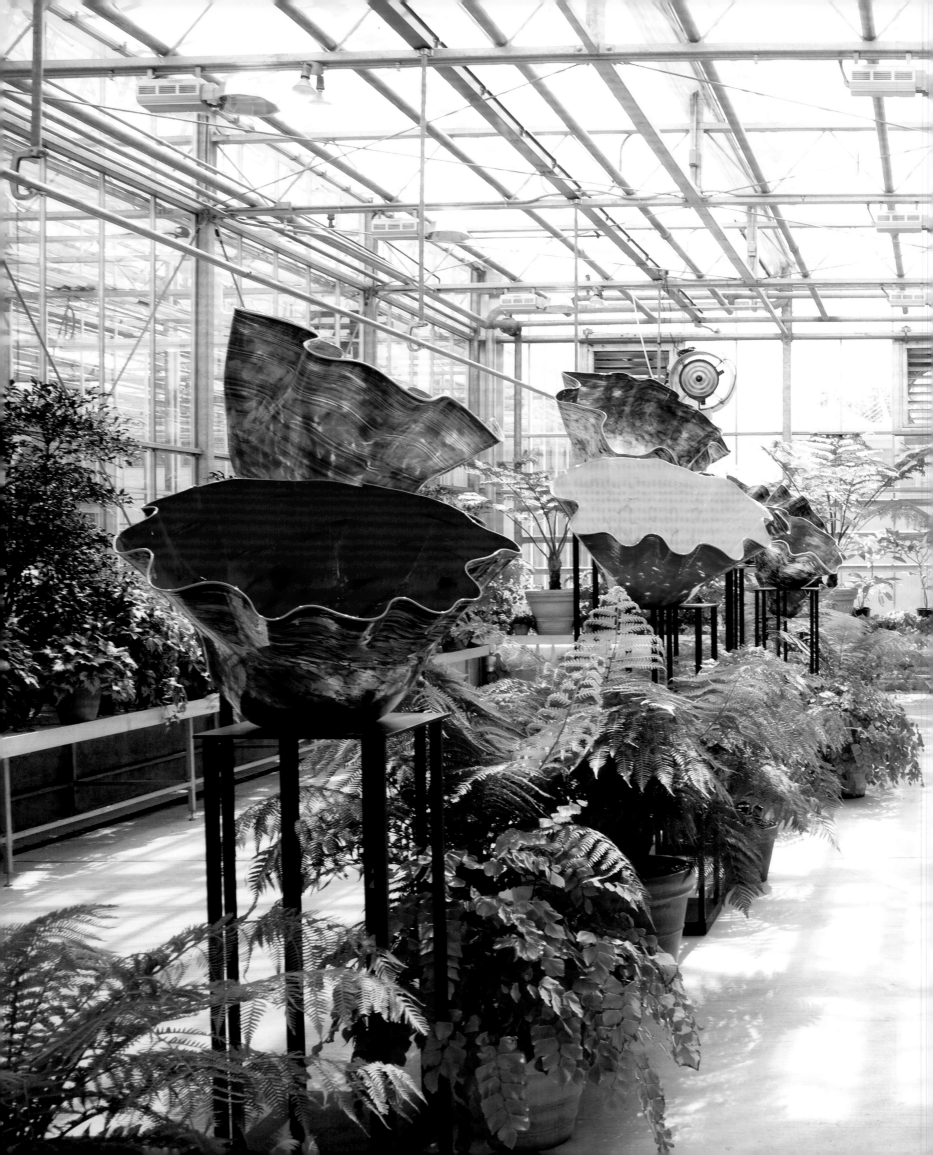

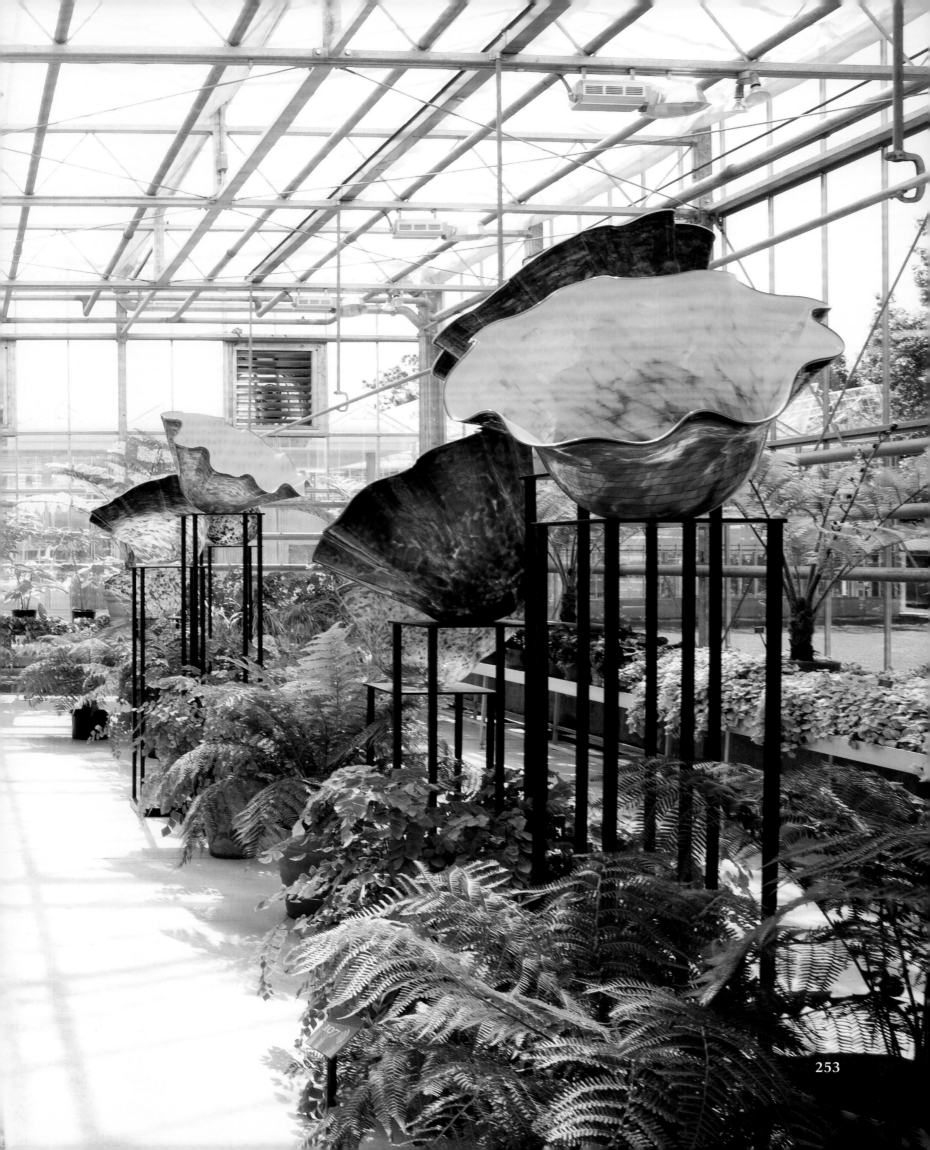

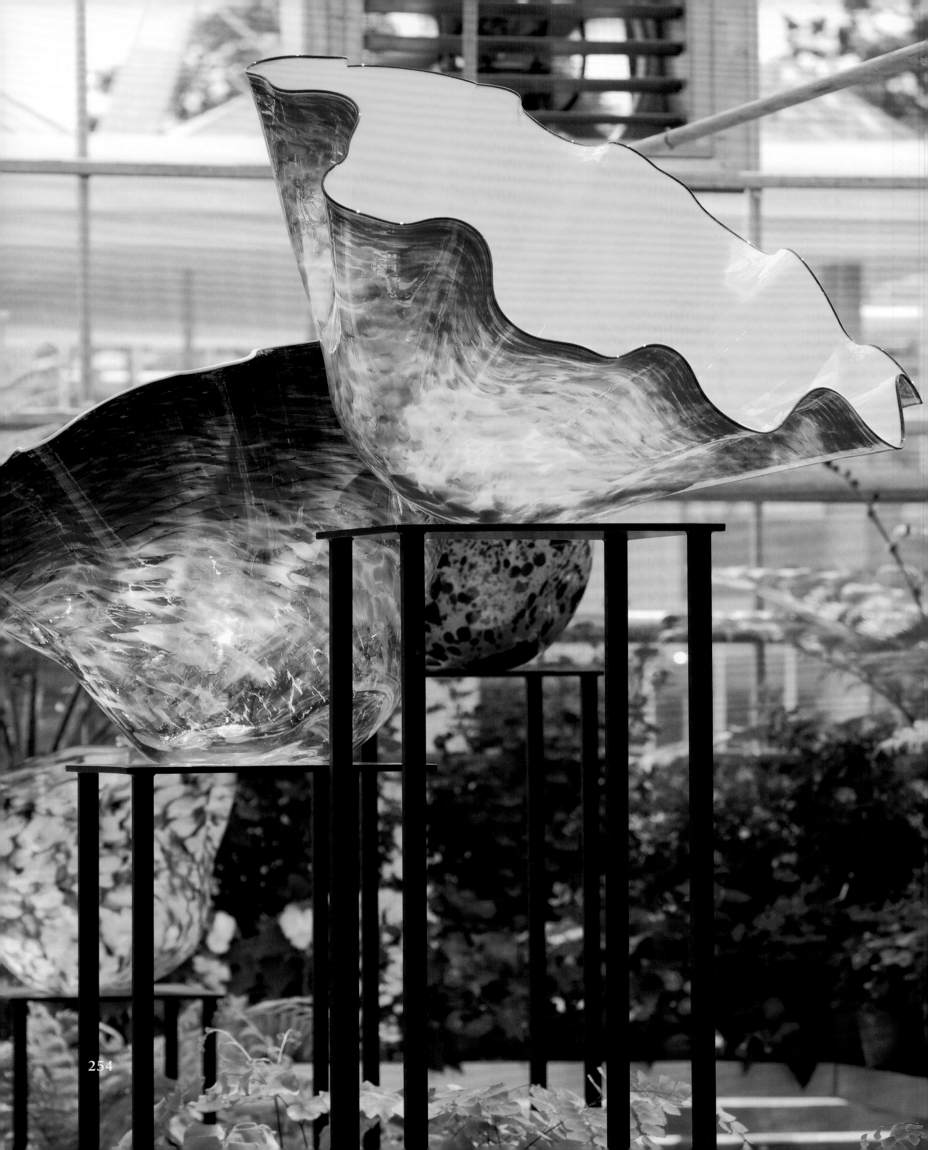

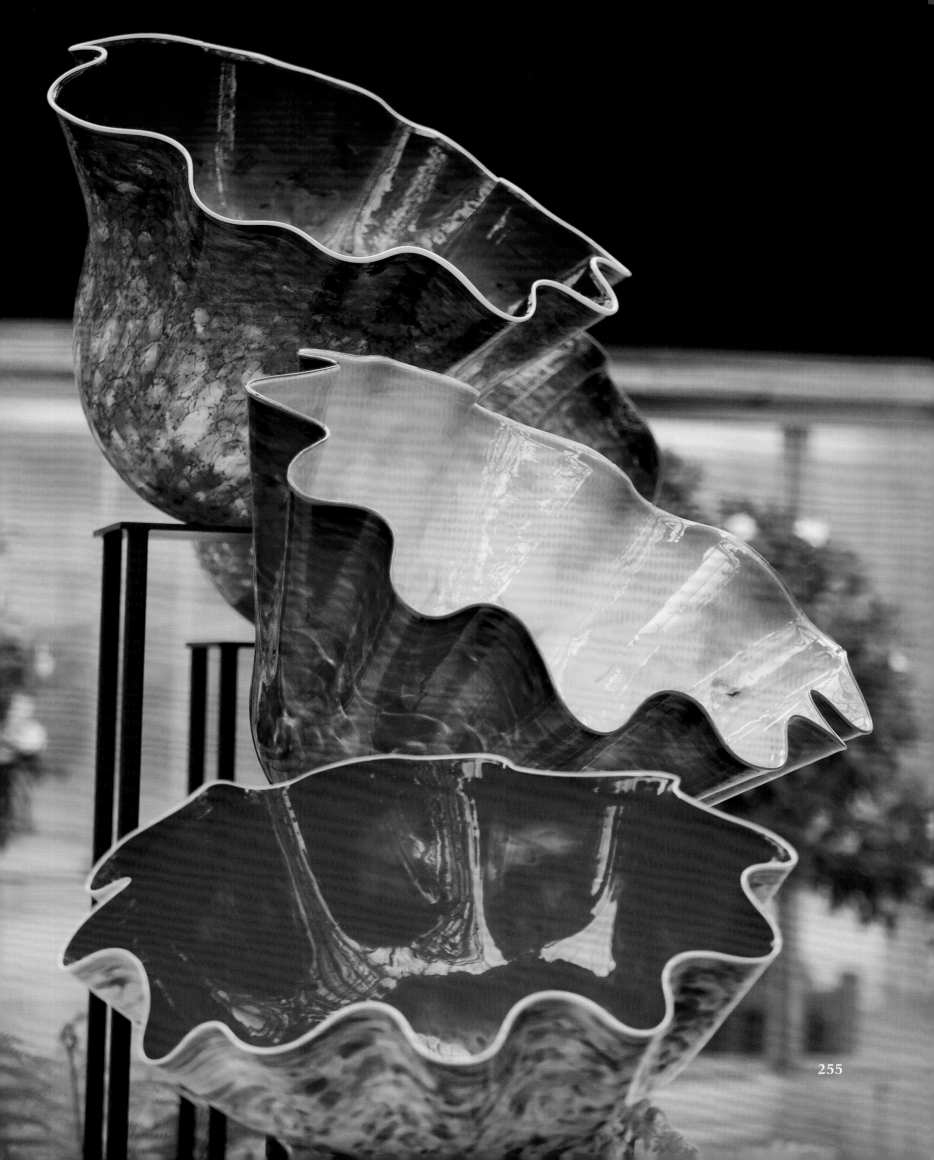

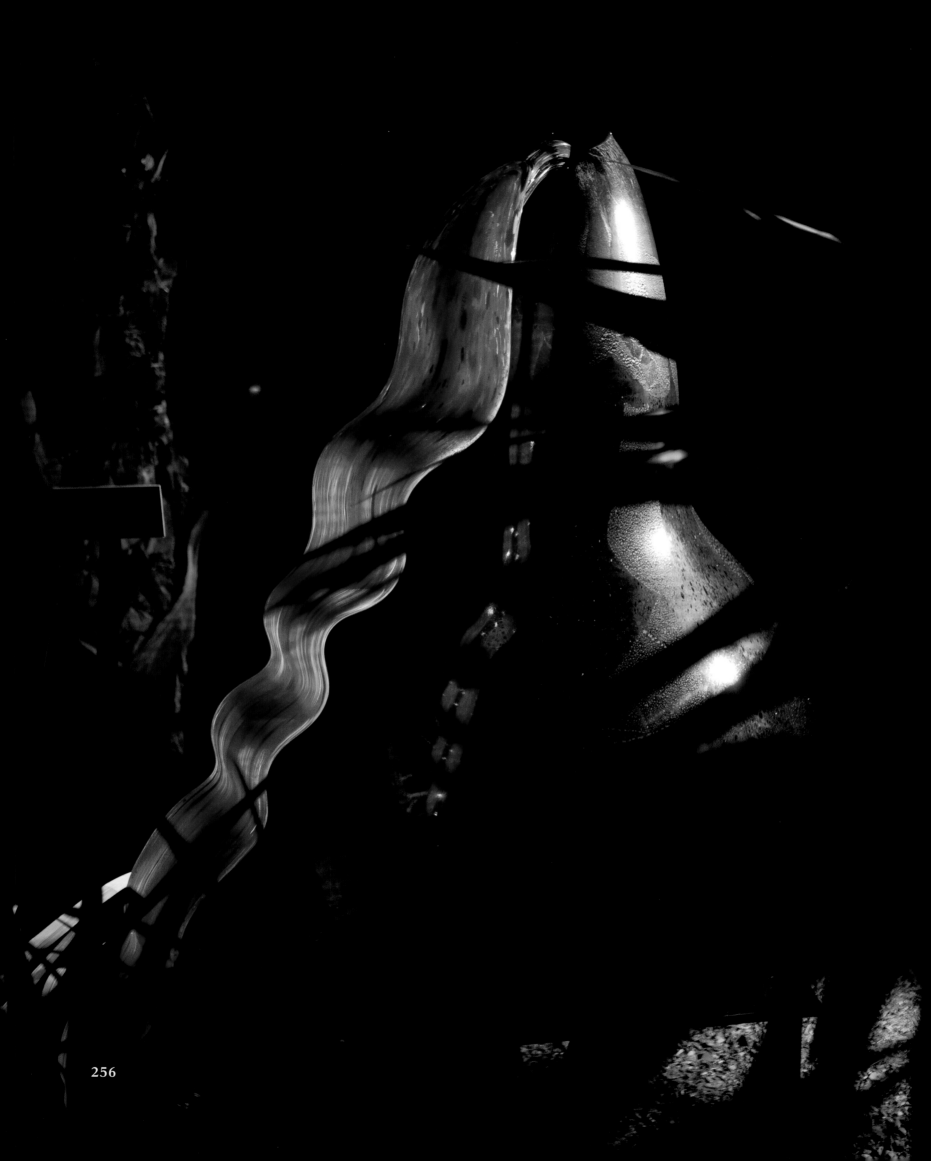

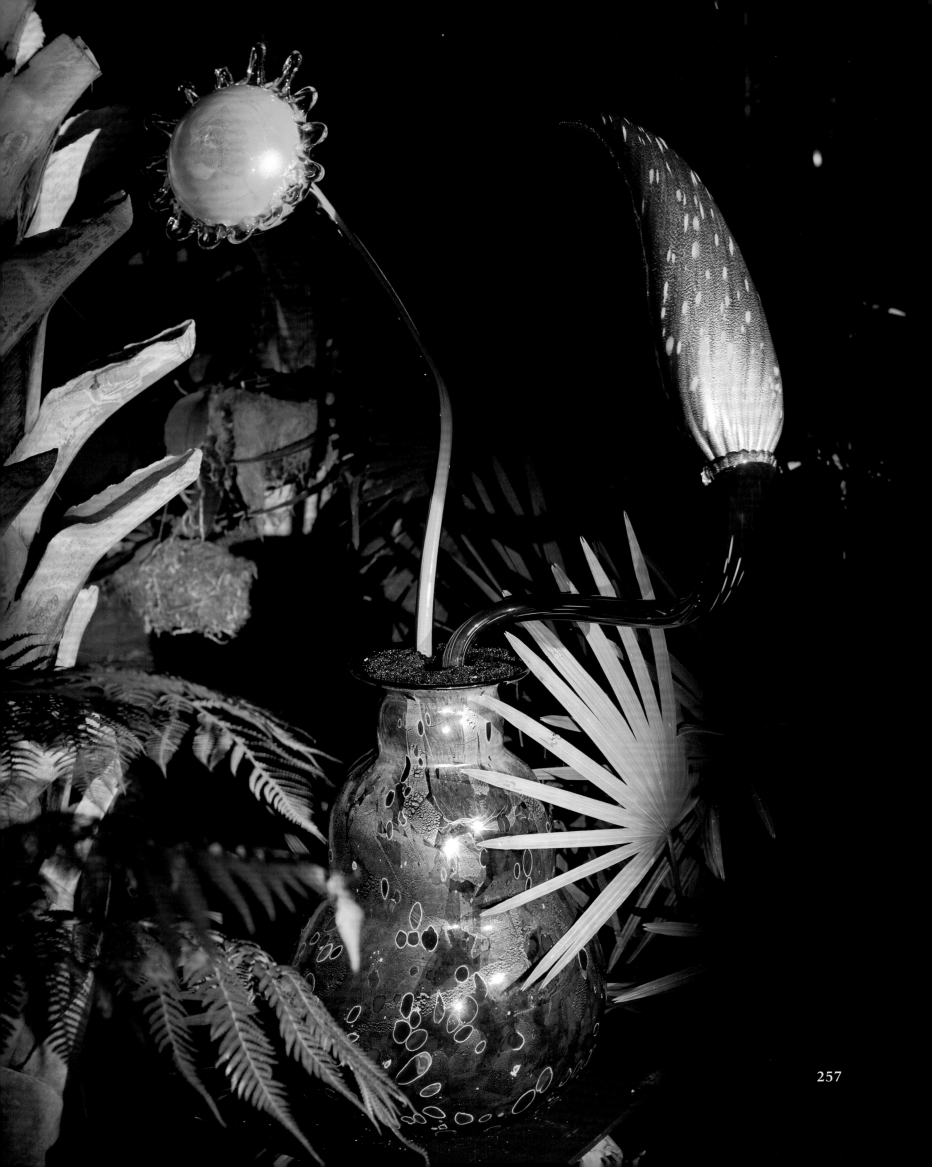

257

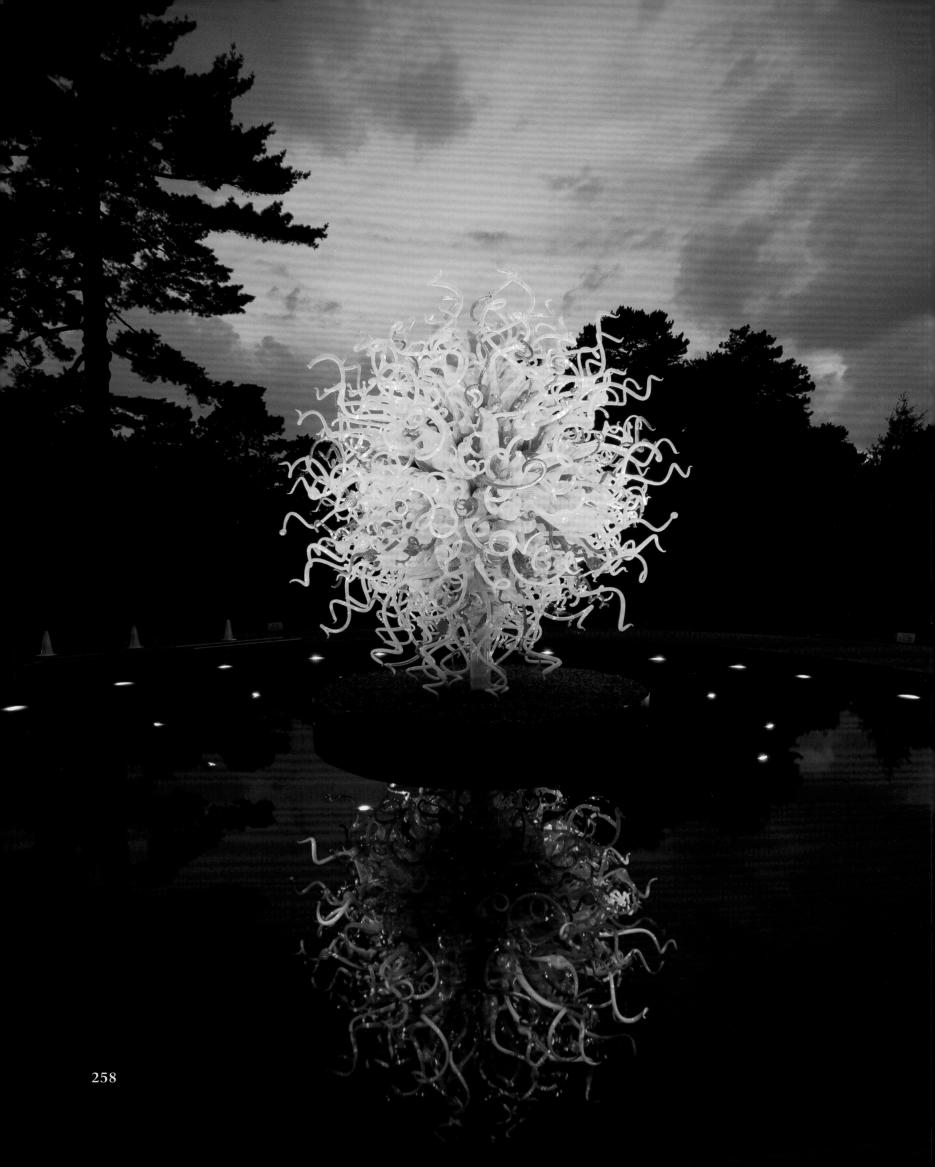

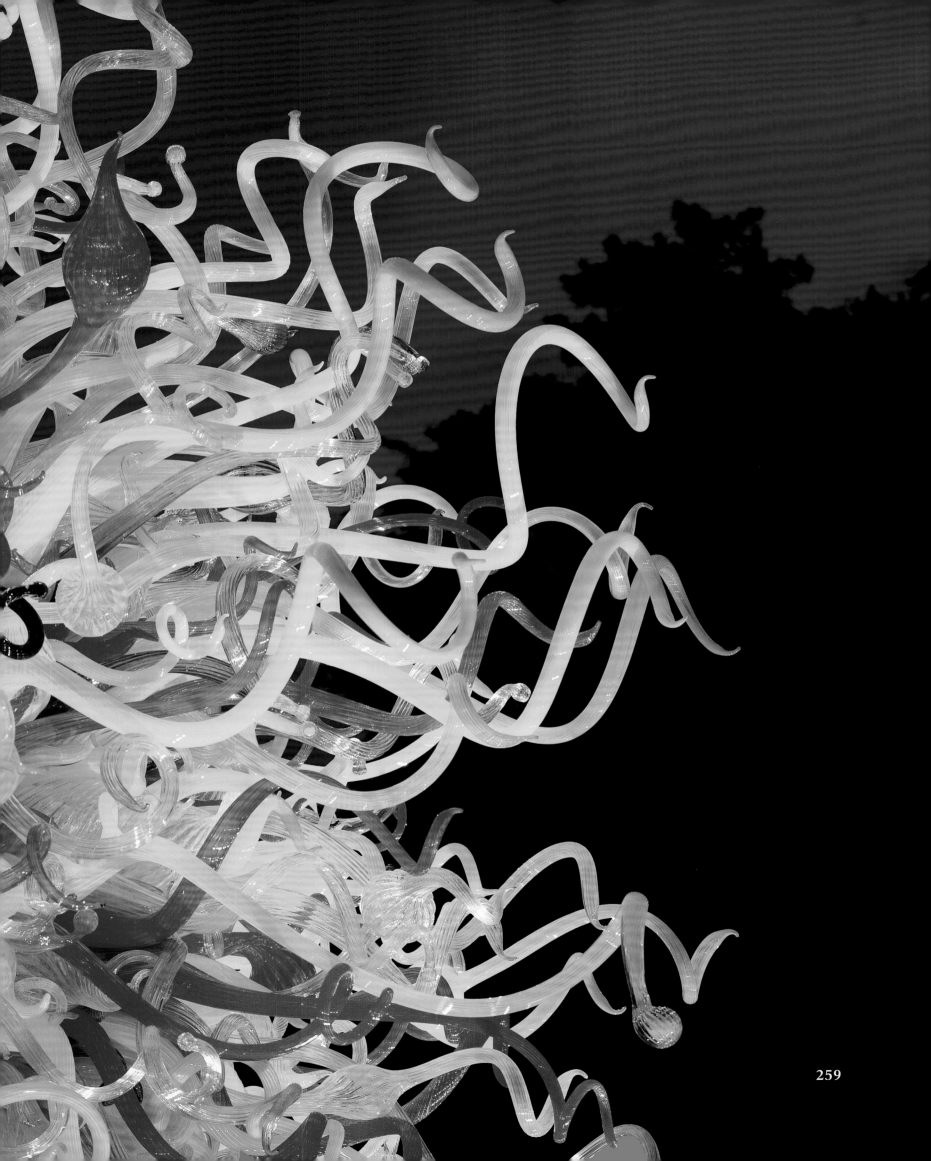

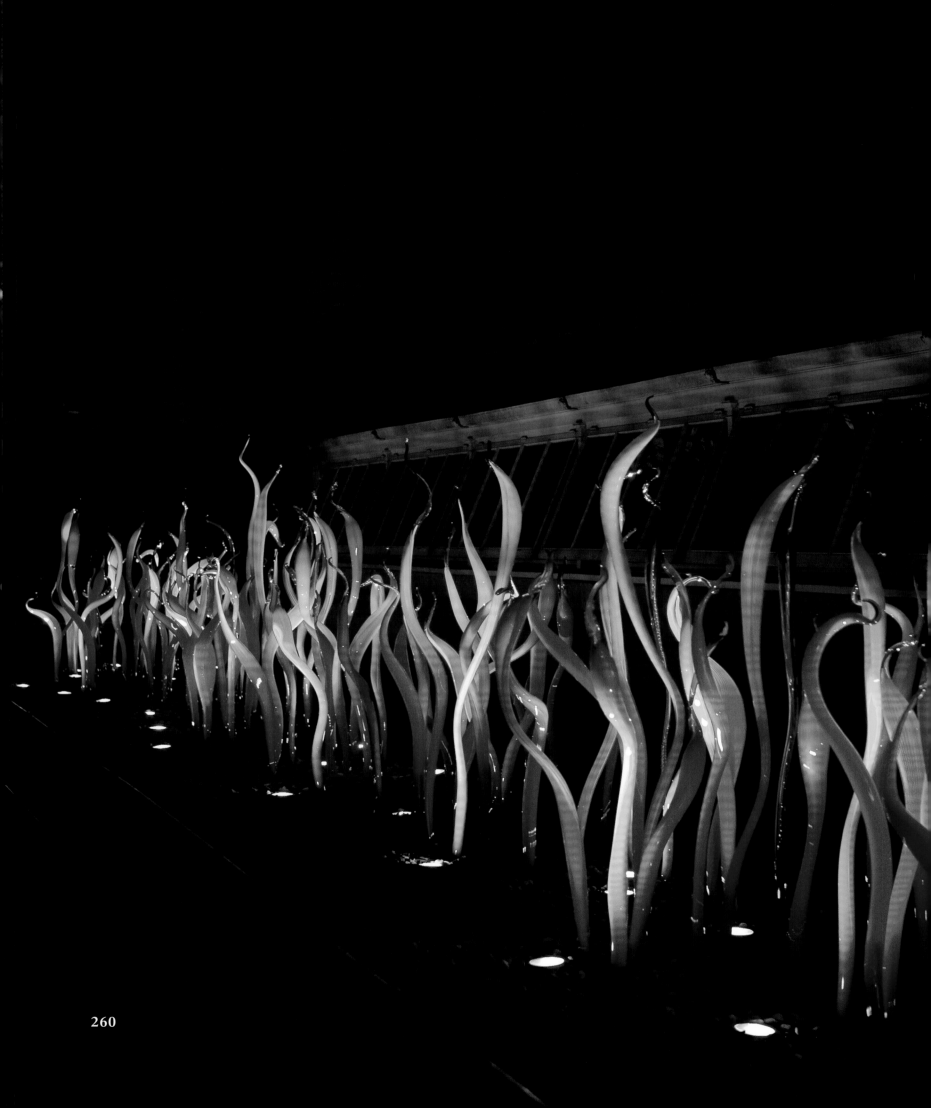

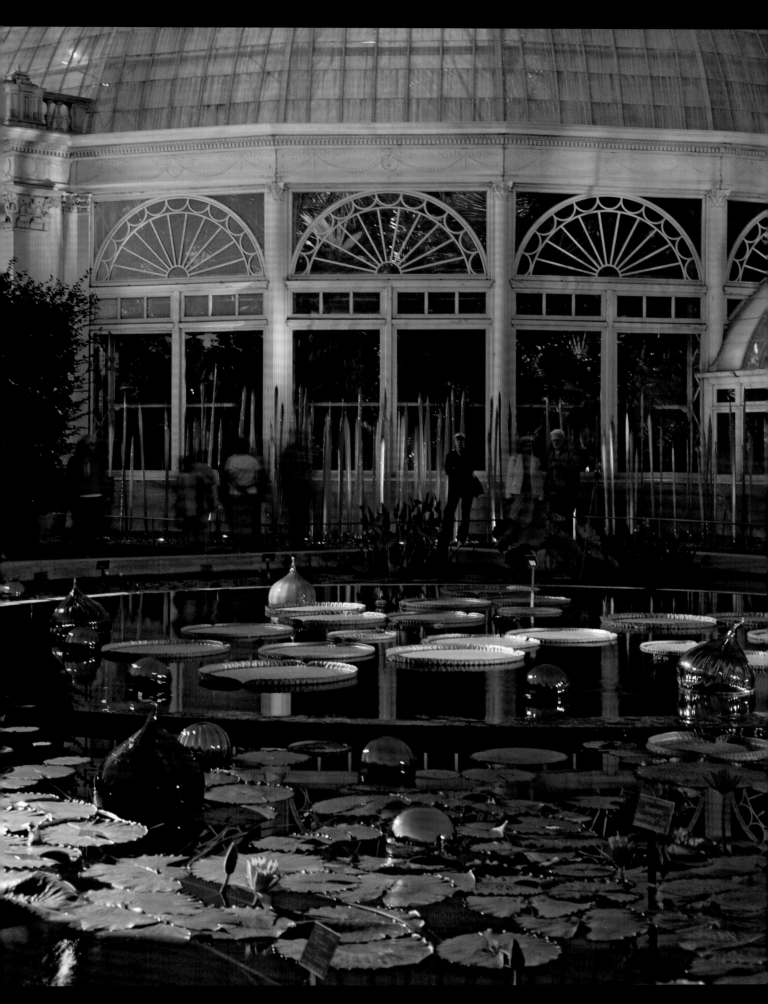

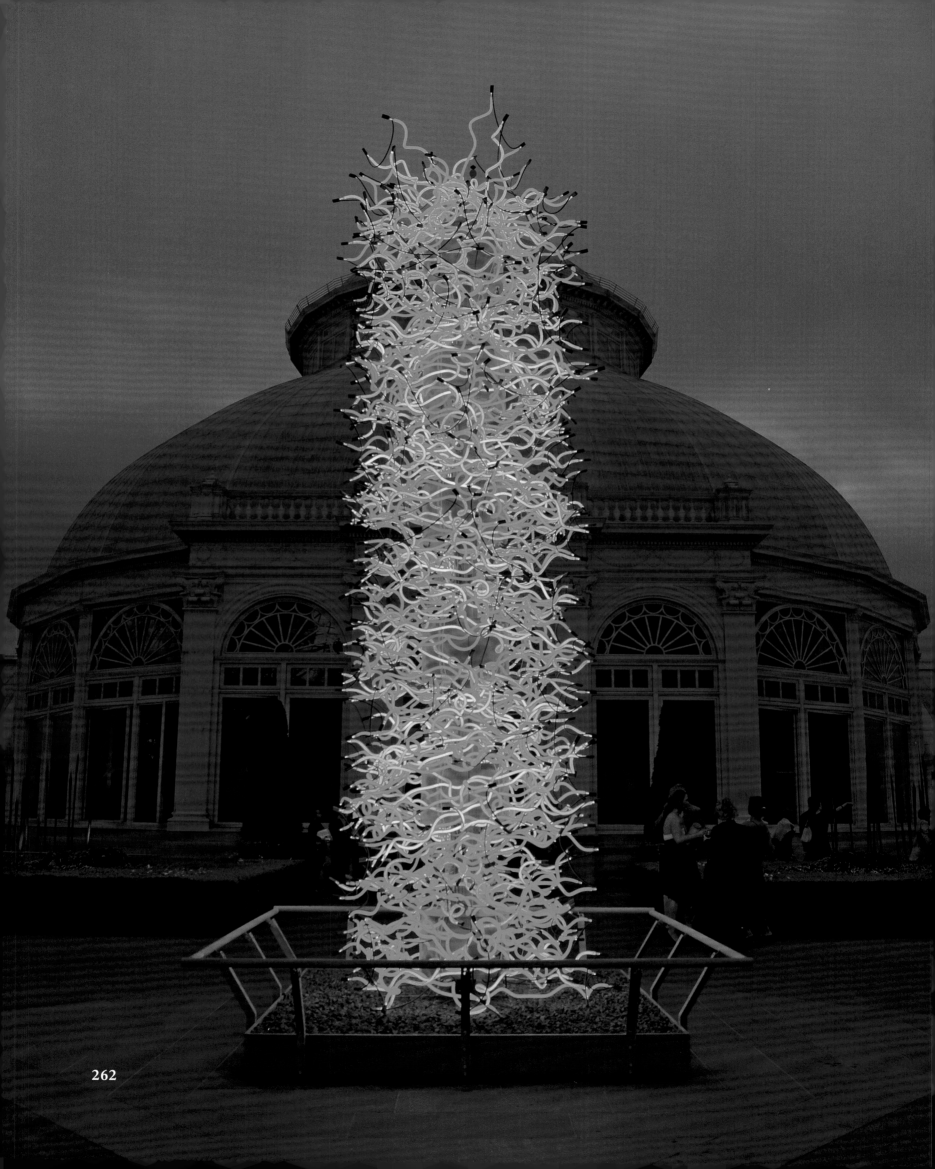

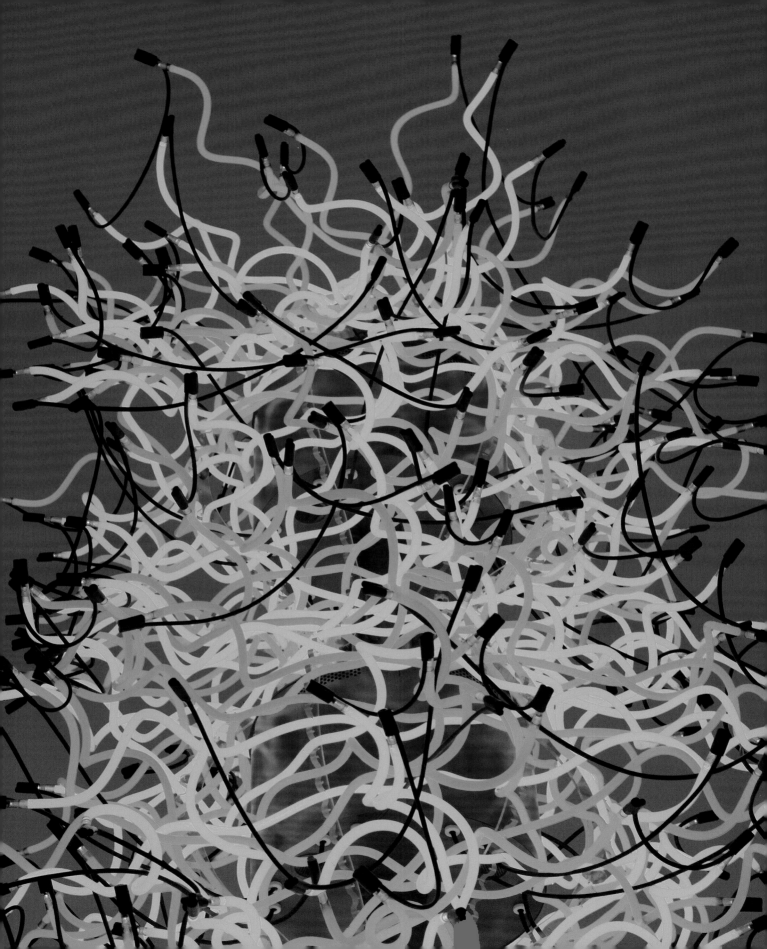

Phipps Conservatory
and Botanical Gardens
Pittsburgh, Pennsylvania

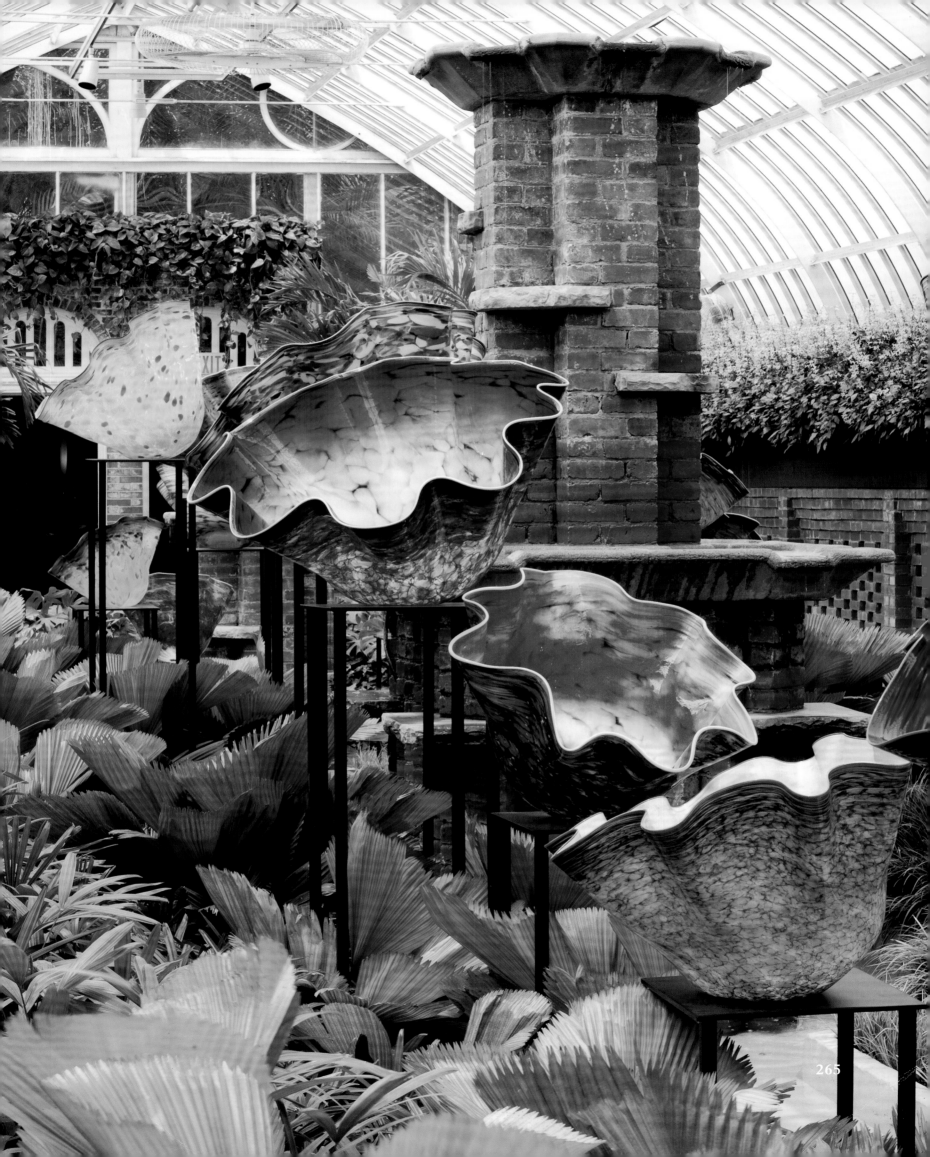

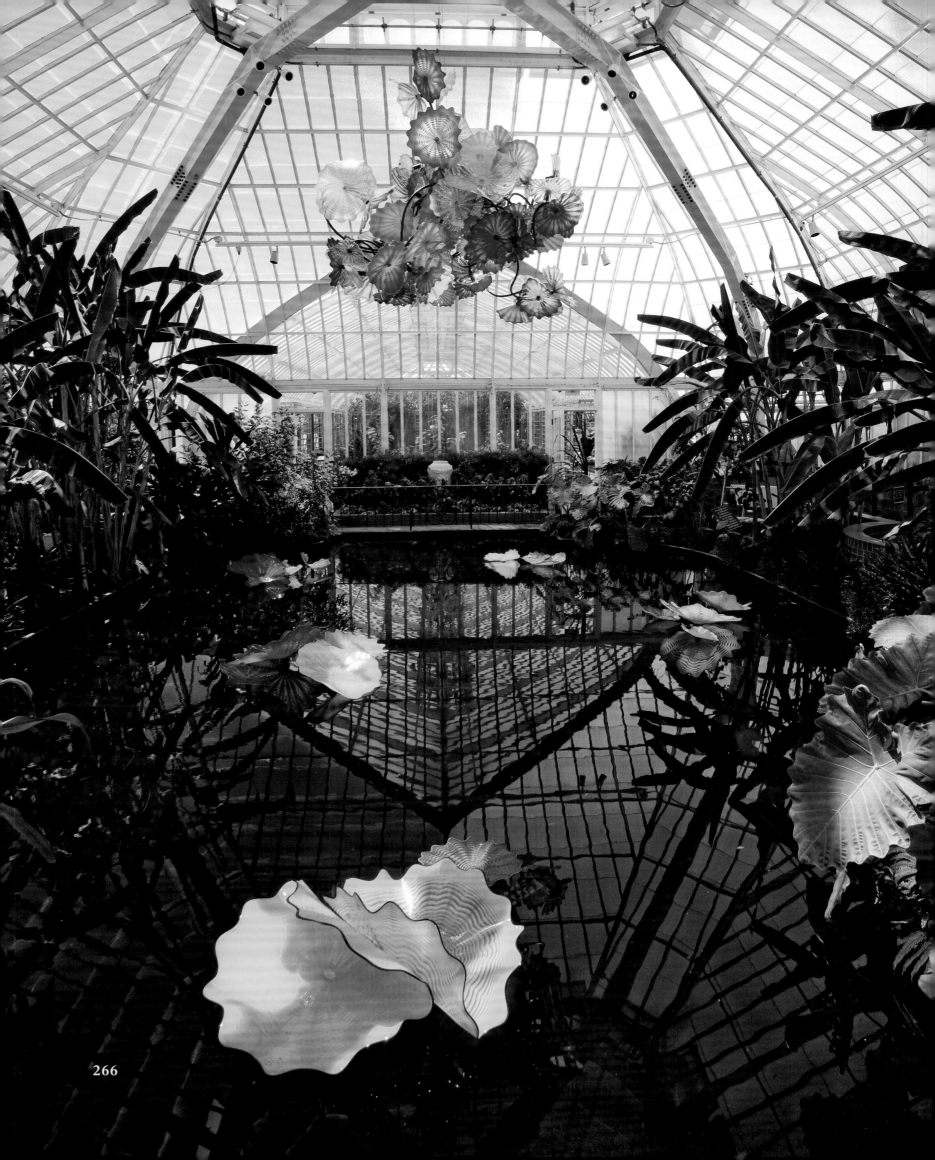

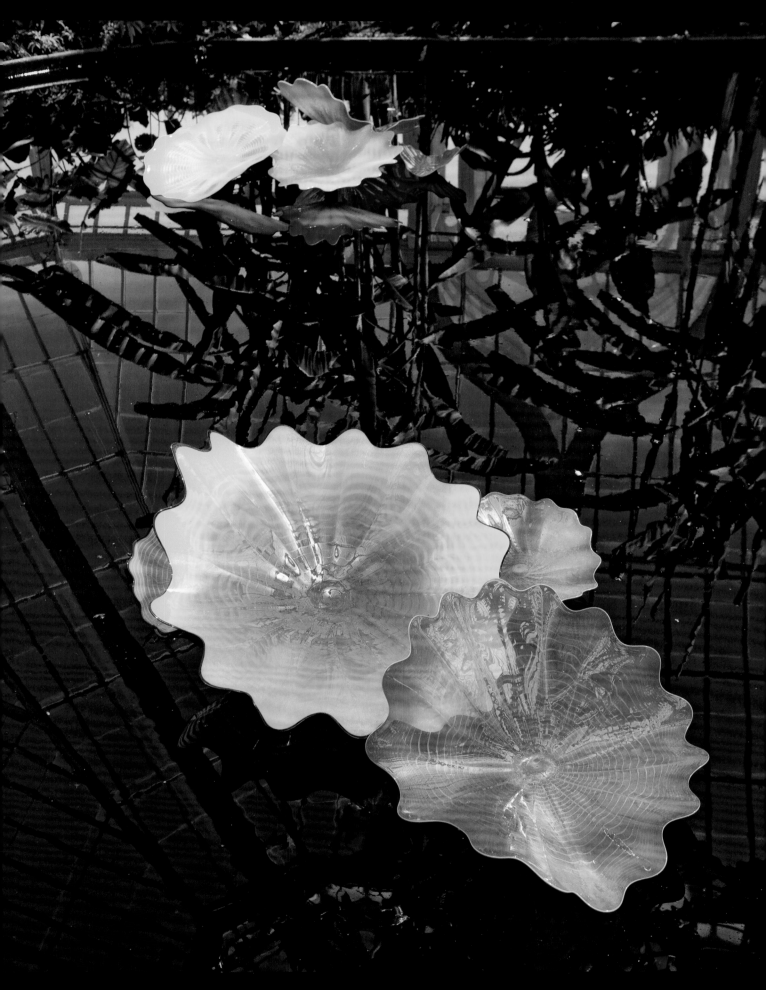

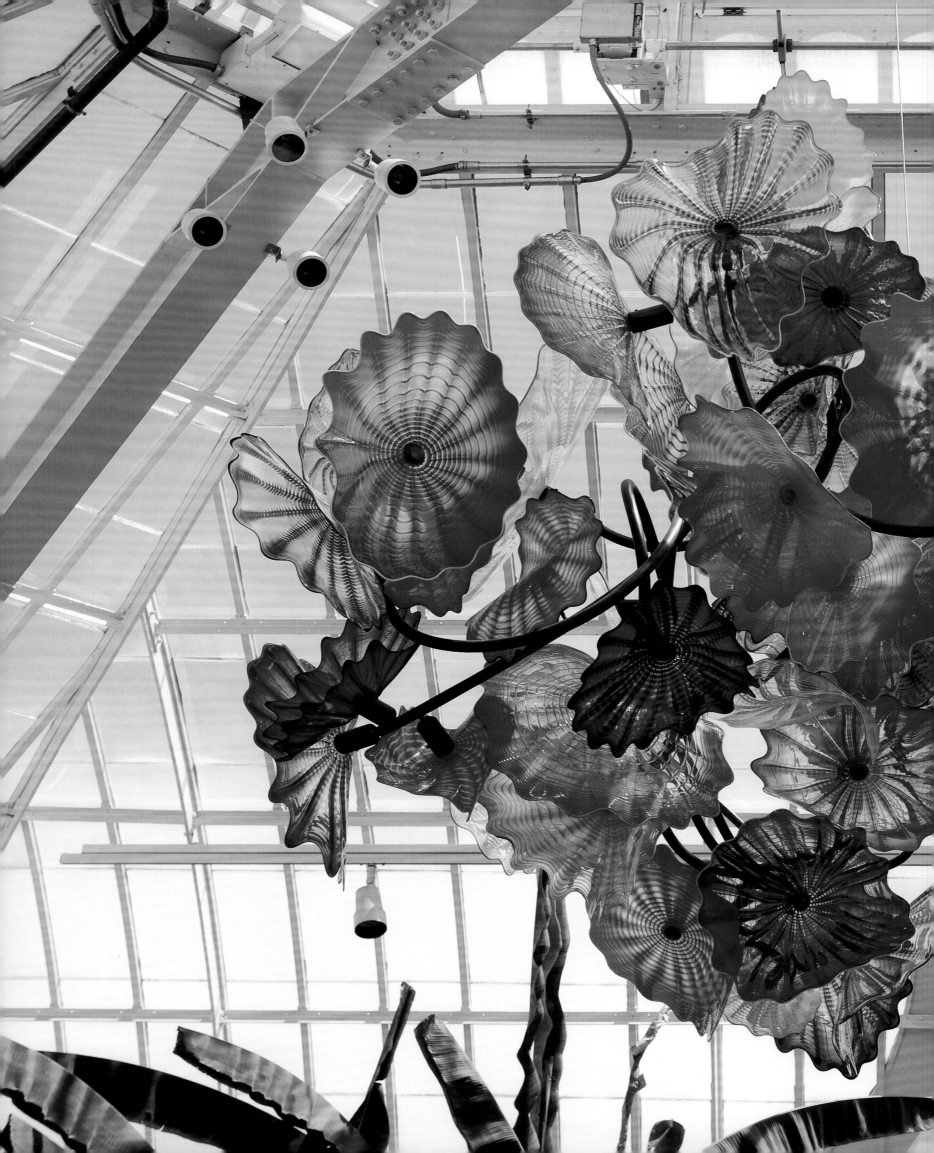

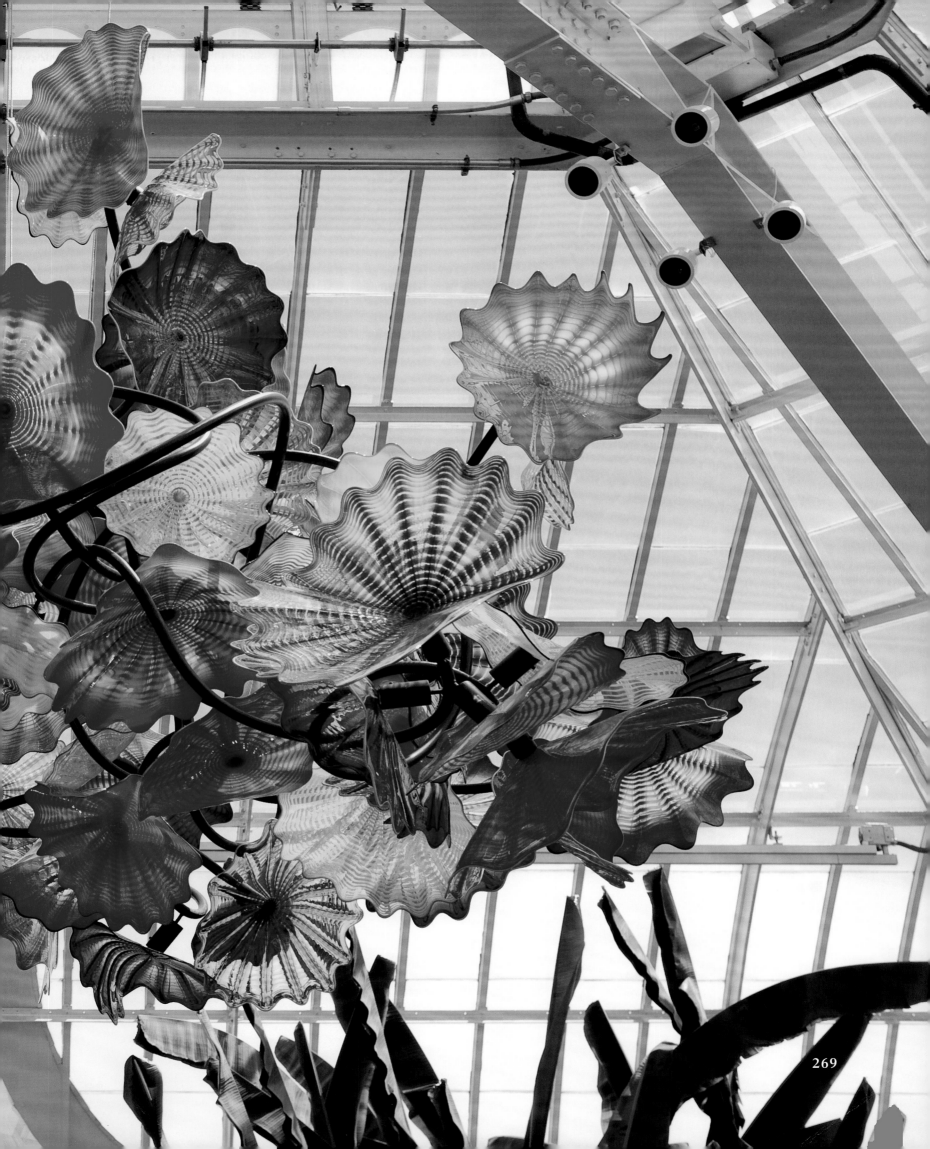

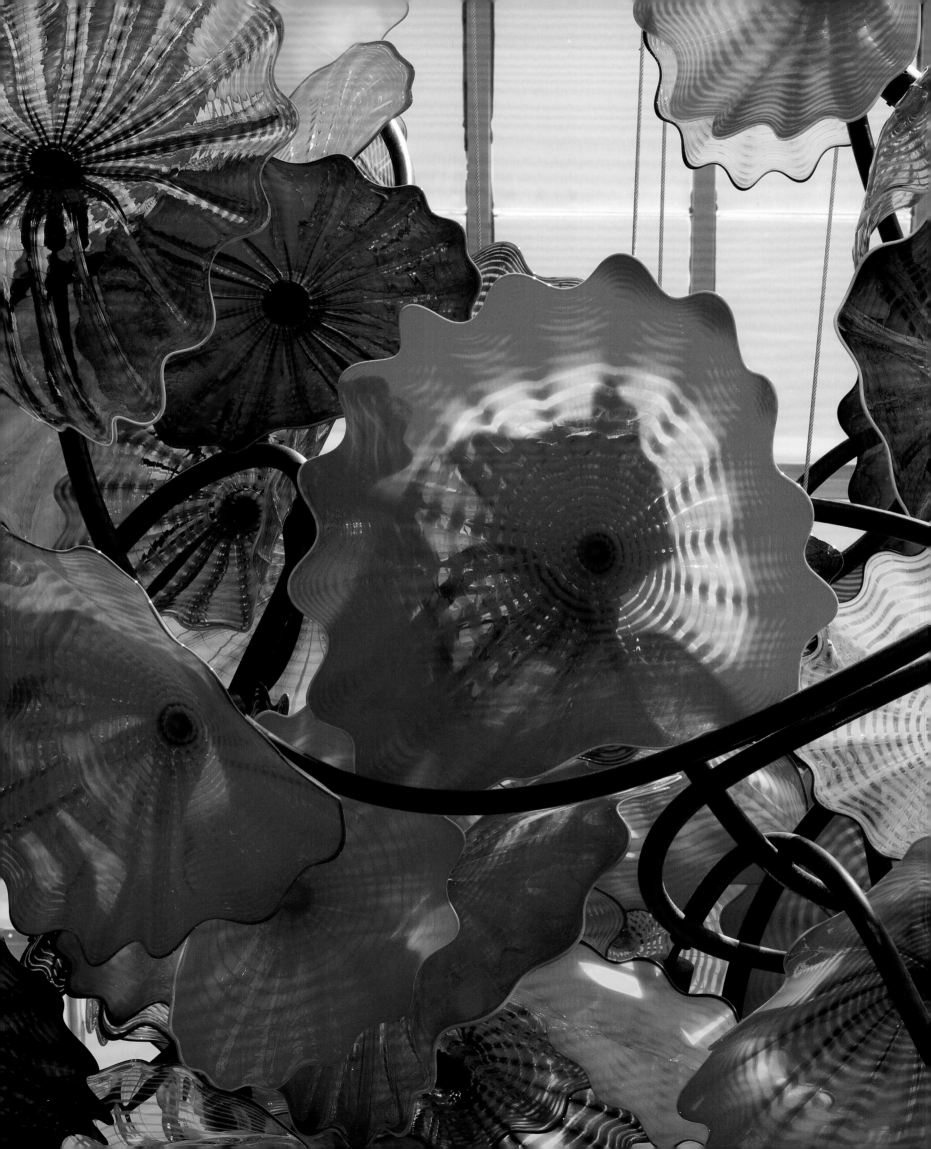

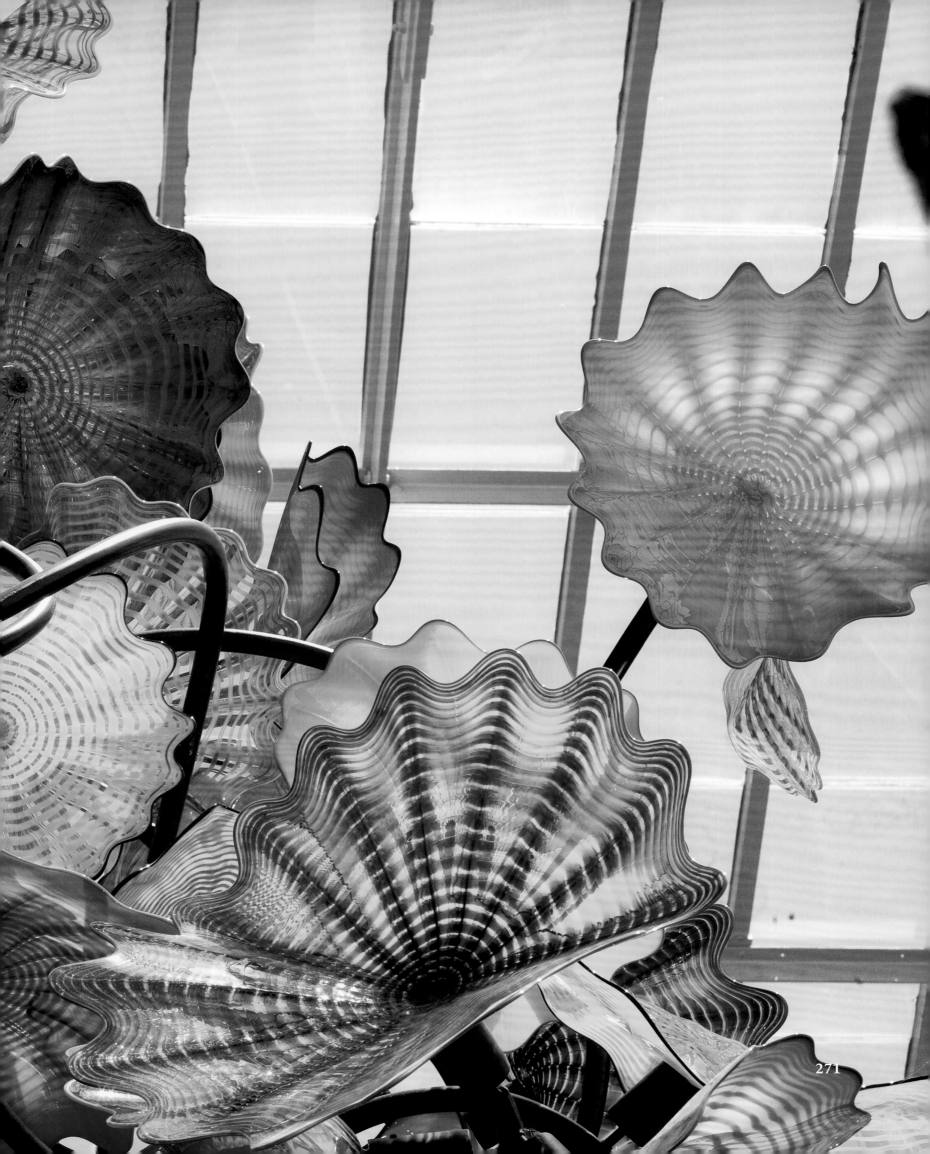
271

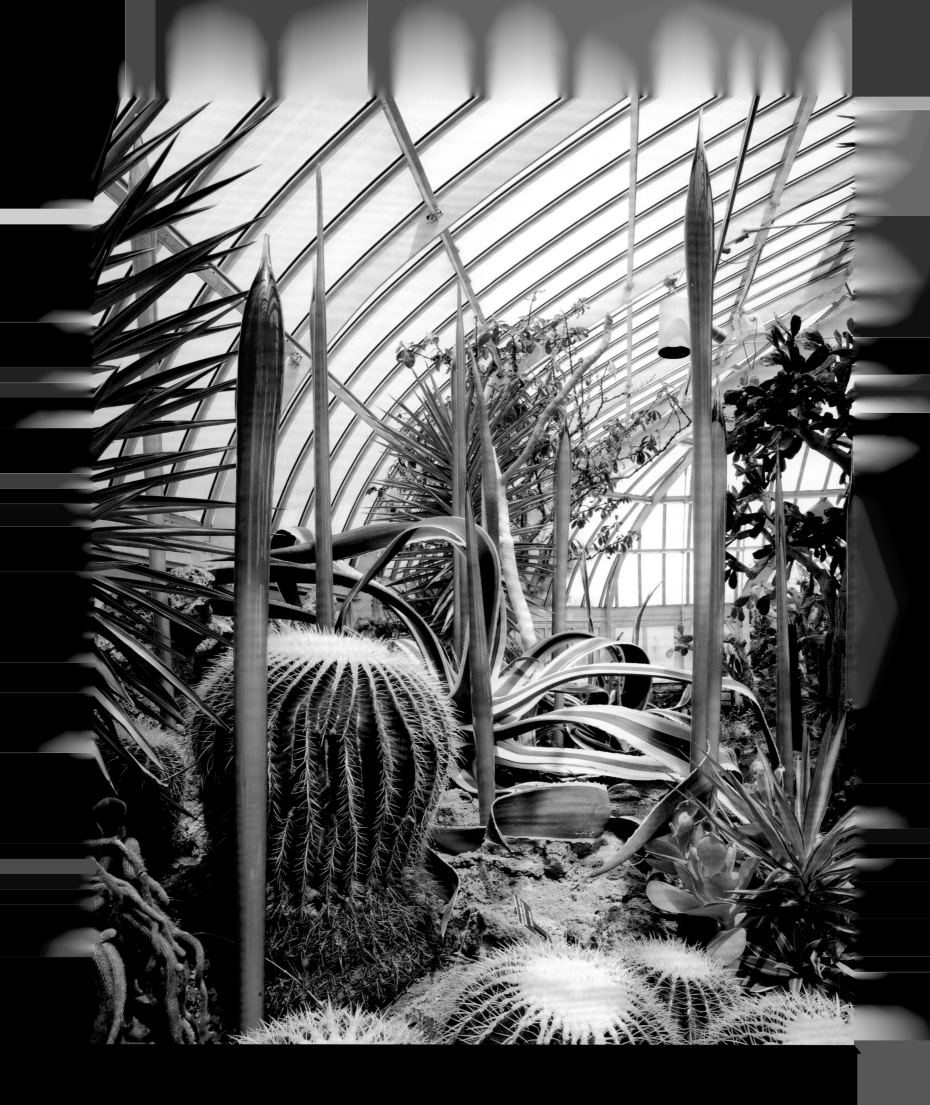

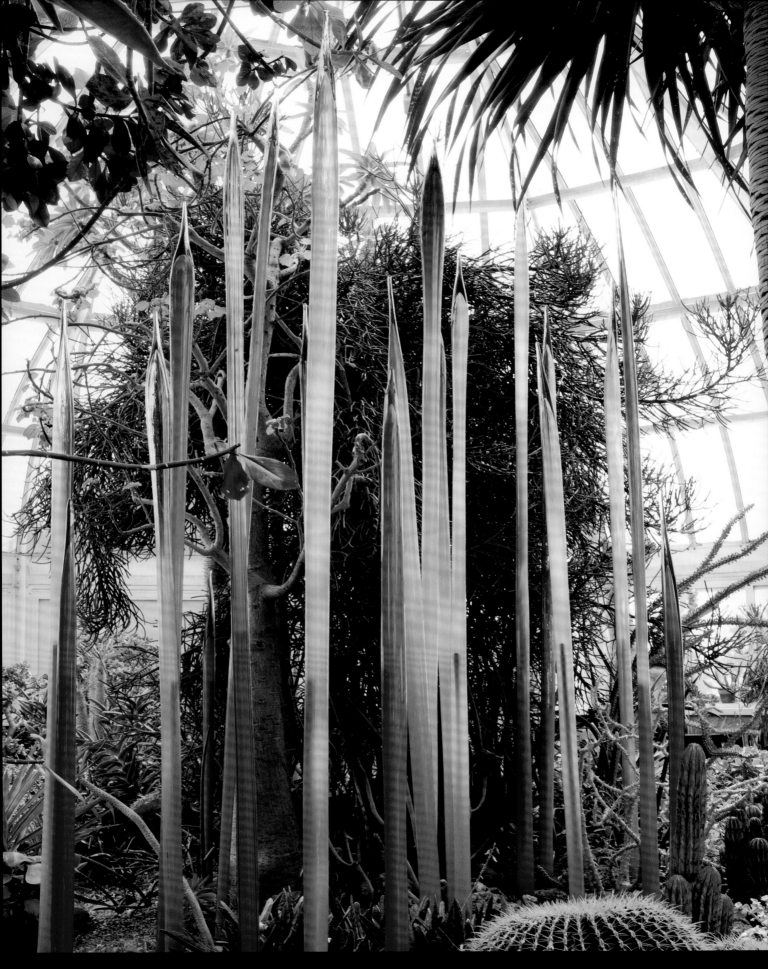

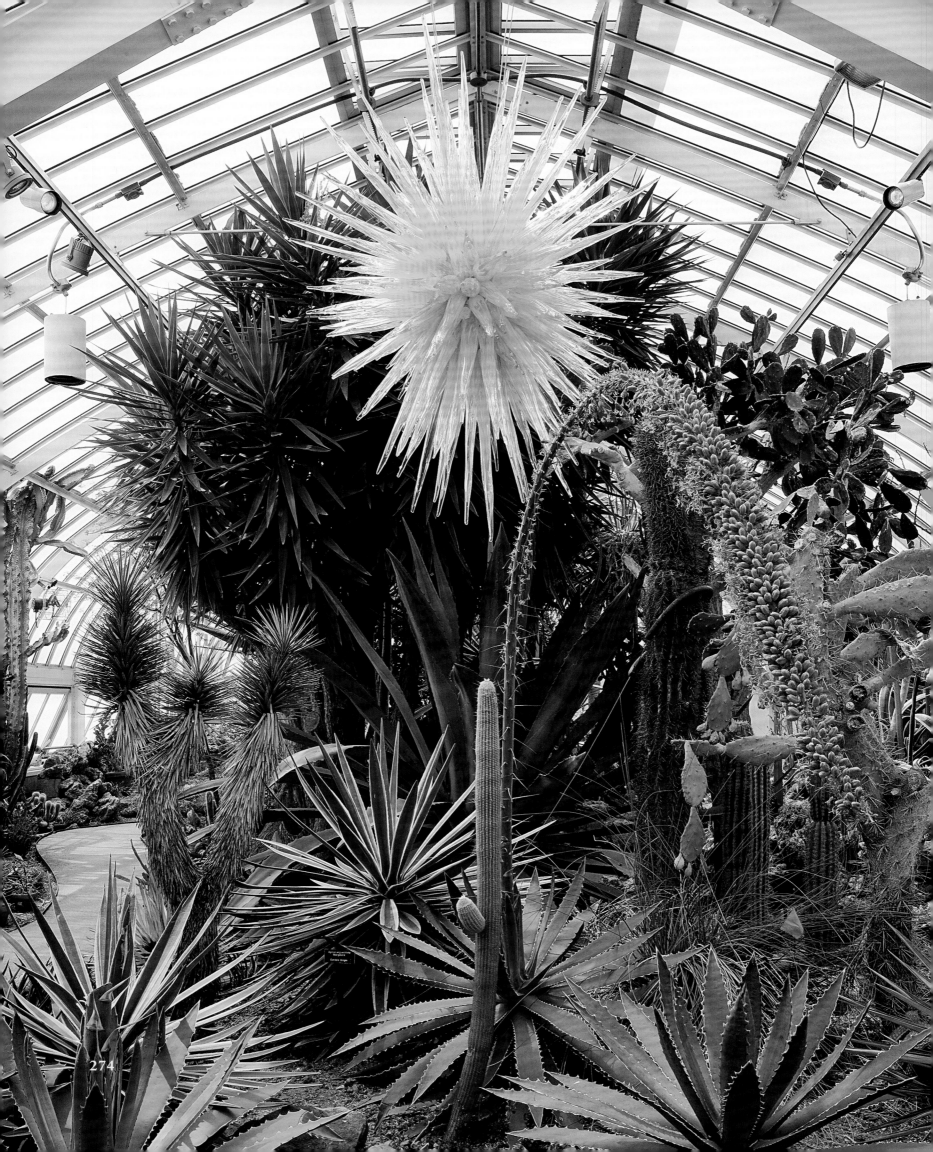

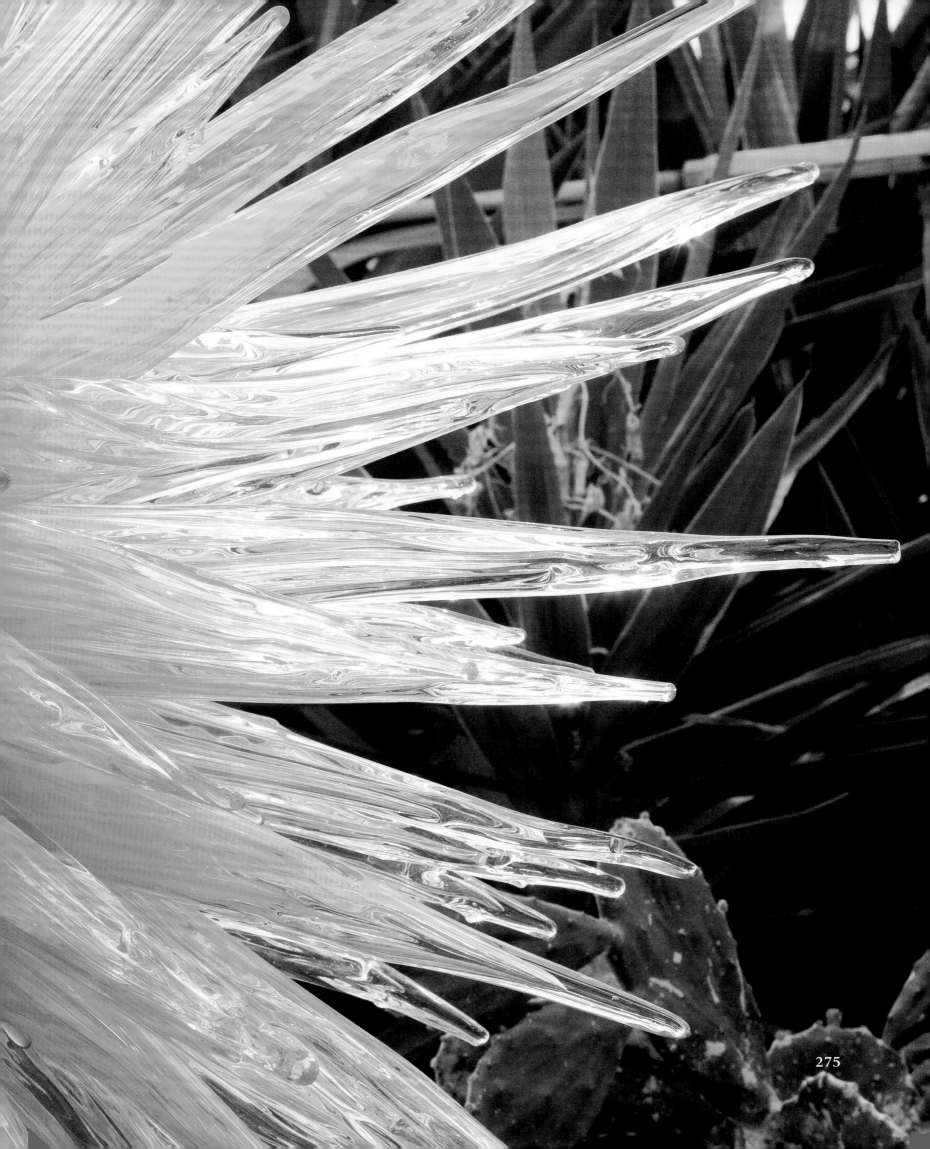

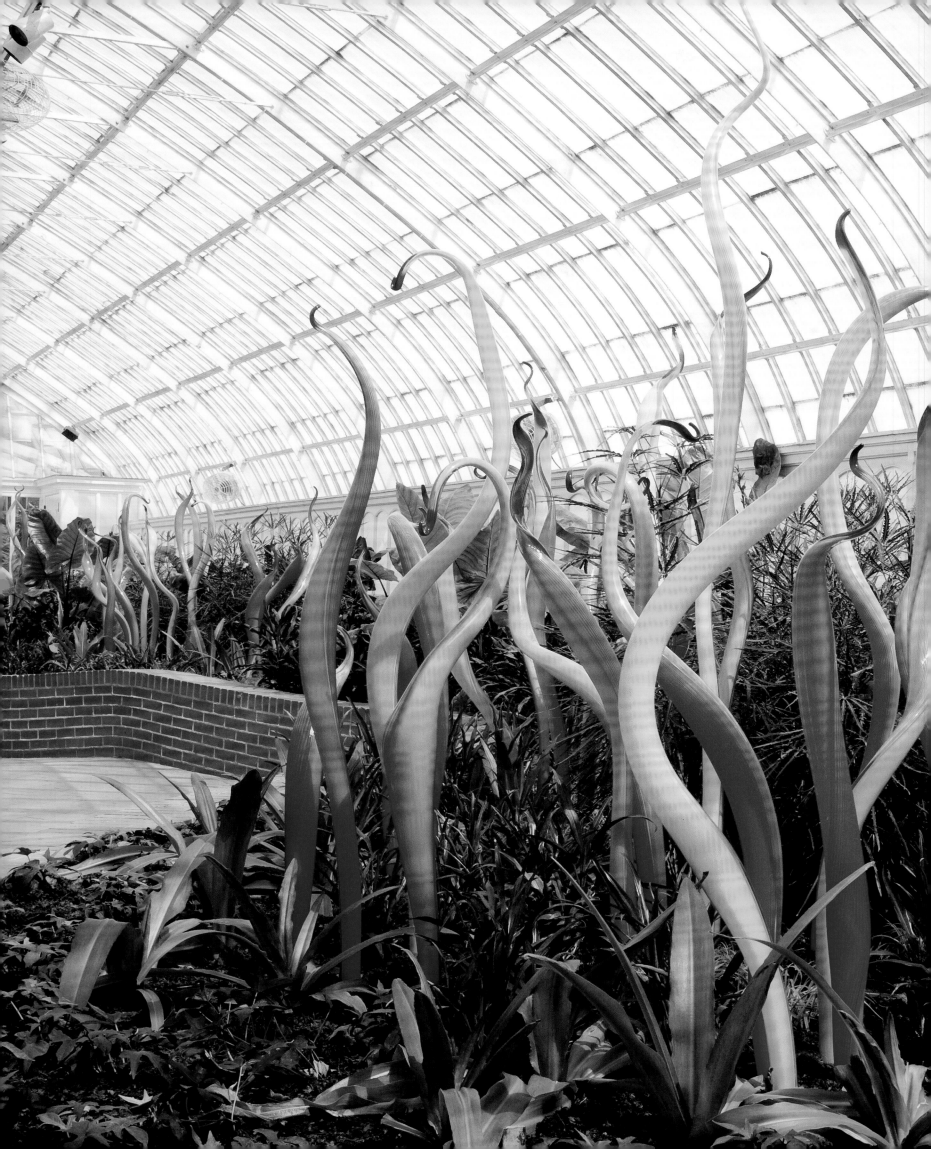

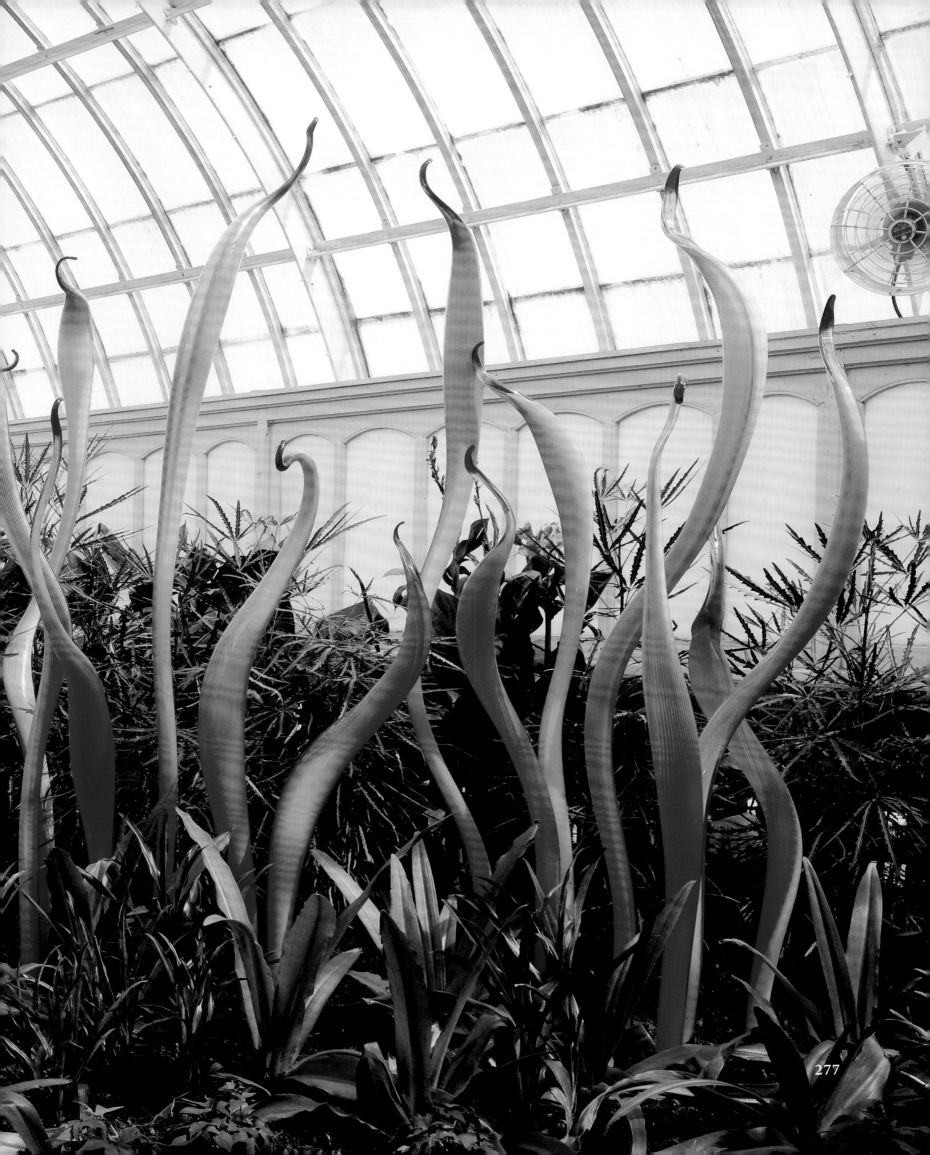

277

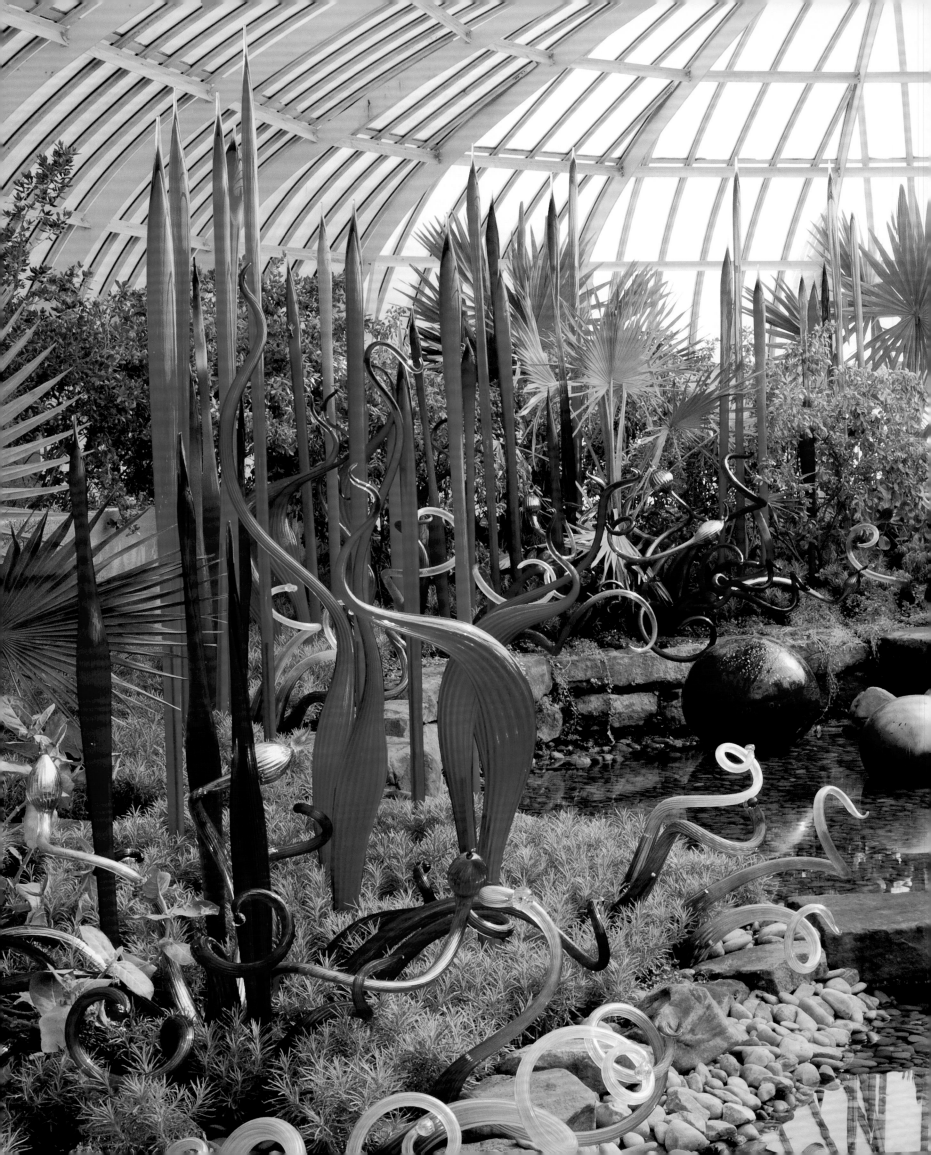

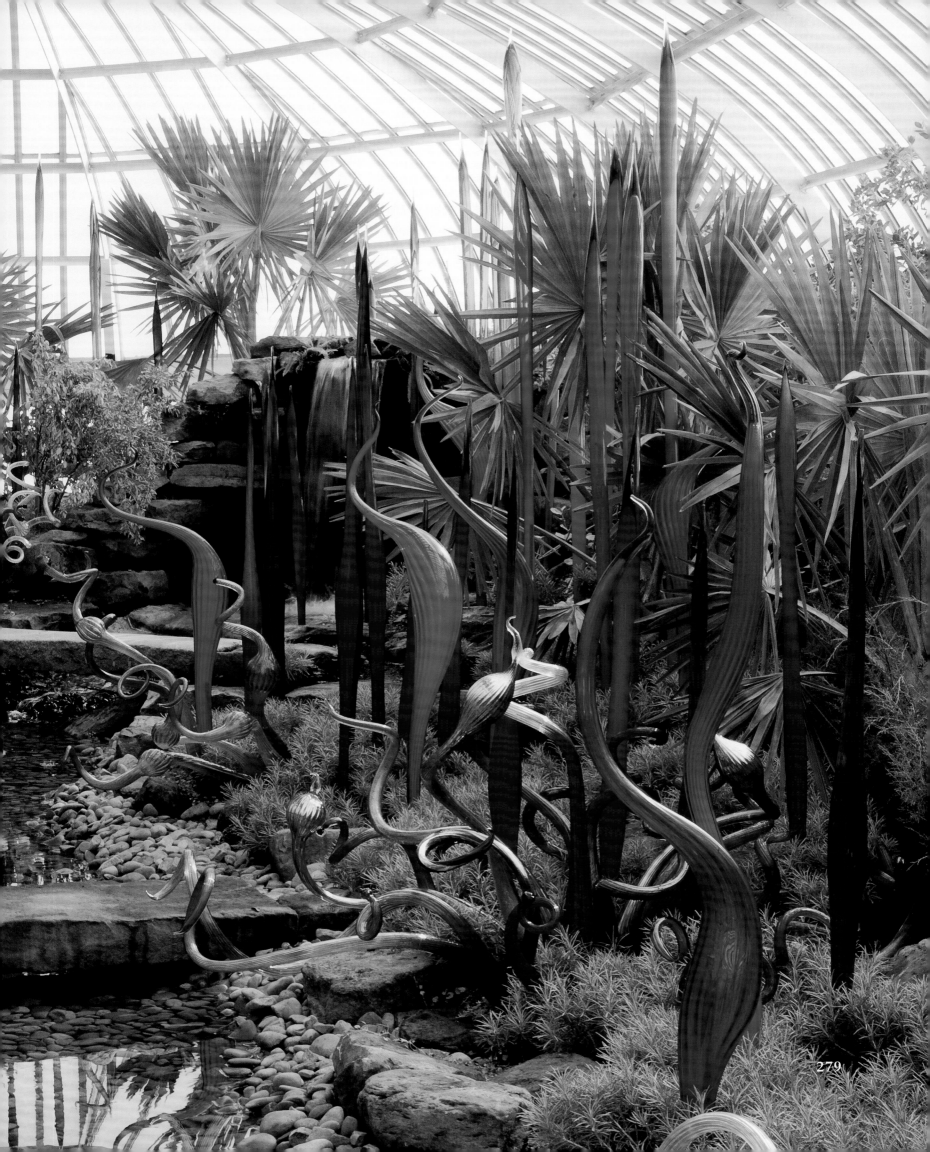

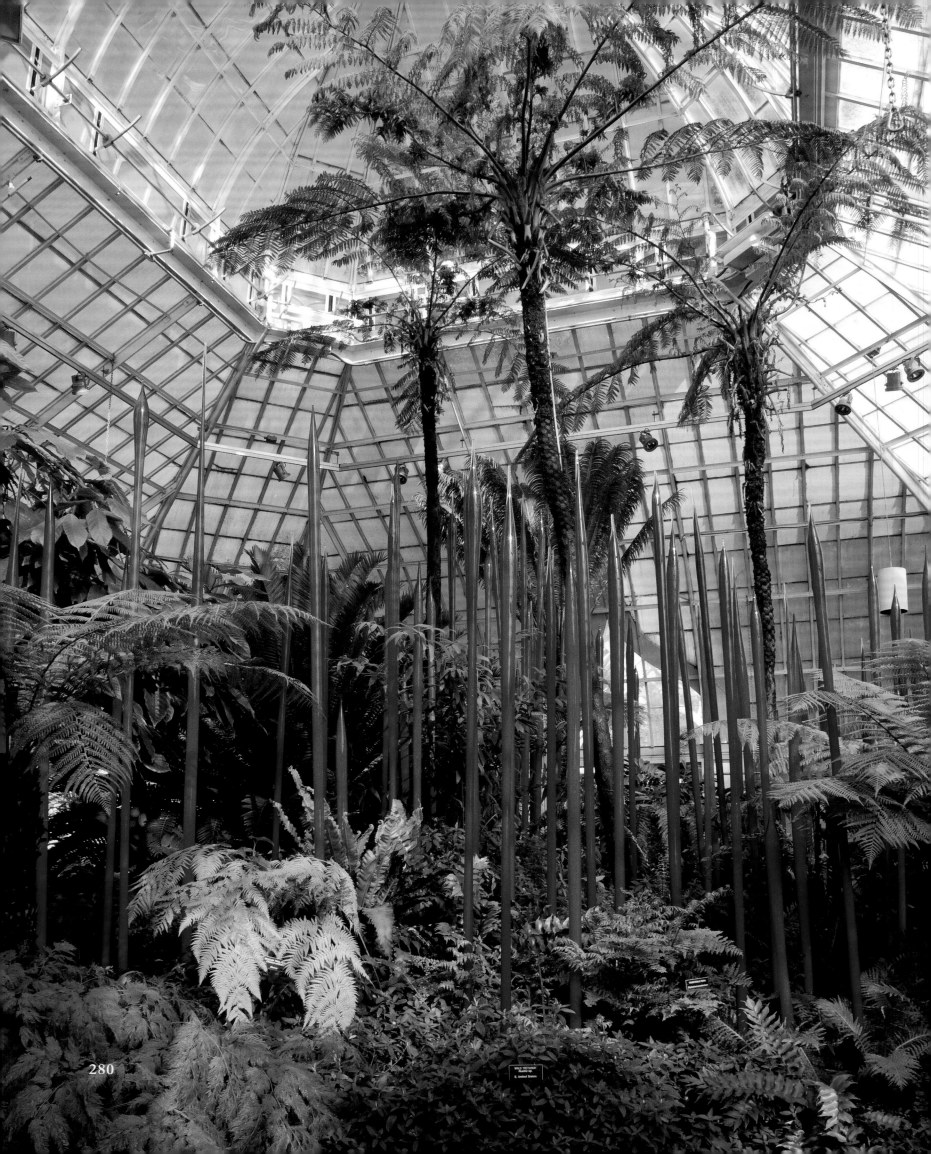

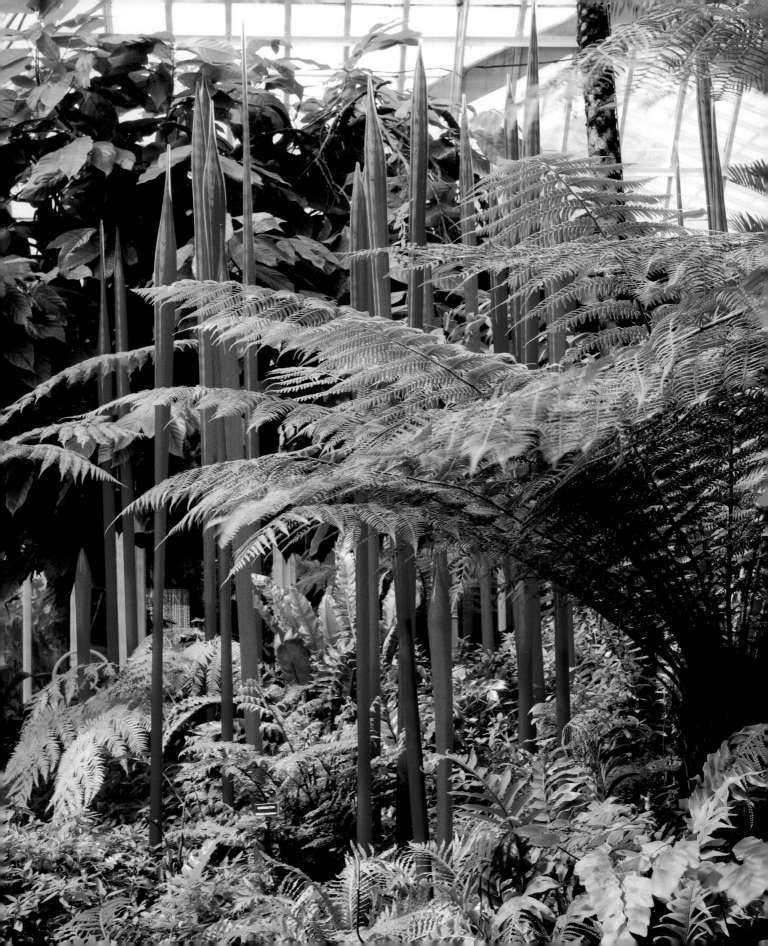

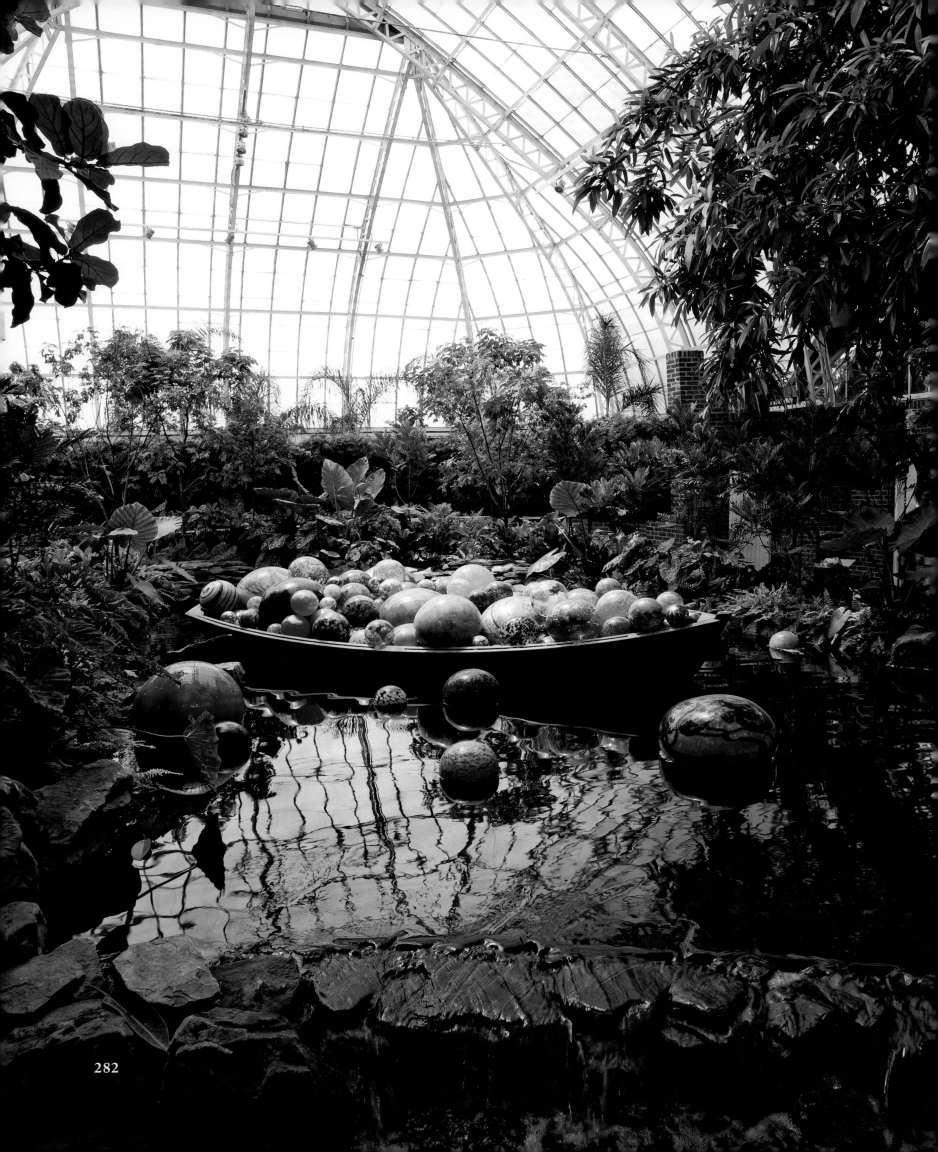

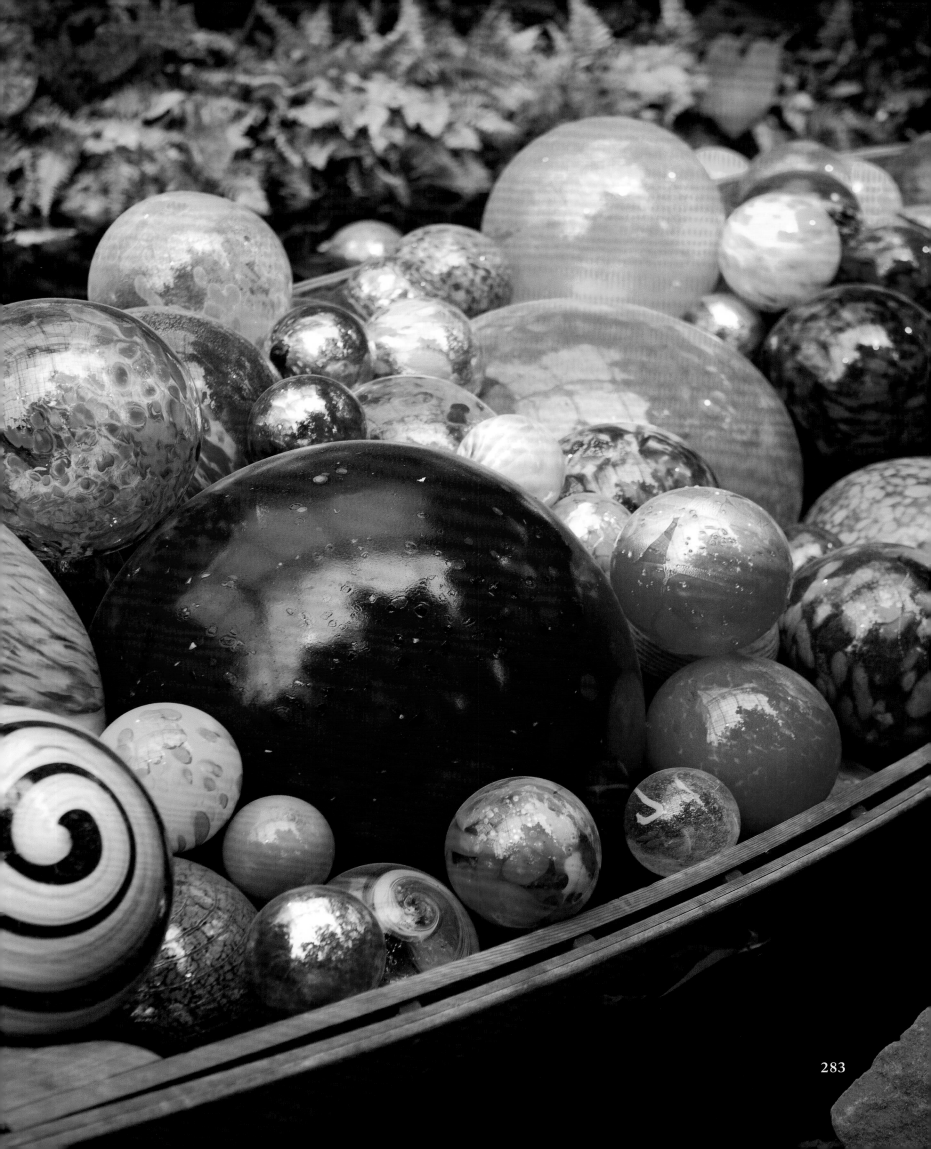

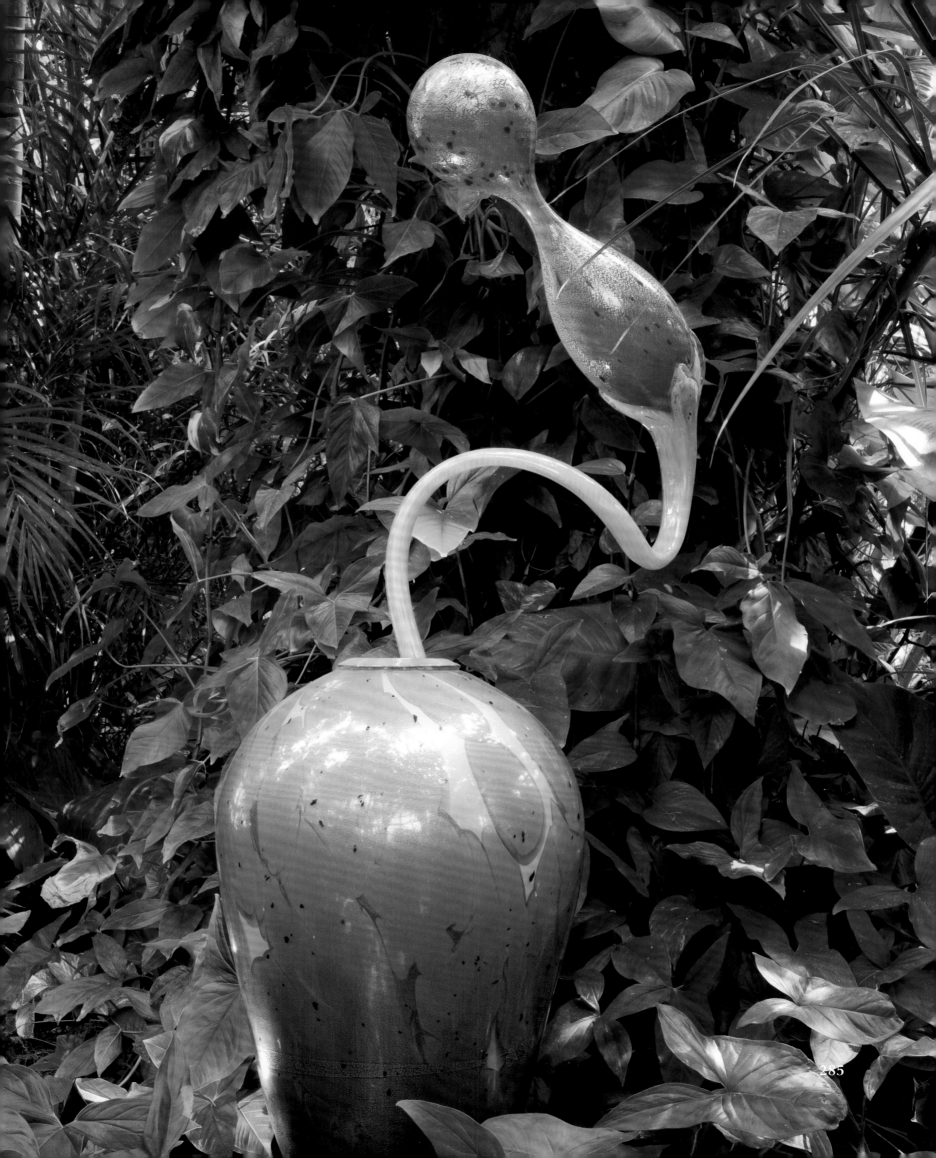

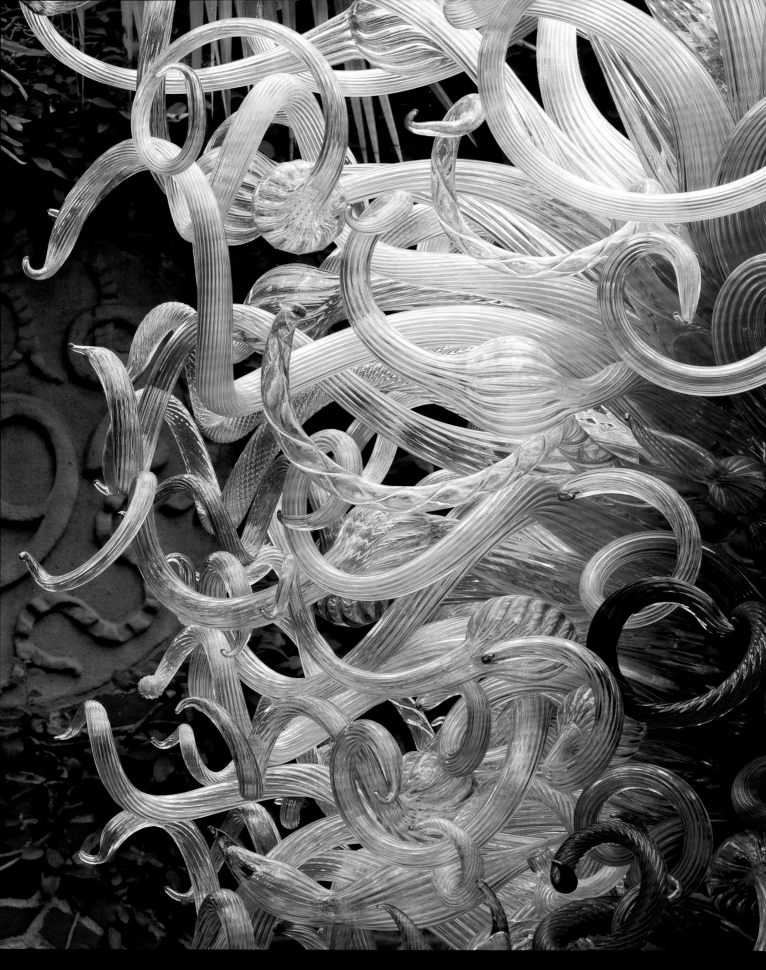

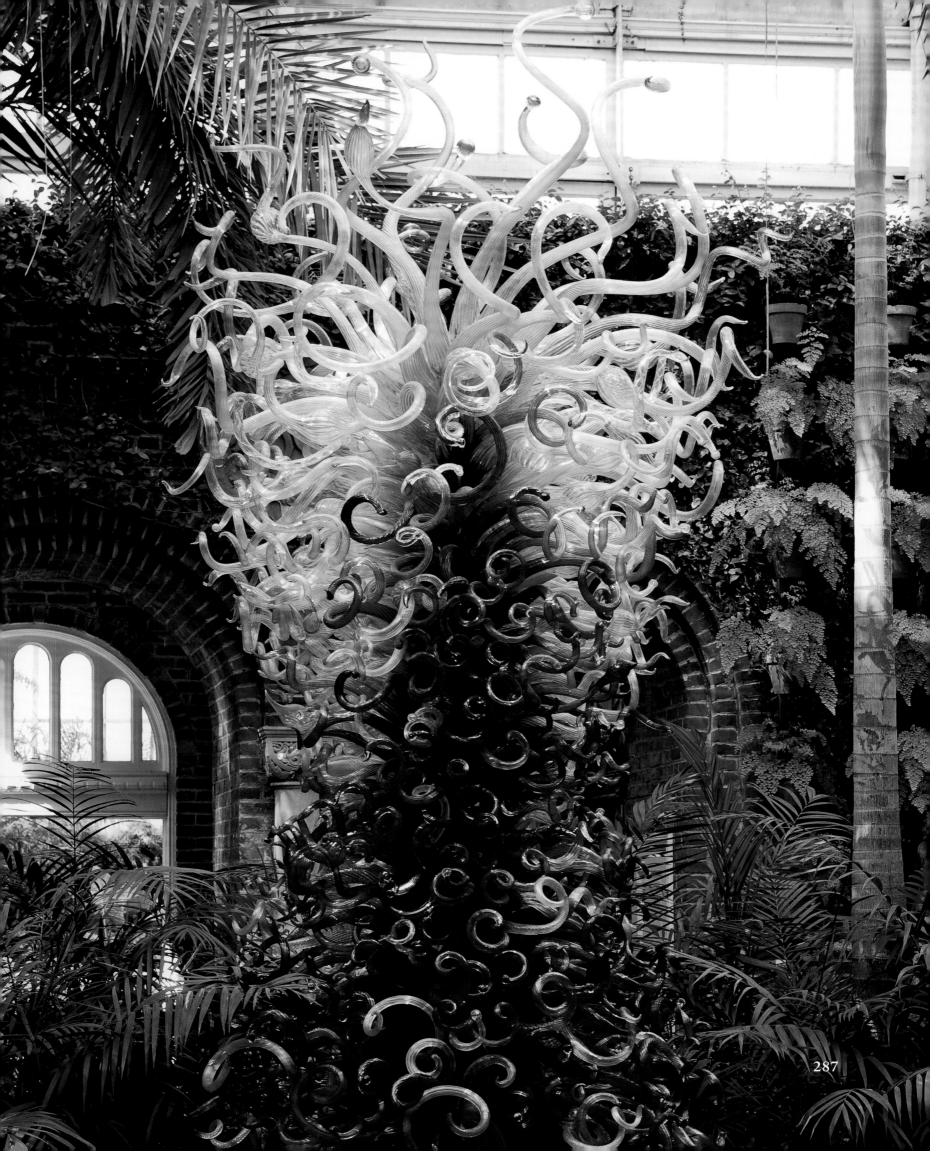

287

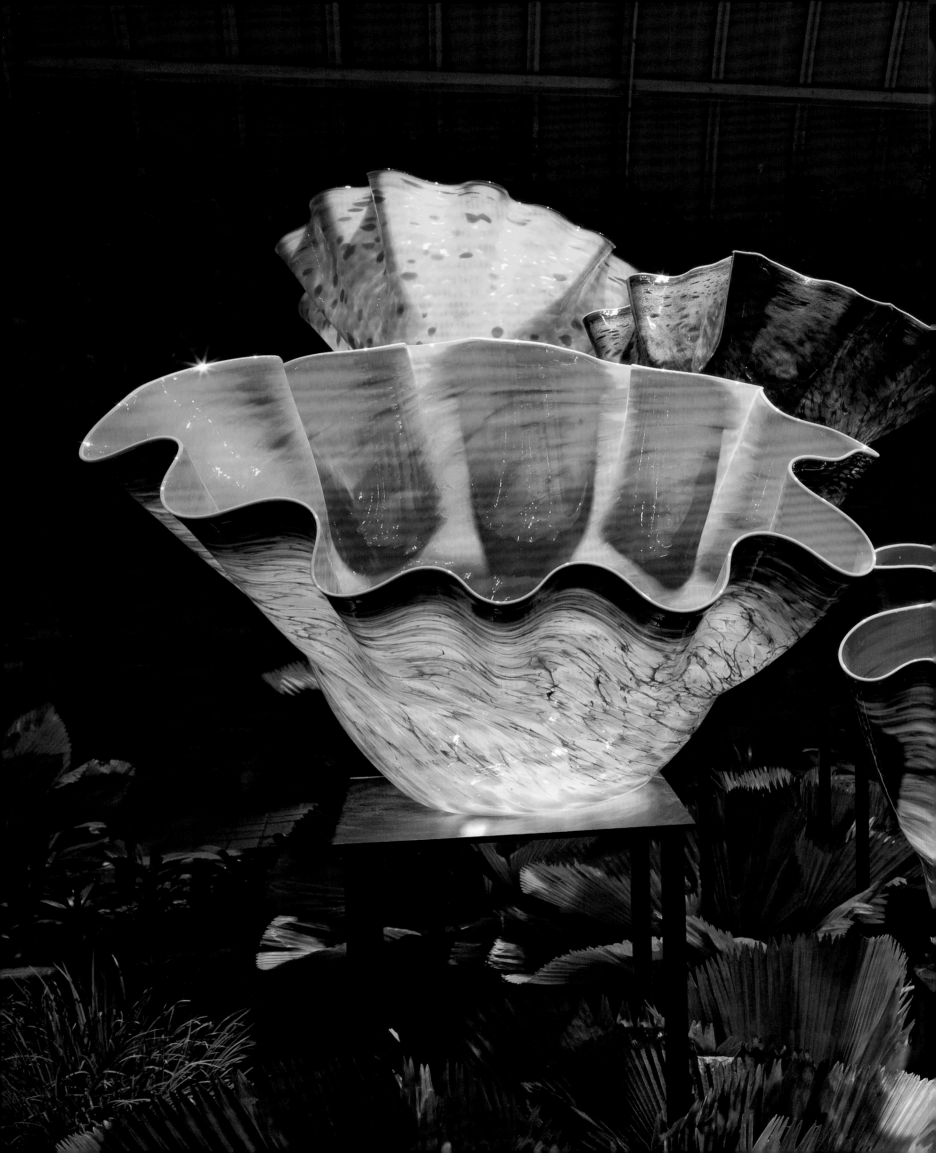

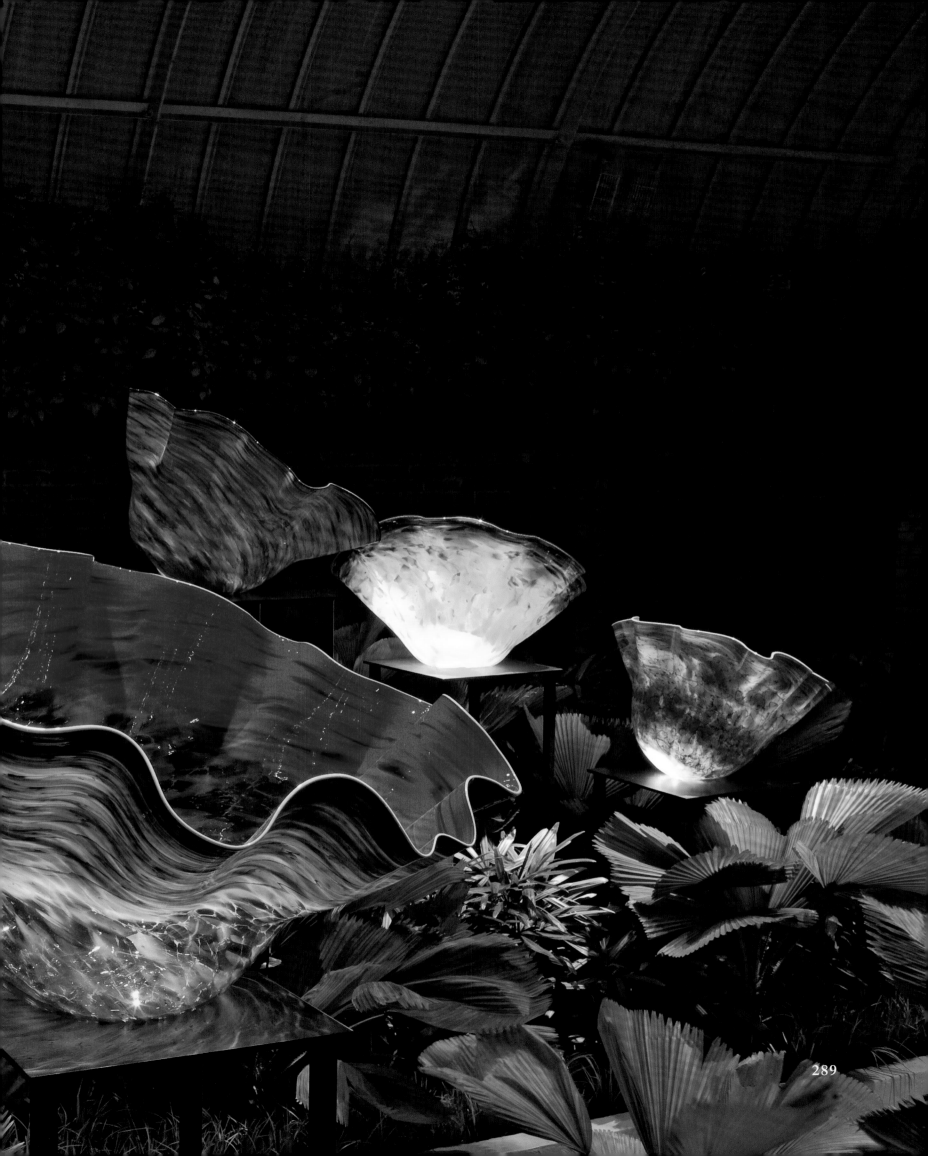

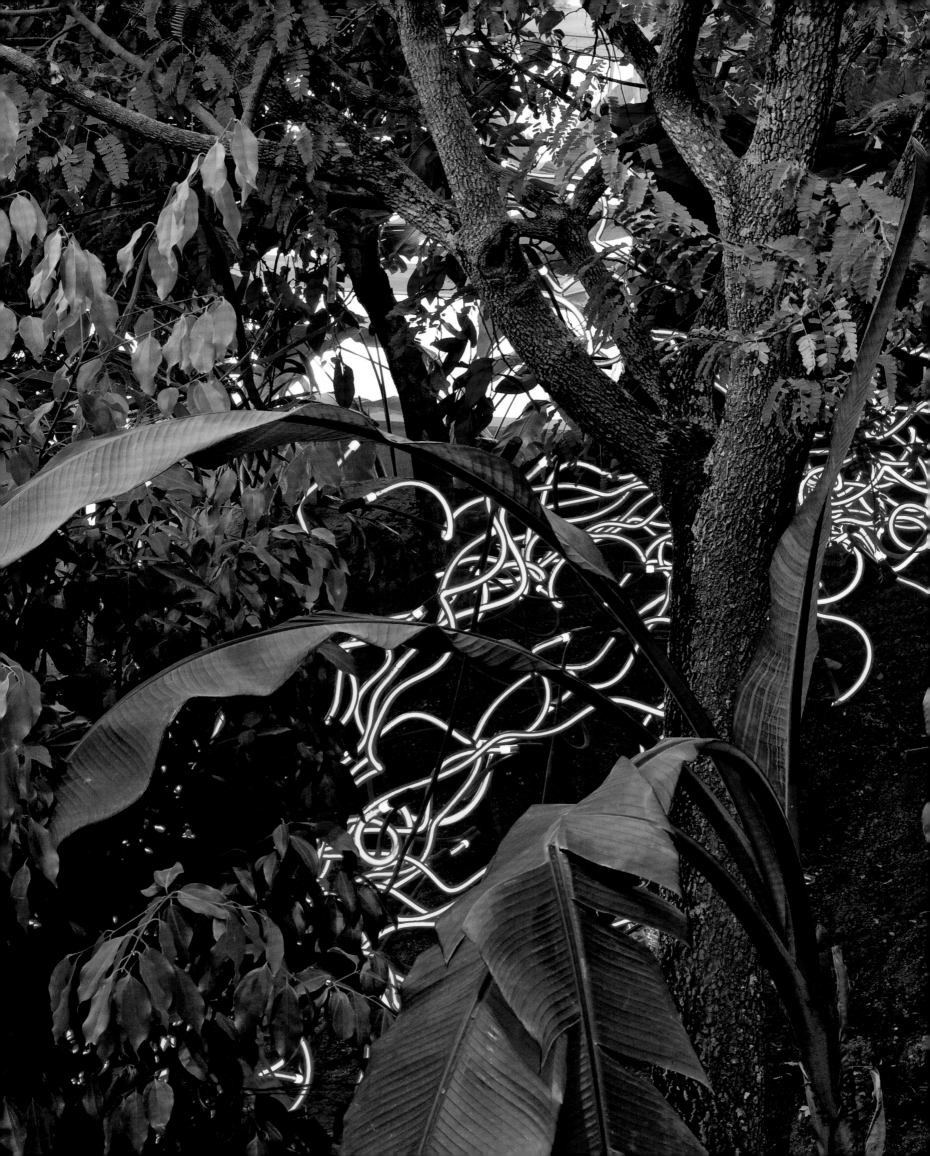

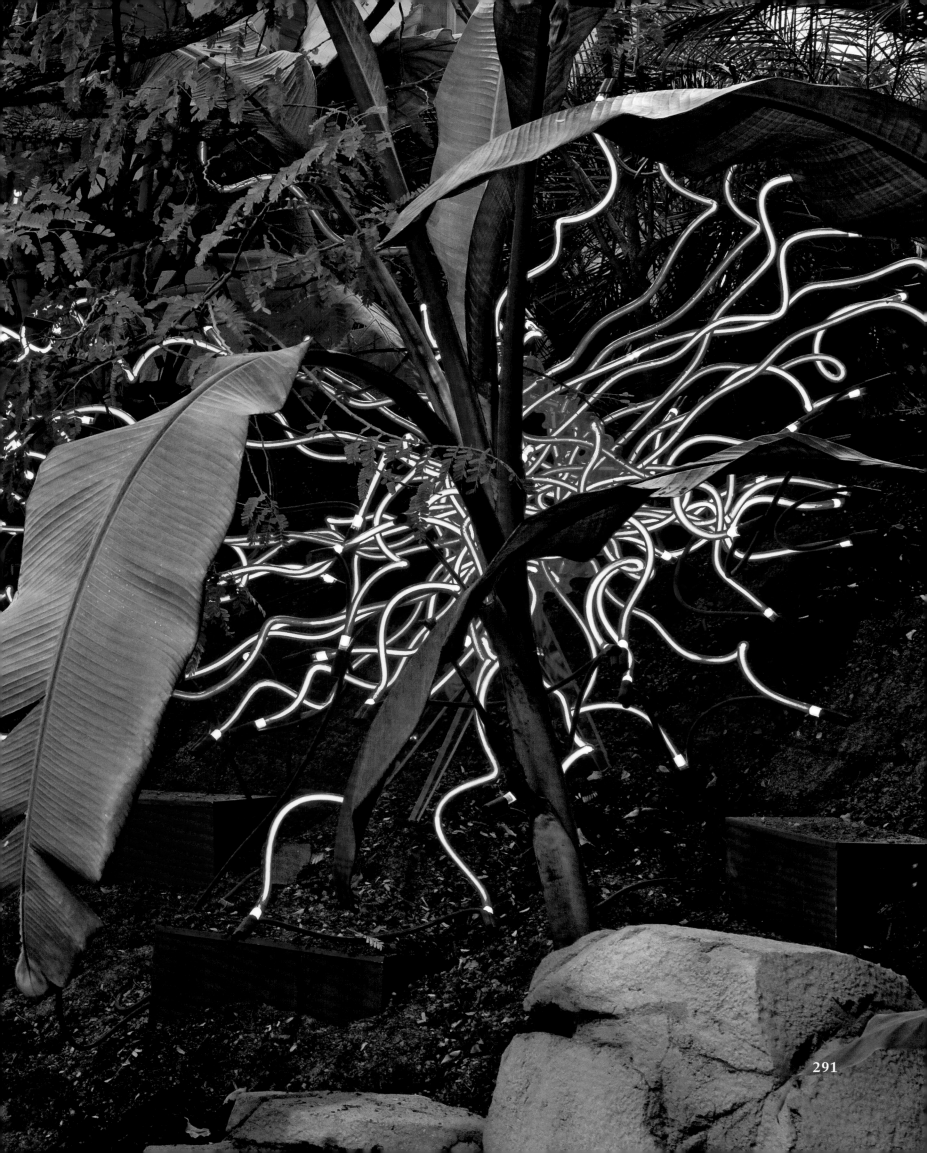

Desert Botanical Garden
Phoenix, Arizona

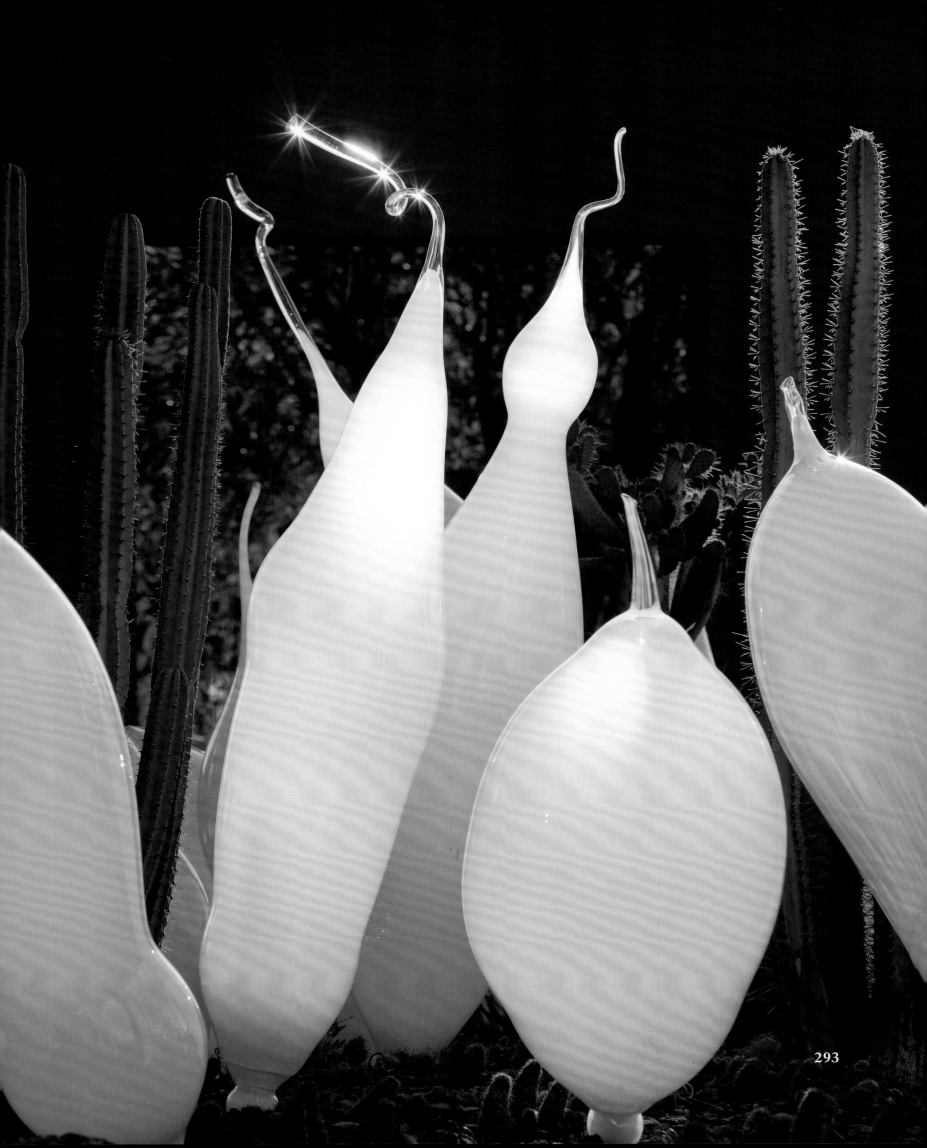

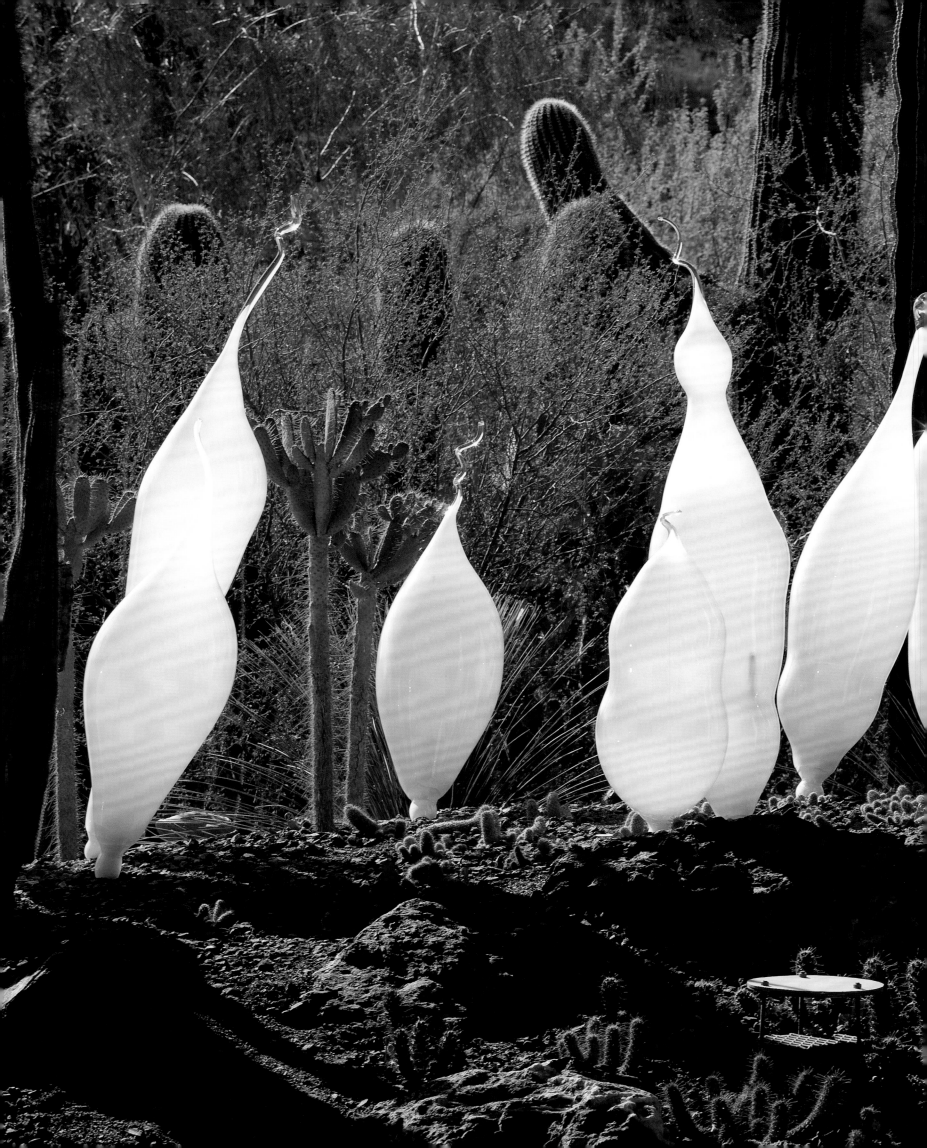

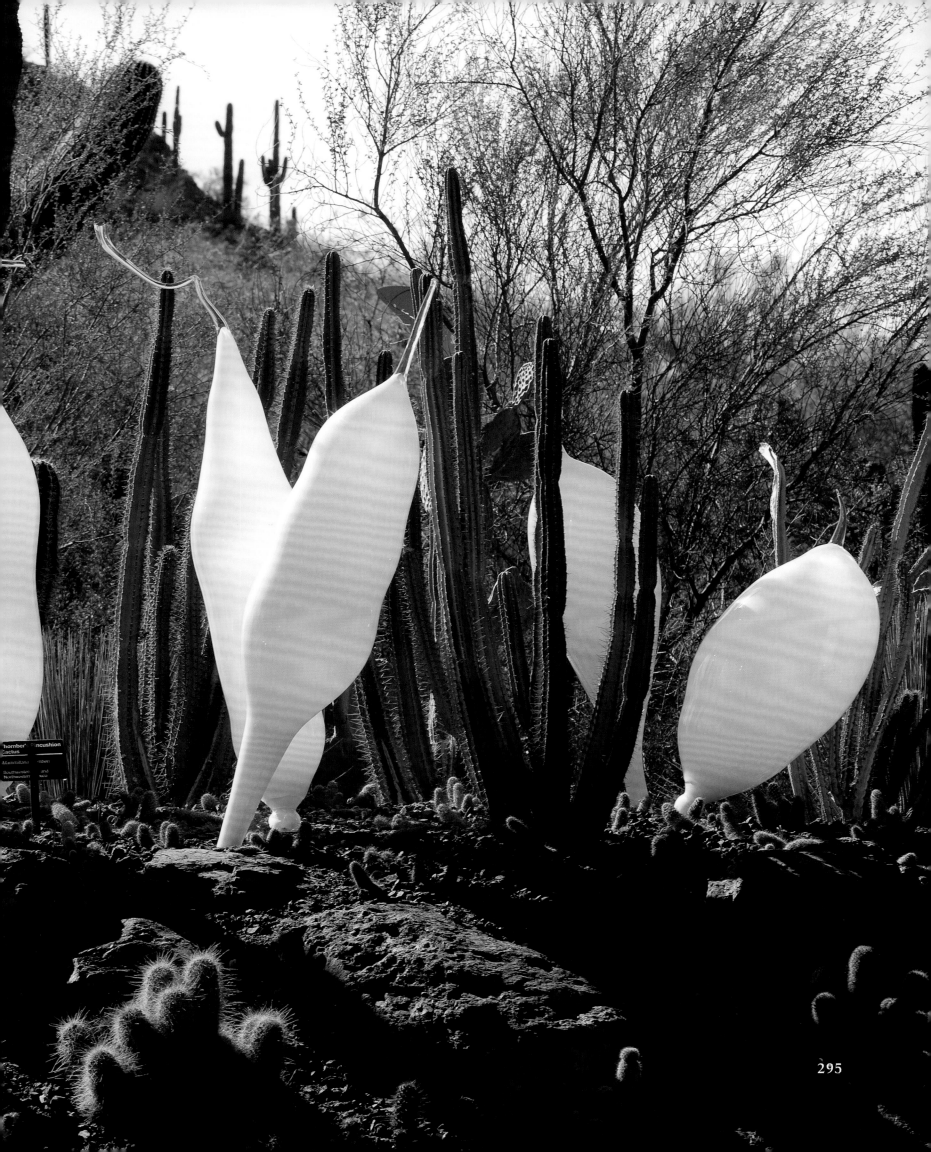

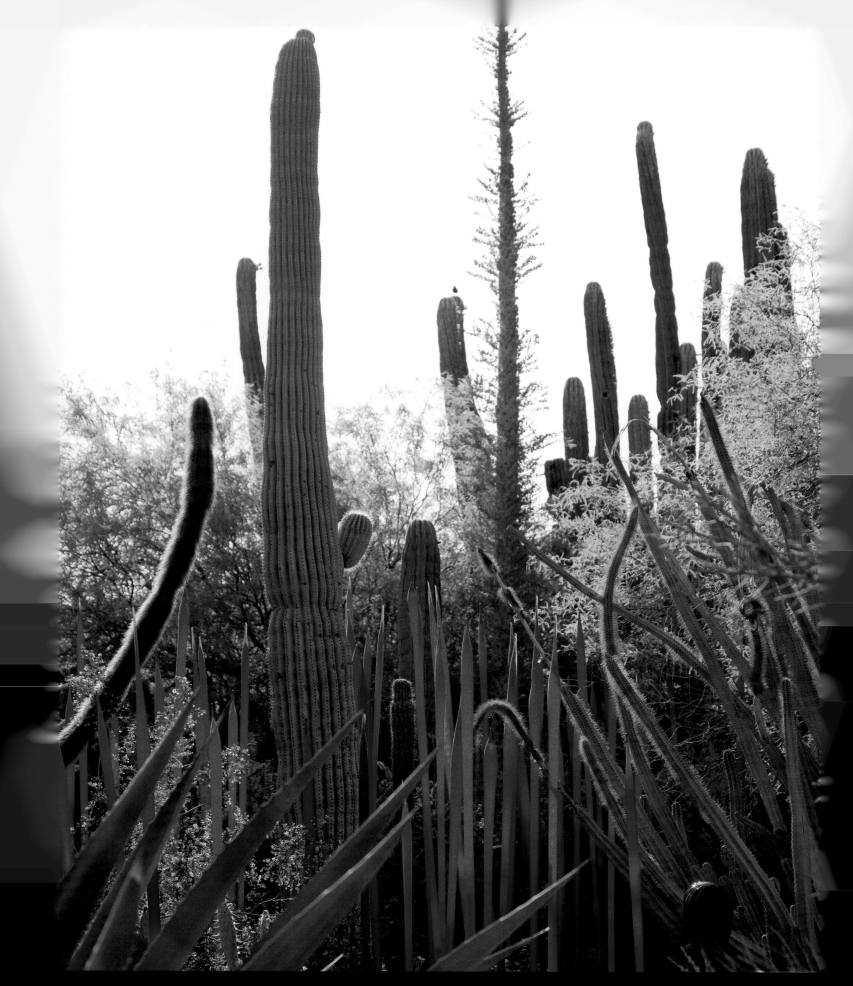

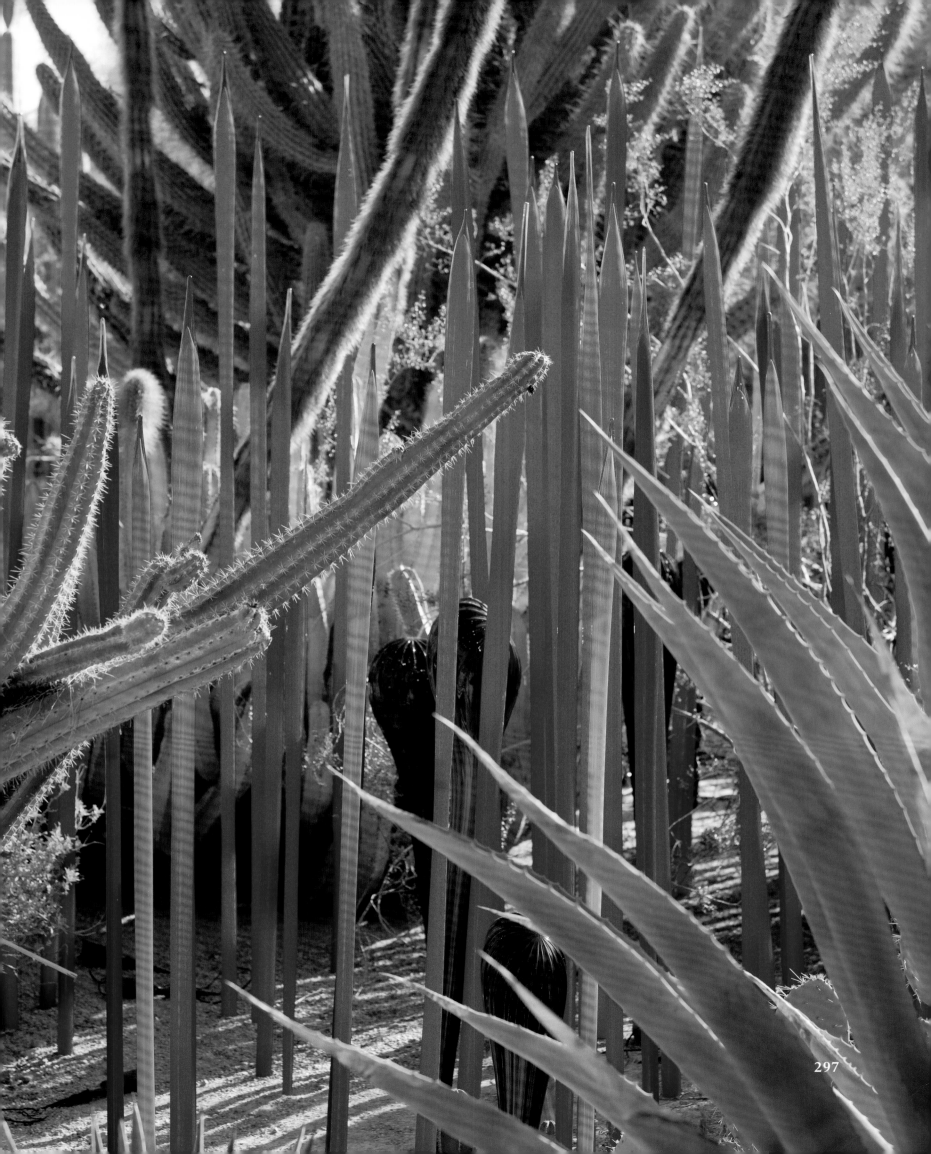

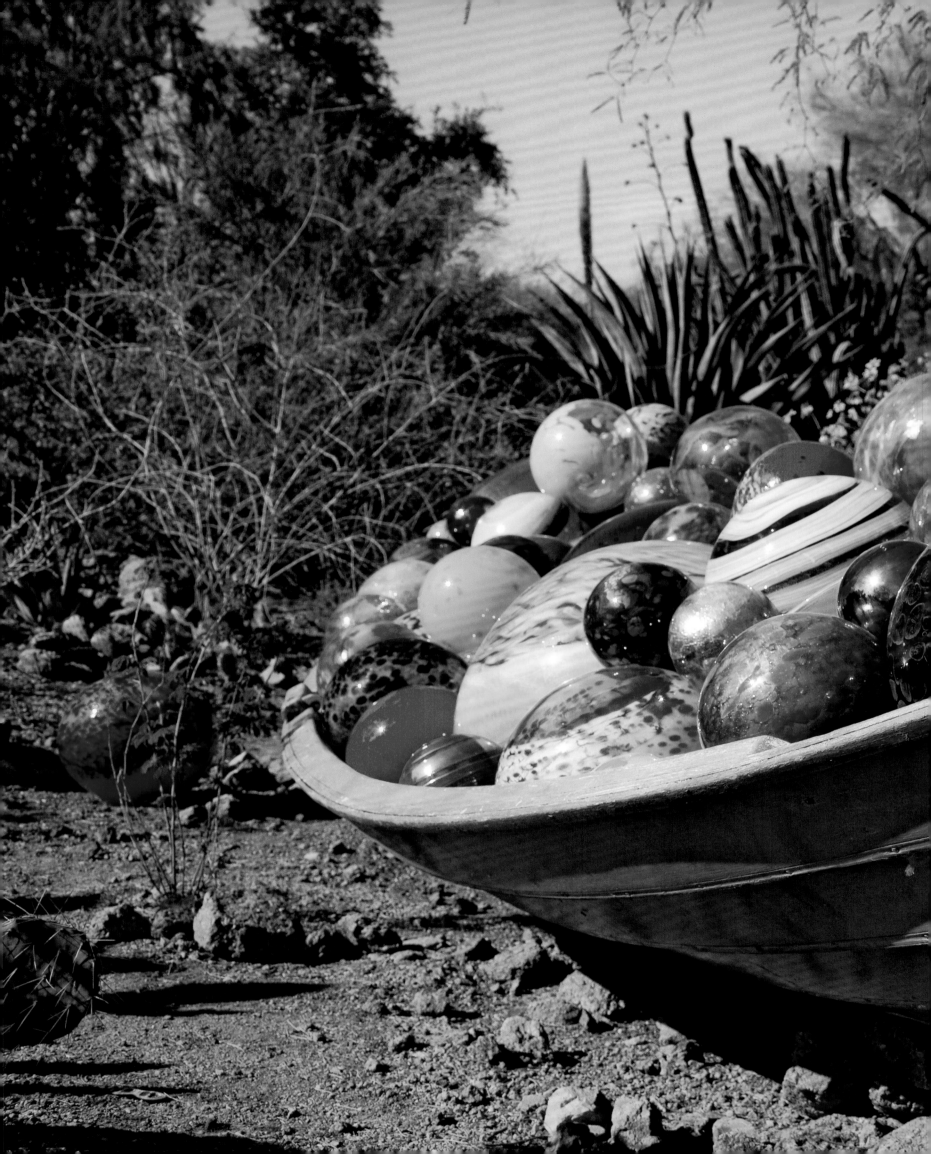

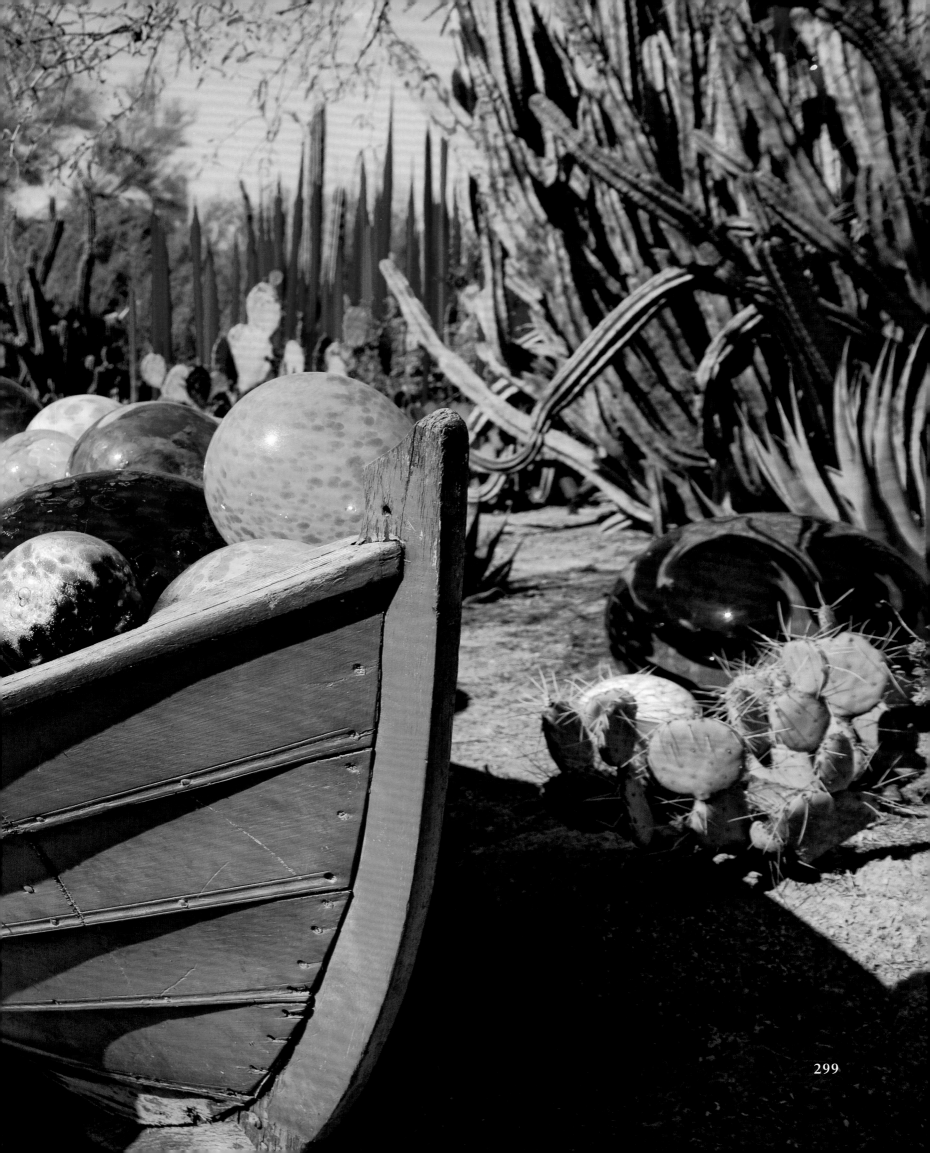

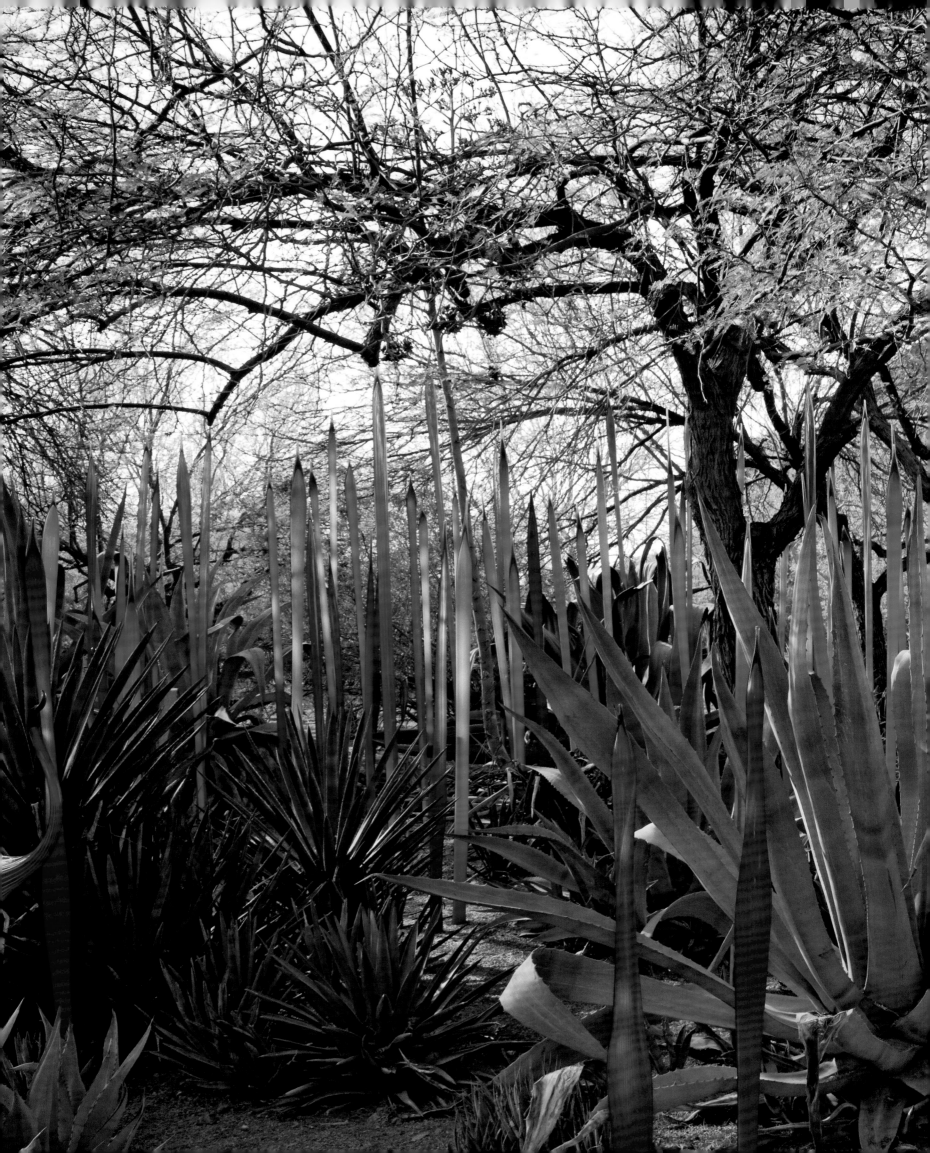

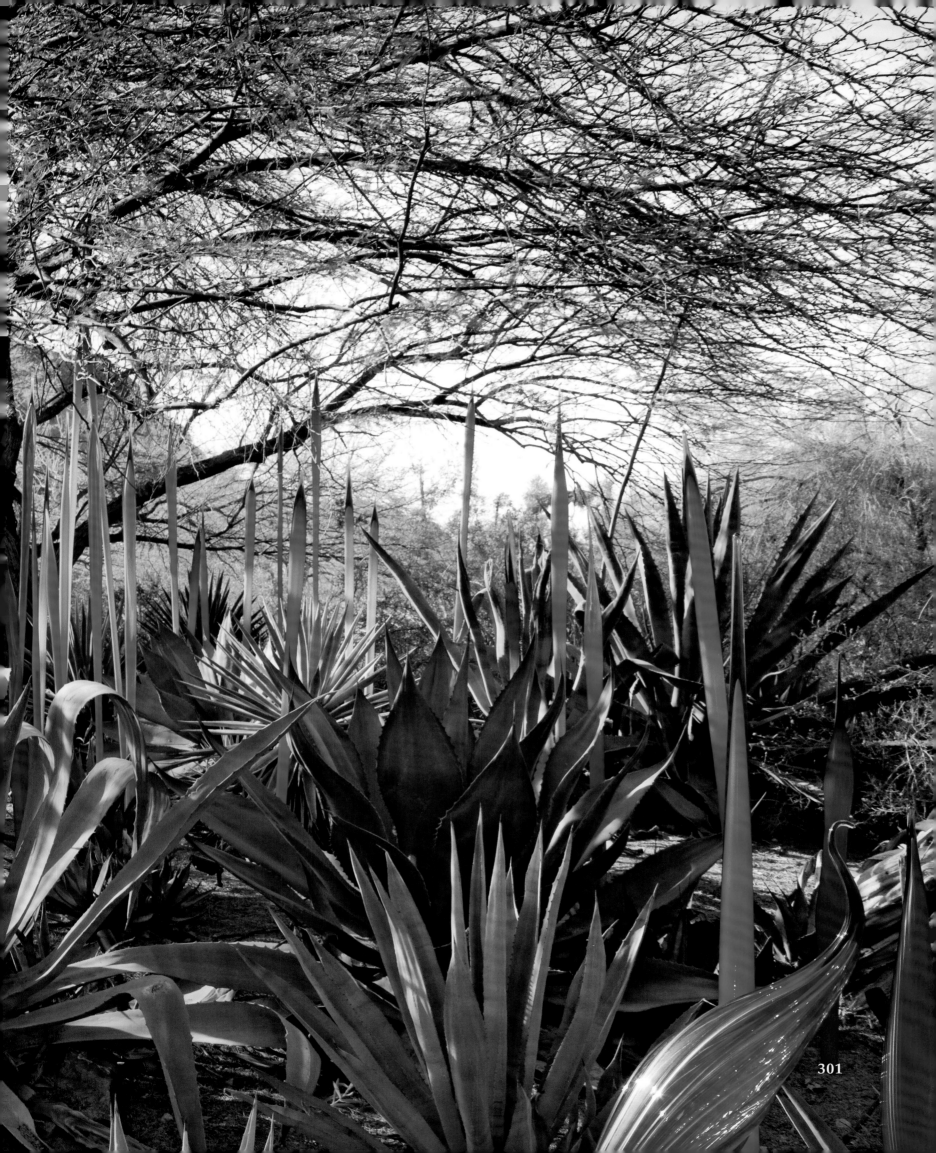

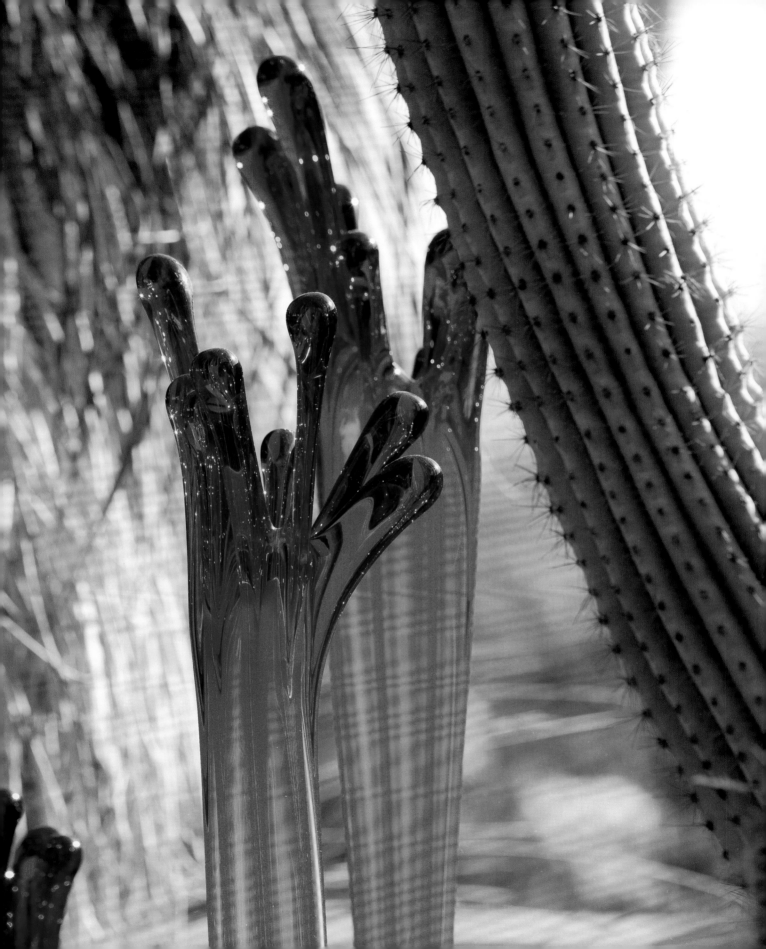

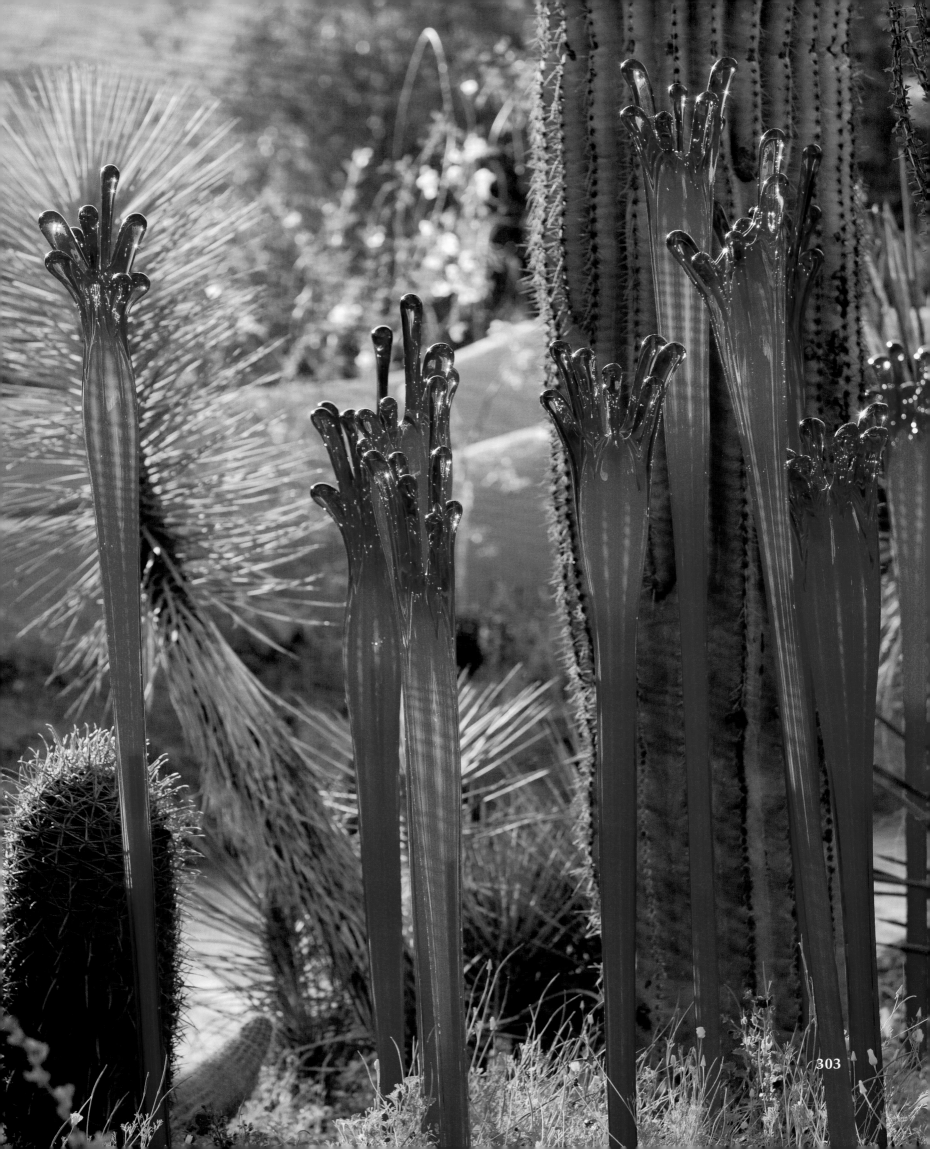

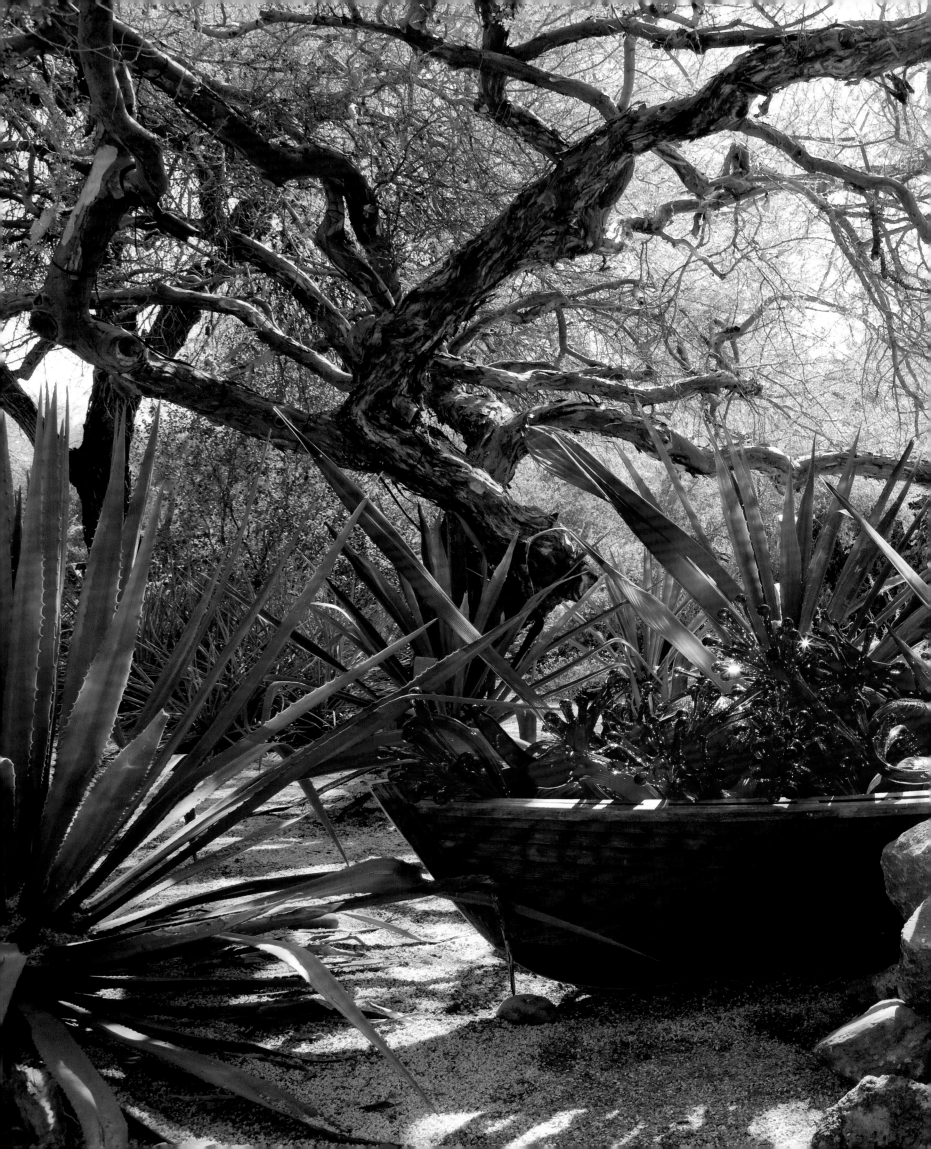

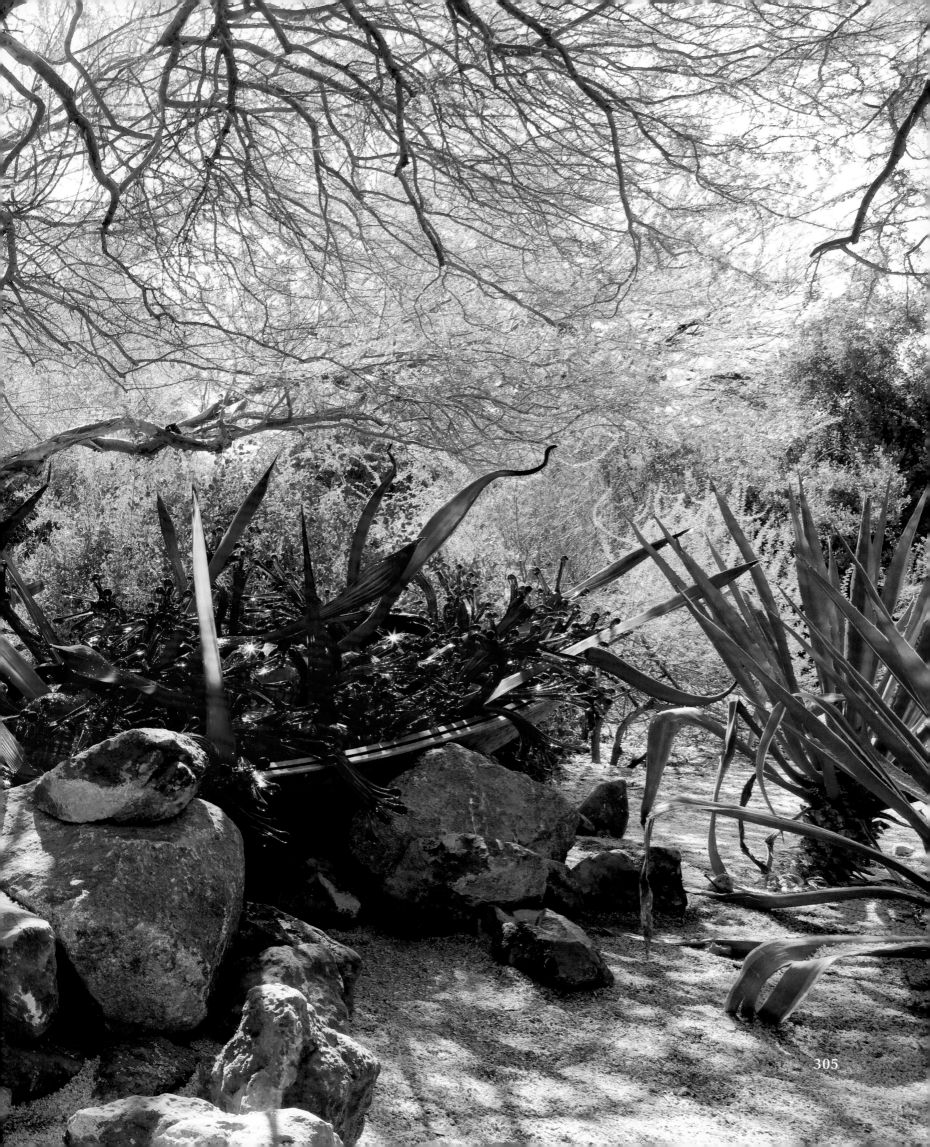

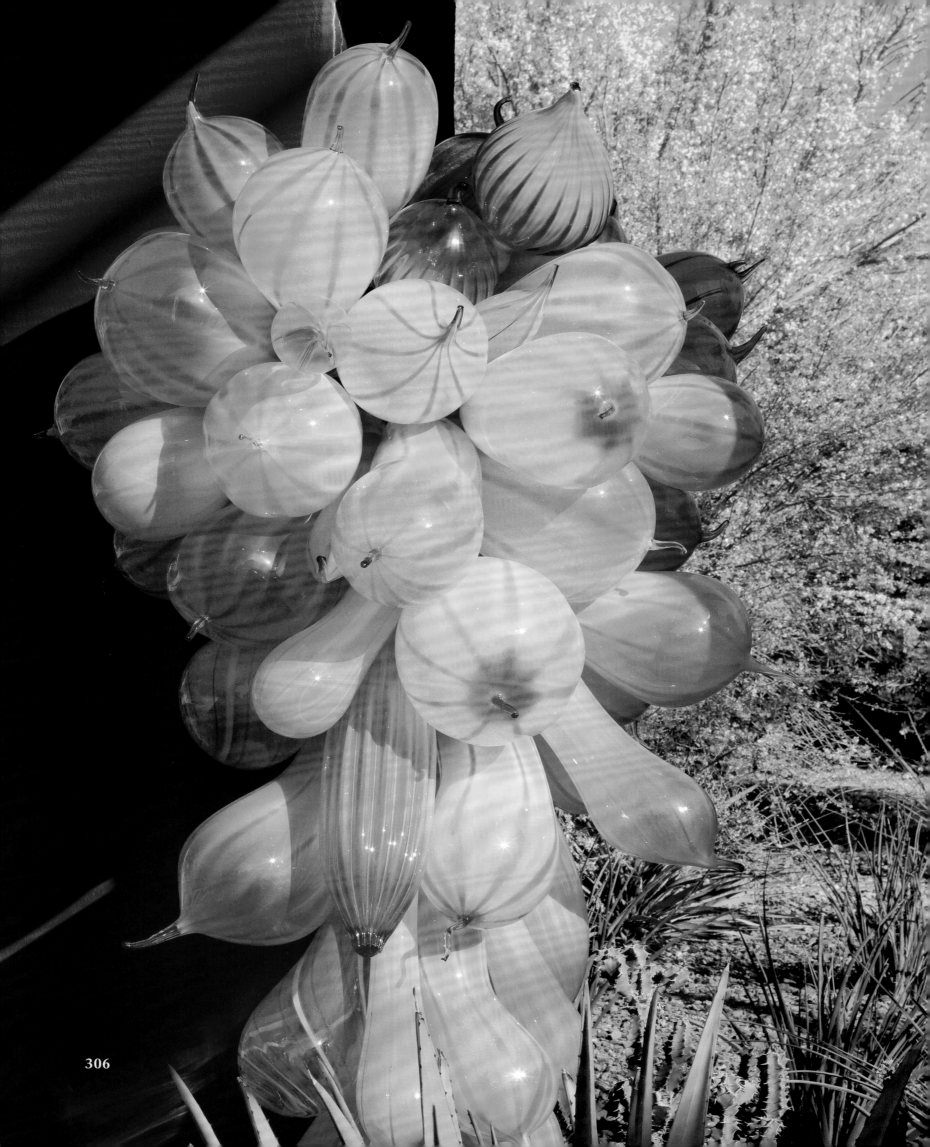

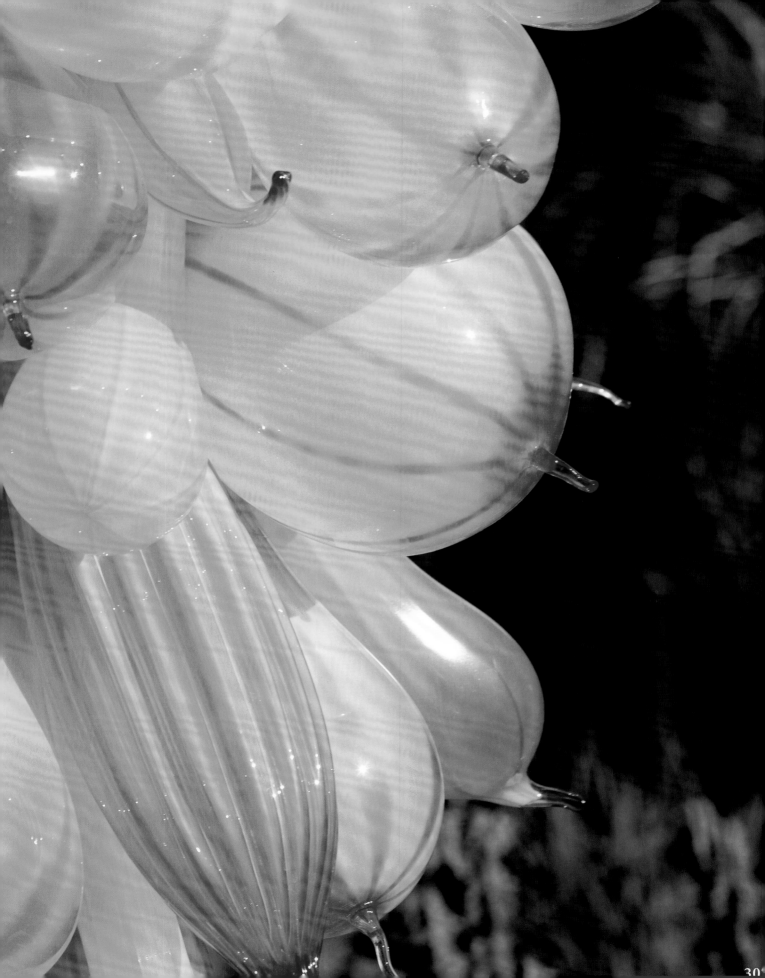

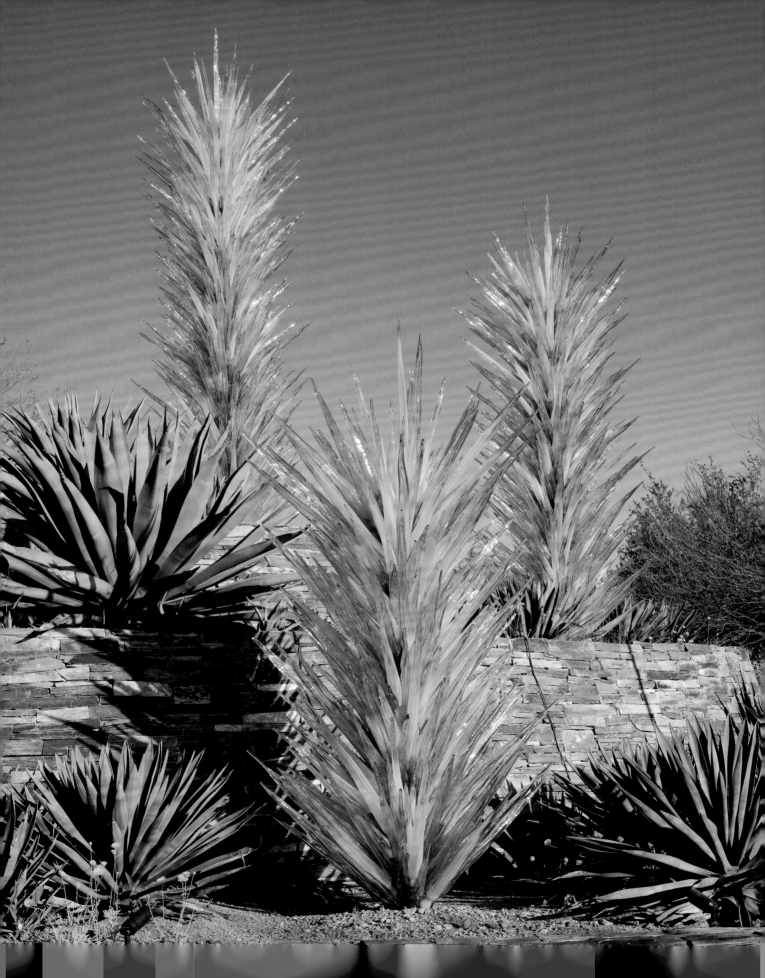

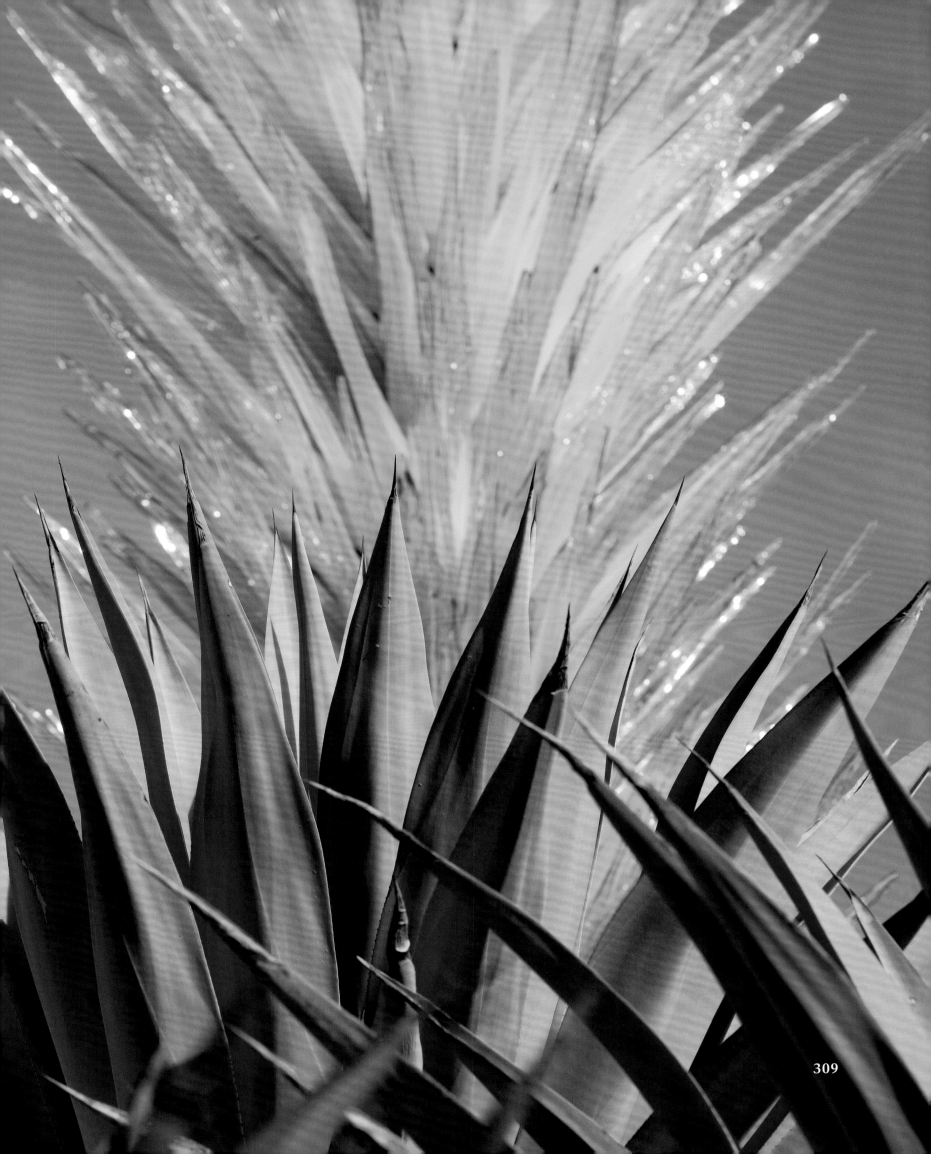

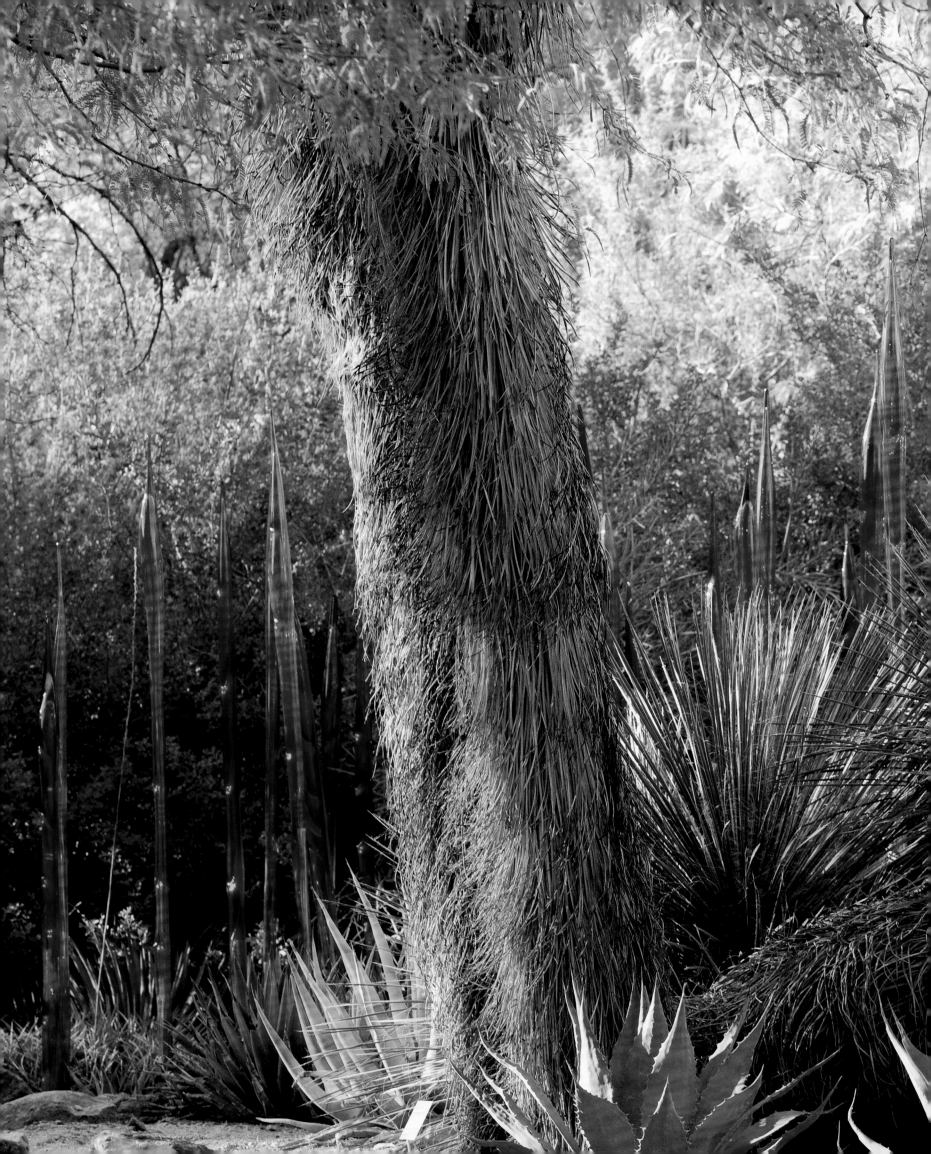

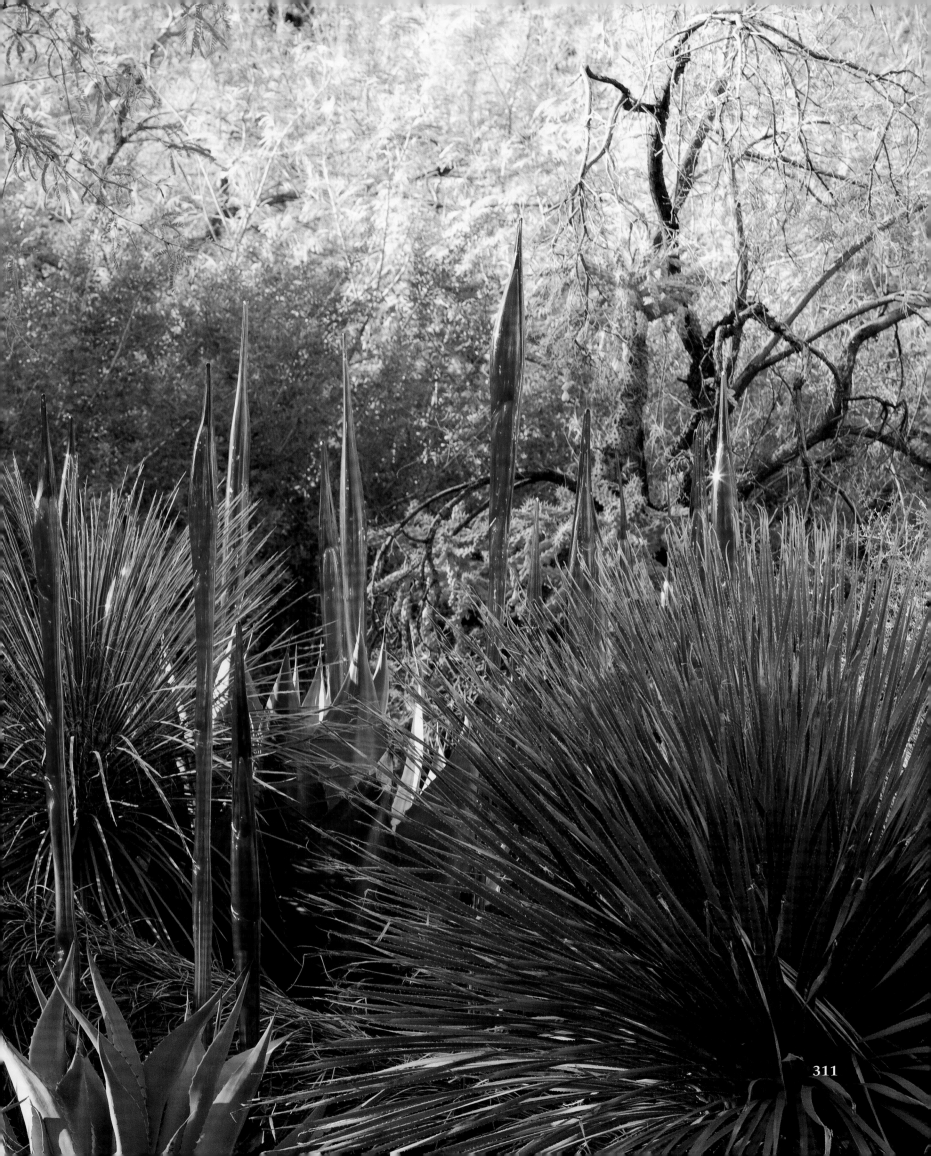

311

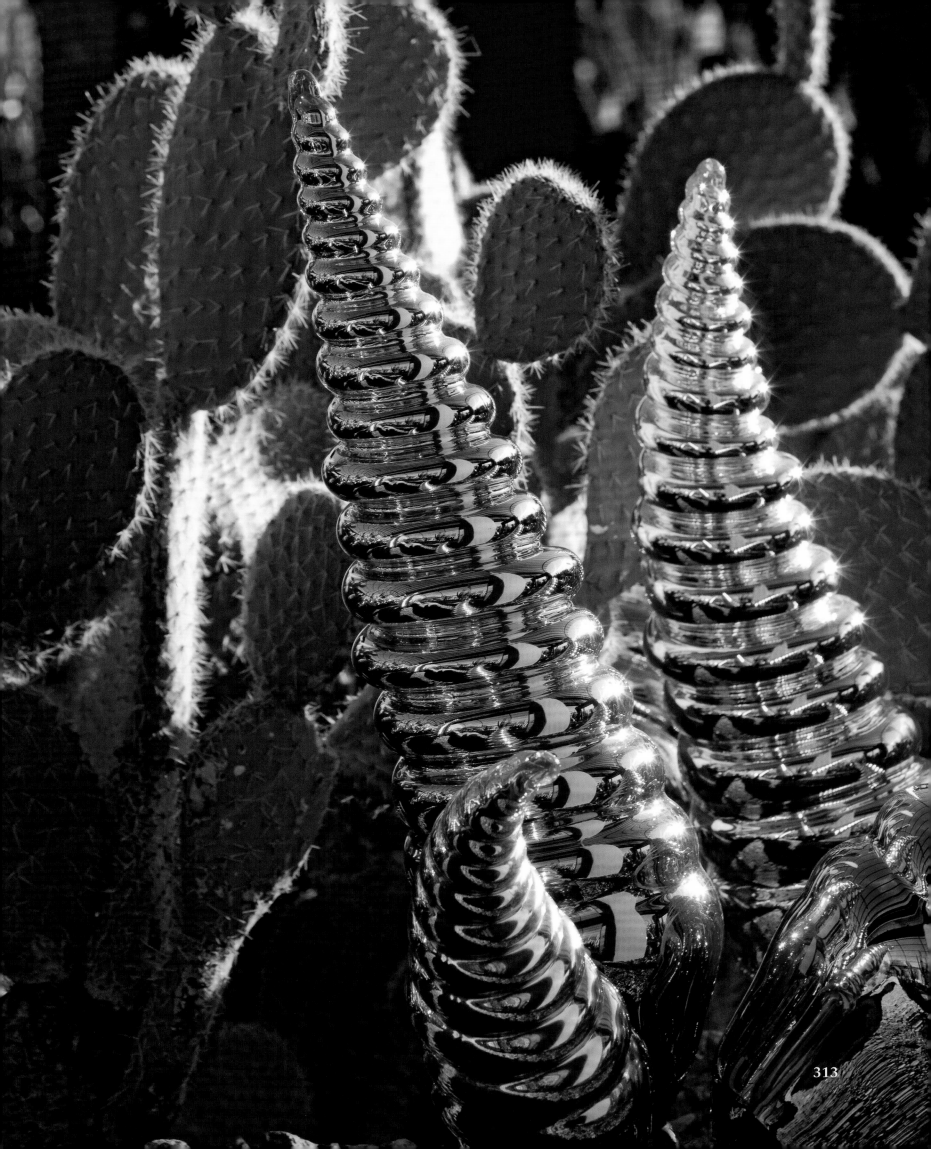

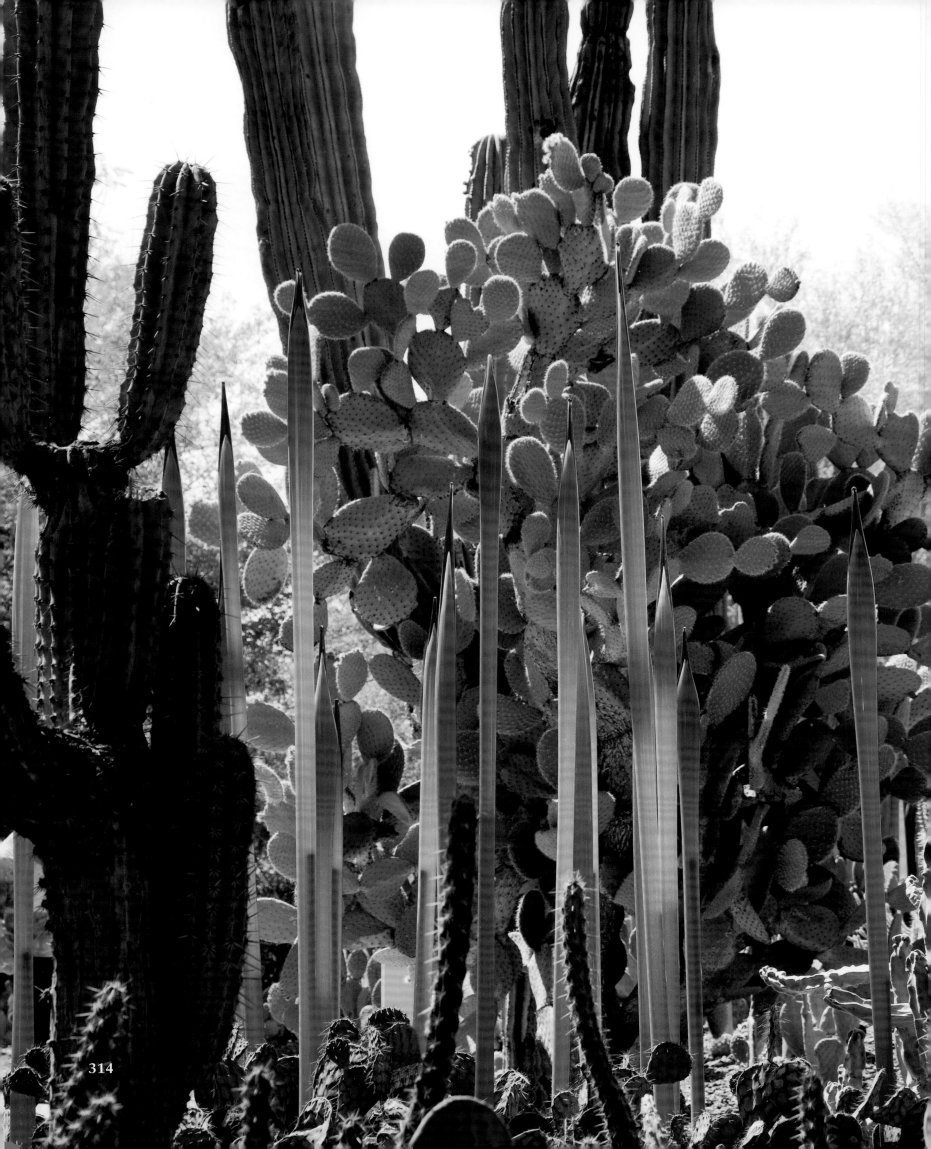

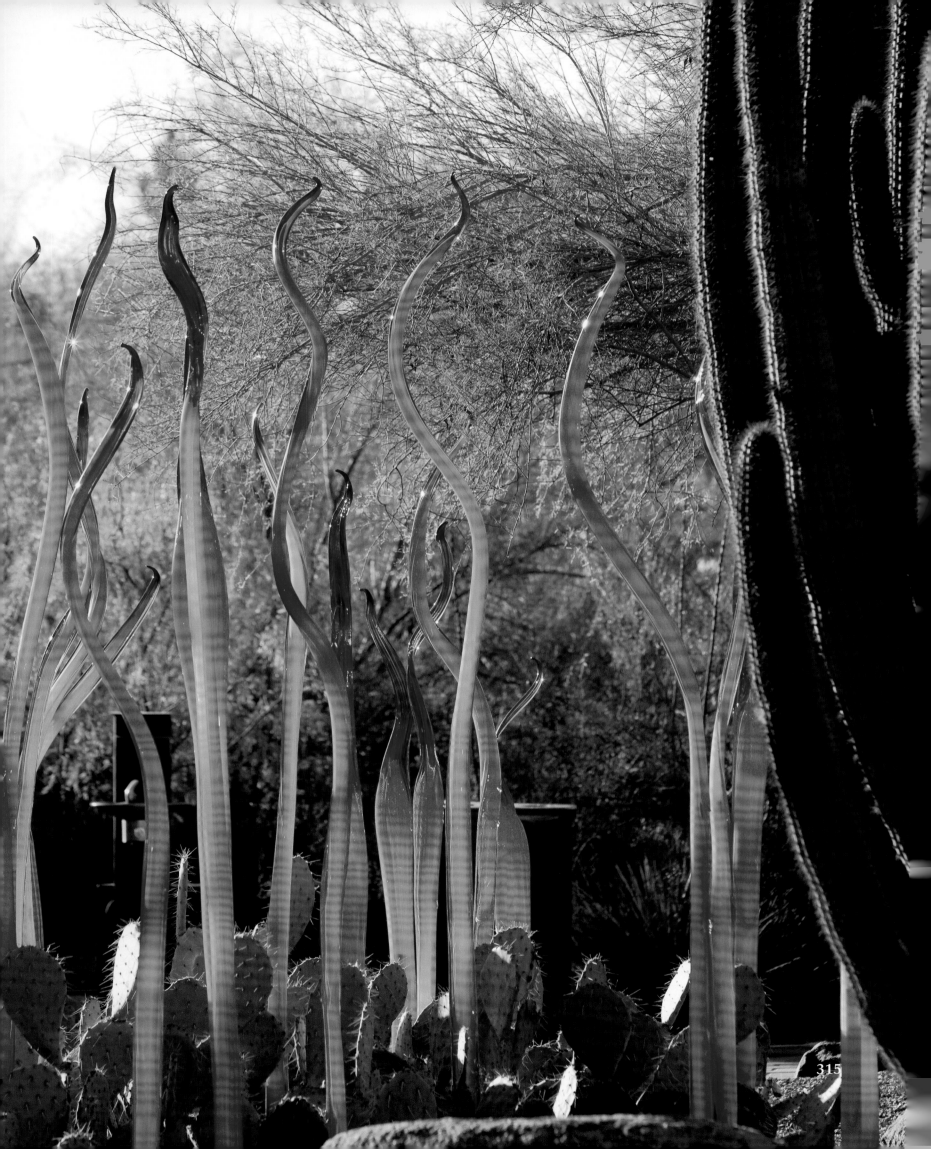

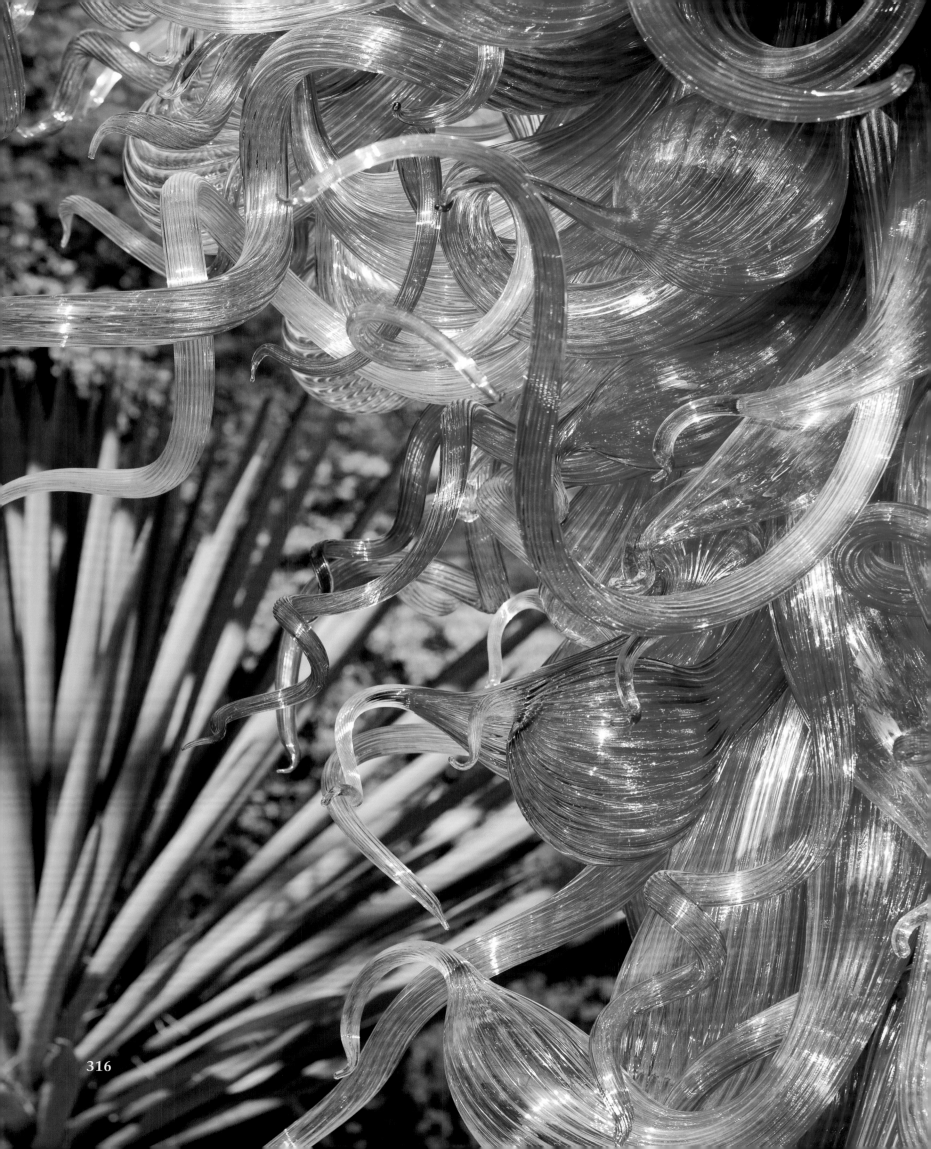

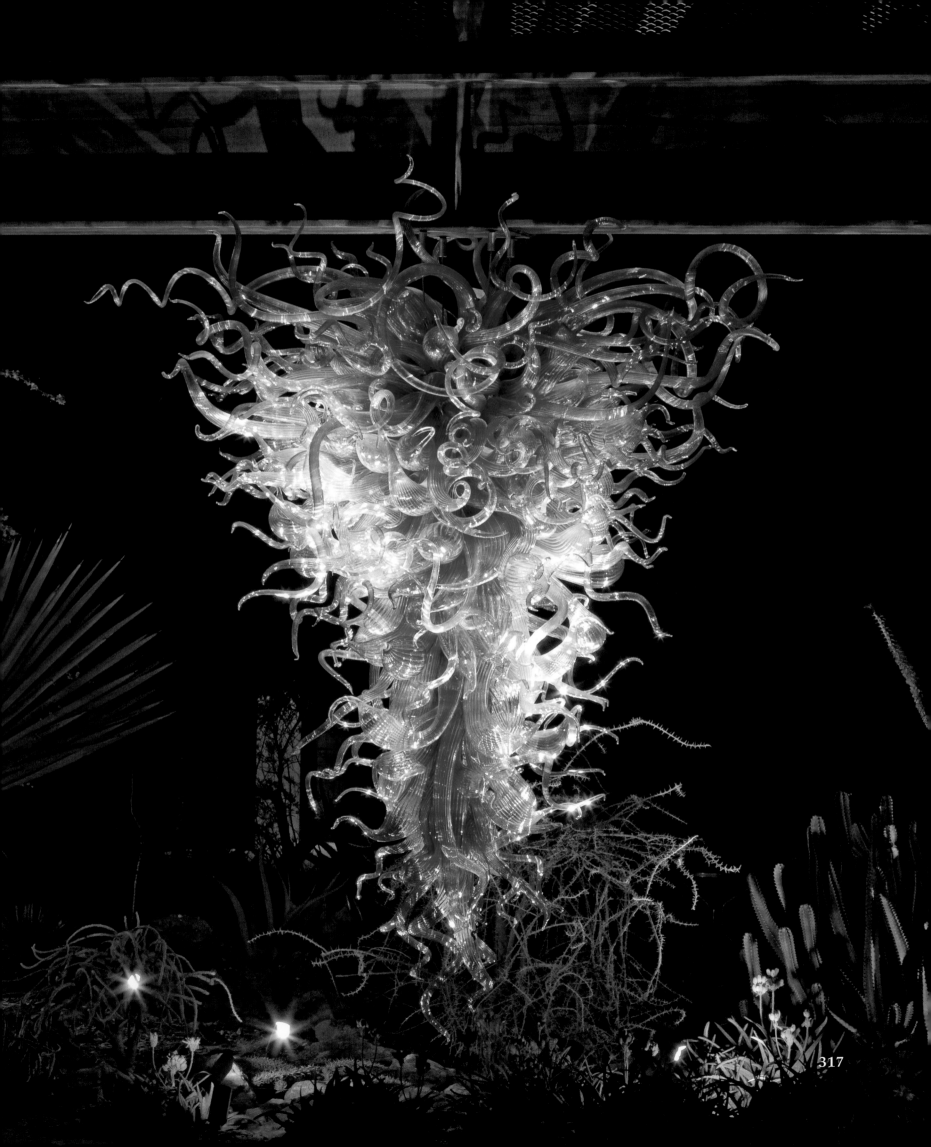

317

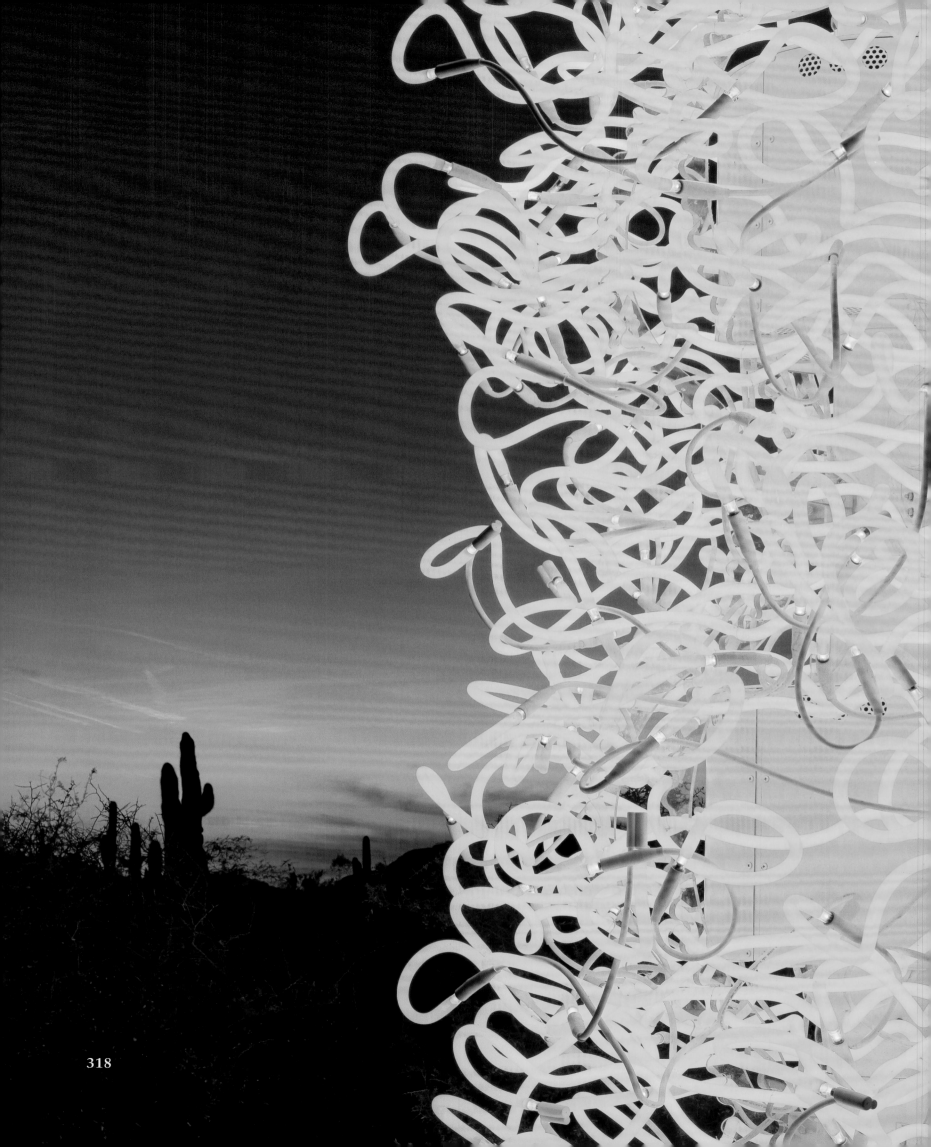

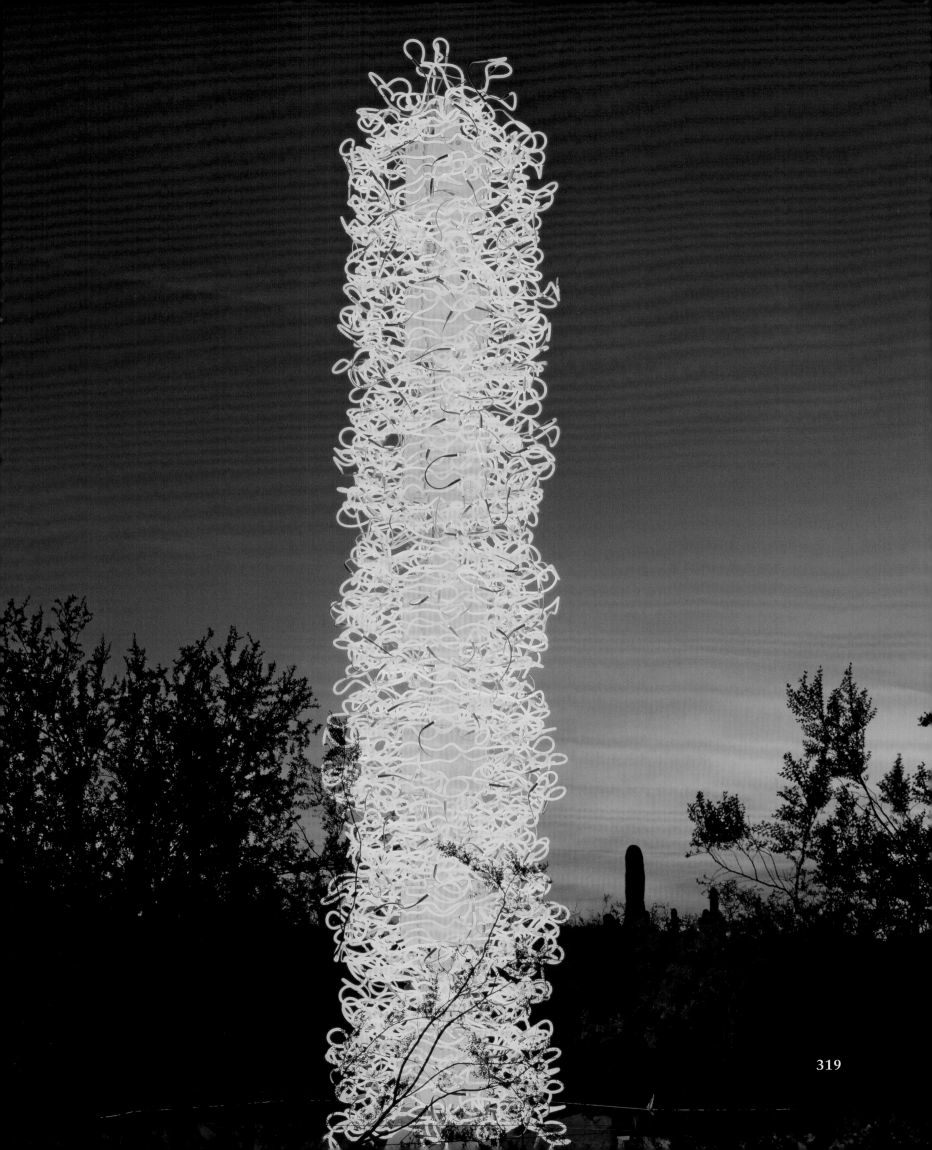

319

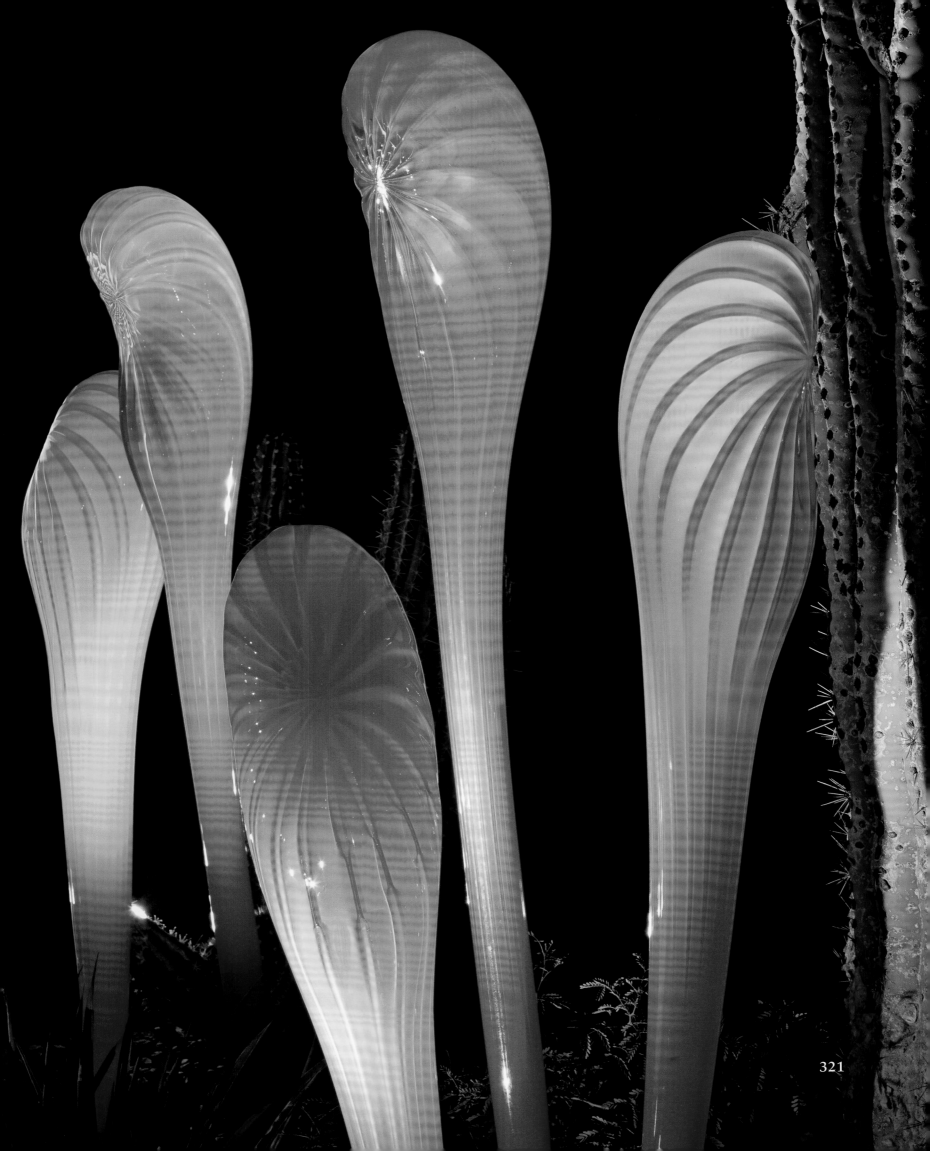

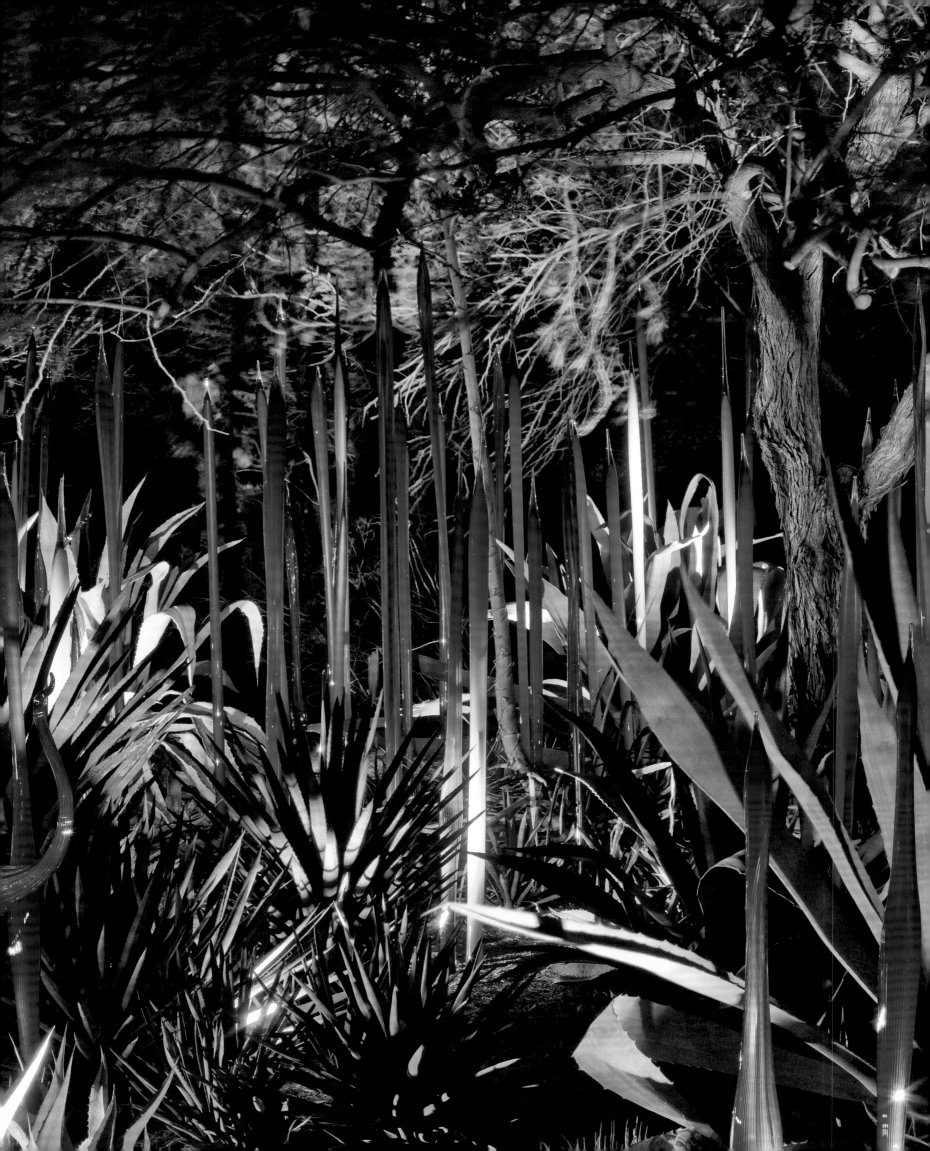

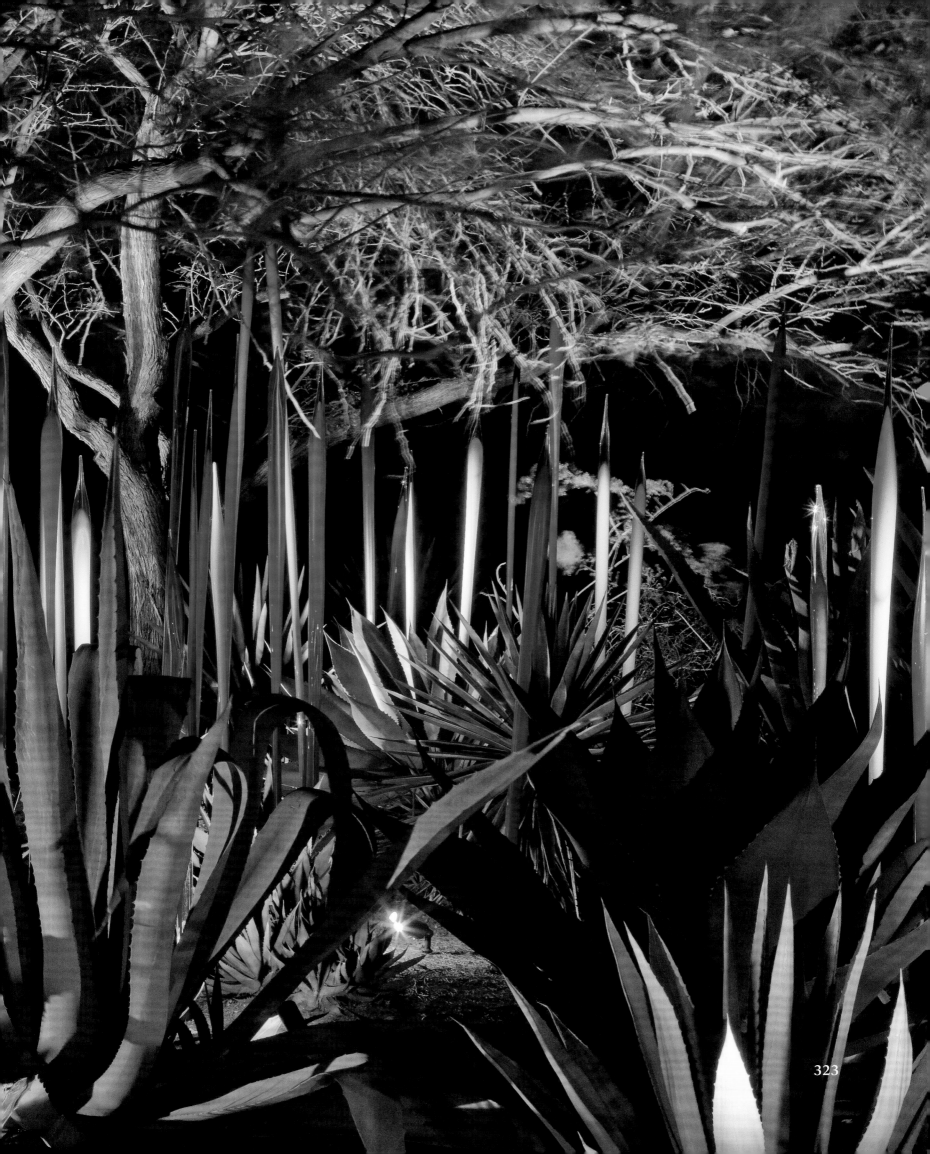

**Frederik Meijer Gardens
& Sculpture Park**
Grand Rapids, Michigan

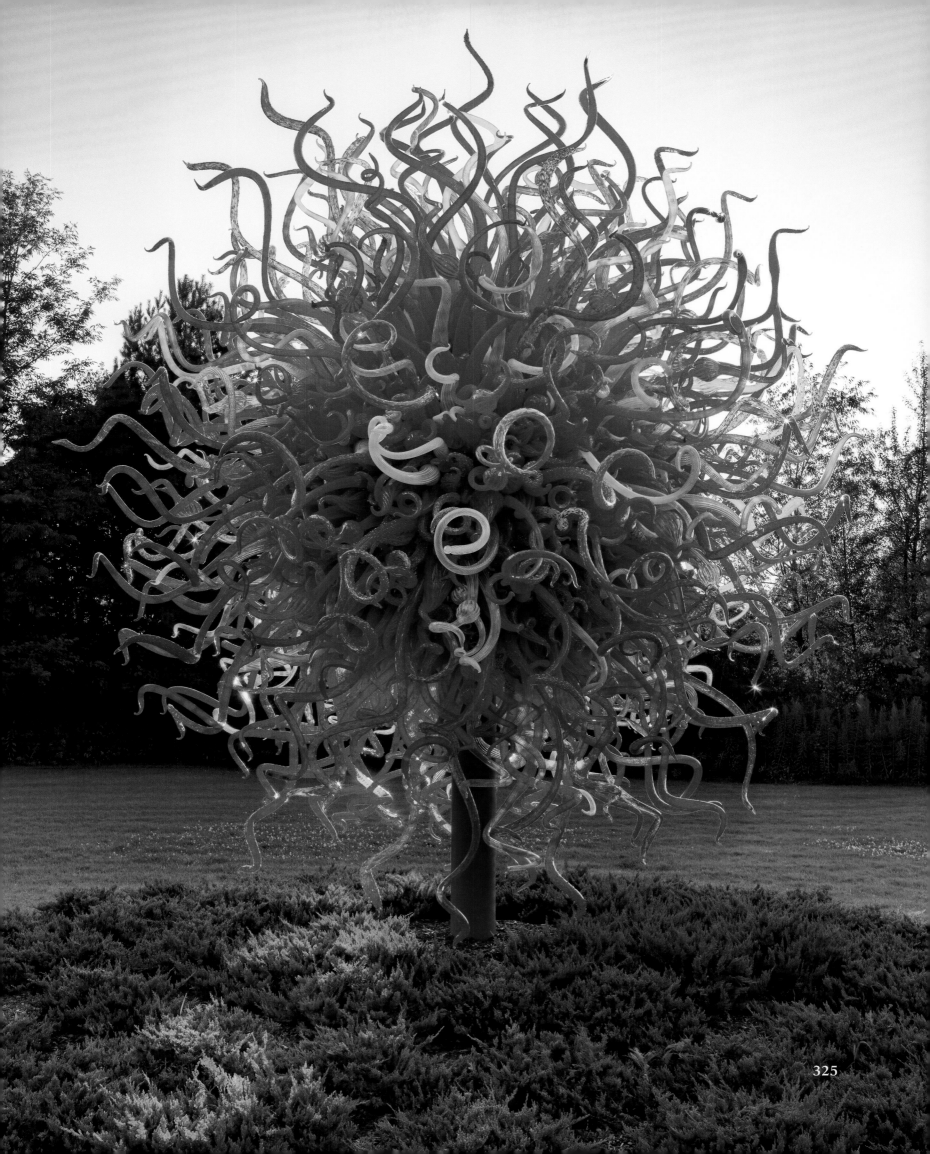

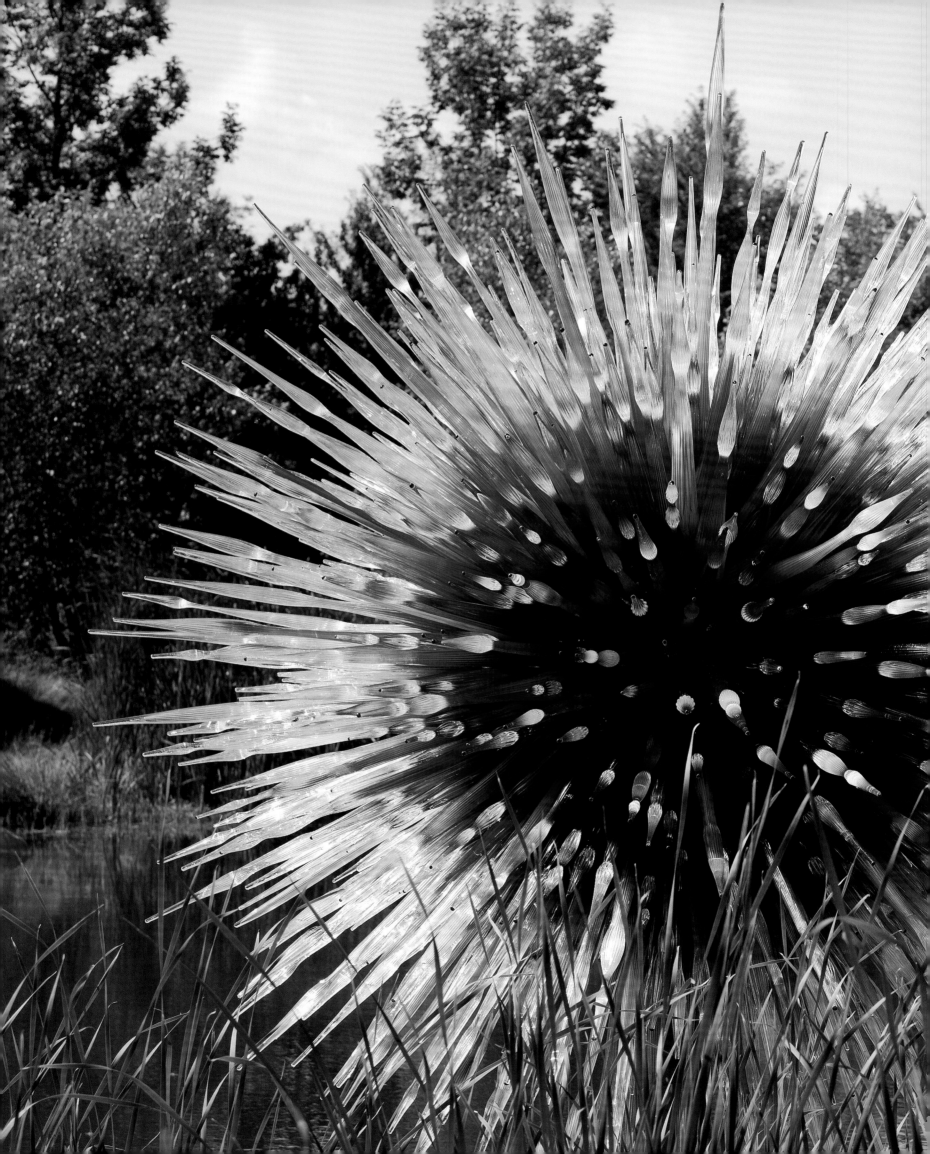

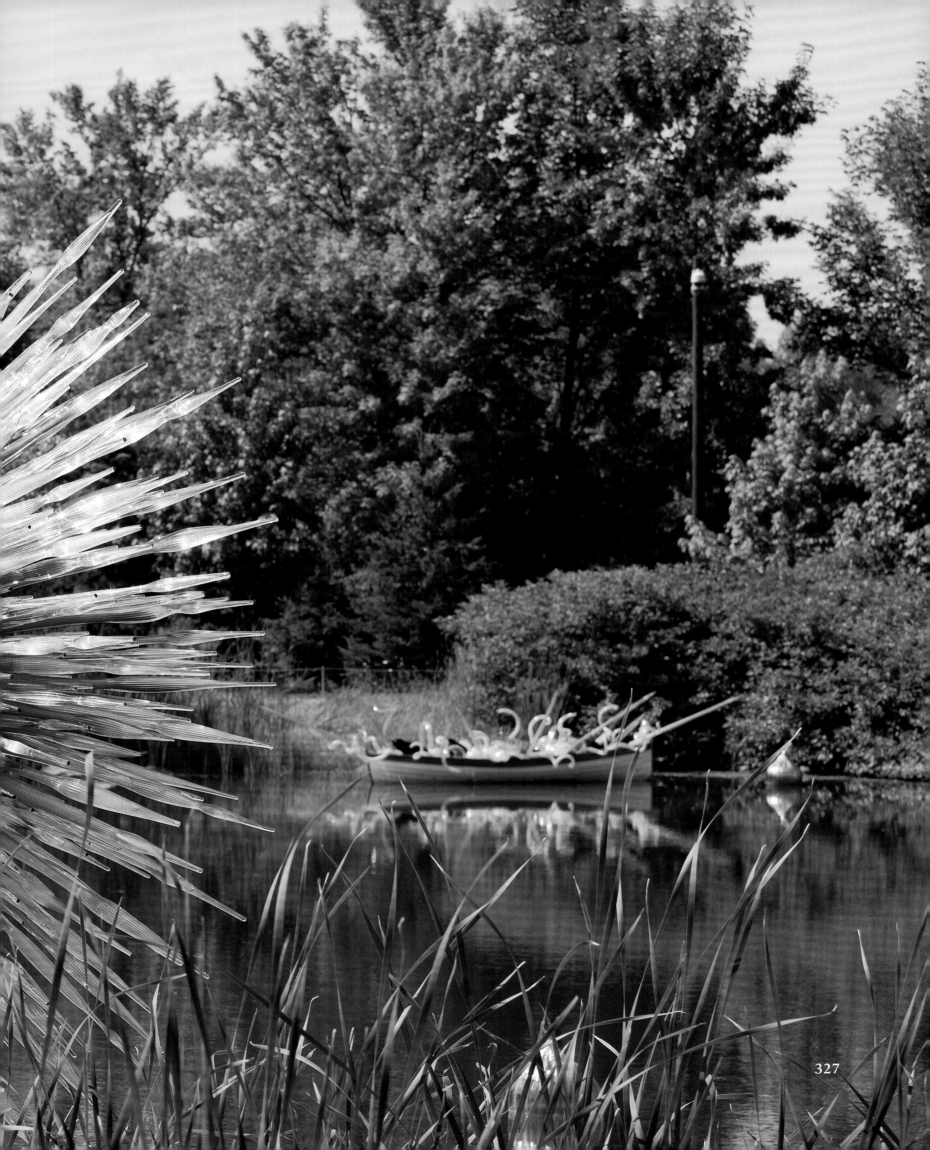

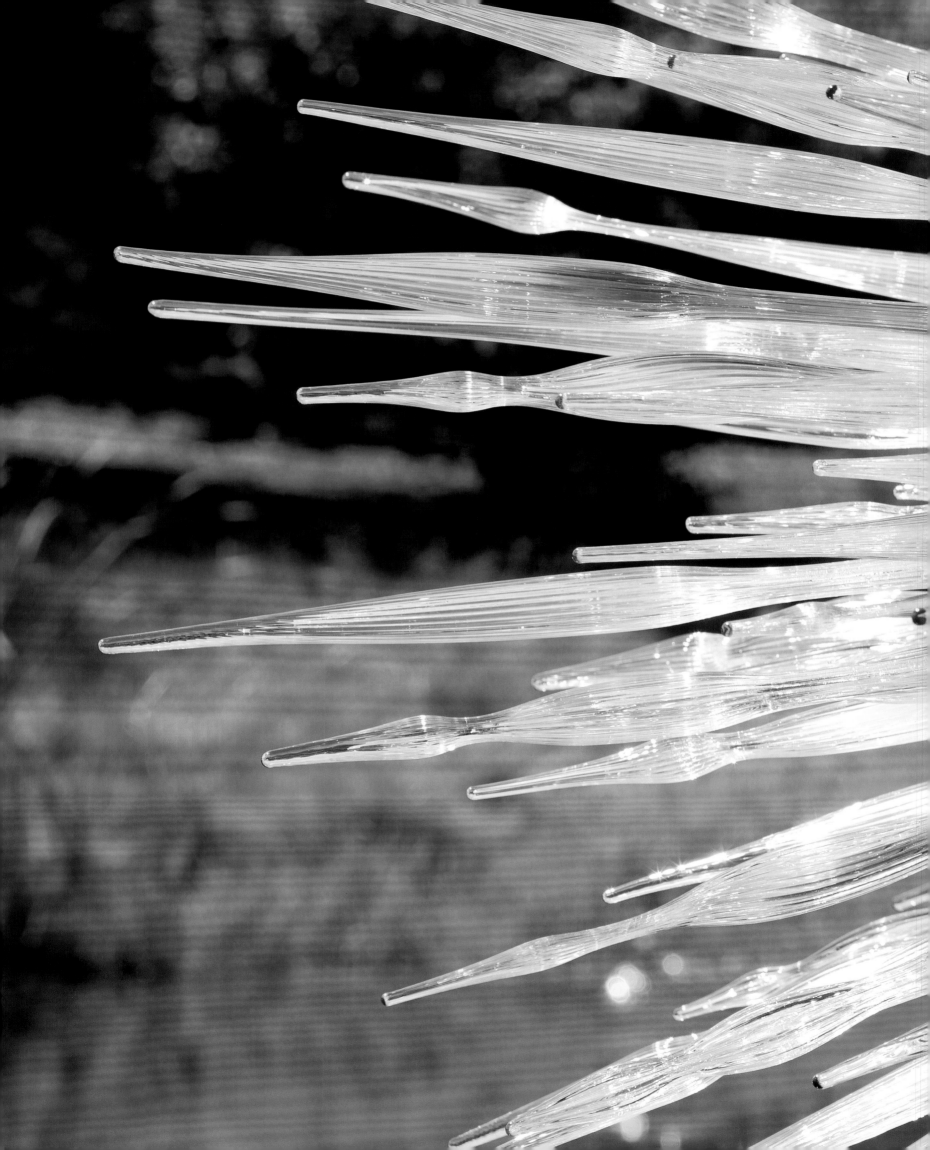

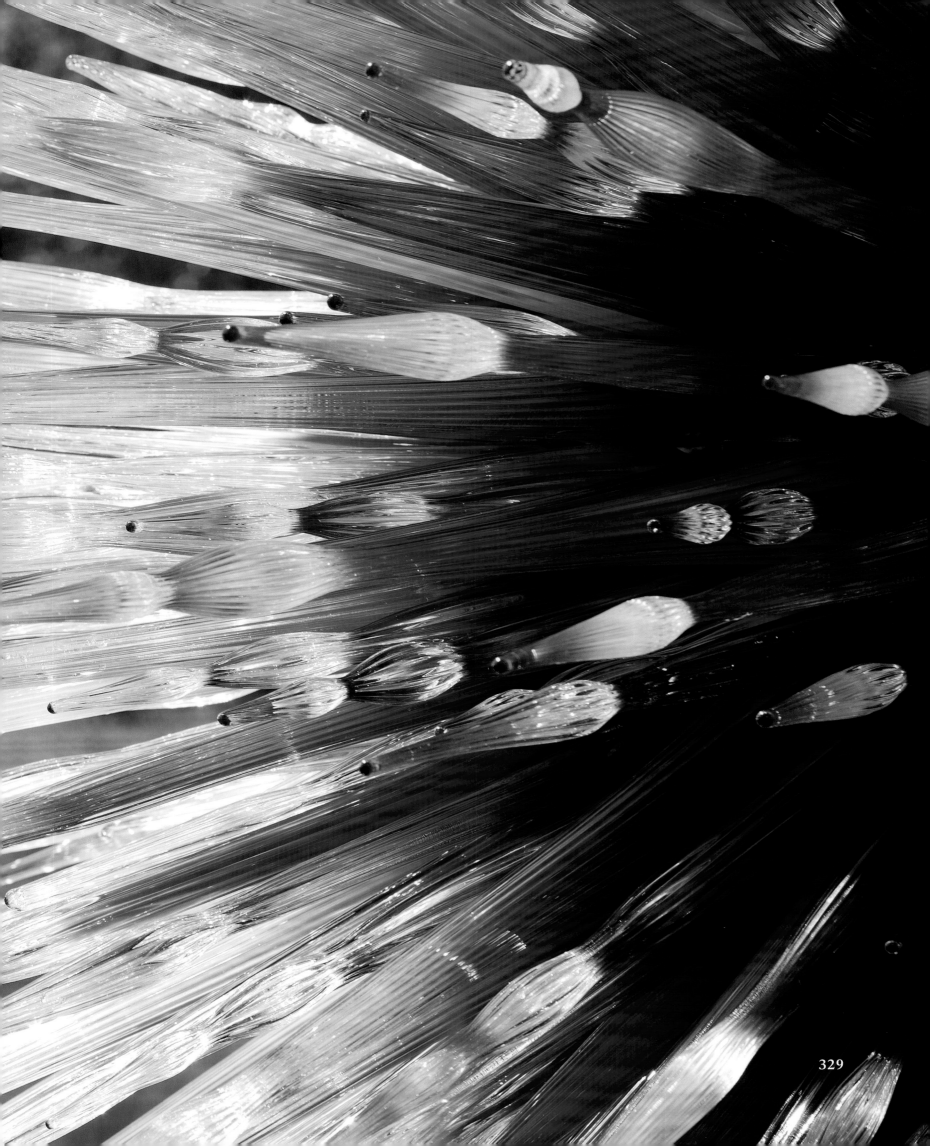

329

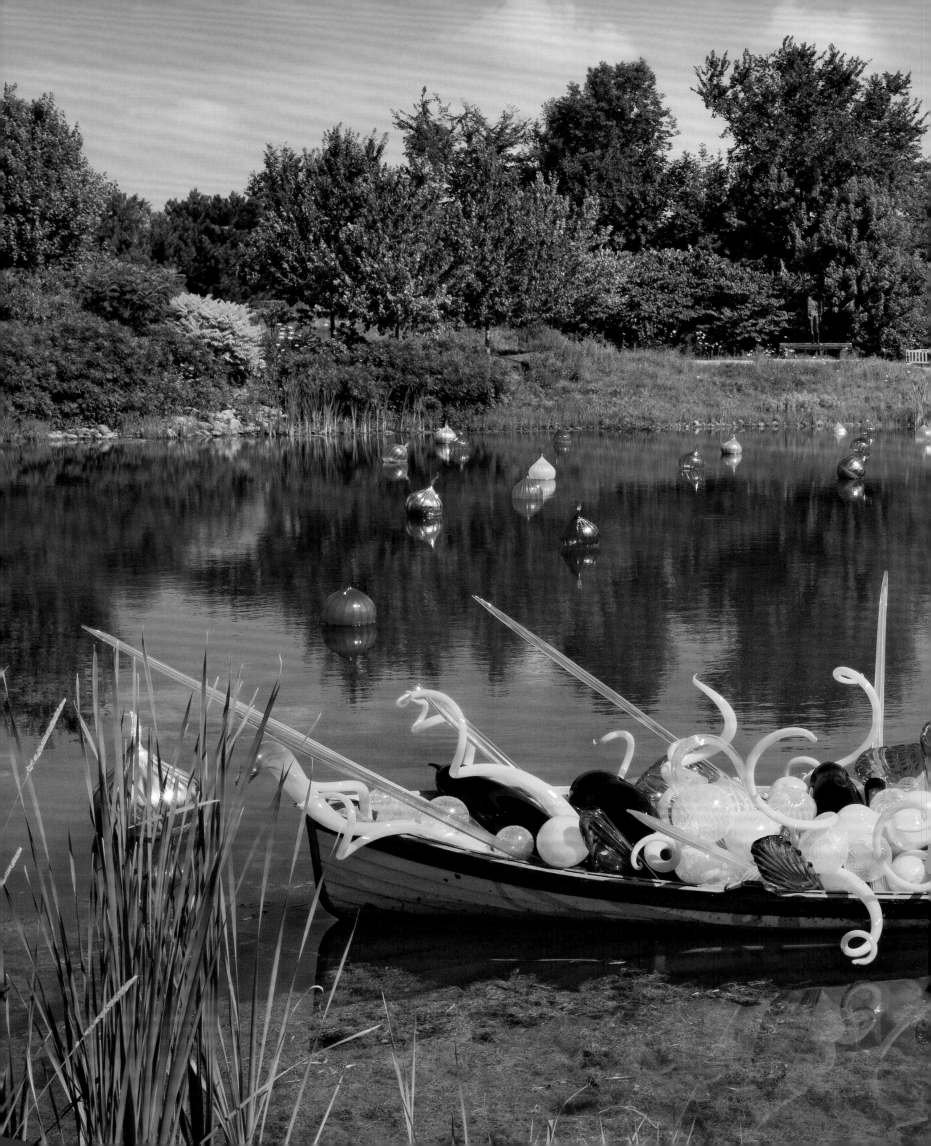

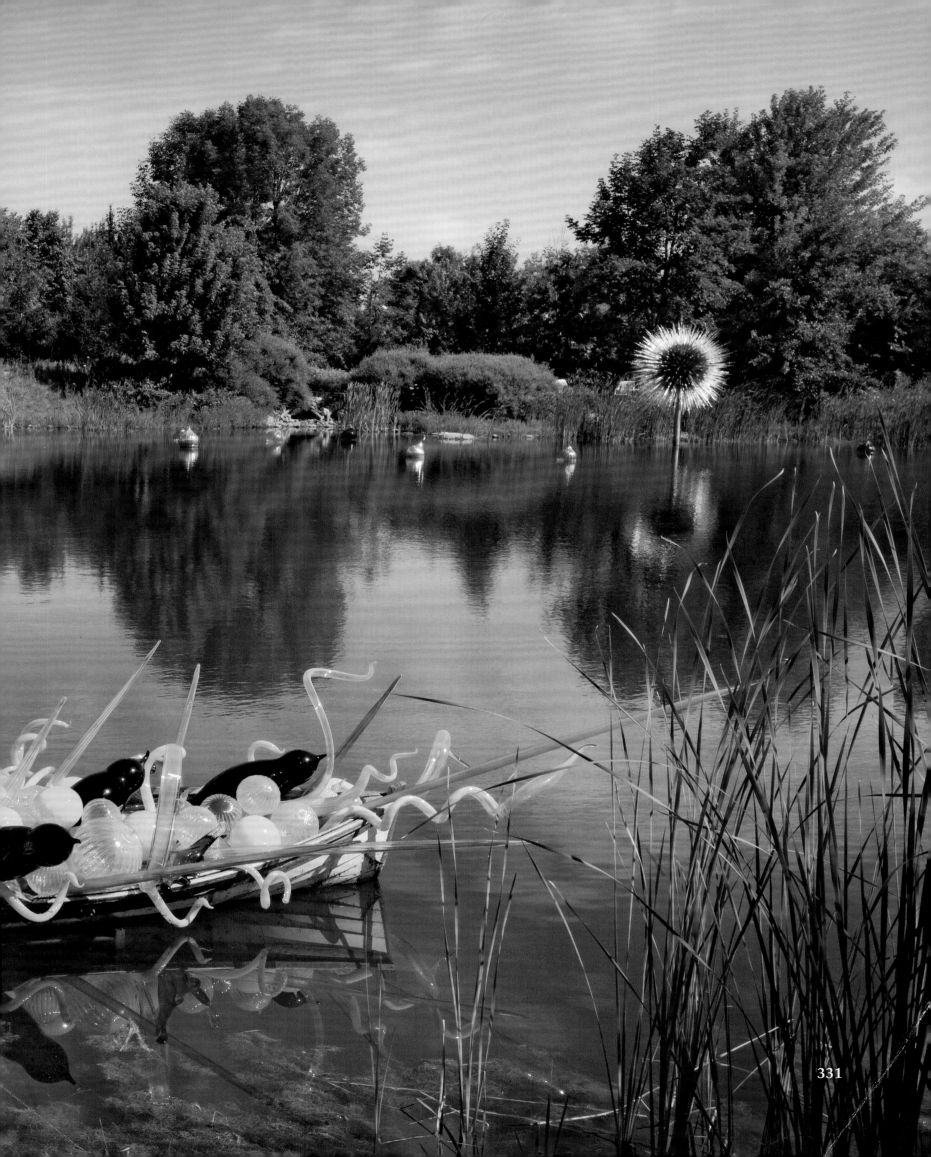

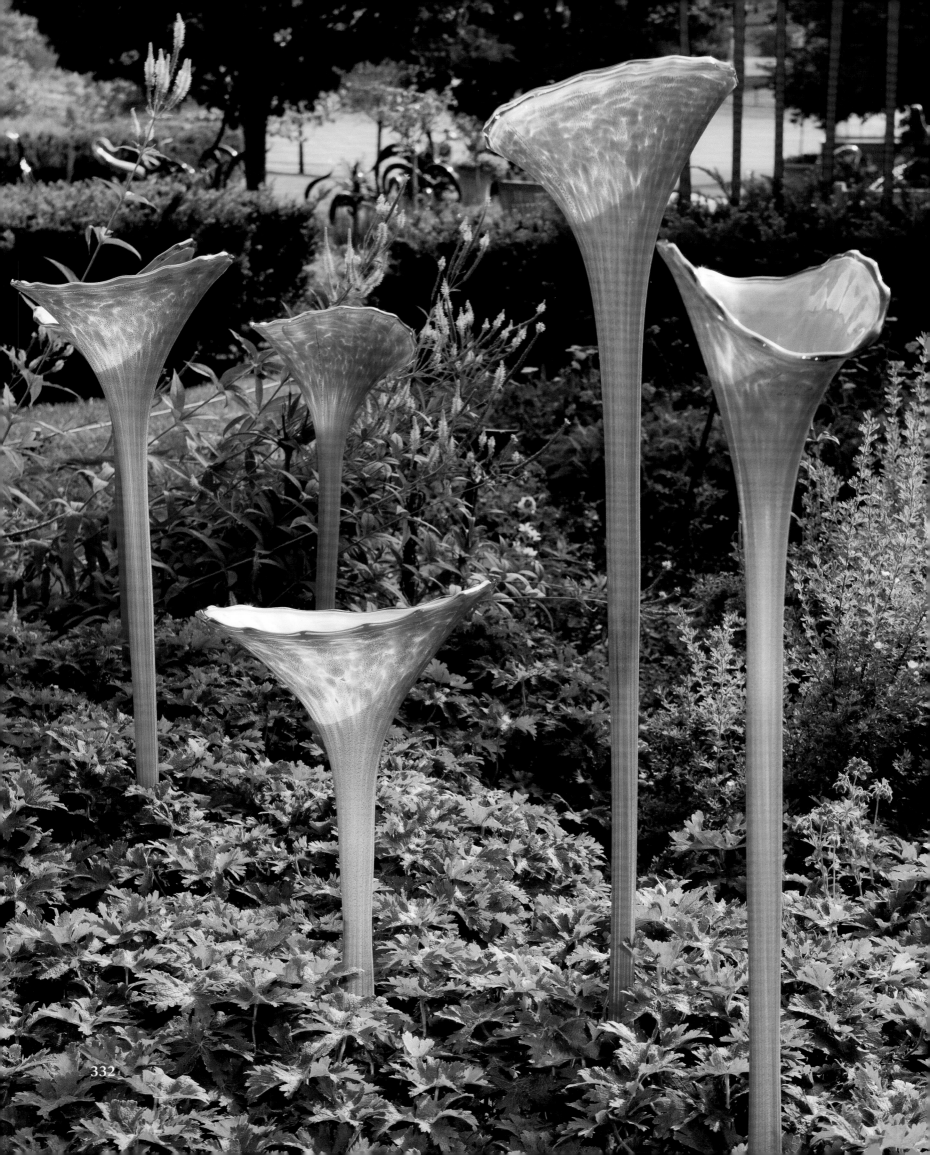

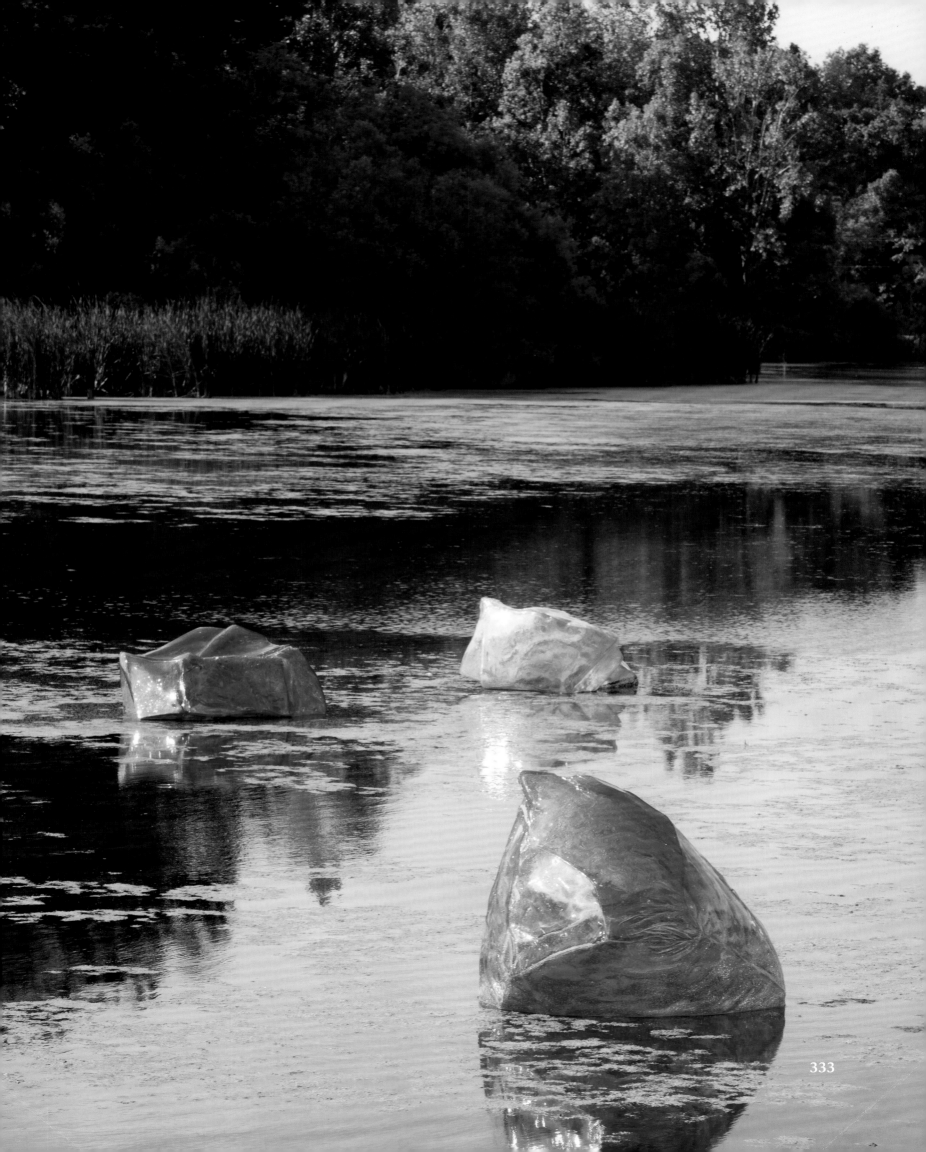

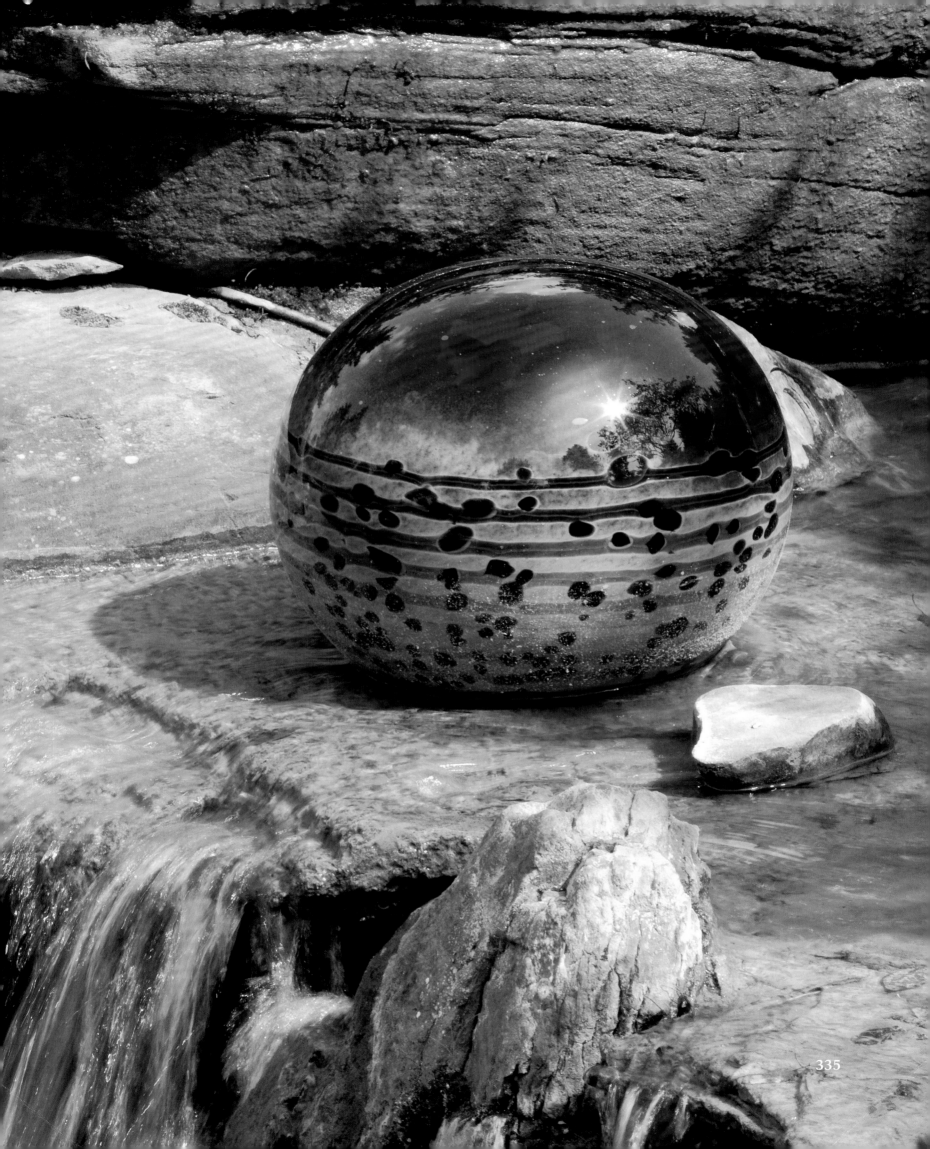

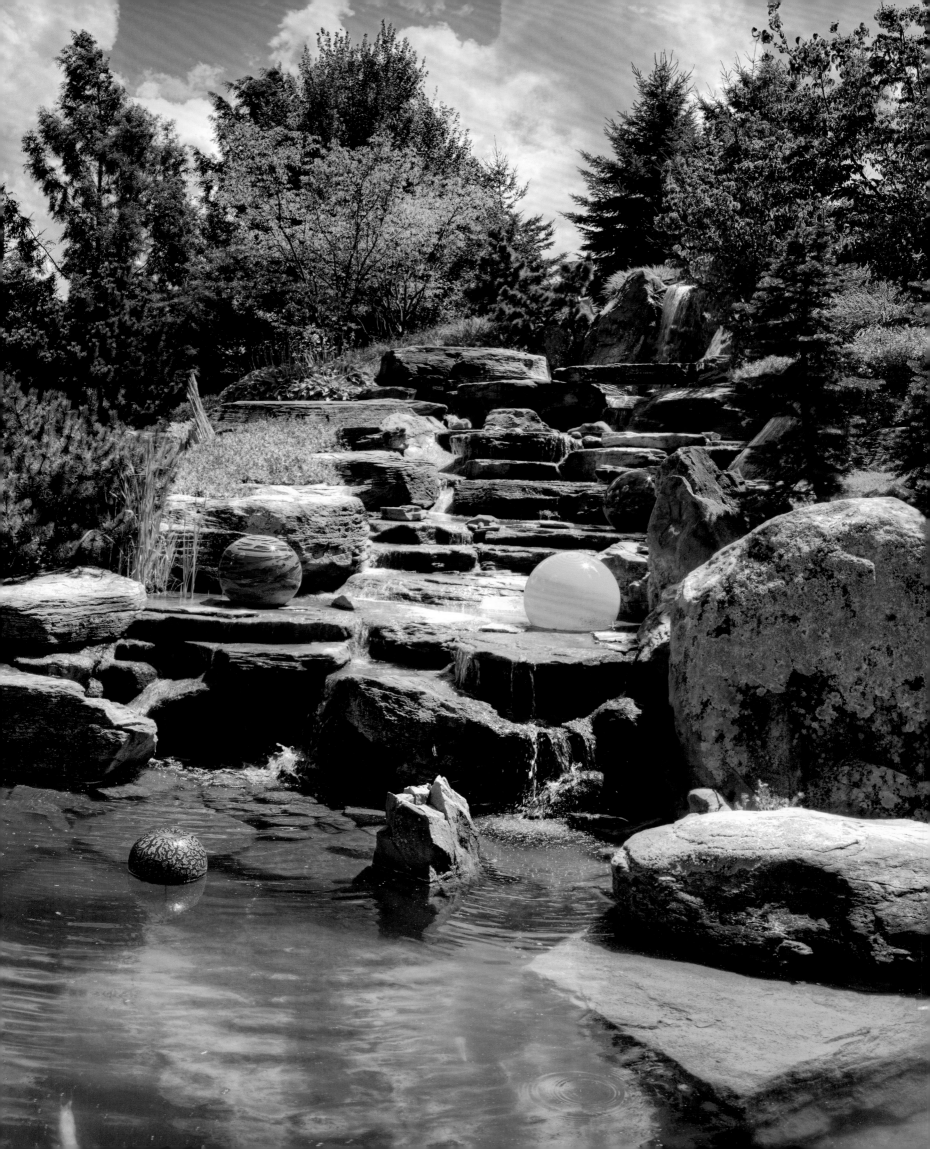

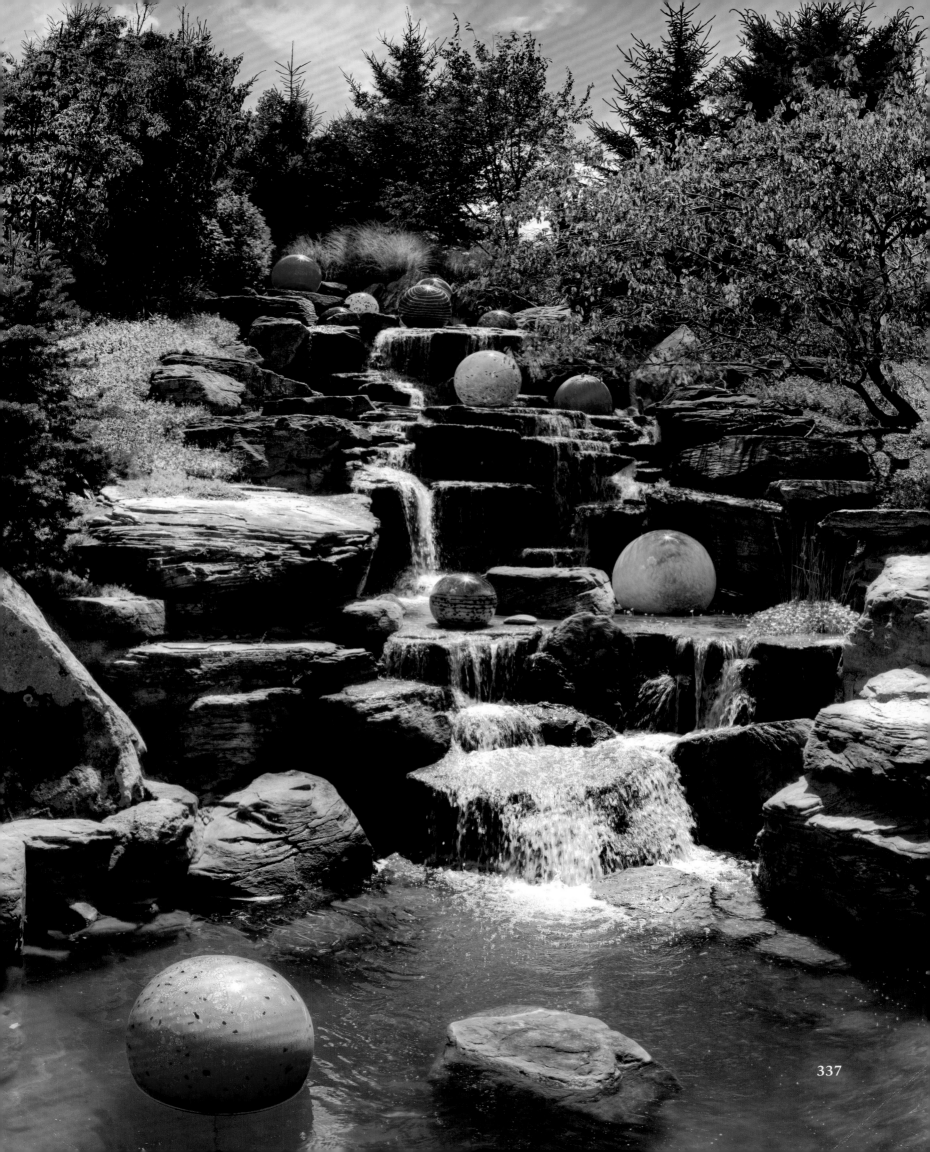

337

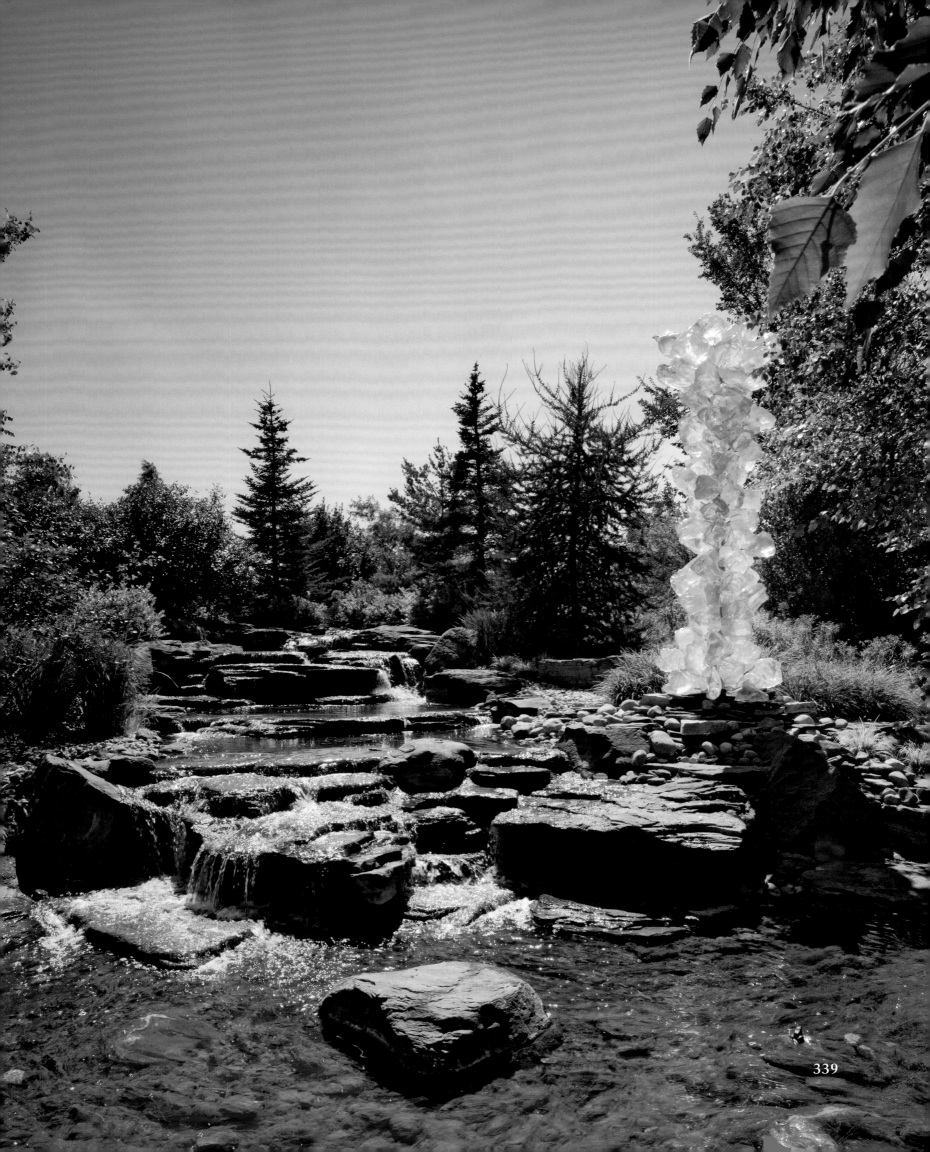

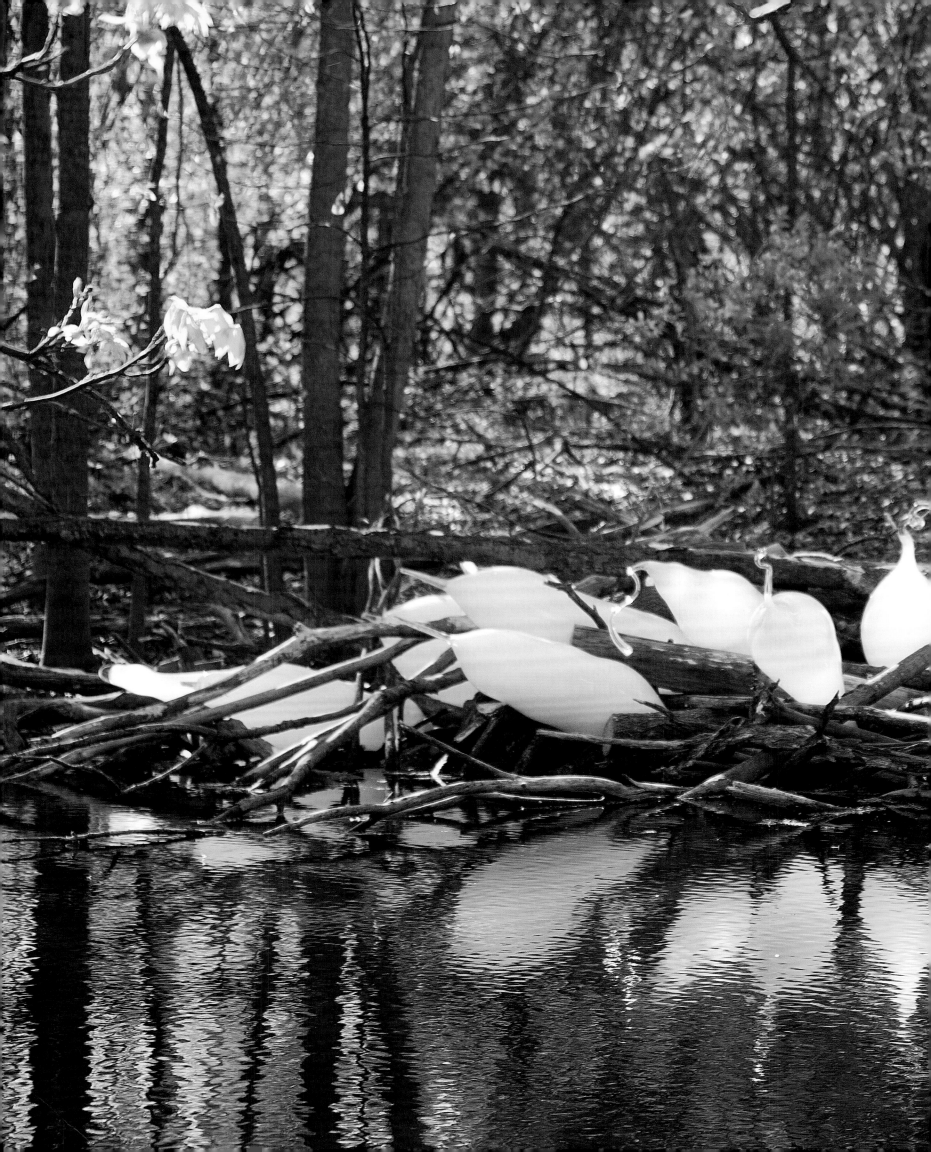

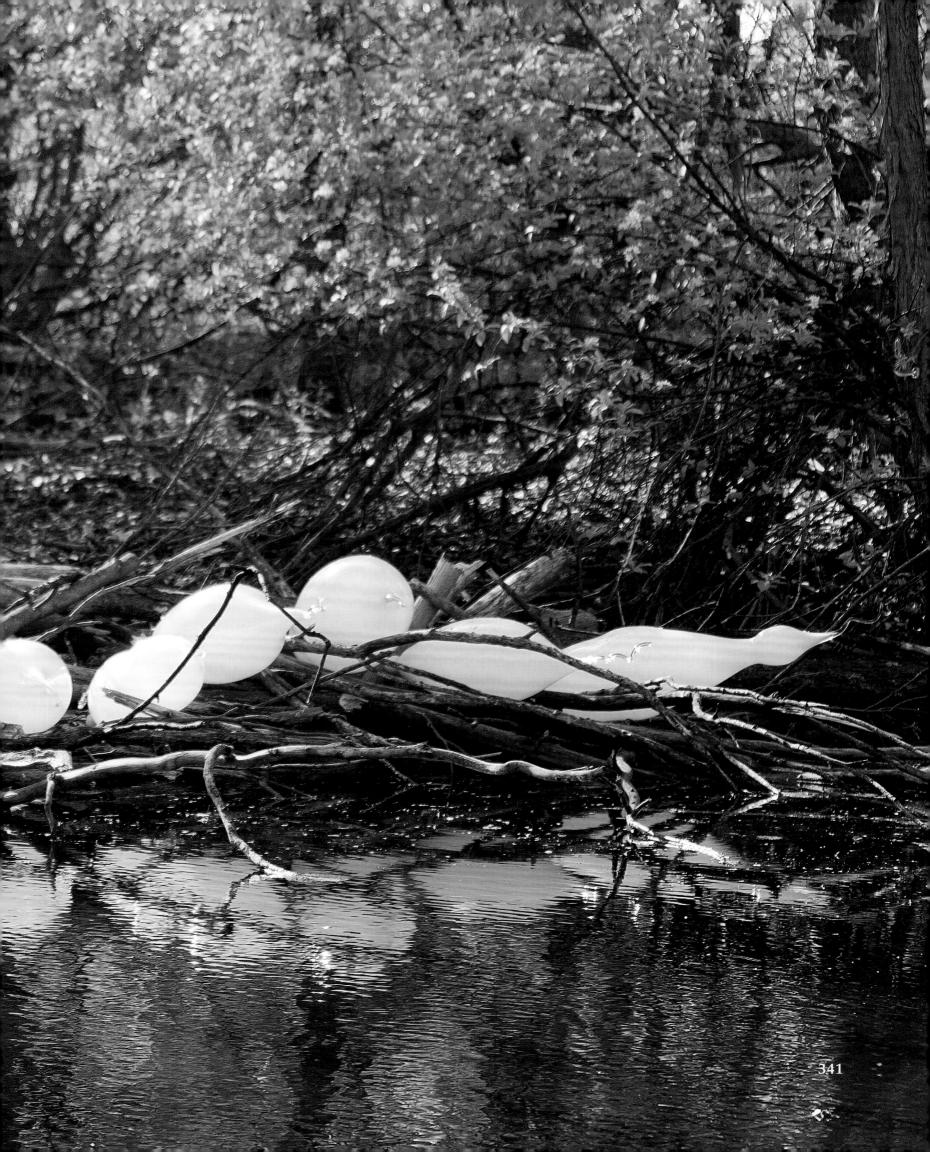

341

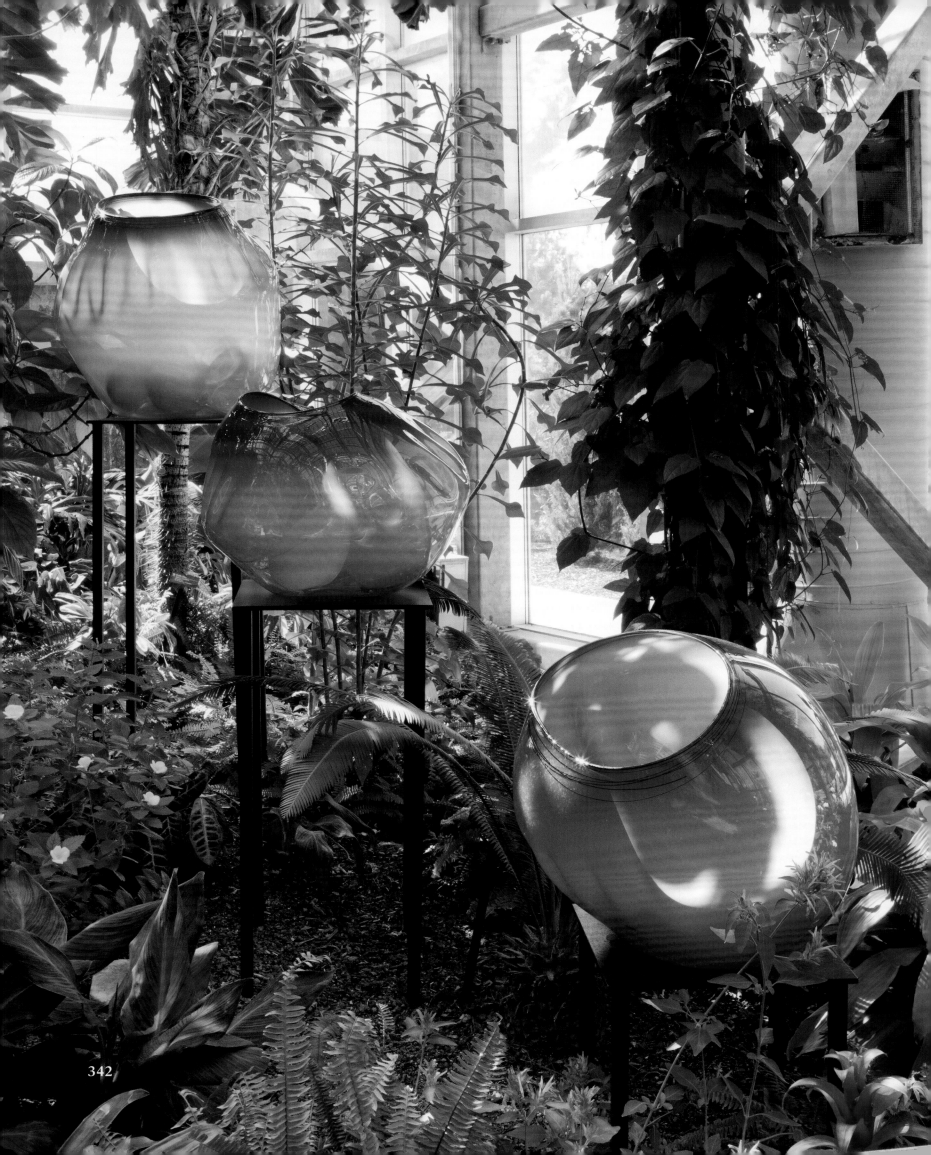

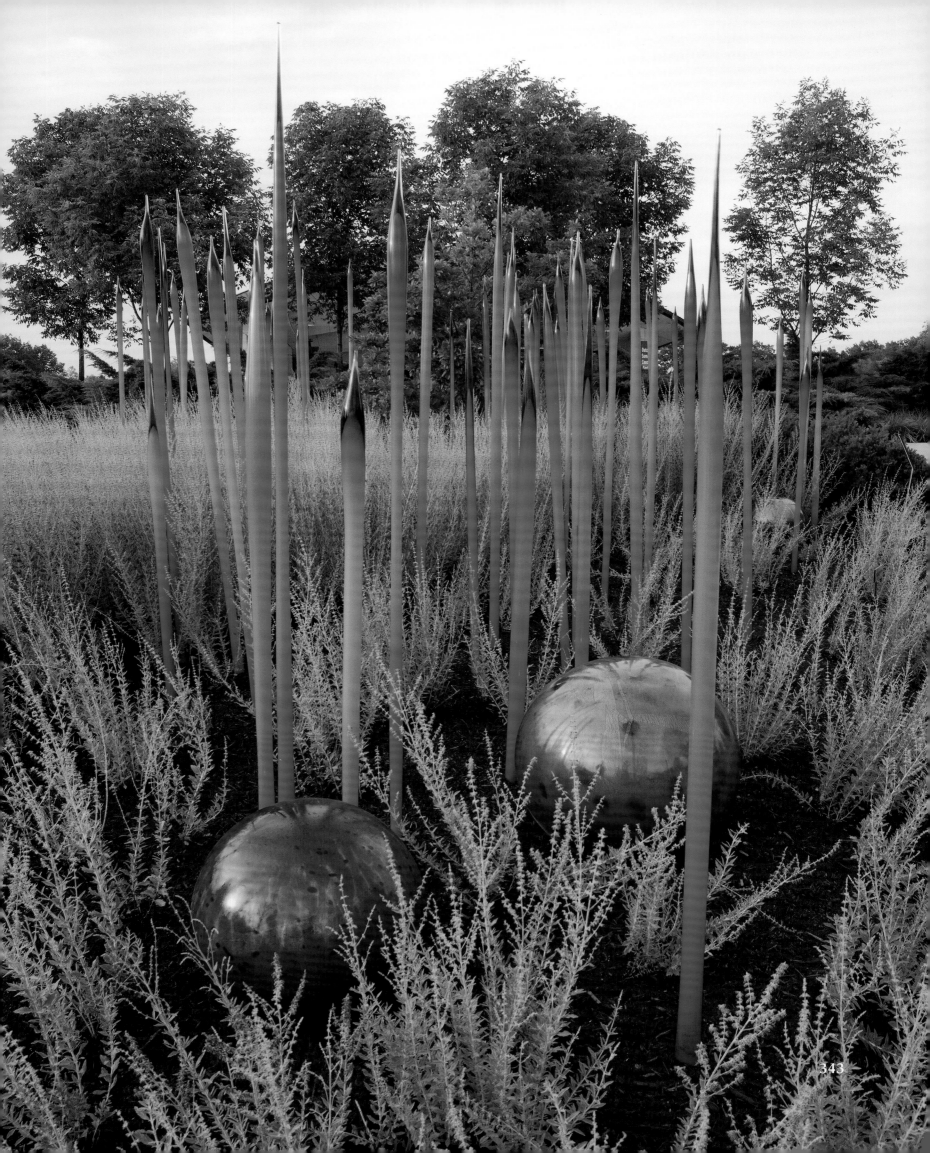

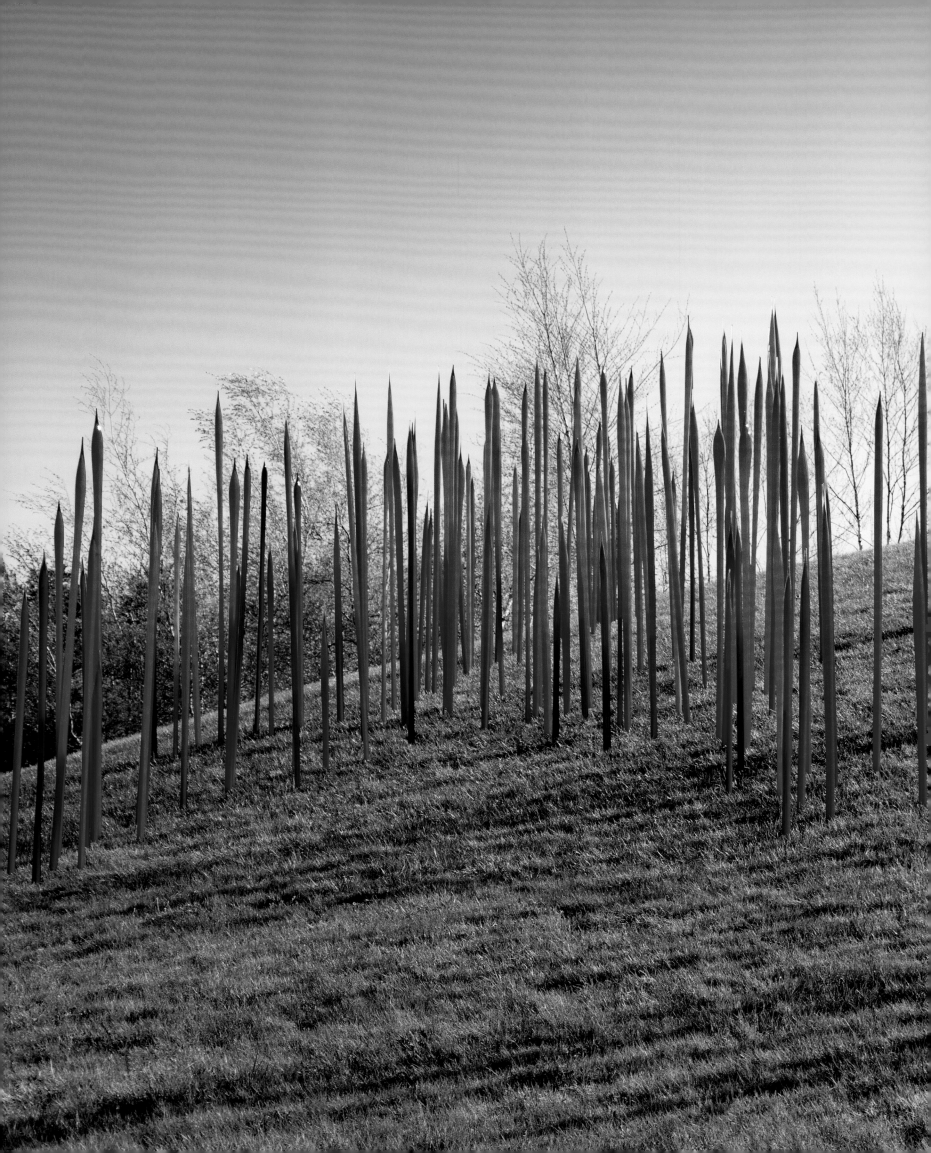

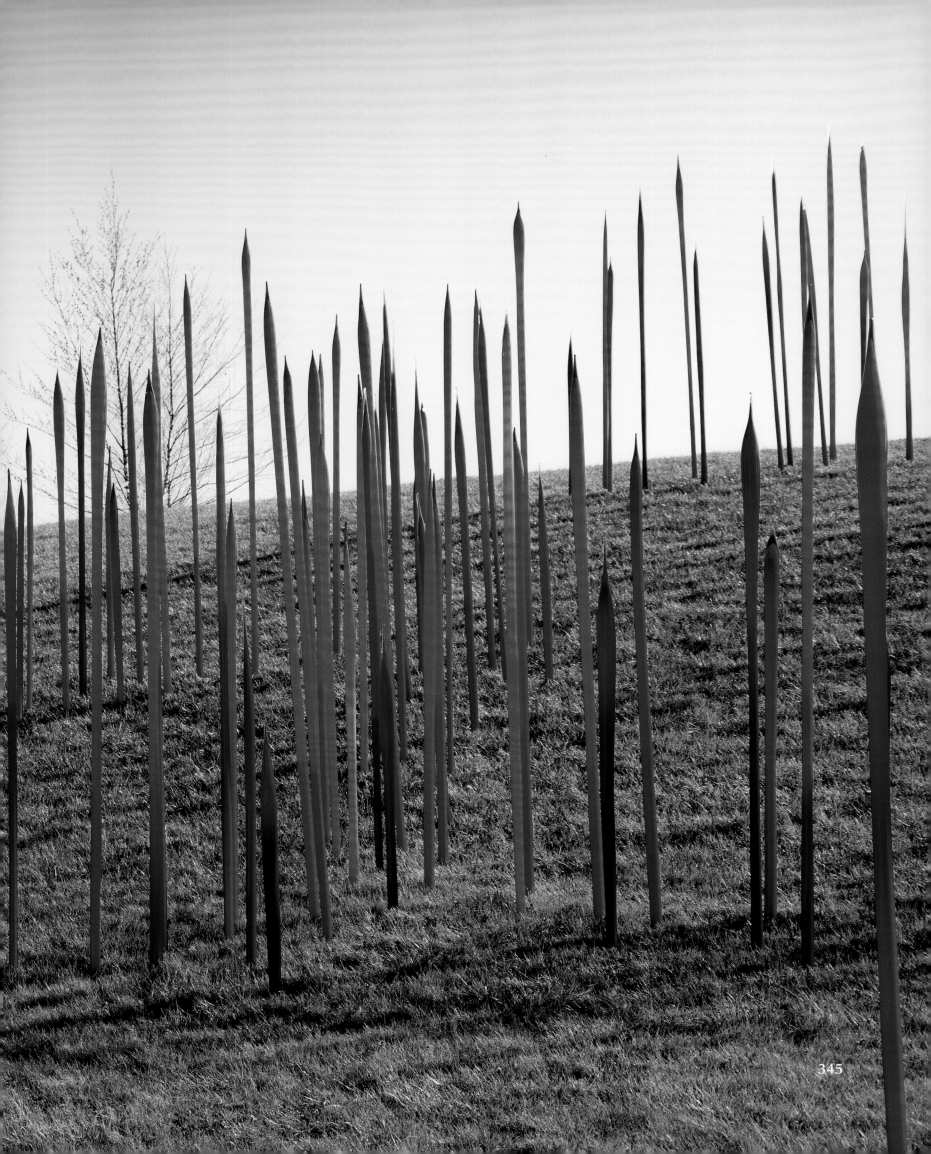

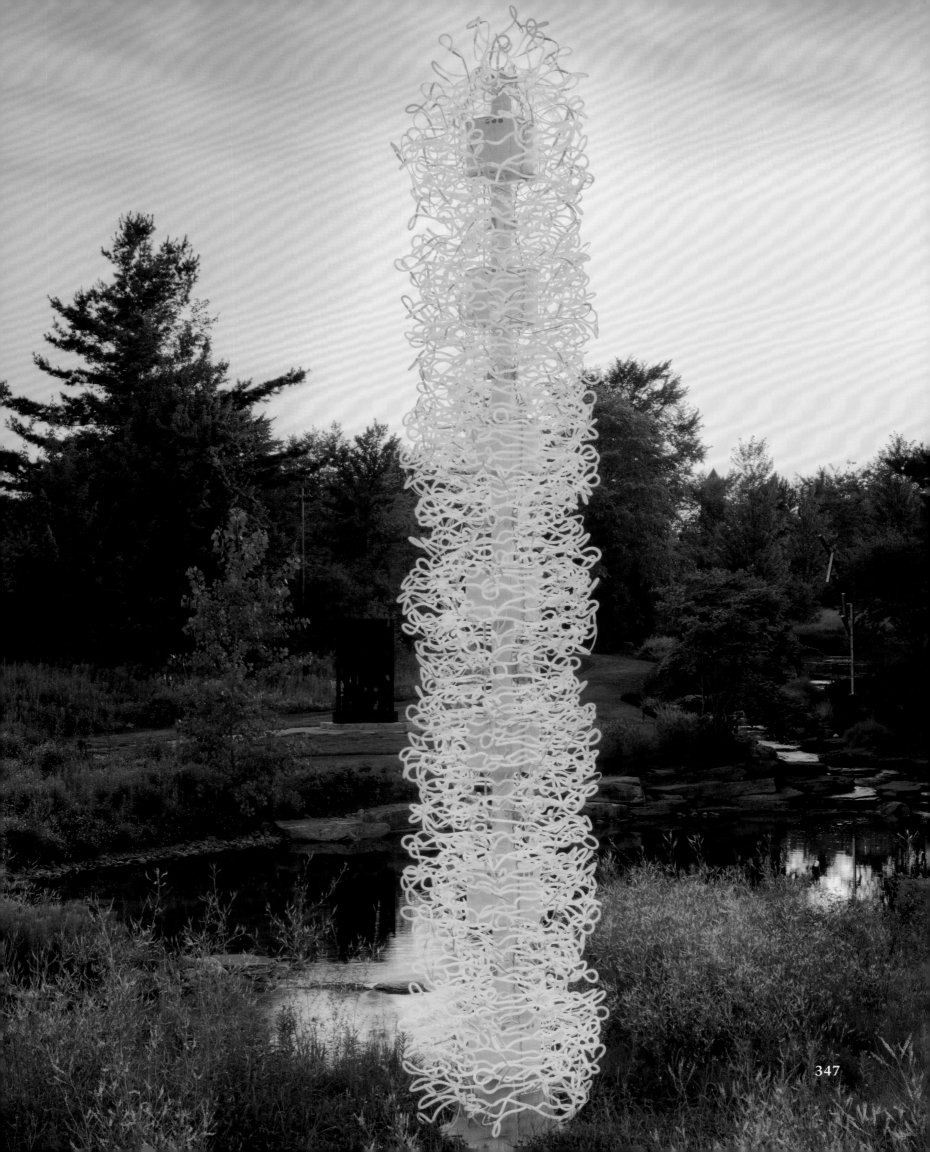

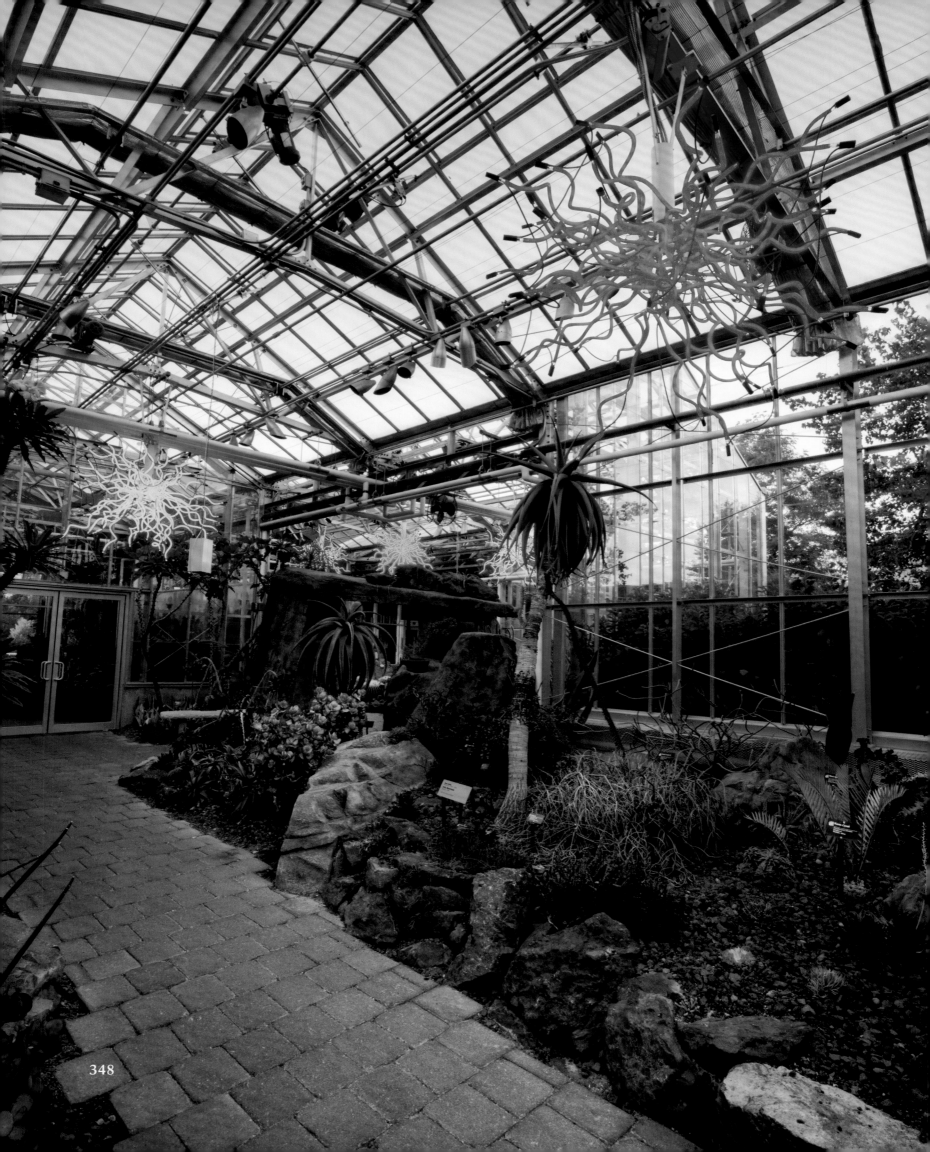

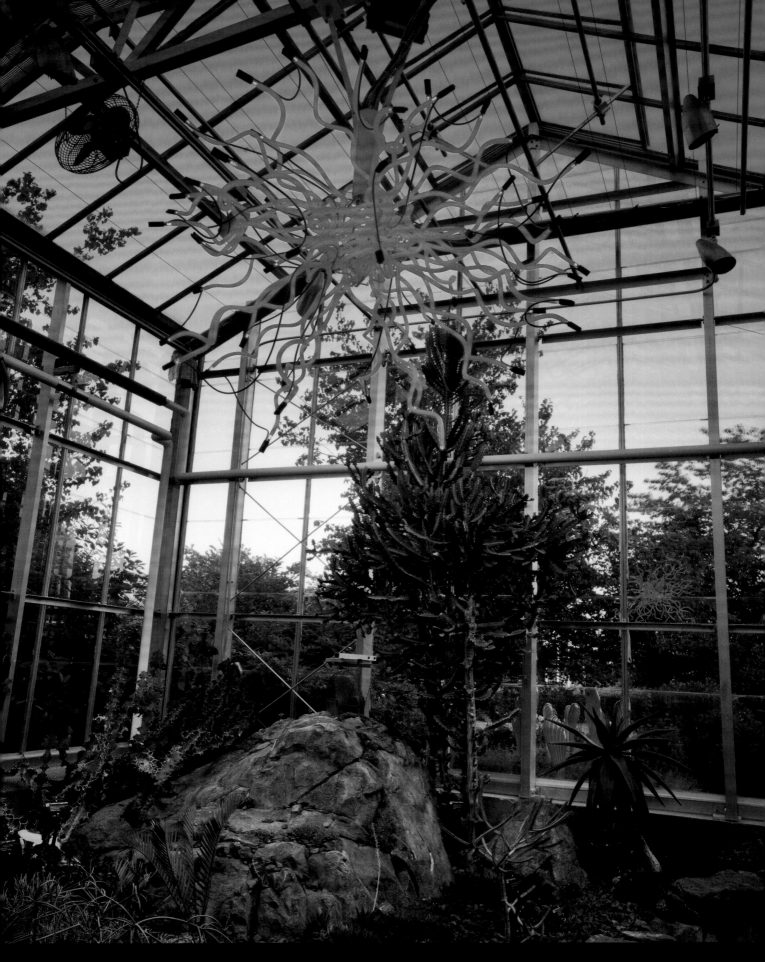

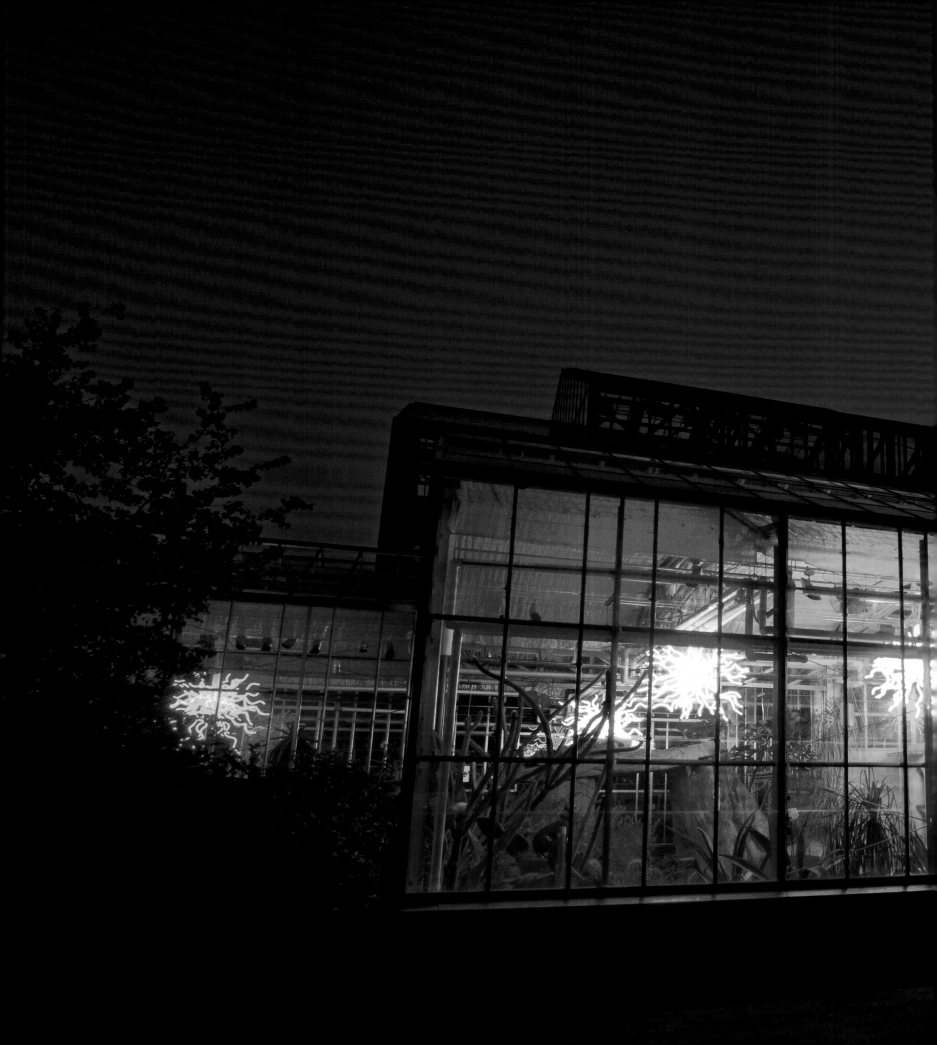

Cheekwood Botanical Garden and Museum of Art
Nashville, Tennessee

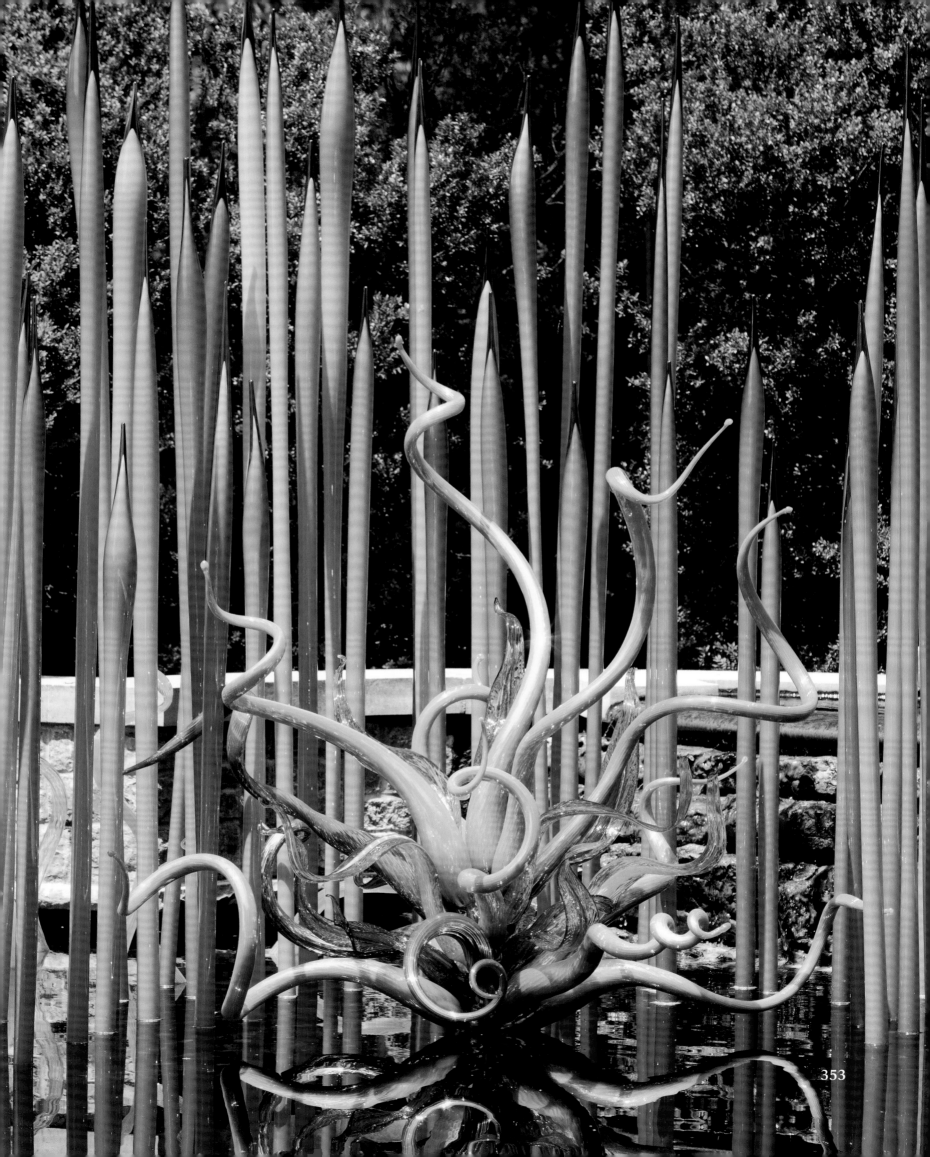

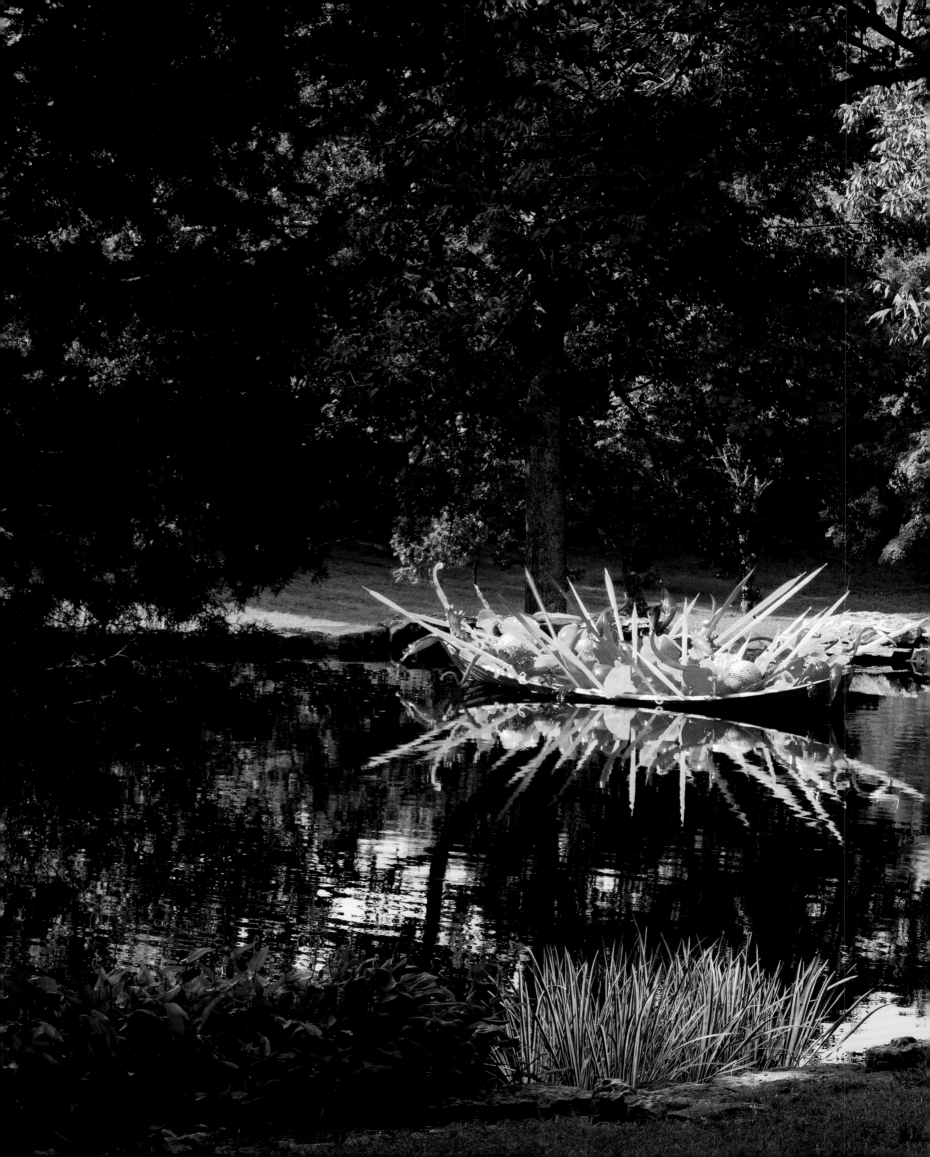

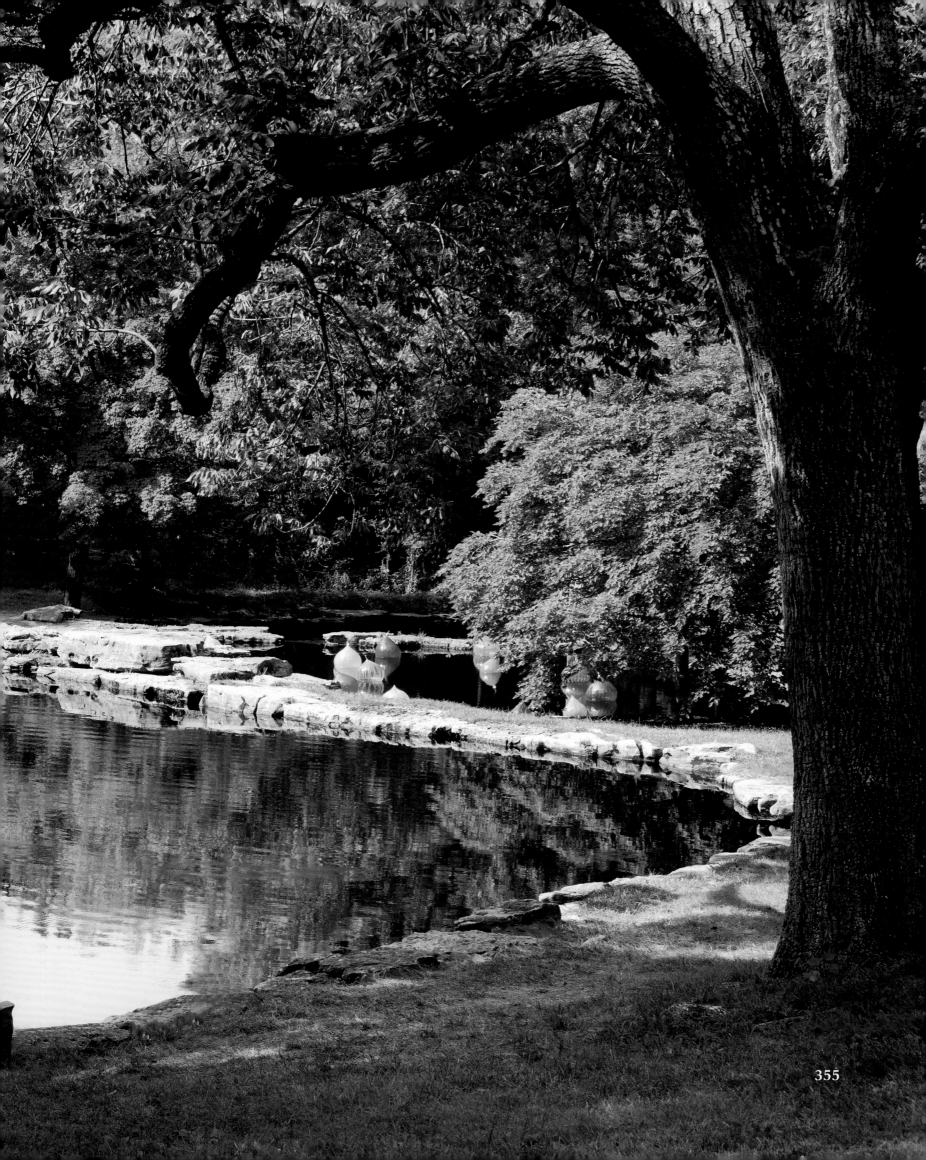

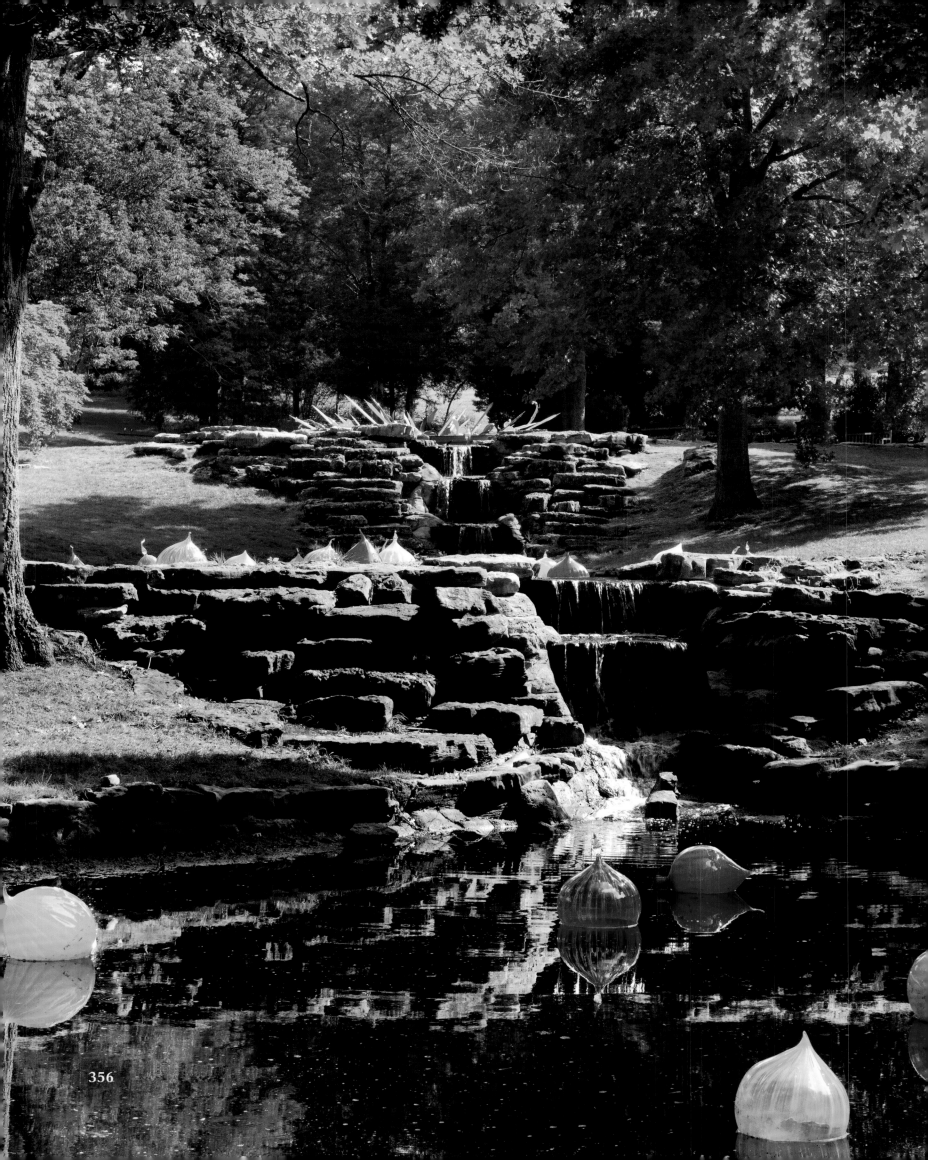

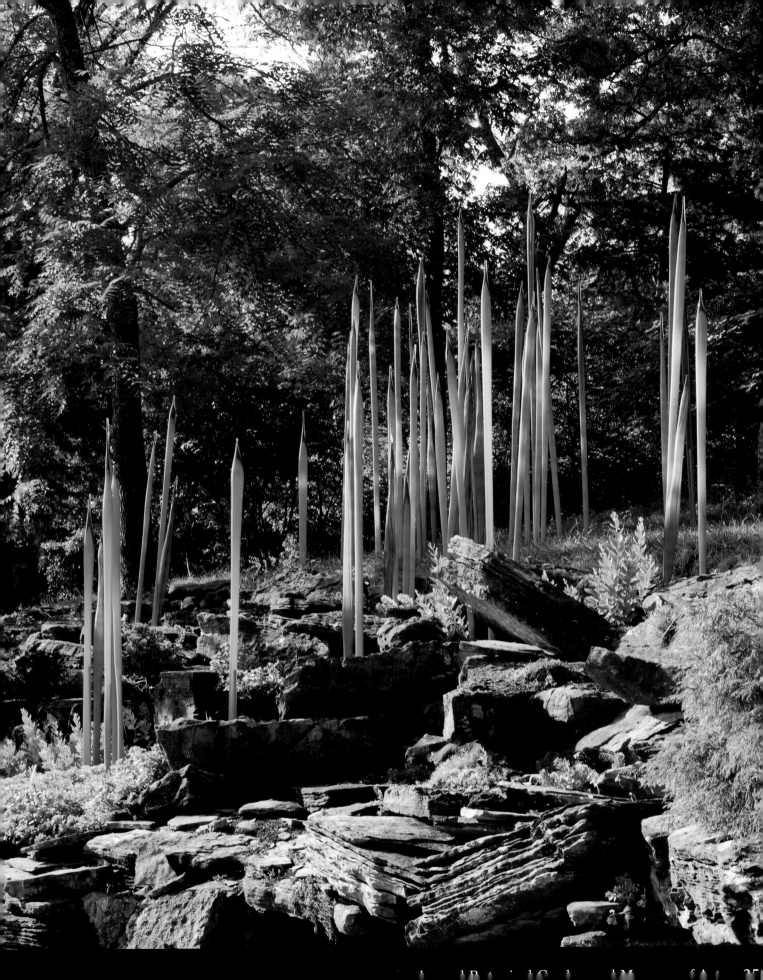

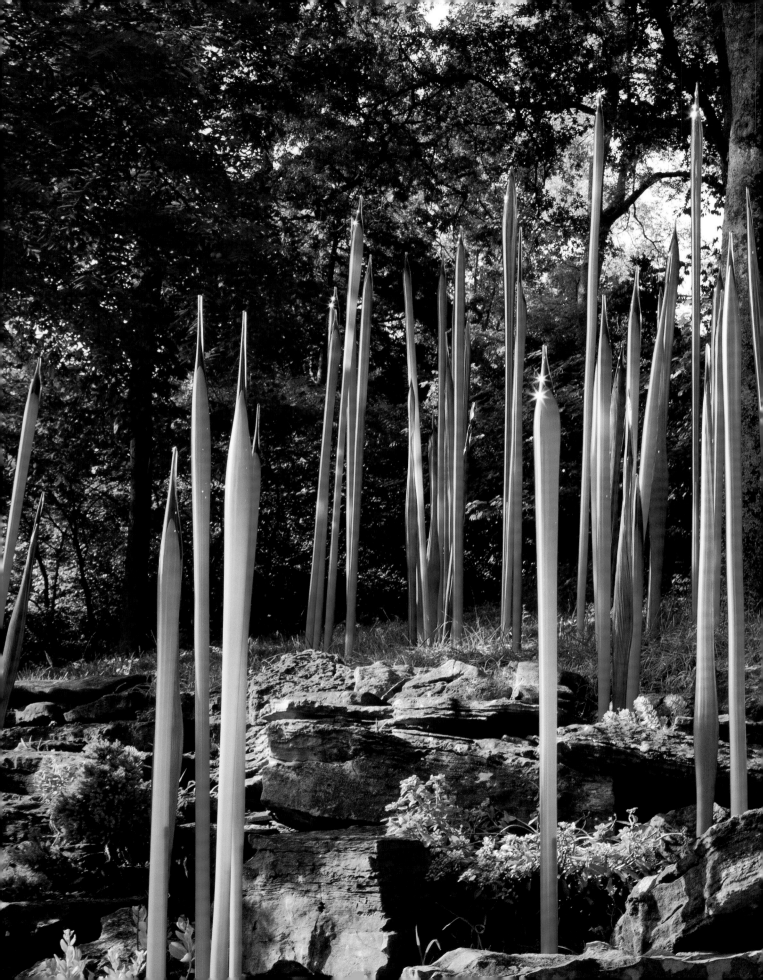

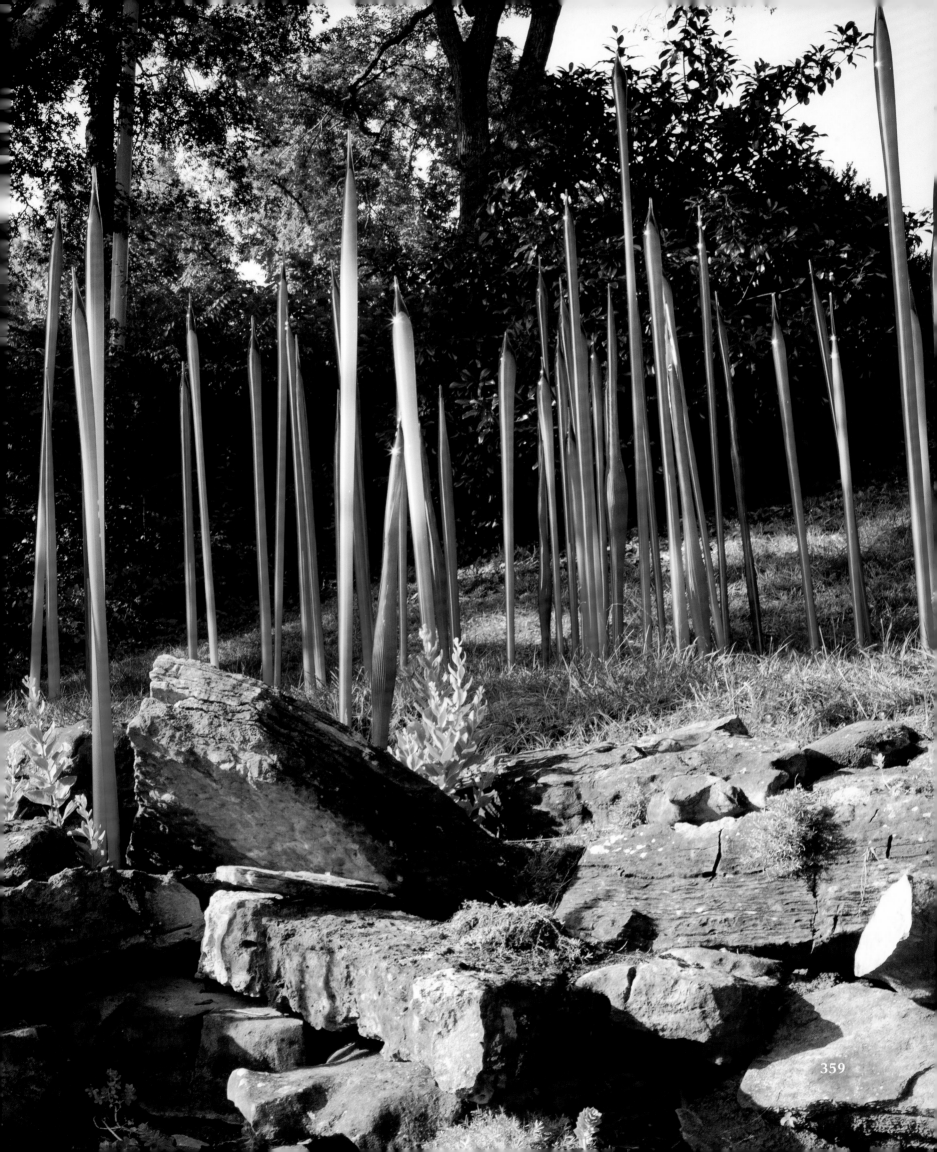

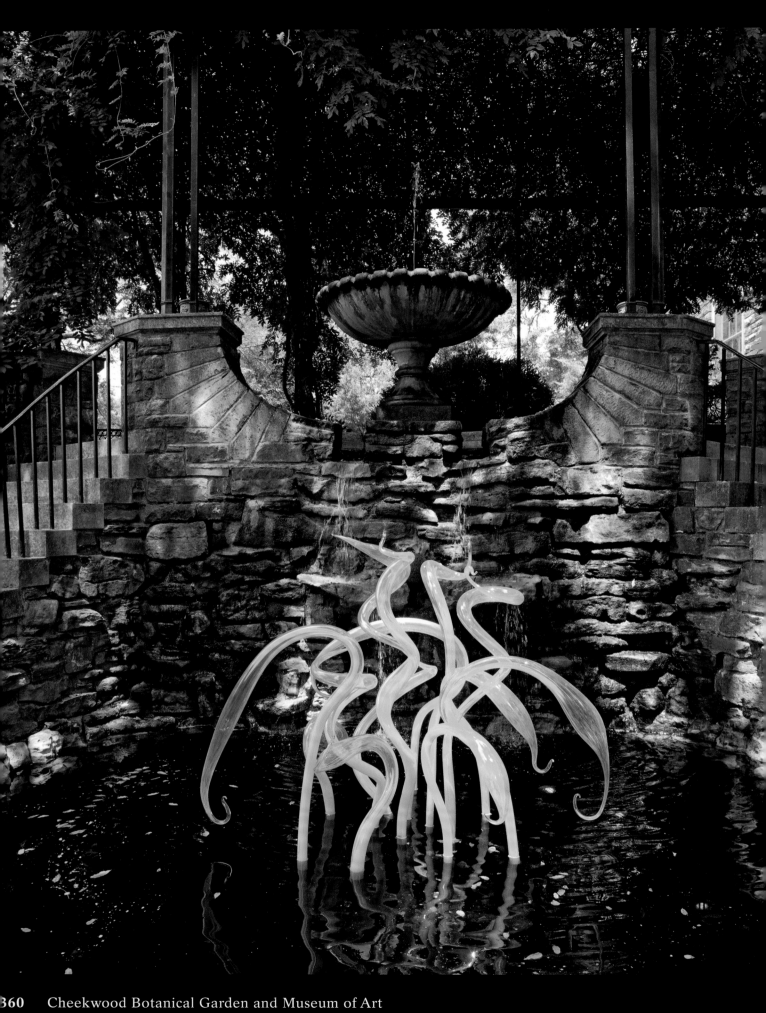

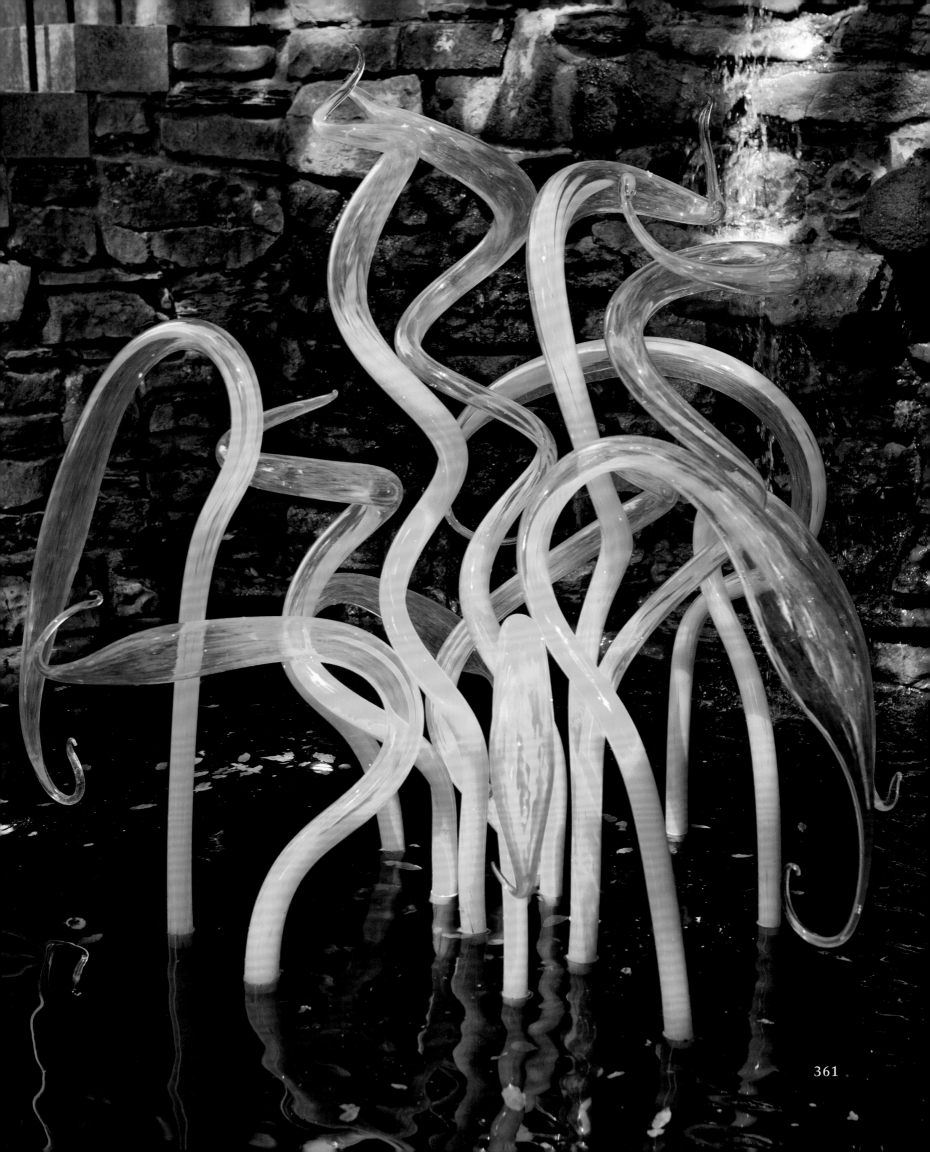

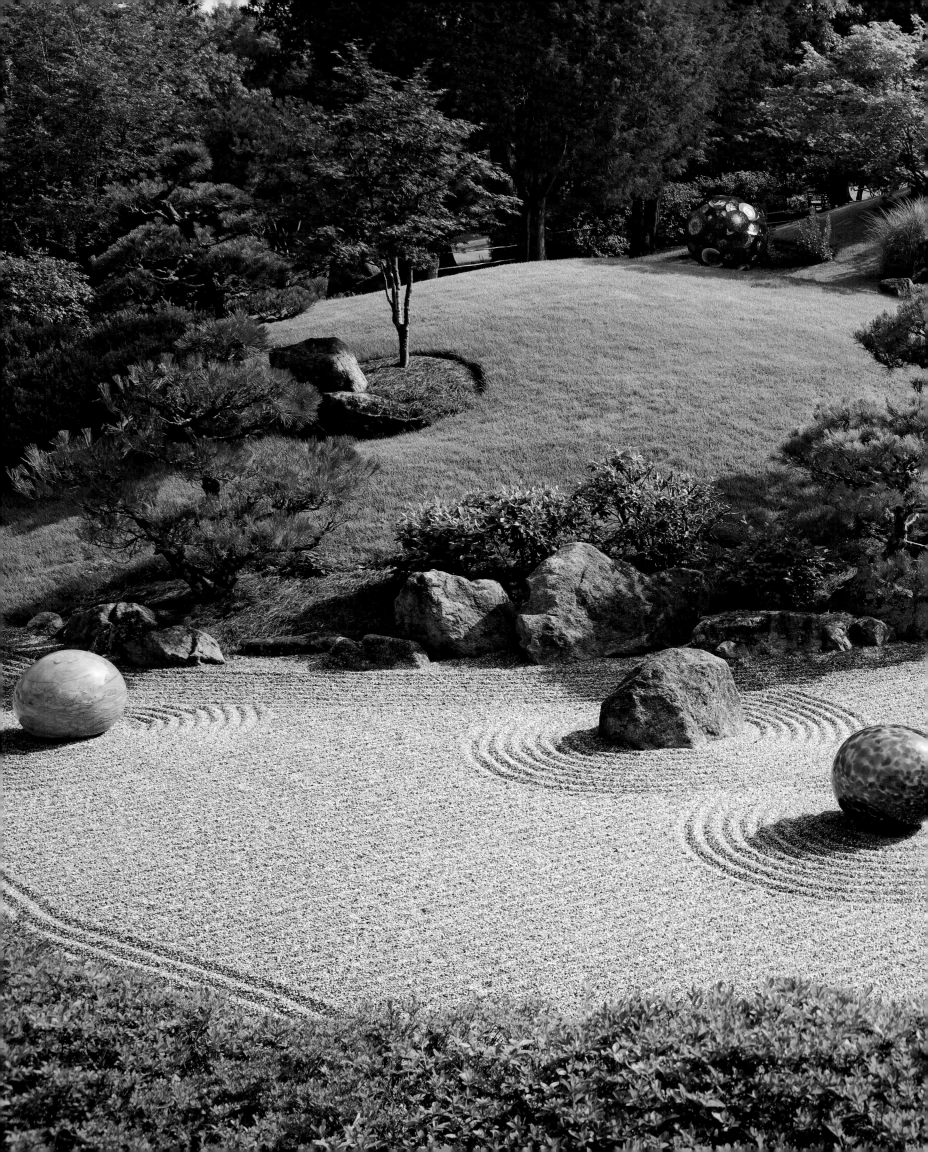

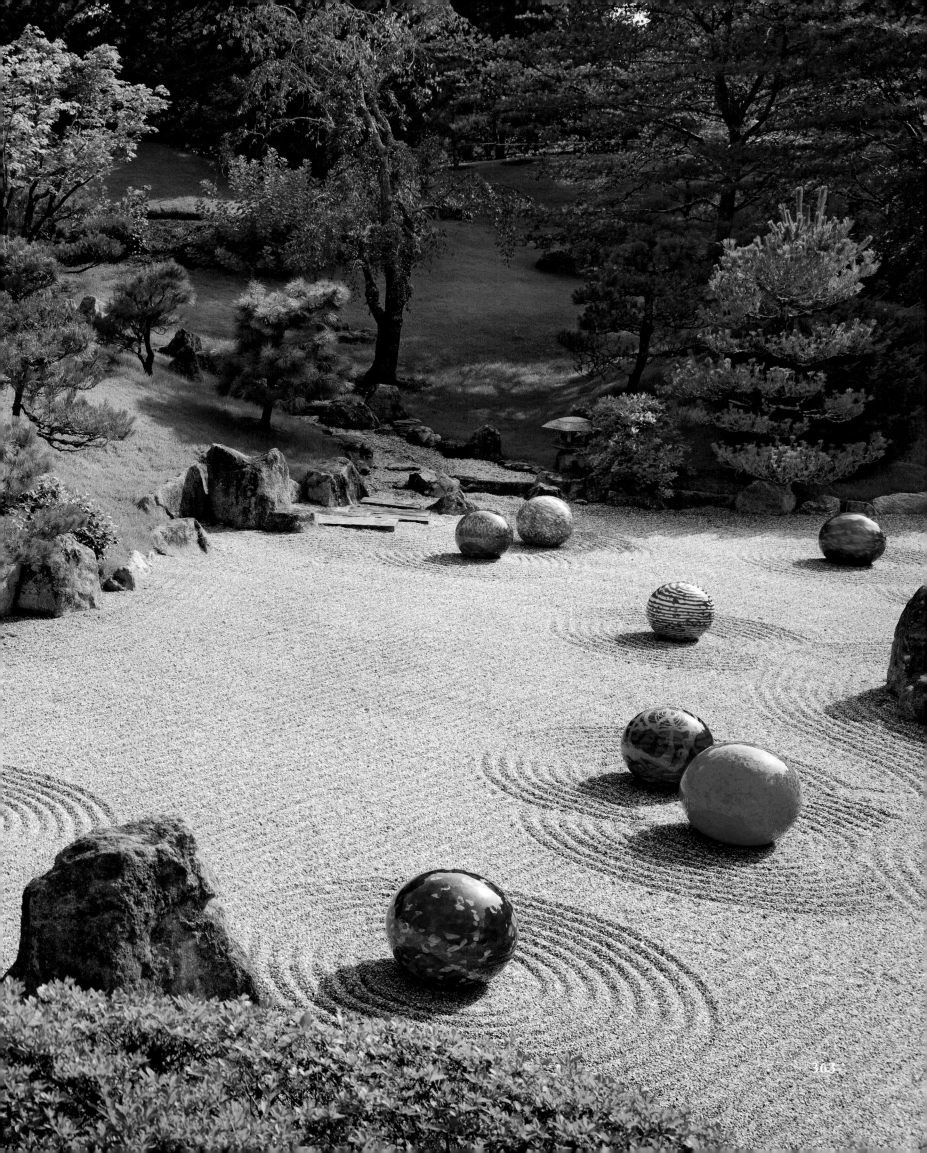

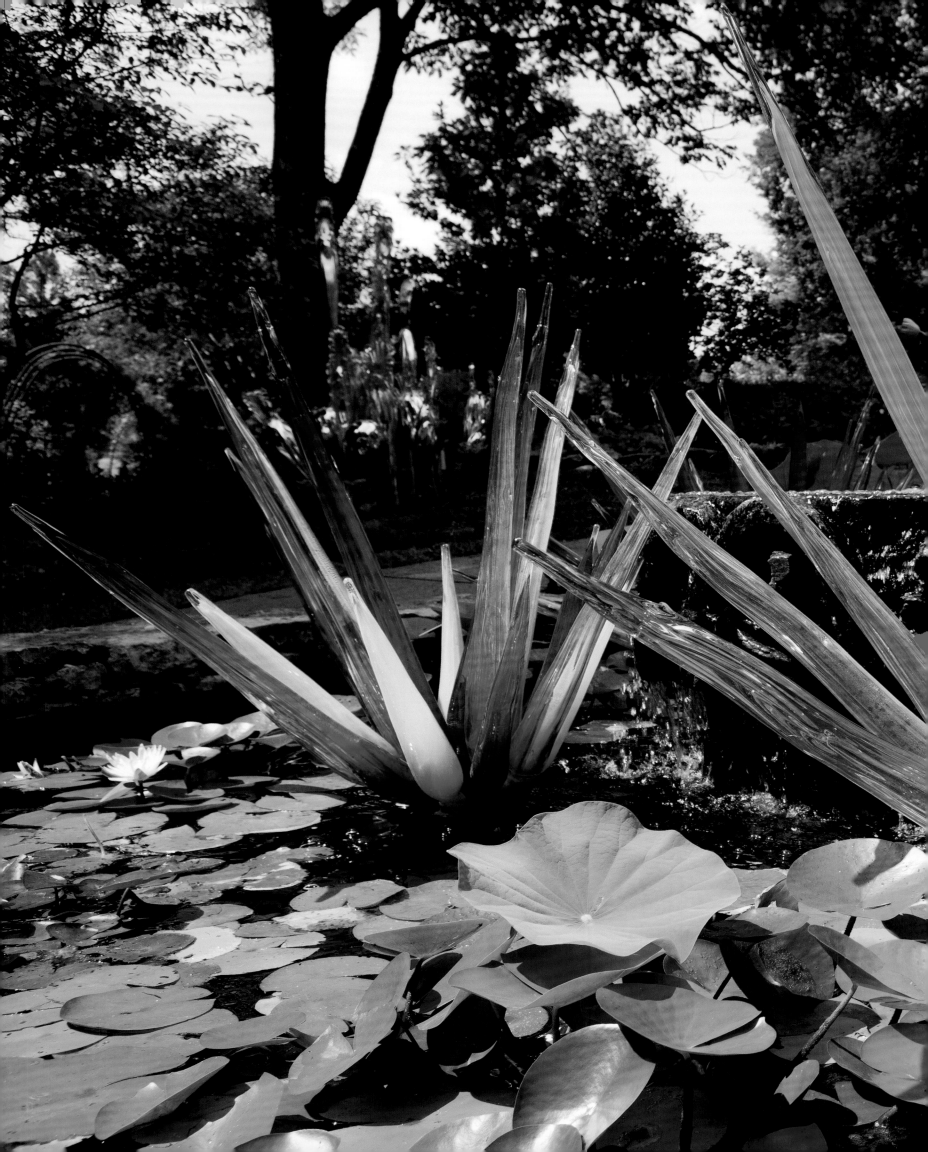

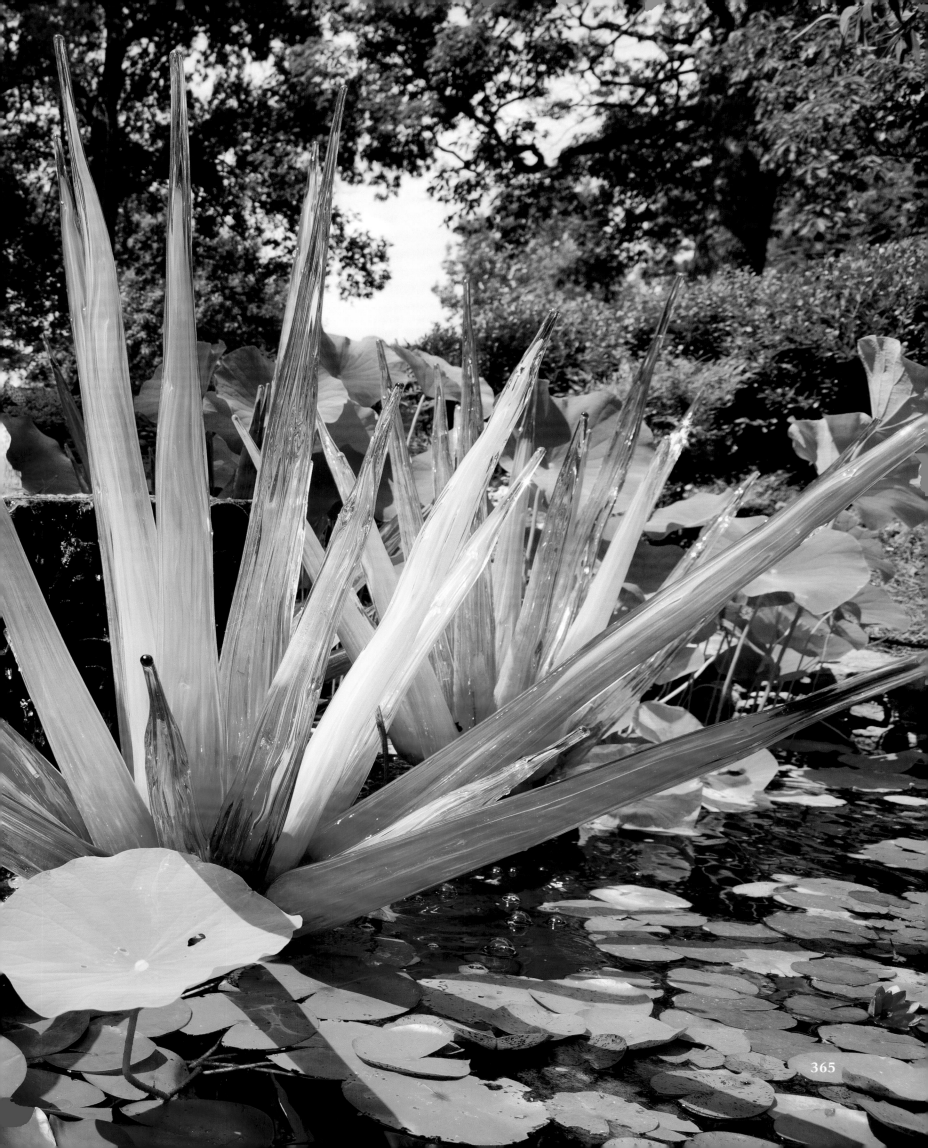

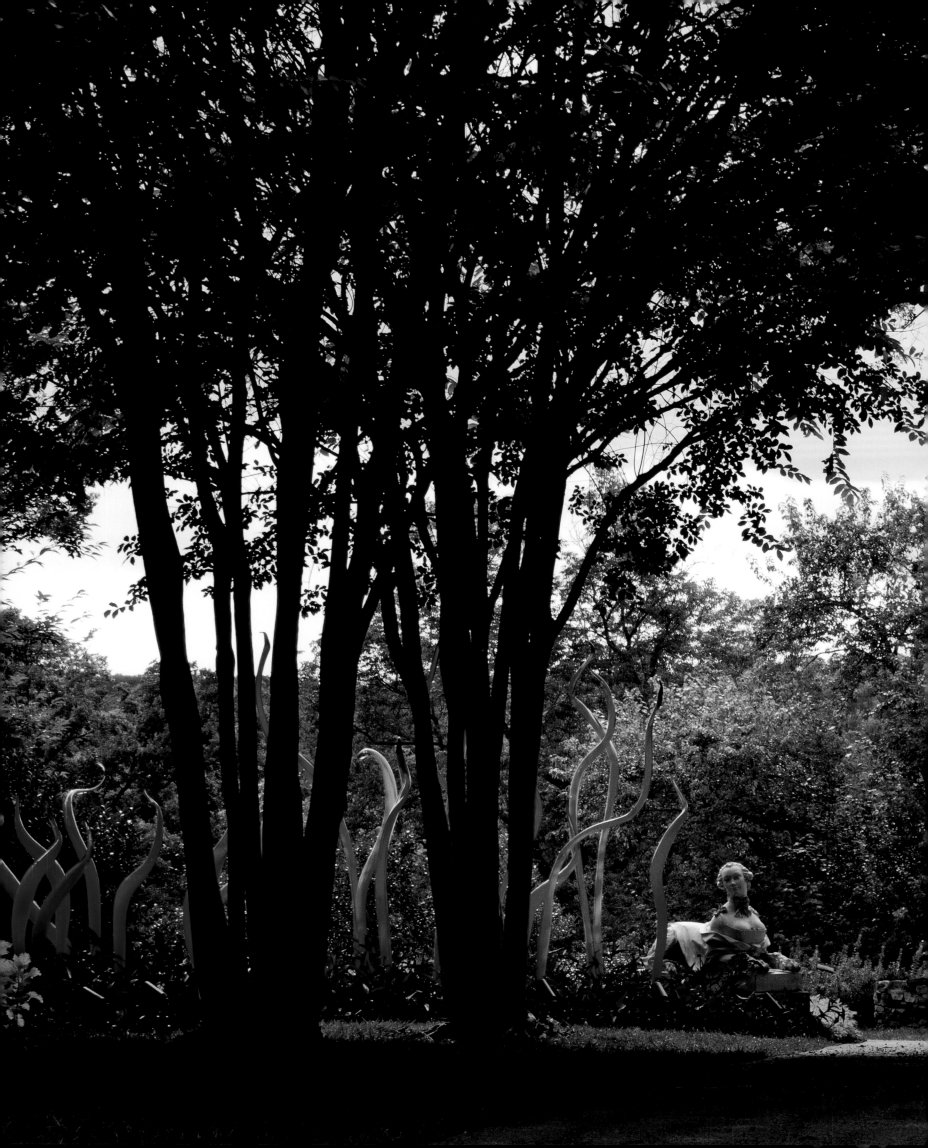

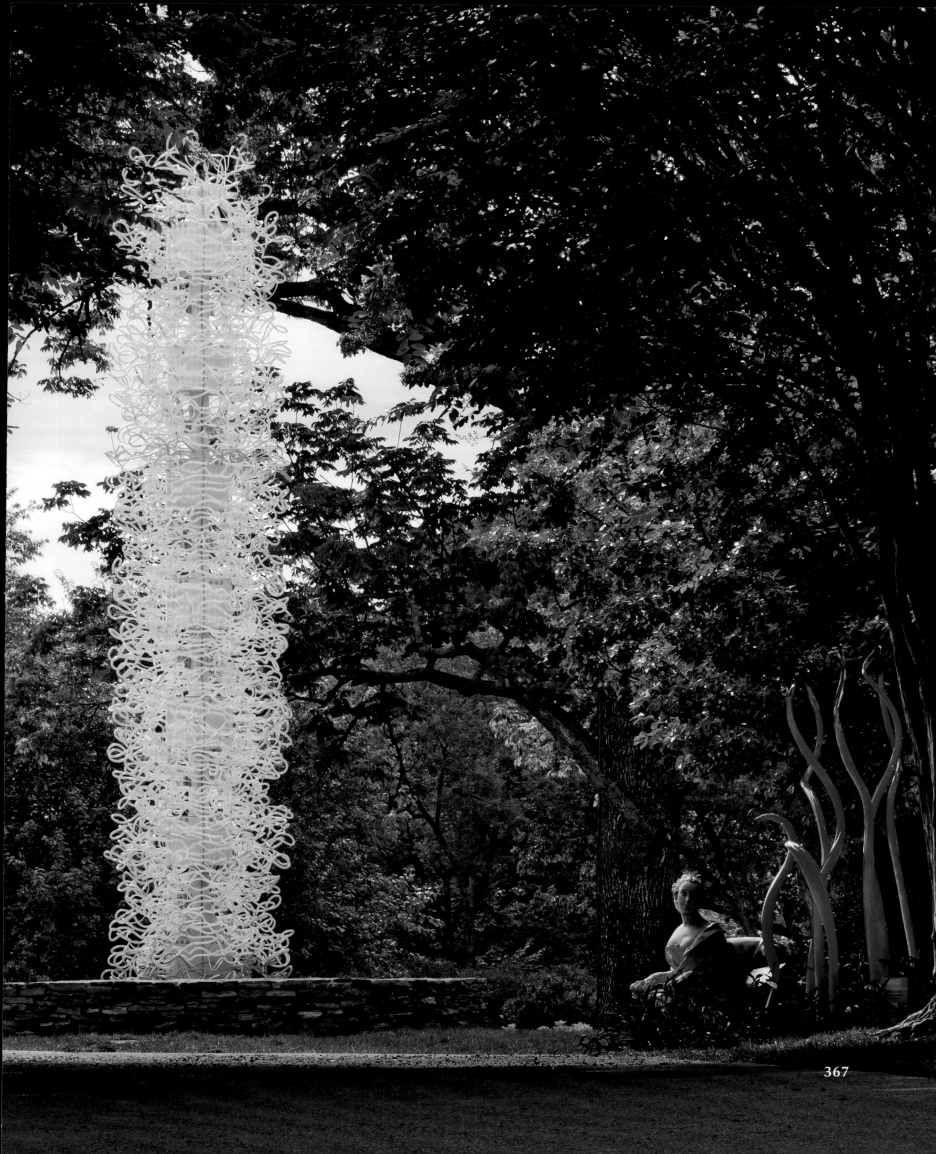

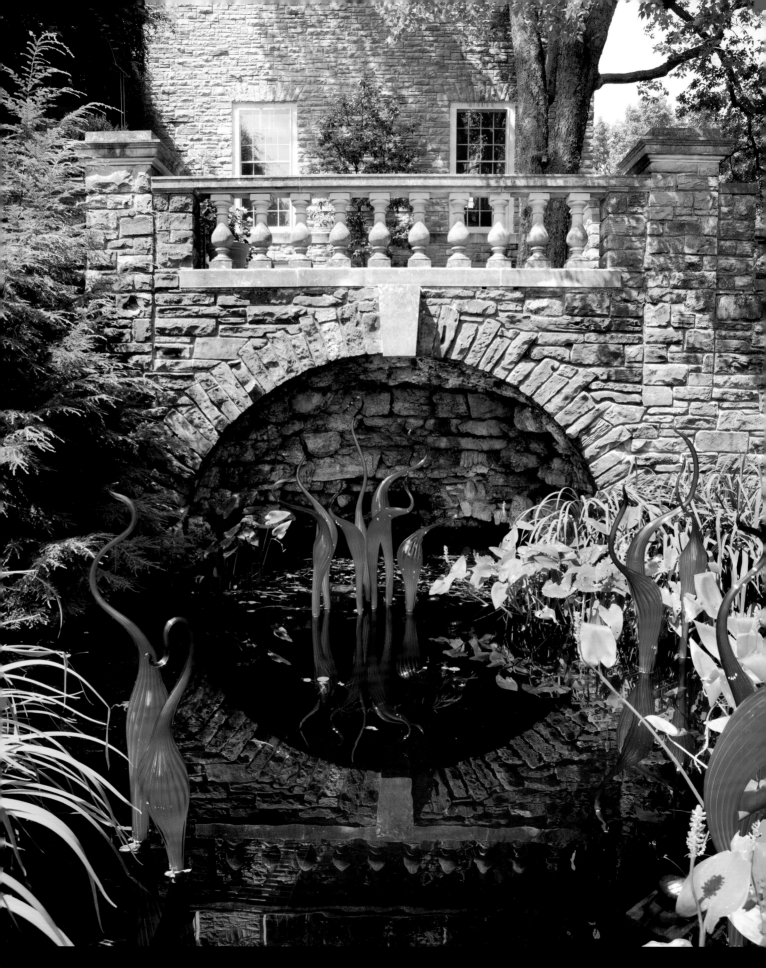

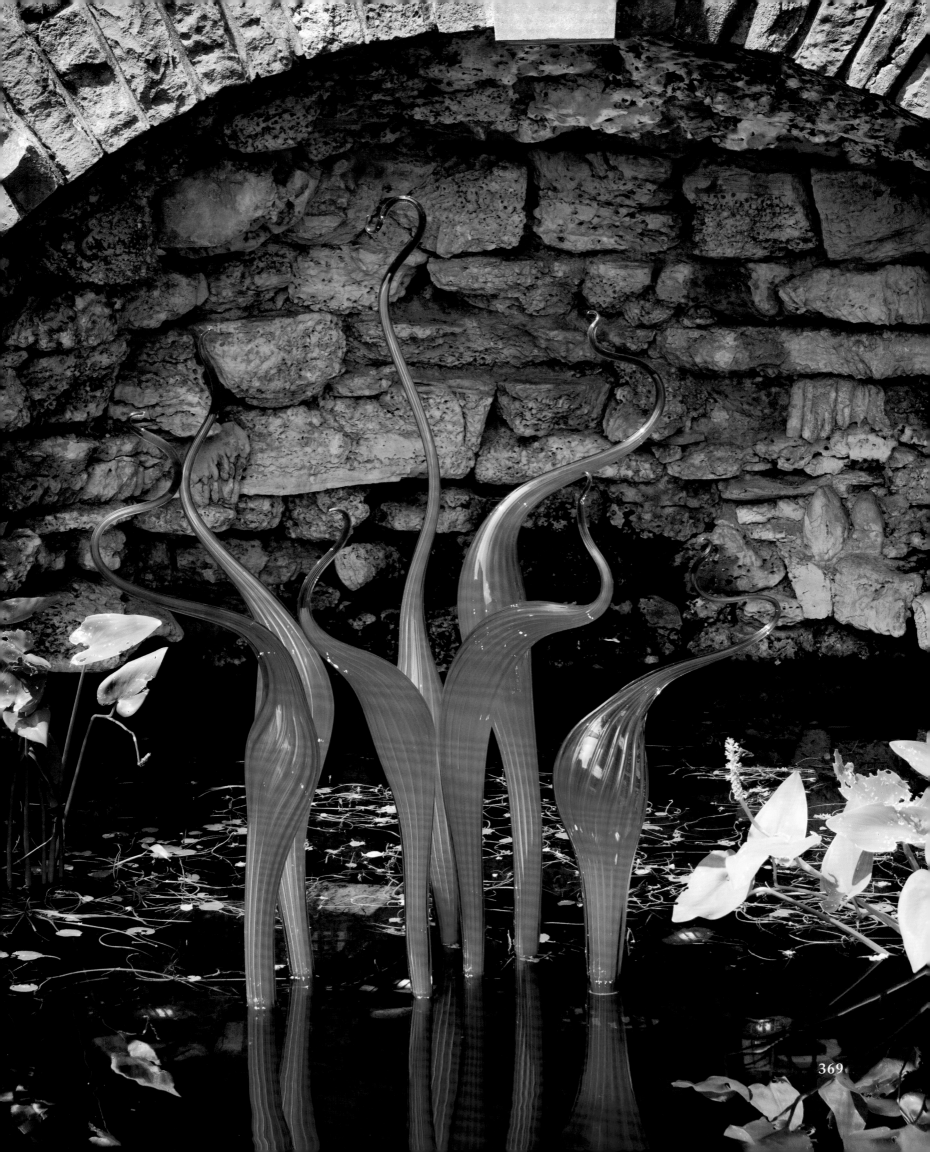

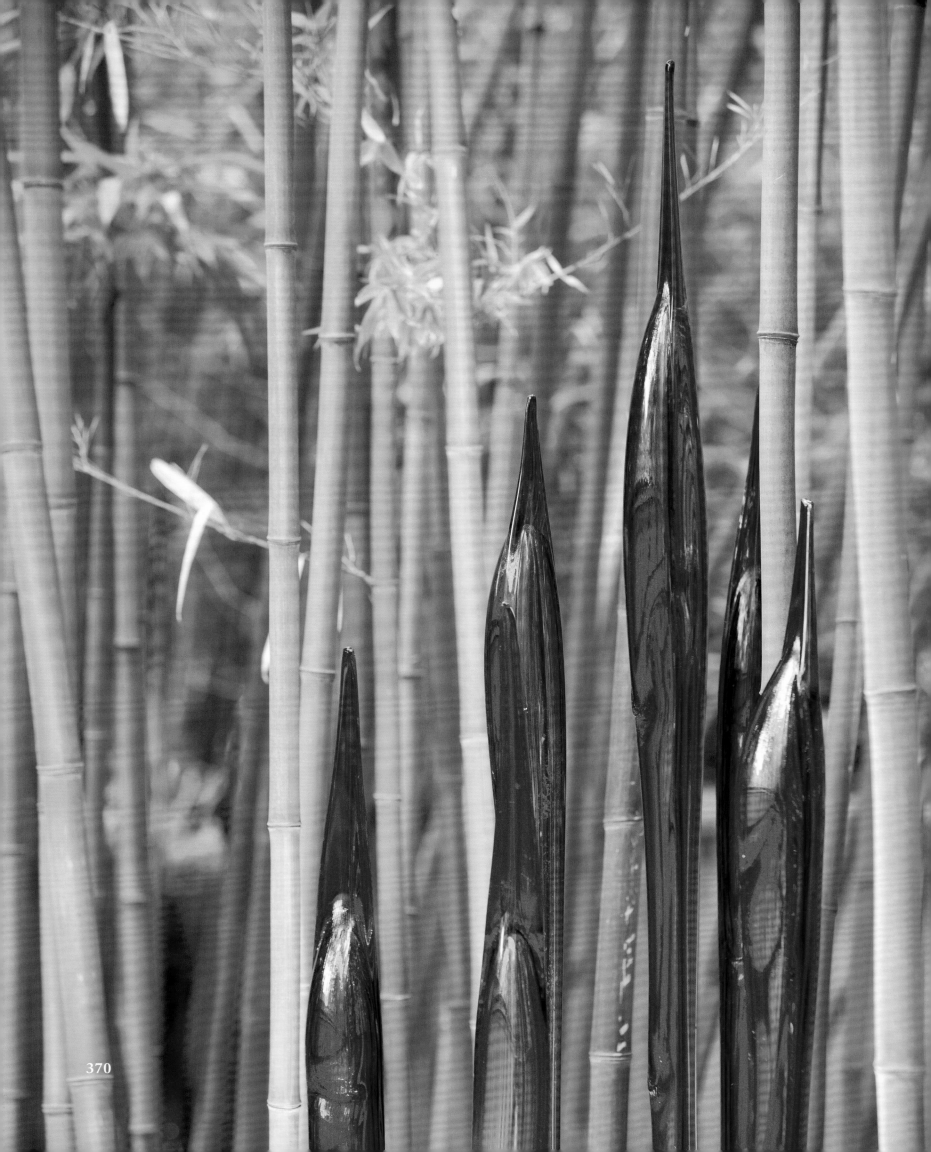

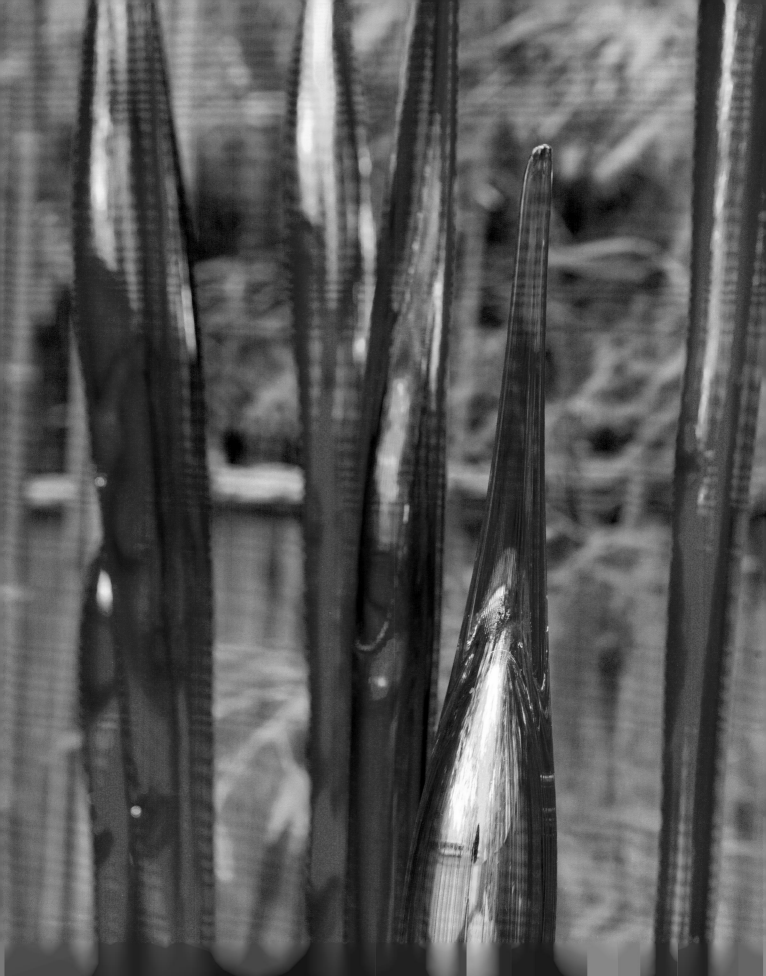

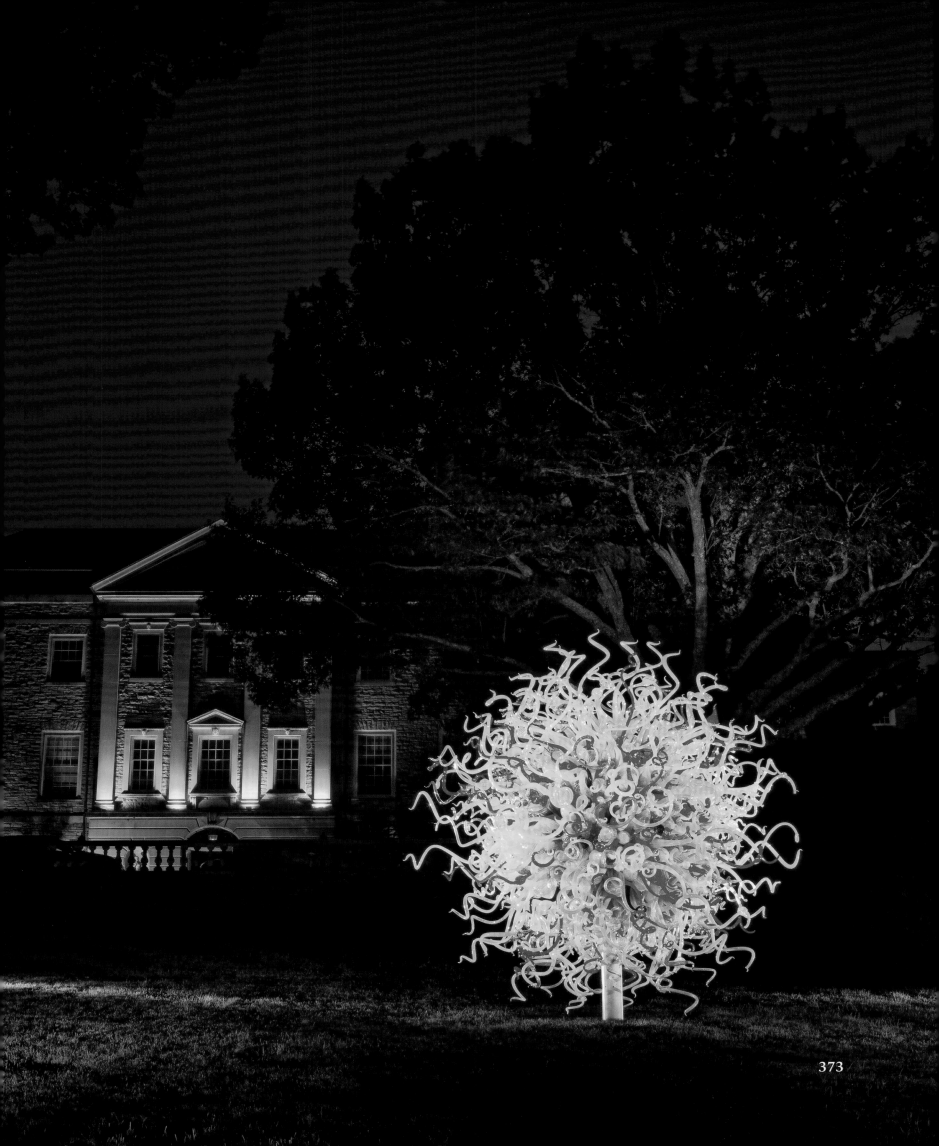

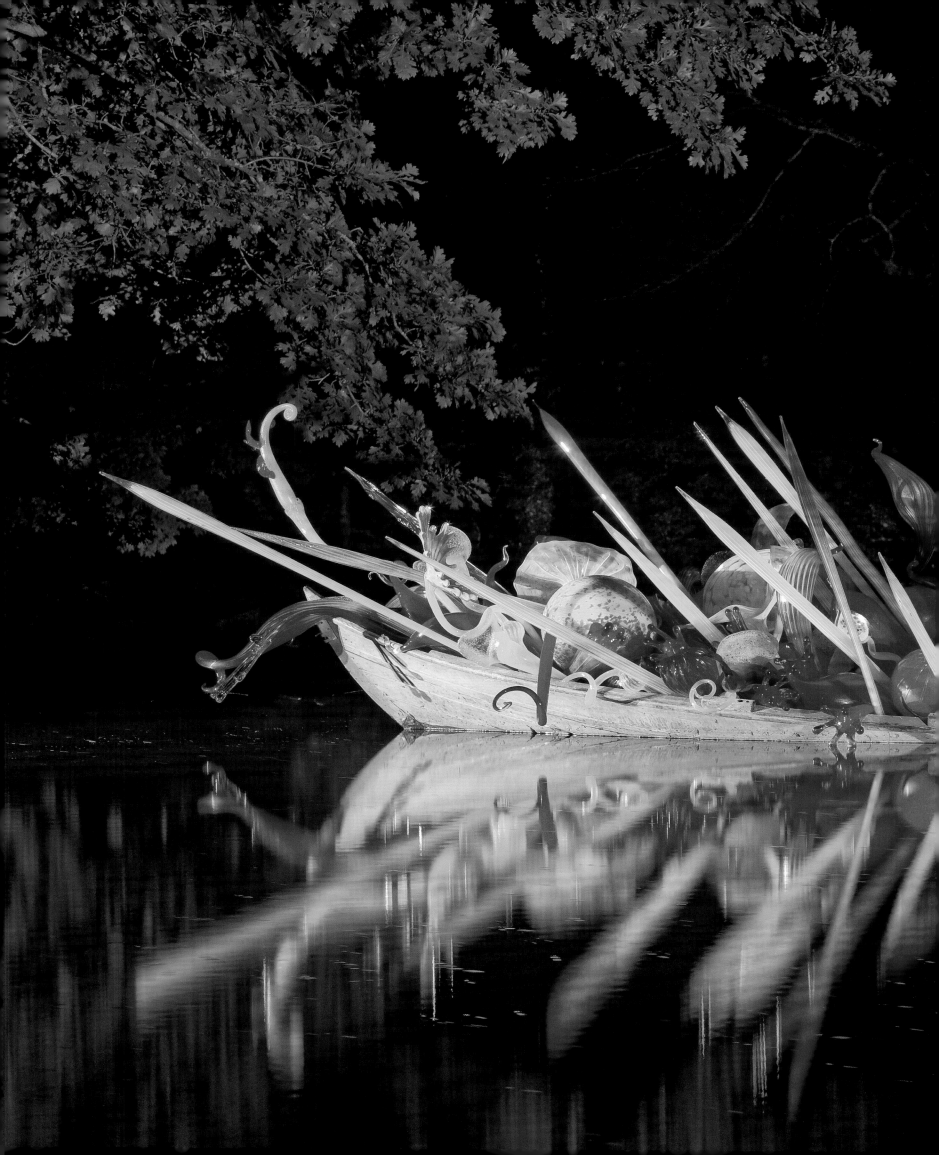

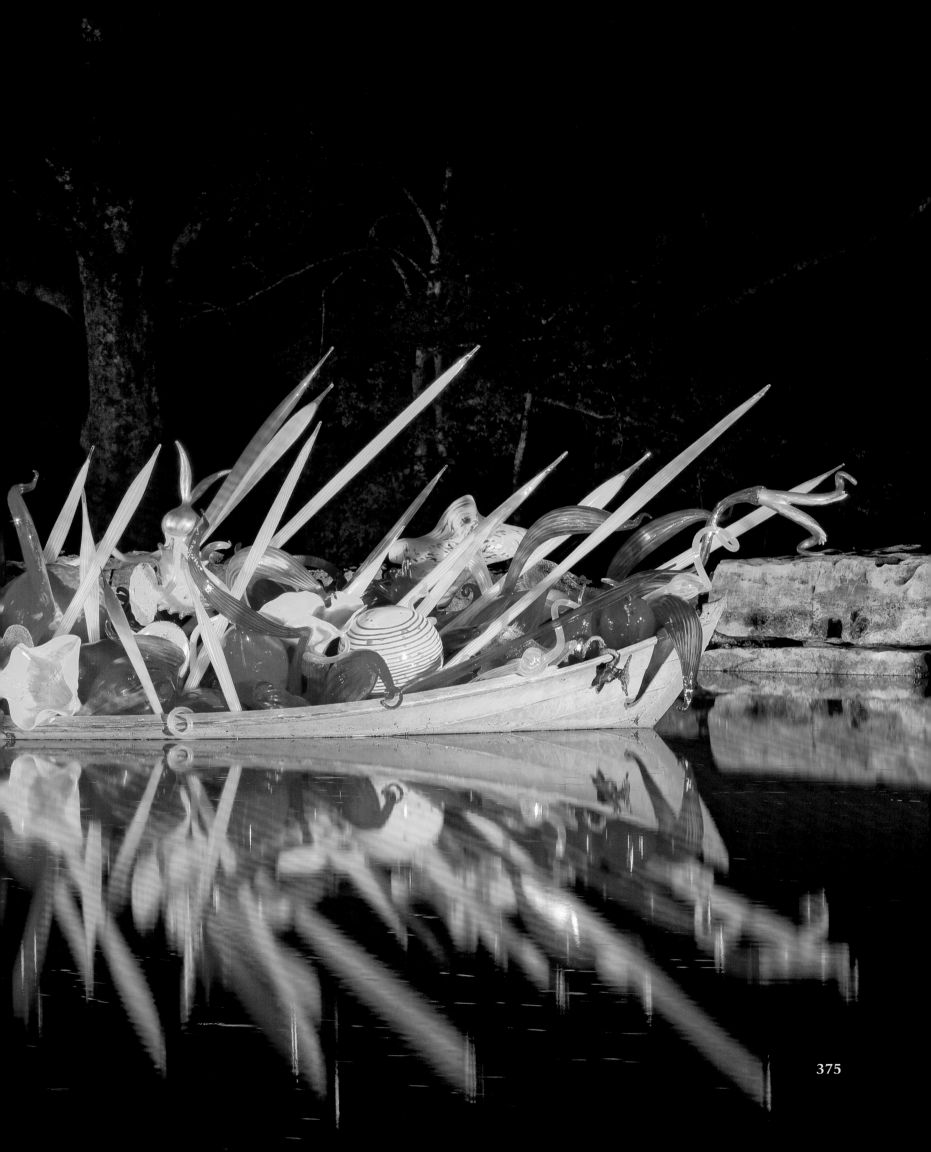

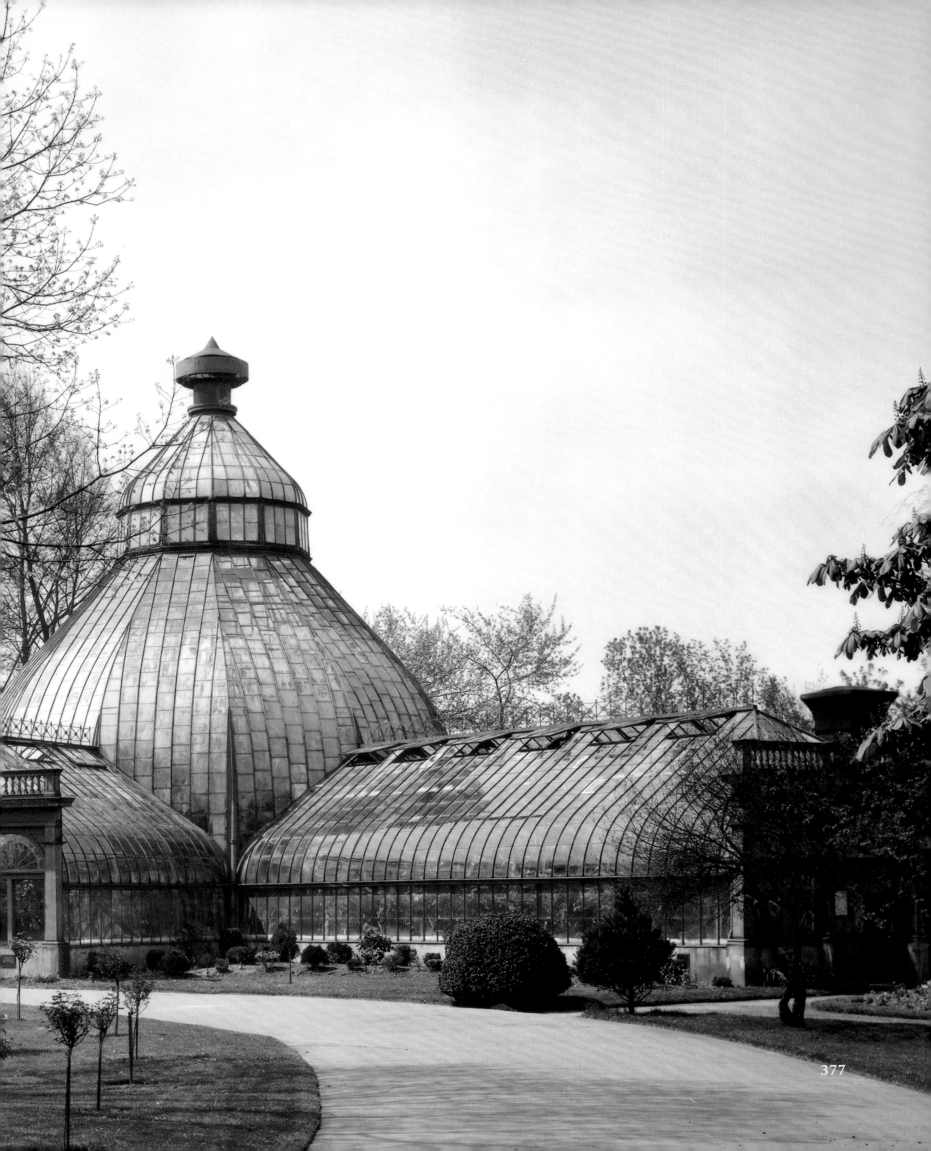

Garfield Park Conservatory
Chicago, Illinois

87	*Persian Pond*, 2001	
89	*Persian Pond* (detail), 2001	
90	*Persian Pond* (detail), 2001	
91	*Persian Pond* (detail), 2001	
92	*Black Saguaros*, 2001	
93	*English Blue Ikebana with Gilded Lily*, 2001	
94	*Ruby Dappled Chartreuse Ikebana with Fiery Red Stems*, 2001	
95	*Ruby Dappled Chartreuse Ikebana with Fiery Red Stems* (detail), 2001	
97	*Peacock Blue Tower*, 2001	
98	*Peacock Blue Tower*, 2001	
99	*Speckled Red Orange Ikebana with Moss Green and Golden Stems*, 2001	
101	*Speckled Red Orange Ikebana with Moss Green and Golden Stems* (detail), 2001	
102	*Sunburst Orange Ikebana with Blue and Green Stems*, 2001	
103	*Sunburst Orange Ikebana with Blue and Green Stems* (detail), 2001	
104	*Tree Urchins*, 2001	
105	*Walla Wallas*, 2001	
106	*Tango Rose Ikebana with Blue Frog Foot and Orange Stem* (detail), 2001	
107	*Tango Rose Ikebana with Blue Frog Foot and Orange Stem*, 2001	
108	*Niijima Floats*, 2001	
109	*Niijima Float*, 2001	
111	*Niijima Floats*, 2001	

Franklin Park Conservatory
Columbus, Ohio

113	*Torchier*, 2009
115	*Blue Reeds and Marlins*, 2009
116	*Niijima Floats*, 2003
117	*Niijima Floats*, 2003
118	*Silvered Plum and Cobalt Polyvitro Float Chandelier*, 2003
119	*Silvered Plum and Cobalt Polyvitro Float Chandelier* (detail), 2003
121	*Torchier*, 2009
123	*Niijima Floats*, 2009
124	*Sunset Tower*, 2003
125	*Sunset Tower* (top view), 2003
127	*Niijima Garden Floats*, 2003
128	*Orange Hornet* and *Eelgrass Chandelier*, 2009
129	*Blue Herons*, 2003
131	*Persian Ceiling* (detail), 2003

Atlanta Botanical Garden
Atlanta, Georgia

133	*Feathers* (detail), 2004
134	*Sibley Fountain Herons* (detail), 2004
135	*Sibley Fountain Herons* (detail), 2004
137	*Niijima Float* (detail), 2004
138	*Nepenthes Chandelier*, 2004
139	*Nepenthes Chandelier* (detail), 2004
141	*Parterre Fountain*, 2004
142	*Walla Wallas*, 2004
143	*Walla Wallas* (detail), 2004
144	*Misty Chartreuse Ikebana with Yellow and Emerald Stems*, 2004
145	*Misty Chartreuse Ikebana with Yellow and Emerald Stems* (detail), 2004
147	*Tiger Lilies*, 2004
148	*Howell Fountain Tower*, 2004
149	*Howell Fountain Tower* (detail), 2004
150	*Macchia Forest* (detail), 2004
151	*Macchia Forest* (detail), 2004

Royal Botanic Gardens, Kew
Richmond, Surrey, England

Fairchild Tropical Botanic Garden
Coral Gables, Florida

Missouri Botanical Garden
St. Louis, Missouri

Desert Botanical Garden
Phoenix, Arizona

Frederik Meijer Gardens & Sculpture Park
Grand Rapids, Michigan

Cheekwood Botanical Garden and Museum of Art
Nashville, Tennessee

Back Matter

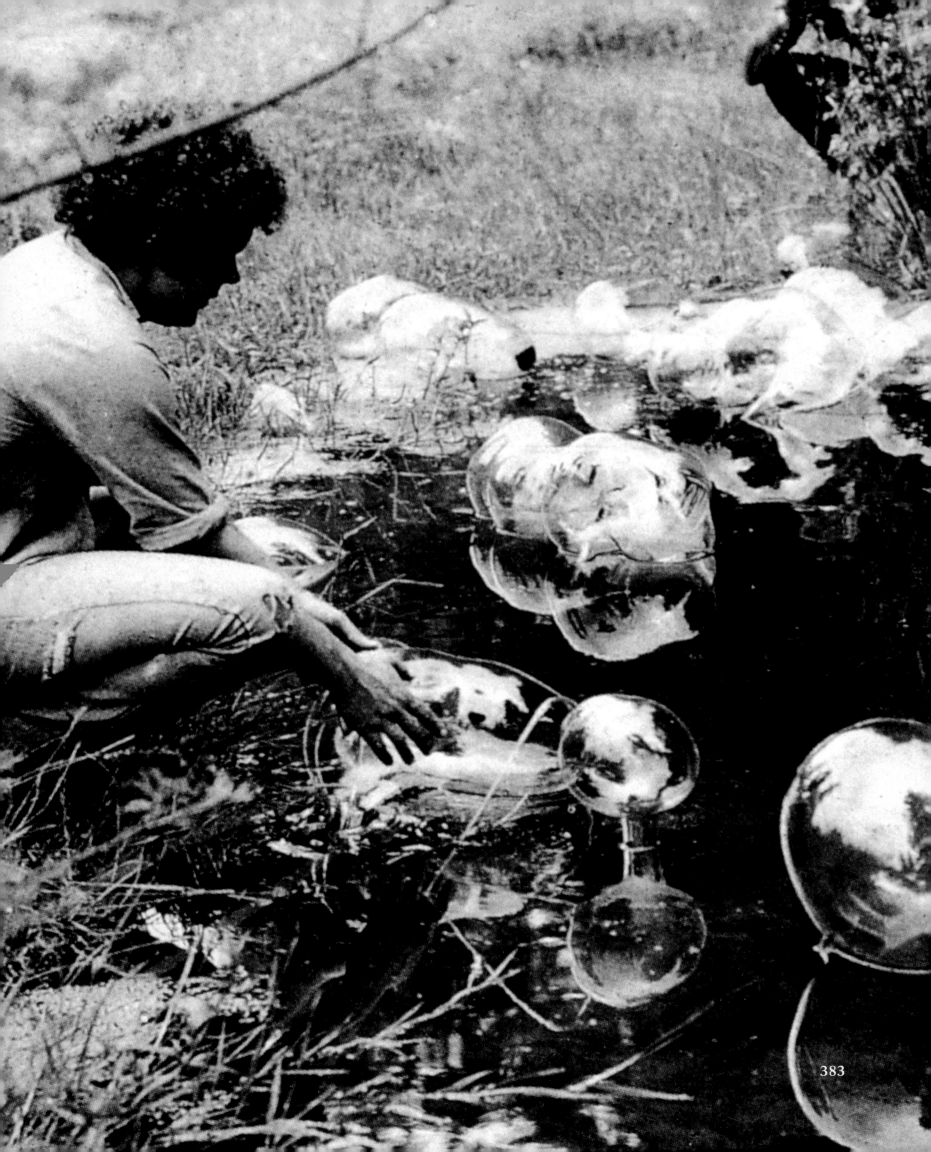

Akita Senshu Museum of Art, Akita, Japan

Akron Art Museum, Akron, Ohio

Albany Museum of Art, Albany, Georgia

Albright-Knox Art Gallery, Buffalo, New York

Allied Arts Association, Richland, Washington

Arizona State University Art Museum, Tempe, Arizona

Arkansas Arts Center, Little Rock, Arkansas

Art Gallery of Greater Victoria, Victoria, British Columbia, Canada

Art Gallery of Western Australia, Perth, Australia

Art Museum of Missoula, Missoula, Montana

Art Museum of South Texas, Corpus Christi, Texas

Art Museum of Southeast Texas, Beaumont, Texas

Arts Centre, Martinsburg, West Virginia

Asheville Art Museum, Asheville, North Carolina

Auckland Museum, Auckland, New Zealand

Austin Museum of Art, Austin, Texas

Azabu Museum of Arts and Crafts, Tokyo, Japan

Ball State University Museum of Art, Muncie, Indiana

Beach Museum of Art, Kansas State University, Manhattan, Kansas

Berkeley Art Museum, University of California,
 Berkeley, California

Birmingham Museum of Art, Birmingham, Alabama

Boca Raton Museum of Art, Boca Raton, Florida

Brauer Museum of Art, Valparaiso University, Valparaiso, Indiana

Brooklyn Museum, Brooklyn, New York

Cafesjian Center for the Arts, Yerevan, Armenia

Canadian Clay & Glass Gallery, Waterloo, Ontario, Canada

Canadian Craft Museum, Vancouver, British Columbia, Canada

Carnegie Museum of Art, Pittsburgh, Pennsylvania

Center for the Arts, Vero Beach, Florida

Charles H. MacNider Art Museum, Mason City, Iowa

Children's Museum of Indianapolis, Indianapolis, Indiana

Chrysler Museum of Art, Norfolk, Virginia

Cincinnati Art Museum, Cincinnati, Ohio

Cleveland Museum of Art, Cleveland, Ohio

Clinton Library and Archives, Little Rock, Arkansas

Colorado Springs Fine Arts Center, Colorado Springs, Colorado

Columbia Museum of Art, Columbia, South Carolina

Columbus Museum, Columbus, Georgia

Columbus Museum of Art, Columbus, Ohio

Contemporary Art Center of Virginia, Virginia Beach, Virginia

Contemporary Arts Center, Cincinnati, Ohio

Contemporary Crafts Association and Gallery, Portland, Oregon

Contemporary Museum, Honolulu, Hawaii

Cooper-Hewitt, National Design Museum, Smithsonian Institution,
 New York, New York

Corcoran Gallery of Art, Washington, D.C.

Corning Museum of Glass, Corning, New York

Crocker Art Museum, Sacramento, California

Currier Gallery of Art, Manchester, New Hampshire

Daiichi Museum, Nagoya, Japan

Dallas Museum of Art, Dallas, Texas

Danske Kunstindustrimuseum, Copenhagen, Denmark

Daum Museum of Contemporary Art, Sedalia, Missouri

David Winton Bell Gallery, Brown University,
 Providence, Rhode Island

Dayton Art Institute, Dayton, Ohio

de Young Museum, San Francisco, California

DeCordova Museum and Sculpture Park, Lincoln, Massachusetts

Delaware Art Museum, Wilmington, Delaware

Denver Art Museum, Denver, Colorado

Design museum Gent, Gent, Belgium

Detroit Institute of Arts, Detroit, Michigan

Dowse Art Museum, Lower Hutt, New Zealand

Eretz Israel Museum, Tel Aviv, Israel

Everson Museum of Art, Syracuse, New York

Experience Music Project, Seattle, Washington

Fine Arts Institute, Edmond, Oklahoma

Flint Institute of Arts, Flint, Michigan

Fonds Régional d'Art Contemporain de Haute-Normandie,
 Sotteville-lès-Rouen, France

Frederik Meijer Gardens & Sculpture Park, Grand Rapids, Michigan

Galéria mesta Bratislavy, Bratislava, Slovakia

Glasmuseet Ebeltoft, Ebeltoft, Denmark

Glasmuseum, Frauenau, Germany

Glasmuseum alter Hof Herding, Glascollection, Ernsting, Germany

Glasmuseum Wertheim, Wertheim, Germany

Haggerty Museum of Art, Marquette University,
 Milwaukee, Wisconsin

Hakone Glass Forest, Ukai Museum, Hakone, Japan

Hawke's Bay Exhibition Centre, Hastings, New Zealand

Henry Art Gallery, Seattle, Washington

High Museum of Art, Atlanta, Georgia

Hilo Art Museum, Hilo, Hawaii

Hiroshima City Museum of Contemporary Art, Hiroshima, Japan

Hokkaido Museum of Modern Art, Hokkaido, Japan

Honolulu Academy of Arts, Honolulu, Hawaii

Hunter Museum of American Art, Chattanooga, Tennessee

Huntington Museum of Art, Huntington, West Virginia

Indianapolis Museum of Art, Indianapolis, Indiana

Israel Museum, Jerusalem, Israel

Japan Institute of Arts and Crafts, Tokyo, Japan

Jesse Besser Museum, Alpena, Michigan

Jesuit Dallas Museum, Dallas, Texas

Joslyn Art Museum, Omaha, Nebraska

Jule Collins Smith Museum of Fine Art, Auburn University,
 Auburn, Alabama

Jundt Art Museum, Gonzaga University, Spokane, Washington

Kalamazoo Institute of Arts, Kalamazoo, Michigan

Kaohsiung Museum of Fine Arts, Kaohsiung, Taiwan

Kemper Museum of Contemporary Art, Kansas City, Missouri

Kestner-Gesellschaft, Hannover, Germany

Kobe City Museum, Kobe, Japan

Krannert Art Museum, University of Illinois, Champaign, Illinois

Krasl Art Center, St. Joseph, Michigan

Kunstmuseum Düsseldorf, Düsseldorf, Germany

Kunstsammlungen der Veste Coburg, Coburg, Germany

Kurita Museum, Tochigi, Japan

Leigh Yawkey Woodson Art Museum, Wausau, Wisconsin

Lobmeyr Museum, Vienna, Austria

LongHouse Reserve, East Hampton, New York

Los Angeles County Museum of Art, Los Angeles, California

Lowe Art Museum, University of Miami, Coral Gables, Florida

Lyman Allyn Art Museum, New London, Connecticut

Manawatu Museum, Palmerston North, New Zealand

Matsushita Art Museum, Kagoshima, Japan

Meguro Museum of Art, Tokyo, Japan

Memorial Art Gallery, University of Rochester,
 Rochester, New York

Metropolitan Museum of Art, New York, New York

Milwaukee Art Museum, Milwaukee, Wisconsin

Mingei International Museum, San Diego, California

Minneapolis Institute of Arts, Minneapolis, Minnesota

Mint Museum of Craft + Design, Charlotte, North Carolina

Mobile Museum of Art, Mobile, Alabama

Montreal Museum of Fine Arts, Montreal, Quebec, Canada

Morris Museum, Morristown, New Jersey

Musée d'Art Moderne et d'Art Contemporain, Nice, France

Musée de Design et d'Arts Appliqués Contemporains,
 Lausanne, Switzerland

Musée des Arts Décoratifs, Palais du Louvre, Paris, France

Musée des Beaux-Arts et de la Céramique, Rouen, France

Museo del Vidrio, Monterrey, Mexico

Museo Vetrario, Murano, Italy

Museum Bellerive, Zurich, Switzerland

Museum Boijmans Van Beuningen, Rotterdam, Netherlands

Museum für Kunst und Gewerbe Hamburg, Hamburg, Germany

Museum für Kunsthandwerk, Frankfurt am Main, Germany

Museum of American Glass at Wheaton Village,
 Millville, New Jersey

Museum of Art, Washington State University, Pullman, Washington

Museum of Art and Archaeology, Columbia, Missouri

Museum of Art Fort Lauderdale, Fort Lauderdale, Florida

Museum of Arts & Design, New York, New York

Museum of Arts and Sciences, Daytona Beach, Florida

Museum of Contemporary Art, Chicago, Illinois

Museum of Contemporary Art San Diego, La Jolla, California

Museum of Fine Arts, Boston, Massachusetts

Museum of Fine Arts, Houston, Houston, Texas

Museum of Fine Arts, St. Petersburg, Florida

Museum of Northwest Art, La Conner, Washington

Museum of Outdoor Arts, Englewood, Colorado

Muskegon Museum of Art, Muskegon, Michigan

Muzeum města Brna, Brno, Czech Republic

Muzeum skla a bižuterie, Jablonec nad Nisou, Czech Republic

Múzeum židovskej kultúry, Bratislava, Slovakia

Naples Museum of Art, Naples, Florida

National Gallery of Australia, Canberra, Australia

National Gallery of Victoria, Melbourne, Australia

National Liberty Museum, Philadelphia, Pennsylvania

National Museum Kyoto, Kyoto, Japan

National Museum of American History, Smithsonian Institution,
 Washington, D.C.

National Museum of Modern Art Kyoto, Kyoto, Japan

National Museum of Modern Art Tokyo, Tokyo, Japan

Nationalmuseum, Stockholm, Sweden

New Britain Museum of American Art, New Britain, Connecticut

New Orleans Museum of Art, New Orleans, Louisiana

Newark Museum, Newark, New Jersey

Niijima Contemporary Art Museum, Niijima, Japan

North Central Washington Museum, Wenatchee, Washington

Norton Museum of Art, West Palm Beach, Florida

Notojima Glass Art Museum, Ishikawa, Japan

O Art Museum, Tokyo, Japan

Oklahoma City Museum of Art, Oklahoma City, Oklahoma

Orange County Museum of Art, Newport Beach, California

Otago Museum, Dunedin, New Zealand

Palm Beach Community College Museum of Art,
 Lake Worth, Florida

Palm Springs Art Museum, Palm Springs, California

Palmer Museum of Art, Pennsylvania State University,
 University Park, Pennsylvania

Philadelphia Museum of Art, Philadelphia, Pennsylvania

Phoenix Art Museum, Phoenix, Arizona

Plains Art Museum, Fargo, North Dakota

Polk Museum of Art, Lakeland, Florida

Portland Art Museum, Portland, Oregon

Portland Museum of Art, Portland, Maine

Powerhouse Museum, Sydney, Australia

Princeton University Art Museum, Princeton, New Jersey

Queensland Art Gallery, South Brisbane, Australia

Racine Art Museum, Racine, Wisconsin

Reading Public Museum, Reading, Pennsylvania

Rhode Island School of Design Museum, Providence, Rhode Island

Ringling College of Art and Design, Sarasota, Florida

Royal Ontario Museum, Toronto, Ontario, Canada

Saint Louis Art Museum, St. Louis, Missouri

Saint Louis University Museum of Art, St. Louis, Missouri

Samuel P. Harn Museum of Art, University of Florida,
 Gainesville, Florida

San Antonio Museum of Art, San Antonio, Texas

San Jose Museum of Art, San Jose, California

Scottsdale Center for the Arts, Scottsdale, Arizona

Seattle Art Museum, Seattle, Washington

Shimonoseki City Art Museum, Shimonoseki, Japan

Singapore Art Museum, Singapore

Slovenská národná galéria, Bratislava, Slovakia

Smith College Museum of Art, Northampton, Massachusetts

Smithsonian American Art Museum, Washington, D.C.

Sogetsu Art Museum, Tokyo, Japan

Speed Art Museum, Louisville, Kentucky

Spencer Museum of Art, University of Kansas, Lawrence, Kansas

Springfield Museum of Fine Arts, Springfield, Massachusetts

Štátna galéria Banská Bystrica, Banská Bystrica, Slovakia

Suntory Museum of Art, Tokyo, Japan

Suomen Lasimuseo, Riihimäki, Finland

Suwa Garasu no Sato Museum, Nagano, Japan

Tacoma Art Museum, Tacoma, Washington

Taipei Fine Arts Museum, Taipei, Taiwan

Tochigi Prefectural Museum of Fine Arts, Tochigi, Japan

Toledo Museum of Art, Toledo, Ohio

Tower of David Museum of the History of Jerusalem,
 Jerusalem, Israel

Uměleckoprůmyslové muzeum, Prague, Czech Republic

University Art Museum, University of California,
 Santa Barbara, California

Utah Museum of Fine Arts, University of Utah,
 Salt Lake City, Utah

Victoria and Albert Museum, London, England

Wadsworth Atheneum, Hartford, Connecticut

Waikato Museum of Art and History, Hamilton, New Zealand

Walker Hill Art Center, Seoul, South Korea

Westmoreland Museum of American Art, Greensburg, Pennsylvania

Whatcom Museum of History and Art, Bellingham, Washington

White House Collection of American Crafts, Washington, D.C.

Whitney Museum of American Art, New York, New York

Wichita Art Museum, Wichita, Kansas

World of Glass, St. Helens, England

Württembergisches Landesmuseum Stuttgart, Stuttgart, Germany

Yale University Art Gallery, New Haven, Connecticut

Yokohama Museum of Art, Yokohama, Japan

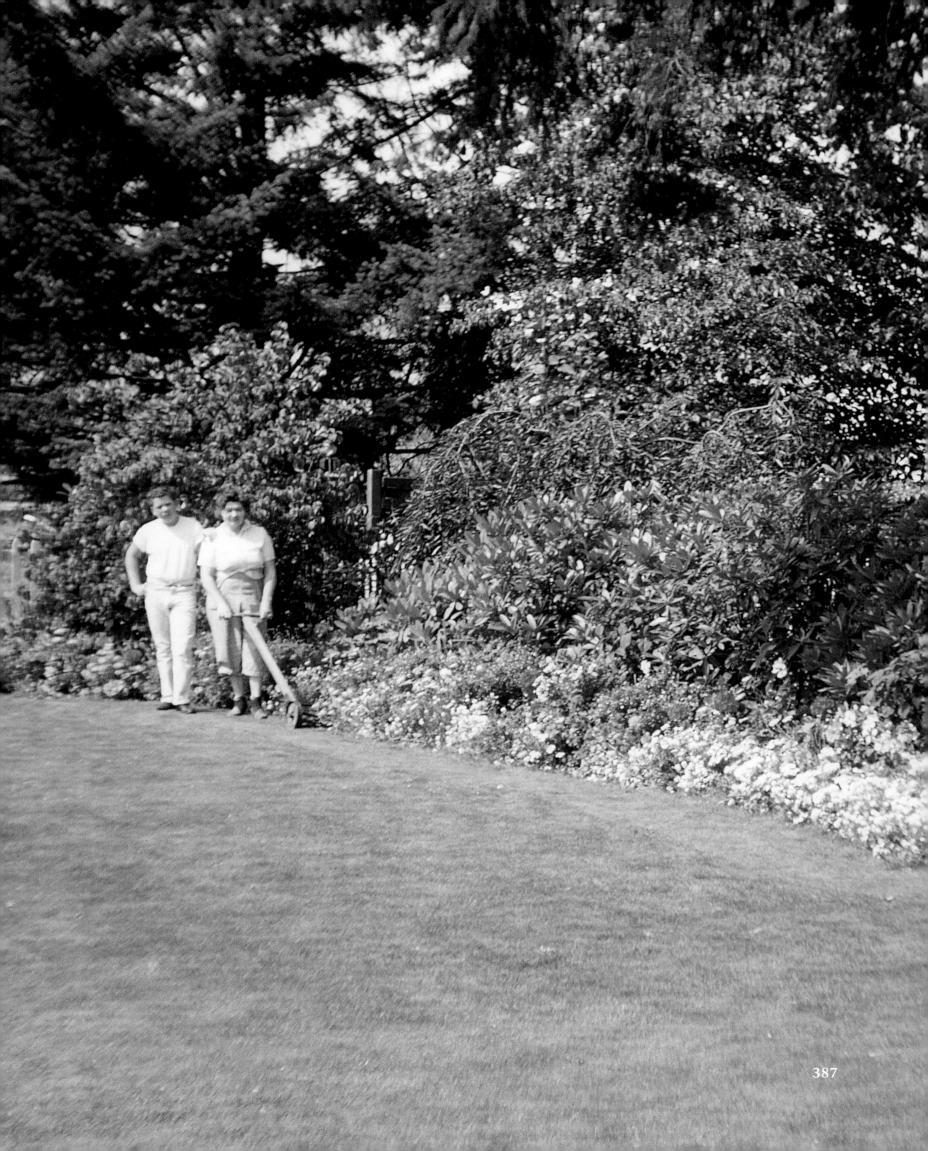

1941 Born September 20 in Tacoma, Washington, to George Chihuly, a butcher and union organizer, and Viola Magnuson Chihuly, a homemaker and avid gardener. His father is predominantly of Hungarian, Czech, and Slavic ancestry; his mother, Swedish and Norwegian.

1957 Older brother and only sibling, George, dies in a Naval Air Force training accident in Pensacola, Florida.

1958 His father suffers a fatal heart attack at age 51, and his mother has to go to work.

1959 Graduates from high school in Tacoma. His mother persuades him to enroll at College of Puget Sound (now University of Puget Sound) in his hometown. The next year, his term paper on Van Gogh and his remodeling of his mother's recreation room motivate him to transfer to University of Washington in Seattle to study interior design and architecture.

1961 Joins Delta Kappa Epsilon fraternity and becomes rush chairman. Learns to melt and fuse glass.

1962 Disillusioned with his studies, he leaves school and travels to Florence to study art. Unable to speak Italian, he moves on to the Middle East.

1963 Works on a kibbutz in Negev Desert. Meets architect Robert Landsman in Jericho, Jordan, and they visit the site of ancient Petra. Reinspired, returns to University of Washington, College of Arts and Sciences, and studies under Hope Foote and Warren Hill. In a weaving class with Doris Brockway, incorporates glass shards into woven tapestries.

1964 While still a student, receives the Seattle Weavers Guild Award for innovative use of glass and fiber. Returns to Europe, visits Leningrad, and makes the first of many trips to Ireland.

1965 Receives B.A. in Interior Design from University of Washington and works as a designer for John Graham Architects in Seattle. Introduced to textile designer Jack Lenor Larsen, who becomes a mentor and friend. Experimenting in his basement studio, Chihuly blows his first glass bubble by melting stained glass and using a metal pipe. Awarded Highest Honors from the American Institute of Interior Designers (now ASID).

1966 Earns money for graduate school as a commercial fisherman in Alaska. Enters University of Wisconsin at Madison, on a full scholarship, and studies glassblowing under Harvey Littleton. It was the first glass program in the United States.

1967 Receives M.S. in Sculpture from University of Wisconsin. Enrolls at Rhode Island School of Design (RISD) in Providence, where he begins exploration of environmental works using neon, argon, and blown glass. Visits Montreal World Exposition '67 and is inspired by the architectural glass works of Stanislav Libenský and Jaroslava Brychtová at the Czechoslovak pavilion. Awarded a Louis Comfort Tiffany Foundation Grant for work in glass. Italo Scanga, then teaching in Pennsylvania State University's Art Department, lectures at RISD, and the two begin a lifelong friendship. They consider themselves brothers.

1968 Receives M.F.A. in Ceramics from RISD. Awarded a Fulbright Fellowship, enabling him to travel and work in Europe. Invited by architect Ludovico de Santillana, son-in-law of Paolo Venini, Chihuly becomes the first American glassblower to work in the Venini factory on the island of Murano. Back in the United States, spends the first of four consecutive summers teaching at Haystack Mountain School of Crafts in Deer Isle, Maine. Its director, Fran Merritt, becomes a friend and lifetime mentor.

1969 Returns to Europe, this time with his mother, visiting relatives in Sweden and making pilgrimages to meet glass masters Erwin Eisch in Germany and Jaroslava Brychtová and Stanislav Libenský in Czechoslovakia. Establishes the glass program at RISD, where he teaches full time for the next eleven years. Students will include Hank Adams, Howard Ben Tré, James Carpenter, Dan Dailey, Michael Glancy, Roni Horn, Flora C. Mace, Mark McDonnell, Benjamin Moore, Pike Powers, Michael Scheiner, Paul Seide, Therman Statom, Steve Weinberg, and Toots Zynsky.

1970 While Chihuly and friends shut down RISD to protest the U.S. offensive in Cambodia, he and student John Landon develop ideas for an alternative school in the Pacific Northwest, inspired by Haystack Mountain School of Crafts. Meets artist Buster Simpson, who later works with Chihuly and Landon at the new school created in 1971. Meets James Carpenter, a student in the Illustration Department, and they begin a four-year collaboration.

1971 On the site of a tree farm owned by Seattle art patrons Anne Gould Hauberg and John Hauberg, the Pilchuck Glass School experiment is started. A $2,000 grant to Chihuly and Ruth Tamura from the Union of Independent Colleges of Art and funding from the Haubergs provide seed money. Pilchuck Glass School grows into an institution with a profound impact on artists working in glass worldwide. Chihuly's first environmental installation at Pilchuck is created that summer. In fall, at RISD, he creates *20,000 Pounds of Ice and Neon*, *Glass Forest #1*, and *Glass Forest #2* with James Carpenter, installations that prefigure later environmental works by Chihuly.

1972 While he is at Pilchuck, his studio on Hobart Street in Providence burns down. Returns to Venice with Carpenter to blow glass for *Glas heute* exhibition at Museum Bellerive, Zurich, Switzerland. They collaborate on more large-scale architectural projects and, using only static architectural structures, create *Rondel Door* and *Cast Glass Door* at Pilchuck. In Providence, they have a conceptual breakthrough with *Dry Ice, Bent Glass and Neon.*

1974 Tours European glass centers with Thomas Buechner of Corning Museum of Glass and Paul Schulze, head of Design Department at Steuben Glass. Makes his first significant purchase of art, *La Donna Perfecta*, an Art Deco glass mosaic. In Santa Fe, New Mexico, he builds a glass shop for the Institute of American Indian Arts. Supported by a National Endowment for the Arts grant at Pilchuck, James Carpenter, a group of students, and he develop a technique to pick up glass thread drawings. In December at RISD, he completes his last collaborative project with Carpenter, *Corning Wall.*

1975 At RISD, begins *Navajo Blanket Cylinder* series. Kate Elliott and, later, Flora C. Mace fabricate the complex thread drawings. He receives the first of two National Endowment for the Arts Individual Artist fellowships. Artist-in-residence with Seaver Leslie at Artpark, on the Niagara Gorge, in New York State. Begins *Irish Cylinders* and *Ulysses Cylinders* with Leslie and Mace.

1976 Visits Great Britain and Ireland with Seaver Leslie. An automobile accident in England leaves him, after weeks in the hospital and 256 stitches in his face, without sight in his left eye and with permanent damage to his right ankle and foot. After recuperating at the home of painter Peter Blake, he returns to Providence to serve as head of the Department of Sculpture and the Program in Glass at RISD. Invites Robert Grosvenor, Fairfield Porter, Dennis Oppenheim, Alan Seret, and John Torreano to RISD as visiting artists. Henry Geldzahler, curator of contemporary art at the Metropolitan Museum of Art in New York, acquires three *Navajo Blanket Cylinders* for the museum's collection—a turning point in Chihuly's career. A friendship between artist and curator commences.

1977 Inspired by Northwest Coast Indian baskets he sees at Washington State Historical Society in Tacoma, begins the *Basket* series at Pilchuck, with Benjamin Moore as gaffer. Continues teaching in both Rhode Island and the Pacific Northwest. Charles Cowles curates a show at Seattle Art Museum of works by Chihuly, Italo Scanga, and James Carpenter.

1978 Meets Pilchuck student William Morris, and the two begin a close, eight-year working relationship. A solo show curated by Michael W. Monroe at the Renwick Gallery, Smithsonian Institution, in Washington, D.C., is another career milestone.

1979 Dislocates his shoulder in a bodysurfing accident and relinquishes the gaffer position for good. William Morris becomes his chief gaffer for several years. Chihuly begins to make drawings as a way to communicate his designs. With Morris, Benjamin Moore, and student assistants Michael Scheiner and Richard Royal, he blows glass in Baden, Austria.

1980 Resigns his teaching position at RISD but returns periodically in the 1980s as artist-in-residence. Begins *Seaform* series at Pilchuck. In Providence, creates another architectural installation: windows for Shaare Emeth Synagogue in St. Louis, Missouri. Purchases his first building, the Boathouse, in Pawtuxet Cove, Rhode Island, for his residence and studio.

1981 Begins *Macchia* series, using up to 300 colors of glass. His mother dubs these wildly spotted, brightly colored forms "the uglies," but his friend Italo Scanga eventually christens them *Macchia*, Italian for "spotted."

1982 With William Morris, tours 1,000 miles of Brittany by bicycle in spring. First major catalog is published: *Chihuly Glass*, designed by RISD colleague and friend Malcolm Grear.

1983 Sells the Boathouse in Rhode Island and returns to the Pacific Northwest after sixteen years on the East Coast. Further develops *Macchia* series at Pilchuck, with William Morris as chief gaffer.

1984 Begins work on *Soft Cylinder* series, with Flora C. Mace and Joey Kirkpatrick executing the glass drawings. Honored as RISD President's Fellow at the Whitney Museum in New York and receives Visual Artists Award from American Council for the Arts and the first of three state Governor's Arts Awards.

1985 Returns to Baden, Austria, this time to teach with William Morris, Flora C. Mace, and Joey Kirkpatrick. Purchases the Buffalo Shoe Company building on the east side of Lake Union in Seattle and begins restoring it for use as a primary studio and residence.

1986 Begins *Persian* series with Martin Blank as gaffer, assisted by Robbie Miller. With *Dale Chihuly objets de verre* at Musée des Arts Décoratifs, Palais du Louvre, in Paris, he becomes one of only four Americans to have had a one-person exhibition at the Louvre. Receives honorary doctorates from RISD and University of Puget Sound, Tacoma.

1987 Establishes his first hotshop in Van de Kamp Building near Lake Union in Seattle. Begins working hot glass on a larger scale and creates several site-specific installations, including *Puget Sound Forms* for Seattle Aquarium. Donates permanent collection to Tacoma Art Museum in memory of his brother and father. Begins association with Parks Anderson, commencing with *Rainbow Room Frieze*, an installation at Rockefeller Center in New York City. Marries playwright Sylvia Peto.

1988 Inspired by a private collection of Italian Art Deco glass, begins *Venetian* series. Working from Chihuly's drawings, Lino Tagliapietra serves as gaffer. Chihuly receives honorary doctorate from California College of Arts and Crafts, Oakland.

1989 With Italian glass masters Lino Tagliapietra and Pino Signoretto, and a team of glassblowers at Pilchuck, begins *Putti* series. With Tagliapietra, Chihuly creates

Ikebana series, inspired by travels to Japan and exposure to ikebana masters.

1990 Purchases historic Pocock Building located on Lake Union, realizing his dream of being on the water in Seattle. Renovated and renamed The Boathouse, it serves as studio, hotshop, and archives. Returns to Japan.

1991 Begins *Niijima Float* series with Richard Royal as gaffer, creating some of the largest pieces of glass ever blown by hand. Completes architectural installations, including those for GTE World Headquarters in Irving, Texas, and Yasui Konpira-gu Shinto Shrine in Kyoto, Japan. He and Sylvia Peto divorce.

1992 Begins *Chandelier* series with a hanging sculpture for *Dale Chihuly: Installations 1964–1992*, curated by Patterson Sims at Seattle Art Museum. Designs sets for Seattle Opera production of Debussy's *Pelléas et Mélisande*, premiering in 1993. The *Pilchuck Stumps* are created during this project but not widely exhibited.

1993 Begins *Piccolo Venetian* series with Lino Tagliapietra. Alumni Association of University of Washington names him Alumnus Summa Laude Dignatus, its most prestigious honor. Creates *100,000 Pounds of Ice and Neon*, a temporary installation in Tacoma Dome, attended by 35,000 visitors in four days.

1994 *Chihuly at Union Station*, five installations for Tacoma's Union Station Federal Courthouse, is sponsored by the Executive Council for a Greater Tacoma and organized by Tacoma Art Museum. Supports Hilltop Artists, a glassblowing program in Tacoma for at-risk youths, created by friend Kathy Kaperick. Within two years, the program partners with Tacoma Public School District. Discussions begin on a project to build Museum of Glass on Thea Foss Waterway in Tacoma and design Chihuly Bridge of Glass, to connect the museum to Tacoma's university district.

1995 *Cerulean Blue Macchia with Chartreuse Lip Wrap* is added to the White House Collection of American Crafts. *Chihuly Over Venice* begins with a glassblowing session in Nuutajärvi, Finland, and subsequent blow at Waterford Crystal factory, Ireland. Creates *Chihuly a Spoleto*, an installation for 38th Spoleto Festival of the Two Worlds, in Spoleto, Italy. Receives honorary doctorate from Pratt Institute, New York.

1996 After a blow in Monterrey, Mexico, *Chihuly Over Venice* culminates with fourteen *Chandeliers* installed all over Venice. *Chihuly Over Venice* begins national tour at Kemper Museum of Contemporary Art in Kansas City, Missouri. Chihuly purchases a building in Seattle's Ballard neighborhood for use as mock-up and studio space. Creates a major installation for Academy of Motion Picture Arts and Sciences Governor's Ball after Academy Awards ceremony in Hollywood, California. Creates his first permanent outdoor installation, *Icicle Creek Chandelier*, for Sleeping Lady resort in Leavenworth, Washington. Receives honorary doctorate from Gonzaga University, Spokane, Washington.

1997 Expands work with experimental plastics he calls Polyvitro in his newly renovated Ballard Studio. *Chihuly* is designed by Massimo Vignelli and copublished by Harry N. Abrams, Inc., New York, and Portland Press, Seattle. An installation of Chihuly's work opens at Hakone Glass Forest, Ukai Museum, in Hakone, Japan. Chihuly and his team invite local high school students to photograph a blow and installation at Vianne factory in France.

1998 Participates in Sydney Arts Festival in Australia. A son, Jackson Viola Chihuly, is born February 12 to Dale Chihuly and Leslie Jackson. Two large *Chandeliers* are created for Benaroya Hall, home of Seattle Symphony. Chihuly's largest sculpture to date, *Fiori di Como*, is installed in Bellagio Resort lobby in Las Vegas. Creates a major installation for Atlantis on Paradise Island, Bahamas. PBS stations air *Chihuly Over Venice*, the nation's first high-definition television (HDTV) broadcast.

1999 Begins *Jerusalem Cylinder* series with gaffer James Mongrain in concert with Flora C. Mace and Joey Kirkpatrick. Chihuly mounts a challenging exhibition, *Chihuly in the Light of Jerusalem 2000*, for which he creates fifteen installations within an ancient fortress, now Tower of David Museum of the History of Jerusalem. Travels to Victoria and Albert Museum, London, to unveil eighteen-foot *Chandelier* gracing its main entrance. Returns to Jerusalem to create a sixty-foot wall from twenty-four massive blocks of ice shipped from Alaska.

2000 Designs and exhibits *Crystal Tree of Light* for White House Millennium Celebration; it will be installed later at Clinton Presidential Center, Little Rock, Arkansas, in 2004. Creates *La Tour de Lumière* sculpture for *Contemporary American Sculpture* exhibition in Monte Carlo. More than a million visitors enter Tower of David Museum to see *Chihuly in the Light of Jerusalem 2000*, breaking world attendance record for a temporary exhibition during 1999–2000. Receives honorary doctorate from Brandeis University. *Chihuly Projects* is published by Portland Press and distributed by Harry N. Abrams, Inc.

2001 *Chihuly at the V&A* opens at Victoria and Albert Museum, London. Groups a series of *Chandeliers* for the first time, as an installation for Mayo Clinic in Rochester, Minnesota. Receives honorary doctorate from University of Hartford, in Connecticut. Presents his first major glasshouse exhibition, *Chihuly in the Park: A Garden of Glass*, at Garfield Park Conservatory, Chicago. Artist Italo Scanga dies after more than three decades as friend and mentor.

2002 Creates installations for Olympic Winter Games in Salt Lake City, Utah. Chihuly Bridge of Glass, conceived by Chihuly and designed in collaboration with Arthur Andersson of Andersson•Wise Architects, is dedicated in Tacoma.

2003 Begins *Fiori* series with gaffer Joey DeCamp for opening exhibition at Tacoma Art Museum's new building. TAM designs a permanent installation for its Chihuly collection. *Chihuly at the Conservatory* opens at Franklin Park Conservatory, Columbus, Ohio. *Chihuly Drawing* is published by Portland Press.

2004 Orlando Museum of Art and Museum of Fine Arts, St. Petersburg, Florida, become first museums to collaborate and present simultaneous major exhibitions of his work. Presents glasshouse and outdoor exhibition at Atlanta Botanical Garden.

2005 Marries Leslie Jackson. Mounts major garden exhibition at Royal Botanic Gardens, Kew, outside London. Exhibits at Fairchild Tropical Botanic Garden, Coral Gables, Florida.

2006 Mother, Viola, dies at age ninety-eight in Tacoma. Begins *Black* series with a *Cylinder* blow. Presents exhibitions at Missouri Botanical Garden, St. Louis, and New York Botanical Garden. *Chihuly in Tacoma*—hotshop sessions at Museum of Glass—reunites Chihuly and glassblowers from important periods of his career. A film, *Chihuly in the Hotshop*, documents this event.

2007 Exhibits at Phipps Conservatory and Botanical Gardens, Pittsburgh. Creates stage set for Seattle Symphony's production of Béla Bartók's opera *Bluebeard's Castle*.

2008 Presents major exhibition at de Young Museum, San Francisco. Returns to his alma mater with an exhibition at RISD Museum of Art. Exhibits at Desert Botanical Garden in Phoenix.

2009 Begins *Silvered* series. Mounts garden exhibition at Franklin Park Conservatory, Columbus, Ohio. Participates in 53rd Venice Biennale with *Mille Fiori Venezia* installation. Creates largest commission with multiple installations at island resort of Sentosa, Singapore.

2010 Creates temporary installations outdoors at Kennedy Center for Performing Arts in Washington, D.C., and Salk Institute for Biological Studies in La Jolla, California. Presents exhibition at Frederik Meijer Gardens & Sculpture Park in Grand Rapids, Michigan. *Chihuly in Nashville* opens with exhibitions at Cheekwood Botanical Garden and Frist Center for the Arts, along with performances of *Bluebeard's Castle*. The opera, featuring his set, is also performed in Tel Aviv by the Israeli Opera.

2011 Opens exhibitions at Museum of Fine Arts, Boston, and Tacoma Art Museum.

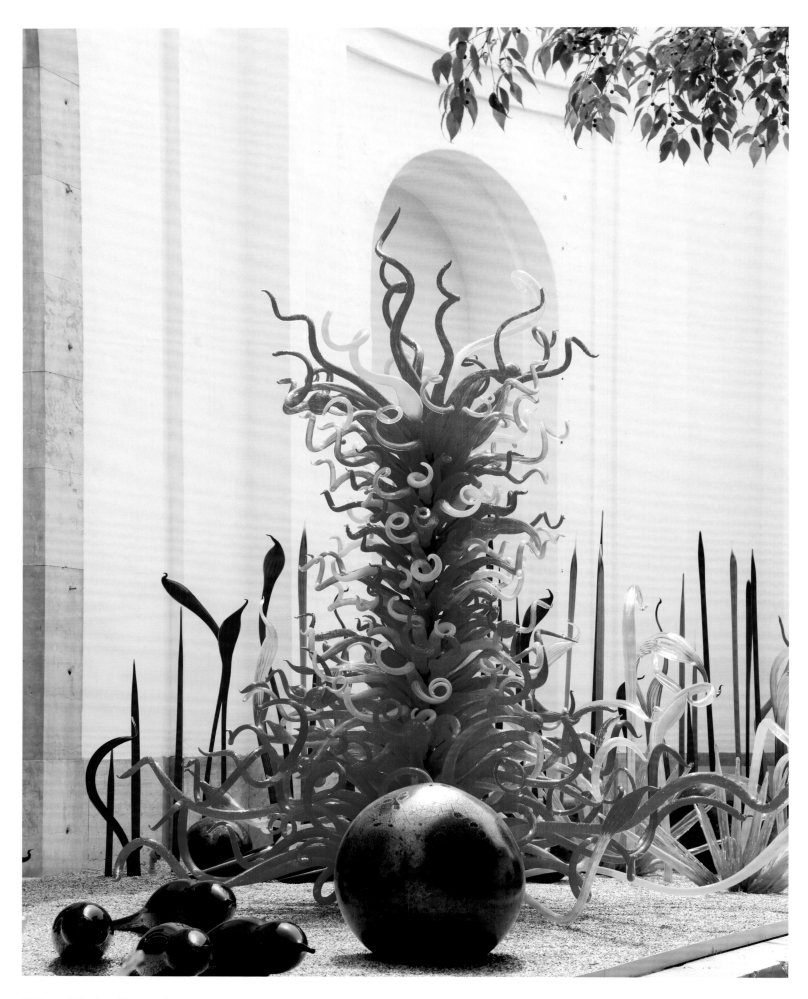

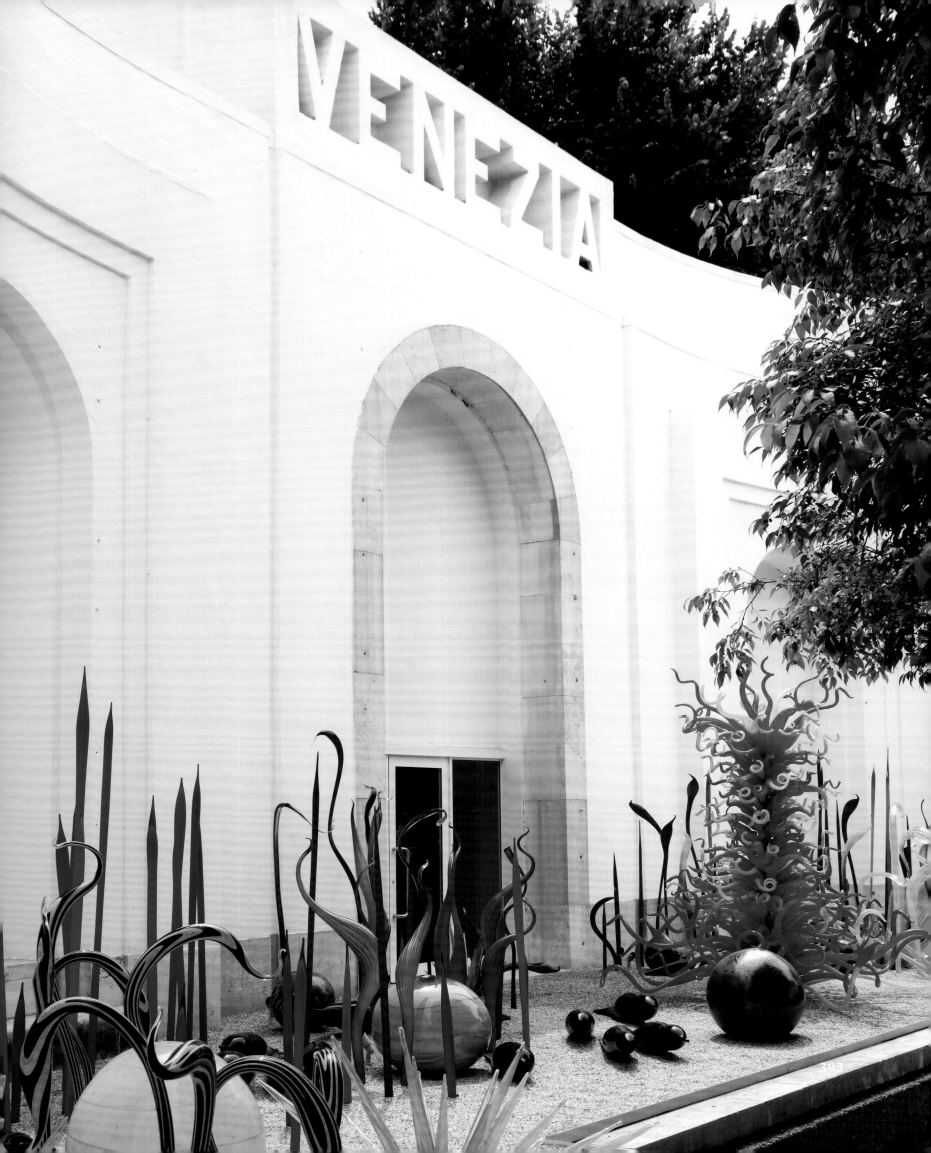

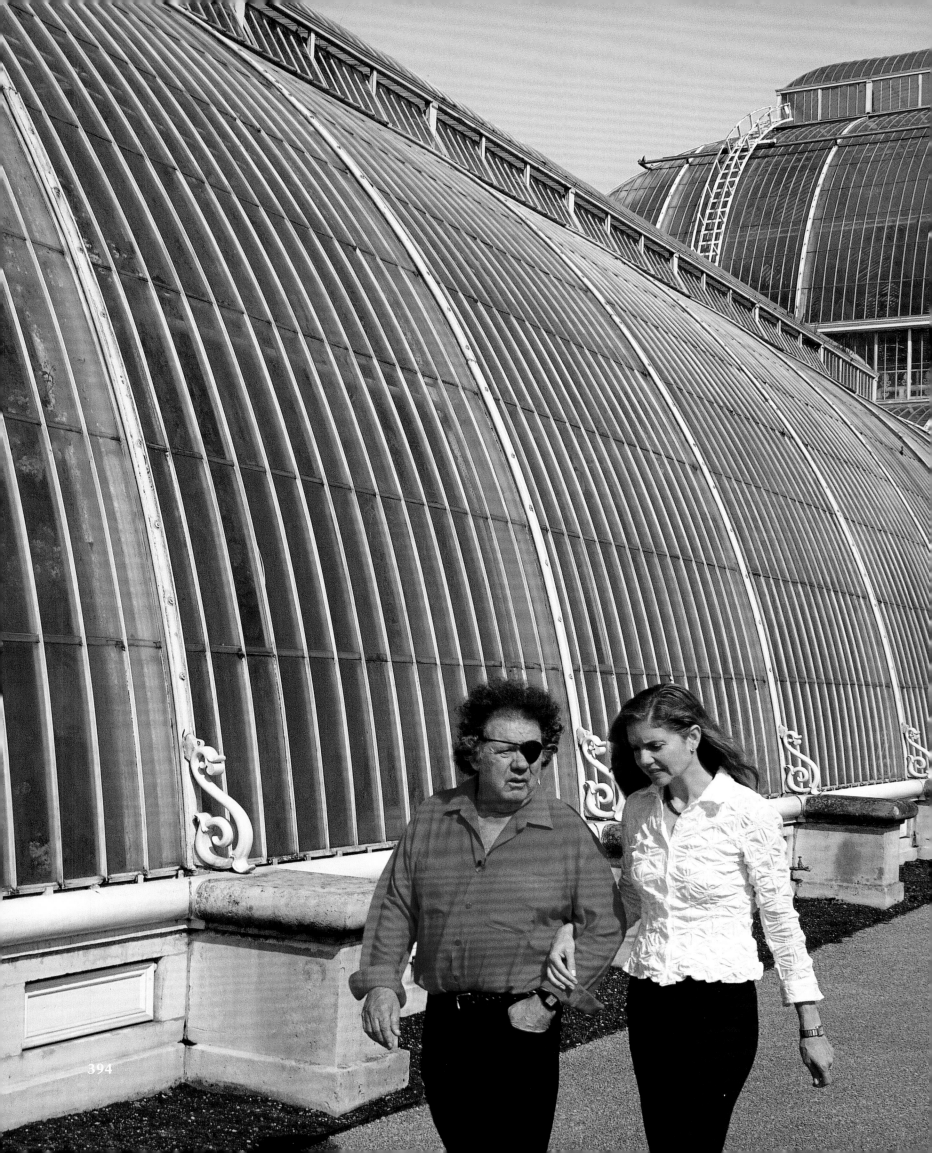

Special Thanks
Dale Chihuly, Leslie Jackson Chihuly, and Billy O'Neill

Design
Janná Giles and Mark McDonnell

Project Editor
Mark McDonnell

Production Manager
Janná Giles

Executive Consultant
Leslie Jackson Chihuly

Photography
Parks Anderson, Heather Arora, Shaun Chappell, Robin Coomer, Ira Garber, Camilo Garza, Louise Heusinkveld, Ron Holt, Koei Iijima, Russell Johnson, Scott M. Leen, John Marshall, Mark McDonnell, Andrew McRobb, Janet Neuhauser, Teresa Nouri Rishel, Terry Rishel, Leon Shabbot, Buster Simpson, Robert Whitworth

Thank You
Ken Clark, Megan Smith, Kavonne Wynn, and the team at Chihuly Studio.
Copyediting by Richard Slovak.

Publisher
Portland Press, Seattle, Washington
www.portlandpress.net
ISBN: 978-1-4197-0103-0

Printed and Bound
In China by Hing Yip Printing Co., Ltd.

Distributor

THE ART OF BOOKS SINCE 1949
115 West 18th Street
New York, NY 10011
www.abramsbooks.com